THE FORMATION OF THE CLASSICAL ISLAMIC WORLD

General Editor: Lawrence I. Conrad

Volume 23

Early Islamic Art and Architecture

THE FORMATION OF THE CLASSICAL ISLAMIC WORLD

General Editor: Lawrence I. Conrad

THE FORMATION OF THE CLASSICAL ISLAMIC WORLD

General Editor: Lawrence I. Conrad

Volume 23

Early Islamic Art and Architecture

edited by
Jonathan M. Bloom

Ashgate

VARIORUM

Published in the series **The Formation of the Classical Islamic World** by

Ashgate Publishing Limited
Gower House, Croft Road
Aldershot, Hampshire
Great Britain

Ashgate Publishing Company
131 Main Street
Burlington, Vermont 05401–5600
USA

ISBN 0–86078–705–2

British Library CIP Data
Early Islamic Art and Architecture. – (The Formation of the Classical Islamic
 World 23)
 1. Art, Islamic – History. 2. Architecture, Islamic – History I. Bloom,
 Jonathan M.
 709.1'7671

US Library of Congress CIP Data
Early Islamic Art and Architecture / edited by Jonathan M. Bloom.
 p. cm. – (The Formation of the Classical Islamic World 23)
 Includes bibliographical references.
 1. Art, Islamic. 2. Architecture, Islamic. I. Bloom, Jonathan M.
 II. Series.
 N6260.E18 2000
 709'.17'671–dc21 00–038979

This volume is printed on acid-free paper.

Printed and bound in Great Britain by
St Edmundsbury Press Limited, Bury St Edmunds, Suffolk

THE FORMATION OF THE CLASSICAL ISLAMIC WORLD-23

Contents

Acknowledgments

CHAPTER 1: Translation of: Max van Berchem, "Notes d'archéologie arabe", *Journal Asiatiques* 11 (Paris, 1891), pp. 411–424. Copyright © 1891 by Libraire Orientaliste Paul Geuthner. Translation by Dr. John Smedley; copyright © 2002 by Ashgate Publishing Ltd.

CHAPTER 2: Translation of: Ernst Herzfeld, "Die Genesis der islamischen Kunst und das *Mshattā* Problem", *Der Islam* i (Berlin, 1910), pp. 27–63, 115–144. Copyright © 1910 by Walter de Gruyter GmbH & Co KG. Translation by Dr Fritz Hillenbrand with assistance from Jonathan M. Bloom; copyright © 2002 by Ashgate Publishing Ltd.

CHAPTER 3 Translation of: Ernst Kühnel, "Die 'abbasidischen Lüsterfayencen", *Ars Islamica* i (Ann Arbor, 1934), pp. 149–159. Copyright © 1934 by *Ars Orientalis*. Translation by Christiane J Gruber, with assistance from Jonathan M. Bloom; copyright © 2002 by Ashgate Publishing Ltd.

CHAPTER 4: K.A.C. Creswell, "The lawfulness of Painting in Eaely Islam" *Ars Islamica* xi/xii (Ann Arbor, 1946), pp. 159–166. Copyright © 1946 by *Ars Orientalis*.

CHAPTER 5: Translation of: Jean Sauvaget, "La mosquée et le palais", *La Mosquée omeyyade de Médine* (Paris, 1947), pp. 122–157. Copyright © 1947 by Editions d'Art et d'Histoire. Translation by Matthew Gordon, with assistance from Jonathan M. Bloom; copyright © 2002 by Ashgate Publishing Ltd.

CHAPTER 6: George C. Miles, "*Miḥrāb* and *'Anazah*: A Study in Islamic Iconography", *Archeologia Orientalia in Memoriam Ernst Herzfeld* (Locust Valley, NY, 1952), pp. 156–171. Copyright © 1952 by *Archeologia Orientalia*.

CHAPTER 7: Kurt Weitzmann, "The Greek Sources of Islamic Scientific Illustration", *Archeologia Orientalia in Memoriam Ernst Herzfeld* (Locust Valley, NY, 1952), pp. 244–266. Copyright © 1952 by *Archeologia Orientalia*.

CHAPTER 8: David Storm Rice, "Deacon or Drink: Some Paintings from Samarra Re-examined", *Arabica* v (Leiden, 1958), pp. 15–33. Copyright © 1958 by E.J. Brill.

CHAPTER 9: Oleg Grabar, "The *Umayyad* Dome of the Rock in Jerusalem", *Ars Orientalis* iii (Ann Arbor, 1959), pp. 33–62. Copyright © 1959 by *Ars Orientalis*.

CHAPTER 10: D.G. Shepherd and W. Henning, "*Zandanījī* Identified?", *Aus der Welt der islamischen Kunst, Festschrift für Ernst Kühnel* (Berlin, 1959), pp. 15–40. Copyright © 1935 by Gebrüder Mann Verlag GmbH & Co.

CHAPTER 11: Richard Ettinghausen, "The Throne and Banquet Hall of Khirbat al-Mafjar", *From Byzantium to Sasanian Iran and the Islamic World* (Leiden, 1972), pp. 17–65. Copyright © 1972 by E.J. Brill.

CHAPTER 12: Robert Hillenbrand, "*La Dolce Vita* in Early Islamic Syria: The Evidence of Later *Umayyad* Palaces", *Art Historys* v (Oxford, 1982), pp. 1–35. Copyright © 1982 by Blackwell Publishers.

CHAPTER 13: Estelle Whelan "The Origins of the *Miḥrab Mujawwaf*: A Reinterpretation", *International Journal of Middle East Studies* xvii (Cambridge, 1986), pp. 205–223. Copyright © 1986 by Cambridge University Press.

CHAPTER 14: Jonathan M. Bloom, "Al-Ma'mun's Blue Koran", *Revue des Etudes Islamiques* 54 (Paris, 1986), pp. 59–65. Copyright © 1988 by Librairie Orientaliste Paul Geuthner.

General Editor's Preface

Since the days of Ignaz Goldziher (1850–1921), generally regarded as the founder of Islamic studies as a field of modern scholarship, the formative period in Islamic history has remained a prominent theme for research. In Goldziher's time it was possible for scholars to work with the whole of the field and practically all of its available sources, but more recently the increasing sophistication of scholarly methodologies, a broad diversification in research interests, and a phenomenal burgeoning of the catalogued and published source material available for study have combined to generate an increasing "compartmentalisation" of research into very specific areas, each with its own interests, priorities, agendas, methodologies, and controversies. While this has undoubtedly led to a deepening and broadening of our understanding in all of these areas, and hence is to be welcomed, it has also tended to isolate scholarship in one subject from research in other areas, and even more so from colleagues outside of Arab-Islamic studies, not to mention students and others seeking to familiarise themselves with a particular topic for the first time.

The Formation of the Classical Islamic World is a reference series that seeks to address this problem by making available a critical selection of the published research that has served to stimulate and define the way modern scholarship has come to understand the formative period of Islamic history, for these purposes taken to mean approximately AD 600–950. Each of the volumes in the series is edited by an expert on its subject, who has chosen a number of studies that taken together serve as a cogent introduction to the state of current knowledge on the topic, the issues and problems particular to it, and the range of scholarly opinion informing it. Articles originally published in languages other than English have been translated, and editors have provided critical introductions and select bibliographies for further reading.

A variety of criteria, varying by topic and in accordance with the judgements of the editors, have determined the contents of these volumes. In some cases an article has been included because it represents the best of current scholarship, the "cutting edge" work from which future research seems most likely to profit. Other articles—certainly no less valuable contributions— have been taken up for the skillful way in which they synthesise the *state* of scholarly knowledge. Yet others are older studies that—if in some ways now superseded—nevertheless merit attention for their illustration of thinking or conclusions that have long been important, or for the decisive stimulus they have provided to scholarly discussion. Some volumes cover themes that have emerged fairly recently, and here it has been necessary to include articles from outside the period covered by the series, as

illustrations of paradigms and methodologies that may prove useful as research develops. Chapters from single author monographs have been considered only in very exceptional cases, and a certain emphasis has been encouraged on important studies that are less readily available than others.

In the present state of the field of early Arab-Islamic studies, in which it is routine for heated controversy to rage over what scholars a generation ago would have regarded as matters of simple fact, it is clearly essential for a series such as this to convey some sense of the richness and variety of the approaches and perspectives represented in the available literature. An effort has thus been made to gain broad international participation in editorial capacities, and to secure the collaboration of colleagues representing differing points of view. Throughout the series, however, the range of possible options for inclusion has been very large, and it is of course impossible to accommodate all of the outstanding research that has served to advance a particular subject. A representative selection of such work does, however, appear in the bibliography compiled by the editor of each volume at the end of the introduction.

The interests and priorities of the editors, and indeed, of the General Editor, will doubtless be evident throughout. Hopefully, however, the various volumes will be found to achieve well-rounded and representative syntheses useful not as the definitive word on their subjects—if, in fact, one can speak of such a thing in the present state of research—but as introductions comprising well-considered points of departure for more detailed inquiry.

A series pursued on this scale is only feasible with the good will and cooperation of colleagues in many areas of expertise. The General Editor would like to express his gratitude to the volume editors for the investment of their time and talents in an age when work of this kind is grossly undervalued to the translators who have taken such care with the articles entrusted to them, and to Dr John Smedley and his staff at Ashgate for their support, assistance and guidance throughout.

Lawrence I. Conrad

Introduction

The field of Islamic art and architecture is generally considered to encompass all the visual arts produced in the Islamic lands between the Atlantic and the Indian Oceans, the steppes of Central Asia and the Sahara Desert from the early 7th century to the early 19th. At its broadest, the field can encompass art produced into the 20th century under Muslim patronage in Eastern Europe, the Balkans, West and East Africa, Southeast Asia and Indonesia, and China, as well as in Western Europe and the Americas. For the purpose of this volume of readings, however, in a series about the formative period (ca. AD 600–950) in the Islamic world, the focus has been restricted to the central region between the Nile and the Oxus in the first four centuries of Islam.

During the early period, the forms, techniques, and themes shared by most forms of Islamic art everywhere—such as the spatial organization of the hypostyle mosque, the use of Arabic writing for decoration and the arabesque (geometricised vegetal ornament)—were developed. Despite the enormous geographical reach of the Umayyad and 'Abbāsid caliphates, there is a remarkable consistency to early Islamic art, although some regional differences can already be noted in the formative period. These differences become more apparent in later times when distinct regional centers emerged, particularly in the western Mediterranean, Egypt, Anatolia, Iran, and India. Consequently it becomes much more difficult to characterize a unified tradition of Islamic art, although many features found in the varied regional styles can be traced back to early Islamic art.

The term "Islamic" art immediately invites comparison with such comparable expressions in the history of art as "Christian" or "Buddhist" art and suggests that Islamic art is simply the art associated with the religion of Islam. While some of the visual arts normally considered to be "Islamic" are indeed expressions of the religion, others had little or nothing to do with the faith. Thus the development of the mosque and calligraphy are intimately tied to matters of religion, but the development of the palace and ceramics are quite independent of it, and, as in other times and places, some arts even fly in the face of prevailing religious attitudes. Some scholars have attempted to correct this ambiguity of expression by creating new adjectives, such as "Islamicate", to refer specifically to matters associated with the general culture rather than the religion, but these ungainly neologisms have not been widely accepted.

In Western art there has been a consensus for over two millennia that painting, sculpture and architecture are the "major" forms of art, which are complemented, but not challenged, by such "minor" arts as textiles, ceramics, metalwork, glass, and the arts of the book. In Islamic art, however, this hierarchy does not hold. Although architecture was just as important in the Islamic lands as it was in the West, painting and sculpture, particularly on a large scale, were hardly known. In contrast, the arts of the book, textiles, and ceramics took on unparalleled importance and must be understood as major artistic vehicles, quite apart from the essential role played, for example, by the trade in textiles, fibers, and dyes in medieval Islamic economies.

Our picture of the relative importance of one art or another may be somewhat skewed in the early period, due to the fragile materials from which some forms of art were made as well as the accidents of survival. For example, for millennia, buildings in greater Syria have been built largely of stone while those in Iraq have been built of mud-brick, which is durable only when its weather-resistant covering is maintained regularly. At the same time, settlements in Syria have tended to stay in the same place, while those in Iraq have moved. Thus, many early Islamic structures survive in Syria, but none remains in use in Iraq, although archaeology (which is treated in another volume in this series) has provided much information about Iraqi architecture in the early period. Unlike many other civilizations, where goods buried with the dead provide information about contemporary material culture, under Islam bodies were wrapped only in plain shrouds before burial, and grave goods did not exist. Of the innumerable textiles produced in early Islamic times, pieces have survived only in the dry climates of Egypt and Central Asia or the relative safety of treasuries in European churches and Tibetan monasteries, and it is probable that this sample does not accurately reflect what was originally made. Few survive of the thousands of metal vessels made and used in early Islamic times, for irreparably dented or broken examples—and even good ones—were melted down and refashioned. Only ceramics had to be thrown away when broken. As ceramics can be retrieved by archaeology, more is consequently known about early Islamic ceramics than about, say, textiles from the same period.

Much of the history of Western art has been concerned with the representation of the human figure, but one of the most striking features of Islamic art is the relative unimportance of human representation. While this attitude has often been likened to Byzantine *iconoclasm*, or destruction of images, Allen (1988) has characterized it more accurately as *aniconism*, or avoidance of images. Western scholars have found this lack of interest in representing the human figure decidedly unsettling, and more ink has probably been spilled on this question than perhaps on any other in Islamic art. The absence of human representation in Islamic art is somewhat overstated, and—with a few notable exceptions—examples of human representations can be produced from most

periods and places in Islamic history, although rarely, if ever, from religious contexts.

In contrast to the history of Western art, the study of the history of Islamic art and architecture is barely a century old. Several European intellectual traditions, including the study of ancient Near Eastern languages and antiquities, Orientalism, and the history of art, came together at the end of the 19th century in a new field of inquiry which blossomed in the first decades of the 20th century in the universities and museums of such cities as London, Paris, Geneva, Vienna and Berlin. In addition to lively debates in scholarly journals, great international exhibitions of Islamic art were organized which brought together scholars and the interested public. This heady atmosphere was dispelled in the 1930s, when the rise of Nazism forced intellectual migrations which reconfigured the intellectual map of Europe. Following World War II, the United States emerged, as in many other fields, as the leading center of scholarship in Islamic art, whether in such musuems as the Freer Gallery of Art in Washington, DC and the Metropolitan Museum of Art in New York or such institutions as the University of Michigan and New York and Harvard universities.

Paradoxically, throughout much of this period, the study of the art and architecture of the Islamic lands remained a rare speciality among the people of these lands themselves, where archaeological research and museum collections tended to focus primarily on pre-Islamic periods. Apart from European teachers and administrators based in the Islamic lands, such as Georges Marçais (1876–1962) in Algeria, K.A.C. Creswell (1879–1974) in Egypt, or André Godard (1881–1965) in Iran, only a very few native scholars of international repute emerged in these countries during the period between the wars. Among the exceptions are Zakī Muḥammad Ḥasan (1908–57) of Egypt, who was trained largely in Paris, and Mehmet Aga-Oglu (1896–1949), who trained in Moscow, Istanbul and Berlin before emigrating from Turkey to the United States in 1929. Beginning in the 1970s, however, the transfer of enormous wealth to many oil-rich countries in the Near East led to a new interest and pride in the artistic traditions of the Islamic period. Rich patrons began to amass splendid private collections of Islamic art in the auction-rooms of Europe and return items to their lands of origin, students were sent abroad for training in European and American universities, and throughout the region museums and university programs were expanded. At the dawn of the 21st century the field of Islamic art is no longer the purview of only European and American scholars, as scholars from the Islamic lands seeking to explain their own culture are opening new perspectives and searching for answers to challenging new questions.

The geographical, chronological, technical and intellectual diversity therefore encompassed by the rubric "Islamic art and architecture" has given rise to a vast literature in many languages representing a myriad of intellectual approaches. These span a gamut from the deductive and archaeological or

philological to the inductive and philosophical or mystical. They are intended
for audiences ranging from the general public to such specific groups as histori-
ans of Islamic art, art historians, historians, orientalists, mystics, and Muslims,
to name but a few. The articles selected for inclusion in this volume, therefore,
could not possibly represent a definitive list of major works. Rather, the deci-
sion to include them has been governed by several—often contradictory—criteria,
namely to present the modern reader with a selection of major articles (and
chapters) by noted scholars in the field as well as to provide a reasonably
coherent introduction to some of the major problems and approaches used to
study early Islamic art. The development of Islamic religious and secular archi-
tecture occupies the largest place in this selection, along with the development
and interpretation of architectural decoration. Other selections deal with such
specific media as ceramics or the arts of the book, but early Islamic metalwork
is not represented here because no apposite article of the appropriate quality
and length came immediately to mind. In addition, the works of many notable
scholars of Islamic art, such as Georges Marçais and André Godard, to name
only two, will not be found here because no example of their work would fit
within the restricted chronological and geographic scope of this anthology. For
practical reasons, the authors of the following essays are discussed in the order
in which their essays were published.

Although European interest in "Moorish" and "Mohammedan" art can be
found throughout the 19th century, the modern study of Islamic art can be
traced to the work of the Swiss scholar Max van Berchem (1863–1921). The
scion of a wealthy Genevan family, he was educated as a philologist and histo-
rian at several European universities. After traveling to Egypt, Palestine and
Syria in 1889, he developed the idea of "Arab archaeology" (archéologie arabe).
For him this was the historical study of "monuments", by which he meant
architecture, painting, decorative arts, inscriptions, coins, seals or manuscripts
themselves in the lands where Arabic was spoken. He saw these "monuments"
not as isolated examples of art but as veritable historical documents which
would reveal the history of the Islamic lands.

Van Berchem's definition of the field and a masterful attempt to explore it
appeared in a series of articles entitled "Notes d'archéologie arabe", published
in the *Journal asiatique* between 1891 and 1904, of which the introduction is
presented in the present volume. In these articles, he reported on the inscrip-
tions he collected from buildings dating to the Ṭūlūnid and Fāṭimid periods
(9th-12th centuries) in Cairo, as well as from inscribed objects preserved in the
Museum of Arab (now Islamic) Art there. At the same time, van Berchem also
proposed the compilation of a corpus of Arabic inscriptions as well as a manual
of Islamic art. He persuaded the French Academy to sponsor the *Corpus
inscriptionum arabicarum*, and from 1894 he contributed volumes or parts of
volumes on the inscriptions of Egypt, Jerusalem, Syria, and Anatolia. Van
Berchem's project for a manual of Islamic art was eventually realized by several

French scholars. Henri Saladin and Gaston Migeon published the *Manuel d'art musulman* (Paris, 1907), followed by Georges Marçais's volume on western Islamic architecture, *Manuel d'art musulman: l'Architecture. Tunisie, Algérie, Maroc, Espagne, Sicile* (Paris, 1926–27), itself in two volumes and revised by the author as *L'Architecture musulmane d'occident* in 1954.

Van Berchem's premature death meant that he did not have many intellectual heirs. His daughter Marguerite collaborated with K.A.C. Creswell on a study of the mosaic decoration of the Dome of the Rock in Jerusalem and the Umayyad Mosque of Damascus. The French historian and epigrapher Gaston Wiet (1887–1971) saw van Berchem's volumes of the *Corpus* through the press of the Institut Français d'Archéologie Orientale in Cairo. Wiet himself contributed an additional volume on Egyptian inscriptions to the *Corpus*. He was also an editor of the related chronological publication of Arabic epigraphy (*Répertoire chronologique d'épigraphie arabe*) and published many catalogues of the Museum of Arab (later Islamic) Art in Cairo, of which he had been appointed director by King Fuad I in 1926.

In contrast to francophone scholarship on Islamic art, which was equally at home in Egypt, Algeria and Paris, German scholarship was firmly focussed on Berlin, where the university and Kaiser-Friedrich (now Pergamon) Museum were centers of art-historical scholarship. The outstanding intellectual personality for the study of Islamic art throughout the first half of the 20th century was the German archaeologist and historian Ernst Herzfeld (1879–1948), who also trained as an architect, in which capacity he served the German excavations at Assur. These early experiences led to a career in which he presented Islamic culture as but one period in the long and brilliant history of civilization in the lands of the Near East. Upon returning from a trip to Iran and the acceptance of his Ph.D. thesis on Pasargardae, Herzfeld embarked on another voyage (1907–08) with his wealthy colleague from Berlin, the archaeologist, art historian, and collector Friedrich Sarre (1865–1945).[1] They traveled through Mesopotamia to choose a suitable Islamic site for excavation, eventually settling on Sāmarrā, the capital of the 'Abbāsid caliphs in the 9th century. The account of their voyage was eventually published in four large volumes as *Archäologische Reise im Euphrat- und Tigris-Gebiet* (Berlin, 1911–20), which remains as timely today as when it was published. The Sāmarrā excavations (1911–13), which were interrupted by World War I, were only incompletely published during Herzfeld's professorship in Berlin (1920–35). Forced to emigrate to London in 1934, he eventually settled in the United States in 1936. Herzfeld's summary volume, *Geschichte der Stadt Samarra* (Hamburg, 1948) was published posthumously, and the projected volume on the architecture of the site never appeared.

[1] On Sarre, see Richard Ettinghausen, "Friedrich Sarre on the Occasion of His One-Hundreth Birthday", *Pantheon* 23 (1965), pp. 318–19 and *Richard Ettinghausen: Islamic Art and Archaeology (Collected Papers)*, ed. M. Rosen-Ayalon (Berlin, 1984), pp. 1270–71.

While employed in the Prussian State Museums and (from 1909) as Privatdozent for Historical Geography at the University of Berlin, Herzfeld, like many of his contemporaries in Berlin, was occupied with establishing the correct date of the palace at Mshattā. This ruined structure, known in the West since its first publication in 1873, had stood south of Amman near the proposed route of the Ḥijāz railroad, which German engineers were building for the Ottoman sultan Abdülhamid II (r. 1876–1909). The engineers proposed to use stones from the palace, including the beautifully carved façade, for the railbed, but the façade was saved from destruction when the Sultan offered it to his friend Kaiser Wilhelm II, who presented the Sultan with a fountain (erected in Istanbul's Atmeydan) in return. At the urging of the Viennese art-historian Joseph Strzygowski, Wilhelm von Bode, the director of the Pergamon Museum in Berlin, accepted the façade for the museum as a work of late-antique art to complement and complete the series of great structures reconstructed there.[2] Because Mshattā lacked any inscriptions, scholars had widely varying opinions about its date, believing it to be Sasanian, Byzantine, Ghassānid, Lakhmid or possibly Umayyad. Strzygowski, for example, favored an attribution to the Ghassānids, the Christian Arab dynasty that ruled in Syria from ca. 490 to the Muslim conquest in the 7th century, while Max van Berchem, admittedly more an epigrapher than an art-historian, favored an attribution to the Lakhmids, the pre-Islamic dynasty (ca. 300–ca. 600) that ruled from Ḥīra in Iraq. In Herzfeld's article, "Die Genesis der islamischen Kunst und das Mshatta-Problem", presented here for the first time in an English translation, the thirty-one-year-old author masterfully argued that the palace had to be a work of Islamic art. Furthermore, he dated it precisely to the reign of al-Walīd II (r. 743–44) and hypothesised how many workers from each region were employed there.

While some of Herzfeld's specific arguments—such as the number of workers employed, the Ayyūbid date of the drum mosaics at the Dome of the Rock, or the primacy of Ṭūlūnid Egyptian ornament—have been revised by later publications including his own from Sāmarrā, Herzfeld's article is still notable for its sophisticated methodology and broad frame of reference. Rather than compare an endless series of details from Mshattā with other places, Herzfeld launched a bold new attack on the problem. Working from what he believed to be securely dated monuments, he devoted the first part of his article to establishing the general characteristics of early Islamic art. In the second part of his article he showed how all the features of Mshattā, from its techniques and materials of construction to its forms of decoration, were consistent only with an Islamic attribution. The range of examples Herzfeld cites is astounding: he had just

[2] For the history of the Mshattā façade, see Volkmar Enderlein, and Michael Meinecke, "Grabern—Forschen—Präsentieren. Probleme der Darstellung vegangener Kulturen am Beispiel der Mschatta-Fassade", *Jahrbuch der Berliner Museen* 34 (1992):137–172.

returned from his trip with Sarre through Mesopotamia, and some of the great monuments of Islamic art, such as the Khāṣṣakī *miḥrāb* and the shrine of Imām Dur, were published here for the first time. Herzfeld's wide-ranging article also prefigures many directions that his later scholarship would take, suggested by his excurses on Ayyūbid woodwork or the role of orthostats in ancient Near Eastern art.

The period before World War I was, as Herzfeld noted, a time of great excitement and exponential growth in Islamic studies: van Berchem's *Corpus* and the *Encyclopaedia of Islam* had begun to appear, and a critical mass of information, particularly visual, was now available. At the beginning of the 21st century the field of Islamic art is seen as somewhat peripheral to the central concerns of art history, but Herzfeld's article shows how central the study of Islamic art was to the theoretical activities of leading European art-historians a century ago. For example, Alois Riegl and Joseph Strzygowski were tackling such thorny questions as the nature of ornament and the origins of the arabesque, and Islamic art, which was seen as standing both between ancient and medieval and eastern and western art, was uniquely positioned to offer a wide range of pertinent examples for their investigations.

Herzfeld's contemporary in Berlin, Ernst Kühnel (1882–1964), was trained as an art-historian in Paris, Vienna, Munich, and Heidelberg. After traveling in North Africa and Spain, he devoted himself to the study of Islamic art, in 1909 becoming Sarre's assistant in Berlin and excavating at Sāmarrā in 1912. After Sarre's retirement in 1931, Kühnel succeeded him as director of the Islamic Museum, where he remained for two decades. After Herzfeld left Germany in 1935, Kühnel also taught at the University of Berlin until 1954. Throughout his career, Kühnel's interests focused primarily on the decorative arts of Islam, about which he developed an encyclopaedic knowledge, summarized in his *Islamische Kleinkunst* (Berlin, 1925; reprinted 1963; English translation by K. Watson as *The Minor Arts of Islam* [Ithaca, NY, 1971]). He is perhaps best known for his work on textiles, but his other works, such as the monumental catalogue of Islamic ivories (1971), remain standard works.[3]

Kühnel's short article on 'Abbāsid lusterwares, which appeared in the first (1934) volume of *Ars Islamica*, remains the standard work on the subject, despite the passage of some six decades. The journal, published by the Seminary in Islamic Art at the University of Michigan, Ann Arbor, was the first periodical devoted exclusively to Islamic art, and reflected growing interest in the subject as well as the legacy of Charles Lang Freer, a Michigan industrialist and collector who had also endowed the Freer Gallery of Art in Washington, DC.

[3] Richard Ettinghausen, "In Memoriam Ernst Kühnel (26.X.1882–5.VIII.1964)", *Madrider Mitteilungen* 6 (1965): 215–36 and *Richard Ettinghausen: Islamic Art and Archaeology (Collected Papers)*, ed. M. Rosen-Ayalon (Berlin, 1984), pp. 1273–94.

The first issue of *Ars Islamica* contained articles by Strzygowski, Sarre, Wiet, and others, as well as reviews of recent publications.

Ceramics played an unusually important role among the arts of the Islamic lands. Earthenwares, made from clay (fine sediments) carried by such great rivers as the Nile, the Tigris, and the Euphrates, had been produced throughout the region since time immemorial and used for such practical functions as storing water and cooking. While the technique of glazing, or covering the porous ceramic surface with a thin but impermeable glassy layer, had already been developed under the Parthians and Sasanians, the decorative potential of colored glazes began to be exploited only in Islamic times, when both alkaline and lead-fluxed glazes allowed a wide range of colors to be used, often simultaneously. The technique of overglaze luster decoration is one of the most important contributions of artisans in the Islamic lands to the global history of ceramics. While it now seems clear that the technique was developed in Egypt or Syria, perhaps already in pre-Islamic times, for decorating glass and then adapted for glazed ceramics, a fierce debate raged when Kühnel was writing whether the technique was originally Egyptian, Iraqi, or Iranian, since luster ceramics had been discovered at several widely-dispersed sites.

Kühnel wisely decided to base his argument on different grounds. Lacking kiln sites and wasters (misfired pieces that would have been discarded at the place of production), Kühnel soberly demonstrated that the "'Abbāsid" type could not have been produced in Iran because these pieces differed from Iranian ceramics in body and glaze. Similarly he excluded an Egyptian origin on technical grounds, arguing that the large numbers of pieces found in Egypt were all exports from Iraq, although the technique was reintroduced into Egypt in the late 10th century. Having established an Iraqi origin for the type in the 9th and 10th centuries, Kühnel then proceeded to define and date four groups on stylistic grounds. The first, with multicolored luster decoration, he dated before ca. 850. The second, which he compared to the tiles set around the *miḥrāb* of the congregational mosque in Kairouan (Tunisia) and which used a palette of brown, yellow, gold, and bottle-green, he dated ca. 860. A third group, with yellow and reddish brown decoration, could be dated ca. 870, while the fourth group, with representations of animals and men, had to date from the 10th century.

K.A.C. Creswell (1879–1974) is best known as *the* historian of early Islamic and Egyptian architecture from his massive green tomes, *Early Muslim Architecture* (Oxford, 1932–40) and *The Muslim Architecture of Egypt* (Oxford, 1952–59). Trained as an electrical engineer in England, Creswell became fascinated with Persian and Indian architecture at an early age. He was posted to Egypt during World War I, after which he was appointed inspector of monuments for areas formerly in Ottoman territory. He returned to Egypt in 1920, where he remained for most of his life, working methodically through the history of Islamic architecture from its beginnings to the Mamlūk period in

Egypt.[4] Creswell's 1946 article on the lawfulness of painting in early Islam, the sixth selection in this volume, represents not a temporary shift of interest to one of the perennial problems in Islamic art, but rather a brief excursus. A revised and supplemented version of his essay about Quṣayr 'Amra for *Early Muslim Architecture*, written in preparation for the revised edition of 1969, Creswell's essay perfectly epitomizes both the subject and his approach.

The small bath house known as Quṣayr 'Amra had been rediscovered by the Austro-Hungarian explorer Alois Musil in 1898 in the steppe east of Amman, now in Jordan. The appearance of Musil's publication, *Kusejr Amra* (Vienna, 1907) brought to wide attention the existence of large-scale paintings from the early Islamic period, seemingly contradicting everything previously said about representational art and Islam, as well as providing a fixed point against which such problematic monuments as Mshattā could be measured. The remarkable series of figural murals on the interior of the building showed that there could not have been any prohibition of images during the Umayyad period, when the building was erected and decorated. Creswell's method was to assemble all the evidence, represented by a massive bibliography of some 50 items taken from the past century and a half, in chronological order. Carefully examining each item in turn, Creswell produced evidence for figural representations in early Islamic times but showed that the *ḥadīth* (Prophetic traditions) were uniformly hostile to representations of living things. Creswell concluded that the Islamic prohibition of images only grew gradually as a result of the "inherent temperamental dislike of Semitic races for representational art, ... the influence of important Jewish converts, and ... the fear of magic." His suggestion that most of these traditions appeared in the second half of the 8th century, thereby reflecting 8th-century concerns about images rather than actual events of Muḥammad's life, directly challenged the views of Sir Thomas W. Arnold (1864–1930). Arnold, whose *Painting in Islam* (1928) was one of the first western books on the subject of images in Islam, believed that at least some of these *ḥadīth* actually reflected events in the time of the Prophet. In subsequent years Creswell's somewhat simplistic and racialist views on this complex problem have been modified by the more nuanced work of several scholars, most notably Rudi Paret and Oleg Grabar,[5] but his meticulous collecting of information remains a foundation for further research.

No sharper contrast to Creswell's positivist approach can be found than in the work of the French scholar, Jean Sauvaget (1901–50). Although Sauvaget never actually excavated, he considered himself more of an archaeologist than an art-historian. Like van Berchem, he believed that archaeology represented an approach rather than a particular discipline, and also like van Berchem, Sauvaget

[4] See *Studies in Islamic Art and Architecture in Honour of Professor K.A.C. Creswell* (Cairo, 1965) and *Muqarnas*, viii (1991) [entire issue entitled *K.A.C. Creswell and His Legacy*].

[5] See bibliography.

saw inscriptions as one of the keys to understanding Islamic art. After studying Arabic in Paris, he became a research fellow at the Institut Français in Damascus in 1924 and its secretary general in 1929. He returned to Paris ten years later to teach Islamic history, Islamic art, and Arabic. He was elected to the Collège de France in 1946, but his brilliant career ended prematurely when he was killed in an automobile accident.

Most of Sauvaget's work concerns the Islamic monuments of Syria; his doctoral thesis on Aleppo, the result of thirteen years' work there, is a brilliant and influential work of urban history, for the author, unlike many of his contemporaries, combined a thorough knowledge of the monuments with a complete knowledge of the historical sources in the original languages. Following Henri Lammens' books on Mu'āwiya and the Umayyads, Sauvaget believed that much of early Islamic culture derived from the synergetic encounter of Muslim Arabs from Arabia with the more sophisticated late antique culture of Syria.[6] This view is evident in the chapter from his extraordinary book on the Umayyad mosque of Medina, from which a chapter is presented in the present volume. While Sauvaget's specific conclusions have been questioned by later scholars (see, for example Estelle Whelan's article in this volume), his method continues to inspire generations of art-historians to search beyond the physical appearance of forms to reveal the meanings behind them.

In this chapter, Sauvaget looked at the group of early Islamic mosques within the context of early Islamic architecture in general, particularly palaces, and saw that both used basilican plans. He found evidence in the sources for the development of an elaborate audience ceremonial under the Umayyads. This evidence contradicted widely-held Orientalist theories about the simplicity of the Umayyads, who were thought to be descendants of desert-dwelling Bedouin Arabs, in contrast to the elaborate ceremonial developed under the 'Abbāsids, Arabs thought to have been "corrupted" by Persian influences. Sauvaget interpreted the basilican halls in palaces as the equivalent to the main reception rooms of private houses. He saw Friday communal worship in the congregational mosque as a largely secular ceremony, with the sermon (Arab. *khuṭba*) as an essentially political and therefore secular act. This comparison was reinforced by his equation of the *minbar* (pulpit) with the throne and the *miḥrāb* with the palatine apse.

Although the *miḥrāb* is a ubiquitous feature of Islamic architecture, its actual meaning and early history are surprisingly obscure, and even Sauvaget's grand theorizing about its meaning was unfortunately short on concrete examples. He did not know of the existence of an early representation of a *miḥrāb* on a rare silver coin minted just before the mosque of Medina was reconstructed. This coin was the subject of a seminal article contributed by the American scholar

[6] For a fascinating assessment of Sauvaget's work, see R. Stephen Humphreys, *Islamic History: A Framework for Inquiry* (Minneapolis, 1988; rev. ed., Princeton, NJ, 1991), pp. 234–38.

George C. Miles (1904–75), the dean of Islamic numismatics, to the volume of essays written in Herzfeld's memory.

Numismatics had played an early role in the development of the study of Islamic art, for the first Islamic objects to arouse western scholarly interest in the 18th century were coins found in Scandinavia, northern Germany and Russia that had been traded in the early Middle Ages.[7] Because most Islamic coins are entirely epigraphic, their primary value is as documents for political and administrative history and to illustrate the development of Arabic writing. Occasionally, however, numismatics and the history of art come together, particularly when coins were decorated with images, as in the case of the rare Umayyad coin minted in AH 75 (AD 695–96). Its reverse depicts a beribboned lance within an arch supported by a pair of spiral columns. Miles identified the lance as the Prophet's 'anaza and compared the coin to a series of Greek imperial coins which depicted images sheltered by ciboria. He compared the niche to other representations of niches in early Islamic art, and suggested that the portrait on the obverse of the coin represented the ruling caliph, 'Abd al-Malik. Although the specific coin type was quickly abandoned, it is important evidence for the fluidity of the official attitude towards images in the early Islamic period and for the general evolution of early Islamic art.

Herzfeld's memorial volume also contained an important contribution by the Byzantinist Kurt Weitzmann (1904–93), who like Herzfeld had trained at several European universities before emigrating to the United States. Like other scholars of his generation, Weitzmann viewed Islamic art as but one facet in the interconnected history of medieval art in the period between ancient and modern times.[8] While a student in Berlin, Weitzmann had not been able to take courses with Herzfeld—who, he later said, was always excavating at Persepolis or Sāmarrā or elsewhere—but later, when both were at the Institute for Advanced Study in Princeton, they became close colleagues. While working on the iconography of some Central Asian silver vessels, Weitzmann had discussed relationships between Hellenic and Oriental art with Herzfeld, and in his article in Herzfeld's memory, Weitzmann traced illustrations in Islamic scientific manuscripts to their classical and Byzantine origins. Although the earliest Islamic scientific manuscripts with illustrations to survive date to the 11th century, there surely were earlier examples that have not survived, and Weitzmann's article underscores how closely related and interdependent the traditions were. Indeed, Weitzmann concluded that the basic differences were

[7] The first scholarly book on Islamic numismatics was G.J. Kehr, *Monarchiae Asiaticae-Saracenicae Status qualis VIII et IX ... seculo fuit, ex nummis argenteis prisca Arabum scriptura kufica ... cusis, et nuper ... effossis, illustratus* (Leipzig, 1724). The author correctly read the kufic inscriptions on coins and provided commentary.

[8] For Weitzmann's life and career, see his memoir, *Sailing with Byzantium from Europe to America: The Memoirs of an Art Historian* (Munich: Editio Maris, 1994).

not between Greek and Arabic manuscripts but between classical and medieval ones, whatever language they were written in.

The British scholar David Storm Rice (1913–62), was born in Austria, raised in Palestine, and educated in Italy and France, where he earned his PhD in 1937 on Aramaic-speaking communities in Syria. Under the influence of Leo A. Mayer and Gaston Wiet, Rice developed an interest in Islamic art, and after World War II he joined the school of Oriental and African Studies at the University of London, where he became a professor in 1959. Although best known for his work on Islamic metalwork,[9] Rice excavated the medieval site of Ḥarrān in south-eastern Turkey and wrote on manuscripts and painting. His delightful article, "Deacon or Drink," reflects his wide interests and expertise, for it uses medieval Arabic poetry to explain some painted jars which Herzfeld had excavated at Sāmarrā. Herzfeld had surmised that the jars, bearing representations of figures and enigmatic Arabic inscriptions, were idols smashed and buried following the trial and crucifixion of Afshīn, the Soghdian general and Manichaean heretic, in 841, but Rice suggested instead that the vessels were jars for wine consumed in the caliph's palace. The jars, decorated and labeled like modern wine bottles, were smashed when their contents had been consumed. Rice's erudite but rather light-hearted article, liberally sprinkled with quotes from contemporary Arabic poetry, provides a sharp contrast to Herzfeld's high seriousness and reveals an often-overlooked aspect of Islamic art, namely frivolity and humor. While official doctrine abhored the consumption of wine, contemporary poetry gives ample evidence that, just as in modern times, what people did was not always what their religion told them to do.

Among the scholars trained in the United States following World War II was Oleg Grabar (1929–). Born in France and educated in Paris and at Harvard and Princeton, where he earned his PhD in 1955, Grabar, like Richard Ettinghausen, was responsible for introducing Islamic art to a large number of Americans in the post-war years.[10] Grabar, teacher to a great number of undergraduate and graduate students at the University of Michigan and at Harvard, retired in 1990 to the Institute for Advanced Study in Princeton. His early interest in the art of the Umayyads is represented by his masterful study of the Dome of the Rock, published in *Ars Orientalis*, the successor journal to *Ars Islamica*. The Dome of the Rock, the first example of Islamic architecture, is one of the most familiar buildings in the world. The subject of many studies, including several chapters by

[9] See for example, *The 'Baptistère de Saint-Louis'* (Paris, 1953); *The Wade Cup in the Cleveland Museum of Art* (Paris, 1955); and "Studies in Islamic Metalwork", *Bulletin of the School of Oriental [and African] Studies*, xiv (1952): 564–78; xv (1953): 61–79, 229–38, 489–503; xvii (1955): 206–31; xxi (1958): 225–53.

[10] For Oleg Grabar, see *Muqarnas*, 10 (1993), a collection of essays in his honor with bibliography. Additional bibliography to date is found in the *Eleventh Presentation of the Charles Lang Freer Medal, April 5, 2001* (Washington, DC: Freer Gallery of Art and Arthur M. Sackler Gallery, 2001).

Creswell and Marguerite van Berchem, it remained (and remains) an enigmatic structure. The reasons usually given for its construction were clearly not supported by the evidence of the building itself, most notably by its mosaic decoration representing jewels and crowns and its long Koranic inscriptions. Grabar's method combined several approaches in earlier scholarship, such as van Berchem's reliance on epigraphy and Sauvaget's inductive and historical techniques. Grabar delved into Umayyad history and the history of Jerusalem and examined the form and decoration of the building itself to propose that it was erected neither to replace the Kaaba nor to commemorate Muḥammad's ascension, but rather to represent physically the new presence of Islam in the place most holy to the older revelations of Judaism and Christianity.

In addition to their artistic role, textiles played an economic role in medieval Islamic society comparable to that played by the iron and steel industries in modern industrial societies. Textiles, from the coarsest tent fabrics to the finest linens and silks, served an extraordinarily wide variety of purposes in the Islamic lands, being used to make shelters, furnishings and clothing for all members of society. Fine textiles and carpets were important items of trade between regions and served as major vehicles for the transmission of artistic motifs. Despite some recognition of their importance in the early years of the 20th century, the study of Islamic textiles became relatively peripheral to the study of Islamic art as it developed by the middle of the century, and the little scholarship that existed tended to focus on carpets and on later textiles, such as Safavid and Ottoman silks.[11] C.J. Lamm, the Swedish historian of Islamic art, had studied medieval cotton textiles, and early Persian silks had been the subject of Phyllis Ackerman's chapter for Arthur Upham Pope's massive *Survey of Persian Art*, which appeared in 1938–39, but many of the so-called "Būyid" textiles she published have subsequently been shown to be 20th-century fakes.[12] At approximately the same time, the Arabist and historian R.B. Serjeant was collecting information from Arabic sources about the history of textiles in the Islamic lands. Ernst Kühnel worked together with Louisa Bellinger on the inscribed *ṭirāz* fabrics in the Textile Museum in Washington, DC, but for most scholars the complexities of technical analysis required to understand medieval Islamic textiles posed a greater problem for art-historians than did learning such languages as Arabic, Persian, and Turkish.

The foremost American student of early Islamic textiles was Dorothy G. Shepherd (1916–92), associated with the Cleveland Museum of Art from 1947

[11] On the formation of the Berlin carpet collection, for example, by Wilhelm von Bode, see Volkmar Enderlein, *Wilhelm von Bode und die Berliner Teppichsammlung* (Berlin: Museum für Islamische Kunst, 1995).

[12] Phyllis Ackerman, "Islamic Textiles: History", *Survey of Persian Art*, edited by Arthur Upham Pope and Phyllis Ackerman (London, 1938–9), pp. 1995–2162; for a summary of the later controversy, see Sheila S. Blair, Jonathan M. Bloom and Anne E. Wardwell, "Re-evaluating the Date of the 'Buyid' Silks by Epigraphic and Radiocarbon Analysis", *Ars Orientalis*, xxii (1993): 1–42.

until her death. She studied at the Institute of Fine Arts in New York, but her plans for a dissertation on medieval Spanish fabrics were interrupted by World War II. From her early interest in Spanish textiles she expanded to study western and eastern Islamic textiles. In 1959 she was placed in charge of Near Eastern art and textiles at the Cleveland Museum, and two decades later she became chief curator of textiles and Islamic art. From the 1970s Shepherd was closely associated with the acrimonious controversy over the "Būyid" silks, as she staunchly defended their authenticity despite accumulating evidence to the contrary. Shepherd was also one of the women who came to play a significant role in the study of Islamic art in the period immediately after World War II. Until then the subject had been largely a male preserve, apart from such figures as the intrepid English explorer Gertrude Bell and Pope's colleague and wife, Phyllis Ackerman. Other women scholars of Islamic art included Florence Day, who began publishing articles on textiles in the 1930s, Katharina Otto-Dorn, a scholar of German birth who taught for many years at the University of California, Los Angeles, and Janine Sourdel-Thomine, a Frenchwoman who taught at the Sorbonne in Paris. At the beginning of the 21st century the central role of women in the field of Islamic art seems assured.

Shepherd's best work, such as her contribution to the festschrift for Ernst Kühnel, combines a curator's knowledge of the material evidence with a scholar's concern for historical and textual information. On the basis of a Sogdian inscription read by W.B. Henning, Shepherd was able not only to ingeniously identify a medieval textile preserved in the church of Notre Dame at Huy, Belgium, as *zandanījī*, a type of fabric made in the region of Bukhārā, but also to show that the type was made during several centuries before and after the Islamic conquest. In a follow-up article on the same subject published two decades later, Shepherd demonstrated on technical grounds that a type of textile heretofore considered Coptic was actually a third type of *zandanījī* fabric.[13]

Perhaps the most versatile scholar of Islamic art in the middle decades of the century was Richard Ettinghausen (1906–79). Ettinghausen had trained as an orientalist in Berlin and became Kühnel's assistant in Berlin, but he was forced to leave Germany in 1933, first for England and then for the United States, where he initially worked on the *Survey of Persian Art*. Ettinghausen taught at the University of Michigan from 1938 to 1944, when he was appointed to the Freer Gallery of Art. He served there successively as Associate, Curator, and Head Curator in Near Eastern Art until 1967. From 1967 to his death he was associated with the Islamic Department at the Metropolitan Museum of Art in New York and the Institute of Fine Arts of New York University. Ettinghausen wrote on virtually every aspect of Islamic art, but was particularly concerned

[13] D.G. Shepherd: "Zandaniji Revisited", *Documenta Textilia, Festschrift für Sigrid Müller-Christensen*, edited by Mechtild Flury-Lemberg and Karen Stolleis (Munich: Deutscher Kunstverlag, 1981), pp. 105–22.

with iconography and style. Although much of his work deals with the decorative arts of the later periods, particularly in Iran, Ettinghausen occasionally dealt with the formative period of Islam, and it is this aspect of his work that is presented here in his essay on the throne and banqueting hall of Khirbat al-Mafjar.

The site, located north of Jericho, was excavated by R.W. Hamilton between 1934 and 1948, and was identified by the excavator as a palace, mosque, and bath-complex built during the reign of the Umayyad caliph Hishām (r. 724–43). The large and elaborately decorated hall attached to the small bathing complex was initially thought to have been a place for relaxation and even frivolity, but Ettinghausen, much as Herzfeld might have done, sought to demonstrate that every one of the architectural elements and decorative features in the building, which he identified as a throne hall, had individual significance. Byzantine and Sasanian artistic elements were therefore integrated into a coherent and meaningful whole, which epitomized the serious nature of the new art that coalesced under Umayyad patronage.

The wealth of decoration from the site of Khirbat al-Mafjar has continued to inspire other scholars to propose new interpretations of Umayyad palace architecture. Grabar, following Sauvaget, stressed the economic importance of the agricultural estates of which the palaces were the foci, while Hamilton maintained his Dionysiac interpretation of the site. In this he was joined by the British scholar Robert Hillenbrand (1941–), whose assessment of the building in his article "La Dolce Vita ..." provides an antithesis to Ettinghausen's Apollonian argument. Rather than concentrate on the sources for each decorative motif, Hillenbrand used contemporary literature to recreate the rollicking life that would have been led in such a late Umayyad palace as Khirbat al-Mafjar.

As the study of Islamic art has reached something of a maturity at the dawn of the 21st century, revising the earlier hypotheses of others—rather than publishing new discoveries—has become a more common scholarly activity. The last two selections re-examine relatively well-known examples of Islamic art in new light. Before her untimely death in 1997, Estelle Whelan had been a meticulous scholar of medieval Islamic iconography and had written several innovative articles on various aspects of early Islamic art, particularly the origins of Arabic calligraphy.[14] Her study of the origins of the concave *miḥrāb*, surely one of the most important if least understood aspects of early Islamic architecture, provides a fresh alternative to Sauvaget's theory, which linked the mosque and the *miḥrāb* to the basilican audience hall of antiquity. Whelan's study furthermore offers a new perspective on early Islamic art, which some scholars had once viewed as a wholesale adoption of the rich material culture of late antique Syria by a band of desert nomads. Whelan suggests to the contrary

[14] Estelle Whelan, "Writing the Word of God: Some Early Qur'an Manuscripts and their Milieux, Part I", *Ars Orientalis* 20 (1990): 113–48.

that the early caliphs were sophisticated patrons of the arts who consciously manipulated visual symbols to develop an expressive and distinctly Islamic art.

Finally, the article by Jonathan Bloom (1950–), the editor of this volume, about a well-known manuscript of the Koran written in gold on blue parchment, has been chosen to represent the massive and complicated subject of the development of Arabic writing and the problem of early Islamic manuscripts, particularly copies of the Koran. All historians of Islamic art agree that writing plays a central role in it, but the history of the Arabic script in early Islamic times has remained one of the most important unsolved problems, despite the pioneering work by such scholars as Nabia Abbott and Adolf Grohmann. The major problem has been sorting the hundreds of thousands of undated fragments from early manuscripts of the Qur'ān and providing them with some sort of date. Since the 1970s a group of younger scholars has begun to deal with the problem in new ways: Whelan, for example, mined Arabic sources for information about writing and calligraphers, while François Déroche has grouped scripts by shared letter forms in a series of catalogues of fragments from Koran manuscripts in public and private collections. Bloom's article has used some of Déroche's findings as well as evidence from scientific instruments to propose a new date and location for this famous manuscript, although Déroche himself prefers a somewhat earlier date.

If any one theme could characterize how scholarship on Islamic art has developed in the second half of the 20th century, it would be the primacy of textual sources. To some extent this reflects the general direction of art-historical scholarship, but much of it is due to the special role of writing in Islamic culture. Much early scholarship on Islamic art was based on a direct and intimate knowledge of the actual works of art, but much recent scholarship uses textual information—history, literature, inscriptions, documents, or deeds—to reveal meanings and provide contexts, and the object itself appears to have diminished in importance. This is particularly true for the arts of the later periods, for which contextual materials are most readily available, but the limits of such an approach are constantly being challenged, and the role of texts in the interpretation of works of art from the early period is growing. There remains a serious—and as yet unanswered—intellectual question as to what extent it is justifiable to extrapolate findings from later periods to earlier ones.

A further problem with relying on textual sources is that it tends to obscure the unique contribution that the study of Islamic visual art can make to Islamic studies in general. Much Islamic art is the product of the same social milieux that produced the religious scholars, historians, and littérateurs whose writings have provided the grist for the mill of Islamic historical scholarship. Thus, one can reasonably search in the historical records for documents which can elucidate the reasons behind the construction of a particular mosque or palace, or look in biographies of calligraphers for discussion of particular scripts, although such references are unfortunately rare. By this method, the evidence provided by art tends to confirm or reinforce ideas generated from textual sources.

Some Islamic art, however, derives from milieux other than the dominant, literate, and primarily male culture known from the written record. Ceramicists and metalworkers, weavers and woodcarvers may have attended prayers in the congregational mosques, but they generally had little to do with the dominant and literate classes except when filling specific commissions. Thus one should not expect to find much written evidence about the crafts of textiles, ceramics, or metalwork. These crafts, however, may provide the historian with otherwise unattainable evidence about segments of society ignored by most normative histories. For example, it has been argued that the decoration on some ceramics illustrates folk astronomy. Similarly, seams on surviving textiles can elucidate aspects of medieval dress. Tombs commemorating saints unknown to the historical record provide as much information about popular religious practice as they do about the forms of vernacular architecture, and an analysis of epitaphs on tombstones reveals as much about the piety of women in medieval times as it does about the development of the Arabic script.[15]

For those scholars with access to and interest in actual works of art, new techniques of examination and analysis have proved to be as fruitful for Islamic art as in other areas of the history of art and have supplanted the aesthetic appreciation that was once the dominant approach in some museums. The use of radiocarbon dating, for example, has finally solved the vexing question of the "Būyid" silks, and thermoluminescence testing (which indicates when a ceramic was last fired) and petrographic analysis (which reveals its composition) are helping to provide a more nuanced picture of the history of Islamic ceramics. The new technique of PIXE (Proton-Induced X-ray Examination), a non-destructive technique for analyzing pigments and paper, promises to be of great value in the study of Islamic manuscripts.

Another direction apparent in some recent scholarship is to question the very notion of Islamic art. Whereas earlier generations of scholars sought to discern the universal principles that united all—or even some of—the arts produced between Spain and Indonesia under the aegis of Islam, current fashion, particularly among non-Muslim scholars in Europe and the United States, is to see "Islamic art" as an inappropriate catchall term invented by Europeans to put essentially unlike things together. According to this view, there are no similarities between Kairouan and Khirbat al-Mafjar, and the arts of the Islamic lands are best understood as representing regional and dynastic styles. As in all other subjects of intellectual inquiry, such strictures reveal more about the interests of the investigator and his society than about the ostensible subject of research. The dismantling of a universalist notion of Islamic art is paralleled by the emergence of distinct nations throughout the region. One can be sure that the

[15] For ceramics, see J. Zick-Nissen, "Figuren auf mittelalterlich-orientalischen Keramikschalen und die *Sphaera barbarica*", *Archäologische Mitteilungen aus Iran* 8 (1975): 217–40; for tombstones, see Jonathan M. Bloom: "The Mosque of the Qarafa in Cairo", *Muqarnas* 4 (1987): 7–20.

study of the arts of the early Islamic period in the 21st century will continue to broaden and represent more viewpoints, as the "western" perspective of European and American scholars who have seen it as one of the many early medieval arts is increasingly challenged by regional, national, ethnic, and religious perspectives.

Bibliography

BIBLIOGRAPHY AND HISTORIOGRAPHY

K.A.C. Creswell: *A Bibliography of the Architecture, Arts and Crafts of Islam to 1st January 1960* (Cairo, 1961/reprinted Vaduz, 1978); *Supplement January 1968 to January 1972* (Cairo, 1973); *Second Supplement January 1972 to December 1980 (with omissions from previous years)* by J.D. Pearson (Cairo, 1984).

Richard Ettinghausen: "Islamic Art and Archaeology", *Near Eastern Culture and Society*, ed. T. Cuyler Young (Princeton, 1951), pp. 17–47; also in *Richard Ettinghausen: Islamic Art and Archaeology (Collected Papers)*, ed. M. Rosen-Ayalon (Berlin, 1984), pp. 1229–69.

J.M. Rogers: "From Antiquarianism to Islamic Archaeology", *Quaderni dell'Istituto Italiano di Cultura per la R A.E.*, n.s. 2 (1974) [entire issue].

Oleg Grabar: "Islamic Art and Archaeology", *The Study of the Middle East: Research and Scholarship in the Humanities and Social Sciences*, ed. L. Binder (New York, 1976), pp. 229–63.

Oleg Grabar: "Reflections on the Study of Islamic Art", *Muqarnas*, 1 (1983): 1–14.

Oleg Grabar: "From the Museum to the University and Back", the *Eleventh Presentation of the Charles Lang Freer Medal, April 5, 2001* (Washington, DC: Freer Gallery of Art and Arthur M. Sackler Gallery, 2001).

REFERENCE WORKS

The Encyclopaedia of Islam, 2nd ed. (Leiden: E. J. Brill, 1954–).

Encyclopaedia Iranica (Costa Mesa, CA: Mazda, 1985–).

The Dictionary of Art (London: Macmillan, 1996).

INTRODUCTIONS TO AND SURVEYS OF ISLAMIC ART AND ARCHITECTURE

Arthur U. Pope and Phyllis Ackerman, eds: *A Survey of Persian Art from Prehistoric Times to the Present*, 5 vols (London and New York: Oxford University Press, 1938–9/Reprint ed. in 14 vols, Tokyo, 1964–7).

Bertold Spuler and Janine Sourdel-Thomine: *Die Kunst des Islam*, Propyläen-Kunstgeschichte (Berlin: Propyläen Verlag, 1973).

Richard Ettinghausen and Oleg Grabar: *The Art and Architecture of Islam: 600–1250*, Pelican History of Art (Harmondsworth: Penguin, 1987); continued by Sheila S. Blair and Jonathan M. Bloom: *The Art and Architecture of Islam: 1250–1800*, Yale-Pelican History of Art (New Haven and London: Yale University Press, 1994).

Barbara Brend: *Islamic Art* (London: British Museum, 1991).

Robert Hillenbrand, *Islamic Architecture: Form, Function and Meaning* (Edinburgh: Edinburgh University Press, 1994).

Jonathan Bloom and Sheila Blair: *Islamic Arts* (London: Phaidon, 1997).

Robert Irwin: *Islamic Art in Context* (New York: Abrams, 1999).

Robert Hillenbrand, *Islamic Art and Architecture* (London: Thames and Hudson, 1999).

WORKS DEALING SPECIFICALLY WITH THE EARLY PERIOD

General

Alois Riegl: *Stilfragen* (Berlin, 1893); Eng. trans. by E. Kain as *Problems of Style* (Princeton: Princeton University Press, 1992).

Oleg Grabar: *The Formation of Islamic Art* (New Haven: Yale University Press, 1973/ R and enlarged 1987).

Terry Allen: *Five Essays on Islamic Art* (Sebastapol, CA: Solipsist, 1988).

Oleg Grabar: *The Mediation of Ornament* (Princeton: Princeton University Press, 1992).

Architecture

K.A.C. Creswell: *Early Muslim Architecture*, 2 vols (Oxford: Clarendon Press, 1932–40/revised ed. of vol. 1, Oxford, 1962/reprint edn in 3 vols. New York: Hacker, 1979).

K.A.C. Creswell: *A Short Account of Early Muslim Architecture* (1958), revised by J. W. Allan (Aldershot: Scolar, 1989).

Robert W. Hamilton: *Khirbat al Mafjar, an Arabian Mansion in the Jordan Valley* (Oxford, 1959).

Oleg Grabar: "The Earliest Islamic Commemorative Structures", *Ars Orientalis*, vi (1966), pp. 7–46.

Ugo Monneret de Villard: *Introduzione allo Studio dell'Archeologia Islamica, Le Origini e il Periodo Omayyade* (Rome, 1966).

Lucien Golvin: *Essai sur l'architecture religieuse musulmane*, 4 vols (Paris, 1970–79).

Robert W. Hamilton: *Al-Walid and His Friends* (Oxford, 1988).

Jonathan Bloom: *Minaret: Symbol of Islam* (Oxford, 1989).

Ceramics

A. Lane: *Early Islamic Pottery* (London, 1947).

E. Atil: *Ceramics from the World of Islam* (Washington, DC, 1973).

H. Philon: *Early Islamic Ceramics: Ninth to Late Twelfth Centuries* (London, 1980).

Metalwork

J.W. Allan: *Persian Metal Technology* (London, 1979).

J.W. Allan: *Nishapur: Metalwork of the Early Islamic Period* (New York, 1982).

Eva Baer: *Metalwork in Medieval Islamic Art* (Albany: SUNY Press, 1983).

E. Atil, W.T. Chase, and P. Jett: *Islamic Metalwork in the Freer Gallery of Art* (Washington, DC, 1985).

B. Marshak: *Silberschätze des Orients: Metallkunst des 3.-13. Jahrhunderts und ihre Kontinuität* (Leipzig, 1986).

A.S. Melikian-Chirvani: *Islamic Metalwork from the Iranian World 8th-18th Centuries*, Victoria and Albert Museum Catalogue (London, 1982).

Textiles

C.J. Lamm, *Cotton in Medieval Textiles of the Near East* (Paris, 1937).

R.B. Serjeant: "Islamic Textiles: Material for a History up to the Mongol Conquest", *Ars Islamica*, 9 (1942): 54–92; 10 (1943): 71–104; 11–12 (1946): 98–145, 13–14 (1948): 75–117; and 15–16 (1951): 29–85; also as a book, *Islamic Textiles: Material for a History up to the Mongol Conquest* (Beirut: Librarie du Liban, 1972).

E. Kühnel and L. Bellinger: *Catalogue of Dated Ṭirāz Fabrics: Umayyad, Abbasid, Fatimid* (Washington, DC: Textile Museum, 1952).

M. Lombard: *Les Textiles dans le monde musulmane du VIIe au XIIe siècle* (Paris: Mouton, 1978).

S.S. Blair, J.M. Bloom and A.E. Wardwell: "Re-evaluating the Date of the 'Buyid' Silks by Epigraphic and Radiocarbon Analysis", *Ars Orientalis*, 22 (1993): 1–42.

Writing

Nabia Abbott, *The Rise of the North Arabic Script and its Ḳur'ānic Development* (Chicago, 1939).

Adolf Grohmann, *Arabische paläographie*, 2 vols (Vienna, 1967/71).

François Déroche: *Les Manuscrits du Coran: Aux origines de la calligraphie coranique, Manuscrits musulmans*, pt 2 of i/1 of *Bibliothèque Nationale, Départment des Manuscrits: Catalogue des manuscrits arabes*, 2 vols (Paris, 1983–5).

Estelle Whelan: "Writing the Word of God: Some Early Qur'ān Manuscripts and Their Milieux, Part I", *Ars Orientalis*, 20 (1990): 113–48.

Sheila S. Blair: *The Monumental Inscriptions of Early Islamic Iran and Transoxiana* (Leiden: E. J. Brill, 1992).

Yasser Tabbaa: "The Transformation of Arabic Writing: Part I, Qur'ānic Calligraphy", *Ars Orientalis*, 21 (1992): 119–48.

François Déroche: *The Abbasid Tradition: Qur'ans of the 8th to the 10th Centuries AD* (1993), i of *The Nasser D. Khalili Collection of Islamic Art*, ed. J. Raby (London and Oxford: Nour Foundation in association with Azimuth Editions and Oxford University Press, 1993–).

Geoffrey Khan: *Bills, Letters and Deeds: Arabic Papyri of the 7th to 11th Centuries*, vi of *The Nasser D. Khalili Collection of Islamic Art*, ed. J. Raby (London and Oxford: Nour Foundation in association with Azimuth Editions and Oxford University Press, 1993–).

Aniconism

Thomas W. Arnold, *Painting in Islam* (Oxford, 1928).

Ahmad Muhammad Isa, "Muslims and Taswir", *The Muslim World* 45 (1955): 250–68.

A. A. Vasiliev, "The Iconoclastic Edict of the Caliph Yazid II, A.D. 721", *Dumbarton Oaks Papers*, 9–10 (1956): 25–47.

Rudi Paret, "Textbelege zum islamischen Bilderverbot", *Das Werk des Künstlers Studien H. Schrade dargebracht* (Stuttgart, 1960): 36–48.

Rudi Paret, "Das islamische Bilderverbot und die Schia", *Festschrift Werner Caskel* (1968): 224–32.

Rudi Paret, "Die islamische Bilderverbot und die Schia (Nachtrag)", *Zeitschrift der Deutschen morgenländischen Gesellschaft*, 120 (1970): 271–73.

Rudi Paret, "Die Entstehung des islamischen Bilverbots", *Kunst des Orients*, 11 (1976–7): 158–81.

Oleg Grabar, "Iconoclasm, Islamic", *Dictionary of the Middle Ages* (New York: Scribners, 1985) 6: 402–404.

1
NOTES ON ARABIC ARCHEOLOGY
Max van Berchem

The study of the monuments in the lands where Arabic is spoken may generally be termed 'Arab archaeology'. By monuments one must understand works of architecture, of the graphic and industrial arts, inscriptions, coins, seals and intaglios – in a word, all the documents that provide some information for history (leaving aside manuscripts), whether by their forms themselves or through the texts they present. Arabic papyri, which are manuscripts too, are closer to archaeological documents, given their fragmentary nature and the particular nature of the information they yield.

Leaving aside pre-Islamic Arabia, which constitutes a separate chapter, Arab archaeology embraces a wide range of studies, linked, in geographical and historical terms, by the civilisation of the Arab lands of the Islamic world.[1] During my first stay in Cairo I was struck by the importance of this branch of the historical sciences, and by the precious support that a still-young and poorly established science could bring to the history of Muslim customs, ideas and civilisation. The monuments of Spain are familiar from numerous studies of art and archaeology. Those of Cairo have been studied from the point of view of their art in the fine works of Coste, Prisse d'Avennes, and Bourgoin, and of their architecture in the recent work of Franz Pacha,[2] the best technical discussion of the monuments there. But in these works the historical dimension has been neglected and, since the *Description de l'Egypte*, there have appeared only a few isolated monographs on the subject.[3] Accordingly, the study of these monu-

[1] The expression 'Arab art', applied to Muslim monuments, is not very satisfactory, given that the Arab race played only a secondary role in the development of the material civilisation of the Islamic world. The general term 'Muslim art' can only be used for the totality of the artistic production of the Islamic world; the term 'Arab art' should therefore be kept for the Muslim monuments of the Arabic-speaking lands. It can be applied more specifically to those of the Syro-Egyptian group, which form a homogenous unit, while calling those of the West 'Western Arab art'. The terms 'Saracen art' and 'Moorish art' define specific periods of Arabic art in Egypt and Syria, on the one hand, and in the West, on the other. The Muslim art of Persia and Central Asia, very different from the above and quite homogenous, can be called 'Persian art'. Finally, the term 'Turkish art', however improper it may be, should be kept for the monuments raised by the Mongols and by the Turks in Asia Minor and in Europe, influenced by Byzantine building and Persian decoration; this style spread in Syria and Egypt in the sixteenth century.

[2] *Die Baukunst des Islam*, Darmstadt, 1887.

[3] Despite the valuable text which accompanies the fine collection by Prisse, a large number of errors of detail make one regret that the author, who very rarely cites his sources, was not able

ments from the point of view of their evolution and of their role in Muslim life remains to be made – to look at how they were built, to find the origins and development of the methods used; at their style, to find how new tastes were expressed; at their overall forms, to see the ideas that they give expression to. To understand the comparative study of forms, to search geography and history for the secrets of the laws that governed their evolution; to see these monuments not as isolated artistic productions, but as true historical documents, and to ask of them the solution to problems which Arab writers scarcely touch upon – that should be the aim of Arab archaeology.

Syria, for its part, abounds in monuments of the Muslim period, still imperfectly studied. We possess a great number of Arabic sources spread through topographical works and those of travellers and geographers, but apart from a few isolated monographs, and the piece-meal descriptions of modern travellers, the Arab monuments have still not been directly examined, in a land where attention is almost entirely dominated by Antiquity.[4] To conclude this survey, Mesopotamia is practically an unknown land.

As for inscriptions, they still offer a vast field of study. Among the many works on the Arabic epigraphy of Egypt and Syria, those of Mehren on the inscriptions of Cairo hold pride of place.[5] However the majority of the Arabic inscriptions of these two countries remains unpublished.

Numismatics is without doubt the most advanced branch of Arabic archaeology, but we have not yet reached the stage of palaeographic analysis of the coins that is required for the comparative studies of their legends. There remain glass tokens, weights and measures, valuable indices for metrology and Arab trade, and the mundane documents one finds in such numbers in Europe and the East.[6]

directly to consult the Arabic sources and to keep his work up to date with the latest research. The same observations apply to the technical part. There are entire pages which are simply copied, more than half a century later, from the articles in the *Description d'Egypte* which deal with Cairo, without the author mentioning this important volume. In the introduction to *Les art arabes*, Bourgoin takes care to say that his work has an artistic perspective, not an archaeological one; from that point of view it deserves whole-hearted admiration. The recent work by Stanley Lane Poole, *The Art of the Saracens in Egypt*, is the first general study from an archaeological viewpoint. This truly scientific book is unique in its coverage of the decorative and industrial arts. Unfortunately the limits imposed by the book's plan have forced the author to abbreviate the chapter on architecture.

[4] This remark applies above all to Damascus and to central and northern Syria. The historical and descriptive essay by the late von Kremer, *Topographie von Damascus*, is no more than the first attempt at a major task to be done. Muslim Palestine is better known, thanks to the magisterial study by de Vogüé of the temple of Jerusalem and the numerous works inspired by the monuments of the Haram.

[5] Mehren, *Câhira og Kerâfat*, Copenhagen, 1870 (see also *Bulletin de l'Académie des sciences de Saint-Pétersburg* XIV, XV and XVI). For Syria the most important monographs are the one on the inscriptions of the Haram published by de Vogüé, and that on the inscriptions of Ramlah, Hebron and Kerak, explained by Sauvaire in the great book by the Duc de Luynes.

[6] It is impossible to refer here to all the works published, so I will mention only that by Reinaud,

The procedures of archaeology are based on direct observation, so this science is increasingly taking a more prominent place in the new school of history that focuses above all on documents, and that prefers analysis to synthesis and detailed examination of the particular to premature generalisation. Given this, and given the existence of so much material to work with, Oriental studies today seem to be faced with a double task: to collect the inscriptions of Egypt and Syria to form the basis of a *Corpus inscriptionum arabicarum*, and to extract from the comparative study of monuments a sort of 'Manual of Arabic archaeology,' of which the main components would be architecture, the decorative arts, epigraphy and numismatics. These two countries appear to bring together the conditions that are most favourable to the realisation of this double project. Easily accessible almost throughout, they offer a large number of archaeological documents of all kinds. Centre and cradle of Arab-Islamic civilisation, they formed one historical entity at almost all epochs of Islamic history, and they also provide an excellent base from which to spread out into the neighbouring lands.

The project of a 'Manual of Arabic archaeology' – which may perhaps seem premature – is greatly facilitated by the fact that new light has been thrown on the question of the origins of Arabic art in Byzantium, Syria, Persia, and in Coptic Egypt. The fine studies of de Vogüé, Choisy, Dieulafoy, Butler, and Gayet will now be the indispensable vade-mecum of the Arabic archaeologist. To the results achieved by European science one should add, to complete the direct study of the Arabic monuments, the valuable information from Maqrizi and the Arabic topographers, and finally the constant aid given by epigraphic texts which are almost always the unmistakable signature of a building.

Certainly, Arabic inscriptions are far from providing history with as valuable a help as Greek or Latin inscriptions. In addition to the large number of Koranic texts, many inscriptions yield nothing, besides pompous titles and banal clichés, more than a date and a few personal names. While these inscriptions are therefore of little interest in themselves, they are indirectly useful for archaeology in that they give a certain date for the monuments where they are found; further, one can almost always glean some information. Some, finally, constitute veritable historical documents.

During my last stay in Cairo I took down in two months more than two hundred inscriptions, and carefully reviewed the majority of the texts published by Mehren. This work, rudely interrupted, will be taken up and finished later on, I trust. The method that I followed consisted of dividing the city into a number of sectors which I explored successively. Taking the inscriptions presented particular difficulties: they are almost all carved in high relief and in large letters, and taking a rubbing was in most cases impossible. Further, as

Monuments arabes, persans et turcs du cabinet du duc de Blacas, the first major work of Arabic archaeology, and those of Longpérier, Clermont-Ganneau, Karabacek, etc.

they frequently play a decorative role, the letters are sometimes so intertwined that one cannot copy them as one would a Greek or Latin inscription. One has to read and understand them on the spot, and then transcribe them in a normal hand into a notebook. The best method is to *transcribe* in this way all that one is certain of having understood correctly, and leaving blank the problematic passages which one *copies* as faithfully as possible, to look at them again at leisure, later on. As these passages become clear one can add them into the transcribed texts, but without touching the copy, which should always serve as the evidence for any new discussion. It is then good, if one has the time, to return to the spot to verify from the original the accuracy of one's interpretation. In order to obtain faithful copies, I practised hard at sketching by eye.

To complete the work one would do well to photograph the texts which are of interest from the point of view of palaeography.[7] An indispensable accessory is a good pair of binoculars, with good magnification and a wide field of view. A ladder is often necessary, also a chisel, to remove whitewash; when the stone is soft or finely worked one should use a wooden instrument. Finally, since one must often enter into private houses, scale walls and force one's way in, one will need some degree of diplomacy, assisted on occasion by some piastres, quite legitimate methods in the service of such a disinterested cause.

In the following notes you will find the inscriptions of the Fatimid period in Cairo, together with the archaeological, historical and palaeographical deductions provided by the texts or by the study of the monuments of this dynasty. I will keep for another article some inscriptions from the period of the Mamluk sultans which present a similar interest. These articles are not therefore just first steps, but not complete monographs either; the most different chapters will be dealt with without logical order, just as they came up in the course of our research. However, the archaeological conclusions deriving from the direct study of the monuments, which are too numerous to have a place here, will form the subject of a special work by way of an introduction to the 'Manual of Arabic archaeology' of which I have already sketched out the plan and main lines.

The quantity of Fatimid inscriptions is very limited, so I will recall in passing the texts which are already known. I have adopted a chronological ordering, and to avoid pointlessly extending the work, I have abbreviated the proper names both in my notes and in the extracts taken from Maqrizi. At the head of each article describing a monument there will be the translation of the relevant chapter of Maqrizi, restricted to the passages which are purely of archaeological interest, followed by my notes and the inscriptions taken down.

[7] As a general rule a good rubbing is more valuable than a photograph, at least for personal study. But for the reproduction of a text with an industrial process a direct photograph is better than one taken of a rubbing, provided one takes care to have good lighting when taking the photograph. In fact, rubbings of Arabic inscriptions rarely give perfect results, due to the size and high relief of the letters.

This comparison between the written work and the monuments presents a particular interest: it shows the precision, the minute care the Arab author brought to his research. Fatimid Cairo was already in ruins in the fifteenth century, and Maqrizi was in much the same position regarding the monuments as a modern observer looking at the mosques of the Mamluk sultans: he is a true archaeologist when he describes them. To be sure, he sometimes dwells on details which seem trifling to us, and passes over facts that would have been much more important for us to know; but let us not forget that our point of view is not that of the Arab writers.

All the great cities of the East have their topographers; Maqrizi surpasses them all, if not in accuracy, at least in the quantity of his information. The discovery of the Fayyum papyri has allowed us to check the accuracy of some information provided by the Arab writers which has been called into question by European critiques. These kinds of counter-proofs are an excellent touch-stone to test the truthfulness of the written documents, giving a precise definition of the extent to which one can have confidence in them; they constitute an important task for archaeology. Sometimes it seems that the modern school of history over-reaches what it is competent to do in its source criticism. In their condemnation of Ibn 'Abbas and the school of the forgers in connection with Muslim traditions, one can with reason reproach Arab scholars for having rejected as false those traditions that did not fit with their scheme of things. Could not one make the same reproach to modern criticism, when it makes a final decision before the case has been fully investigated? Archaeology has the mission of halting this; it is a dangerous path that opens the gate to the arbitrary.

I will give just one example, taken from outside Egypt. It was believed, relying on some Arabic writers, that the great mosque of Damascus had been almost entirely destroyed by the fire set there by Tamerlane during his sack of the city in 1400.[8] The examination of this magnificent building, which deserves a detailed monograph, shows at first glance that a considerable part of it must have escaped this disaster. The overall plan, the grand court with its porticos and the basilical sanctuary, the way this is built, with three naves and a transept, the semicircular arches, the dome resting on an octagonal drum and four pendentives, the square minarets, the details of architecture and decoration – all betray an ancient origin. One can see, besides, the traces of many restorations prior to the fifteenth century. To the epigraphic texts of the thirteenth and fourteenth centuries published by Kremer in his *Topographie*, one can add the fine Kufic inscriptions carved on the four pillars that support the springing of the great arches below the dome (*Qubbat an-nasr*); they are in the name of Malik Shah and date to 475 AH (1082 AD). Here is a part of one of these, copied in haste:

[8] Guy le Strange, *Palestine under the Moslems*, p. 272.

Max van Berchem

بسم الله الرحمن الرحيم.....أمر بعمارة هذه القبّة والمقصورة

والسقف والكامل (؟)... في خلافة الدولة العبّاسيّة أيّام

الإمام المقتضى بأمر الله أبي القاسم عبد الله أمير المؤمنـين

وفي دولة السلطان المعظّم شاهنشاه الأعظم سيّد ملوك الأمـم

مولى (؟) العرب والعجم ملك شاه بن محمّد بن داود يمين (؟)

أمير المؤمنين.......في شهور سنة خمس وسبعين وأربعمائة.

In the name of Allah, etc. ... The construction of this dome, of the
reserved precinct, of the roof and of ...? was ordered ... under the
caliphate of the Abbasid dynasty, under the reign of the imam al-
Muqtadi bi' amri-llah Abu-l qasim 'Abd-allah, prince of the believers,
and under the government of the venerated sultan, great king of
kings, lord of kings and nations, master (?) of the Arabs and the
Persians, Malik Shah ibn Muhammad[9] ibn Dawud, right hand (?)
of the caliph ... in the months of the year 475.

One knows that Futuh, the brother of Malik Shah, came to the aid of the
Seljukid Atsiz who was besieged in Damascus by the army of the caliph al-
Mustansir, and took possession of the city about 1077; from that time it belonged
to the Seljuk sultans. The antagonism between the spiritual and secular powers
emerges in a striking manner from this text: the place of honour is left for the
caliph, but all the titles are reserved for the sultan, in other words only for the
actual sovereign. These honorific titles, so foreign to the Arab spirit, can be
found later on in Egypt under the Ayyubids and the Mamluks; one can detect
here their Persian origin. I publish, in passing, this historical text because the
name of Malik Shah gives it a special value, and because it is contemporary
with the Fatimid inscriptions. Accordingly, the dome and the roof of the great
mosque of Damascus were built, or rather rebuilt, at the time of Malik Shah,
and it is reasonable to suppose that the fire of 1400, which spared the pillars at
its base, also spared the dome itself (and its construction shows evidence of
Byzantine methods, which had probably disappeared at the time of Tamerlane).[10]

[9] Muhammad was the Arabic name of sultan Alp Arslan. See Ibn Khallikan, trans. de Slane, III,
p.440.

[10] See Choisy, *L'art de bâtir chez les Byzantins*, p. 85, pl. XXI. The zone of transition between the
square plan and the base of the dome, with its four squinches and octagonal drum, is very
reminiscent of Fatimid domes preserved in Cairo. I thus believe that one can date the present
dome to 475 AH. After the Fatimids this arrangement occurs very rarely, at least in Cairo.

2
THE GENESIS OF ISLAMIC ART AND THE PROBLEM OF MSHATTĀ

Ernst Herzfeld

I

[27] The monuments of the first three centuries of Islam present the art historian with a unique and complex problem—*how was it possible for a unique art form to evolve throughout the entire Islamic world*, from Gibraltar to India, from the Sudan to Turkestan? Hellenistic art, the forerunner of Islamic art, provides an analogy, because its geographical extent is almost identical to that of Islamic art, and so is the degree of relationship and variation among the provinces. That Hellenistic art, despite all its provincial differences, remained uniform even beyond the frontiers of Alexander's realm and the Roman Empire was a precondition without which Islamic art would have been impossible, indeed unthinkable. It is in fact its very basis. Yet if one looks more closely at that comparison, the intrinsic differences as well as the extreme contrasts become apparent. When Hellenism conquered the world under Alexander the Great, the conquerors were the most artistically gifted people on earth; thus the victorious progress of Alexander's armies simultaneously represented the victorious progress of Hellenistic art. Alexandria, Seleucia and Antioch were the centres from which Greek art and culture were disseminated to many lands. In contrast, the armies of 'Umar and al-Walīd had neither artisans nor artists among their ranks; they lacked all artistic traditions and aesthetic requirements. There can have been few world conquerors [28] as hostile to any form of fine art as these Arabs, whose bedouin heritage was still in their blood after the passage of two centuries. Their Qaṣr and Madīna, 'Askar and Fusṭāṭ could not disseminate artistic ideas but at best could only collect them. If one regards the Macedonian conquerors as givers, the Arabs were receivers. The Hellenized countries had been united by Greek culture, while in the Islamic lands there was only religion and government. All artistic activities remained in the hands of the conquered peoples. In the Hellenistic world their input gave rise to the transformation and eventual decay of Greek art, whereas in the Islamic world their labours resulted in the creation of Islamic art.

1

2 *Ernst Herzfeld*

I shall try to explain and solve this problem by discussing some well-known and also recently discovered monuments. Perhaps this will make the concept of the development of Islamic art more readily comprehensible. At the same time, perhaps, a means might be found to define and classify a monument that is among the most disputed of all, namely Mshattā. The study of Islamic art history and archæology is indeed very young, yet in the last few years several monuments have either been discovered or become better known, and these will reveal new ways to solve our problem. In addition, the entire culture of the first Islamic centuries has been clarified, to an extent that one could never have expected only a short while ago, by editions, translations, the *Corpus Inscriptionum Arabicarum*, the *Encyclopaedia of Islam*, and especially by papyrology. The art-historical problem must, however, be tackled in the context of historical and cultural circumstances. In this essay, of course, only a sketch can be attempted. Anyone familiar with the monuments, however, can easily augment the examples given and find parallels for the generalizations based on these few examples. When these generalizations are put on a broader base, it will be possible to confirm their justification and validity.

When 'Abd al-Malik ibn Marwān began to build the Ḥaram al-Sharīf in the year AH 69, his aim was to create a universal Islamic sanctuary, the splendour of which would draw to Jerusalem some of the annual throng of pilgrims to Mecca. At that time the cities of the Prophet were in the hands of the anti-caliph 'Abd Allāh ibn al-Zubayr. The Dome of the Rock is in all important respects a work of this period. The al-Aqṣā Mosque, in contrast, has shared the fate of most of the first mosques of Islam, for continued rebuilding has preserved only a few parts of the original [29] structure.[1] What can we then learn from this, the oldest Islamic sanctuary known to us, with regard to the artistic methods and tendencies of its time?

In plan, the building is related to Christian pilgrimage churches. The site of the holy grave is occupied here by the holy rock, which was—according to Islamic tradition—the centre of David's temple. It is covered by a dome carried on columns. Circumambulation (*ṭawāf*) of the holy site is essential for pilgrimage, and it is facilitated by an octagonal, two-aisled ambulatory which surrounds the inner circle. Its form is characteristic, the transition from circle to octagon to square being one of the most common attributes of Graeco-Roman architecture. The apse, so indispensable to Christian mar-

[1]De Vogüé's monograph, *Le temple de Jérusalem* (Paris, 1863) discusses the structural history of the building in an exemplary manner. The Arabic sources and inscriptions are discussed by Ch. Schefer. The pictures are so comprehensive and additional photographs so easily accessible that any further description here is superfluous.

The Genesis of Islamic Art and the Problem of Mshattā 3

tyria, is absent in the Dome of the Rock; moreover, there is no *miḥrāb* to indicate the *qibla* for prayer, for the rock itself is the mystical centre of the world. The materials, construction, proportions, and decoration adhere faithfully to the traditions of late Hellenistic architecture. The underlying construction is far removed from the unsurpassed technical perfection of antique Syrian edifices of the second Christian century. The columns were taken from Classical buildings. The pointed form of the arches in the drum dates them to the period of the marble revetment put in place by Saladin; the original structure used a simple semicircular arch throughout. There are heavy wooden tie-beams above the impost blocks of the ambulatory columns.[2] In Syria, a region known for virtuoso arches, this type of construction has not been found previously, although it does appear inconspicuously and almost hidden away in the side aisles of Hagia Sophia. This is one of the standard and most conspicuous features of all columned buildings of Islamic origin, and de Vogüé not incorrectly considers it to be a leitmotif of the Islamic period. All the dimensions of the elevation are based on a system of geometric proportions, not only proof of the survival of the traditional architectural practices of Antiquity but also an important indication of the spirit in which the architecture was composed.

[30] In the *decoration*, foreign elements mingle with traditional ones. The heavy tie-beams of the ambulatory of the Dome of the Rock still show the original cladding of embossed *copper plaques*. De Vogüé illustrates three examples of their soffits. Two of them have a graceful, slender vine scroll which springs from an acanthus calyx and from a vase in the centre of the panel. The third example shows a double wavy line in mirror image; where the lines converge there is a small ring, a *corona*, only one delicate half-palmette branches off either side, in addition there is a fruit form in the centre of the inner field. Two marginal bands always border these scrolls. Sometimes there is a plain series of arches terminating in blossoms, sometimes a row of small arcades filled with alternating decoration of rosettes and palmette calices, and sometimes oblong rhomboids with rosettes in the centre and buds in the spandrels. The vine scroll arising from the acanthus calyx or the vase, the row of arcades, and the series of vine scrolls are plainly of antique Syrian origin, but the double wavy scroll and the arch border already proclaim the arabesque.

[2]Like some other Byzantine peculiarities of the Dome of the Rock, this part of the structure may have been modelled after another specifically Byzantine building nearby. [It is no longer believed that the drum and its mosaics date to the period of Saladin.]

De Vogüé illustrates two examples of the old *capitals* of the al-Aqṣā Mosque. The columns and pillars, complete with capitals, of 'Abd al-Malik's structure—dated AH 73—were produced *ad hoc*. They stand in the three middle aisles in front of Saladin's cupola and are identical. The column capitals are decorated with a row of pearls instead of the apophyge and the astragals. Lower down there is a garland of eight acanthus leaves, and above them a semi-globular basket bordered above by a trellis band from which eight acanthus leaves emerge. The axial acanthus leaves, whose serrations are widely spaced, are small and circumscribed by an atrophied volute. The diagonals support the corners of a curved abacus which rests on a semi-covered kalathos into which the rudiments of an egg-and-dart moulding are inserted. The related pilaster capitals of the second example display the orthodox Corinthian structure: two well-formed garlands of acanthus leaves above which emerge normal double volutes with supporting acanthus leaves; one blossom is placed in the middle in front of the concavity of the abacus. Characteristically there is no apophyge.

The *mosaics* of both buildings give a fuller picture of their ornament. The ambulatory of the Dome of the Rock still displays the mosaics of the time of 'Abd al-Malik, of AH 72. The mosaics of the drum and of its four main pillars date from the restoration by the Imām al-Ẓāhir in AH 418, and those of the dome in the transept of the al-Aqṣā Mosque belong to the building of Saladin in AH 583. The two later periods differ from the early one only in technique, as [31] such novel materials as silver and mother-of-pearl were introduced. Stylistically the ornament differs considerably; the mosaics of Saladin clearly depend on contemporary naturalistic painting and miniatures and, at the same time, imitate elements of the oldest mosaics; the mosaics of al-Ẓāhir are very classicizing, although their splendidly formed acanthus leaves incorporate Oriental details, in particular the winged palmette. This ornamental motif derives from the decoration on the crown and helmet of Varahrān II, Varahrān IV, Pērōz, Khusraw II, Parwēz, and Yazdegerd III, which appeared to the Arabs as the typical helmet decoration of the Sasanians. It is, however, impossible to analyse the mosaics of 'Abd al-Malik with such brevity. They occupy the fields of the spandrels between the arches of the ambulatory. The lines of the arches themselves have plain geometrical borders of pure Byzantine character. At the top there is a blue band with the date and inscription of 'Abd al-Malik, into which al-Ma'mūn substituted his own name. The letters are in gold and are typical of the first century and a half of the *hijra*. The background of the spandrels is also in gold, but the ornament of each of the 32 fields varies. Only the general design and the relationship between subject and ground show a well-considered

equilibrium. De Vogüé depicts only four of the fields. The composition is always based on the concept of a flower vase. The vase contains a rich, heavy bouquet, which is in the centre of the spandrel. Loose and free scrolls branch off from the bouquet and also from the base itself. Yet the details of all these decorative features are most peculiar. Sometimes the vase is dissolved into vegetal forms, sometimes the bouquet appears as a luxuriant blossom and sometimes as entirely non-vegetal. The scrolls are sometimes vine scrolls, sometimes quite fantastic creations. Obvious similarities to the blossom forms of Sasanian ornament can be seen in the bouquets, as well as Byzantine compositions of acanthus leaves.[3] What is most remarkable and novel in its scope, however, is the representation of precious metalwork, which appears in the vases, bouquets and scrolls and invests the whole with a highly individual anti-naturalistic character. Crowns, necklaces, bracelets, clasps in gold, jewels and pearls alternate here with the vegetal elements, [32] alongside of which are depicted unmistakable representations of cloisonné enamel work. De Vogüé has already pointed out the relationship of these forms to the crowns and jewels of the Visigoths and Merovingians; but now one must compare them to Sasanian and early Islamic precious metalwork.[4] In these four examples the winged palmette is absent; the later mosaics, however, prove without any doubt that winged palmettes occur among the other 28 variations of the bouquet, and if not here, they also appeared frequently in the now-vanished original mosaics of the drum. We know from Ibn al-Athīr that Saladin arranged for material and workmen to be brought from Constantinople for his mosaics and that al-Walīd ordered the mosaics for the Umayyad Mosque in Damascus from Constantinople. There can, therefore, be no doubt that the mosaics of 'Abd al-Malik and of al-Ẓāhir in Jerusalem were also executed by Byzantine mosaicists.

What are then the characteristics of the Umayyad buildings in Jerusalem that make them monuments of Islamic art? It is the connection with old

[3] Compare the piers and the inner capitals of Tāq-i Bustān near Kirmanshāh, the capitals of Bīsutūn and Iṣfahān, in Eugène Flandin and Pascal Coste, *Voyage en Perse* (Paris, 1851–54), Pls. 17, 17bis, 27 and 28; Sarre/Herzfeld, *Iranische Felsreliefs* (Berlin, 1910), Fig. 100. As to the Byzantine monuments: Vladimir Stasov, *L'ornement slave et oriental* (St. Petersburg, 1887) and Prince Grégoire Gagarine, *Receuil d'ornements et d'architecture byzantins* (St. Petersburg, 1897).

[4] De Vogüé cites the western examples. See J.I. Smirnoff, *Argenterie orientale* (St. Petersburg, 1919), Pl. XXIV, the Khusraw bowl, also in Marcel Dieulafoy, *L'art antique de la Perse*, V, Pl. XXII; but especially the jug of St. Maurice, Hārūn's present to Charlemagne; Edouard Aubert, *Le trésor de l'abbaye de Saint-Maurice d'Agaune* (Paris, 1872), Pls. 19–22, and Samuel Guyer, *Die christlichen Denkmäler des ersten Jahrtausends in der Schweiz* (Leipzig, 1907), pp. 102–104.

types put to new uses with empirically acquired adaptations. It is the adaptation of old methods of construction, some of which had been used only occasionally and were half-forgotten, but which now become principles. It is the use of antique spolia, particularly columns and capitals, though not at the cost of losing the potential of individual craftsmanship. It is the knowledge of the traditional laws of architectural aesthetics that elevates these structures from the sphere of plain utilitarianism and the domination of mere need. Then there is the cost of the materials used, linked to a disregard of all considerations of economy. It is, too, the cooperation of foreign artists and artisans gathered from far afield. And then there is the decoration in which one finds close juxtaposition of western and eastern, local and imported elements. There is the unhindered play of fantasy, the invention of ₌ew forms and combinations rooted in the principle of variety. And finally, there is the transfer of special architectural skills and of architectonic ornament. Before I attempt to explain these characteristics, however, I must give further examples.

[33] When Friedrich Sarre and I came to Baghdad on our expedition through Asia Minor, the Jazīra and Iraq in January and February 1908, we discovered an extremely ancient *miḥrāb* in the Jāmiʻ al-Khāṣṣakī.[5] On the outside it had been built into a low wall which separates the left part of a vaulted portico from the courtyard; it consists of a single block of fine crystalline marble with a slightly yellowish tinge. The base had broken away and clumsily been put back into position. So far as one can determine, the block is 1.60 metres high, 0.93 metres wide, and the niche is 0.31 metres deep. This ancient *miḥrāb* already represents the later, canonical type: the round niche with a shell resting on engaged columns (Plate I).

The base of the columns is Attic and rests on the Attic-profiled socle of the *miḥrāb*. The shaft, which stands in three-quarters relief, has spiral fluting and a pearl ring instead of the apophyge and astragals. The two capitals are Corinthian (Plate II). The two rows of alternating acanthus leaves are as expected, but the volutes with their supporting leaves have an unusual form—the supporting leaves have become large acanthus palmettes, while the volutes, now separate from them, are free scrolls (Plate IIc). All details of the two capitals differ, the eight complete leaves and six half-

[5]Professor Sarre has allowed me to present here the preliminary publication of this important monument. I have described it as briefly as possible, because the full publication is intended to appear in the first volume of our [*Archäologische Reise im Euphrat- und Tigrisgebiet*] (Berlin, 1911–20), when further illustrations will be produced. A brief note about this *miḥrāb* appeared in Murray's *Reisenhandbuch*; Henri Viollet supplies a small illustration in *Comptes rendus* (Paris, 1909), p. 371, Fig. 2.

leaves being divided into no less than four basic types with two additional variants, making a total of six forms altogether. The left capital (Plate II top, a and b) has two garlands of acanthi with turned-down, wind-blown tips. In the lower row the leaves are barely divided, while in the upper the leaves are deeply divided by two deep cuts. Its full supporting leaf (Plate IIa) is deeply subdivided by six cuts; a scroll is superimposed upon the half-leaf. The right capital has a wreath of pointed Syrian acanthus leaves. The complete supporting leaf is articulated by means of eight circular holes which give it the form of a palmette. The half-leaf (Plate IIc) resembles it, its lobes like an inward-curling scroll, with small lancet-shaped leaves along its spine. Neither of the two capitals has an abacus, although they directly support a magnificent shell niche. Its outline is horseshoe-shaped with its centre formed by a full-blown palmette (Plate IId). [**34**] The ribs of the lower edges also turn into half-palmettes. The *miḥrāb* has a peculiar band of decoration ascending vertically in the axis of its cylindrical section, which is otherwise plain (Plates I and IIe). It is 16 cm. wide and—as far as can be determined—84 cm. high, for the base has been destroyed. The middle section comprises a series of superposed vase-form elements; at the very bottom is a tall slender vase, above which is a pinecone between two acanthus leaves; above them is a richly decorated globular vase from which a trefoil acanthus calyx unfurls. Its central lobe encircles a straight high cornucopia on which stands a vase with an ornamented globular body, a stem and two handles; at the very top is perhaps another vase-like element. The whole is entwined, interlaced and grown through by a luxuriant grapevine, asymmetrical at the top and composed of a symmetrical arabesque at the bottom. The stems terminate in three berries in the centre of the serrated and ribbed, five-part leaves.

The technical quality of the work is of the highest virtuosity; the relief is powerful and swelling, the detail ranges from high relief to delicate engraving; the surface has been polished. If this work of art were not a *miḥrāb*, one would hardly have thought of attributing it to Islamic art. In what respect then does this monument as a whole and in its parts surpass its possible prototypes?

The type is related to certain forms of niches found in Christian churches, be it on the façade between the three doors, be it perhaps elsewhere.[6] In

[6] For examples see Josef Strzygowski, *Kleinasien. Ein Neuland der Kunstgeschichte* (Leipzig, 1903), pp. 162 ff. S. Guyer and I have again examined Alahan Monastery (Kodja Kalesi), and we are preparing to publish it. Also see the conches in Coptic churches, Josef Strzygowski, *Koptische Kunst* (Vienna, 1904), nos 7295, 7300, etc. Niches with conches are especially frequent in Syrian and Chaldean churches in Mosul.

every case these niches form an integral part of a stone wall and function only as architectural decoration. Here in the *miḥrāb*, this form fulfils a new liturgical purpose. As the major ornament of the mosque, to which all eyes are directed, the *miḥrāb* is fashioned out of a single block of precious material and is most heavily decorated. Although all decorative elements are traditional, the composition itself reveals a new spirit. This is apparent in the pearl ring at the top of the column shafts, the structure of the capitals, the basic variation of the forms of the leaves, and the conch placed directly on the capitals. The composition of the ornamental bands shows this most clearly in the accumulation of recognizable motifs such as vases and cornucopiae which form [35] an essential part of the developed arabesque, and in the juxtaposition of the symmetrical and asymmetrical compositions.

These characteristics are evidently related to those that classify the monuments of Jerusalem as Umayyad, despite the incongruity of the subject itself. Any attempt, however, to determine the exact date and art-historical setting of this *miḥrāb* is frustrated by quite unusual obstacles. It shows how poor our knowledge of these early monuments still is. I suggest as a date the year in which Baghdad was founded, AH 145; the artistic setting could include northern Syria, Antioch–Latakia, or northern Mesopotamia, Diyārbakr and possibly—although less likely—Mosul.[7]

[7]Nowadays the site of the Jāmiʿ al-Khāṣṣakī is enclosed by the Christian quarter of Baghdad. Christians of Baghdad told us that a church once stood on the site of the mosque. J.F. Jones, "Memoir on the Province of Baghdad," *Selections from the Records of the Bombay Government* 43 (1857), p. 312, states the same, when in 1853 he briefly remarks about the Jāmiʿ al-Khāṣṣakī: "Mosque said to have been an old Christian church; built AH 1094." This local tradition could lead to erroneous conclusions did we not possess a confirming literary source. Murtaḍā Naẓmī-zādeh, whose father composed a chronogram for the mosque, relates the history of its building in the *Gulshan-i khulafā* (Clement Huart, *Histoire de Bagdad* [Paris, 1901], p. 100). According to him, Muḥammad Pāshā al-Khāṣṣakī al-Siliḥdār (AH 1067–69) had heard that Christian monks had built a church near the tomb of Shaykh Muḥammad al-Azharī. Enraged about this—for there had been neither a church nor a monastery built in Baghdad since the city's foundation—the Pasha had this church pulled down and founded his mosque at the same site in AH 1069; his tomb is there and the mosque was only completed in 1094 under Ibrāhīm Pāshā, with the support of a follower of Khāṣṣakī. It is certainly untenable to suppose that the *miḥrāb* came from this mosque or from a church which had been built immediately before the mosque—because the whole mosque dates from this modern period. The whole part of the town, the Maḥallat al-Faḍl, lies in a region that was, under the last ʿAbbāsids, the Dār al-Khilāfa with its castles and parks. It was undeveloped until al-Muʿtaḍid began its construction. It is also clear that the *miḥrāb* does not stand in its original location, but was taken in a damaged condition to its present site. For this reason it cannot have been moved from any great distance at that time (AH 1069). The widespread ruins of Baghdad's early period of splendour covered the city in the north and west during the

The Genesis of Islamic Art and the Problem of Mshattā 9

[36] The monuments of the first two centuries of the *hijra* are few, and they are scattered all over the Islamic world. They occur nowhere in any considerable number nor as a compact group—unless in new or in not yet (properly) recognised monuments. It is risky to draw any conclusions by generalizing from isolated examples. Before I try to explain the forces responsible for this artistic change, I must deal with a well-definable artistic setting, a group of monuments represented in great numbers. For this reason we must turn to the third century AH.

The *ornament of the mosque of Aḥmad ibn Ṭūlūn* in Cairo[8] represents

Middle Ages. The *miḥrāb* can only come from these ruins. The material of the *miḥrāb* has doubtless been imported. It is highly improbable that the complete *miḥrāb* was imported during Baghdad's heyday, or after the removal to Sāmarrā, since it was possible to produce prayer niches locally. The *miḥrāb* must have been in Baghdad since the time of the city's founding; considering its forms the only alternative is that it came from a mosque of the pre-'Abbāsid period and was taken by al-Manṣūr to Baghdad (like the gates of the Madīnat al-Salām), or that it was ordered by him for Baghdad. The first supposition is less likely: while the valves of doors, *minbars*, and other moveable objects may always have been transported, the removal of such a prayer niche presupposes the destruction of the *qibla* wall. It is most unlikely that a (whole) mosque would have been destroyed merely for the sake of a *miḥrāb*. Also, in AH 145 it is unlikely that there were any ruined mosques. [36] All these general reasons suggest that the *miḥrāb* should be dated about AH 145, the year of the founding of Baghdad. The artistic forms make this date quite probable. The discovery of Quṣayr 'Amrā has emphasized how antique early Islamic monuments appear. If this building was erected between AH 94 and 97, the *miḥrāb* may well have been made about AH 145. The comparison with Byzantine monuments from the time of Heraclius and of a later period confirms this.

There are hardly any guidelines to determine the artistic setting. I am sure in one respect: one cannot consider the *miḥrāb* as an example of Iraqi art. Irrespective of whether it was imported in its finished state or whether it was only completed (after arrival) in Baghdad, the stonemason must have been a foreigner. We know that al-Manṣūr ordered artisans of all sorts to come from Syria, the Jazīra, Persia and Iraq; Egypt was hardly an exception. This *miḥrāb* shows that materials as well as workmen were imported, and even if this was not obvious from the start, the history of the foundation of Sāmarrā shows it. The mineralogical origin of the marble cannot be determined, nor do we know anything about the marble quarries of the northern provinces. There then remains a choice between northern Syria or the northern Jazīra. In favour of the art of Antioch and Latakia is the analogy of Sāmarrā, because when that city was founded marble was imported there. The ruins of Sāmarrā have yielded numerous splinters of only bluish-white marble. Transportation by water from Bālis (Eski Meskene) is a possibility, but from Diyārbakr only water transport is possible. A similar yellowish marble was used for the Assyrian sculptures of Nimrud, but its origin is unknown. Viollet and others call it Mosul marble. That is also the name used for the crystalline alabaster of the Jabal Maqlūb, the material of Assyrian sculpture (*marmar* in Arabic), which is not marble.

[8]Drawings by Prisse d'Avennes; analysis of the ornament by Alois Riegl, *Stilfragen. Grundlegungen zu einer Geschichte der Ornamentik* (Berlin, 1893); for the history of the building see E.K. Corbet, "The Life and Works of Ibn Ṭūlūn," *Journal of the Royal Asi-*

such an artistic setting. I will completely ignore the groundplan and ele-
vation[9] of the mosque [37] and deal only with its ornament, in which the
arabesque is presented to us for the first time in a form that is at once old-
fashioned and regionally distinct, yet complete in all essential features. The
ornament has been cut by hand directly into the fresh plaster. It comprises
friezes surrounding all the arches which are connected horizontally at the
level of the springing, horizontal bands at the top of all the walls, decorated
archivolts around the window niches, panels on the soffits of the large arches
and the window arches, and finally capitals on the large engaged columns
of the piers and of the small columns in the window niches. Only a little of
it is of carved wood: merely the epigraphic friezes containing a considerable
part of the Qur'ān, and the *soffit boards of the doors*, of which the southeast
door of the Ḥaram survives; today one usually enters the mosque through it.

I begin with these elements because they are the key to the understanding
of the whole ornamental scheme of the mosque, namely, the *principle of
design* (cf. Fig. 1).[10] The decoration is arranged as a band and in such
a way that undecorated fields also appear as bands. At first glance the
ornament appears as a tangled mass of forcibly bent curved lines terminating
in tight spirals. The profile of these lines is triangular [38] and cut at an
angle [*kerbschnitt*]. This first view of the ornament is deceptive, for the
ornament is the field defined by these lines, not the lines themselves. The
eye is compelled to see them as the ornament by the small indentations that
emerge sometimes from the straight edge, sometimes from the spirals. This
is particularly noticeable in the central square element. This appears to
be a group of four leaves, yet it is produced by a spiral from each corner
and two indentations emerging from the edges. To these two elements—the
spiral line and the indentation—a third element is added which is not used
in this central square: a deep dot with a flat stroke scratched in. These
three elements generate the ornament for several kilometres of friezes. Any
stippling or hatching of the fields is incidental. The principle of the design is
therefore extraordinarily simple. In the ornament itself, however, there are
two operational principles—the absolute requirement to fill an empty space,

rtic Society (1891), pp. 527–62; shorter notices, with several illustrations, in Julius Franz
Pasha, *Kairo* (Leipzig, 1903); Henri Saladin, *Manuel d'art musulman*, I: *L'architecture*
(Paris, 1907); Josef Strzygowski, "Mshatta," *Jahrbuch der Königliche Preusische Kunst-
sammlungen* 25 (1904), pp. 205ff.

[9] All the more so, as I have dealt with this relatively important question in the chapter
"Samarra" in Sarre/Herzfeld, *Archäologische Reise im Euphrat- und Tigrisgebiet.*

[10] I made this and the following sketches in Cairo in 1908, and I have reproduced them
here directly from my sketchbook without any retouching.

the true horror vacui, *and the union of the individual elements* without any clear separation. One may question which is the cause and which the effect, the principle of design or the two principles of ornament. They are interdependent. We shall see that both phenomena have precursors. If one now asks how they could have reached such absolute dominance here, one must find the answer in the simplicity of the design principle. When 'Amr and Aḥmad ibn Ṭūlūn founded their cities, it was essential to save time and labour. Thus an economic factor determined the selection of the artistic principles. What appears probable *a priori* and by deduction thus becomes tangible evidence—new economic conditions directly motivate the development of art.

The elements of the ornament are not new. Its character is hardly recognizable in the soffits of the doors; only very rarely—as in the central field—can one detect some suggestion of vegetal forms. These become more noticeable in the better-finished *plaster ornament*. There is first of all the large band at the top of each wall (Plate III top).[11] The generative lines are high stilted arches connected at the bottom by three-quarter circles and worked as double lines. In the axis of each arch is an indentation which terminates in a vertical stroke. In the centre of each three-quarter circle is a deep dot. [39] Two indentations descend from the upper edge between the apices of each pair of arches. Thus an ornament is created which is clearly derived from the arch motif of a band containing blossoms and buds. This motif has been indigenous in Egypt since remote antiquity and never died out. It also appears in several variants in the Ṭūlūnid Mosque[12] and is among the predominant motifs of this ornament.

I have sketched two examples of the *soffits of the large arches* in the north of the western hall. As these arches are broad, the ornament is a geometrically divided field with borders. In Fig. 2a the border is a zigzag strip. The resulting triangles are edged with small indentations, making them resemble leaves. The strip with the zigzag pattern is accompanied by a repeating motif of two rows of buttons. The main field is occupied by orthogonally positioned squares connected by smaller diagonally placed squares, thereby producing eight-pointed stars in the interstices. This geo-

[11] Cf. Max van Berchem, *Materiaux pour un Corpus Inscriptionem Arabicarum*, I: *Egypte*, I (Cairo, 1894–1903), *Cairo*, Pl. XIV, 1; a similar plate in Corbet, *op. cit.*; Strzygowski, "Mshatta," Fig. 113.

[12] Compare the archivolts of the window niches in Strzygowski, "Mshatta," Fig. 113; see also Gaston Migeon, *Manuel d'art musulman*, II: *Les arts plastiques et industriels* (Paris, 1907), ill. 225, for the splendid Fāṭimid–Egyptian gold lustre vase in the Fouquet collection.

metrical pattern is generated by a strapwork band. The vegetal filler motifs in the compartments have been created entirely by the previously mentioned design principle. The fillings vary in every row. [40] From the principles ⌐f design and of absolute space-filling everywhere, it is quite certain that the overwhelming quantity of the innumerable variations of vegetal forms must be of local origin. The examples described display a well-planned equilibrium. All fillings are variants of the same motif. In the centre is a heart-shaped leaf which sometimes resembles a fruit, sometimes a vase. On either side is a kind of cornucopia, torch, trumpet, or leaf. If one tries to visualize these motifs multiplied and arranged next to each other, the result is a modification of the motif of the blossom-and-bud band intimately connected with the arch. Even more succinctly, one should conceive these forms as the individual elements of an intermittent scroll; the trumpet-like forms appear then as variations of half-palmettes, a supporting leaf, or a forked scroll. Two principles reveal themselves in these motifs: they are composed out of an *infinite repetition* in one direction, and their isolation produces *variants that become new types.*

The second example (Fig. 2b) shows a border pattern that has been abstracted from an endless row of heart-shaped leaves standing on their points (compare Fig. 9b). The field is a simple T-based lattice pattern somewhat enriched by the oblique positioning of the ends of the lattice elements, making the outer fields star-shaped. There are again infinite variants of equal value in the fillings of the compartments. As no amount of fantasy could possibly invent such an immense number of symmetrical patterns, an asymmetrical composition is introduced, which in this form of a geometrical pattern cannot be unravelled even if seen in mirror image. Again, everything has been created out of the design principle, and the variants show the originality and the indigenous nature of the invention. In this respect it is also important to note that all the ornament of the mosque was done freehand, directly into the fresh plaster without copying it from a drawing. This is proven by the repeated minor irregularities and differences in detail as well as in the general arrangement. Again it becomes clear as a principle that the filler motifs can be extended in one direction *in infinitum*: the symmetrical ones upwards, the asymmetrical ones sideways. In the latter case the motif is a luxuriantly detailed intermittent scroll, in the former it is not so easily comprehensible.

The *ornament of a window soffit* at the east end of the *qibla* wall (Fig. 3a) may serve as a comparison. This is nothing other than an infinite upward repetition of the symmetrical elements [41]. The vegetal character is less prominent here. The individual forms have some representational

character: the heart-shaped leaf resembles a vase, the half-palmettes on the sides look like horns. If one imagines such a form repeated sideways, the result is again a blossom-and-bud arrangement or an intermittent scroll. All the characteristics described above recur in this ornament. It now becomes truly comprehensible how the principles of design and of space-filling engender new variants depending on the frame. One new feature becomes more pronounced—the *individual elements* have become an *abstract ornament* to such a degree that their objective meaning and their origin are completely obliterated. Whether they are to be called vase or heart-shaped leaf, horn, trumpet or palmette, or forked scroll, they are at once all those and none.

The motif, however, from which this form derives is not in doubt. This is clear from a piece of *border* ornament from the *soffit of the large arch* in the east hall (Fig. 4). The vase-like form of the central heart-shaped leaf in the previous example obscured the connection. Here, in the ascending border, it is clear: the motif is that of the ascending row of the Coptic finger-shaped leaf (compare Fig. 12). The horizontal segment of border seen in Fig. 2a is a good example how fillers arranged sideways next to each other produce an intermittent wave-like scroll.

Two further examples from the *window soffits* confirm and expand the concept of this ornament. Both have a geometrical structure, the one (Fig. 3b) a wavy line in mirror image, the other (Fig. 5) circles that alternate with oblong rhomboids. The pointed ovals of the first example enclose variants of the vase motif which are shaped by the frame; these forms are so irregular that they could hardly be understood without reference to the ornament as a whole. The circles of the second example are filled with motifs that because of the larger number of indentations [42] make the leafy characteric more distinct; they hardly differ from Coptic antique prototypes. All the filler motifs in the rhomboids vary; one shows a modification of the vase motif, something that would become a favourite in later ornament; the other shows an only half-symmetrical form—a central palmette leaf between two lateral leaves, for which Fig. 11 gives a parallel. The remaining spaces in the corners are filled with forms similar to forked scrolls and horns which are derived from the design principle.

We cannot deal here with the full range of ornament in the Ṭūlūnid Mosque. I omit the elements that Alois Riegl has made the basis of his studies on the arabesque, namely the large number of simpler scrolls, following the motif of the wave-like scroll, the wave-like scroll in mirror image, the intermittent wave-like scroll with half-palmettes and forked scrolls which show a direct relationship to the Coptic antique. I only mention here one characteristic feature which Riegl has recognised as specifically arabesque

and as derived from Coptic scrolls,[13] namely, the inversion of the continuous tendril in the opposite direction. The *main frieze*, the richest of the ornament, which surrounds all large arches in the same way, requires a short analysis because it is above all most likely to be misinterpreted (Plate III top).[14] The scroll is intermittent with the one difference that the lower fillers do not emerge as suspended plant forms from the upper points where the scrolls are in contact, but from the lower ones as freestanding where they then become "circumscribed" by the intermittent scroll. An upright heart-shaped leaf, which becomes a trefoil at the top, forms its centre. Both the slenderness and the marked indentations allow the vegetal image to predominate. The remainder of the filler also retains vegetal form. Two turned-up scrolls branch off from the lower part of the heart-shaped leaf; they terminate above in a vine leaf and below in a grape-like form. The upper compartments [43] of the intermittent scroll are similarly filled: a pointed heart-shaped leaf emerges from the lower point of contact with the scroll itself. The remainder of the ground is filled with a fully detached motif of an inward-curling leaf connected by its stem with one of the familiar cornucopia-like forms; here it looks particularly unlike any plant form because of the detailed dot-and-tassel pattern. There is not a single element that diverges from the standard ornament.

Finally, we should consider the capitals (Fig. 6). The capitals of the large pillars differ only in secondary elements. Their derivation from the Corinthian capital is quite clear. The two acanthus garlands are replaced by a two-course scroll. The two double volutes with their supporting leaves are replaced by trefoil volutes and the supporting leaves by two variants of a broad leaf with turned-over tip. The abacus still retains a remnant of the prominent centre from late Corinthian capitals. With regard to the degree to which the antique forms have been transformed toward the arabesque, these capitals occupy the same position as the large frieze of intermittent wave-like scrolls.

The *capitals of the small columns* in the windows are altogether different (Fig. 7). Their silhouette is similar to that of the large capitals—the plain, vase-shaped calathus becomes a square on top. Its composition is always the same, a curved lyre-shaped band. Most of the capitals are like those shown in Fig. 7a, although some are of the more decorated type, as in Fig. 7b, with variants in the details. The first type is easily understandable— [44] one only has to imagine that the plain frieze on top of all the walls (cf.

[13] *Stilfragen*, pp. 304–305 and 296.
[14] Cf. Strzygowski, "Mshatta," Fig. 113.

Plate III top) were placed around the calathus. Sometimes the broad leaf is divided by smaller vegetal motifs in the corners. In this way the transition to the second type is made. This second type, however, can be understood as an intermittent scroll placed directly around the calyx, somewhat assimilating the first type. These capitals merge so completely with the entire ornament that there is no need to look for an earlier compositional model. Yet, there exists a prototype, and indeed in the mosque itself. These are the antique *column capitals of the old* miḥrāb:[15] calyx-shaped impost capitals (*Kämpferkapitelle*). In the centre is an upright vine leaf, the prototype of the vase-like heart-shaped leaf. The lyre-like branches of the intermittent scroll are accompanied here by halves of acanthus leaves. On the corner is a combination of plant forms, and a grape motif. These marble capitals are undercut to such a degree that their decoration seems to have been carried out quite *à jour*. They are of Constantinopolitan origin.

Quite similar examples decorate the old *miḥrāb* of the mosque of Sīdī ʻUqba in al-Qayrawān and occur elsewhere in this mosque.[16] Identical ones can also be seen on the main façade of San Marco and elsewhere along the Mediterranean coast where they were brought by sea from Constantinople. There is no doubt that the small capitals of the Ṭūlūnid Mosque depend in their composition on this Constantinopolitan form, and consequently also the later capitals with their lyre-like decoration.[17]

What makes the ornament of the Mosque of Ibn Ṭūlūn arabesque?

First of all, it is not the design principle, the absolute filling of space, nor any qualitative factors conditioned by the material employed. All these are incidental points which miss the essential one. The arabesque character lies neither in the compositional motifs nor in its elements. As Riegl[18] has already stated, *the difference between Late Antique and arabesque ornament is only incremental, not fundamental.* The character of the arabesque [45] lies in the specific transformation of the formal elements through the free play of fantasy, the principle of variation that creates new combinations and variants, the composition arising from the idea of the infinite repetition in one or two axes, and the dematerialization of the elements that causes the complete disappearance of their vegetal or objective meaning and produces new abstract decorative values. In this way there is a combined coalescence

[15] Illustrated in Franz Pascha, *Cairo*, Pl. 11.

[16] Saladin, *La Mosqué de Sidi Okba à Kairouan* (Paris, 1899), Pl. xxii; and *Manuel*, Figs 134–35.

[17] They are typical of the buildings of Nūr al-Dīn and his time, e.g. in al-Raqqa and Mosul.

[18] *Stilfragen*, p. 306.

Ernst Herzfeld

and symbiosis of elements and of the union of vase, stem, leaf, blossom, and fruit without any accentuated separation—all this characterises this ornament as arabesque.

The ornament of the mosque is not unique; on the contrary, it is merely *an example* of an extremely extensive and uniform group, comprising carved wooden ornament. The Coptic department of the Egyptian Museum, the Musée Arabe in Cairo and the Coptic churches of Miṣr al-ʿAtīqa [Old Cairo] possess many examples. Comparison with them reveals the ultimate derivation of the ornament of the Ṭūlūnid Mosque. On Fig. 8 I have assembled five such examples, numbered 16–20 from Hall VI of the Arab Museum.[19] The similarities between this ornament and that of the mosque are so striking that they require no individual attention here. More important is something else—recourse to the same design principle. The spiral lines have been produced by slanted cutting similar to beveling. The indentations are simple beveled cuts. The engraved dots with a flat stroke have been punched with a ring-like instrument as delicate circles. Painting enriches the larger fields wherever an area executed in plaster shows a pattern of lines and dots. One can, therefore, see that *the originality lies in the woodworking technique*— the design principle derives from that technique. Forms best suited to wood have been transferred to plaster, a medium in which it is very easy to imitate and one not subject to any condition depending on its form, therefore devoid of creative originality. This transfer of a range of forms from one medium to another is a [46] specific feature of the arabesque. Unlike any other type of ornament, the arabesque is independent of the material because its forms are so abstract. In our examples survivals assert themselves in the egg-and-dart (no. 20) and in the border scrolls (nos 17 and 19), as they are also found among the ornament in the mosque.[20]

[47] Already the astonishing uniformity, independence, and frequency make it probable that this entire ornament is *indigenous to Egypt*. These principles also suggest that much of it must have been invented locally. A

[19] Published examples in Josef Strzygowski, *Koptische Kunst*, nos 7242, 7243 and 8796, there also references to examples in the British Museum; Max Herz Bey, *Catalogue sommaire des monuments exposés dans le Musée national de art arabe* (Cairo, 1895), Salle VI, 16–20, 24 (no ills.); Franz Pascha, *Kairo*, Pl. 8; Migeon, *Manuel*, II, Fig. 78, from the Louvre. Other examples from Takrīt on the Tigris will be published in *Archäologische Reise*. In general these examples belong to the period of the Ṭūlūnid Mosque, although some may be older, others more recent. Object 16 in Hall VI at Cairo can be dated paleographically not earlier than AH 285 on the basis of the type of script on two identical boards.

[20] For the edge of VI, 17, compare especially the Coptic example in Strzygowski, *Koptische Kunst*, no. 8793.

quick comparison of several *monuments from the time immediately preceding the Arabic conquest* serves to confirm this view. I have sketched three Coptic gable sculptures in Figs 9 and 10. The first two are nos 8676 and 8677 in the Egyptian Museum, the third did not yet have a number.[21] The first two, which differ only in some minor details, are mainly of interest because of the acanthus leaves of the acroteria and the borders, as in the range of heart-shaped leaves (8677b) from which the border in the mosque (Fig. 2b) is derived, the undulating vine of the cyma (8676) with its absolute space-filling as in the [48] acroteria, and the lines and indentations arising from it. The unnumbered example (Fig. 10) is even more characteristic. It is still entirely Coptic, yet it already displays the two distinguishing features of Ṭūlūnid ornament, namely the principles of absolute space-filling and of design; the entire ornament is created with a few spiral lines and indentations. A fourth example is the relief panel (Fig. 11).[22] The zigzag border is almost identical with that in Fig. 2a. The entire composition of the geometrically interlaced centre field with its border accompanied by strapwork bands is exactly like that on the soffits of the large arches of the Mosque of Ibn Ṭūlūn. The compartments of the inner field are entirely filled with vegetal motifs; these have been realized by merely a few indentations and central points. Only half-symmetrical forms appear here; they become symmetrical only in mirror-reverse image and then correspond entirely to the fillers in Fig. 5. Finally there is a good example of the ascending row of Coptic finger-shaped leaves.[23] It has the same basic characteristics, and the centre of the leaf already displays a form further developed in arabesque examples of this compositional motif, as in Fig. 4 and even more so in Fig. 3a. However, earlier forms, like the acanthus of Console 8777 (Fig. 13), are instructive about the origin of the finger-shaped leaf, where the same design principle—the spiral line curling inwards and the indentation—is already quite visible.

There can therefore be no doubt that the ornament of the Ibn Ṭūlūn Mosque and its artistic sphere is *intrinsically Egyptian*. It is represented by the fully developed, although still specifically Egyptian, arabesque. The reason for this development is cultural. It is not the case of a new nation [49] replacing an earlier one. The tradition of craftsmanship was not discontinued; it remained at first in the same hands as before. Only economic circumstances conditioned this change. The foundation of al-Fusṭāṭ, ʿAskar

[21]They are missing from Strzygowski's *Koptische Kunst*. The acanthus cyma will be relevant in a later connection (discussed in Part II of this essay, pp. 37ff.).

[22]Strzygowski, *Koptische Kunst*, no 7369.

[23] *Ibid.*, 8750.

and al-Qaṭā'i' brought about great tasks, requiring many workmen and a quick completion. Thus the most suitable principles and means were chosen. As always such novel undertakings have an almost accidental quality; beginning and end come so close together that at first glance the result appears to be something new and strange. The phases of development lie so closely together. Many details are thereby developed that prove a failure and disappear in the course of later evolution.

Ṭūlūnid ornament survives as an indigenous feature in the *later monuments* of Egypt; a brief reference to them must suffice here. I refer to the ornament of the al-Ḥākim Mosque, the al-Azhar Mosque[24] and associated monuments. This development was directed toward the aim of reducing the infinite variations to a classically small number of forms; within these forms there is a tendency to achieve a beautiful equilibrium of individual elements, as in Fig. 15d. The spiral forms, which are vividly reminiscent of Irish trumpet ornament (cf. Fig. 17b and c), appear remarkably characteristic. The geometric interlaced patterns have become noticeably more complex, and a new principle emerges of the contrast between flat and low relief or of the specifically Ṭūlūnid ornament with other types.

Other modes appear in the Egyptian ornament already discussed, especially in such other media as textiles, ivory, inlay, and metal, but they are of only secondary importance. I will briefly mention only one of them. The Arab Museum in Cairo possesses several thousand *Arabic tombstones*, and the Kaiser Friedrich Museum, the British Museum and the Louvre have several dozen; made of marble or limestone, they come mainly from cemeteries in the vicinity of Cairo. There is already a small literature about them; it deals primarily with the content of their formulaic inscriptions, less so with their palaeography, and hardly at all with the ornament.[25] The oldest known [50] examples are in Berlin. Those of approximately AH 200 are entirely without decoration in the border and script. The absence of any decoration on the slab remains the rule later on as well. However, from AH 200 onwards, the apices at the ends of the letters are decorated, very simply at first, then a little more ornately in the shape of half-palmettes. The latter must definitely be distinguished from "foliated Kufic"; it appears at first only in the first line of the inscription, the *basmala*. At the same

[24]["Madrasa" in the German original.]

[25]These tombstones cannot be discussed here in any detail. With the help of Dr M. Sobernheim, a philologist, I am in the process of preparing a publication about the Berlin tombstones from the paleographic point of view. The following is the result of this detailed study. I have taken the ornament of these tombstones as an example here because they have been put into consideration in the discussion of Mshattā, to which they do not belong.

time quite simple borders of chain or wave-like lines appear, occasionally in
a triangular form at the end of the stele. This form has been repeatedly mis-
understood. The meaning is shown quite clearly in the stones of horizontal
format, where these triangles are placed on either side of the stone: it is the
ansa (handle) of the *tabella* (or *tabula*) *ansata*. It is quite unnecessary to
state what role this Roman form of inscription played in Arabic epigraphy,
as there are innumerable examples everywhere. Moreover, the tombstones
also retain the vestige of the nails on these tabellas as small rosettes or hex-
agrams. This border becomes further enriched by the apices of the letters
which have been transformed into triangles and a wavy line which thus be-
comes a wave-like scroll. The period from AH 230 to the end of the third
century is characterised by exuberant apices in the shape of half-palmettes
and five-lobed leaves. The side borders show many variants of these apices
as leaves of the wavy scroll and of the *ansa*. [51] From about AH 240 there
also appeared a kind of stone inscribed *en relief*—where the background is
carved away to reveal the letters; until then they had all been *en creux*—
where the subject (i.e. the letters) is carved out, exactly as the inscription
on the building of the Jāmi' Ibn Ṭūlūn. Only rarely do they have any kind
of ornament. Where it occurs it comprises a simple wavy scroll, quite anal-
ogous to the small borders as in Fig. 8 no. 17 or Fig. 13 no. 8676; there are
also rows of buttons and simple beveled patterns. The ornament of these
tombstones, which occasionally also occurs on other objects, is thus clearly
a function of the development of the script and has originated there.[26] Its
meaning is strictly local, and it only tells us how new combinations can grow
everywhere from the roots of old motifs when stimulated by new cultural
factors.

The typical Egyptian ornament of the Ṭūlūnid period had a wide *dis-
tribution abroad*. This was particularly the case under the last Fāṭimids,
under Nūr al-Dīn Maḥmūd and under Saladin. At that time there was a
lively degree of interaction between developments in different provinces. It
was this interaction that brought about the culmination of Islamic art in
general. The distinctive style of the works of Nūr al-Dīn and his time dis-
tinguish it from all the others. At the same time Egyptian, Syrian and
northern Mesopotamian forms are united in a perfect equilibrium. Fig. 14
shows several ornamental elements of the old *minbar* from the [52] Jāmi'
Nūrī in Ḥamā.[27] They completely resemble the details of Nūr al-Dīn's *min-*

[26] A copy of the ornament in Strzygowski, "Mshatta," Figs 59–62.

[27] I took this photo and the following ones of the examples from Aleppo when I had
opportunity in the spring of 1908. Dr Sobernheim, with whose kind consent I reproduce
them here, collected the inscriptions of these places for the *Corpus*. The detailed pub-

bar in Jerusalem, which Saladin had moved there from Aleppo, and Nūr al-Dīn's *miḥrāb* in the Masjid Ibrāhīm in the Citadel of Aleppo. The same mixture of Egyptian and Mesopotamian elements can be seen in the old *miḥrāb* of the Great Mosque of Mosul, dated AH 545, which Nūr al-Dīn founded in AH 566–68 (Fig. 15).[28] It is interesting to see how the Ṭūlūnid capitals have been transformed here into the style of Mosul. This style of Nūr al-Dīn, characteristic of buildings, eventually conquered the Syrian and Chaldean ecclesiastical architecture of Mosul and its region. An identical phenomenon took place at the same time in Aleppo. Fig. 16 depicts several Egyptian and Syrian ornamental elements from the still entirely Classical cornice of a Fāṭimid structure at the Bāb Anṭākiya in Aleppo, dated AH 545. Finally, Fig. 17 gives an example of the ornament of a group of tombs of the sixth and seventh centuries in Ṣāliḥīn near Aleppo. As one can see, the Ṭūlūnid ornament has undergone a certain degree of development [53] which is identical to the ornament of the al-Ḥākim and al-Azhar mosques. From this it follows that these forms had not been further developed in Syria and Mosul, but rather that they had been recently imported from Egypt. This sphere of Egyptian ornament extends still further. It also appears in Asia Minor from the sixth century, as in the capitals that decorate the gate of the Jāmiʻ al-Qalʻa in Divriği (AH 576 or 596),[29] or on the crowns of the genii in the Konya Museum, the sole remaining remnant of the walls of ʻAlāʼ al-Dīn Kayqubādh I from the beginning of his reign, AH 618–34.[30] Two wood carvings must, however, be mentioned here, for they count among the most beautiful and most mature works of Islamic art, namely, the *minbar* of the ʻAlāʼ al-Dīn Mosque in Konya, of AH 550, and the window shutters of the Turbat ʻAlāʼ al-Dīn there, of AH 616.[31]

That Egyptian ornament in the old Ṭūlūnid form—and not in the more mature form—spread to other provinces is proved by a single but highly remarkable example. On his expedition in Syria and Mesopotamia in 1899, Dr Max Baron von Oppenheim was the first European to traverse the Jabal ʻAbd al-ʻAzīz, a mountain range between Balīkh and Khābūr in the Jazīra. Roughly in the centre of that mountain range lies the small place known as

lication of this rich material will follow in the volumes Aleppo and Ḥamāh–Ḥimṣ of the *Corpus*.

[28] Photographed during the expedition of F. Sarre and reproduced here with his kind permission. For the detailed publication of this *miḥrāb* and of many other examples, cf. Sarre/Herzfeld, *Archäol. Reise.*

[29] M. van Berchem, *Corpus Insc. Arab.*, volume *Siwas-Diwrigi* by van Berchem and Halil Edhem Bey. Cf. my article "Arabesque" in the *Encyclopaedia of Islam.*

[30] Cf. F. Sarre, *Seldschukische Kleinkunst* (Leipzig, 1909), Pl. 1.

[31] Cf. *ibid.*, Pl. VI and Fig. 25.

al-Gharra, where the Baron von Oppenheim discovered the Makān of 'Abd al-'Azīz. He took several photographs of it, which he gave me as kindly as always.[32] The tomb of the saint is situated on a partly hollowed spur, the upper strata of which are perhaps not geological formations but may have been used as human habitations. The present shape of the domed structure derives from a restoration of AH 1313, as indicated by an inscription on the ornate modern portal. In the interior is an old prayer niche, of which the stucco decoration is partly intact (Plate IV). The elevated modern floor covers up the base of the old wall. The niche has been installed in a rough manner, and parts of the original [54] decoration may perhaps be concealed behind this work. Only the conch of the niche has been left clear. On either side of the niche are two small round columns, which share one capital. The wall, frame of the conch, and the conch itself have been decorated in the flat style of the Ṭūlūnid Mosque. The means by which the design has been accomplished are the well-known spiral lines, indentations, and punched patterns, here on a larger scale because of the many entirely empty fields. The execution is noticeably much rougher than that in the Ṭūlūnid Mosque, as every ornamental motif has been cut directly into the fresh plaster, without preliminary drawing or compass lines, and apparently also without any preparatory design.

The upper frame of the conch has a blossom-and-bud band. Compared to the friezes of the Jāmi' Ibn Ṭūlūn, the details of that band have progressed somewhat further in the direction of the more mature later Egyptian arabesque. The corners have been composed diagonally, which is not yet the case in the Ṭūlūnid Mosque. On the contrary, there the more primitive manner predominates in which the friezes are bent and the patterns fail to connect. It is also peculiar that earlier Egyptian ornament never achieved a satisfactory solution to the problem of bending ornamental bands around corners. The bending of the pattern in our example connects the different motifs on the lateral edges of the frame. These are composed as an ascending scroll in a somewhat rough manner, with a suggestion of a vase form, like the ascending scrolls in Fig. 3a, again in a somewhat more developed form. The spandrels enclosed by this frame have been cleverly filled with a diagonally placed heart-shaped leaf, and with horn-like half-leaves in the remaining corners. The conch has on its edge a strapwork band with longish

[32]The whole mountain range of Jabal 'Abd al-'Azīz has been named after this tomb. The inscription is barely legible, but it seems to me that after the name of 'Abd al-'Azīz may be the word *muhājir*. Despite the kind help of M. van Berchem and I. Goldziher, it has so far been impossible to find out anything about the person commemorated by the tomb.

slits, otherwise one unit of the ascending scroll fills the whole field. This motif in particular has been executed rather sloppily, and it seems that it was not quite understood, although it is also found frequently in Egypt (Figs 2a and b, 3a, 4, 8, nos 17 and 19). Furthermore the motif shows a somewhat more developed stage on the way to forms such as Figs 14d, 15d, and 16b and c. The capitals have the shape of an intermittent scroll, like an S lying on its side. The decoration of the wall is a geometrical pattern between small borders. The simplicity of the pattern (which is somewhat reminiscent of the decoration of a glazed tile) is suggestive of its age. The border is an oblique strapwork band like that on the edge of the conch and often found in the Ṭūlūnid Mosque. The pattern consists of squares with cut-off corners with small rhomboids between [55] them. At the bottom of the wall the pattern dissolves into two small prayer niches, very similar to how it was done at al-Qayrawān. The two niches have different and very complex arch forms; as always architectural representations are more fantastic than real architecture. The compartments have been entirely decorated according to the principles of Ṭūlūnid ornament. Here too one sees variants, although without any definite rhythm. Insofar as the decoration of the small prayer niches is still recognizable, its motifs harmonize with the fillers of the large conch. Similarly the octagons each contain no more than one unit of the ascending scroll of the conch rim in two variants. The fillers of the small rhomboids are more freely drawn.

Everywhere one can see that the work has been carried out by unskilled hands and with little imagination. Although variants were intended, the entire ornamental scheme consists of only two motifs we have encountered already at the Ṭūlūnid Mosque: the ascending scroll with its vase-like stem and the blossom-and-bud arrangement. The *miḥrāb* of 'Abd al-'Azīz would be entirely unthinkable without the precedent of the ornament of the Jāmi' Ibn Ṭūlūn. On the other hand, its ornament clearly approaches the range of forms found in the al-Ḥākim Mosque, especially of the door of the mosque in the Musée Arabe in Cairo. The *miḥrāb* must therefore date between AH 255 and 393, probably in the first half of the fourth century of the *hijra*. It can also be assumed that a piece of a stucco moulding which Baron von Oppenheim collected from the shrine and of which Plate III (bottom) gives the front view and Fig. 18 the profile, belongs to the same period, although it looks rather older.[33] The fragment [56] shows that the cornice

[33] The shrine must have at all times been held in esteem and well maintained. This is shown from several other pieces collected by Baron von Oppenheim. Some of them are smooth and glazed in a light turquoise blue; the colour has not been applied under the glaze but in the glaze itself, as is usual in the ceramics of the seventh and eighth centuries

The Genesis of Islamic Art and the Problem of Mshattā 23

was fashioned mechanically by pressing the plaster into moulds, thereby forming the ornament. This may well explain the greater width of every third leaf of the egg-and-dart and of every second lancet-shaped leaf of the cyma. The cyma has an intermittent scroll, dissolved into upright S-forms with trefoils and tripartite lanceolate leaves. The comparison with later moulded plaster ornament from Asia Minor suggests that a similar type of ornament is quite likely at the time of the *miḥrāb*. The profile and the egg-and-dart should be even less surprising, for survivals, as we saw in Ṭūlūnid ornament, still occur in Syria in the fifth and sixth centuries [AH].

We have thus been enabled to study the *process of the origin of the arabesque* as a typical manifestation of Islamic art in one of its most important and most original provinces as well as its spread to other provinces. Quite analagous processes can be seen in Spain or Syria, and this exchange did not take place in only the one direction described. If one were to apply this observation to *other provinces*, the results would be formally but not essentially different. Thus in Spanish arabesque the acanthus is always the predominant element. In Syrian arabesque the vine scroll with leaf and grape, acanthus and vase are preserved much more naturalistically than in Egypt. Nowhere are the finest antique traditions preserved so well as in Syria. The degree of space-filling is, however, different everywhere, as are the principles of design and, for example, of relief. We can only guess at the evolution in Iraq, because the only evidence for its ornament established so far are such proven examples as the *minbar* and a part of the glazed lustre tiles of the *miḥrāb* of al-Qayrawān—both monuments of the end of the third century [AH]—and by parts[34] of the plaster ornament of the Dayr al-Suryānī of the first half of the fourth century [AH]. To these examples, which are no longer in their original country, one might add the carved wooden boards in the Arab Museum in Cairo (Hall VI, no. 21)[35] and above all the moulded stucco reliefs in the [57] Kaiser Friedrich Museum.[36] What is revealed in these few pieces is almost the exact opposite of the Egyptian arabesque. Its most important characteristics are a high swelling relief in contrast to the

AH. Another piece is a tile glazed in cobalt blue over a black drawing on a slightly raised ground, probably datable to the tenth to eleventh century.

[34] Other parts, as the flat ornament, are straightforward Egyptian; cf. Stryzgowski, *Mshattā*, Fig. 109.

[35] Illustrated in the *Catalog*, Fig. 26, and in Strzygowski, "Mshatta," Fig. 94. From the original and from a good photograph, for which I am obliged to Dr Sobernheim, the characteristics of the carving are more apparent, and from the inscription one can deduce the paleographic date of AH 230–60.

[36] Published by F. Sarre, "Makam Ali", *Jahrbuch der Preuss. Kunstsammlungen* 2 (1908), Fig. 7. The Iraqi origin of these pieces has now been established.

deep ornamental ground, and the development of contrast of these highly sculptural forms against an independent, flat and infinitely delicate filling of the ground. Both of these principles survive in the monuments of Baghdad and al-Baṣra from the seventh to the ninth centuries. Therein lies, on the one hand, the proof that these characteristics are Iraqi, and, on the other hand, that the tradition that attributes an Iraqi origin to the other pieces is correct.[37] There are hardly any early examples from the Jazīra with the exception of a few remnants from the early Umayyad period. Yet I believe the forms depicted in Figs 14b, 15a, b and c are specifically Mesopotamian [58] (Mosul). The Syrian arabesque is shown in Figs 14c and 16a and d, and in Fig. 19 there is an older, entirely Classical example of the Syrian acanthus arabesque in the ornament of the great minaret of the main mosque of Aleppo, dated AH 483. The Syrian vine leaf arabesque is characterized by the five-lobed leaf with superimposed grapes, shown in early phases on Plates I and II and a not very typical later example in Fig. 17. Were one to briefly describe the difference between the early Egyptian arabesque and all the others with an obvious external feature, one would state that the Ṭūlūnid arabesque lacks *any overlapping*.

So far I have not mentioned one feature in discussing the ornament of ꓸhe Ṭūlūnid Mosque, namely, *stucco*, the material in which this wooden ornamental style was executed. One may safely assume that stucco had been known in Egypt since Classical times, yet its use here to this extent as a material for sculptural decoration is quite new. *Baked brick*, the building

[37]While I was correcting this essay the article by Henri Viollet, "Description du palais de al-Moutasim à Samara", appeared in the *Mémoires présentés par divers savants à l'Académie des inscriptions et belles-lettres* 12.2 (Paris, 1909 [published in Feb. 1910]) which the author kindly sent me. Remains of the ornamental decoration in marble and stucco are gathered on Pl. XVI. These came from structures connected with the Dār al-Khalīfa, founded in AH 221 by al-Muʻtaṣim. One of these ornamental remains, Fig. 1, shows forms hardly changed from those of late Sasanian Persian ornament, under Khusraw Parwēz, AD 590–629, about which we know little, apart from a few other examples such as Ṭāq-i Bustān; cf. Flandin and Coste, *Voyage en Perse*, I, Pl. 6; Sarre/Herzfeld, *Iranische Felsreliefs*, Pl. XXXVII; F. Sarre, "Mittelalterliche Knüpfteppiche kleinasiat. und span. Herkunft," in *Kunst- u. Kunsthandwerk* 10 (München, 1907), Fig. 16. A change is noticeable only in the denser filling of space. However the other part, Fig. 3, completely corresponds to the abbreviated form of Ṭūlūnid ornament, as in the door soffits, Fig. 1, and it also particularly resembles one of the wooden boards from Takrīt in the possession of Friedrich Sarre. There is still little of that material available, yet it seems that in the Iraqi ornament of the second and third centuries AH, northern Mosopotamian or northern Syrian (Khāṣṣakī *miḥrāb*), Iraqi (stucco rosettes in the K. Friedrich Museum), al-Qayrawān *minbar*), Persian (Viollet Pl. XVI, Fig. 1) and Egyptian (Viollet, XVI, 3) elements are already mixed. In this way the scant remains give us a hint of things to come.

The Genesis of Islamic Art and the Problem of Mshattā 25

material of the mosque, was not generally used during earlier times in Egypt, at least pure brick construction is not usual. And, because in the time of Aḥmad ibn Ṭūlūn the relations between Egypt and Iraq, the centre of the empire, were very close, and as the entire intellectual and economic culture was strongly influenced by Iraq, it is certainly correct to assume that the use of brick and stucco was due to influence from Baghdad and Sāmarrā. One should not forget, however, that baked brick was not at all the usual building material in those lands, as the ruins of Sāmarrā show. Economic factors, which we have also seen influencing other forms of art, were decisive in its introduction, for the construction of al-Qaṭā'i' required quick work. Spolia, still so widely used at al-Fusṭāṭ and 'Askar, began to run out, as was to have been expected from the outset; this is clearly recorded.[38] One uses, therefore, the experiences and methods of other countries, and without connecting this to an immediate [59] import of another art form, such manifestations contribute essentially to the assimilation and formation of the same principles in early Islamic art.

These considerations again lead back to the starting point of the investigation. We have by now become acquainted with quite a range of characteristics of early Islamic monuments as well as several factors and effective means by which these characteristics were created. And now we can approach *the aim of our study*, which may have been overlooked until now. By assembling all the scattered evidence we may perhaps find the *answer to the problem* formulated at the beginning.

To meet the requirements of the new rulers and the new religion, artists and artisans select the most suitable types from their repertoires, which they adapt to new purposes with only slight changes; this is the case for buildings, individual objects such as prayer niches and tombs, as well as decoration. Together with building types, techniques of construction and building materials are taken over. This happens locally at first, but very soon it is transferred from one province to another. The consequence is that certain techniques of construction, hitherto only present in an embryonic form, are developed into a fully formed principle. This is so with the tie-beams in the construction of arches; another example is the pointed arch, which has

[38] One can observe an analogous situation in early basilicas of Italy and southern France. There too the transition from columnar to pier-based building took place, and there too the gradual disappearance of spolia was an essential factor in architectural development. Here too buildings employ engaged columns, as in Egypt. One can find other examples in Germany, or also in western Mesopotamia. The similarity of external circumstances and of the forms produced by them is so striking that the subject could well be made into a most promising study on the comparative history of architecture.

Ernst Herzfeld

spread, together with Islam, across half the globe. The traditions of learning architecture and other artistic techniques survived. Older artisans, however, were at first only able to work in their provincial manner. The transfer of the new practices from province to province presupposed a transfer of the artisans themselves, a process by which they acquired new practices in their ɪew environments in addition to their indigenous ones. The transfer of the formal vocabulary from one medium to another is closely connected with it: native workmen had to cope with imported materials, and imported workmen with local materials. This relationship of the mixture of artisanal teaching is very clearly reflected in details in the decoration: fantasy, which manifests itself in the invention of ever new combinations, is expressed in the principle of variation; the coexistence of forms of different provincial origin, and the fact that the elements of antique ornament lost their former importance and themselves gained new decorative values—all this presupposes a mixture of workmen and a special organization of labour.

[60] It is thus principally *economic factors*, therefore, that determine the development of art forms. The monuments show that it is not a matter of isolated occurrences, but an economic principle, an *institutional phenomenon*, that becomes apparent in all public buildings, cities, mosques and palaces. The foundation of numerous cities in the entire region of Islam demanded enormous resources. There were abundant resources, and costs were irrelevant. However, men were needed in enormous numbers, and extraordinary speed of execution was essential. Papyrology has revealed the institution used to fulfil these requirements, namely, *corvée labour*.[39] In Egypt this becomes particularly clear. It not only comprised the recruitment of workmen, means of transport, tools for road and canal-building and the supply of natural products of all sorts, but also the provision of trained civil servants, the supply of materials for public buildings and other requirements of public life in different countries. The papyri show that Egypt, to mention but one example, had to contribute towards the Umayyad structures in Syria. We are told that money, material and labourers were demanded from

[39] C.H. Becker, in addition to H.I. Bell, has made this material accessible to us. He has repeatedly emphasized the art-historical aspect "of these important new discoveries that not only inform us about details but open up and correct whole new prospects." Anyone familiar with the subject will have noted immediately how much I have depended on him, as I shall do in the following text, quoting whole sentences of his work almost verbatim because I cannot improve on his expression of the facts. See his "Grundlinien der wirtschaftlichen Entwicklung Ägyptens in den ersten Jahrhunderten des Islams", *Klio*, 9.2 (1908), and "Papyrusstudien", *Zeitschrift für Assyriologie und verwandte Gebiete* 21 (1909), especially pp. 153–54. Also his "Mshattā", *Zeitschrift für Assyriologie und verwandte Gebiete* 19 (1907), pp. 420ff.

Aphrodito, for example, for the mosques in Jerusalem and Damascus. We also know that these and other large structures were carried out by corvée. Of course the papyri tell us particularly about conditions in Egypt. If it accordingly follows that this practice was applied to the whole realm, it is still not at all clear to what extent it applied to the eastern provinces, and how long it continued in the same way. In Egypt a transition already took place from corvée in its original form to taxation. In their letters, however, officials repeatedly admonish the recipients to supply men and material, and not monetary remuneration, the *apargyrismos*.

Some literary references seem to indicate that *corvée was still practised under the first 'Abbāsids* [61] during the foundation of Baghdad and Sāmarrā. Thus al-Khaṭīb [al-Baghdādī] wrote concerning the founding of Baghdad:[40] "al-Manṣūr wrote to each town to send anyone skilled in building work, and he did not begin the structure until he had assembled many thousands of bricklayers and artisans." Al-Ṭabarī [41] mentions Syria, Mosul, Persia (al-Jabal), al-Kūfa, Wāsiṭ and al-Baṣra as the provinces from which labourers were sent. Egypt was certainly not exempted. Al-Ya'qūbī,[42] like al-Ṭabarī, mentions a fixed number of 100,000 workmen. The building operations of the city were supervised by four men, one of whom was the Imām Abū Ḥanīfa. In the history of the building of Sāmarrā, al-Ya'qūbī similarly states that:

> al-Mu'taṣim sent for (*kataba fī*) labourers, bricklayers and artisans such as smiths, carpenters and all other tradesmen; he ordered the import of teakwood and all wood suitable for building and palm trunks from al-Baṣra and its vicinity, from Baghdad and the whole Sawād, and from Anṭākiya and all the coastal towns of Syria; and the import of artisans skilled in marble and marble–plaster work, with the result that in al-Lādhiqīya and elsewhere marble workshops were started.[43]

The number of workmen must have been enormous here as well, as is evident from the structures erected within an incredibly short time. In the same way, when a little later, in AH 245, al-Mutawakkil built the city of Ja'farīya, which borders Sāmarrā on the north, the ruins of which now cover about seventeen square km., no less than 12,000 labourers were employed for the

[40] G. Salmon, *L'introduction topographique à l'histoire de Baghdâdh etc.* (Paris, 1904), text p. 1, translation p. 75.

[41] *Ta'rīkh al-rusul wa-l-mulūk*, ed. M.J. de Goeje (Leiden, 1879–1901), III, 276.

[42] *Kitāb al-buldān*, ed. M.J. de Goeje (Leiden, 1892), 238.

[43] *Ibid.*, 258:11ff.

building of the canals alone.[44] The accumulation of such masses of human beings is hardly conceivable without the existence of corvée, which must be understood when the caliph euphemistically "sends for" this huge labour force. Just as the caliph required the population of almost the whole of his entire realm, provincial governors like 'Amr and Aḥmad ibn Ṭūlūn similarly made use of their provincial power bases. In addition, they too requested masters and materials for special tasks from distant provinces and from abroad. Thus it has been reported that the Aghlabid Ibrāhīm ordered the *minbar* of Sīdī 'Uqba in al-Qayrawān from Baghdad,[45] as well as [62] part of the lustre tiles (*chīnī*) of the *miḥrāb*,[46] and that he had ordered a master to come who completed the remainder of that structure there, and thus transplanted the technique to al-Qayrawān. Likewise, 'Abd al-Raḥmān I, in AH 168 [sic] sent for Byzantine mosaicists for his mosque in Cordoba, who then founded there the school of the Spanish *mufaṣṣaṣ*.[47]

We can therefore appreciate that *religion* and *government*, which alone unify the Islamic lands, are two essential factors in the formation of Islamic art, in their roles as patrons. Corvée and its sequel are the economic factors that bring about mixture and equalization among the provinces; the immediate import functions in the same way, not as an isolated phenomenon but as a generalized one. The *organization of labour* provides a further key for the understanding of the individual characteristics of early Islamic art. In all large buildings several people were entrusted with the supervision. The business side of it was always in the hands of prominent dignitaries. In addition there were several technical managers, usually non-Arab *mawālī* of the caliphs. Thus during the building of the Umayyad Mosque at Damascus, a Persian acted as the executive architect.[48] During the building of the Ḥaram at Jerusalem the business manager was Abū Miqdam Rijā' ibn Hārul al-Kindī, assisted by the *mawlā* of 'Abd al-Malik, Yazīd ibn Sallam, himself a man from Jerusalem, and two of his sons.[49] Thus we ought to imagine how the organization worked in descending order. The various artisans, including the imported ones, worked in groups under the supervi-

[44] For the above see my *Samarra* (Berlin, 1907).

[45] Saladin, *La mosquée de Sidi Okba*, p. 16. M. Roy, after a *Kitāb al-iftikhār*. However, this is a source the authenticity of which ought to be proven; all the other reports and quotes are incorrect.

[46] [The text has *minbar* in the original.]

[47] According to al-Idrīsī; cf. Saladin, *Manuel*, I, 225, and Migeon, *Manuel*, II, 80. [There is some confusion here: the mosaicists are said to have been requested in the fourth century AH/tenth century AD by the Spanish Umayyad caliph al-Ḥakam.]

[48] Cf. Becker, "Grundlinien," p. 154; Brit. Mus. Papyrus nos 1368, 1334.

[49] Cf. de Vogüé, *Temple de Jérusalem*.

The Genesis of Islamic Art and the Problem of Mshattā 29

sion of official executive architects and along with cheaper native builders' assistants. However, these supervising officials could not interfere with the specialised work of foreign artisans, such as Byzantine mosaicists. Therefore, these workers had more freedom just because they were imported. Anyone who had worked as a journeyman under a master's direction in his native land became now in this foreign country himself a master and teacher of his craft. The independent work of many serves as an explanation for the rich fantasy and the principle of variation in contrast to the Classical uniformity and to the timid beginnings of variation in [63] late Hellenistic art, like freehand, only for the purpose of maintaining a general equilibrium. This equilibrium, however, had to be based on a general directive in which the influence of the executive architect becomes apparent. Thus the appearance of Iraqi elements in the ornament of the mosaics in Jerusalem. They cannot have been inspired by Byzantine mosaicists, yet only they can have executed them. Like a Persian at Damascus, Iraqis must, therefore, have worked at the Ḥaram in Jerusalem.

In this mixture of workmen who had been brought together by corvée, men acqui·ed the techniques of their foreign companions along with their native ones, hence the original juxtaposition of alien forms and their quick adaptation; for a new generation, which fused methods of many different derivations in their training, developed among the journeymen and apprentices. The next generation implanted the alien methods in the new country, hence the basic views are expressed in the same manner, despite all provincial differences. It is not a matter of new people replacing older ones. Only later will an ethnic shift imperceptibly come about. In Egypt, the converted *mawālī* separate from the Copts who remained Christians and mix with immigrant Arabs. The latter had come at first as masters, officials, and warriors; they were unsophisticated and of nomadic origin, but descended into lower social strata, and so had become apprentices of the subjugated. This development was completed in the course of the third century [AH], and simultaneously the characteristics of Islamic art developed.

During the following three hundred years this art reached its acme. During that time one further adjustment occurred, although this was a development brought about by other factors. Political divisions and connections replace economic factors. This is shown by the works of the later Fāṭimids, Nūr al-Dīn and Saladin. This poses another problem. However, as a *result* of this study we can maintain that the problem formulated at the beginning, namely how Islamic art originated, is solved by our understanding of the cultural and economic situation. It was inevitable that the character of Islamic art was determined by these general factors. Similarly, the converse of this

concept will be confirmed: works of art that possess these characteristics must and can only be products of early Islamic art.

II

[105] In the first part of this essay I tried to solve the problem of how it was possible for a uniform art to evolve in the Islamic lands. I chose a few examples at random, such as the Ḥaram al-Sharīf in Jerusalem, the *miḥrāb* of the Jāmiʿ al-Khāṣṣakī in Baghdād, Ṭūlūnid ornament in Egypt, and its offshoots in the diaspora, in order to analyse the characteristics of these monuments from the first three centuries of the *hijra* and to determine the motivating forces that created them. I said at the beginning that the solution to this problem would provide the means for the art-historical classification of one of the most controversial monuments of Oriental architecture, namely Mshattā. In conclusion I stated that the reversal of the earlier view about the forces that motivated the peculiar character of early Islamic art was justified, namely, that works of art of this type could only belong to early Islamic art.[50]

[106] Since its original discovery in 1865[51] or thereabouts by Tristram, and even more so since its thorough survey by Brünnow and von Domaszewski from 1895–98 (published by them in 1905) and its transfer by B. Schultz to the Kaiser Friedrich Museum, and by its art-historical investigation by Strzygowski in 1904, Mshattā has become a veritable *crux interpretum* for art historians. Five hypotheses about its age and its origin have been put forward: 1. Sasanian, 2. Byzantine, 3. Ghassānid, 4. Lakhmid, and 5. Umayyad.[52]

[50]Thereby my point of view about Mshattā is already explained: I believe it to be an Umayyad structure. I expressed this opinion already in 1906 in my essay *Samarra* (cf. p. 18) which was published in 1907 and had been inspired by a lecture given by D. Wulff at Berlin University during the summer term of 1906. I reiterated my view in the *Führer durch Berlin* (cf. p. 272), which was later published for the participants of the Internationalen Kongress für historische Wissenschaften, which took place in Berlin from 6th–12th August 1908.

[51]The great Sir Henry Layard was the first to visit Mshattā—as he did so many other monuments—cf. the unrivalled model of all Oriental travel books, his *Early Adventures* (London, 1887), I, 1145.

[52]The story of these various theories has been recounted by Max van Berchem in his "Aux pays de Moab et d'Edom", *Journal des savants* (July–September, 1909). One will find there a detailed account of the amazingly extensive bibliography on Mshattā. As utter brevity is demanded in this essay of mine, as also regarding van Berchem's statements, I can rely entirely on his easily accessible work, with the exception of the recently published essay by H. Lammens, S.J., "La Bâdia et la Ḥîra sous les Omaiyyades: un mot à propos de Mśattâ," *Mémoires de la Faculté Orientale de Beyrout* 4 (1910), pp. 91–112, to which

It is an odd story. When the first photographs of Quṣayr ʿAmrā became known, A. Riegl took this unique structure to be Late Antique; then, under the force of Karabacek's arguments, the view of an ʿAbbāsid origin gained ground, despite the dissenting view of A. Musil, who had discovered it. Eventually, through the joint investigations by Becker, Littmann and Nöldeke, the accurate attribution to the Umayyad period prevailed. In this change of theory one can observe a certain parallel between ʿAmrā and Mshattā. And the recognition of ʿAmrā had repercussions on the problem of Mshattā. Already in 1905 Becker had considered both castles together from the beginning, when the only views available were Musil's first report on ʿAmrā with his Ghassānid theory and Karabacek's lecture at the Academy with his ʿAbbāsid thesis. When ʿAmrā was later established epigraphically to be Umayyad, Becker took this to be a confirmation of his view regarding Mshattā. Whoever—like D. Wulff and me—shared this view was considerably supported by Becker's opinion. On the other hand, the proponents of other views reacted quite differently; they felt that if ʿAmrā were considered Islamic, this could not be so for Mshattā.

Both the Sasanian and the Byzantine hypothesis have long vanished from scholarly dispute. Only the Lakhmid, Ghassānid and Umayyad hypotheses are still [107] debatable. Everyone agrees that Arabs built the structure. On the other hand, there is general agreement that there is no such thing as an Arab art. Why then does one assume that Mshattā was built by an Arab architect? Because of the quite peculiar mixture of heterogenous elements in this structure. To assign it to Arabs and to exclude Byzantines and Sasanians rests on negative and indirect arguments. An inscription[53]— positive direct proof, which would, as at Quṣayr ʿAmrā, have solved the argument at once—is lacking. For this reason one can approach the attribution of the structure within the context of artistic development from two perspectives, the historical-cultural and the art-historical. This has happened, with greater emphasis either on the cultural-historical aspects or the art-historical ones. Of all studies, the results of the two latest are the most contradictory: Max van Berchem, who assigns Mshattā to the Lakhmids, and who like Clermont-Ganneau and Dussaud attributes it to Imru' al-Qays I in the early fourth century, against Lammens, who counts it among the Umayyad *bādiyas* and *ḥīras*. The studies of Strzygowski and Lammens are

nothing has to be added.

[53] Van Berchem indicates how inscriptions in Islamic architecture are already in Umayyad times closely connected with both structure and decoration. This is an *argumentum ex silentio*, which has to be contrasted with the unfinished state of the structure of Mshattā.

extreme opposites in method: Strzygowski bases his work on an extraordinary amount of material, while Lammens bases his on an astonishingly thorough knowledge of Umayyad history and culture. The results differ considerably; the former places the structure in the fourth–sixth centuries and makes it definitely non-Islamic, while the latter dates it to the early eighth century and specifically to Yazīd II.

If one studies van Berchem's work, which deals exhaustively with the problem as it stands, one gains the vivid impression of how intimately the cultural-historical and art-historical viewpoints are intertwined and how interdependent they are. If Brünnow maintains the view of Mshattā's Ghassānid origin against the historically contradictory stand of Dussaud, one of the main representatives of the Lakhmid hypothesis, he places Mshattā, for archaeological reasons, in the sixth century. Van Berchem entirely rejects the Ghassānid hypothesis mainly for historical reasons and supports a Lakhmid origin: he thereby excludes the Umayyad hypothesis, although he relies strongly Strzygowski's art-historical [108] assumption that the style of Mshattā was not in the manner of the eighth century. Thus he is forced to push the date back to the early fourth century—the time of Imru' al-Qays I—which is the earliest given by Strzygowski. As already mentioned, both Strzygowski and van Berchem share the view that if any proof were needed that Mshattā could not be of Umayyad origin, its contrast with Quṣayr 'Amrā supplies it.

This interdependency of views evidently shows that historical considerations alone will not solve the puzzle. The arguments of Becker and Lammens will not convert a follower of Strzygowski's theory, nor will van Berchem's arguments convince a believer in the Umayyad hypothesis. Art-historical investigation must play a decisive role. Thus the problem has to be tackled once again from the art-historical perspective, and particularly because van Berchem's work has again brought the controversy into focus. One cannot deny that the compromise Ghassānid hypothesis does not have much going for it, and that the truth must lie in one of the two extremes, namely, the Lakhmid in the fourth, or the Umayyad in the eighth century. However, it is unthinkable that the history of art lacks any means to date a monument such as Mshattā more precisely than by merely placing it within such a broad time span as 400 years. The art-historical problem is this: *Given our current knowledge of the monuments, is the art-historically proven fact that Mshattā is pre-Islamic really unshakeable? If its style is not really attributable to the early eighth century, is it not then less so to the early fourth century? And with it the closely related question: Given our greater knowledge of early Islamic art, does the contrast between Umayyad Quṣayr 'Amrā*

and Mshattā really prove the non-Islamic origin of Mshattā?

This is how I would formulate the question. Before I attempt to answer it I have to set the stage. The discoveries of Musil and Brünnow have shown that Mshattā does not stand alone. Just as beautiful Quṣayr ʿAmrā is associated with the plain Qubbat al-Bīr, so is Mshattā associated with a whole group of structures, including Qaṣr al-Ṭūba, al-Kharānā, al-Abyaḍ, and some smaller ones. A special position is occupied by **[109]** al-Muwaqqar. Just as Lammens's cultural-historical study dealt comprehensively with all the *bādiya*s and *ḥīra*s of the Umayyads, so must these structures be comprehensively analyzed through art history. The photographs of L. Massignon and Miss G.L. Bell have recently opened up the new but related area of Ukhaydir and its group, still only poorly understood.[54] The task is now to conquer the whole realm of these monuments of Islamic art and thereby to clarify and deepen the understanding of that art with which we have begun in the first part of this essay.

As we now possess exhaustive photographs of Mshattā I can forego any description and immediately begin *in media res* the analysis of the whole structure. I shall only make the preliminary remark that the peculiar condition of being incomplete at any rate establishes one fact beyond any doubt, that *the whole structure is of a piece*, although this very incompleteness has led to the drawing of various questionable conclusions about Mshattā's date.

I begin with the *technical aspects*.

Mshattā is a structure in which baked brick, ashlar masonry, rubble, marble pillars and wooden beams were all used. In this way, entire parts of the structure were made of different materials: the front walls of rubble faced with ashlar and the side walls less solidly built; in contrast the walls and vaults of the inner complex on the north are built of brick, and only certain parts, such as socles, corners, pillars and arches, were built of ashlar masonry. This type of mixed construction is alien to the antique structures of Syria and other provinces. Such a composite structure occurs only when a specific material is associated with a specific part of the building—as, for example, in northern Mesopotamia where stone is used for the load-bearing

[54]Louis Massignon, "Les châteaux des princes de Ḥīrah," *Gazette des beaux-arts* (April 1909), pp. 297–306. Miss G.L. Bell, "The Vaulting System of Ukhaidar," *Journal of Hellenic Studies*, 30 (1910), pp. 69–81. Both of them at present merely announce a definitive publication. Ukhaydir was mentioned first by Karsten Niebuhr, *Reisebeschreibung von Arabien und anderen umliegenden Ländern* (Copenhagen, 1774–78), II, 225 n. and 236. Since 1903 I have heard quite a bit from the locals about these castles, of which Ukhaydir may well be only the largest. Apart from al-Kūfa, al-Ḥīra and al-Khawarnaq, they mentioned Sahla, Abū Sukhayr, a ruin between Jaʾra and Shanafīya, as well as Shifāta (i.e. Shathāta), which local tradition ascribes to one Shimʿān al-Yahūdī in pre-Islamic times.

Ernst Herzfeld

walls and brick for the vaults, or in parts of northern Syria and in the central
Euphrates, where the Byzantine method of alternating courses of rubble and
brick is used. Here, however, it is quite clear that the various parts of the
structure were executed according to the methods used in *different lands.*

[110] The *brick technique of Mshattā* is simply *Iraqi.* Exactly as at
Sāmarrā, the bricks vary in size from 21 to 27 cm.; ten courses at Sāmarrā
usually measure 90 cm., at Mshattā eight courses measure 72 cm., or ten
courses 90 cm. At both sites the bricks are about 6.5 cm. thick, thus leaving
2–2.5 cm. for the layers of mortar. The vertical joints vary considerably, from
3–4.5 cm. at Mshattā to as much as 7–8 cm. at Sāmarrā. The material used
at Mshattā, al-Ṭūba and Sāmarrā is therefore identical. Sasanian bricks are
larger in format. At Ctesiphon I measured them to be 31.5 cm. square on
average, ten courses measuring 100 cm., horizontal joints *ca.* 3 cm.; or at
Dastajird on the Diyāla they are 35.5–37 cm. square, ten courses measuring
106 cm. The same is true elsewhere. The brick construction is therefore not
merely Iraqi, but Islamic Iraqi. Its brick bond differs from the "Byzantine"
method found in the middle Euphrates. At Bālis-Eski Meskene, for example,
the bricks measure 42 x 50 cm., ten courses measure 92 cm., of which 50
cm. is mortar. These colossal bricks and courses of mortar thicker than the
bricks are found, together with alternating courses of stone and brick, on all
Justinianic structures, and also in Constantinople.

Like forms and brick bonds, *arch construction* at Mshattā is also Islamic
Iraqi. All the arches are double, so that the faces of the bricks are visible
on the inner arch and the edges of the bricks are visible on the outer arch
(Fig. 20). This method, which has no technical justification, is traditional
in Iraq. It is widely used on the Tāq-i Kisrā at Ctesiphon[55] and might be
explained by the fanciful changing courses in all Parthian brick walls. At
Sāmarrā I have characterized this same method as typical of early 'Abbāsid
architecture in Iraq. We find it again in the old gateway of al-Raqqa, a
monument of Hārūn al-Rashīd, and exactly the same in Mshattā and al-
Ṭūba. It does not occur in other countries. Within this same method there
is a characteristic chronological difference. In Sasanian arches the span of
the arch is wider than the opening below. This is traditional in Iraq as well;
we see it already on the arches of Nebuchadnezzar's palace in Babylon.[56]
In 'Abbāsid examples, in contrast, the span of the arch is a little narrower
than the opening below, and the arches project a little [111] from the walls.

[55] Herzfeld, *Samarra*, 17, Fig. 7.

[56] *Mitteilungen der Deutschen Orient-Gesellschaft* 8 (1901), p. 5. [The gate at al-Raqqa,
known as Bāb Baghdād, is now generally considered to date from the Zangid or Ayyūbid
period.]

Mshattā appears to occupy a middle position; according to B. Schulz[57] and Brünnow[58] both have the same width (Fig. 20).[59] The slight projection of the arches also occurs on vaults. This is not found on any antique or Sasanian structures. This is an obligatory feature, however, for all vaulted structures of the Islamic period, from the oldest to the most recent. As at Sāmarrā, one finds it commonly at Mshattā and al-Ṭūba. One more detail should be mentioned. Schulz describes the large broken areas found on all door jambs directly under the arch. He explains this as resulting from the wooden beams once used to separate the rectangular opening of the door from the tympanum. Above the beams there was a horizontal course of bricks. The exact same feature is found in all the doors of Sāmarrā and of Ṭāq-i Kisrā—it is the typical Iraqi type of door construction.

The shape of the arches is a further consideration. Typical early Islamic pointed arches are found at Sāmarrā, on the old gate of al-Raqqa, on all Umayyad column mosques and on 'Abbāsid pier mosques. As an architectonic principle the pointed arch is entirely alien to the pre-Islamic period. It remained unknown to Classical architecture right up to the end. Sasanian architecture employed the tall irregular elliptical arch for its large barrel vaults; it used the semicircular arch for small vaults and all [112] doors and windows in Iran as well as Iraq.[60] But the seeds of the pointed arch lie in

[57] Fig. 9 and Plate VI.

[58] II, 125, Figs 717 and 719.

[59] However nobody has measured it, and according to a photograph by Brünnow (II, 128, Fig. 720) it appears that the span of the arch (140 cm.) was slightly wider than the door opening (132 cm.).

[60] Strzygowski has put forward one structure as evidence against this statement. But this does not hold. At the very top of the inside curtain walls of Ṭāq-i Kisrā is a row of small niches. These are vaulted in such a way that each half of the arch consists of two bricks, each 33.5 cm. long; these arches are therefore the half of an elongated octagon. When seen from a distance, they somewhat resemble a pointed arch or an elongated elliptic arch, but they were certainly not consciously meant to be pointed arches. The small dimensions and the method of placing the bricks make it impossible to produce a semicircle. Given five bricks, the brick at the apex would have to have been placed horizontally, in which case it would have collapsed from the weight of the masonry above. I know of another example. The inner side of the town walls of Dastajird has some narrow window-like chemins-de-ronde, which are only 96 cm. wide; they have vaults with pointed arches. The chemins-de-ronde themselves are, in the old way, narrower than the arches. Otherwise the parabolic arch predominates in Dastarjird. The walls can hardly be older than the time of Khusraw II Parwēz, therefore AD 590. It is probable that the strengthening or repair work, which one can see, was carried out in 627–28, after the war of Heraclius; see Sarre/Herzfeld, *Iranische Felsreliefs*, p. 237. There can therefore be no question of the pointed arch occurring before the last few years of the Sasanian period. Yet these embryonic examples reveal that there was a tendency toward the pointed arch inherent

Sasanian architecture in Iraq. I have no doubt that the first arch structures of the Islamic period in Iraq grew from these seeds. Together with Islam, the pointed arch spread, at first in its specific Iraqi form, across half the world, to al-Raqqa, Mshattā, al-Ṭūba, Cairo and al-Qayrawān. Only Syria did not at first let itself be conquered by this novel idea. Just like Asia Minor and Byzantium, which remained Christian, it refused to accept it. Throughout the Fāṭimid period the semicircular arch repeatedly reemerges.

As far as I am concerned, I would be content to exclude a pre-Islamic origin based solely on the constructional and formal aspects of the brick and vault structure of Mshattā. I do not wish, however, to anticipate my general conclusion, but will merely state for the moment that *the inner, northern complex was carried out by Iraqi builders*.

These Iraqis, however, would never have been able to execute the ashlar masonry on the suite of rooms, namely the triple-arched façade of the basilical hall, the arch, and the engaged columns of the triconch. These parts, like the surrounding walls with the main façade, belong to a different type of building. The *ashlar masonry* suggests the kind of material used in *western provinces*. [113] In Syria virtuoso ashlar masonry predominates as long as there are any antique monuments in existence. The ashlar blocks, rectangular solids in shape and almost always as thick as the entire wall, were erected without mortar and with great stereotomic skill. Even the simplest private buildings of the sixth century were constructed in this exaggeratedly solid and costly technique. The still remarkable stone construction at Mshattā with its rubble core bound with mortar and faced with ashlar surpasses anything customarily encountered in Asia Minor, or even more so in the Sasanian buildings of Iran, those miserable structures put together any which way with rough fist-sized stones, the same way in which the many Roman camps of the Provincia Arabia were built. The masons there must have been natives. It is precisely this technique in the Provincia Arabia that later became the one generally adopted in Islamic architecture even where other methods were in use, as in Syria. The *gros oeuvre* has surely *been executed by native labourers* (Fig. 21).

However, this cannot apply to the stonemasons' work on *profiles*. Here Mshattā possesses rather different forms, quite unlike the dull, simplified and rustic mouldings and profiles [114] of all the ruins of the Provincia Arabia. The architectonic profile can easily be overlooked in photographs, yet it is really of great importance in any critical assessment of styles. Who

in these brick structures, and that it only required some strong impetus to develop into a principle. For this see my chapter "Samarra" in Sarre/Herzfeld, *Archäologische Reise*.

can doubt that one can determine a Gothic building most accurately merely from its profiles? In few things does this manifest itself so clearly as here in the workshop tradition. There is the tradition of a school. Classical Greek architecture perfected profiles with an unparalleled elegance of aesthetic feeling. Hellenism dispersed these canonized forms with the three "orders" all over the globe. But wherever these forms were planted into unsuitable soil, as in the eastern provinces, they soon degenerated. In Iran and Iraq buildings dating from the turn of our era already show many bastardised forms. These countries acquired neither the aesthetic feeling nor an understanding of the elegance of Greek architecture.[61] This is, in the broadest sense, rather different in Syria. Syria is the Oriental province of Hellenism in which the tradition of the Hellenistic school survived strongest and longest, even much longer than in the West, in fact right into the High Middle Ages.[62] Syrian architecture is distinguished from that in all other provinces by the plasticity of profiles on a grand scale as well as by the precision of the details. The profiles of Mshattā possess both these qualities in a remarkable way.

In Mshattā we see *two systems of architectonic profiles*, that of the façade and that of the basilical building. *On the façade* we have the main cornice above, the door frames, and the socle; in addition there are the zigzag cyma and the rosettes. The main cornice is a tripartite Corinthian cornice consisting of architrave, frieze and string course. Yet it has undergone strange transformations, due to the desire to avoid any smooth fields, which had led to the richness of the decoration in antique moulding. This idea is connected to the decorative principle which is so alien to the antique. The smooth fasciae of the architrave are also absent; only its astragals and its upper cymatium are closely squeezed together. The overhanging part of the string course is absent, and its cymatia are close to the cyma. Consoles and dog-tooth are absent, and instead of consoles there is an alternation of two cylindrical mouldings and an acanthus palmette, and instead of the dog-tooth there is a simple [115] meander band. An excessive display of ornament entirely obliterates the structure of the entablature. On the archivolts of al-Ruṣāfa we find the same relief of the profile, the same atrophy of individual elements, the same replacement of dog-tooth and consoles and

[61] This situation is similar in the interior of Asia Minor: cf. the example of Bin Bir Kilisse in William M. Ramsay and Gertrude L. Bell, *The Thousand and One Churches* (London, 1909).

[62] As shown, for example, in profiles and cornices from Fāṭimid structures in Aleppo of the fifth and sixth centuries AH.

the same special ornament.[63] Yet here, as on the archivolts, an abbrevia-
tion of the cornice became necessary. And in some respects Mshattā exceeds
al-Ruṣāfa: the archivolt profile is here the main cornice, also the rudiments
of the smooth plates of the architrave have disappeared, and the ornament
extends across all of the elements. The special arrangement and ornament of
al-Ruṣāfa does not quite coincide with that dominant elsewhere in northern
Syria, especially at Qalʿat Simʿān. In contrast, all that we know from ʿUrfa,
Edessa, Nisibis and Ṭūr ʿAbdīn resembles al-Ruṣāfa. Therefore it does not
belong to the Syrian but to the north Mesopotamian school, of which Āmid
can be regarded as the prototype. In al-Ruṣāfa and its region the cyma
usually supports a row of acanthus palmettes, as for example the cymatium
of the atrophied architrave at Mshattā.[64] A plain row of acanthi, as in
Mshattā, does not, as far as I know, occur in that other region. It is com-
mon nowhere but is possible everywhere.[65] Without placing too much value
on its provenance, I would like to emphasize that this very old-fashioned
motif is found several times on Islamic monuments. In the ʿAmr Mosque in
Cairo wooden beams, or wooden corbels, extend across the columns of the
northern hall, to the right of the present entrance, as well as in the Ḥaram
above the columns that stand close to the west wall. They are carved as an
acanthus cyma. Further, one can see acanthus forms in the northern hall
which are more archaic and more Classical than those of Mshattā [116] and
which can (at the very latest) date only to the second century AH. In the
Ḥaram these forms were copied in a later phase of construction, presumably
in the third century AH, in a completely different concept which approxi-
mates the style of the carved wooden doors of Sīdī ʿUqba at Biskra.[66] In

[63] Sarre, "Rusafa-Sergiopolis," in the *Monatshefte für Kunstwissenschaft*, 1909, pp. 95–
107.

[64] The same ornament occurs as a separate cornice in a degenerate form on Strzygowski's
small bronze tablets from Ephesus (p. 266, Fig. 43) and on his fragment of an ivory
diptych in the British Museum (p. 277, Fig. 49). It is unusual to place ornament in
isolation above the cyma. This is connected, however, with the rows of cusped arches that
occur everywhere in Syrian architecture of the sixth century. Butler describes them as
"cuspidated outer mouldings". These cusps, like the simple meander band instead of the
dog-tooth pattern, are usual in north Syrian architecture of the fifth and sixth centuries
AH, as at the *miḥrāb* of the mausoleum in Ṣāliḥīn near Aleppo of 505, on the minaret of
the great mosque of Aleppo of 583, and on the Mūristān al-ʿAtīq there, a structure of Nūr
al-Dīn.

[65] It is found in the octagonal courtyard of Qalʿat Simʿān. Compare also the acanthus
cyma of the Coptic example in Part I, Fig. 9. Even in the time of Nūr al-Dīn, a Classical
row of acanthi forms a corbel frieze in the great mosque of al-Raqqa.

[66] I was not able to publish my photographs. Drawings can be found in the article
"Arabesque" in the *Encyclopaedia of Islam*. Below the acanthus cyma in the north hall

Mshattā it is not the arrangement of the row of acanthus leaves, but rather a special variant of that leaf which can be traced back to that style, common in the fifth and sixth centuries AD in al-Ruṣāfa and in northern Mesopotamia. They are distinguished by the particularly small size of the edge of the leaf as it curls inwards, almost like a small bulb beneath a narrow cut. The profile of the door frame of Mshattā imitates the cornice in miniature.

The base of the façade belongs to the Attic–Corinthian type, but it is peculiarly enriched and at the same time degenerated. The projection in steps, the gradual broadening downwards, precisely what makes this profile into a base, are missing here. The lack of understanding of this element goes so far that the face of the wall below the profile recedes into the face of the upper wall, thereby utterly negating the purpose of the base. Examples in Syrian architecture from the sixth century AD on show that this projection is not a gradual one, as the upper torus projects as far as the lower plinth. Yet, the role of the base is never quite suspended. This profile is therefore clearly of a later date than the sixth century AD. On the one hand the profile of the first system of the main façade thus appears to be later than the sixth century; on the other hand it belongs to the artistic practice of northwestern Mesopotamia. Therefore, not native bricklayers but *stonemasons from the province of Diyārbakr must have made them.*

A further characteristic of these profiles must be given its proper place: The main cornice is something of an exception,[67] but otherwise the three elements of the base lie in the same virtual plane as the projecting edges of the zigzag cyma and the rosettes. Likewise all indentations return to the same wall-plane, as does even the lower edge of the base. The whole relief thus lies between these two planes. The same is true of the second system of profiles on the basilical building. Antique architecture does not [117] confine itself in the relief of its architectonic elements. The individual profiles are constructed with a gradually increasing projection, and the various profiles of a building are independent of each other. The boundary between two planes is only an appearance which stems from the material used; it is appropriate to the material. It allows the most efficient use of the ashlar by demanding the minimum work. At the same time, it shows a fondness for exact geometrical harmony, to which Classical architecture attached no value, preferring strong sculptural relief that generates a rich interplay between light and shadow. The tendency toward geometric decora-

is an equally Classical egg-and-dart moulding.

[67]This is not quite so. The height of the relief of its architraves and friezes also lies within that same virtual plane.

tion is manifested, however, in Islamic architecture in the limitation of relief between two planes, as seen in all the older Islamic buildings of northern Syria, as at Aleppo, Ma'arrat al-Nu'mān and elsewhere.

The *second system of profiles* (Plate 5), on the basilical structure, is, as regards this limitation of relief, in keeping with that of the façade, although otherwise it is motivated by entirely different concepts. It is no longer the tripartite antique cornice, but merely a modulated string course or cyma in the form of a torus of a little more than the transverse section of a semicircle, a quarter-chamfer, and a flat surface above. This profile surrounds the arches on the three-arched façade, crowning the abacuses, and folds at the edges of the façade, thus forming a rectangular frame. On the arch of the triconch the profile surrounds the semicircle as archivolts, but the habit of moulding is so strong that the profile does not emerge vertically from the abacuses but is folded over horizontally where the profile ends.

The *torus profiles* are themselves typical of Syrian architecture. If one just glances at the works of de Vogüé or Butler, one cannot doubt this at all. It has been attempted to give them a Persian origin, but this will not do. From the outset, it is improbable, as Persian architecture uses plaster quite unsuitable for high relief. Not much of it is extant, but among what is there are no Syrian tori, neither in Iran nor in Iraq. From the Arsacid period we find examples in the Anahita temple at Kangawar, the Ṭāq-i Girrā in Media, and the ruins of Warka, Nippur, Tello, Assur and Hatra in Babylonia and Assyria.[68] In none of these can any Syrian forms be detected. The characteristic is the S-shaped cyma which replaces other elements. In Sasanian architecture [118] we must strictly distinguish two periods, the third and fourth centuries and the end of the sixth, apart from the regions of Iran and Iraq. We may get a picture of the early period in Iran from the door and window frames at Fīrūzābād and from the beautiful ashlar masonry at the well at Shāpūr.[69] The Achaemenid, Egyptianizing cavetto moulding is characteristic. Nothing survives from this period in Iraq, yet on the basis of earlier Arsacid monuments and contemporary ones in Iran, we cannot assume that the Syrian type existed. From the later period we know the profiles of Ṭāq-i Bustān, cut into the rock, as well as some at Qaṣr-i Shīrīn, cut in plaster.[70] There is no evidence of the Syrian torus.

[68] Cf. Sarre/Herzfeld, *Iranische Felsreliefs*, pp. 224–35.

[69] Cf. Flandin and Coste, *Voyage en Perse*, I, Pl. 42 and 46; Dieulafoy, *L'art antique de la Perse*, IV, Pls. 15 and 16.

[70] Flandin and Coste, *Voyage en Perse*, I, Pl. 5–8; Jacques de Morgan, *Mission scientifique en Perse* (Paris, 1894–1905), IV.1–2.

The torus form of the superabacus [*Kämpferkapitelle*] has already been noted, of which six examples are already known: two in Iṣfahān, two in Bīsutūn, two on the Ṭāq-i Bustān.[71] A comparison of the ornament and figural sculpture with that of Ṭāq-i Bustān shows that these capitals date to the time of Khusraw II, that is, the turn of the sixth to the seventh century AD. They had once been thought to belong to an earlier period and been assigned an important role in the development of the whole type; neither view can be substantiated. Early Sasanian architecture of the third and fourth centuries AD not only did not know this form, but it had no use for it. The superabacus is not merely decorative, it had a technical purpose. In Classical architecture, horizontal timbers were placed on Corinthian capitals, the delicate exposed sculpture of the capital being protected by an invisible thin plate, the *scamillum*. The whole surface of the capital is not used as a supportive element, only the cross-section of the column. Therefore, these capitals become unsuitable the moment that columns begin to support arches, and even more so vaults. This is the main problem of Late Antique and Byzantine architecture. In the huge vaults of the thermae, the rudiments of a complete entablature are therefore interposed between the capital and the beginning of the cross-vaults. Already in the time of Diocletian architecture was liberated from the fetters of [119] such ancient tradition. The transformation of the Corinthian capital coincided with the abandonment of the remainder of the entablature. It had to take a form which allowed it to support the weight of vaults directly by using the entire surface area. This is an organic development which could only have taken place in relationship to an entire range of architectonic aims.[72] However this large problem is entirely alien to Sasanian architecture. When, around 600 AD, the superabacus appeared in Iran, this form must have been imported from Byzantium. Also, when we find it in Mshattā on the arch of the triconch, there are enough examples in its vicinity.

It is of no importance that the ornamented astragals of these six Sasanian capitals have a torus profile, if one considers the abundance of Syrian torus profiles. Butler is undoubtedly right when he says that these torus mouldings, which continuously encircle each other and roll themselves up

[71] Flandin and Coste, *Voyage en Perse*, I, Pl. 17, 17bis, 27, 27bis; Sarre/Herzfeld, *Iranische Felsreliefs*, Fig. 110. There are other photographs of the capitals of Ṭāq-i Bustān among unpublished photographs in Friedrich Sarre's possession.

[72] The impost block is nothing more than the boss of the Corinthian capital; therefore each of them must have developed from the embryonic form of the corbelled capital. It transforms the upper part of the calathus into a square, where the free volutes of the corners atrophy; the rudiments, though, are usually retained as vestiges of their origin.

into spirals, are a specifically local feature in northern Syria whose precise period is the sixth century AD.[73] The octagonal courtyard of St. Symon Stylities, among other examples, shows that the complete antique architrave was used as well. In Mshattā, however, Syrian forms intermingle with northern Mesopotamian ones. In addition, the torus profiles at Mshattā exceed all Syrian examples; even the intrados of the arches, which elsewhere remain smooth in the Classical manner, has here been divided into four thick tori. This form has not been reported anywhere else; it can only derive from the Syrian style of the sixth century AD, and it shows, like the profiles of the system of the façade, that the profiles are later than the sixth century AD.[74] However, I shall again [120] postpone the problem of dating and only state that *apart from native bricklayers, stonemasons from Diyārbakr and northern Syria have cooperated on the ashlar masonry of Mshattā.*

The basilical hall of Mshattā, which was never finished, was planned to have two rows of five columns each. Schultz's excavations uncovered the entire stylobate of the eastern row, but no trace was found of where any of the columns would have stood. Yet at the northern end of the western row one base was uncovered *in situ*, and the trace of a second column was found in the sand. The base was hewn of grey marble in the best Corinthian style. In addition, three monolithic *cipollino*[75] column shafts were discovered, and nearby in the rubble of the triconch, a Corinthian capital matching the

[73] These forms have developed from tendencies in Syrian architecture of the fourth and fifth centuries, during which time it became entirely separate from architectural developments in Asia Minor and Byzantium. At the moment of its forcible end, about the turn of the sixth to the seventh centuries, it attained a height of ability and a summit of taste by far surpassing the level of all other provinces of that time.

[74] Islamic architecture of the sixth and seventh centuries AH in northern Syria shows that the Syrian round moulding and curling upwards of the profiles survived into Islamic times. Proof of this and also evidence of the vitality of the antique tradition are, *inter alia*, the magnificent minaret of Malikshāh of the great mosque at Aleppo, 483 AH, or the minaret, built a century later, of the great mosque of Ma'arrat al-Nu'man. This will be published in M. Sobernheim's volume *Aleppo* of the *CIA*. The massive interlaced bands in marble incrustation, which are characteristic for the early Ayyubid style of Aleppo, stem from these plastic forms. From there and from Damascus this style conquered both Egypt and Asia Minor. Compare the Saljuq architecture of Konya in F. Sarre, *Denkmauler persischer Baukunst* (Berlin, 1909), especially the façade of the Karatay Madrasa.

[75] The technical terms available for the description of materials are unfortunately used in rather different ways. *Cipollino* usually describes Italian green marble with a yellowish tinge. However, a kind of porphyry of very homogenous, micro-crystalline, dark green material with yellow particles is occasionally called *cipollino*; Samuel Guyer and I have seen it in abundance in the churches of Cilicia. This is not *verde antico*. William Francis Ainsworth, *Travels and Researches in Asia Minor, etc.* (London, 1842), p. 20. describes *cipollino* as limestone with mica, found in the Cilician Taurus; cf. Carl Ritter, X, 916.

columns and made of the same marble as the base. This capital, now in the Kaiser Friedrich Museum, still shows traces of blue, yellow and red paint and of gilding. I know of identical capitals from structures of the second century AD; this alone would prove that *the entire column ensemble is comprised of spolia.* According to B. Schultz, this is confirmed by the reuse of some spolia for bases and shafts. We have no example of the use of spolia in pre-Islamic Syria. Yet even Strzygowski, although he thought Mshattā to be pre-Islamic, did not want to accept this. In contrast, the use of spolia columns is simply characteristic of early Islamic architecture. The noble material, the painting and gilding show that it was intended to give the interior decoration of Mshattā such splendour that it would not be inferior to the façade. In the eastern part of the court, where the stonemasons worked, pieces of a peculiar green stone were found, indicating that they had already begun to be sawn into plaques. Their ultimate use remains uncertain. It is possible that they were meant for paving or for facing socles. This rare imported material also proves the *splendour of the decoration.*

[121] One last technical detail. Above the capital of the triconch arch and under its plain superabacus, a *piece of wood* has been preserved measuring 9 x 9 cm. in its transverse section; it is the *remainder of the tie-beam of the arch.* Two such tie-beams secured the arch, which had a span of only 6.80 metres. Schultz, therefore, certainly correctly assumes that the three arches of the façade (the central one measuring 5.50 metres, the two on each side only 2.95 metres) also had such double wooden tie-beams. I have referred to the wooden tie-beams of the Dome of the Rock in the first part: this form of construction is not used in Syria. It occurs, although almost concealed, in the aisles of Hagia Sophia. There, however, the columns directly support the complicated vaults of these aisles. In all columnal structures of Islamic origin this is one of the most striking and inevitable features which de Vogüé, not inappropriately, has described as a distinctive emblem of the Islamic period. Here at Mshattā the wooden tie-beams are not placed above columns, but next to a simple arch which rests on strong walls. If the *wooden tie-beam* is *a specific feature of Islamic columnar architecture,* its use on a plain arch is quite impossible in antique architecture.

I have given these technical considerations a great deal of space. An excuse may be that they are usually dealt with far too briefly in art-historical considerations. Yet these technical foundations are to the archaeologist and to the art historian what skull and skeleton are to the comparative anatomist and anthropologist. Let us briefly assemble the *results of this technical analysis.*

In the various parts of this structure, different provincial types of building coexist. Brickwork has been carried out by labourers from Iraq, rough stonework by masons from Provincia Arabia, and the architectonic profiles were fashioned by stonemasons from Diyārbakr and North Syria. Thereby building methods of different origins intermingle on one and the same object: thus we see on Iraqi brickbuilding special parts in Syrian ashlar masonry. Likewise on stone walls erected in the manner used in Provincia Arabia the profiles have been made in the north Mesopotamian way. Within the different building methods, we find details of construction which had either not occurred at all before or only in a primitive form. These have now become the dominant principle, such as the projection of arches and vaults in front of the supporting walls, but especially the pointed arches and then the wooden tie-beams. The profiles have been [122] further developed as the workshop tradition became less rigid—the awareness of the essential nature of the elements of antique architecture faded, for example, in the base and on the cornice in the form of the archivolts; from the material one arrives at new principles which contradict the workshop tradition, as in restricting the relief between two planes. Beautiful spolia are used, and to further increase the splendour of the interior decoration, rare stone material was imported for plaster or wall facing. The imposing size of the whole layout, the solidity of the structure, and the richness of the decoration lavished on it show clearly a complete disregard of any economic considerations.

All these features are exactly what we have regarded as characteristic of early Islamic architecture.[76] They are so deeply rooted in the economic and artisanal conditions of the Umayyad period that it is quite inconceivable that they could occur in Lakhmid or Ghassānid structures. Mshattā is Islamic to its very core—quite apart from that all this could also be chronologically possible only from the end of the sixth century AD. The brickwork is identical with that of Sāmarrā of the ninth century. The principle of the pointed arch was as yet unknown in the early seventh century. The profiles of the ashlar masonry are more advanced than the late Syrian antique. The pre-Islamic period makes no use of spoils, nor of wooden tie-beams in the construction of simple arches. On the other hand, all these elements survive in Islamic architecture of the immediately subsequent period.

What then is Mshattā? The general layout belongs to the large genus of the castrum (Fig. 22). The researches of Brünnow and von Domaszewski, Dussaud and Macler, and Musil have acquainted us with a large number of Roman castra in the Orient. A comparison makes it immediately clear

[76] Cf. Part I, p. 32.

that Mshattā is not representatve of the genre of such legionary castra as al-Lajjūn but rather belongs to the group of smaller camps—perhaps intended for a cohort—such as Qaṣr al-Abyaḍ, Bshīr, and especially Qaṣṭal near Mshattā. Mshattā corresponds on the whole to these structures seen in the same area and along the whole edge of the desert.

It has been said repeatedly that in the east opposite the Roman limes was a similar Arsacid–Sasanian fortification system. Nothing is known of any such buildings. We merely know from literary sources of the Parthian and Sasanian wars that the Persian towns along the middle Euphrates were fortified, as were [123] a number of towns along the middle Tigris. We also hear of forts and strongholds on the Armenian frontier. Only a few remains of the fortifications of large residences such as Seleucia, Dastajird-i Khosrau and Qaṣr-i Shīrīn are extant and known.[77] Of these only the Qal'a-i Khusraw in Qaṣr is a castrum, which defends access from the Alwān valley to the plateau with its castles and parks. These ruins belong to the large legion camp type. Not this [124] ruin but Chuār Qapu, another one at Qaṣr-i Shīrīn, resembles Mshattā in some respects, as has been known for a long time. The major difference is that Chuār Qapu has no fortified enceinte, and is therefore not a camp. The purpose of the structure is uncertain; it was not a palace either, for one stands closeby in a large *paradeisos* and is of an entirely different type. Perhaps Chuār Qapu was a fire temple with surrounding lodgings for priests. The similarity to Mshattā rests in the agglomeration of living quarters and of courtyards. This relationship seems to be indirect. So far no Sasanian castrum of the Qaṣṭal type (a cohort camp) has been discovered.[78]

The difference between Mshattā and the Sasanian ruins is therefore an essential one. Mshattā, however, is not a cohort camp. Its surrounding walls

[77] I am in the process of preparing my own photographs of Seleucia for Sarre/Herzfeld, *Archäol. Reise* For Dastajird, cf. Sarre/Herzfeld, *Iranische Felsreliefs*, p. 237. J. de Morgan, in his *Mission scientifique en Perse*, IV: *Recherches archéologiques*, has published excellent photographs of Qaṣr-i Shīrīn. I verified them on the spot in 1905. I have briefly published the fort Qal'at al-Bint and the fortress Qal'at Jabbār, both situated on the Tigris south of Assur, in the journal *Memnon*, 1907 I, i. Qal'at Jabbār is a sort of fortified refuge, the massive walls of which ascend the steep mountain slope like sharp wedges. The particular terrain led to the unusual form, which can hardly be numbered among the castra. It reminds one vividly of Zenobia–Ḥalabīya on the Euphrates; cf. my preliminary plan in Sarre, "Reise in Mesopotamien," in *Zeitschrift der Geschichte für Erdkunde* (Berlin) 7 (1909), Plate 8.

[78] Flandin and Coste, *Voyage en Perse*, IV, Pl. 213, describe a Qal'a-i Kuhna near Sarpul as a "forteresse". One may wonder whether this is to be regarded as a caravanserai or a castrum. It is a colossal rectangular structure, with round towers on the outside and a row of small barrel vaults within.

were never seriously meant as fortification; this is obvious from the massive—
i.e. inaccessible—towers without stairs. It is altogether only loosely con-
nected with the Qaṣṭal type, as in the grouping of its rooms along the four
walls which face the courtyard, but it differs in the arrangement of these
rooms as a whole. Today we can assume with some degree of certainty that
the origin of these structures was al-Ḥīra.

The whole layout of Mshattā is undoubtedly well planned and artistically
composed. It does not appear to have been a first attempt, but suggests a
certain maturity which indicates long practice. One has justifiably identified
the rooms in the front as guard and living accommodations; behind it, in the
basilical part with the triconch, was the throne room, with the two groups
of rooms on either side as the living quarters of the palace. There is only
disagreement as to the definition of the large, deep oblong hall to the right
of the entrance, with its round niche in the south wall, which once had two
small engaged columns on either side.

Miss Bell's photographs of Ukhayḍir, which lies near Shithāta, the old
'Ayn al-Tamr, has thrown new light on the [125] understanding of the
general layout of Mshattā (Fig. 23).[79] At Ukhayḍir the layout resembling
Mshattā has once again been placed into a large square castrum. Apart from
this, there are only secondary differences between the two. Ukhayḍir lacks
the second, broad oblong forecourt of Mshattā; the arrangement of its living
quarters differs somewhat, but they have the same position in the ground
plan. It is enriched by some passages which are absent in Mshattā. Instead
of the basilical hall and the triconch it has a highly interesting structure.
In the axis of the great courtyard [126] is a wide open, deep oblong room,
an *īwān*, on either side of which are two utility rooms with barrel vaults
arranged at right angles, and with one door each to the courtyard, to the
īwān, and to each other; behind the *īwān* is a square room. This complex
is nothing else but that part of *Sasanian palaces* consisting of the open hall
for the public and the square hall for private audience.[80] I shall refer later
to the importance of this feature for the development of this type.

[79] Cf. above, p. 109, n. 1. As regards the dating of Ukhayḍir, I only wish to remark
briefly that I think, as Miss Bell does, that the complicated forms of vaults, the pointed
arch, the projections from the vaults, the many variations of conches, the shell-like ribbed
cupola, and *last not least* the cross vaulting seem to exclude a pre-Islamic origin. However,
I cannot think of any reasons which would disallow a dating of Ukhayḍir as late as the
first 'Abbāsid period. This is how we must imagine the appearance of the multistoried
gates of the Madīnat al-Manṣūr.

[80] I have dealt with this type, which can be observed from the Achaemenid to the late
Islamic periods, in my *Samarra*, further in "Pasargadae," *Klio* 8, 1, and lastly in *Iranische
Felsreliefs*.

In Ukhayḍir there is also an analogy for the last room whose meaning in Mshattā remained disputable—the hall with a niche flanked by columns in the south wall to the right of the gate, separated from it by a guard room. Here too is a room on the right side of the gate, only separated from it by small guard rooms, which does not fit into the usual grouping of courts, guard rooms, living quarters and throne rooms. It is a rectangular courtyard, accessible from the north by two doors, which has a wider open hall on its south wall and narrower ones on its west and east walls. As at Mshattā, one is, although independently, led to think that these might have been *mosques*. At Mshattā it is the niche in the *qibla* wall, and in Ukhayḍir the hall of the *ḥaram* on the south side that indicates such a possibility. The fact that such reasoning has on both accounts been arrived at independently seems to me to confirm this supposition.[81]

Ukhayḍir with its audience halls modelled on the Sasanian type is closer to Sasanian Iraqi architecture than is Mshattā with its Syrian basilica and the triconch. Moreover, Iraqi techniques and indigenous forms of construction predominate at Ukhayḍir. Only the cross-vaulting is otherwise alien to Iraq, and the vault forms are unknown in the Sasanian period. Ukhayḍir, like Mshattā, has rightly to be grouped among the structures of the Qasṭal type. Both structures represent, however, the mature well-developed layout. For this reason it is improbable that Ukhayḍir is an offspring [127] of the Mshattā type, in which the western elements are replaced by Iraqi ones. On the contrary, it is more likely that Mshattā substituted its Syrian elements for originally Iraqi ones. It follows, therefore, that the type must have existed before Mshattā and in a form closer to Ukhayḍir and to Iraqi architecture than Mshattā. The geographical situation of Ukhayḍir points toward the place where we might find this type, namely, in al-Ḥīra. There is much to be said for the hypothesis that the cohort camps of Provincia Arabia were transformed into palaces by the Lakhmids, rulers and protectors of the frontier, before Islam.[82] The restricted analogies between the

[81]Mshattā and Ukhayḍir are positioned in opposite directions. But niche as well as hall lie on the south wall, i.e. the *qibla*, in both structures. The absence of the *miḥrāb* at Ukhayḍir is of as little importance as it is, for example, in the two great mosques of Sāmarrā and Mutawakkilīya. Miss Bell's text is silent about this room: is her photograph really quite informative enough?

[82]The name *ḥīra*, essentially an appellative noun, is of Syriac origin, and means [in Greek] *mándra*, *laúra*. It designates the army camp of the Ghassānids and Lakhmids. The original mobile tent camp became fixed at an early date; the al-Ḥīra of the Lakhmids had already become a fixed residence at the beginning of the fifth century, perhaps even earlier. Moreover Mshattā and Ukhayḍir developed from the Roman cohort camp of the eastern limes of the al-Ḥīra type. Lammens has analysed the meanings of the word *ḥīra* in

Sasanian Chuār Qapu and Mshattā can then be explained; it was modelled on the architecture of al-Ḥīra. It is not without reason that both the Arabic and Persian traditions are full of the glory of the castles of al-Ḥīra, for their crowning jewel, al-Khawarnaq, was built for Bahram V Gōr by the Byzantine master Sinimmar, the father of Qaṭṭūs, creator of Ṭāq-i Bustān.[83] Thus legend reflects clearly and truly the situation of interdependence that we must conclude from the monuments.[84] The type of Mshattā and Ukhaydir developed from the Roman cohort camps in al-Ḥīra. It influenced Sasanian architecture, and was transferred by the Umayyads to the Bilqā.

[128] What, in conclusion, are we to make of Ukhaydir and Mshattā? A *ḥīra*, *a winter and desert residence, a* bādiya, of the richest type found in any extant monument. And Mshattā, in its unparalleled splendour, is a *ḥīra* which only the command of an all-powerful person, a caliph, could have created. To develop this thought in detail would mean enlarging the essay of H. Lammens further. Naturally, I have nothing to add to his findings.

In this connection one has to conclude that the design of Mshattā as a whole must be attributed to a master who was familiar with Ḥīra-style castles, thus surely an Iraqi if not actually someone from al-Ḥīra. The Ḥīra type already belongs to the cohort camp type. Apart from the mixed technique, the only Syrian elements that can be found in its structure are the construction of the throne room as a basilical hall and the triconch. As we have recognised the whole layout of Mshattā as characteristic of early Islamic art, it is also connected with older types, merely adapting them by slight modifications when required. As always in the past, here again it must be stated that whatever has been created in the Umayyad period continues to survive into the later Islamic period. The castrum-like outer walls with

Umayyad usage as "camp, château, ou villa". Cf. Sigmund Fränkel, *Die Aramäischen Fremdwörter im Arabischen* (Leiden, 1886), XI, XVII–XVIII; Theodor Nöldeke, *Die ghassânischen Fürsten aus dem Hause Ġafna's* (Berlin, 1887), pp. 47–49; G. Hoffman, *ZDMG* 32, p. 755 n. 3; Gustav Rothstein, *Die Dynastie der Laḥmiden in al-Ḥīra* (Berlin, 1899), pp. 12–13.

[83] Cf. Theodor Nöldeke, *Geschichte der Perser und Araber zur Zeit der Sasaniden* (Leiden 1879), pp. 79ff. Ruins one German mile SSW from al-Ḥīra, two miles from al-Kūfa and from Najaf are designated today as al-Khawarnaq. Cf. B. Meissner in the *Sendschriften der DOG* 2 (1901). Accordingly al-Khawarnaq is also a brick castrum 90 paces to a side. The etymology of Khuwaranag as "bestowing good defence, having a fine roof", thus "tent, tent roof, pavilion", following F.C. Andreas in Rothstein, *Laḥmiden*, pp. 144–45.

[84] Nevertheless, these masters should not be understood as historical personalities. What is historically true is only the condition of dependence expressed in legend. But Justinian also sent Khusraw I master-builders of walls and rooms as well as Greek marble for a palace and the building of New Antioch near Ctesiphon, according to Theophylact V, 6, 10.

their round towers are almost the only typical forms of decoration of the external architecture of Sāmarrā, and also much later in Iraq, as shown by the shrines of Imām Dūr north of Sāmarrā and on the Shaṭṭ al-Nīl and also the ruins of the great mosque of Old Baṣra.[85]

Everything that has been discovered so far about Mshattā can be applied almost unchanged to nearby al-Ṭūba, which cannot really be separated from Mshattā. Yet one has to go further. The ruins of al-Muwaqqar lie also very close to Mshattā. One has hardly known what to do with it; one has only felt, as with Quṣayr 'Amrā, that it is something totally different from Mshattā. These differences have been much emphasized and have led to a very different dating. True, there are differences, but it is wrong to infer a different period from them. What we can see from Brünnow's and Musil's photographs[86] is Iranian–Sasanian. [129] In order to see this one has only to know the Sasanian monuments of Iran better. Among those monuments from the end of the sixth century are the castles Haji Qalasi in Qaṣr-i Shīrīn, and Haushkuri nearby to the north.[87] They consist of wide, artificially elevated platforms, the edges of which are formed by rows of low semicylindrical forms. On these stand palaces of the type occurring in Fīrūzābād and Ctesiphon, although in solitary form. In these summer castles situated in the midst of enormous parks, open columnal halls replace the fortress-like walls of urban palaces. Similar ruins on a smaller scale exist in the Iranian mountains, in the Pusht-i Kūh, in Lūristān, and in Fārs. When travelling there in 1905, I saw some of them, like the Kalek-i Ambdānān on the southern end of the Kawur Kūh or in Sharrafī between Behbehän and Telespīd in Fārs.[88] We see the same terraces with columned halls at al-Muwaqqar, where the terraces themselves have been built in the Iranian rubble technique. Much of the decoration is also Iranian. Brünnow describes on p. 185 and on Plate XLIX in Figs 760–65 some quite pecu-

[85] These buildings will be published in *Archäologische Reise*. Also, one may expect more far-reaching conclusions about all these connections from a more detailed examination of the castra of Sāmarrā.

[86] Brünnow, II, pp. 182–89 and Pl. xlix; Alois Musil, *Arabia Petraea* (Vienna, 1907–1908), I, pp. 188–97.

[87] J. de Morgan, *Mission scientifique en Perse*, IV.2: *Recherches archéologiques*.

[88] See my "Reise durch Luristan, Arabistan und Fars," in *Petermanns Mitteilungen* (1907), III. and IV. Further examples of terrace constructions are the Qal'a-i Būlāq and the Qal'a-i Kūhnah near Sarpul-Hulwān, Flandin and Coste, *Voyage en Perse*, Pls 209 and 212. The building of terraces is already typical in the Achaemenid period; it has continued in Iran from the Middle Ages until the present. I think here of the palace of 'Abbās in Ashraf, or the impressive seven terraces of the Bagh-i Takht of Shīrāz; Jane Dieulafoy, *La Perse, la Chaldée et la Susiane* (Paris, 1887), p. 461.

liar superabaci which come from this hypostyle hall. In this form of the superabacus, there is first a connection with the six Sasanian superabaci.[89] Although those of al-Muwaqqar differ from Sasanian examples because they retain rudimentary volutes, and although some have the broadly serrated acanthus decorated entirely in the Byzantine taste, one is forced to assume here—in contrast to Mshattā—that such peculiar forms like the capitals 760 and 763 have been inspired by Iran. One should compare the extraordinary trefoils of 760 with the Sasanian plaster ornament that Mrs. Rich found in Kifri (between Baghdad and Irbīl)[90] or with the textile designs of Ṭāq-i Bustān.[91] When one compares the stone described as "a piece of a frieze" and its scale ornament with the *colonne historiée* of Qal'a-i Hazārdār [130] in Derre-i Shahr, illustrated by de Morgan,[92] one will notice that here, on the al-Muwaqqar capitals, we have examples of Iranian ornament. Only the broadly serrated acanthus and the special modelling of the capitals is not Iranian but generally western in style. It is therefore quite obvious that the general design and also the directives for its detailed execution must have come from a *Persian master* while the execution remained in the hands of *native workmen*. Western influence brought about the superior quality of execution at al-Muwaqqar compared to its Iranian models, for these are only immense in their dimensions but miserable in their construction.

Al-Muwaqqar is the first known structure of the Bilqā whose creator was a true Persian, not merely an Iraqi.[93] The dating is quite clear: these are Iranian forms imported and translated into Syrian forms which in Iran only occur under Khusraw II Parwēz around 600. For this reason, even if the specific Islamic character in this mixture and its transformation and improvement were apparent, the earliest possible date for al-Muwaqqar would be the seventh century AD. Now we know from Yāqūt that Yazīd II ibn 'Abd al-Malik used al-Muwaqqar as a *bādiya*; al-Muwaqqar must date be-

[89] Cf. p. 118 above.

[90] In Claudius J. Rich, *Narrative of a Residence in Koordistan* (London, 1836), I, p. 343.

[91] In de Morgan, *Mission*, IV, or in Julius Lessing, *Die Gewebesammlung des Kunstgewerbe-Museums zu Berlin* (Berlin, 1900–13).

[92] *Mission*, l.c. Identical patterns occur on the niches of the gatehouse of the citadel of Ribāṭ 'Ammān together with other Iranian elements. This structure, too, belongs to the Umayyad period.

[93] The material is so huge that one cannot deal with everything here. Al-Kharānā too is Umayyad, although it is entirely different. Its rubble walls and leveling courses remind one of those of the Qal'at al-Bint and of Qal'at Jabbār (cf. above p. 123 n. 1); its brick friezes and windows are identical with those of Abū Hurayra, Eski Meskene and al-Raqqa (*Archäologische Reise*). This leads to the southern Jazīra, which, poor as it was in any art form, did not contribute anything else to Umayyad structures.

tween 720 and 724.

We have, therefore, to conclude that if Quṣayr 'Amrā, which is almost entirely Syrian, was built between 712 and 715 and al-Muwaqqar, which is almost entirely Iranian, between 720 and 724, *the most essential argument for an earlier date for Mshattā is completely untenable*, namely the idea of seeing the contrast between Mshattā and Quṣayr 'Amrā as proof of the non-Umayyad origin of Mshattā. It is, in fact, just the other way round. As the mixture of heterogenous elements from the very different provinces characterizes Mshattā as an Islamic structure, *the contrasts between Quṣayr 'Amrā, Mshattā and al-Ṭūba, al-Muwaqqar, al-Kharānā identify all these structures* [131] *as early Islamic*. This bizarre fact can be summed up in this paradox: Because all these structures are so different, they must all have been built at the same period.

The art-historical examination of Mshattā has always concentrated on its *ornament*, which is indeed unequalled. Faced with this exuberance, the art historian finds himself in a veritable *embarras de richesse* and it is, therefore, not surprising that not every one of the many questions posed can be answered. The available comparative material is, as regards certain art-historical fields, still rather inadequate. Principles arise which at first appear entirely new and individual, and it is extremely difficult to track down their roots in earlier periods.

One of them has so far neither been recognised nor explained: the *placement of the decoration*. It is a fact that it is placed not in the centre of the long façade, but on the socle of the otherwise bare walls. Ever since Classical architecture, viz. since Hellenism found itself with the task of decorating large wall surfaces, this was achieved less by the decoration itself than by structure. The wall was not an entity in its own right, but an organism consisting of elements of varying importance. The whole richness of illusionistic architecture can be traced back to three motifs: the succession of niches or aedicules which reiterate any door and window openings in a strict rhythm; pilasters or engaged columns, a motif probably traceable to pseudoperipteral temple walls; and third, the combination of the position of the engaged columns with the succession of the niches between the columns. Over time arcades replaced horizontal entablatures and complicated rhythms replaced simple ones. The system, however, remained structural even in the most baroque form of illusionistic architecture. The Hellenistic principle is, therefore, in its style, composition, and elements absolutely different from that of Mshattā, where the decoration is confined to the socle, simply composed to fill an empty surface, and consisting of ornamental elements.

This non-structural decorative principle, however, has a structural ar-

Ernst Herzfeld

chitectonic basis. The placement of the decoration reveals that it is a reap-
pearance of the old *orthostatic system*. The socle is not formed by vertically
placed slabs but built in layers like the rest of the wall. The dimensions are
too large to use slabs. But the fact [132] that the decoration is confined
to the socle can only be explained by means of orthostats. The composi-
tion and its elements also suggest it. The orthostats are an entity which
are decorated not from a structural but from a decorative perspective with
figures or ornament distributed as uniformly as possible over the whole area.
The use of orthostats can only be indigenous where mainly clay, together
with stone and wood, is used for building. We find it in remote antiquity
in Hittite Asia Minor, although especially in Hittite–Aramaic North Syria,
North Mesopotamia and in Assyria. But not in Babylonia. In Iran we find
it in the oldest monuments, those of Pasargadae, whence it must have come
via Media. Beginning with the structures of Darius, the use of orthostats
disappears or becomes essentially transformed.[94] How is it possible that
an aesthetic principle based on this structural origin could suddenly surface
at Mshattā after an interval of over a thousand years? One might suppose
via Iran in its post-Achaemenid period, yet this route is barred, because
neither the Parthian nor the Sasanian monuments show anything of the
sort; moreover, they were all dominated by Hellenistic structural systems.
The orthostatic system never took root in Babylon. Hatra and Assur show
that in Assyria too the ancient Oriental principle became extinct along with
Hellenism. In North Syria square stone masonry was used even in private
building since early Hellenism. The only likely country where a connection
is possible is northwest Mesopotamia.[95] Here too, however, the well-known
monumental structures were not built with orthostats, but civil architec-
ture here lacks the monumentality one finds in Syria. Nevertheless, we can
assume that old indigenous modes of building with clay and with stone or-
thostats survived in urban and rural architecture, and that consequently
allowed the atavistic reappearance of the old principle.[96]

[94]For structures with orthostats, which entered Greece via Asia Minor, cf. Dourpfeld
in *Historische und philologische Aufsätze* (Ernst Curtius Festschrift) (Berlin, 1884), p.
143; Robert Koldewey and Otto Puchstein, *Die griechischen Tempel in Unteritalien und
Sizilien* (Berlin, 1899), p. 72; cf. also my *Pasargardae* (Tübingen, 1907), p. 55; *Iranische
Felsreliefs*, ills. and 181–84.

[95]Also a solitary appearance of the orthostatic principle, but in Hellenistic structural
form, occurs in the Qaṣr Fir'awn at Petra; cf. the monograph by Heinrich Kohl, *Kasr
Firaun in Petra* (Leipzig, 1910).

[96]At Mshattā we do not have orthostats but merely this decorative principle connected
with this substratum. Yet the orthostats themselves must have continued to exist further,
although this is not yet apparent in the monuments themselves. In Safavid architecture

[133] The decoration of ancient Near Eastern orthostats is always figural. Its themes mostly belong to the fine arts, although frequently they are merely decorative, being related to the decorative arts; never are they entirely ornamental. Whether the orthostat is undivided or sculpted into zones, whether the representation occupies only one slab or extends over a whole series, the orthostats are never arranged structurally. There are, therefore, two differences between the decoration of orthostats in the ancient Near East and at Mshattā: at Mshattā the decoration is ornamental and in it the Islamic character can already be seen. Furthermore, base and cornice give the whole a structural frame wherein can be seen the Hellenistic influence. Apart from base and cornice, Mshattā also has the sculptural zigzag band in the form of a cyma, as well as sculptural rosettes, hexagonal in the upright triangles and octagonals in the inverted ones. It seems to me quite futile to look for this decorative framework anywhere in ancient Near Eastern art or Hellenistic architecture. One could never expect to comprehend in this way the essence of the decoration at Mshattā. Neither the ancient Near Eastern pinnacles, nor the Classical series of gables are socle decoration, and triangles and rosettes by themselves appear everywhere. That the decoration of Mshattā is placed on the socle shows that the root of its architectonic fundament is the structure of orthostats; but neither the mode of composition nor the elements of its decoration derive from architecture. *The ornament of Mshattā is minor art translated into architecture.* When we understand this, we understand a process of fundamental importance in the formation of Islamic art.[97] When we study the representation of goldsmiths' work in 'Abd al-Malik's mosaics in the Dome of the Rock we find something similar. While Antique art treats every artisanal object according to the principles of sculpture and architecture on the grand scale, Islamic art deals with a building as if it were a jewel case or some precious cloth. We should, therefore, not separate the sculptural scheme of Mshattā's decoration from its ornamental foundations [134], but we must seek comparisons for the whole in the minor arts. It is no accident, but quite to the point, that Strzygowski has discovered true parallels of this decorative motif only on works of Islamic minor arts, such as a Moorish ivory casket

in Iṣfahān, and from there in Shīrāz, in Baghdad and in the Shīʿī sanctuaries of Iraq orthostats reappear all of a sudden. In Fārs I found that rural houses today are built with the same methods used for erecting Achaemenid palaces. Along the great road over the Taurus in Cilicia, I found modern houses that resemble those of Zenjirli. Thus I propose the survival of building with orthostats in northwest Mesopotamia.

[97] This thought seems to me to go further still; it ought to be given much more priority for the problem of the Late Antique.

and Egyptian wood carvings.

That same principle of ornament that Strzygowski has characterised as "deep shadow" (*Tiefendunkel*) also derives from minor art and not from architecture. It is a painterly principle, it imitates the appearance of metal objects produced *à jour*; it is always found in ivory work, more rarely on wood, it occurs in stone masonry, where the stonemason avoids using more delicate tools in favour of overusing the drill. Thus we find the timid beginnings of deep shadow in marble sculpture and architectonic ornament of the Late Antique. But still in the sixth century, when it already had a wide reputation in Byzantine ornament, it was neither developed to such a degree nor became so dominant as at Mshattā. Here the entire ornament is determined by two planes, the slightly wavy and chiseled surface and the deeply carved ground that lies in full shadow. It now seems—and this is important—that the principle of deep shadow was especially popular in the in architectonic ornament of northwest Mesopotamia. Sarre has already pointed this out,[98] and photographs from 'Urfa, Edessa and Nisibis show the same style. Perhaps the material itself may play a role here. Al-Ruṣāfa was built with a slate-like gypsum, from talc. This material is common in northwest Jazīra. It is impossible to use this for rounded sculptural relief, for any ornament made of this material will necessarily be flat with sharp edges.[99] We have already noted in architecture that a characteristic of Islamic monuments is that forms originally only present in the bud become dominant and develop into a principle. We see here the same process in the aesthetic realm. In the ornament of later Islamic architecture deep shadow is very frequent. This is especially the case in the region of Mosul, where in the sixth to seventh centuries AH it developed to an extreme: in order to heighten the *ajouré* effect, the luxuriant detail is worked with an undercut profile. [135] In the limitation of the relief to two planes we find something related to deep shadow, a further peculiarity of Islamic architecture.

The subtle system of space-filling in the background ornament, the exaggerated decoration of the sculptural elements, and the avoidance of all smooth lines arise from the tendency to achieve as uniform an effect despite the sculptural scheme. The decoration of the socle is derived from a unified concept which seems to have grown from the realm of textile art. Not without good reason has the idea emerged so frequently that textiles can be sculpted in stone. The original idea must have come from one master. But it

[98] See his *Ruṣāfa*, pp. 105–106.

[99] In plaster stucco, a substance commonly used in the Jazīra, the ground is also simply cut out, and the relief cut angularly. The ground in Parthian ornament extends over such a large area that the cast shadow does not cover it.

is extremely difficult to come any closer to this personality. The details are no help at all, although the principles of the decoration possibly are. Next we shall have to consider that the master is likely to have come from a country with a flourishing textile art. Yet this does not lead us any further, as textile art flourished in almost all provinces. The other principles, however, the old idea of orthostats as well as the aesthetic principle of deep shadow, lead rather obviously towards northwestern Mesopotamia. We know nothing indeed about any textile art in that area, but these two indices are supported by a further one: the luxuriant ornament of Mshattā is repeated in some respect only once, in the Great Mosque of Āmid, a monument which will soon play a role [in this argument]. These available facts suggest that *a master from the province of Diyārbakr designed the decoration.*

One of the greatest puzzles Mshattā poses is the deep intrinsic contradiction that dominates the style of its ornament when examined in detail. At first one only notices the equilibrium of the entire composition. That was the responsibility of the designing master. A more careful observation, however, reveals more profound differences. For these only the workmen employed on the structure could have been responsible. They are so great that one would have to think that they might have been produced at different times, if such an assumption were not impossible. As different periods can be excluded, the differences in style can only be due to different artistic regions; the stonemasons employed must have come from different provinces. In his analysis Strzygowski already distinguished four stylistic groups to which the twenty whole and two half upright triangles can be attributed. The inverted triangles, as far as they have been completed, belong to these [136] groupings. The different styles are not mixed helter-skelter, but are strictly separated with regard to their position in the building. The first style—from left to right—comprises the three first triangles (A–C); the second, the following seven whole and the two halves next to the door (D–L); the third, the eight following triangles to the right of the door (M–T); and the fourth the two last triangles (U–V) on the right. This spatial separation shows that workmen of different origins worked in groups according to their nationality. They had, therefore, considerable license in their execution of the design, which manifests itself in the inexhaustible variety, but even more so in the great differences among the four groups of styles. All share, however, the compositional scheme, the general ornamental concept, and the execution of deep shadow as a matter of principle.

While we had to adhere to the common principles in order to gain an opinion about the region whence the master came, it is precisely the different characteristics that enables us to recognise the provinces from which the

workmen came. The first two groups can be distinguished from the other two because their ornament depicts animals, while the last two do not. More important is the difference in the scale of the ornament to the filled space. The two groups on the left resemble each other in this regard; their proportions are much larger than those two on the right. This difference is so pronounced that it overpowers the more subtle differences between the left and right halves. The most vivid contrast, therefore, becomes visible between the left and the right halves of the façade. Within each half the contrast is much less.

The first group is distinguished by the attempt to divide geometrically the triangular compartments around the hexagonal rosette. This is achieved by a horizontal line touching the lower rim of the rosette. In A the horizontal strip thereby separated is filled with four circles. These consist of pearled bands and are knotted at all points of contact. This circular motif is also continued in the spandrels of the rosette. Field B has a spiral scroll instead. This forms itself into four circles which are almost equal to the pearled bands. Their stalks consist of nested acanthus leaves in cornucopia-like variants. In C the four horizontal strips are divided by four others. Apart from this the vine scroll occupies the field; it is more naturalistic in the spandrels than in the horizontal strips. Its leaves are—as everywhere **[137]** in the entire ornamental program—characterised by superimposed small grapes. In addition, there are the small animals, especially birds, in A a kind of cat and a peculiar mask, in B a vase from which a cornucopia scroll originates, and in C four more small rosettes in the intersecting circles. No attempt has been made to achieve a geometrical division in the other three stylistic groups.

The second group, D–L, surpasses the first one with regard to the scale of its individual elements. In this respect it is the most generous of all. Its principal motifs are vines, growing from the soil as they do in nature, and confronted animals either drinking from a vase or backing on one. Only in the two fields I and K to the left of the door is there no vase. There are crossing vine leaves in its place. While we find birds, especially in the branches, below there are almost always either real or fantastic quadrupeds, among which are a so-called Sasanian griffin in field D and a centaur in F.

All these elements are known in the same mixture and the same special forms in the treasury of types of Islamic textile art, miniature painting and other minor arts. How then can one obtain an indication to determine the native place of these two styles? I shall mention my own view first. *The style of the first group is Syrian, and that of the second Egyptian.* I am aware of the difficulty of providing proof. First, the attempt at a geometrical

arrangement is more architectonically conceived than that of the other three styles. Syria is also the country where the architectonic teaching tradition was best and dominant. Next, we find similar geometrical arrangements of field ornaments in great numbers and since time immemorial. One need only think of the ceilings of Baalbek and Palmyra. The cornucopia scroll probably appears first in the sixth century on the church of Khirbat Tēzīn.[100] Nowhere can it be seen in such splendour as in the mosaics of the Dome of the Rock, which date from 418/1027, of al-Ẓāhir's period.[101] Intersecting circles occur in abundance; one must especially compare the soffits of [138] Diocletian's repository for ceremonial standards in Palmyra.[102] A scheme completely identical to Mshattā can be seen in a bevel-carved wooden board from Egypt, now in the Kaiser Friedrich Museum.[103] But I would especially emphasize that the interlacing of motifs with pearl or grooved bands is specific to Syrian Islamic ornament.[104] It is also important to realise that the best analogies for all these items only come from Islamic times. I do not dare to decide whether the vine leaf with its superimposed grapes is Syrian in origin. Syrzygowski has investigated it. Most of the older examples come from Egypt. It is certain that the Islamic Syrian vine foliage ornament constantly uses this peculiar leaf; there are many esamples of it from Baalbek, Aleppo, and elsewhere. The *miḥrāb* of the Jāmiʿ al-Khāṣṣakī, where the same leaf occurs, suggests the possibility of a northwest Mesopotamian origin.

Strzygowski has already assembled the reasons that allow us to consider the second style-group as Egyptian. The naturalistically growing trees with animals and vases are so typical of Coptic ivory and ebony carvings, the relationship of these carvings to the ornament of the second group of Mshattā is so indisputable, that I have come to the conclusion that Copts must have cooperated here—a conclusion that Strzygowski at first considered and then

[100] Alfred J. Putler, *The Ancient Coptic Churches of Egypt* (Oxford, 1884), p. 215.

[101] Provided that these mosaics, which indeed look very "Islamic", have been produced by natives. Strzygowski (Fig. 87) gives one of the rare examples of a cornucopia scroll from Egypt, though this is not a real scroll. Cornucopiae alone, without the fusion with the scroll, are especially characteristic of capitals from the time of Heraclius. Yet only in the mosaic in the apse of San Clemente in Rome (twelfth century AD) do cornucopia appear as classical as those in Mshattā and in Jerusalem; Riegl, *Stilfragen*, p. 337.

[102] Strzygowski, Fig. 105.

[103] Cf. Josef Strzygowski, *Der Dom zu Aachen und seine Entstellung* (Leipzig, 1904), on the ivory reliefs there, the stone niche in the Cairo Museum, and the marble relief from Venice with the peacocks and the drinking stag in the K. Friedrich Museum. Also Part I, Fig. 9, the Coptic gable relief with the peacocks; or the early Fāṭimid intarsia in the Arab Museum in Cairo, Hall VII, showcase A, nos 16–18 from Edfu, with a falcon catching a hare.

[104] Cf. Part I, Figs 14–16.

rejected.[105] To me, above all, the scale of this ornament is decisive: the size of the leaves in relationship to the scrolls, of the vegetal forms to the animals, and in general the proportions compared to those of the other groups. One cannot invalidate this by stating that some single features of animals do not correspond to the vocabulary of Egyptian ornament. How few examples do we possess of the inexhaustible repertory of Egyptian textile art! Moreover, the existence of a few contradictory motifs is of little consequence in this consideration. More of this anon. Whatever proof we have suggests that the first [139] group of Mshattā reflects a Syrian style and the second group an Egyptian one. A closer relationship in the perception of art and the material motifs between Syria and Egypt undoubtedly exists in ancient as well as in Islamic times; this is thus in general contrast to the artistic milieu we shall now discuss, to which must belong the third and fourth groups.

The absence of figural elements and the much smaller, downright minute scale of the basic ornament are the main differences of these two groups as compared with the first two. The minute scale is therefore the most important point. This is minor art. Only craftsmen to whom architectonic sculpture on the grand scale was unfamiliar could carry that out. The ornament of the third group, M–T, is entirely dominated by vine scrolls. They emerge four times from a slender vase, three times from a tiny acanthus root; only once, in field O, has something else been chosen as a milieu: a thin embellished staff with a capital formed of a volute calyx and a winged palmette. The same crowning form occurs once in the field, in the scroll. It is followed by a number of flower forms, rather frequently in field O, only very rarely in P and R, fields that show a combination of folded-up acanthus leaves of a peculiar shape. These extraordinary forms are the rule in the fourth group, and we shall there examine their importance. Apart from these scattered elements, the ornament is quite homogenous. The capricious delineation of the scrolls is characteristic; the balanced, circular involutions are strictly avoided; only in the first of these fields, M, is a trace of it noticeable. However, the design of the scrolls is most difficult to disentangle. The superficial impression is that of a naturalistic composition. Yet, this is pseudo-naturalism. The awkward filling dominates the design. A comparison with the vine scrolls, which embellish the convex frieze of the cornice and the swelling torus of the base, shows us the home of this form of art. This is the very same kind of vine scroll—in its detail, in the manner in which the scroll has been developed, in the scale. In these borders the

[105] Strzygowski, p. 311. The board, belonging neither to the Ṭūlūnid nor the Baghdad type ornament, should be dated on palaeographical grounds between AH 180–280.

The Genesis of Islamic Art and the Problem of Mshattā 59

arabesque element is clearly evident in the uniaxial interlacing, in the knob which marks the points where the stems intersect, in the branches with their scrolls being like the botanical *cirrhus*. We have already seen that the profiles of these parts is due to the particular northwestern Mesopotamian mode of building, as in al-Ruṣāfa, Āmid and Naṣībīn, and that workmen from [140] this province of Diyārbakr have carried out the core, and that the acanthi of the profiles stem from a variety usual in that area. The same stonemasons have also executed these vine leaf borders. This is proven by identical vine leaf borders on the great mosque of Āmid.[106] These parts, which must already belong to the Umayyad period, and which reappear in the fifth century, resemble Mshattā throughout. And as these borders fully harmonise with the fields of the third group, *the third group M–T must have been carried out by workers from the province of Diyārbakr.*

Now to the fourth group. The strangely unnaturalistic vegetal forms that appear in isolation in the fields O, P, and Q entirely replace the vine foliage here. In field U the scroll motif is at least preserved in the composition. In V, however, these elements are merely pushed together. Composite blossom forms replace the vine leaves here, bulbous forms resembling pinecones take the place of grapes. In addition, small volute calyxes occur regularly, and occasionally winged palmettes. In the last field one finds something quite novel: three large circular shields which have a rim and a central filling. In those on the side the rim consists of a row of small blossoms resembling forget-me-nots, in the centre one a garland of acanthus palmettes, always surrounded by pearled bands. The filling consists of composite flowers on the right and left: in the middle it is non-vegetal. These three shields have been put quite inorganically amidst the vegetal ornament. This whole highly individual type of ornament is known to us from the *minbar* of al-Qayrawān. One cannot imagine a more complete harmony. This *minbar* comes from Baghdad and dates from the third century AH. *The fourth group of Mshattā is therefore Iraqi art of the first centuries of Islam.* Hitherto it has been described as entirely Persian, probably because of the winged palmette. However, all examples of the winged palmette seen up to now come from Iraq. The stucco reliefs in the Kaiser Friedrich Museum, published by Sarre and of which new ones appear on the market via Baghdad, are [141]

[106] The material collected by Baron von Oppenheim, General de Beyliea and Miss Bell will be published by Strzygowski in his *Amida: matériaux pour l'epigraphie et l'histoire musulmanes du Diyar-bakr* (Heidelberg, 1910). The illustrations 107 and 108 in Strzygowski, "Mshatta," are only copies of the old ornaments of AH 559. René Dussaud, *Les arabes en Syrie avant l'Islam* (Paris, 1907), Fig. 13, gives a little-noticed example of this ornament from the great Umayyad Mosque of Damascus.

Iraqi.[107] The *minbar* and the lustre tiles of the al-Qayrawān *miḥrāb* come from Baghdad.[108] The wooden board in the Cairo Museum, whose winged palmette and other features indicate that it is not from Egypt, has surely to be attributed to the art of Baghdad. The winged palmette is, after all, not a picture of the Sasanian crown itself, but that of a special crown or helmet ornament which appeared to the *Arabs* as a typical embellishment of the Kisrā. Moreover, the ornament of truly Iranian Sasanian monuments of the turn of the sixth to the seventh century AD represents the greatest contrast imaginable to this Iraqi ornament: the background is not timidly filled, but overwhelms the ornament. The large-leaved acanthus and the blossom compositions emerging from them, the similarly heavy shape of the vine leaves, also the large-spaced trefoils, as seen in Ṭāq-i Bustān, on the capitals of the Ṭāq, Bīsutūn and Iṣfahān, as well as on the other examples which I have quoted on the capitals of al-Muwaqqar, all this is Iranian and in contrast to Iraqi ornament. This genre too survives into Islamic times, apart from the capitals of al-Muwaqqar also in ornamental pieces that H. Viollet found among the ruins of the Bayt al-Khalīfa at Sāmarrā.[109] Earlier I referred to a principle as characteristic of Iraq which has been suppressed here,[110] namely, the contrast of full-blown high relief on a deeply carved background against a flat, infinitely delicate background filling. The principle has here been abandoned in favour of the simple deep shadow. However, the stonemasons could not quite omit the full-blown high relief that interferes with deep shadow in the last two fields, merely the flat, delicate ground ornament we see in the borders of the al-Qayrawān *minbar*. Just in the design this stands close to the third group of Mshattā. The habit of letting different elements form an immediate contrast is shown clearly in the three round shields of field V. There exists only one example for the transposition of such strange motifs into the otherwise homogenous ornament, namely, the manner in which goldsmiths' work interlaced with vegetal ornament is depicted in the mosaics of 'Abd [142] al-Malik at the Dome of the Rock. These shields, especially the middle one, also give an effect similar to the representations of goldsmiths' work. All the central fillings of the hexagonal or octagonal rosettes are also formed in the same manner. If anyone had any doubt when I described these elements of the Dome of the Rock as Iraqi,

[107] Cf. Part I, pp. 56f. and 61f.

[108] Viollet, "Palais de al-Moutasim," Pl. XVI, Fig. 1; cf. Part I, p. 57 n. 1. Neither this Iranian nor the Iraqi ornament is of the Ṭūlūnid Egyptian type.

[109] This also follows from the Islamic Iraqi ceramics with stamped symbols. Cf. Part I, p. 57 n. 1.

[110] Part I, p. 96.

this is the necessary proof.

The four stylistic groups—Syrian, Egyptian, northwest Mesopotamian and Iraqi—were placed in geographical juxtaposition as the organization of labour became necessary during the building process. On the left side of the façade Syrians and Copts were employed, and on the right men from Diyārbakr and from Iraq. The individual triangles are only 2.50 m. wide. One may therefore assume that only two stonemasons worked on one field, and in such a way that they divided the field symmetrically among themselves. We may further assume that 6 Syrians, 16 Copts, 16 Mesopotamians and 4 Iraqis were at work there. One could argue that, if the sculptural parts had been produced in Mesopotamia, the whole system would have been disturbed. But this argument itself merely becomes a further confirmation. The degree of incompleteness makes it obvious that the sculptural elements were executed before the blocks of stone were moved into place, but the basic patterns afterwards. The 20 men from Diyārbakr and from Iraq would therefore have executed the cornices and rosettes, the 4 Iraqis in particular the fillings of the rosettes. When these blocks were completed, the entire wall was moved into place by native labourers. Meanwhile the 16 Syrians worked at the ashlar masonry of the throne room. Then the labourers, arranged according to their nationalities, were placed at the façade in order to execute the background sculptures there. The men from Diyārbakr therefore did most of the work of the façade, and out of their midst came the master to whom the design must be attributed. He had first let his own men execute the sculptural scheme; next he revealed the general plan for the ground ornament, which, as the ruins show, had first been painted on and then lightly carved. These designs in which the individual labourers had vast freedom, only being restricted by equilibrium and deep shadow, were then revised by the master. This explains the inexhaustible fantasy, the systematic variation and simultaneously the invasion of singular motifs in the neighbouring groups. These labourers naturally saw what their neighbours produced. The different workmen also left behind quite individual traces of their work. The Syrians and Copts carved their Greek stonemason's marks, a Mesopotamian [143] presumably cut the cross of Golgotha on steps, and an Iraqi engraved the head of a Kisrā into the ashlar. There just does not exist any other monument which so vividly demonstrates the process of its genesis like Mshattā. *It is a prototypical example for the formation of Islamic art.*

Let us go over it once again. Technical analysis confirmed that Iraqis, men from Provincia Arabia, from Diyārbakr and from Syria cooperated. The analysis of the general plan suggested that the general design, into which some Syrian elements were adapted, must be attributed either to an Iraqi or

a Ḥīran architect. The analysis of the façade showed that the design of the decorated façade was the work of a master mason from Diyārbakr, while the execution was in the hands of stonemasons from Syria, Egypt, Diyārbakr and Iraq. One may differ over details, but that does not detract from the whole. One may state that this or that decorative or structural element may have had a different origin, this or that might have originated already earlier than after the sixth century AD: Mshattā, as it is, as a whole and in detail, is Umayyad. It is Islamic in all its characteristics. Such a work could most certainly originate in the first period of Islam. I refer once more to the conclusive final paragraphs of Part I of this essay. Word by word, point by point, everything that we have there deduced from other Islamic monuments is confirmed. This proves the Umayyad origin of Mshattā, and at the same time proves the validity of the characterisation of early Islamic art.

And now, to answer our questions formulated at the beginning. No art-historical evidence has indicated that Mshattā is a pre-Islamic structure. Not only is its style compatible with the early eighth century, it even demands this date and entirely excludes an earlier one, before the seventh century. Nor is the contrast with Quṣayr ʿAmrā proof against the Islamic origin of Mshattā, but it supports it, like the internal contrast of Mshattā itself. Understandably, an art-historical examination cannot provide any date, but here a historical examination offers some help. All we have regarding historic information has been dealt with exhaustively by H. Lammens. It suggests that Mshattā is the unfinished structure of a *bādiya* of Yazīd II (720–24) or of Walīd II (743–44). The greater number of proofs suggests Yazīd II.

[144] Now everything falls like a ripe piece of fruit: just as ʿAmrā and Mshattā, so also al-Ṭūba, al-Muwaqqar, al-Kharānā, all the *ḥīra*s and *bādiya*s of the Bilqā, Ukhayḍir and the like, the citadel of Ribāṭ ʿAmmān, the great mosque of Diyārbakr, of Ḥarrān. And further, how many wood and ivory carvings, how many textile objects which are still classified as Coptic and Sasanian in museums! We have won a whole huge realm for Islamic art. Mshattā is no longer a problem.

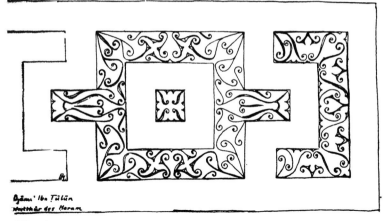

Fig. 1

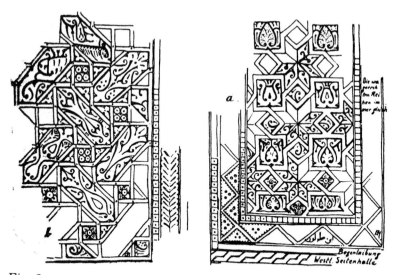

Fig. 2

Fig. 3

Fig. 4

Fig. 5

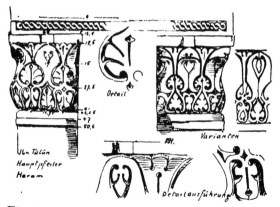

Fig. 6

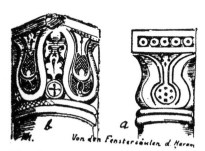

Fig. 7

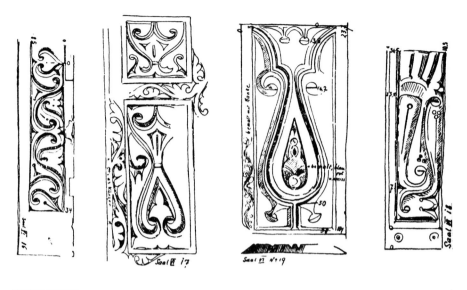

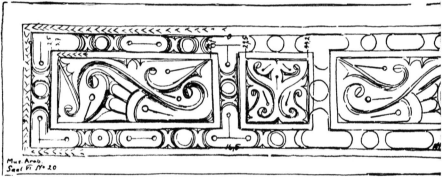

Fig. 8

Fig. 9

Fig. 10

Fig. 11 Fig. 12 Fig. 13

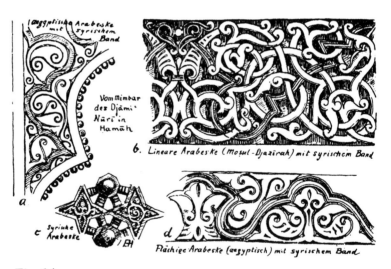

Fig. 14

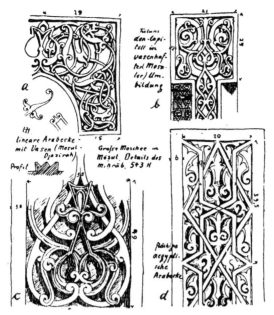

Fig. 15

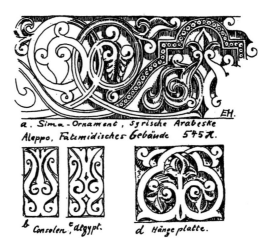

a. Sima-Ornament, syrische Arabeske
Aleppo, Fatimidisches Gebäude 545 H.

b Consolen, ägypt. d Hänge platte.

Fig. 16

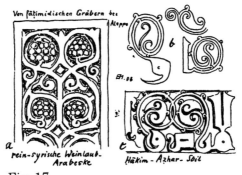

Von fätimidischen Gräbern bei Aleppo

a rein-syrische Weinlaub-Arabeske

Häkim-Azhar-Stil

Fig. 17

Fig. 18

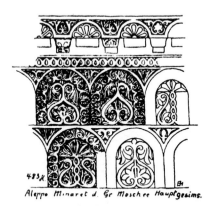

Fig. 19

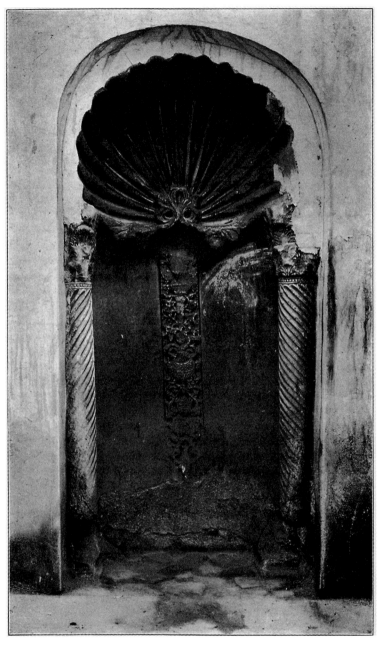

Phot. Sarre.

Fig. 20 Baghdād, Djāmi' al-Khāṣakī, Miḥrāb.

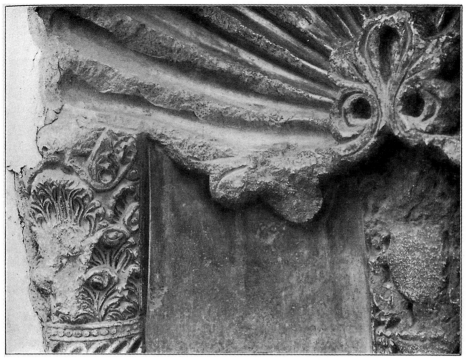

Phot. Sarre.

Fig. 21

Baghdād, Djāmiʿ al-Khāṣakī,
Details des Miḥrāb.

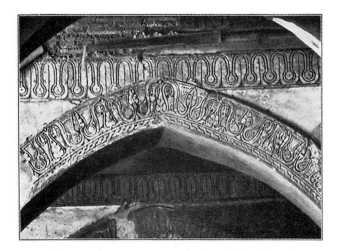

Fig. 22 Kairo, Djāmiʿ Ibn Ṭūlūn.
 Großes Band und Bogenfries.

Phot. v. Oppenheim.

Fig. 23 al-Gharrah, Makān ʿAbd al-ʿazīz.
 Stuckgesims.

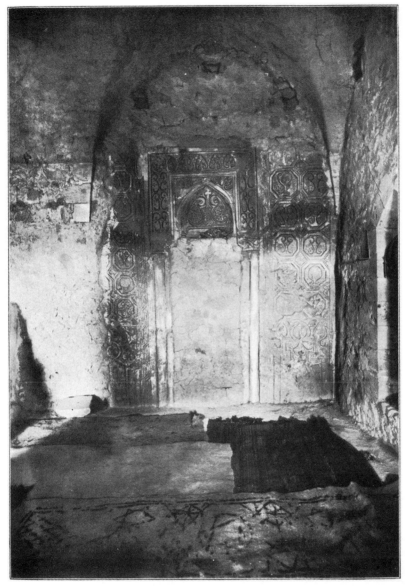

Phot. v. Oppenheim.

Fig. 24 al-Gharrah, Makān Abd al-ʿazīz, Miḥrāb.

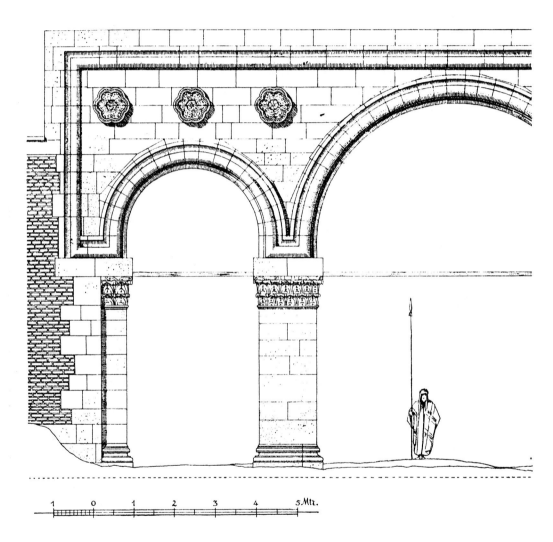

Fig. 27

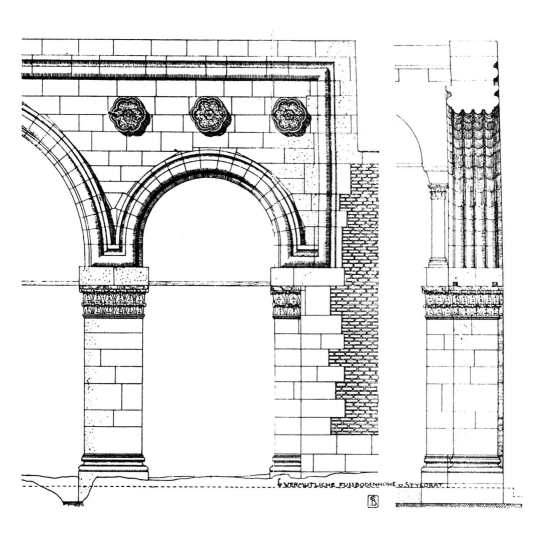

VERMUTLICHE FUSSBODENHÖHE v STYLOBAT

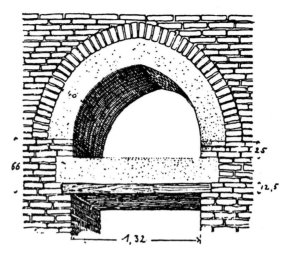

Fig. 25 Bogenkonstruktion von Mshättä.
Aus »Jahrbuch d. Kgl. Preuß. Kunstsammlungen«. 25. Bd.

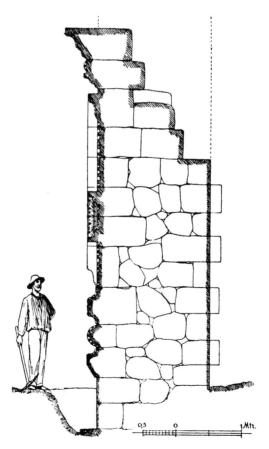

Fig. 26 Schnitt durch die Torfront von Mshättä.
Aus »Jahrbuch d. Kgl. Preuß. Kunstsammlungen«. 25. Bd.

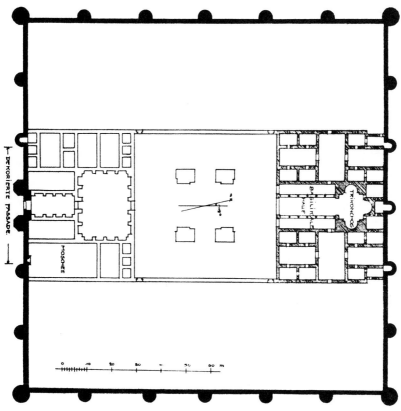

Fig. 28 Plan von Mshattā.

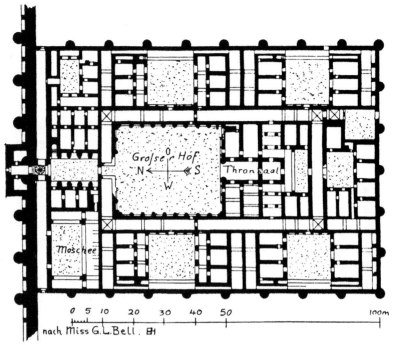

Fig. 29 Plan von Ukhaiḍir.

3
'ABBASID LUSTREWARES
Ernst Kühnel

It is not my intention, despite the great zeal and little resolution with which the question has been discussed over the last few years, to explore where and when the technique of producing luster effects on earthenwares and glass was first invented. I must confess furthermore that the so-called arguments for an Egyptian origin have in no way convinced me. On the other hand, if the argument is accepted *ipso facto* that the secret of metallic luster was known to Egyptian craftsmen before the 8th century, luster still first played a role in ceramic decoration under the 'Abbasids, who then furthered the immense artistic development of this particular technique. Relying upon the results of earlier research and following subsequent data, it is clear that the first use of luster painting *per se* was in Mesopotamia. One may leave aside the question whether the luster technique was developed indigenously or was rather derived from foreign wares. The question of primacy in the art-historical context remains unresolved.

Alongside extant Islamic lusterwares, numerous groups of superior 'Abbasid wares make it quite clear and conclusive – and it can scarcely be debated – that their origins should be sought between 800 A.D at the earliest and 1000 A. D. at the latest. However, we cannot be certain whether these wares were produced in a single or at several locations, perhaps even in various lands. The ceramic finds leave no such doubt: they are always made from the same finely levigated clay body which varies between sulfur yellow and pinkish yellow, always with the same glaze – very smooth and regular, rather thick and lightly crackled – on both the vessels' inner and outer walls, so that in their material conditions they are immediately distinguishable from any other lusterwares. The variations in tonality and choice of designs can be explained without much difficulty through the coexistence of various production centers and by a long period of development. During the excavations at Samarra, large quantities of these wares, as well as other closely-related types, came to light. All these finds have been described unhesitatingly as "Samarra Wares" and considered as examples of the same production. In 1914, Charles Vignier drove a wedge in the harmony of scholarly opinions by asserting that many of the excavated 'Abbasid lusterwares had been produced in Persia, specifically in the city of Rayy, and that these should be seen as prototypes for the wares

of Samarra.[1] Maurice Pézard and also Raymond Koechlin essentially agreed with him.[2] On the other hand, A. J. Butler and Aly Bey Bahgat viewed at least the "Samarra" wares discovered in the Nile Valley as local production. H. C. Gallois, as well, wanted to attribute the provenance of the famous Qairawan tiles to Egypt, despite Georges Marçais' [150] argument that there is evidence for 'Iraqi origins.[3]

Whatever ceramics were first found in Persia must therefore be related to our category, and they must all have been imported for the following reasons:

1. Neither the earlier, the contemporary, nor the entirely later ceramics of Persia have any peculiarities of clay or glaze that reveal an Iranian manufacture. Despite the fact that the extant lusterwares use quite different clays and various glazes, the variants are nevertheless so similar to the "Samarra" technique that they can all be thought to have come from one common production center.
2. The decoration of 'Abbasid lusterwares has no parallel in the contemporary "Gabri" wares of Persia, and the difference in technique is not sufficient enough to explain the striking stylistic differences.
3. The first dated example of Persian lusterware is from the year 1179,[4] and among all the other attested examples we do not have any piece which we could attribute on stylistic grounds alone before the middle of the 12th century. Whoever believes that there was indeed a luster industry in Persia during the 9th century and still in the 10th century, must also explain its complete decline and subsequent reappearance two hundred years later. The claim of uninterrupted flowering of ceramic production over the entire period cannot be supported by the smallest shred of evidence; rather, once having ascertained the character of luster development, one will doubtlessly be able to pursue it further.

Entirely different, but no less clear is the case of Egypt. Among the thousands of luster fragments found in the rubbish heaps of Old Cairo, the Samarra type is readily detectable simply because of its particular ceramic nature. There are no demonstrably Egyptian wares with similar clays or glazes so these wares must have been imported. However, the situation is so different from that of Persia that it is possible to propose an indigenous center of production, whose wares soon replaced those imported from abroad. Among the incontestably Egyptian

[1] Roger Fry and Charles Vignier, "New Excavations at Raghes," *Burlington Magazine*, xxv, July 1914, 211–18.

[2] Maurice Pézard, *La Céramique archaïque de l'Islam et ses origines*, Paris: 1920; Raymond Koechlin, *Les Céramiques musulmanes de Suse au Musée du Louvre*, Paris: 1928.

[3] A. J. Butler, *Islamic Pottery*, London: 1926; Aly Bey Bahgat and Felix Massoul, *La Céramique musulmane de l'Égypt*, Cairo: 1930; Henri Gallois in *Aréthuse*, no. 28, 1930.

[4] Ernst Kühnel, "Dated Persian Lustred Pottery," *Eastern Art*, III, 1931, pp. 223–5, fig. 1.

wares we encounter monochromatic luster fragments with a reddish body and a noticeably thin glaze on the exterior of the vessel. These wares, whose motifs undoubtedly imitate imported types, must have been developed during the 9th century at the earliest. It is not improbable that Ibn Tulun, who was acquainted with 'Abbasid art in Baghdad and Samarra, brought along with him the stucco style, which can be admired in his mosque, as well as luster pottery and perhaps even potters to establish a local industry in the Nile valley. The champions of a theory of [151] Egyptian primacy may argue that it was not necessarily so and that it only required a cursory stimulus from abroad in order to bring about an active development of luster painting within Egypt. However, the proponents of such a thesis must not, like Aly Bey Bahgat, confuse foreign wares and indigenous ones, nor must they, like A. J. Butler, erroneously date ceramic shards with Fatimid decoration to the 9th century.[5] One must not forget, moreover, the fact that imported wares found in Egypt (in Fustat, Bahnasa, and Ashmunain) closely resemble those excavated in Samarra more than those from Rayy, and that they consist exclusively of lusterwares, while large quantities of other Samarra wares were found in Persia.

If one believes that the 'Abbasid luster genre was neither produced in Persia nor in Egypt, then one can hardly doubt that its birthplace is to be found in 'Iraq. A single, yet debatable, argument against this provenance has been raised: namely, that the pre-conditions for a sudden ceramic efflorescence in Mesopotamia simply were not present. It is true that the archaeological finds from Ctesiphon suggest relatively modest activity in the production of domestic pottery during the Sasanian period, but the grand traditions of the Parthian period, which had a rich development at the time, must not have been forgotten. There must have been powerful impulses, such as the extraordinary case of the founding of Baghdad as the new metropolis of the Orient, to spur craftsmanship to new heights of achievement. That an indigenous tradition of luxury wares did not exist is proved by the continued use of Chinese stoneware and porcelain into the Samarra period, as well as through the use of overglazing and other east Asian techniques which were already handled with great skill in Mesopotamian wares, and through the appearance on the market of wares decorated, for example, in cobalt blue and turquoise green. First of all, the use of the luster procedure allowed for the manufacture of luxury wares, which were attractive enough to eventually drive out T'ang ceramics, and one can even hypothesize that the caliph's court, for the sake of prestige alone, actively patronized all attempts to this end. No one can honestly suggest that all lusterwares were imported into 'Iraq; rather, he must first consider the ceramic situation on objective grounds. One has to confront the existence of the Samarra wares found by F. Sarre,[6] with the lack of evidence for

[5] Aly Bey Bahgat, op. cit. and the attributions in the tables in *La Céramique égyptienne de l'époque musulmane*, Bâle: 1922; A. J. Butler, op. cit., pl. IX.

[6] Friedrich Sarre, *Die Keramik von Samarra*, Berlin: 1925.

such wares during the time of Harun al-Rashid and his successors, to which only the most bitter Egyptologists may object. One exception, however, must be mentioned here: the reliefwares with uniform, iridescent lustrous glazes found at Samarra, Ctesiphon, and Susa are made of a different clay, just as fine as that used in Fustat, but harder and redder. Leaving aside these similarities, which distinguish these wares from the Samarra group, they must be attributed to another production center. As positive identification for this production center [152] is lacking, so we must search both within and beyond 'Iraq. We mention these wares not because we consider them 'Abbasid lusterwares, but rather because they are the finest technical antecedents for the wares with which this article is concerned. For the moment, we will leave them aside.

Based upon the careful acceptance of the ceramic evidence, I believe that one cannot refute the theory that the origins of Islamic luster painting lie in 'Iraq. Most importantly, wherever the Samarra genre appears, it must be recognized as an import. Such is the case for Egypt and Persia, as well as for Spain,[7] North Africa,[8] India,[9] and Central Asia.[10] There can be no possible explanation for this tremendous spread, despite the fact that it reveals surprising innovation, except the desire of the entire world to use luster. The extant data however permits still further conclusions with regard to the localization, date and stylistic development.

One has noted many times that the role of Samarra itself, as a production center for excavated wares and wares named after it, has come into question.[11] Those who doubt the existence of one single production center at Samarra point to the fact that neither kilns nor wasters were found and that the extant luster evidence undoubtedly survives after the Samarra period (838–883). We know that the city was already abandoned in 900 and then destroyed – the caliph al-Mu'tazz notes it himself – but among the types of luster that continue to attract our attention are examples which – albeit on debatable grounds – could have been produced in the 10th century. We must also acknowledge that they could have been produced elsewhere, specifically in a place located so close to Samarra that it supplied all the capital's ceramic requirements. In all likelihood this city was Baghdad, which was explicitly mentioned as a center of pottery-production[12] and which possessed the best conceivable situation for the quick

[7] Ricardo Velazquez-Bocso, *Medina Azzahra y Alamiria*, Madrid: 1912, pp. 49–52.

[8] Georges Marçais, *Les Fayences à reflets métalliques de la Grande Mosquée de Kairouan*, Paris: 1928. I have not yet examined the luster shards found in the Qal'at of Bani Hammad. However, it seems possible to me that they could be Fatimid wares. Therefore, they will not be considered in this essay.

[9] Brahminabad, cf. R. L. Hobson, *Guide to the Islamic Pottery*, London: 1932, p. 8.

[10] See the shard finds from Afrasiyab near Samarqand in the Victoria and Albert Museum, London, R. L. Hobson, op. cit., p. 10, and in the Islamic section of the Berlin Museum.

[11] Sarre, op. cit., occasionally also raised by other authors.

[12] Josef von Karabacek, "Zur muslimischen Keramik", *Österreichische Monatschrift fur den Orient*, X 1884, no. 12.

dissemination of its ceramic products to all Islamic lands. As it happens, so-called "Samarra Wares" are found occasionally in the area of the former "Round City",[13] but reliable evidence that they were indeed produced there is completely lacking, and a clear answer to the question of the place of production unfortunately cannot be given at this time.

We are in a better position with regards to the problem of dating, for a careful technical and stylistic examination of the extant data reveals a seemingly indisputable development. I will try to delineate the development of the ceramics [153] that must have developed out of the luster production of Baghdad – or, more carefully said, of 'Iraq. I will be comparing these pieces to those precisely described in the relevant literature, in particular in the fundamental publications of Friedrich Sarre and Raymond Koechlin.[14]

When one approaches the subject from the not completely unjustified premise that lusterwares were meant to supplant East Asian porcelains and stonewares, so must one suppose that these wares did not exist prior to the founding of Samarra. Otherwise, the Chinese wares would hardly exist in such large quantities. However, it is obvious that both luxury types, primarily in the caliph's household, were present alongside one another for a long time. At Samarra itself, the luster procedure can be traced back to its first stages. It appears on plain bowls and jugs with a white glaze, whose outer sides and especially outer rims are covered with ruby-red luster painting (Sarre, pl. XVII, 4). The first pieces to be decorated with drawings are some bowls with palmettes or arabesque patterns in a hazy ruby luster, delineated and outlined by extremely bright gold luster, while these same vessels' outer walls are decorated with a monochromatic ruby-red luster (fig. 1, after Koechlin, pl. XXII, 157 and M. S. Dimand, fig. 91). In this case at least two luster shades are used, and their numbers will increase among the most magnificent finds at Samarra (Sarre, pl. XVII, 1–3), which combine similar decoration in gold, yellow, ruby-red, and purple luster and whose outer walls are covered with alternating irregular striations of red luster on a white glaze. It is very probable that they were produced in unified groups from one unique production center, whose activity prior to 850 we cannot yet determine. The characteristic ruby-red luster with the slightly fluid effect reminiscent of east Asian ceramics is not much found in later types, and an even more remarkable change takes place in the designs.[15]

[13] Friedrich Sarre and Ernst Herzfeld, *Archäologische Reise im Euphrat- und Tigrisbiet*, Berlin: 1920, II, p. 1148.

[14] Besides these two studies, the following works will be cited occasionally : Gaston Migeon, *L'Orient musulman*, Paris: 1922 and Maurice S. Dimand, *A Handbook of Mohammedan Decorative Arts*, New York: 1930.

[15] The same rich range is observable in some of the colorful speckled tiles decorated with figures of cocks within wreaths found in Samarra (Sarre, pl. XXII). These also must have been created very early, albeit for a different purpose.

Likewise, the next series uses still more luster tones, but a heavy lacquer brown – seemingly unknown up until then – predominates alongside yellow, gold, and bottle-green luster. The patterns are best illustrated through the well-known tiles from Qairawan which, according to the convincing explanation of G. Marçais, were presumably placed on the mihrab of Sidi 'Uqba in 862.[16] These display mostly an unusual range of palmette and flower designs, chief among which are the many variants on the winged palmette, conceived on a large scale. These motifs are outlined by peculiar curl, fishbone, or speckle designs, often with the [154] intention of strengthening the luster effect and discreetly empha-sizing the designs. One bowl excavated at Samarra with wing motifs in four luster tones and with inner walls with irregular striations (fig. 2) clearly proves to have the same provenance, and other well-known pieces such as the dish from Bahnasa and the Gulbenkian bowl in the Louvre (Migeon, pl. 16, after M.S. Dimand, fig. 93 and Koechlin, pl. XXI, 143) find their closest parallels in Qairawan. The finest is a flat dish from Samarra (Sarre, pl. XVII, 5–10), deco-rated with the usual minute decoration on the exterior and broad flowing volute tendrils with trefoil leaves in green and yellow luster on its inner walls. Similar vegetal ornament occasionally led to the complete omission of smaller decora-tive patterns, as in the case of a jug from Susa (Koechlin, pl. XXII, 158). We would be hardly mistaken to place the apogee of this group around 860. To this extent, these pieces characterize the high point of the entire development, which achieves particularly striking luster effects by completely uniform means.

A third, almost contemporary production center restricted itself to yellow and reddish-brown lusterwares, only exceptionally using a greenish-brown tone on the monochromatic outer walls and showing a very unusual preference for designs of tangled leaves and branches of flowers (fig. 3, after Sarre, pl. XIII, I and fig. 95, Koechlin, pl. XXI and XXII, Pézard, pl. 133). Some of the monochro-matic Qairawan tiles (Marçais, pls. V and VI) and dishes such as those in the British Museum (Hobson, fig. 7) prove a close relationship with the aforemen-tioned series, most especially in terms of the common leafy branch, curl, [157] and fishbone patterns. Lattice-work patterns are also popular in this genre: they fill the ground next to the thick scrollwork in the famous eagle dish from Samarra (fig. 4, Fr. Sarre, pl. XXIII), a piece which we must consider an extraordinarily splendid example of brown-yellow lusterware. In turn, through the splendid stylized bird motif,[17] this series culminates so powerfully in the animal and floral dishes painted in beautiful brown luster on a dazzling white ground (Fr. Sarre, figs. 126-130). In addition, these pieces provide us with

[16] Marçais, op. cit. I believe, like Marçais, that only the polychromatic series are imported, whereas the monochromatic pieces could have been placed there subsequently. Whether this actually took place in Qairawan necessitates a genuine verification of the material. Stylistically, these tiles definitely belong to the 'Iraqi genre.

[17] One can hardly agree with H. Gallois, in *Aréthuse*, Oct. 1928, p. 14, that a jug is depicted here.

another interesting parallel to the leafy branch and heraldic motifs found on a whole number of blue-and-white 'Abbasid wares, which in general exhibit rather plain decoration (Sarre, figs. 99, 103, 104; Koechlin, pls. XI, p. 83, and XII, p. 92; Pézard, pl. 103; Hobson, figs. 10, 11). Undoubtedly, these point to reciprocal influences. If we accept that this style was present around 870, then we can also establish an approximate date for the end of polychrome luster painting.

We must face the possibility that monochromatic lusterwares, from the very beginning, could have been produced in conjunction with polychromatic ones. Oddly enough, the excavated examples of these wares from Samarra are so coarse and unrefined in drawing that one is compelled to date all of them to the end of that period. The uniform luster decoration is often a lovely golden-yellow, in some cases greenish or green-yellow, and, often, also olive-brown. Light lattice-work and scribbled letters in circles or ovals comprise the modest decoration (Fr. Sarre, pls. XIV, p. 2, XV, I, p. 4, and XVI, I) although sometimes more broadly painted ornament is also used. Animal representations are no longer found; however, when they are present in excavated finds, we can postulate that they were more frequently intended as export goods.[18] In truth, these pieces also fail to support this hypothesis, because they belong to a single type which first developed only after 880 and was no longer used in Samarra. At any rate, there are a few pieces among those preserved examples which prove unmistakably to have a direct connection to the group under consideration. The beautiful griffin bowl from the Louvre (fig. 5) places the animal on a plain ground, in a stylized manner which is unquestionably reminiscent of the previously mentioned eagle dish. The bird and the band around the vessel's body are outlined by the same round dots, much as in the Qairawan phase, and the exterior has fluidly painted dots and strokes, which we have already seen. A date of circa 875 would be appropriate, if our presuppositions are correct. No less instructive is the very pale peacock dish from Berlin (fig. 6), whose center contains the same Qairawan dots – usually a typical contrast pattern for polychrome lusterwares – which seem without purpose here. Thus, it is also [158] connected to its earlier stage. The birds rise out of the white plane of the background, which here, for the first time presents a pattern of thick, punch-like strokes. This type of ground appears for the first time at Samarra in a bowl inscribed with good wishes (Sarre, pl. XIV, p. 2). As this pattern is lacking in the other finds, so we must certainly date it after 880.

Other wares known up until now which are decorated with animal or figural representations – most of which comprise the 'Abbasid lusterwares excavated in Rayy (see the description in Pézard, pls. 114–18,121) – must therefore be dated

[18] Sarre, op. cit., observes that the walls of pieces produced in Persia and Egypt were thicker than was customary in Samarra. However, I have hardly found this speculation to be entirely true. It must only be an accidental deviation from the norm or, for example, the apparent handling of the surface.

Ernst Kühnel

at the earliest around 900, a large portion of which was actually produced well into the 10th century. Those wares whose motifs are presented on a completely white ground like the famous Kelekian bowl (*Syria*, 1924, pl. XXI) often belong to a different workshop tradition than the aforementioned one, which is characterized by a majority of wares with dotted backgrounds. By careful examination, the surfaces appear constant in their decoration of tiny hooks, but in more humble pieces crude dots seem to be strung in a careless manner. Such vessel types can also be seen as later examples of luster production centers in 'Iraq, such as fragments of vessels which came to light in the excavations at Medina al-Zahra near Cordoba, and which surely could not have found a place in the household goods of 'Abd al-Rahman III's recreational palace before its founding (937).[19] This is also the case for the group of lusterwares from Brahminabad which seem to belong mainly to the last phase (see Hobson, fig. 14) of this artistic development.[20] An example of this closing phase is the bowl with two bulls (fig. 7) which must have been made about 950 at the earliest. In this case, the outer walls are still sparsely decorated, like most examples of monochrome lusterware which usually have similar outer decorations: dots made of dark strokes interlaced with circles, squiggles, and so forth. They are reminiscent of depictions placed on the visible parts of objects datable to around 860. Despite the much heavier potting, these wares show a clear continuity through the usual scalloped motifs found on the rim, a decorative device that first emerged in the ruby-red wares and then vanished over the course of a century, and also replaced blue-and-white 'Iraqi wares. Calligraphic decoration, on the other hand, does not emerge until later and hardly presents secure chronological data. With few exceptions, it is limited to only one class of recurring inscriptions which are often abbreviated or deformed blessings to the owner.[21] The few extant signatures (Habib, Muslim, 'Ali, Abu Shaddad, and others) on the outer walls of the vessels have no impact on the general classification of the wares since we have no other details about these artists.

The preceding study shows that is entirely possible to classify 'Abbasid lusterwares into the course of a little over one century [159], and that their chronology can, to some extent, be put in line with their technical and decorative development. Despite the corrections it will be necessary to make to one or another aspect of this study in the future, it should be obvious that we can no longer agree with Charles Vignier and Raymond Koechlin that the monochromatic lusterwares with hatched backgrounds found in Rayy should be dated to the beginning, rather than at the end, of this artistic period. Most of all, it seems to me that the unity of this type of luster painting finds its origins in one

[19] see footnote 7.

[20] Hobson, op. cit., notes an interesting fact: at the end of the 10th century, a close connection continued to exist between the royal families from Brahminabad and Baghdad.

[21] Samuel Flury, "Une formule épigraphique dans la céramique musulmane", *Syria*, 1924, p. 533.

single center, with precedence given to 'Iraq. Almost certainly Cairo takes on a leading role in the production of these wares at the beginning of the Fatimid period (970). Moreover, the fact that from this time onward lusterwares are no longer found in 'Iraq seems to support Oscar Raphael's hypothesis[22] that the technique migrated with potters to the newly established Egyptian capital. These potters were perhaps Shiites who found patronage under the Fatimid caliphs. We can even further propose that, two centuries later with the fall of the Fatimids (1170), the production of luster began in Rayy with the concurrent move to Persia of Shiite master potters. The famous statement by Nasir-i Khusraw (1050), who expresses his admiration for the so-called "iridescent" wares manufactured in Egypt, seems therefore accurate: lusterwares – supposing this is what he means – were not yet present in Persia and no longer made in 'Iraq. It is also plausible that these wares attracted his attention in Cairo for the first time. We must therefore be on our guard with regards to the luster puzzle. The Samanids, in any case, did not know how to make lusterwares, as the many Central Asian wares of the 10th century prove.[23] In vain, these wares take pains to achieve similar "Samarra" effects, both in the color of the glazes and in the particular painterly idioms such as hatched backgrounds, scroll designs, etc.

[22] Oscar Raphael, "Some Notes on the Early Pottery of the Near East," *Transactions of the Oriental Ceramic Society*, 1925/6, 27-31.

[23] Pézard, op. cit., pls. 92–4.

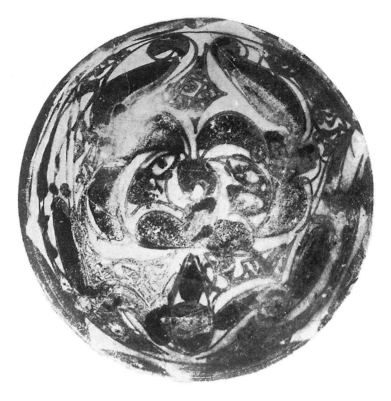

Figure 1 – Dish with ruby-colored luster ca 850. Paris, Musée du Louvre.

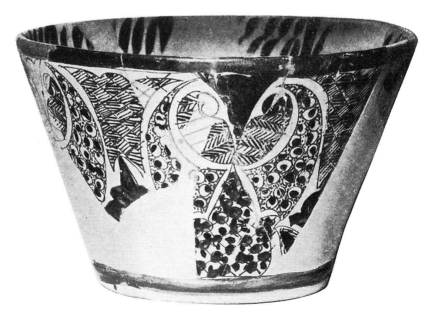

Figure 2 – Bowl with Kairouan-type luster, ca 860. Berlin, Staatliche Museen.

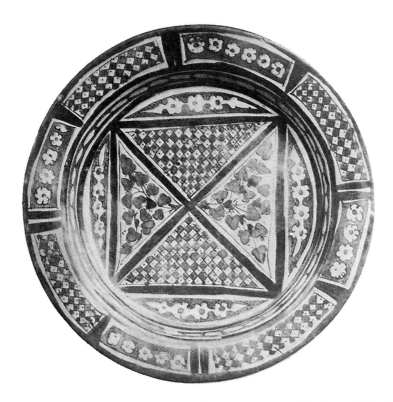

Figure 3 – Dish with Brown and Yellow Luster, ca 870. London, D.K. Kilekian Coll.

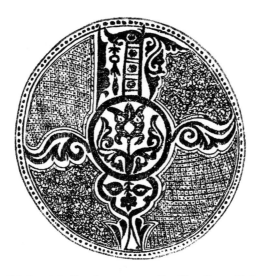

Figure 4 – Dish with Eagle, ca 870. Berlin, Staatliche Museen.

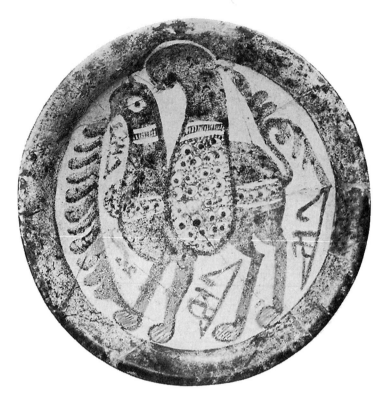

Figure 5 – Dish with Monochrome Luster, ca 875. Paris, Musée du Louvre.

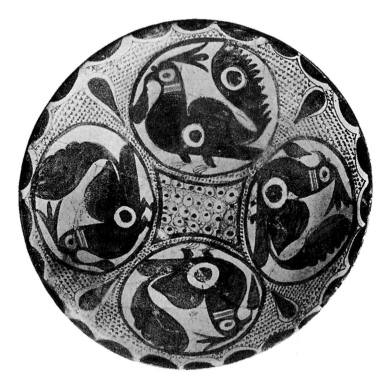

Figure 6 – Dish with Monochrome Luster, ca 880. Berlin, Staatliche Museen.

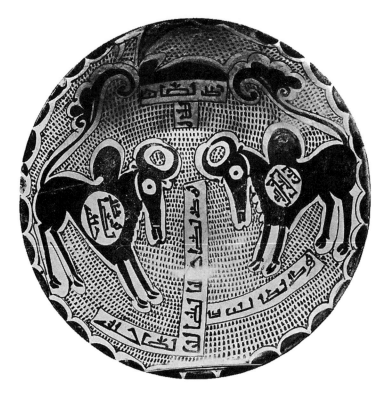

Figure 7 – Dish with Monochrome Luster, ca 950.

4

THE LAWFULNESS OF PAINTING IN EARLY ISLAM*

K.A.C. Creswell

THE PAINTINGS OF ḲUṢAIR ʿAMRA RAISE, IN AN IMPERATIVE FASHION, THE QUESTION OF the lawfulness or otherwise of painting in Islam. Even at the present day the belief is very widely held that all forms of painting are forbidden by explicit passages in the Koran, but

* Bibliography: G. B. Toderini, *Letteratura turchesca* (Venezia, 1787), III, 45–74; *idem, De la Littérature des Turcs* (Paris, 1789), III, 47–78; *idem, Literatur der Türken* (Königsberg, 1790), II, 193–209. H. Lavoix, "Les Peintures musulmans," *Revue de l'Orient, de l'Algérie, et des colonies*, n.s., IX (1859), 353–69. H. Montaut, "De la Représentation des figures animées chez les musulmans," *Mém. de l'inst. égyptien*, I (1862), 61–65. F. Pharaon, "La Peinture et la sculpture chez les musulmans," *Mém. de l'inst. égyptien*, I (1862), I (1869), 442–46. L. Viardot, "Quelques notes sur la peinture et la sculpture chez les musulmans," *Gazette des beaux-arts*, I (1869), 556–59. H. Lavoix, "Les Arts musulmans," *Gazette des beaux-arts*, XII (1875), 97–113, 312–21, and 423–37. S. Lane-Poole, "Mohammad's Condemnation of Pictures," *Academy*, VIII (1875), 233 and 250–51; *idem*, [Review of *Les Arts Musulmans: Les Peintures arabes*, by H. Lavoix], *ibid.*, X (1876), 364. C. A. C. Barbier de Meynard [Review of *Les Peintures arabes*], *Revue critique d'hist. et de litt.*, n.s., I (1876), 333–35. J. Karabaček, "Über das angebliche Bilderverbot des Islām," *Kunst und Gewerbe*, X (1876), 281–83, 289–91, 297–99, 307–8, 315–17, and 332–33. M. de Nahuys, "Les Images chez les Arabes," *Annales de l'acad. d'archéol. de Belgique*, XLVIII (1895), 229–34. V. Chauvin, "La Défense des images chez les musulmans," *Annales de l'acad. d'archéol. de Belgique*, XLIX (1896) 403–30. J. von Karabaček, "Über die Auffindung eines Chalifenschlosses in der nordarabischen Wüste," *Almanach der K. Akad. der Wissensch.*, LII (1902), 356–57. Th. W. Juynboll, *Handleiding tot de Kennis van Mohammedaansche Wet* (Leiden, 1903), pp. 157–58. Muhammad ʿAbduh, "al-Ṣuwar wa'l-Tamāthil wa-Fawāʾiduha wa-Ḥukmuha," *al-Manār*, VIII (1904), 35, reprinted by Muhammad Rashīd Riḍāʾ, *Taʾrīkh Muhammad ʿAbduh*, II (1925), 499–501. M. van Berchem, "L'Art musulman au Musée de Tlemcen," *Journ. des savants*, n.s. IV (1906), 418. C. Snouck Hurgronje, "Ḳuṣejr ʿAmra und das Bilderverbot," *Zeitschr. d. deutsch. morgenl. Gesellsch. (=Z.D.M.G.)*, LXI (1907), 186–91; reprinted in his *Verspreide Geschriften* (Bonn und Leipzig, 1923), II, 449–56. L. Bréhier, "Les Origines de l'art musulman," *Revue des idées*, VII

(1910), 196–98. M. van Berchem, "Nouvelles et correspondance," *Journ. des savants*, n.s., VII (1909), 134–35; *idem*, "Aux Pays de Moab et d'Edom," *ibid.*, pp. 370–72. J. Horovitz, "Die Beschreibung eines Gemäldes bei Mutanabbi," *Der Islam*, I (1910), 385–88. T. W. Juynboll, *Handbuch des islamischen Gesetzes* (Leiden, 1910), pp. 166–67. Abd al-Aziz Shawish, "al-Taṣwir wa-Ittikhadd al-Ṣuwar," *al-Hindaya*, II (1911), 487–91. C. H. Becker, "Christliche Polemik und islamische Dogmenbildung," *Zeitschr. f. Assyriol.*, XXVI (1911), 191–95, reprinted in his *Islamstudien* (Leipzig, 1924), I, 445–48. M. van Berchem, "Arabische Inschriften," *in* F. Sarre and E. Herzfeld, *Archäologische Reise im Euphrat- und Tigris-Gebiet* (Berlin, 1911), I, 36–38 (apropos of the Talisman Gate at Baghdad). M. H. Bulley, *Ancient and Medieval Art* (New York, 1914), pp. 265–66. H. Lammens, "L'Attitude de l'Islam primitif en face des arts figurés," *Journ. asiatique*, IIme série, VI (1915), 239–79. A. Enani, "Beurteilung der Bilderfrage im Islam nach der Ansicht eines Muslim," *Mitteil. des Seminars für orientalische Sprachen zu Berlin*, XXII (1919), II Abt., 1–40. I. Goldziher, "Zum islamischen Bilderverbot," *Z.D.M.G.*, LXXIV (1920), 288. L. Massignon, "Les Méthodes de réalisation artistique des peuples de l'Islam," *Syria*, II (1921), 47–53. A. J. Wensinck, "The Second Commandment," *Mededeelingen der Koninklijke Akad. van Wetenschappen*, Afd. Letterkunde, Deel LIX (1925), Ser. A, No. 6. E. Herzfeld, *Die Malereien von Samarra* (Berlin, 1927), pp. 1–3. G. Migeon, *Manuel d'art musulman* (2d ed.; Paris, 1927), I, 101–3. T. W. Arnold, *Painting in Islam* (Oxford, 1928), pp. 1–40. Aly Bahgat and F. Massoul, *La Céramique musulmane de l'Égypte* (Cairo, 1930), pp. 38–39. Ahmed Mousa, *Zur Geschichte der islämischen Buchmalerei in Aegypten* (Cairo, 1931), pp. 15–16. G. Wiet, "Le Décor des édifices—L'Interdiction des images," *in* L. Hautecoeur and G. Wiet, *Les Mosquées du Caire* (Paris, 1932), I, 167–83. A. J. Wensinck, "Ṣūra," *Encycl. Islām* (Leyden-London, 1934), IV, 561–63. G. Marçais, "La Question des images dans l'art musulman," *Byzantion*, VII (1933), 161–83. C. J. Lamm, "The Spirit of Moslem Art," *Bull. Faculty of Letters, Egyptian Univ.*, III (1935), 3–5. Zakī M. Ḥasan, in his notes to Ahmed Taymur Pasha, *Painting, Sculpture and*

this is a popular error for no such passages exist, as orientalists have frequently pointed out.[1]

Azraḳī (d. 858 A.D.), author of the earliest extant history of Mecca, tells that Muhammad, after his triumphal entry into that city in Ramadan 8 (December, 629–January, 630) went inside the Kaaba and ordered the pictures in it to be obliterated, but put his hand over a picture of Mary with Jesus seated on her lap, and said: "Rub out all the pictures except these under my hands"; and Azraḳī goes on to say that this picture remained until the Kaaba was destroyed in 63 H.[2]

Sa'd ibn Abī Waḳḳāṣ and his Arabs at the capture of al-Madā'in, or Ctesiphon, used the great īwān for the Friday prayer and were not disturbed by the paintings decorating it, one of which represented the siege of Antioch by Khusrau Anūshirwān (538 A.D.).[3] Zakī Hasan tries to explain away this fact partly by the lack of time, the troops being so anxious to give thanks for their great victory that they did not stop to obliterate them, and partly by saying that "victorious armies do not always act according to religious principles."[4] But he has to admit that these paintings were allowed to remain for two and a half centuries at least, for they were seen by al-Buḥturī, who died in 897 A.D.[5] An early example of Muslim painting may be mentioned; Yākūt says that the palace of al-Baidā' at Basra, built by 'Ubaid Allah the son of Ziyād ibn Abihi, was decorated with wall paintings.[6] Then, again, the rigid Caliph Omar used a censer with human figures on it, which he had brought from Syria, to perfume the mosque of Medina, and it was only in 785 A.D. that a governor of Medina had these figures erased.[7] This hardening of opinion toward the end of the eighth century is in perfect keeping with the evidence given below.

It is also well known that Mu'āwiya and 'Abd al-Malik struck coins with their own effigies.[8] Recently, Zakī Hasan[9] has sought to explain the undisputed existence of painting under the Umayyad caliphs by saying that "they did not keep the straight and narrow way in

the Reproduction of Living Forms Among the Arabs [in Arabic] (Cairo, 1942), pp. 119–39.

[Professor Creswell's article is a revised and supplemented version of his essay first published in his *Early Muslim Architecture* (Oxford, 1932), I, 269–71. ED.]

[1] The first to point out that the prohibition against painting comes not from the Koran but from the Hadith, was Lavoix, in 1859, in "Les Peintures musulmans," pp. 353–54. He was followed by Pharaon, *op. cit.*, pp. 443–44; Lavoix, "Les Arts musulmans," pp. 98–99; Karabaček, "Über das angebliche Bilderverbot des Islām," p. 291; De Nahuys, *op. cit.*, pp. 229 and 233; Chauvin, *op. cit.*, pp. 405–6; Lammens, *op. cit.*, pp. 242–43; E. Kühnel, *Kunst des Orients* (Wildpark-Potsdam, 1929), p. 1; Migeon, *op. cit.*, I, 101–2; Arnold, *op. cit.*, pp. 4 ff.; Ahmed Mousa, *op. cit.*, p. 16.

[2] F. Wüstenfeld's ed., in *Die Chroniken der Stadt Mekka* (Leipzig, 1857–61), pp. 111–13; quoted by Arnold, *op. cit.*, p. 7. This obliteration of pictures inside

the Kaaba is also mentioned by Balādhurī, *Futūḥ al-Buldān*, ed. M. J. de Goeje (Leyden, 1866), p. 40; P. K. Hitti's trans. (New York, 1916), p. 66. See also Creswell, *op. cit.*, I, 40.

[3] *Ibid.*, p. 15.

[4] *Op. cit.*, p. 124.

[5] Creswell, *op. cit.*, p. 15, n. 10.

[6] *Mu'djam al-Buldān*, ed. F. Wüstenfeld (Leipzig, 1866–73), I, 792, l. 21—p. 793, l. 4. 'Ubaid Allāh was killed at the battle of the river Khāzir, near Mosul in 67 H. (686 A.D.); K. V. Zetterstéen's article, "'Ubaid Allāh b. Ziyād," *Encycl. Islām* (Leyden-London, 1934), IV, 985.

[7] Ibn Rusta, *Kitāb al-A'lāḳ al-Nafisa*, ed. M. J. de Goeje, *Bibliotheca Geographorum Arabicorum* (= B.G.A.) (Leyden, 1892), III, 66, ll. 15–19; quoted by Enani, *op. cit.*, p. 25, and Arnold, *op. cit.*, pp. 8–9.

[8] Creswell, *op. cit.*, p. 96.

[9] *Op. cit.*, p. 127.

matters of religion," except Omar ibn Abd al-Aziz, who, on one occasion, actually is recorded to have objected to a picture in a bath. He had it obliterated and exclaimed: "If only I could find out who painted it, I would have him severely beaten." [10] I suggest that this painting was most probably pornographic, as was often the case in hammams [11] and that this was the real cause of Omar's anger, for it has just been seen that he had no objection to a censer with human figures on it which was used to perfume the mosque of Medina.

Yet in spite of the silence of the Koran, the Traditions (Hadith) [12] are uniformly hostile to all representations of living forms.[13] Arnold, the latest scholar to discuss this question, believed that this hostility dates almost from the time of Muhammad, and held that the paintings of Ḳuṣair 'Amra were executed in defiance of it.[14] Now although later caliphs and sultans certainly did defy the prohibition on many occasions, there appears to be good reason for believing that this prohibition had not yet been formulated at the time when the frescoes of Ḳuṣair 'Amra were executed. When did the change take place? A valuable clue is provided, curiously enough, by the Patrology. Our first witness is John, Patriarch of Damascus [15] and the great opponent of the Iconoclasts, who in the words of Becker, "represents the whole world of thought of the Eastern church at that time." He did not live secluded in some distant monastery, but occupied a prominent place in the court life of the later Umayyad period, although he retired to a monastery shortly before his death. He belonged to an old Damascus family, the Banu Sardjūn, which had played an important part in the state administration under 'Abd al-Malik and even earlier. His active life must be placed roughly between 700 and 750 A.D.,[16] so that he was a contemporary of Ḳuṣair 'Amra.

[10] Ibn al-Djawzī, Manāḳib 'Umar ibn 'Abd al-'Azīz, ed. C. H. Becker (Leipzig, 1899), p. 80; quoted by Enani, op. cit., p. 33, and Arnold, op. cit., pp. 46–47.

[11] al-Ghuzūlī, Maṭāli' al-Budūr (Cairo, 1300 H.), II, 8; and Ibn al-Ḥādjdj, Mudkhal (Cairo, 1348 H.), II, 178–79.

[12] The Hadith are traditions concerning the actions and sayings of Muhammad, which circulated orally until they were collected, sifted, accepted or rejected, systematized, and written down for the first time in the ninth century by Bukhārī, Muslim, Abū Dā'ūd, Malik ibn Anas, Ibn Sa'd, Ahmed Ibn Ḥanbal, and Ibn Hishām, each tradition being accompanied by its isnād, or chain of oral descent (e.g., so-and-so heard it from his father, who heard it from so-and-so, who knew the blessed Prophet). As early as the middle of the ninth century the number of Hadith in circulation was enormous, the majority false or suspect, for Bukhārī, who died in 870 A.D., only accepted seven thousand out of six hundred thousand which he had heard; see R. A. Nicholson, Literary History of the Arabs (Cambridge, 1930), p. 146.

[13] Snouck Hurgronje, op. cit., pp. 186–91. van Berchem, op. cit., p. 371. Lammens, op. cit., p. 249. Enani, op. cit., pp. 1–40. Arnold, op. cit., pp. 5–19, 31, and 38–40.

For a complete list of references to this question in the early collections of Hadith, see A. J. Wensinck, A Handbook of Early Muhammadan Tradition (Leiden, 1927), p. 108. Snouck Hurgronje has shown that Karabaček's contention, that paintings are permissible in the entrance hall of a building ("Ḳuṣejr 'Amra," p. 229 and n. 69 on p. 237), is due to a misunderstanding of the text of al-'Askalānī. See also C. H. Becker, "Das Wiener Ḳuṣair 'Amra-Werk," Zeitschr. f. Assyriol., XX (1906), 373–75; reprinted in his Islamstudien, I, 300–304.

[14] Arnold, op. cit., pp. 4–9 and 19.

[15] He died ca. 750 A.D. For his life and works see F. A. Perrier, Jean Damascène: sa vie et ses écrits (Strasbourg, 1863); J. Langen, Johannes von Damaskus (Gotha, 1879); J. H. Lupton, Saint John of Damascus (London, 1882); V. Ermoni, Saint Jean Damascène (Paris, 1904); and Becker, "Christliche Polemik und islamische Dogmenbildung," pp. 177–87; reprinted in his Islamstudien, I, 434–43. His three treatises "against those who depreciate the holy images" were written between 726 and 737 A.D.

[16] Becker, "Christliche Polemik....," pp. 177–78; reprinted in his Islamstudien, p. 434.

As Becker has pointed out, John knew the doctrines of Islam well, his quotations from the Koran in Greek are sometimes almost literal translations of the original, and he even gives the actual names of the suras cited.[17]

But although he was a violent opponent of the Iconoclastic movement and wrote his treatises "against those who depreciate the holy images"[18] under the strong emotion caused by the edict of 726, and although he wrote against Islam, he never refers to the Muslims as being guilty in this respect, but only to the Christians and Jews, whereas Theodore Abū Ḳurra, bishop of Ḥarrān,[19] who was a contemporary of Harun-al-Rashid and al-Ma'mūn and the first Father of the Church to write in Arabic, although he took most of his ideas from the writings of John, differs from him in this respect, for he includes the Muslims among the people opposed to painting. He does not actually refer to them as Muslims, but merely says: "Those who assert that he who paints anything living, will be compelled on the Day of Resurrection, to breathe into it a soul."[20] Although the Muslims are not actually named, the almost literal citation of the Muslim Hadith[21] proves that they are meant and, in addition, that the Hadith in question was already in circulation among the Muslims in the time of Abū Ḳurra. Thus the movement may be placed toward the end of the eighth century.

This fact is of considerable importance to students of Byzantine art, for it renders untenable the theory, put forward by Diehl[22] and Dalton,[23] that the Iconoclastic movement,[24] which took definite form in the edict of the Emperor Leo the Isaurian[25] in 726, was partly due to defeats inflicted on the image-worshipping Byzantine army by an army of men hos-

[17] "Christliche Polemik....," pp. 179–80; *Islam-studien*, p. 436. This suffices to show that Zakī Hasan's remark that Abū Ḳurra "could judge the Muslims by what he read in their books and not only by what they practiced" (*op. cit.*, p. 180), applies equally to John.

[18] Λογος πρωτος (—δευτερος—τριτος) απολογητικος προς τους διαβαλλοντας τας αγιας εικονας, in J. P. Migne, *Patrologia, Series Graeca* (Paris, 1857–81), XCIV, cols. 1231–1420, and three smaller treatises in XCV, cols. 309–86, and XCVI, cols. 1347–62.

[19] For his life, see C. Bacha, *Un Traité des oeuvres arabes de Théodore Abou-Kurra* (Tripoli, 1905), pp. 3–7. His works have been published at Beirut in 1904, and by G. Graf, *Die arabischen Schriften des Theodor Abû Qurra* (Paderborn, 1910); and the part that concerns us by J. P. Arendzen, *Theodori Abu Kurra de cultu imaginum libellus e codice arabico* (Bonn, 1897).

[20] *Ibid.*, pp. 18–19; and Graf, *op. cit.*, pp. 297–98.

[21] From Buk̲h̲ārī, *Le Recueil des traditions mahométans*, ed. L. Krehl and T. W. Juynboll (Leiden, 1862–1908), II, 41, and IV, 106: "On the Day of Judgment the punishment of hell will be meted out to the painter, and he will be called upon to breathe life into the forms that he has fashioned; but he cannot breathe life into anything"; see Arnold, *op. cit.*, p. 5.

[22] C. Diehl, *Manuel d'art byzantin* (Paris, 1910), p. 336.

[23] O. M. Dalton, *Byzantine Art and Archaeology* (Oxford, 1911), p. 13, and *idem, East Christian Art* (Oxford, 1925), p. 15.

[24] For an account of this movement see: K. Papparrēgopoulos, *Histoire de la civilisation hellénique* (Paris, 1878). K. J. von Hefele, *A History of the Councils of the Church*, W. R. Clark's trans. (Edinburgh, 1896), V, 370 ff.; K. Schwarzlose, *Der Bilderstreit* (Gotha, 1890); A. Lombard, *Études d'histoire byzantine* (Paris, 1902), pp. 105–28; L. Bréhier, *La Querelle des images* (Paris, 1904); Diehl, *op. cit.*, pp. 334–39 (2d ed.; Paris, 1925), I, 360–65; Dalton, *Byzantine Art*, pp. 13–16; C. Diehl, "Leo III and the Isaurian Dynasty," *Cambridge Medieval History* (New York-Cambridge, 1936), IV, 5–11; H. Leclercq, "Images," in F. Cabrol and H. Leclercq, *Dictionnaire d'archéologie chrétienne* (Paris, 1907), VII, cols. 232–302; G. Ostrogorsky, *Studien zur Geschichte des byzantinischen Bilderstreites* (Breslau, 1929); G. Ostrogorsky, "Les Débuts de la querelle des images," in *Mélanges Charles Diehl* (Paris, 1930), I, 235–55; A. A. Vasiliev, *Histoire de l'empire byzantin* (Paris, 1932), I, 333–51.

[25] As a result of recent research, it now seems probable that Leo was of North Syrian and not of Isaurian origin; see Vasiliev, *op. cit.*, I, 311–12.

tile to all forms of human representation. This theory has been accepted by Wiet, who, after citing the decree of the Caliph Yazīd (see below), quotes Michael the Syrian to the effect that "l'empereur des Grecs, Léon, ordonna *lui aussi, à l'exemple du roi des arabes,* d'arracher les images des parois, et il fit abattre les images qui étaient dans les églises et les maisons, celles des saints aussi bien que celles des empereurs ou d'autres."

"Michel le Syrien," adds Wiet, "est logique avec la tradition de l'Église. On sait qu'au deuxième concile de Nicée, tenu en 787, les évêques qui condamnèrent les iconoclastes estimèrent que les mesures prises contre les images l'avaient été à l'imitation des musulmans." [26]

What was this decree of Yazīd? According to Theophanes (d. 818) "a Jew of Latakia, coming in haste to Yazīd, promised him a reign of forty years over the Arabs if he destroyed the holy ikons which were adored in the churches of the Christians in all his empire. But in this same year Yazīd died before most of the people had even had time to hear about his Satanic order." [27] The execution of this order had already begun in Egypt [28] when Yazīd died (January 26, 724), and his successor Hishām revoked it on his accession.

As for the famous Council of Nicaea of 787, Michael the Syrian, who wrote in the second half of the twelfth century, does not tell the whole story. The true facts may be learned

[26] G. Wiet, "Introduction," *in* E. Pauty, *Bois sculptés d'églises coptes* (Cairo, 1930), pp. 3–4.

[27] *Theophanis Chronographia*, ed. G. de Boor (Leipzig, 1883–85), p. 401. He places this event in the Year of the World 6215 (724 A.D.). Dionysius of Tell Maḥrē (d. 845 A.D.) places it in the year of the Greeks 1035 (723–24 A.D.); J. B. Chabot, ed., "Chronique de Denys de Tell-Mahré," *Bibliothèque de l'école des hautes études*, fasc. 112 (Paris, 1895), p. 19, and trans., p. 17. Michael the Syrian (*Chronique de Michel le Syrien, patriarche jacobite d'Antioche,* J. B. Chabot, ed. [Paris, 1899–1904], II, 457; trans., II, 489) and Bar Hebraeus (*Chronography,* ed. P. Bedjan, *Makhtĕbhânûth Zabhnê* [Paris, 1890], p. 118; *The Chronography of Gregory Abû 'l Faraj,* trans. E. A. W. Budge [London, 1932], I, 109) also mention it but without giving a date. Maḳrīzī (*Khiṭaṭ* [Bulaq, 1853] I, 302, line 31; trans by P. Casanova, *Mém. inst. franç. d'arch. orient. du Caire,* III [1893–1920], 165) said that it took place in 104 H. (June, 723–June, 724 A.D.). I must add, however, that doubts have been expressed regarding the authenticity of this story, e.g., by J. Wellhausen (*Das arabische Reich und sein Sturz* [Berlin, 1902], pp. 202–3) and A. Musil (*Ḳuṣejr 'Amra* [Wien, 1907], p. 155). It is true that Ṭabarī, as Wellhausen points out, merely stated that a Jew had prophesied that Yazīd would reign forty years, and that Eutychius and Butrūs ibn Rāhib knew nothing of the matter. But the silence is not complete, for other writers, equally early, speak of it, e.g., the Arabic historian al-Kindī (d. 961 A.D.), and three ecclesiastical historians, Dionysius of Tell Maḥrē, quoted above, the anonymous Syriac chronicle of the year 846

A.D., published and translated by E. W. Brooks, "A Syriac Chronicle of the Year 846," *Z.D.M.G.,* LI(1897), p. 584, and Severus ibn al-Muḳaffa', bishop of Ashmūnain in the tenth century; see al-Kindī, *The Governors and Judges of Egypt; or Kitāb el-'Umarā' (el-Wulāh) wa Kitāb el-Quḍāh,* ed. R. Guest, E. J. W. Gibb Mem. Ser., XIX (Leiden-London, 1912), 71–72; and Severus ibn al-Muḳaffa', ed. B. T. A. Evetts, trans., *Patrologia Orientalis (History of the Patriarchs of the Coptic Church of Alexandria)* (Paris, 1904–10), V, 72–73 (or ed. C. F. Seybold, *Alexandrinische Patriarchen—Geschichte* [Hamburg,1912], p. 153, line 7); quoted by Lammens, *op. cit.,* p. 278. The objections of Wellhausen and Musil are therefore invalid. Moreover, on reading the proceedings of the Council of Nicaea, I have come across a contemporary witness, the bishop of Messina who, at the fifth session, stated that he was a boy in Syria when the caliph (σύμβουλος) of the Saracens threw down the images: G. D. Mansi, *Sacrorum Conciliorum nova et amplissima Collectio* (Florentiae, 1769), XIII, col. 200.

[28] It is to this order that J. E. Quibell attributed the mutilation of the paintings and sculptures found during his excavations at the Monastery of Apa Jeremias at Sakkāra; see his *Excavations at Saqqara (1908–9, 1909–10)* (Cairo, 1912), p. iv. J. W. Crowfoot found that the figure subjects in the floor mosaics of the churches at Jerash had been mutilated before the final destruction of the city by an earthquake, probably that of 747; see his *Churches of Jerash (British School Archaeol. at Jerusalem, Suppl. Papers,* 3) (London, 1932), p. 4; there can be little doubt that this was done in compliance with the same decree.

by referring to an original document, viz., the actual proceedings of the Council in question, which may be consulted by turning to the great work of Mansi. There we read that at the reopening of the fifth session (October 4, 787), Tarasius remarked that the accusers of the Christians had in their destruction of images "imitated the Jews, Pagans, Samaritans, Manichaeans, and Phantasiasti (or Theopaschites)."[29]

Whereupon the monk John, representative of the Eastern Patriarchate, asked permission to correct these erroneous ideas and to clear up the real origin of the attack on images, apparently speaking, like the bishop of Messina[30] from first-hand knowledge of the facts.[31] This is what he said:

After Omar's death [February 9, 720] Ezid (Yazīd II), a frivolous and unstable man, succeeded him. There lived at Tiberias a leader of the lawless Jews, a magician and a fortuneteller and a tool of soul-destroying demons, named Tessarakontapechys [= 40 cubits high] . . . On learning of the frivolity of the ruler Ezid, he approached him and began to utter prophecies . . . saying: "You will live long and reign for thirty years if you follow my advice . . . Give order immediately without any delay or postponement, that an encyclical letter be issued throughout your empire to the effect that every representational ($\epsilon i\kappa o\nu\iota\kappa\dot{\eta}\nu$) painting, whether on tablets or in wall-mosaics or on sacred vessels and altar coverings, and all such objects as are found in all Christian churches, be destroyed and finally abolished, and so also all representations of any kind whatever that adorn and embellish the market places of cities. . . ." The impious tyrant, yielding to his advice, sent [officials] and most frivolously destroyed the holy ikons and all other representations in the whole province under his rule and, thanks to the Jewish magician, thus ruthlessly robbed the churches of God under his sway of all ornaments, before the evil came into this land. As the Christians fled lest they should [have to] overthrow the holy images with their own hands, the emirs who were sent for this purpose pressed into service abominable Jews and wretched Arabs; and thus they burnt the venerable ikons, and either smeared or scraped the ecclesiastical buildings.

On hearing this the pseudo-bishop of Nicolia and his followers imitated the lawless Jews and impious Arabs and outraged the churches of God. . . . When after doing this, the Caliph ($\Sigma \acute{\nu}\mu\beta o\nu\lambda o\varsigma$) Ezid died no more than two and one-half years later [25 Sha'bān 105 = January 27, 724],[32] the images were restored to their pristine position and honor. His son Oὔλιδος (= al-Walīd—should be Hishām), filled with indignation, ordered the magician to be ignominiously put to a parricide's death as a due reward for his false prophecy.[33]

Thus, this act of Yazīd was in no way inspired by the doctrine of Islam at that period; on the contrary it would never have taken place had it not been for the vain promises of a fortuneteller,[34] and it was promptly revoked by his successor.

How did the feeling arise? It has been suggested that it arose through the inherent

[29] Mansi, *op. cit.*, XIII, col. 196.

[30] See end of footnote 27.

[31] The importance of this cannot be overrated, for all the works of the Iconoclasts, the imperial decrees, and the acts of the iconoclastic councils of 753–54 A.D. and 815 A.D. were destroyed when their adversaries triumphed.

[32] This gives the end of July, 721 A.D., for the date of Yazīd's act.

[33] Mansi, *op. cit.*, XIII, cols. 198 and 200.

[34] Let us remember that this was a period when "individuals" as Diehl says "put faith in the prophecies of wizards, and Leo III himself, like Leontius or Philippicus, had been met in the way by one who had said to him: 'Thou shalt be King'"; *op. cit.*, IV, 6.

temperamental dislike of the Semite for human representations in sculpture and painting,[35] an antinaturalistic reaction in fact. This undoubtedly helped, but the internal evidence points to a direct Jewish influence. Lammens points out that the Hadith bearing on the question in many cases shows Jewish inspiration, for example, the sayings: "The angels will not enter a house containing a bell, a picture or a dog," and "at the end of the world when 'Isā appears he will break the cross and kill the pigs." [36] Bells were unknown in the time of Muhammad, and the semantron did not inspire the Arabs with any antipathy. Nor did they before Islam experience any special repugnance for pigs. The name khinzīr is met with, and the flesh of the wild boar appeared at feasts. The sayings cited above can only be explained as due to Talmudic influence.[37] Again it is remarkable that the earliest recorded instance of hostility to images and painting appears to have been inspired by Jewish influence, viz., the iconoclasm of Yazīd II, cited above. A Christian influence, springing from the iconoclastic movement which broke out in 726 A.D., is therefore unlikely, likewise a spontaneous Muslim impulse.

This Jewish influence was doubtless due to the internal effect of Jews who had been converted to Islam, like the famous Yemenite Jew Ka'b al-Aḥbār, who was called Rabbi Ka'b on account of his wealth of theological and especially Biblical knowledge. Ka'b entered Jerusalem with Omar, was converted to Islam in 638 A.D., and died in 652 or 654. He is frequently cited as an authority for Hadith, and Abd Allah ibn Abbas, one of the earliest expositors of the Koran, was a pupil of his, likewise Abū Huraira. Another famous Jewish convert was Wahb ibn Munabbih. These two men were the great authorities among the early Muslims on all points of ancient history.[38]

Finally, as a predisposing psychological basis for the hostility to painting, there was the feeling, so common among primitive peoples, that the maker of an image or a painting in some way transfers part of the personality of the subject to the image or painting, and in so doing acquires magical powers over the person reproduced.[39] This feeling, which is still prevalent in some parts of the world, was once very widely spread. The practice of making wax images of the person to be bewitched, and thrusting pins through them, was known to the Egyptians,[40] Greeks, and Romans, and was widely spread in medieval Europe, e.g., John of

[35] Viardot, op. cit., I, 556–59; Barbier de Meynard, op. cit., I, 333–35.

[36] Lammens, op. cit., pp. 276–77.

[37] Ibid., pp. 276–79.

[38] See G. Le Strange, Palestine under the Moslems (London, 1890), p. 142; and M. Schmitz, "Ka'b al-Aḥbār," Encycl. Islām (Leiden-London, 1927), II, 582–83.

[39] See P. Sébillot, "Superstitions iconographiques. I, Les Portraits," Revue des traditions populaires, I(1886), No. 12, 349–54, and idem, "Superstitions iconographiques. II, Les Statues," ibid., II (1887), No. 1, 16–23; Chauvin, op. cit., p. 423 ff.; E. Doutté, Merrâkech (Paris, 1905), pp. 136–38; his Magie et religion dans

l'Afrique du Nord (Alger, 1909), pp. 16–17; and J. G. Frazer, The Golden Bough (London-New York, 1890), I, 148–49 (2d ed.; London-New York, 1900), I, 10–18 and 295–97.

[40] A small model of a man made of wax, papyrus, and hair, which was intended to be burned slowly in a fire while incantations were recited, in order to produce some evil effect upon the person whom it represented, was obtained in Egypt by Budge in 1895. It is now in the British Museum, No. 37, 918; see E. A. W. Budge, By Nile and Tigris (London, 1920), II, 347; idem, Guide to the Third and Fourth Egyptian Rooms (London, 1904), p. 20.

Nottingham's attempt to bring about the death of Edward II in 1324, and the similar attempt of Agnes Sampson on the life of James VI of Scotland in 1589; [41] also the League's attempt to kill Henry III of France.[42] A similar attempt on the life of Muhammad is related by Djannābī and Ali al-Ḥalabī.[43]

My conclusion, therefore, is that the prohibition against painting did not exist in early Islam, but that it grew up gradually, partly as a result of the inherent temperamental dislike of Semitic races for representational art, partly because of the influence of important Jewish converts, and partly because of the fear of magic. It also follows that Muslim influence on the Edict of Milan is excluded.

[41] See M. Summers' introduction to his translation of [Institoris, Henricus], *Malleus Maleficarum* (London, 1928), pp. xix-xx and xxii. The wax dolls were called "Mommets."

[42] See P. de L'Éstoile, "Veritable fatalité de Saint-Cloud," *Journ. des choses mémorables advenues durant le régne de Henry III*, ed. by J. Le Duchat and D. Godefroy (Cologne [Bruxelles], 1720), art. 8.

[43] Chauvin, *op. cit.*, pp. 425–26.

5
THE MOSQUE AND THE PALACE
Jean Sauvaget

[122] There is hardly a work on Islamic art that does not contain at least some discussion of the architectural origins of the mosque. The critical examination of the succession of views professed therein, however, would lead us far astray and, moreover, is of but limited interest. The views advanced to date share a common weakness, one sufficiently pronounced as to leave them effectively void of all authority: the monuments have all been studied *in the abstract* and exclusively from an aesthetic angle. At no point is concern shown for the architectural work in relation to the forms of social life for which it was to provide a setting. It has always been seen as if the sole preoccupation of the builders was to "make something beautiful," without making any attempt – as it would have been rational to do – to inquire as to whether the composition of the edifice responded to certain requirements of the *practical sort* which were themselves related to the manner in which contemporary institutions functioned. On this score, the work of Creswell progresses little further than that of his predecessors: the mosque of Damascus – the oldest mosque of the axial nave style of which he was aware – was, to his mind, little more that an amalgam of architectural motifs of diverse origin assembled in one and the same monument simply on an architect's whim.[1]

But this approach to the study of "architectural origins," quite apart from the fact that at no point does it relate to the methods of architectural composition used in antiquity,[2] disregards, in the most regrettable fashion, the entire homogeneity of conception and execution of the edifice. It can account only for the individual elements of construction, each of which is viewed in isolation and on its own terms, but is incapable of clarifying the part played by each element *in the whole.*

Finally, consideration needs to be given not only to the mosque in Damascus. Although the composition of Syrian mosques of the Umayyad period [123] adheres closely to the conception adopted in Damascus, they differ from one

[1] K.A.C. Creswell, *Early Muslim architecture, I: Umayyads* (Oxford: Oxford University Press, 1932), 135–137.

[2] These methods are known from the work of Vitruvius and from the analysis of certain outlines of plans. Finally, see M. Échochard, Le Sanctuaire de Qal'at Sem'an: Notes archéologiques, *Bulletin d'études orientales*, VI (1936), 79–84.

another in terms of a number of variants (the form and relative proportions of the prayer hall and courtyard, the distribution and type of support structures, the relative dimensions of the axial nave and the arrangement of its façade, the placement of the minaret, etc.) which indicate clearly that one was not limited to the creation of slavish copies of a fixed monument type. Had this been the case, all of the features of the one building would have been duplicated all over without noticeable modification. These mosques cannot have been pure, simple copies of that built in Damascus, least of all the mosque in Medina which was too profoundly distinct and, in addition, *of an earlier date* than all the others, including that in Damascus. The proper explanation for their shared features can only lie, therefore, in the fact that they represent *so many different realizations of the same monumental type that adheres to the diagram of a simple plan which, while easily characterized, is flexible enough to lend itself to numerous variations of detail.* Once these are set aside, so as to retain only the permanent features common to all of the structures that we have cited,[3] the diagram of the plan can be defined in a single word: these mosques, which constitute in essence a set of structures endowed with a raised axial nave, correspond precisely to what we know as *the basilica.*[4]

The comparison has been made so often that it is now routine to find the mosque in Damascus designated as an "edifice of the basilican plan." It is unclear, however, that as such it bears the same meaning which we intend to convey here.[5] Thus, to be precise: having oriented the plan correctly (which is to say, in line with an immutable rule which locates the principal entrance *below*, and the axis of symmetry on the vertical, such that the eye grasps the plan in the same fashion, and on the same angle, as that by which the gaze discerns the interior composition of the monument upon entering it), it is our view that *the central raised section of the building*, at the far end of which is located the mihrab, and which constitutes the axis of construction, represents the *central nave of the basilica* (from which originates the term "axial nave" which, deliberately, we have used to designate it), and that its *aisles* are composed *of the two*

[3] The mosque at Medina, given what we have stated above, no longer constitutes an exception.

[4] I use the term here in the sense assigned it by common usage which I do not mean to prejudge.

[5] It is at the very least disconcerting to find that the plan of the Damascus mosque is nearly always reproduced with the wrong orientation, that is, with the north at the top. See, for example, Henri Saladin, *Manuel d'art musulman, I., l'architecture* (Paris: A. Picart, 1907), fig, 31; Hermann Thiersch, *Pharos, antike, Islam und Occident* (Leipzig: B.G. Teubner, 1909), fig. 394; Creswell, *op cit.*, figs. 57 and 66; Jean Sauvaget, Les Monuments historiques de Damas (Beirut: Imprimerie Catholique, 1932) fig. 6; Henri Terrasse, *L'art hispano-mauresque des origines au XIIIe siècle* (Paris: G. van Oest, 1900), fig.2. On the other hand, those best disposed to recognize a basilica identify its axial nave as a "transept": Max van Berchem, *Bulletin d'études orientales*, VII–VIII (1937–1938): 41 and passim; Creswell, *op cit.*, 9 ("transversal nave"); Sauvaget *loc cit.*, 29–30 ("transept"). The term, which evokes the idea of a *transverse* enclosure, implies that the plan should be viewed from east to west. One can see, in sum, that there is nothing superfluous about the care with which I seek to clarify my position.

lateral wings of the prayer hall, regardless of the manner in which they have been represented and the orientation of their interior spaces. [124]

However paradoxical this interpretation may seem at first, it is the only correct and strictly precise one, and the only one which conforms to reasoned methods of analysis of an architectural structure; we will find, moreover, and when it becomes necessary, that there is much to support this view. It is in this sense that we designate the particular type of Umayyad mosque as a basilica preceded by a courtyard with a peripheral covered portico (fig. 1).

To explain the motives behind the adoption of this type of monument, two approaches are possible. We can tackle the question directly, by searching in the literary sources for indications that allow us to decide whether the arrangement of these mosques was imposed by considerations of a practical nature and if it responds to specific demands of the ceremonial of "communal prayer" (*ṣalāt al-jum'a*) By proceeding in such a manner, however, we run the considerable risk of being deeply dissatisfied or of being directed only toward uncertain conclusions inasmuch as our channels of information on the Umayyad era remain inadequate; these are far more valu-

Figure 1

able for intimate anecdotes of a general interest than information suitable for the elucidation of the history and function of institutions. We have adopted an alternative method, one which is likely to provide the argument with a wider, firmer foundation: having pointed out that Umayyad architecture does not restrict the basilican plan to the mosque, we will attempt first to explain the adoption of this design in other monuments in which it is found, following which we return to the mosque itself, better informed by the investigation of a much wider number of examples.

Umayyad Audience Halls

How is it that up to now it has not been pointed out that the principal room of Umayyad palaces and princely residences is itself a basilica and, as a result, bears obvious similarities with the mosque? The first writers to treat the origins of the mosque can be forgiven for not recognizing the relationship since, in their time, neither Mshatta nor similar monuments had been assigned a definitive dating.[6] It seems as if more recent authors, however, were dissuaded from such a comparison only by the too hasty character of their research methods. Three of

[6] For example, Thiersch, *op cit.*, where the restoration proposed for the facade at Mshatta provides ample indication of the state of research at that point in time.

4 *Jean Sauvaget*

the structures discussed here have been analyzed by Creswell [125] in the same manner as the great mosque of Damascus, which is to say by emphasizing details at the expense of the composition as a whole – the entire scheme of the structure – which ought to be the sole object of consideration insofar as the question at hand concerns architectural origins. Five others were intentionally set aside on his part because he understood them to be pre-Islamic whereas one has excellent grounds on which to date them to the first two centuries of the Hijra. Only the final example is a recent discovery.[7]

KHIRBAT AL-MINYA

The central hall of the palace (fig. 2) is a square room, measuring nearly 20 meters on a side , which is divided lengthwise by two series of columns into three

Figure 2

spaces of unequal size, the largest at the center, with two others, narrower, to the right and left.[8] Despite the absence of a terminal apse, and although the condition of the remains of the structure makes it impossible to determine whether the central area was raised in such a way as to allow for illumination of the premises, one cannot deny that it qualifies as a basilica.[9] The role of this hall is attested in turn by its particular arrangement; by the layer of marble which covers its floors and walls; by the manner in which it is connected to the mosque of the palace; and, finally, by the particularly careful decoration used in the living quarters to which it gives access.

MSHATTA

The great hall of Mshatta (fig. 3) is situated at the end of the central courtyard of the palace and on its axis. It resembles a basilica with three naves, open to the courtyard through three grand arches, and at the far end of which is located a triconch crowned by a cupola. On either side of the axial apse are two small rooms open to the great hall; one of these rooms leads to a privy.[10]

[7] Although we are familiar with a large number of Umayyad palaces, which I treat further on, very few audience halls have survived since these were generally constructed on an upper floor, nearly all the examples of which have disappeared.
[8] A.M. Schneider and Oswin Puttrich-Reignard, *Ein frühislamischer Bau am See Genesareth* (Cologne, 1937), 30.
[9] The greater elevation of the axial nave and the apse are no more than secondary features of the basilica.
[10] On Mshatta, see Creswell, 350–389.

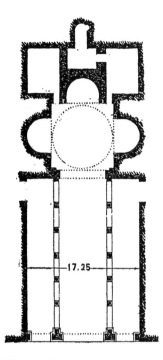

AL-MUWAQQAR

The residence of Yazīd II was plundered with such violence by the Abbasids that only scant traces remain of the site. One at least [126] can make out the layout of the principal building which was composed of a residential palace to one side of which was joined, certainly when the proprietor arrived, a basilican hall of three naves (fig. 4) the purpose of which seems hardly in doubt.[11]

QUṢAYR 'AMRĀ AND ḤAMMĀM AL-ṢARAKH

Each of the two sites includes a small bath outfitted with a relatively spacious room for changing and relaxation.[12] As regards their function, these rooms cannot be divorced from the palace audience halls: the prolonged period of exposure to hot steam, the abundant sweating, and massage made the steam-bath an exhausting exercise for the body, one which had to be followed by an extended period of rest. In the

Figure 3

Umayyad period, as in our own, it was only by passing several consecutive hours in the changing area, prostrate in a state of sensual lassitude, that the bather could restore his energies.[13] As in our own time, certain individuals would not hesitate to reserve the bath for their exclusive use,[14] and there enjoy,[15] as a complement to their repose, the pleasures of

Figure 4

[11] Creswell ignored this building. On its attribution to the Umayyads, see my *Remarques sur les monuments omeyyades* (Paris: Imprimerie Nationale, 1939), 35, which also contains bibliographic references. I will consider this site again in connection with the Umayyad palaces.

[12] On these buildings, see Creswell, 253–284. The actual use of the main room has been identified by Edmond Pauty, *Les hammams du Caire* (Cairo: L'institut français d'archéologie orientale, 1933), 17ff.

[13] On present usage, see Michel Ecochard and Claude Le Coeur, *Les Bains de Damas* (Beirut: Institut français de Damas, 1942) (well documented). Cf. Edward Lane, *An Account of the Manners and Customs of the Modern Egyptians* (London: John Murray, 1860: 336–43.

[14] See, for example, Carl H. Becker, *Ibn Gāuzi's Manāqib 'Omar ibn 'Abd el Azīz* (Leipzig: 1899), 33.

[15] Abu al-Faraj al-Iṣfahānī, *Kitāb al-aghānī* (Bulaq, 1284–1285/1867–1869): IV:79.

conversation. Thus, to a certain de-
gree, the main bathing area
assumed the role of the reception
hall.[16]

The relaxation area in Quṣayr
'Amrā, and that of Ḥammām al-
Sarakh, the one identical to [127]
the other,[17] are square rooms in
which were constructed two longi-
tudinal arches (which rise from
pillars attached to the walls and
which support the roof) and at the
end of which opens a small alcove
flanked on the right and left by two
small recesses (fig. 5).

Figure 5

J. Strygowski has compared this arrangement to a basilican church complete
with an apse located between two sacristies. Creswell rejects the comparison,
arguing justly that the impression conveyed on-site is that of a square room
without interior partitions.[18]

My view is that, nevertheless, the
two interiors ought to be counted
among those basilicas in which pillars
and arches have replaced columns and
architraves (fig. 6): though they pro-
duce the effect of a square room, this
is simply because the *small dimen-
sions of the covered space* allowed the
usual series of longitudinal arches to
be reduced to *a single bay*. These bath
areas are to that of Mshatta what
Church No. 3 of al-Amtā'īya or the
West Church of Bāqirḥā were to the
basilicas of Constantine in Jerusalem
and Bethlehem or the basilica of
Mijlīyā.[19]

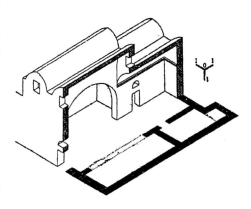

Figure 6

[16] Which explains why, to the present day, it has been regarded as an audience hall. Creswell
(254) adheres to this interpretation.

[17] They cannot be distinguished except by the manner of construction and the look of two
recesses flanking the axial alcove, both insignificant variations.

[18] *Op cit.*, 278.

[19] Howard C. Butler, *Early churches in Syria* (Princeton: Princeton Monographs in Art and
Architecture, 1929), fig. 137. Cf. Heinrich Glück, *Der Breit und Langhausbau in Syrien* (Heidelberg:
C. Winter, 1916), pl. II, no. 18; pl. III, no. 18.

KHARĀNA

The palace of Kharāna, which Creswell considers to be pre-Islamic but which I view as Umayyad,[20] is a very modest structure, erected with rudimentary means, a feature we would do well [128] to keep in mind while examining its principal hall, which is located on the upper floor, over the entrance.

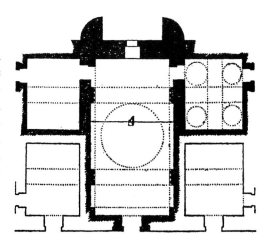

Figure 7

This room (fig. 7) consists of a chamber oriented lengthwise at the end of which is a window. The central section of the vault consisted, in all likelihood, of a dome resting on two transverse arches rising from four groups of three engaged colonettes. Two lateral rooms open onto the rear section of the hall; the ceiling of one of the two rooms is decorated with a system of coffers which appears in no other room of the palace.

Given this characteristic detail (which underscores the ceremonial function assigned to this space), and due to the fact that among the other rooms that flank the principal hall, the two rooms at the rear are the only ones to communicate with it (in contrast with the arrangement in the rest of the palace), one can regard the two lateral rooms as a copy of those which, in Mshatta, Quṣayr ʿAmrā and Ḥammām al-Ṣarakh, flank on the right and left the exedra or rear apse. In the principal hall itself, the dome, which very much resembles a monumental canopy in front of the rear of the space, immediately evokes the image of that at Mshatta. Lastly, a comparison (which is justified given the remarkable affinities of construction) with two rooms in the Sasanian palace at Sarvistān,[21] shows that the groups of engaged colonettes did not simply have an ornamental function. They represented the two rows of supports for a basilican hall which were joined here to the lateral walls of the room, due to a misunderstanding and lack of technical skill,. Thus, given these points of comparison, the great hall of Kharāna can be viewed as *a debasement of the basilican hall,* the first phase of which appears in the palace of Sarvistān. Kharāna is, in sum, a poor and exceedingly clumsy replica of the great hall at Mshatta.[22] [129]

[20] See my *Remarques*, 16f. with bibliographic references.

[21] See Sauvaget, *La mosquée Omeyyade de Médine,* 164–165.

[22] Of course one should not view the latter as having been a source of inspiration for the builders of Kharāna: the relative dating of the two structures remains unknown.

AL-QASTAL

The great hall of this palace,[23] which is also situated above the entryway, in no way recalls a basilica (fig. 8). Nevertheless, its elongated shape, the transversal arch which – although unnecessary on purely technical grounds – provides the back of the room with a certain character, the two lateral alcoves which open onto the principal hall, and the axial window (cf. Kharāna) cause it to resemble rather closely the examples cited earlier, such that one can view it, on these grounds, as a product of the decline of the basilica, much like the hall at Kharāna.

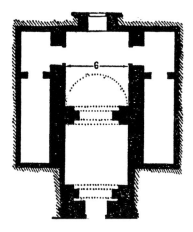

Figure 8

JABAL SAYS

The great hall of the palace, which stood over the entryway, has almost entirely disappeared, but it retains the particular motif located at its end, namely a semi-circular exedra. Likewise, the principal bath, although it contained only a single hall, ended in an apse as well.[24] By this detail, the two rooms can be identified with those we have considered earlier.

Thus, of the nine audience halls of the Umayyad era known to us, five were basilicas more or less seriously debased and often quite removed from the original model, but which still share characteristic elements, the role of which we will identify, with basilican halls: lateral rooms flanking the rear of the principal space, or a terminal exedra in the form of an apse. Thus, all of these halls were related, closely or more distantly, to the Umayyad mosques of Syria insofar as their interior arrangement was concerned.[25]

The Ceremonial of the Audience

One cannot repeat often enough that studies of the history of the Umayyad period have completely distorted the image one ought to have of the caliphal court. By focussing too much on the simplicity of behavior (real or affected, and, in any case, imposed by circumstance) on the part of some of these monarchs, they unfortunately have obscured the existence of a highly developed ceremo-

[23] Attributed by Creswell to the Ghassanids. On reasons to date it to the Umayyads, see my *Remarques*, 18, which contains a bibliography.

[24] See J. Sauvaget, "Les ruines omeyyades de Djebel Seis," *Syria* XX (1939), 244 and 246.

[25] Notwithstanding dissimilarities which are to be considered later.

nial which, from the earliest days of the dynasty, regulated relations between the Commander of the Faithful and his subjects. [130] Happily, direct reference to the sources allows for correction, which is essential if one is to explain the arrangement of the audience halls that we have presented.

From the time of Mu'āwiya, no person, be it father, brother or spouse, addressed the caliph or his designated heir without bestowing upon him his official title, and often by employing the third person:

> "Commander of the Faithful, upon whom rests the trust of the Muslims, al-Walīd, the son of the Commander of the Faithful..."[26]
> "Would that the Commander of the Faithful pardon me for what has transpired..."[27]
> "Commander of the Faithful, may God aid you! You are aware with what esteem he was held by the Commander of the Faithful, Mu'āwiya and the Commander of the Faithful, Yazīd..."[28]

One could not contradict the caliphs without committing a breach of etiquette.[29] Their closest relatives kissed them on the hand or foot or upon the stirrup if they were on horseback; often one even kissed the ground in front of them.[30] Referring to themselves, the caliphs occasionally used the royal 'We'.

> To you the Commander of the Faithful replies: 'a poet with whom we are not acquainted and from whom we have not heard a single poem cannot be allowed access to us. Since we have heard nothing from you, we are not informed sufficiently to allow you to be admitted into our presence.[31]

These references alone suffice to demonstrate that the ancient bedouin ideal of equality had given way, and that it was no longer the basis upon which the interior of the caliphal residence was organized. On this matter, we possess, moreover, other abundant and detailed evidence that is even more pertinent to our discussion.

Access to the caliph was not unfettered even for his intimate companions. When the Commander of the Faithful chose to remain alone or take a nap,[32] his

[26] *Aghānī*, XVI, 91 (Khālid b. Yazīd b. Mu'āwiya to 'Abd al-Malik).

[27] Ibid., VI, 161 (to Mu'āwiya).

[28] Ibid., II, 140 ('Atiqa to her husband 'Abd al-Malik). Also see ibid., VII, 189 (Yazīd to his father Mu'āwiya: "Commander of the Faithful..."); XV, 115 at bottom (Maslama b. Hishām to his father); XVI, 91 (Mu'āwiya b. Marwān to his brother 'Abd al-Malik); XVI, 90 (the wife of Marwān to her husband); VI, 103 (a son of Hishām's presents himself: "Sa'id, son of the Commander of the Faithful"). Cf. Ibid., XVI, 91 and the inscription at Qaṣr Burqu' in *Répertoire chronologique d'épigraphie arabe* (Cairo: Institut français d'archéologie orientale du Caire, 1931), no. 12.

[29] *Aghānī*, V, 144.

[30] Ibid., I, 101; VI, 147; VII, 66; VIII, 179; XII, 81.

[31] Ibid., VII, 52.

[32] Wilhelm Ahlwardt, *Anonyme arabische Chronik, band XI* (Greifswald: published by the author, 1883), 243.

door remained shut,[33] and none might enter to see him. When he elected to receive, the visitors had to be announced and request to be introduced[34] in such a way as to permit the monarch to know precisely with whom he was dealing,[35] and to await at the door[36] authorization to enter which could always be refused.[37] Depending on his mood, the [131] caliph limited the right to be received to his familiars or extended it to all who presented themselves.[38] Only he could decide on the nature of the session, that is, whether it was to be general or exclusive, and later we will consider the importance attached to this aspect of matters.

Announcing visitors, introducing them, forbidding – with "blows of the sword" if necessary[39] – entrance to those who had been refused audience: this was the role of the chamberlain (*ḥājib*), who first makes his appearance in the court in the reign of Mu'āwiya.[40]

In the reception hall, the caliph sat at the end and along the axis of the room (*fī ṣadr al-majlis*), facing the principal entrance.[41] There he sat upon a bed (*sarīr*),[42] next to which fragrances burned in perfuming pans.[43] He held a staff (*qaḍīb*),[44] which no doubt was originally identified with the cane with which the earliest Arabs were never without, no less than the modern bedouin,[45] but which rapidly acquired (at any rate, by the time of its use by the caliph himself) the value of a virtual scepter.[46] In front of him hung a curtain. This important point has been questioned, although the sources are perfectly clear on this score.[47]

> "When I entered his residence, the eunuchs told me: 'the Commander of the Faithful is behind the red curtain'. I then greeted him using his caliphal title."[48]

[33] *Aghānī*, VI, 131.

[34] *Ista'dhana: Aghānī, passim.*

[35] One's name, not *kunya*, was to be given: *Ghurar al-siyar* cited by Leone Caetani in *Scritti per il centenario della nascita di Michele Amari* (Palermo: Società siciliana per la storia patria, 1910): II:369.

[36] *Aghānī*, VIII, 90; XIII, 105; etc.

[37] Ibid., VII, 52.

[38] See, for example, Ahlwardt, 28. Cf. *Aghānī*, IV, 80: during a general (*'amm*) audience before al-Walīd II, his relatives, freedmen, poets and those with petitions in hand presented themselves. The general audience was held only if such were the wish of the caliph: *Aghānī*, IV, 79.

[39] *Aghānī*, IV, 79.

[40] *Aghānī*, VI, 159; XIV, 125, 127. Cf. ibid., VII, 52 (the chamberlain of Yazīd I). Provincial governors also had their chamberlains: ibid., XIII, 47; II, 124.

[41] *Fragmenta historicorum arabicorum* (from Anon., *Kitāb al-'uyūn wa'l-ḥadā'iq*) ed. M.J. de Goeje (Leiden: E.J. Brill, 1869): I:62; *Aghānī*, VI, 103 (lines 10 and 17).

[42] *Aghānī*, II, 65; IV, 80; XII, 43; XXI, 170.

[43] Ibid., I, 26; V, 166.

[44] Ibid., VI, 109; XV, 116; XIV, 77.

[45] Albert de Boucheman, *Matériel de la vie bédouine* (Paris: Librarie Leroux, 1934), 103 at bottom.

[46] Creswell, 10, with references.

[47] Creswell, 259.

[48] *Aghānī*, VI, 123.

"When I went in to him, he was in an alcove in front of which a curtain had been hung; he spoke to me from behind the curtain."[49] "Ma'bad was brought forward. He saw a hung curtain and the seat of a single man. The chamberlains told him: 'Ma'bad, greet the Commander of the Faithful...' and al-Walīd, from behind the curtain, returned his greeting.[50]

Although one might question the historic value of these anecdotes, one cannot impugn the testimony of a poet, a panegyrist of the Umayyads, according to whom the caliph is "an imam whom one greets behind a hung curtain."[51] Furthermore, it is from the term used to designate curtain (*ḥijāb*) that the title of chamberlain (*ḥājib*) is derived, while other comparable locutions[52] establish in the most formal way this aspect of the ceremonial. [132]

Behind the bed bearing the caliph stood a bodyguard holding an unsheathed sword (*sayyāf*),[53] or a eunuch,[54] who was perhaps the same as the former individual.

Visitors announced by the chamberlain were treated in various ways, depending on their rank and the nature of the audience. In ordinary circumstances, the caliph provided his familiars or those to whom he wished to show respect with a cushion or seat to be used to sit either next to or in front of him.[55] To be invited to sit upon the caliphal bed was an exceptional sign of consideration and favor, greatly desired and envied.[56] But, during solemn receptions such as those held on the occasion of the accession of a caliph, this intimate arrangement was set aside for a more elaborate and impressive ceremonial. Those on hand would arrange themselves in two "lines" (*simāṭ*) along the lateral walls of the hall, leaving the middle area entirely free for those seeking to address the monarch: ambassadors, deputations, orators and poets.[57] In all circumstances, those in

[49] Ibid., III, 99. The anecdote is suspect (it is used to provide further detail to an analogous short tale: ibid., II, 72), though on this point one has no reason to place it in doubt given that its testimony does not stand in isolation.

[50] Ibid., I, 27 (cf. I, 26). See also ibid., III, 99: "he was in an alcove (*bahw*) whose curtains were shut."

[51] *Dīwān Kuthayyir 'Azza*, ed. Henri Pérès (as *Dīwān [de] Kotayyir-'Azza*) (Algiers: J. Carbonel, 1928): II:61.

[52] For example, *ṣāḥib al-sitr* (*Aghānī*, II, 72); *laysa 'alayhi ḥijāb* (ibid., IV, 79); *laysa 'alā al-amīr ḥijāb wa-lā sitr* (ibid., XXI, 12), which is to say, 'one can approach him'. Cf. the Persian *parda-dār*.

[53] Becker, *Manāqib*, 22 and 23.

[54] *Aghānī*, IV, 78 and 106.

[55] Ibid., X, 83; XII, 26; XVI, 42; and *passim*. Contrary to the view of Henri Lammens, *Études sur le règne du calife Omaiyade Mo'āwia Ier* (Beirut: Imprimerie Catholique, 1906), 273, note 3, the terms *minbar*, *kursī* and *sarīr* cannot be viewed as synonymous and interchangeable. *Kursī* was a portable seat with no back, a stool. On *sarīr*, see Sauvaget, *Mosquée omeyyade*, 131 and, on *minbar*, see comments below.

[56] *Aghānī*, IV, 173; VII, 176.

[57] Ibid., VI, 146 (congratulations to Hishām on the occasion of his accession); VII, 72 (Jarīr before al-Walīd); XIX, 37 (al-Farazdaq before Mu'āwiya). Cf. al-Mubarrad, *al-Kāmil fī l-lugha wa'l-adab*

Jean Sauvaget

attendance could not deviate from dignified conduct consistent with the pomp of the ceremony and the respect due the master of the house.[58]

The point is clear enough: there is absolutely no reason to contrast, as is so often done, the wholly Arab simplicity of the Umayyads[59] to the "Iranian" ostentation of the 'Abbasids. On the contrary, one finds already established in the court of the Syrian caliphs all of the aspects of the ceremony that later would assume such force in the palaces of Baghdad and Samarra.

In seeking out the possible connection between the ceremonial that regulated these receptions and the arrangement of the space that served as their setting, it is not difficult to conclude that the caliph remained in the alcove or rear apse,[60] in front of which the curtain is suspended, and that the two rows of participants placed themselves in the aisles of the hall, leaving open the center nave. In such cases where the construction of the room did not adhere strictly to the basilican plan, also where [133] the individual who received was other than the monarch, one has absolutely no reason to believe that the ceremony was conducted very differently since, as is generally the rule, the practice of royal courts tends to hold sway over the ruling classes of society who adhere to it as faithfully as possible. Moreover, the essential elements of the ceremonial have remained, to our time, in practice in Oriental receptions; visitors take their place on benches arranged along the lateral walls of the room, leaving the central area free and locating the place of honor (situated facing the door) where the master of the house receives particularly distinguished guests.[61]

The sole remaining point to be considered concerns the existence of two small rooms set on either side of the rear exedra. It seems to me to have been related to the essentially *private* character that one must ascribe to these occasions, even those in which the caliph assumed the principal role. The term "audience hall" that we have used up to now is imprecise: not a single one of the rooms that we have discussed played a specific role, one reserved for receptions. The essential characteristic of Umayyad castles and palaces in which such rooms were located was, in effect, that the roofed area of the building was divided into a certain

(Cairo, 1286/1869), 324 (reception for a Byzantine ambassador) and al-Jāḥiẓ, *al-Bayān wa'l-tabyīn*, ed. Ḥasan Sandūbī (Cairo: al-Maṭba'a al-Tijārīya al-Kubrā, 1926): I:130: *yaqūmu bi-khuṭbati al-'īdi aw yawma al-simaṭayn aw fī suddati dāri al-khilāfa*, which is to say, on all the occasions appropriate to a set speech.

[58] *Aghānī*, VI, 163: during a reception for Ibrahīm b. Hishām, the retort of a poet stirred the laughter of those in attendance. "The chamberlain ordered them out; once in the vestibule, they laughed freely."

[59] To which one might add that there is much to reconsider about the simplicity of lifestyle and egalitarianism of the pre-Islamic Arabs.

[60] This interpretation is confirmed, moreover, by a detail of the decoration in the hall at Quṣayr 'Amrā: the rear wall of the alcove contains a painting representing the caliph seated majestically between two acolytes (see most recently Creswell, 259).

[61] Though I would not dwell on this point, it should be recalled that *ṣadr* was among the official titles of the Ottoman grand vizir and was assigned him precisely because he occupied the position of honor in the divan. See Jean Deny, *EI*, s.v. *ṣadr a'ẓam*.

number of identical *apartments*, each composed of a central room, of greater
length than width, onto which opened two or four smaller lateral rooms.[62] In such
cases where we can identify the connection between what we have called the
"audience hall" and the other elements of construction (at Kharāna, al-Qasṭal and
Mshatta), it is evident that this hall is nothing other than the central room, larger
and more ornate, of an apartment which otherwise closely resembles the others.
And given that these palaces were built to house families of the patriarchal kind,
in which sons and grandsons, sometimes even brothers and nephews, were grouped
around a given individual, one definitely can conclude that this particular suite,
with its greater comfort and luxury, was that which had been earmarked for the
head of the family. These rooms, built on the *basilican* plan, were hardly "audi-
ence halls" in the strictest sense of the term, but simply *the principal room of the
suite inhabited by the master of the house*, in which he habitually relaxed (hence
the term *majlis*) and received his visitors. Closer to our time, the *qā'a* of Syrian
homes and the *bahw* of Tunisian houses plays the same role.[63] Thus, [134] by
indicating the presence of a "great hall" in Umayyad palaces, one can explain the
apparent casualness that dictated the conduct of certain notable figures in their
majlis,[64] and the whim with which they decided on either the public or limited
form of the audience: they were *in their own home*, receiving if they so desired and
whom they chose, be it in their *majlis* or in some other place[65] in which they
happened to be when the visitors presented themselves. The comparison with the
custom in the great palace in Samarra, where a simple curtain hung before a door
that separated the wives of the caliph from the room in which he was receiving,[66]
clinches the argument that a hall of the kind we are discussing was no more, in
effect, than *the principal element of a suite of rooms of a private nature*. Thus, to
the corner spaces which flank the terminal alcove of Umayyad halls, one must
assign the same role as that played by closets which flank the Tunisian *bahw*,[67]

[62] On this characteristic distribution of spaces, see Creswell, 386 (where the the use of the term
bayt to designate these suites does not strike me as wholly correct).

[63] Georges Marçais, *Manuel d'art musulman: l'architecture. II* (Paris: A. Picard, 1927): II:872.
Although these are modern homes, the comparison is useful since the arrangement in question
reproduces an ancient prototype of the 'Abbasid era. The very term for the rear alcove of Tunisian
rooms (*bahw*) is attested in this sense and from the Umayyad period. See Ibn 'Abd
Rabbih, *'Iqd al-farīd (al-Juz' al-awwāl min al-'Iqd al-farīd)* (Cairo: al-Maṭba'a al-Azharīya, 1903):
III:198. In Baghdad, it designated the alcove in which the caliph sat behind a curtain. See al-
Bundarī, *Histoire des Seldjoucides de l'Iraq*, ed. M. Th. Houtsma (Leiden: E.J. Brill, 1889): 13 and
14. One completes, in this sense, the study of A. Dessus-Lamare, "Etude sur le *bahwu*, organe
d'architecture musulmane", *Journal Asiatique*, 228 (1936): 529–547.

[64] Walīd II, alone in his *majlis*, slept on his bed (*Aghānī*, V, 79); just as he was about to conduct
an audience, he commenced drinking with his friends, and the chamberlain was obliged to bar the
visitors (ibid., VI, 130).

[65] Examples of audiences held outside the *majlis* have been gathered, for example by Alois Musil,
Palmyrena, a topographical itinerary (New York: American Geographical Society of New York,
1928), 280ff.: although the texts are often misinterpreted, it suffices here to simply cite the work.

[66] Al-Ṭabarī, *Ta'rīkh al-rusul wa'l-mulūk*, ed. M.J. de Goeje et al. (Leiden: E.J. Brill, 1879–1901):
III:1459 (= ed. M.A.F. Ibrāhīm, Cairo: Dār al-Ma'ārif, 1960–1969, XI:65).

that is, to see them as *the sleeping rooms* in which the master of the house spends the night.

This observation sheds new light on the arrangement of Umayyad halls and establishes, with no uncertainty, the close correlation of this arrangement to the manner in which the premises were used. It remains now to determine whether the same was true for the mosque.

The Ritual of the Khutba

The point on which we must focus our entire attention, because it holds the key to our present problem, is as follows: in the Umayyad period, the gathering of the community in the principal mosque contained no liturgical elements, while the *ṣalāt al-jumʿa* had nothing in common with ritual prayer. The point has been made frequently enough,[68] and so it is unnecessary to insist upon it here. We will limit ourselves, therefore, to a simple reminder and to quoting some typical passages whose description of these gatherings is sufficient for our present concerns.

In contrast with ritual prayer, the *ṣalāt al-jumʿa* was never conducted on a regular basis in the Umayyad period. The community came together in the great mosque only when circumstances required, by order of its leadership, or when summoned by public criers.[69] Compelled by divine law to carry out daily ritual prayers, a Muslim could neglect these duties without fear of punishment in this life, at least in the period which concerns us here. By contrast no person could elect to absent himself from the *ṣalāt al-jumʿa* without exposing himself to legal sanctions.[70] Finally (and herein no doubt lies the most characteristic distinction), while the ritual prayer could be carried out anywhere, the *ṣalāt al-jumʿa* could *only* be conducted in the great mosque, while only certain fixed localities, relatively few in number, possessed a great mosque, in which all the surrounding populace would assemble.[71]

The community gathered in the great mosque not to observe the ritual prayer but to hear the "khutba." It is certainly true that this was preceded (or followed, it is unclear) by a general session of prayer, but this was in no way connected with the khutba; though it was incorporated into the ceremony, this was solely because

[67] Marçais, *loc. cit.*

[68] For example, Creswell, 34, with bibliographic references. Cf. the substantial treatment by Johannes Pedersen, *EI*, s.v. *masdjid*, 396–397, which I will cite just this once.

[69] For example, on the occasion of the arrival of a new governor, which obviously could take place on any day of the week and at any hour of the day.

[70] On this matter, see Lammens, "Avènement des Marwānides," *Mélange de l'Université St.-Joseph*, XII (1927): 67. Cf. *idem.*, *Moʿāwiya*, 342ff.

[71] I will take up this point again my *Châteaux omeyyades*. Cf. *idem.*, *Mosquée omeyyade*, 95ff.: the list of Umayyad mosques in Syria (one perhaps should add one located in Khunāṣira).

the communal prayer represented a kind of spiritual communion which bound the members together before God and before men.[72] The uncertainty of the legal specialists over whether this prayer should open or close the ceremony[73] is moreover a sure indication that it had no necessary connection to the khutba.

The khutba is today nothing more than a sermon, an exhortation to fear God and a reminder to uphold the duties which the Law and the Muslim ethic impose upon believers. The formula by which the person performing it invokes God's favor upon the community of believers and its leader seems in our time to be nothing more than a customary phrase shorn of its original meaning, a simple relic. But in the Umayyad period, the term *khutba* still retained its generic, original meaning of "speech," and it was used to designate an address *of a political nature* given by the head of the community or his official representative to their subjects, and which had nothing in common with the homily of the contemporary Muslim liturgy. Who is not able to bring to mind the sharply worded khutbas, those celebrated expressions of Arab eloquence, in which Ziyād or al-Ḥajjāj lavishly bestowed threats and promises of dire consequences on the populace of Iraq?

> God is my witness that I will accord wickedness its proper weight, fit it with its proper size, and repay it fully in kind! Here I see ripened heads whose time has come to be harvested; already I can see the blood flow onto turbans and beards...the Commander of the Faithful has emptied his quiver and used his teeth on his arrows (to test them), and has found no more bitter and hard a one than me, and so has launched me against you... . For, by God, I will strip you [136] as one does a branch, bind you as one does a thorn bush, thrash you as one does unfamiliar camels (chased from the herd)! And, by God, I make no promises I do not keep; when I start the task, I complete it... As God is my witness, I will have you, without faltering, follow the proper path, or see to it that each of you grows preoccupied with the state of your flesh... .[74]

Others delivered the khutba in verse,[75] which, in the period under consideration, would have been incompatible with a ceremony of a religious character. Most often, the khutba was the occasion of a pungent exchange between orator and audience:

[72] Cf. the recitation of the *Fātiḥa* on the occasion of the execution of a contract.

[73] See Becker, *Islamstudien* (Leipzig: Quelle & Meyer, 1924): I:472ff (and "article title???" *Der Islam*, III (1912): 374ff.).

[74] The inaugural khutba of al-Ḥajjāj in Kufa. I have relied on the text of al-Ṭabarī, II: 864ff.

[75] Al-Ḥajjāj: Ibn Qutayba, *'Uyūn al-akhbār* (Cairo: Dār al-Kutūb, 1925): II:10; Walīd II: *Aghānī*, VI, 128–129; a governor of al-Fusṭāṭ: al-Kindī, *Kitāb al-wulāt wa-kitāb al-qudāt*, ed. Rhuvon Guest (*The governors and judges of Egypt*) (Leiden: E.J. Brill and London: Luzac and Co., 1912): 89. 'Abd al-Malik desires to have lines of verse of Kuthayyir recited from the minbars of Kufa and Basra because of their political value: *Aghānī*, VIII, 30 and 31.

Upon learning that his domain, which he had just departed, was in ferment, a governor of Egypt returned quickly to al-Fustat, hastened to the mosque, ascended the minbar, and spoke: 'People of Egypt, you hold out, as the reason for your refusal to submit, the severity with which you are treated; however, appointed over you is a man who never makes a promise he does not keep. Should you refuse to submit, he will strike you with his hand; should you continue to refuse, he will strike you with his blade... . Each of you knows the terms of the oath which binds us: I have every right to require your submission, you have the right to demand justice from me. Thus, should one of us violate his word, his partner is freed from all obligation.' At this the Egyptians shouted at him, from all corners of the mosque, 'we will submit, we will submit,' and he replied to them, 'I will be just, I will be just,' after which he descended.[76]

The caliph 'Abd al-Malik, during a visit to the Hijaz in 75 A.H., "sat atop the minbar, and set about bitterly reprimanding the people of Medina. He then said to them: 'And, by God, people of Medina, I have tested you and found you to be greedy as regards trifles, and selfish as regards things of substance, and I can think of no better way to express it than with the verse of your *mukhannath* and brother, al-Aḥwaṣ:

How often have come great trials in which you have abandoned me,
 but never have I humbled myself to ask you Help!
And when they left off, without having caused me suffering, yet I
 did not leave you struggling against adversity.

At this, Nawfal b. Musāḥiq rose and said: 'O Commander of the Faithful, we acknowledge our misdeed and seek forgiveness for it, but retract your criticism: this would befit us all. After all, the one whom you have cited said, after his first two lines:

But I will be patient, and I will wait, even if you do no yield to
 misfortune
I hope that you recognize that people other than you ca discern
 accurately, and that you finally come to a firm decision.[77]

On occasion, speakers might have even been stoned on the minbar,[79] or participants have come to blows in the mosque.[80] There are many anecdotes one could

[76] Al-Kindī, 35.
[77] *Aghānī*, IV, 52.
[78] *Aghānī*, IV, 52.
[79] See, for example, al-Ṭabarī, II: 865.
[80] For example, the famous "Day of Jayrūn": Lammens, "Marwānides," 28ff.

cite which would remain incomprehensible if the ceremony, and the khutba along with it, were of a religious nature: individuals lamenting the obligation to [137] have to speak in the mosque;[81] or drinking and eating on the minbar;[82] or resorting, while delivering the khutba, to jokes of dubious taste:

> Just when al-Walīd II was preparing to deliver the khutba, an individual named al-Bundār approached him to say: 'O Commander, today is one in which people will gather to participate from all over; could you honor me in some fashion?' 'What would you have me do?' 'Could you address me, once you have ascended the minbar, in such a way as to make people say that you shared a secret with me.' 'So be it.' Once he assumed his place on the minbar, al-Walīd called out: 'al-Bundār!' I stepped forward and he motioned me to approach; as soon as I came to him, he whispered to me: 'al-Bundār is a son of a whore, al-Walīd is a son of a whore, and all those gathered around us are sons of whores. Do I make myself clear?' 'Yes.' 'Then, descend.' I got down.[83]

The profane nature of the khutba also explains why the caliphs, on those occasions when they were to address the assembled community, paid particular attention to their appearance and language.[84]

Viewed from this perspective, the Umayyad mosque carefully preserved the essential features of Muhammad's *masjid*. Leone Caetani has shown, in irrefutable fashion, that by no means was it a place devoted to worship but rather functioned as the courtyard, open to all, of the Prophet's residence, a courtyard which served not only as the site for *ṣalāt* but also receptions for ambassadors, banquets, and festivals.[85] It constituted a kind of public annex for the home of

[81] 'Abd al-Malik to an individual who expressed surprise at his prematurely grey hair: "how could it be otherwise, given that I have to squander my intelligence in addressing the people once or twice in every open assembly of the community?": *Kitāb al-'uyūn*, II: 258. 'Ubayd Allāh b. Ziyād: "how nice to occupy the position of *amīr*, were it not for the sound of the mail horses (bringing messages of remonstrance from the caliph) and the obligation to give speeches from up there!: ibid..

[82] *Kitāb al-'uyūn*, II: 38; al-Mubarrad, 19–20. More typical still is the following anecdote whose source, unfortunately, I neglected to note down: standing on the Prophet's own minbar, an Umayyad governor of Medina ate dates and flung the pits at those in attendance. Finally, a protest was made: 'Hey, you, the spot you are standing on is no place on which to eat dates!' 'I am perfectly aware that this is no place on which to eat dates but I want to let you know what I think of you.'

[83] *Aghānī*, VI, 129.

[84] Sulaymā chose his most fetching turban: al-Mas'ūdī, *Murūj al-dhahab*, ed. and trans. (French) C. Barbier de Meynard and Pavet de Courteille (*Les prairies d'or*) (Paris: Imprimerie Impériale and Imprimerie Nationale, 1861–1877): V: 402–403. Mu'āwiya refused to deliver the khutba after he had lost his front teeth: al-Jāḥiẓ, *Bayān*, I:66; 'Abd al-Malik had his loose teeth secured with a gold wire, saying 'were it not for the khutba and women, I would care little if they fell out': ibid..

[85] On this aspect of the *masjid* of Medina, see Lammens, "Les Sanctuaires pre-islamiques dans l'Arabie occidentale", *Melariges de la Faculté Orientale de l'Université St-Joseph de Beyrouth*, 63ff. (with references) and 76–77. Cf. *idem.*, "Ziyād ibn Abīhi", *Revista degli studi orientali*, IV (1912), 119.

the head of the community.[86] The Umayyad mosque, similarly, remained –
although of a different architectural form – a *kind of public annex of the palace*
in which the caliph would bring together, and thus have contact with, all the
members of the community, regardless of social rank, and including those with
whom he would not consent to meet in private audience in his own residence.
All of the unexpected ways in which, according to the sources, the mosque was
used in the Umayyad period find justification in the very close relationship
[138] which existed between this building and the palace. The mosque was,
above all, the site for official communication with the populace;[87] it served as a
tribunal,[88] an arms depot,[89] and the place where the public treasury was main-
tained;[90] and it was there where severed heads and other grim relics were
displayed.[91] It is significant that all the manifestations of government activity
found a place in the mosque and not in the caliphal residence as might normally
be the case. More striking still is that certain administrative functions were not
carried out solely within the palace or mosque, but *simultaneously in both
venues* which, it should be recalled, were usually contiguous to, and communi-
cated directly with one another through the imam's door. Thus, when the
treasury was housed *in the mosque*, and when night arrived and the building
was emptied in order to protect the public wealth from theft,[92] one placed the
keys *in the palace* which also housed the treasurers.[93] Inversely, if the post-
master lived *in the palace* in Damascus,[94] it should be noted [that there was] *in
the adjoining mosque* a "gate of the courier" (*bāb al-barīd*), a designation which
certainly was related to the function of this institution.[95] Similarly, the head of
the caliphal guard, living in the palace,[96] appeared frequently in the mosque
leading his men.[97]

[86] Which would explain why the terms *majlis* and *masjid* were at least originally seen as
synonymous. See Lammens, "Sanctuaires," source [???] 66, 77.

[87] Pedersen, "Masd̲j̲id, 398".]

[88] *Fragmenta*, I:92.

[89] Al-Ṭabarī, II:1791 = *Aghānī*, VI:138.

[90] See Sauvaget, *Mosquée omeyyade*, 95, 100, 104. Cf. Ibn Asākir, *Ta'rīkh madīnat Dimashq*,
eds. 'Abd al-Qādir Badrān and Aḥmad 'Ubayd (Damascus: al-Maktaba al-'Arabīya, 1911–1932):
I:206.

[91] Severed head: al-Kindī, 114; the severed fingers of Nā'ila, 'Uthmān's bloody shirt, and Mu'āwiya
II's shroud: al-Ya'qūbī, *Ta'rīkh*, ed. M. Th. Houtsma (*Ibn Wādhih qui dicitur al-Ja'qūbī Historiae*)
(Leiden: E.J. Brill, 1883): II:284; the severed hand of al-Mukhtār b. Abī 'Ubayd: *EI*, s.v. *Mukhtār*,
766.

[92] Ibn Rusta, *Kitāb al-a'lāq al-nafīsa*, ed. M.J. de Goeje (*BGA*, 7) (Leiden: E.J. Brill, 1892): 116.

[93] *Aghānī*, 128 and 138. Cf. al-Ṭabarī, II:1790.

[94] *Aghānī*, VI:138 and al-Ṭabarī, II:1790.

[95] Which explains the fact that living near the gate was Qabīṣa b. Du'ayb, 'Abd al-Malik's
secretary, whose task it was to receive the dispatches and read them to the caliph. See Ibn Kathīr,
al-Bidāya wa'l-nihāya (Cairo: Maṭba'at al-Sa'āda, 1932–1939): IX:73.

[96] *Aghānī*, VI:138 and al-Ṭabarī, II:1790.

[97] Lammens, "Ziyād," 123–124. Cf. al-Kindī, 62 and my own comments below.

Arranged more clearly than ever before, such evidence induces us to see the mosque in a new light, that is, by considering it less as a autonomous site designed for purposes of worship than as *a mere annex of the caliphal palace* or governor's residence that was set aside, according to the tradition initiated by the Prophet himself, for all the purposes that were deemed unsuitable for these spaces of a *private* nature. It is therefore clearly not in relation to the devotional liturgy that one should explain the architectural arrangement of the mosque but rather the institutions of government, or, better yet, *the ceremony of the royal council.*

Once the problem is posed in this manner, it is not difficult, despite the paucity of documentation, to find the elements of the solution in the ritual of the khutba.

THE MINBAR

The origin and history of the minbar have given rise to a whole series of studies, the list of which is contained in Creswell's work; he has brought [139] their conclusions to bear upon Muḥammad's minbar,[98] and, in addition, has elaborated upon them with regard to the minbar in the mosque of al-Fustat,[99] with a new interpretation that strikes me as not altogether sound.

Like C.H. Becker,[100] Creswell considers Muḥammad's minbar to have been a throne, one derived from that of the *khaṭīb* of pre-Islamic Arabia. The minbar in the mosque of 'Amr, by contrast, was nothing other than the adaptation of the pulpit of Christian churches, a notion which "is confirmed in striking manner by the six-step pulpit discovered by Quibell in the excavation at Saqqara, a pulpit which, as he points out, might well have been the prototype of the Muslim minbar."[101] His reasoning relies, first, upon the formal resemblance seen between the structure at Saqqara and Muslim minbars, and, second, upon certain texts relative to the minbar in the mosque at Fustat.

The perceived resemblance strikes me as having little real import, however closely the Coptic structure and the customary form of the minbar might resemble one another. We do not, after all, know what minbars looked like in the first century of the Hijra, and it is by no means certain that they adhered to the multi-step type generally in use in the medieval period. The type itself assumed variant forms of no little interest inasmuch as they represent successive stages in the development of the style: the absence or presence of a door with leaves; of railings (either solid or with grating); and of a kiosk above the seat of the

[98] *Op. cit.*, 9–10 and notes (note four contains the bibliographic references).
[99] Ibid., 29 and, especially 31–32.
[100] *Die Kanzel im Kultus des alten Islams* in *Orientalische Studien Th. Nöldeke...gewidmet* (Giessen, 1906) and in his *Islamstudien*, I:450–471.
[101] Creswell, *op cit.*, 32.

khatib.[102] Deprived of archeological evidence, we cannot decide *a priori* which of its features date to the origins of the minbar, and this holds true as well with regard to the height of the structure, whose proportions varied considerably from one period and region to the next.[103] Various evidence allows one to imagine that particular minbars of the first two centuries of the Hijra were very modest in height, a feature shared by the minbar of Muhammad. One reads of a governor of Egypt that he delivered the khutba from a "small" minbar,[104] while other minbars built in mosques were portable.[105] Finally, although certain [140] specialists in the Law spoke out against the considerable height of minbars built in their day,[106] this cannot have been true, their statements notwithstanding, simply because the result was a needless obstruction of the prayer area. It is noteworthy that in certain regions of the Islamic world rather unaware of innovations introduced elsewhere (e.g. India) or rigorously traditionalist (e.g. Persia),[107] the minbar appears most often as a structure of modest height, thus by far the closest to that used by the Prophet. Given such indications, I have nothing positive to conclude as regards the Umayyad minbar, but can only offer the following negative conclusion: that there is nothing to the suggested comparison with the structure at Saqqara, since it has nothing to do with the *early* phase of the minbar (about which we know little) but rather a relatively late form of the minbar, whose pristine features may well have evolved over time.

Furthermore, traditions regarding the minbar in the mosque of Fustat are inadmissible. One notes, first of all, that they occur only in late compilations (14th–15th century) whose reliability remains to be checked. One also notes their uneven nature and their contradictions. Ibn Duqmāq and al-Maqrīzī provide exactly the same text.

> (Qurra b. Sharīk) put the new minbar in place in the year 94 (A.H.)
> and removed the minbar that had been in the mosque. It was

[102] The only Umayyad minbar about which we have any sort of detailed knowledge is precisely that of the Medina mosque; see Sauvaget, *Mosquée omeyyade*, 85ff. But one should not make too much of it, given its very exceptional character. The structure is devoid of homogeneity; its most notable feature is nothing short of a monumental pedestal, of precious material, whose intent is to underscore (and, in some measure, to protect) the Prophetic relic that sits atop the structure. On the minbar in general, see E. Diez in *EI* s.v.

[103] The oldest extant minbar, that of Qayrawan, has seventeen steps. That of Bosra, with its plain, inferior masonry, has only two.

[104] Al-Kindī, 119 (dating to the rise of the 'Abbasid period).

[105] Lammens, *Mo'āwiya*, 205 and Becker, *Manāqib*, 34. The second of these texts may allude to the practice of storing the minbar in a designated room, an annex of the mosque, which was an apparently ancient practice widely used (cf. *Madkhal*, II:212) in the Maghrib by a previous civilization. Even here, the transportable nature of the structure seems incompatible with large dimensions; cf. the minbar of Fez according to Henri Terrasse, *La Mosquée des Andalous à Fès* (Paris: Les Editions d'art et d'histoire, 1939), plate 50.

[106] *Madkhal*, II:212.

[107] On this traditionalist aspect of Shi'ism, see Henri Massé, *L'Islam* (Paris: A. Colin, 1930): 149.

reported that 'Amr b. al-'Aṣ had put it in place, perhaps after the death of 'Umar. It was also said that it was the minbar of 'Abd al-'Azīz b. Marwān, and it was reported that he had had it brought from one of the churches in Egypt. It was reported, as well, that Zakariyā b. Margana, the Nubian king, had offered it as a gift to 'Abd Allāh b. Sa'd b. Abū Sarḥ, sending with it a carpenter who assembled it. The carpenter's name was Buqtur and he was from Dandarah.[108]

Thus, with regard to the one minbar in Fustat, the two authors provide *three contradictory traditions*,[109] *none* of which is supported by anything more secure or precise than that "one reports (that)."

Ibn Taghrībirdī provides the same text as well, with several inconsequential differences, but names his source.

Al-Kindī reports, in his *Book of Princes*,...that he installed the new minbar in the year 94 (A.H.), and that he removed the minbar that had been in the mosque. It is reported...etc.[110] To weigh the reliability of information in these later compilations [141], it suffices to refer to al-Kindī's work: the passage occurs there, it is true, but is followed by a phrase left out by the three later authors who replaced it with the traditions that we have cited. He set up the new minbar in the mosque in the year 94 (A.H.). *One is led to believe that in no other province is there a more ancient minbar after that of the Prophet.*[111]

The indication is clear: in the author's period, Medina and Fustat were *the only cities in which ancient minbars from the first period of Islam were preserved*, all the others having been replaced by more recent structures. Indeed, al-Kindī, who died in 961, could still attest to the presence of Qurra's minbar which remained in situ in the mosque until 989.[112] Al-Kindī's reliability survives this test intact.

One cannot say as much about our three compilers, since a comparison of the three texts indicates that they, no doubt in line with an author, unknown to me, whom each of the authors has copied,[113] have substituted for the neutral, truthful report of the earliest chronicler *imaginary and tendentious traditions which rest entirely on an error of interpretation*. Al-Kindī's text was read too quickly

[108] Ibn Duqmāq, *Kitāb al-intiṣār* (Cairo: 1309/1891–1892): IV:63 and al-Maqrīzī, *Kitāb al-mawā'iz wa'l-i'tibār fī dhikr al-khiṭaṭ wa'l-āthār* (Bulaq, 1270/1853–1854): II:248.

[109] Creswell laid the first of these aside although to date there is no reason to believe that it is any less reliable than the two others.

[110] *Abu'l-Mahasin ibn Tagri Bardii Annales* (= *al-Nujūm al-Zāhira*), eds. T.W.J. Juynboll and B.F. Matthews (Leiden: E.J. Brill, 1852–1861): I:78.

[111] Al-Kindī, 65.

[112] Creswell, *La Mosquée de 'Amru* (Cairo, 1932): 127, note 2 with references.

[113] The precise resemblance of the three texts cannot be explained except in terms of the use of a common source which, I confess, I have made no effort to identify. The problem is of little present concern.

and erroneously:[114] it was seen to contain the evidence that Fustat was the first provincial city *to have been endowed with a minbar*. But since this interpretation, no doubt flattering to Egyptian pride, found no reliable authority to rely on, its pedigree was forged from scraps with the support of "it was reported" and of precise details which were easy enough to fabricate.

Having clarified matters in this fashion, and by setting aside the parochial view, we can again address the crux of the problem in a more global manner.

The consensus appears to be that the term *minbar* was borrowed by ancient Arabic from the Ethiopian,[115] apparently through southern Arabia which came under the control of the kings of Aksum in the fourth century and then in the sixth century. It is indeed remarkable that this borrowing occurred prior to Islam and that the first Arab to whom tradition attributes the use of the minbar was a Yemeni.[116] [142]

Given this origin, it is evident that the term did not enter Arabic bearing the meaning of "pulpit," which it does not possess in Ethiopian,[117] but rather the original, etymological sense of "seat," which might be further limited to refer to the seat *par excellence*: *the throne of the king*, bishop, or judge.[118] In addition, a number of ancient Ethiopian stone minbars have been preserved in Aksum;[119] with their two– or three–step base and their cubic seat with high back and rectangular armrests, they clearly represent the type of furnishing that served as the model for Muhammad's minbar.[120] The latter was therefore indeed a *throne*, in the proper sense of the term,[121] and just as, in the same period, other individuals with no official standing could ascend the minbar,[122] it is clear that from the advent of Islam the use of the structure had undergone no significant development.

[114] The error was made easier by the use of *ba'd* in place of *illā* or *ghayr* which, while not altering the meaning in any serious fashion, would have provided greater clarity.

[115] Friedrich Schwally, "Lexicalische Studien," *ZDMG*, 52 (1898), 146ff; Theodor Nöldeke, *Neue Beiträge zur semitischen Sprachwissenschaft* (Strassburg: Karl J. Trübner, 1910): 49; Josef Horovitz, "Bemerkungen zur Geschichte und Terminologie des islamischen Kultus," *Der Islam* XVI (1927): 249–263.

[116] *Aghānī*, III: 3; Becker, *Kanzel*, 458; and Schwally, 147. He also appears to have been the first to employ a *sarīr* although it is possible that this tradition relies on the near-synonymy of *sarīr* and *minbar* (see below). It should however also be noted that *sarīr* had its own counterpart in Ethiopia in the *angaren*: see *Deutsche Aksum Expedition* (Berlin: G. Reimer, 1913): III:23 and figure 75.

[117] Schwally, 147.

[118] Schwally, 146 and Nöldeke, 49.

[119] *Deutsche Aksum Expedition*, III. Cf. Albert Kammerer, *Essai sur l'histoire antique d'Abyssinie* (Paris: P. Geuthner, 1926): 133.

[120] The only significant difference is that the minbar in Medina, which was intended to stand in a covered space, does not have the canopy supported by four small columns which shades the thrones in Aksum (which were used outside).

[121] Clearly I am not dealing here with the numerous traditions regarding the uses that Muhammad made of his minbar. These have little to do with other concerns except to identify the Prophetic sunna as the origin of later developments.

[122] Ḥassān b. Thābit recited verse from atop a minbar in the *masjid* of Medina. See Lammens, "Sanctuaires," 63.

As paradoxical as this opinion might appear, it seems to me that, on this point, the Umayyad period simply and purely prolonged previous practice. Cited earlier in this regard, and with good reason, were the verses that mention the *minbar al-mulk*, translated as "the throne of the empire," and those which associate the minbar with the person of the Commander of the Faithful.[123] But one must also adduce texts that indicate that the use of the minbar was not reserved *either for one caliph alone or only for the mosque*, along with certain details concerning the ritual of the khutba.

> Hishām, performing the Hajj during the reign of his brother al-Walīd, strained to touch the Black Stone with his hand but failed to do so because of the crowd. A minbar was erected for him, on which he sat to watch the people.[124]
>
> "When I was young, my mother sent me to ask for something from 'Aṭā b. Abū Rabāḥ. I found him in his residence...seated upon a minbar. He had just had his son circumcised and a feast was being served before him."[125]
>
> The poet al-Farazdaq came to Medina to see Sa'īd b. al-'Aṣ, the governor of the city under Mu'āwiya. 'When he entered, Sa'īd was receiving; Sa'īd was seated upon a minbar and the others upon stools.'[126] [143]

On the basis of our previous comments, those concerning the original function of the minbar as well as the ceremonial of Umayyad receptions, we can only consider the minbar, to which the three texts refer, as none other than an honorary seat reserved for individual of greatest prominence at a ceremony. It is, in sum, a precise replica of the *sarīr* with the only difference being the form of the structure.

If we now recall that certain indications suggest that we consider Umayyad minbars (or at least some of them) as having been of moderate height,[127] and that the khutba in the period under consideration assumed a distinctly profane character, many details of the ceremony oblige us to view the minbar as nothing less than *the throne of the political head of the community*. First of all, it was common practice for the Umayyads to perform the khutba while *seated*,[128]

[123] In particular, Horovitz, 257–259 and Reinhard Mielck in *Der Islam* XIII (1913): 110. Cf. Lammens, *Mo'āwiya*, 203ff. and Becker, *Kanzel*, 461.

[124] *Aghānī*, XIV:78. Cited as well by Horovitz, 258, note 1, who does not seem to have noticed that the event took place prior to Hishām's accession to office, which is, however, the most significant point.

[125] *Aghānī*, I:109.

[126] Ibid., XXI:196.

[127] See above. Cf. *Aghānī*, XIII:165 (cited by Schwally, 147), where Yazīd I is carried on a minbar atop the shoulders of attendants. For obvious reasons of weight and balance, one is certainly dealing here with a low minbar.

[128] Ignaz Goldziher, *Muhammedanische Studien* (Halle: Max Niemeyer, 1889–1890): II:41–42;

holding either a staff or weapon,[129] traditional prerogatives of a leader in most civilisations. The custom that, since the medieval period, required the khatib to rap with his staff or sword upon the steps of the minbar as he ascended the pulpit was probably the last vestige of a gesture with which a chief, taking his place upon a throne, won the attention of those in attendance while providing greater solemnity to his conduct. How else to explain the phrase "to rap on the minbar" (*qara'a al-minbar*) which occurs here and there in the work of Umayyad poets in reference to the caliphal khutba?[130] Without pressing the parallel too far, and without meaning any disrespect, one cannot help but recall the "officer" of our churches who strikes with his staff upon the flagstones as he precedes the clergymen.[131] Equally, one also must account for the fact that one never performed the khutba without donning one's turban,[132] which thus remained the ceremonial headdress of choice, substituted by the cap (*qalansuwa*) in daily usage.[133] Al-Jāḥiẓ's well known quip, "one can perform the khutba entirely nude as long as one wears the turban and sword,"[134] [144] surely derives from the solemn demeanor of the caliph seated "in majesty" upon the minbar, in ceremonial garb, and with the emblem of his power in hand.

It is certainly true that little more could be made of all this were it not for two further details that greatly require our attention: the presence of the caliphal guard around the minbar, to which we will return later,[135] and *the practice of burning incense during the khutba*. It has been related to Christian practice[136] because the manner in which incensing is carried out today suggests no better explanation. But it is quite remarkable that in Medina, even up to the thirteenth century, scent was burned during the communal prayer "next to and behind the minbar, during the performance of the khutba by the imam."[137] This

Fragmenta, I:7; and al-Ṭabarī, II:1234. In addition, note that numerous references to caliphal khutbas do not refer to the caliph, as they do for other individuals, as having "risen" to perform the address, but simply indicate *fa-jalasa 'alā al-minbar wa qāla*.

[129] Cf. Becker, *Kanzel*, 456ff where the author, although sensitive to the importance of these facts, complicates matters by seeking, in rather imprecise manner, an explanation by means of the comparative history of religion and folklore.

[130] Becker, *Kanzel*, 461 and especially Kuthayyir, II:62: "when they rap on the minbar, then gesture with their fingers as if writing."

[131] Becker, *Kanzel*, 459ff., it seems to me, has needlessly complicated matters by introducing concerns that are wholly alien to the subject and for having gone to such lengths to relate *qara'a al-minbar* to an ancient Arab proverbial phrase about which the lexicographers provide a patently absurd explanation.

[132] For example, al-Yaqūbī, II:284, and above, note 83. There is little need to cite further references on this point; their frequency in the sources is evidence enough.

[133] Cf. *Aghānī*, XVII:103: "the prince's turban...with which he presides over feastdays and gatherings of the community, and which he dons in meetings with the caliphs."

[134] Cited by Schwally, 148, note 3 and Becker, 456.

[135] See my comments below.

[136] Pedersen, 393–394. The Muslim authors naturally trace the origins of the practice to the time of the caliph 'Umar.

[137] Ibn Najjār, *Kitāb al-durra al-tamīma fī akhbār al-Madīna* (Ms. Paris, ar. 1630): 26 *verso*.

simultaneity, and more so the location in which the rite was carried out, requires one to associate it with *the person of the speaker*, precisely in the manner that it was associated, in sessions of court, with the person of the caliph seated atop the throne. The exceptional nature of Medinan practice, far from challenging such an interpretation, seems to demonstrate that such had been, of old, the true function of incensing. In this case, where the minbar – in rather unusual manner – was accessible on all sides, the rite could be carried out in its ancient form, whereas the practice elsewhere of situating the minbar against the wall of the mosque required that its use be modified with the result that it lost its original import.

This last detail of the ceremony underscores further the resemblance between the minbar and the throne. To even a greater extent than the evidence previously examined, it serves to explain why even as late as the ninth and tenth centuries the first Arab translators of the Greek version of the Psalms could not find a better way to render the *thronos* of the text than by *minbar*.[138]

Thus, and without pretending for the moment to have drawn unwarranted conclusions from these observations (whose value and scope will be amplified by our subsequent analysis), we can identify an indisputable similarity between the ceremony of the audience and that of the khutba on the basis of three common features: the elevated seat designated for the principal individual in attendance (*sarīr* or *minbar*); the symbol of authority (here: the rod, there: the weapon or staff); and the use of incense. Dissimilar features will be accounted for in due course when we will have treated the other fundamental elements of the mosque.

THE MIHRAB

"It is generally agreed that the mihrab...was borrowed from the church...and one can say that this innovation was introduced to the mosque for architectural reasons."[139] Despite its wide acceptance, this view, to which Creswell adds his particular twist by tying it to Coptic Egypt,[140] is not altogether satisfactory. It pays insufficient attention to the original meaning of the term *miḥrāb*, one which remains of considerable interest. In addition, it is not enough to identify a

[138] Anton Baumstark, "Minbar = Thron, und älteste arabische Psaltertext," *OLZ*, (1943):337–341. Later translators replaced *minbar* with *kursī*.

[139] Pedersen, 387. Cf. E. Diez, *EI* s.v. "Miḥrāb," wherein the alternative notion occurs, one that common sense prevents us from taking seriously any longer: that one trace the origins of the mihrab to the Buddhist niche.

[140] *Op. cit.*, 98–99. He links the mihrab to the *haykal* of Coptic churches on the grounds that the prayer hall in Medina, in which the first mihrab was built in the form of a niche, was constructed by Egyptian workers. I have indicated above (114) why I find this argument unconvincing. Ahmad Fikry, *Nouvelles recherches sur la Grande Mosquée de Kairouan* (Paris: H. Laurens, 1934): 62 views the mihrab as having been an Islamic innovation, a view poorly supported by our new approach to the question as well as the derivation which we have established above.

formal connection between two architectural elements for the continuity between them to be demonstrated *ipso facto*: one must also show that there exist *functional* relationships between these elements that would explain the borrowing. These lapses in the inquiry necessitate a closer look at the facts.

Although the etymology of the term *miḥrāb* remains in doubt, its earliest meaning is certain.[141] In the discourse of the earliest poets, it most often designates the area of the palace in which the prince situated himself; it also sometimes referred to a niche containing a statue or an elevated spot in which musk or aromatics were placed. All of these meanings are retained in the language of the Umayyad period.[142] In the Qur'an, the term designates, in some cases, an element of the building whose identification the context leaves unclear (34:12);[143] in other cases, the tribunal of the sovereign to which supplicants "ascend" (38:20)[144]; and, finally, what we designate as the "sanctuary" of a temple (3:32–33, 19:12).[145] It should be noted that in this last case, the term corresponds to the Ethiopian *mekuerāb* which is used to translate the *naos* of the Evangelical text,[146] which, in turn, may indicate the etymology of the Arabic word.[147] Whatever the case, we are well enough acquainted with the architectural forms of the (Near) East in Late Antiquity to be able to suggest a translation for the term *miḥrāb* which, by drawing together each sense of the word, effectively reduces them to shaded nuances of the same meaning. *Miḥrāb* indicates *a semi-circular recess* or *rounded niche*, whether it is sufficiently spacious to constitute an apse with a raised floor,[148] or only just large enough to contain a statue. Thus, the Islamic sense of the term vindicates itself immediately, [146] since the mihrab of the mosque constitutes precisely a semi-circular niche: Islam did nothing more than add an additional nuance to a word whose meaning had been long established.

The apse had become a necessary element of the church because it met a liturgical need: sheltering the altar and the officiating clergyman, it served as the site of the sacred sacrifice.[149] The major characteristic of the mihrab of the

[141] See especially Horovitz, 260–263, with a series of examples; E.W. Lane, *Arabic-English Lexicon* s.v. (a systematic scrutiny of Arab lexicographic works). Cf. Nöldeke, 52, note 3.

[142] In my view, the meaning "an area of a residence reserved for women" (see Horovitz, 362) should be set aside. *Rabbat al-miḥrāb*, it seems to me, rather contains an implicit comparison and indicates nothing more than "beautiful as a statue."

[143] *Sūrat Saba'* (= verse 13).

[144] *Sūrat Ṣād* (= verse 21).

[145] *Sūrat Āl Imrān* (= verse 39) and *Sūrat Maryam* (= verse 11).

[146] See Horovitz, 261.

[147] That is, if one holds that the loan word was "reshaped" and affixed through popular etymology to the verbal root *ḥ-r-b*.

[148] I use "apse" here in the general and not the Christian sense.

[149] On the introduction of the apse to the church, see finally the conclusions – which are very well-founded and suggestive although perhaps insufficiently nuanced – of Ejnar Dyggve, "Probleme des altchristlichen Kultbaus," *Zeitschrift für Kirschengeschichte, Third Series*, 59 (1940): 103–113. Cf. Sauvaget, *Mosquée omeyyade*, 173.

mosque – insofar as its actual use is concerned – is its *inutility*. It is taken, of course, to orient the faithful during ritual, but in actual practice it serves no purpose. In a mosque of any real size, the dimensions of the niche are dwarfed by those of the prayer hall such that only those persons situated more or less along its axis. (see figure 9) can actually view it. Given the laws of perspective and screening brought into play by the lines of supports, con-cealing it from the worshipers, how can they use it to position

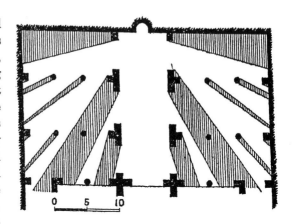

Figure 9

themselves correctly? In practice, it is not the mihrab that marks the direction of prayer, rather *the entire wall at the end of the hall*; when this is incorrectly oriented, the faithful cannot position themselves as they should if the imam, standing himself before the mihrab, and having adjusted his position deliber-ately, does not serve as their model. To remedy this inconvenience, care is generally taken to provide multiple mihrabs by constructing auxiliary niches at different points along the wall; Umayyad mosques, however, employ no such device, which constitutes, after all, little more than a last resort. In mosques containing a single mihrab, the greater the size of the hall, the supports become more numerous, densely placed and voluminous, and, there-fore, the greater becomes the inutility of the axial niche and the less likely that the function of the mihrab is imposed by liturgical necessity. Given the universal reliance upon such a function, one cannot simply assign the niche a merely decorative role, which it cannot [147] satisfy in any case given its small scale except in an imperfect fashion. Thus there arises a problem, an urgent problem.

It can be resolved easily enough provided that, here as well, one is willing to carefully put aside recent patterns of usage and the manner in which these were justified by the jurists, who all lived long after the Umayyad period. Although they were seldom at a loss for answers, these, although more or less ingenious, seldom explained facts no longer understood. Here as well, it is *only* through a close reading of contemporary evidence that we seek to shed light upon early practice. The end result is that although we rest our interpretation upon an extremely narrow foundation, the extreme inadequacy of the sources being what it is, our conclusions emerge all the stronger to the extent that they find support from archeological findings.

Regarding the function of Umayyad mihrabs, I have only the support of two texts.[150] They are, at any rate, precise and above suspicion such that I find them conclusive.

1. An individual reported that, in 132/749–750, he presented himself at the home of Ibn Hubayra, the Umayyad governor of Iraq.

> The chamberlain informed me that he was in *his private chapel*[151] and would not come out. I insisted: 'tell him that I seek him out on an important matter.' He consented to receive me and when I entered I found him seated *upon his mihrab*.[152]

Some time later, when the persons sent to him by the 'Abbasids to execute him presented themselves before him, they found Ibn Hubayra in the same position.

> He had assumed his place *in his private chapel* in the palace, *his back resting against the mihrab*, and his face turned to the hall.[153]

2. Two versions exist of the second anecdote of which we will make use.
(a) Qurra b. Sharīk, upon his appointment as governor of Egypt, arrived in Fustat incognito with two travelling companions and made his way immediately to the mosque.

> "He carried out the ritual prayer near the back wall (*qibla*) with his travelling companions on either side of him. The guardians of the mosque approached them...and said: 'this is *where the governor sits (majlis)*, there is plenty of room for you elsewhere in the mosque.'"[154] [148]

(b) The same incident is preserved by another author as follows:

> "He prostrated himself *in the mihrab* then sat with crossed legs and remained there seated. One of his two companions stood at his side while the other remained standing behind him.'" The person who brought the matter to the attention of Qurra's predecessor repeated: "'then *he entered the mihrab* and prostrated himself.'"[155]

[150] A systematic investigation of the *adab* works, which time has not permitted me to carry out, may serve to supplement with a few examples this pitifully small body of evidence which should come as a surprise only to those unfamiliar with the present state of information on the Umayyad era.

[151] *Trans. note: dans son oratoire.*

[152] Al-Dīnawarī, *Kitāb al-akhbār al-ṭiwāl*, ed. Vladimir Guirgass (Leiden: E.J. Brill, 1888): 355.

[153] Ibid.

[154] Al-Kindī, 62.

[155] Ibn 'Abd al-Ḥakam, *Futūḥ Miṣr wa akhbāruhu*, ed. C.C. Torrey (*The History of the Conquest of Egypt, North Africa and Spain*)(New Haven: Yale University Press, 1922): 238.

In isolation the first of these texts is insignificant since it refers only to the personal conduct of Ibn Hubayra.[156] It takes on greater significance, however, when read in conjunction with the second text.

Of the two descriptions of Qurra's arrival, the second does not seem to merit much confidence given the anachronism which one identifies: the mosque of Fustat was outfitted with a mihrab only by Qurra ibn Sharīk himself during his tenure as governor,[157] thus at a point subsequent to that of the event in question. But one also thereby understands how it is that a narrator who is either inattentive or insufficiently informed can commit such an error: by antedating slightly the mihrab,[158] which had been put in place by the very person described in the anecdote. Thus the anachronism is itself a kind of indirect evidence for the veracity of the account.

What this report makes clear, after one has reconciled the two extant versions, is that the *majlis* of the governor, that is, the place where he settled himself, was located either in front or within the opening of the niche. Thus one encounters, if by accident, the original meaning of *miḥrāb* ("an apse in which the prince seats himself") as well as the arrangement of audience halls. And it is certain, although I have not been able to discover other historical evidence apart from these two texts, that some people even carried out the ritual prayer *in the niche itself* since the jurists decry the practice and were able to uncover hadiths (of an obviously anachronistic and, thus, apocryphal sort) to condemn it.[159] As paradoxical as this conclusion may first appear, it is supported by archaeological evidence which shows that the mihrab bore certain peculiar characteristics which, if inexplicable when considered in light of current practice, become altogether clear once one acknowledges that the niche was a reduced replica of the terminal apse of the audience hall.

At first glance the fact that the mosque contained, in the period which concerns us here, [149] *only one mihrab* is, for reasons considered previously, entirely inexplicable from a liturgical point of view. This seeming anomaly, however, must be considered as a rational device if the niche was intended to mark the place of the imam rather than the direction of prayer; the mosque only

[156] Later, we see a Fatimid governor of Damascus take his place *in the mihrab* of the *muṣallā*; see Ibn Qalānisī, *Ta'rīkh Abī Ya'lā Hamza ibn al-Qalānisī*, ed. H.F. Amedroz (Leiden, 1908): 9. The report does not pertain to the present debate, however, not only because of its dating which falls beyond our framework, but also because it can be explained quite simply in terms of the exceptional dimensions normally accorded the mihrab of the *muṣallā*. There the individual in question stands in the shade very much as if he were beneath a tree. I cite this detail solely to emphasize the care which is required if one is to carry out such an inquiry with the requisite precision.

[157] Creswell, *Mosquée de 'Amru*, 126. Cf. my earlier comments.

[158] To be precise, by 29 months (Qurra's arrival in Fustat took place in Rabī'a I, 90 A.H. while the reconstruction of the mosque was begun in Sha'ban 92 A.H.).

[159] For example, see Ibrahim Rif'at (Pasha), *Mir'at al-Ḥaramayn* (Cairo: Dār al-Kutub al-Miṣrīya, 1925): 468, note 1.

had *one mihrab* precisely because the community which gathered therein had *only one leader*.

The dimensions of the niche, which were relatively tiny in large mosques, were *relatively large in smaller ones*: 1.20 meters wide in Quṣayr al-Ḥallabāt (for a hall measuring 11.80 meters wide), 1.09 meters in Jabal Says (for a hall measuring 9.30 meters), and 1.62 meters in Mshattā (for a hall measuring 13.40 meters).[160] If, in certain cases,[161] the niche seems to have been constructed in greater conformity with the size of the space, this does not change the fact that the lack of proportion is impossible to explain unless it was intended to mark *the position of a man* who had been chosen as the exemplar.[162]

Finally, and here we come to the essential point, why was the mihrab *decorated with such care*? One recalls the decor of the Umayyad mosque in Medina, gleaming with gold, and with its polychromatic marble and agate, surmounted by "the mirror of Khusraw" and the chandelier, *the only* chandelier in the mosque.[163] We should also think of the huge rock-crystal block which glistened at the back of the mihrab in Damascus: "gleaming like a chandelier."[164] In these buildings, in which costly materials had been liberally used, why the insistence on concentrating them in the niche of the mihrab? Why indeed, unless it was intended to designate the place of the leader? There is no other admissible explanation for this particular feature.

We should also note that in certain mosques (Medina, Damascus), a dome in front of the mihrab serves as a kind of monumental canopy that has its equivalent in the Umayyad audience hall.

To conclude: the location and function of the mihrab in the mosque corresponds to the location and function of the terminal apse in the audience hall, just as its form corresponds to that of the apse. The resemblance between these two architectural features ought to have been all the more striking in the case of mihrabs featuring a particularly wide opening such as those in Medina and Ramla. Thus the mihrab is nothing less than *a smaller replica of the palace apse*, and constitutes a new feature common to both the palace and the mosque. If certain questions appear to be unresolved, we shall set them aside with the aim of resolving them shortly.

[160] Creswell, *op. cit.*, figures 331 and 438. Cf. Sauvaget, "Les Ruines omeyyades de Djebel Seis *Syria*, XX (1939): 245.

[161] Medina (see Sauvaget, *Mosquée omeyyade*, 84), Ramla (see ibid., 96).

[162] Fikry, 62, arrives at a conclusion similar to our own – that is, that the mihrab marked the area reserved for the imam's prayer session – but he had in mind only the ritual aspect of the mosque, and does not speculate except as regards theoretical matters rather than to proceed to a demonstration.

[163] Ibn Rusta, 76.

[164] Ibn Asākir, I:211. Cf. al-Muqaddasī, *Kitāb aḥsan al-taqāsīm fī ma'rifat al-aqālīm*, ed. M.J. de Goeje (*BGA*, 3)(Leiden: E.J. Brill, 1877): 157–158.

THE MAQṢÛRA

The *maqṣūra* (that is, "an area set off, separated") is [150] the part of the mosque reserved for the sovereign. Situated at the end of the axial nave immediately in front of the south wall, it is set apart by a latticed grill and encloses the mihrab, minbar and the imam's door.[165]

The date of its introduction is in doubt because it has been attributed variously to 'Uthman, Marwān b. al-Ḥakam and Mu'āwiya.[166] Some compare it, even implicitly, with the mat partition that Muhammad used to seclude himself in the mosque.[167] Its origins, in short, are unclear; the question, in any case, is of little concern to the present inquiry whose principal goal is to identify the function of this interior feature of the mosque.

On this matter, it seems at first that we are better informed since all authors, without exception, present the introduction of the maqṣūra in terms of assuring the security of the sovereign. Following attempts on their lives, 'Uthman, Marwān and Mu'āwiya chose to erect this screen, which would have allowed them to lead the sessions of prayer without fear of assassination.[168]

It is troubling, nevertheless, to see that an otherwise well-informed source assigns the introduction of the maqṣūra to a date that "negates all connection with [historically attested] attacks" and "offers little support to the idea of precautions taken to secure the safety of the sovereign."[169] The latter was, however, sufficiently ensured by the presence of an armed bodyguard positioned around the person of the leader, a presence to which we have already made reference,[170] and to which we will return in due course. Here we will simply provide a text that demonstrates the manner in which the deployment of force rendered superfluous the establishment of a screen in front of the mihrab.

> ('Ubayd Allāh b. Ziyād) ascended the minbar...then ordered his
> herald to announce the start of the *salāt*. Someone then said to

[165] No Umayyad *maqṣūra* has survived to the present day, but given that the structure is used without significant variation in all mosques of the Islamic world, it is certain that it has survived more or less in this form since the onset of Islam. On several early examples, see G. Marçais, I:113–115. In the Umayyad period, the *maqṣūra* enclosed the minbar (*Aghānī*, VIII, 182) and the imam's door (Bar Hebraeus, *Ta'rīkh mukhtasar al-duwal*, ed. Antun Salihani (Beirut: al-Matba'a al-Kathulikīya, 1890): II, 206–207).

[166] For example, al-Samhūdī, *Khulāṣat al-wafā* (Cairo, 1316/1898–9, 136, where each of these attributions are listed one after the next. One notes that all of these individuals were Umayyads.

[167] Al-Bayhaqī, *Kitāb al-sunan al-kubrā* (Hayderabad: Maṭba'a Majlis Da'irat al-Ma'ārif al-Nizāmīya, 1925–1937): III:109. The connection is made in *Madkhal*, II, 204–205, in which one also finds the opposition of a rigorist to the use of a personal *maqṣūra*.

[168] Pedersen, 384–385.

[169] Lammens, *Mo'āwiya*, 202, note 9 (citing a passage from al-Ya'qūbī, II:265). The traditional explanation is subtly reshaped by the same author (*ibid.*, 203); his position, although rather close to our own, retains the character of personal opinion too thinly supported by the facts.

[170] See my earlier comments above.

> him: 'lead the prayer if you wish, but you also might allow someone
> other than you to do so and return to the palace to perform the
> ritual prayer, since I fear that one of your enemies will catch you
> unawares.' 'Order my guards,' he responded, *'to remain standing
> behind me* (while I carry out the prayer).'[171] [151]

It should be added that the political leader did not remain entirely alone in the
maqṣūra. Although he spoke through the grating to unimportant individuals
whom he had summoned,[172] those to whom he wished to extend special consid-
eration were introduced into the interior of the latticed enclosure,[173] to which
the leading members of the community were also admitted, honored as they
were with a spot immediately behind the imam during prayer. This intimacy
did not always sit well with the ruler:

> Someone asked Ibn ʿAbbās: 'Do you perform the prayer behind
> these people (i.e., the Umayyads) *inside the maqṣūra?*' 'Yes,' he
> replied, 'and *they are very afraid that we might rip their guts out.*[174]

The presence of the screen provided the sovereign, therefore, with only an illusory
guarantee of security. On the other hand, if the screen was indeed intended as a
means of protection, how does one explain that the word *maqṣūra* could be used
later to designate certain areas of mosques which were encircled by a low railing
and earmarked either for teaching or for the devotions of certain categories of
believers,[175] or even the alcove used by bathers in the hammam for reasons of
privacy?[176] How, in a serious manner, does one reconcile these meanings with the
notion of security? One certainly must relate them to the etymology of the word,
that is, "a separate area, reserved." One is justified in asking oneself, therefore,
whether the received explanation is unreliable or has as its basis anything more
serious than personal impressions with little real value.

The new approach that is set out here allows one to quickly resolve these
difficulties. One needs only point out that the *maqṣūra* enclosed both the el-
evated seat and the area designated for the sovereign; that it was there where
incense was burned; that on occasion one could hold an audience within it; that
it was set aside for particularly distinguished individuals; and, finally, that it

[171] Al-Ṭabarī, II:260.

[172] Al-Kindī, 120 (from the ʿAbbasid period). On a summons to come to the *maqṣūra*, see *Fragmenta*,
I:87.

[173] On the reception of a *wafd* in the *maqṣūra* by ʿAbd al-Malik, see al-Balādhurī, *Ansāb al-
ashrāf*, vol. V, ed. S.D. Goitein (Jerusalem: Hebrew University Press, 1936): 311. Later, the
maqṣūra was open to the close associates of the ruler. See *Madkhal*, II:206.

[174] Al-Bayhaqī, III:110.

[175] R.P.A. Dozy, *Supplément aux dictionnaires arabes* (Leiden: E.J. Brill, 1881), s.v. with exam-
ples. One needs to omit the meaning given therein (358 *b.*, line 20) of "trésor", which relies on an
erroneous reading of the details of the revolt of Yazīd II, to which we have made reference earlier
(above, notes 88, 92, 93, 95).

[176] See Sauvaget, "Un bain damascain du XIIIe siècle " *Syria* xi (1930): 373ff.

was located at the end of the axial nave. The similarities between the *maqṣūra* and the terminal apse of the audience hall become all the more striking as a result, and since the grill was intended to function, as the etymological value of the term *maqṣūra* would indicate, as a "separation," we are justified in comparing it with *the curtain suspended in front of the apse of the audience halls* in order to "separate" the monarch and his intimates from the rest of the gathering. Thus, it seems [152] to have been intended more as a means by which to enhance the majesty and prestige of the leader rather than to assure his security.

It is true that one can raise a certain objection to this interpretation by drawing attention to the readily apparent difference in scale between the *maqṣūra* and the mihrab, which we have compared with the apse. For the moment we will set the question aside.

THE AXIAL NAVE

All of the features of the mosque that we can safely associate with the person of the sovereign, or his representative, are clustered at the end of the axial nave of the mosque, just as, in the palace, they are clustered at the end of the axial nave of the audience hall. Can one extend the parallel by admitting that the function of the axial nave is identical in both cases? Yes, without question: although the texts upon which one relies to make the case are few, they make the point clearly enough to obviate all hesitation, provided that one keeps in mind the facts established up to this point.

Two texts prove first of all that, in line with a practice that perhaps dates to the time of Muhammad,[177] during assemblies (which, again, were of a political nature) held in the mosque, the members of each tribe gathered around their leader in a specific area of the building which constituted their gathering place and took their name; the practice has been attested for the Qays in Fustat,[178] and for the Sakāsik in Damascus.[179] In the mosque at Damascus, which was of the basilicalbasilican type, the subject of our present comments, the gathering place was a *column*.[180] It was located, in other words, in one of the aisles of the prayer hall. While certainly thin and even perhaps forced, this first indication acquires far greater value when considered alongside the following text.

Based on an eyewitness account (which we have considered earlier), it describes a ceremony that took place in the mosque of Medina at the moment when al-Walīd, during his sojourn in the Hijaz, solemnly "inaugurated" the

[177] Al-Samhūdī, *Khulaṣat*, 122–125; it may be that such localizations only contain pious legends of fairly recent date although the social structure of Arabia in the seventh century lends them verisimilitude.

[178] Ibn 'Abd al-Ḥakam, 131 (at the bottom).

[179] Ibn al-Faqīh, 107.

[180] The same pillar which rises above the crypt containing the head of John the Baptist.

building, the rebuilding of which he had just carried out, and whose arrangement we have redrawn.

> Isḥāq b. Yaḥyā reported to me: 'I saw al-Walīd perform the khutba from the minbar of the Prophet of God. It was the day on which the community assembled (Friday), when he carried out the pilgrimage. *His bodyguard had been arranged in two rows from the minbar to the last wall of the mosque*,[181] with iron rods in hand and iron clubs upon their shoulders.[182] [153]

The great value of the passage is that it concerns a building that we know well enough to be able to appreciate fully the details of the account.

The security measures taken around the caliph's person can be explained by the fact that the minbar, rather than being located in the interior of the maqṣūra grill, is here situated outside it and is accessible from all sides.[183] But this cannot explain the extension of the double line of armed bodyguards from the minbar *to the north wall of the prayer hall*. If, on the other hand, we endeavor to trace the unfolding of the ceremony on the plan, while noting that the minbar stood between two rows of supports, we can admit – with great likelihood and without any fear of contradiction – that the guards stood between the columns whose interval formeds the axial nave (at the end of which stood the minbar) and *thereby leaving the nave entirely unobstructed all the way to the courtyard of the mosque*. There is all the more reason to proceed in the same fashion in the mosques in which, unlike Medina, the axial space was provided with a special arrangement.

The axial nave of the mosque thus remained empty, precisely in the manner of the axial nave of the audience hall. This would explain why it was designated, at a very early point, with the term *bahw*[184] which, due certainly to a contraction in meaning, was subsequently used only for the final exedra of the hall.

THE DISSIMILARITIES

In contrast with the many and close similarities that we have remarked upon, the dissimilarities between the arrangement of the mosque and that of the audience hall appear rather inconsequential as long as one does not insist on dwelling upon their formal aspects alone. Besides, it is extremely easy to account for these once one comes to terms with the building that initiated the

[181] Here, as in a number of texts that we have cited above, the reference is to "the prayer hall" and not the entire building. Here, in effect, the caliph, making his entrance from the imam's door, did not have to cross the entire length of the mosque in order to reach the mihrab or the minbar.

[182] Al-Ṭabarī, II:1234 (and see *Fragmenta*, I:7) and al-Ya'qūbī, II:341.

[183] The references to the armed guard that periodically appear (Lammens, *Mo'āwiya*, 203, note 2) ought to be seen as well in relation to the absence of a *maqṣūra* in the mosque.

[184] Dessus-Lamare, "Étude," 530.

series of Umayyad mosques and represented the first use of their characteristic arrangement: the mosque of Medina.

As we have observed, that same mosque could only roughly approximate the plan of the basilican model since an effort was made to conserve as closely as possible the earlier character of the sites. Its arrangement was no less than a compromise between the *masjid* of the Prophet and the basilican scheme used in other Umayyad mosques and the audience halls of the same period. This came to us as a revelation. The mosque of Medina has remained, through each of its transformations, the mosque of the Prophet. It was rebuilt [154] on a monumental scale *before all others*; its composition has been carefully studied *by the representatives of the Prophetic tradition* and in such a way as to *reflect that of Muhammad's mosque*; its sentimental value and its early date must certainly have given it *the status of a prototype* and assured that certain details of its composition became *de rigueur* (because of the perceived relationship between them and the Prophet's tradition) in mosques built after it, and, subsequently, in all of the mosques of the Islamic world. Just as the architectural arrangement of this mosque in Medina was nothing short of a compromise between that of Muhammad's *majlis* and the Umayyad basilican *majlis*, the details of its composition are to be explained simply as a compromise between the tradition of the Prophet and the court ceremonial of the Umayyad era. Furthermore, these details were imposed, because of the particular standing of the Medinan mosque, as an obligatory model everywhere that the builders of Umayyad mosques, when unimpeded by the pre-existing arrangement of sites, could freely assign to their mosques the basilicanl plan which was the best suited to their function.

From an architectural point of view, the fundamental difference between the mosque and the audience hall lies with the dimensions of the terminal exedra which, in one case, may be largely open in the form of an apse, and, in the other, reduced in size so as to be nothing more than a mihrab. This reduction in size becomes meaningful and immediately comprehensible as soon as one observes, first, that the first mihrab to be put in place *was precisely that of the mosque in Medina* and, second, that the Prophet's own mosque *did not include a mihrab*. Thus it is clear that the modest size assigned to the niche was but a compromise between two desires: on the one hand, to provide the mosque with the customary layout of the audience hall (with an apse) and, on the other, to respect the extant arrangement (without an apse). The sole solution was to *reduce to the greatest extent possible the opening of the niche* so as to neither significantly alter the nature of the assembly area nor underscore the fact that it was not meant to reflect the status of the person standing before it.[185]

[185] The *haykal* of Coptic churches is itself an atrophied apse (see above) and it may be that for the Muslims it became a model to emulate. I continue to believe, however, that the mihrab cannot have been a simple, literal copy of the niche used in Coptic liturgy; a host of indications militate

Jean Sauvaget

But, at the same time, the reduction in scale inevitably entailed *a modification of other features of the hall that stood in relation to the person of the sovereign.* From that point on, the apse was incapable of accommodating the throne, and consequently, the curtain suspended over its opening now lost its justification [155]. This would then explain *the displacement of the minbar,* placed next to but outside the niche, and the *substitution* of the curtain with the *maqṣūra,* an exact replica of the chancel that, in a number of audience halls, surrounds the particular area set aside for the monarch and that also in some instances doubles for the curtain hung in front of the apse. It is altogether striking that in certain churches,[186] the chancel of the *presbytery* encroaches relatively far upon the nave, thus assuming, in relation to the wall at the back of the hall, exactly the place assumed by the *maqṣūra* in relation to the back wall of the mosque (fig. 10), which serves to illuminate the origin of the model adopted in Islamic usage.

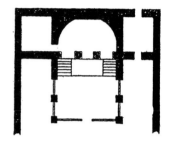

Figure 10

And the introduction of the *maqṣūra* acts upon the visibility of the minbar: apart from such exceptional cases – such as that of Medina, where the minbar of the Prophet was left standing on the spot it had occupied to that point, and in certain mosques where the minbar was placed, following no doubt the example of Medina, outside the *maqṣūra*[187] – the latter's presence might have had the effect of concealing the speaker from the audience had care not been taken, *as a result, to raise the minbar.*[188] Given its height, the structure henceforth assumed a disproportionate size to that of the mihrab for which a modest opening was kept for the reason we have stated: barred from introducing it into the niche, a step that would have constituted an innovation (*bid'a*), it was retained *where Muhammad had placed his own,* against the wall at the end of the mosque and on its axis. But just as this same space logically would have contained the apse according to the scheme of the plan that one sought to reproduce, the minbar was moved slightly aside and *to the right* because Muhammad's minbar was situated precisely in this way in relation to the spot where he had placed himself when leading the prayer.

against such a simplistic view. One notes as well, by way of consequence, that the reduction in size imposed on the apse entailed the removal of two lateral alcoves that could no longer be accomodated between the concavity of the niche and the exterior walls.

[186] The affinities between the church and the audience hall that support such a comparison are discussed in Sauvaget, *Mosquée omeyyade,* 167ff.

[187] For example at Fustat where the minbar was "small" and located "outside the *maqṣūra*." See al-Kindī, 119.

[188] I noted earlier (see note 101) that the minbar of Medina constitutes an exception in my view: one cannot cite its height, therefore, to challenge my argument.

The entire arrangement of the area at the end of the axial nave of the mosque thus can be understood as *a compromise between the arrangement of the basilican audience hall and the practice fixed by the Prophet's tradition.*

No doubt much the same can be said of the courtyard with porticos and the minaret; given the new function assumed by both elements in Umayyad mosques, these represented in effect *a large-scale replica of certain elements of the Prophet's* [156] *masjid.* This seems self-evident insofar as the courtyard is concerned. As for the minaret, the origins of which, even to the present day, have been sought outside of Islamic civilization,[189] I am of the view that its prototype can be found in early Islamic practice as evidenced by a tradition that, although left out of the principal collections of hadith, has been preserved for us by a reliable source.

> In the home of 'Abd Allāh b. 'Umar there was a column (*usṭuwāna*) situated to the south of the mosque and from the top of which Bilāl issued the call to prayer. He would reach its summit by climbing. The column was square and remains standing even today; it is called *al-Miṭmār*. It (now) stands in the house of 'Ubayd Allāh, 'Abd Allāh's b. 'Umar's son.[190]

Although it is impossible to support this view with precise, duly controlled data, at least one can note in its favor that through an investigation of most of the features of the Medina mosque we have already arrived at an identical conclusion, one that leads us without fail back to the origins of Islam. Given that the minarets of Medina are the earliest whose existence can be attested with certainty,[191] it clearly would appear that this tradition, which explains their origin in terms of *a local situation connected to the biography of the Prophet,* seriously merits close consideration.

Yet another trait distinguishes the mosque from the audience hall: in the latter the axial nave is wider than the two aisles, whereas in the mosque *the aisles* have received the greatest development, such that without the greater elevation of its roof, its furnishings, and the transverse direction given to the lateral colonnades, the axial nave would barely stand out from the rest of the features.[192] Of all the dissimilarities that we have identified, none is easier to

[189] Creswell, 38–39, and especially 328–329 which contains a list of earlier works.

[190] Ibn Zabāla, in *Khol.*, 141. Since the possible connections between the pillar and the minaret were not noted by the Muslim authors, the tradition does not appear to be tendentious. Cf. Mahmoud Akkouch, "Contribution à une étude des origines de l'architecture musulmane: la grande-mosquée de Médine," *Mémoires (Institut Français d'archéologie orientale)*, vol. 68 (1935) = *Mélanges Maspero*, III:408.

[191] On the possibility of earlier minarets, see Creswell, 35 and 38–39. Their existence in no way weakens the argument presented here: these too would have been a replica of Bilāl's column. This is why, I confess, I felt no compulsion to investigate them more closely. It is to be noted that our interpretation also explains the form (square) of the early minarets.

[192] Cf. the mosque of Cordoba where, because of the placement of the columns toward the back wall, relatively less emphasis was laid upon the axial nave.

explain, at least in terms of the approach adopted here. That which distinguishes, in fact, the mosque from the audience hall (whose private character is important to recall) is the far greater number of participants; far from being composed solely of the caliph's intimates, here all Muslim males of a given administrative district, who had come of age and were free, were gathered together. Naturally this difference was reflected in the plan, and because the participants gathered in the aisles of the basilican halls, it clearly follows that the *aisles bore the effort* [157] *of adaptation.*

Thus one is persuaded that the vast lateral aisles of the Syrian mosques were nothing other than the aisles of a basilican hall *intentionally* "inflated" so as to provide the space required to shelter the anticipated number of faithful. The five-aisled Constantinian churches which were intended to accommodate the large crowds of pilgrims (the Holy Sepulchre, Bethlehem, St. Peter's in Rome) serve to demonstrate that an adaptation of this kind was by no means unusual in the history of the basilican plan. By the same token, the interpretation we have proposed regarding the role assumed by the axial nave of the mosque is confirmed indirectly, and one can see why we have attached no importance to the manner in which the lateral colonnades were placed. Their placement has in fact no significance for the utilization of the site and relies, there where it may appear aberrant, only on functional necessity.[193]

Therefore, the analogy that we have established between the mosque and the audience hall remains intact. Even better: it emerges from close examination as entirely well founded since all the noted dissimilarities between the mosque and the audience hall can be explained, in the final assessment, by the correspondence itself. We stand convinced that the arrangement of the mosque and that of the audience hall was nothing other than two distinct realizations of one and the same type of plan, and that the utilization of the two spaces, otherwise similar in terms of their composition, is imposed by the same ceremonial: *mosque and audience hall are entirely one.* The problem of the architectural origins of the mosque thus rests on an entirely new basis in the sense that it is indissolubly linked to that of the origins of the basilican audience hall, so much so that its solution would need to be sought not (as has been the practice to date) in terms of religious architecture but rather in terms of palace architecture and the court ceremonial of earlier periods.

[193] The transversal placement of columns in Damascus, for example, clearly was imposed by the obligation to strengthen the base of the high lateral walls of the axial nave which the weight of the structure (and of the cupola, when such was present) tended to make buckle to the right and left.

The Mosque and the Palace 39

TRANSLATOR'S ACKNOWLEDGEMENT

[I wish to thank my colleague, Professor Mark McKinney of the Department of French and Italian at Miami University, for his suggestions and comments on this translation].

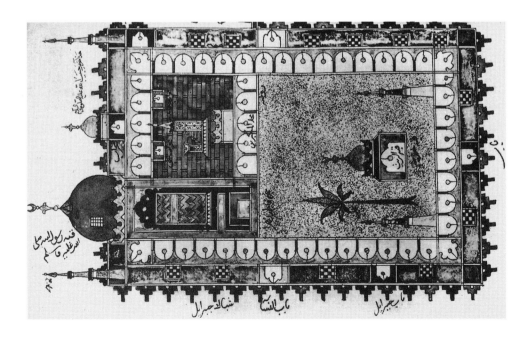

6
MIḤRĀB AND 'ANAZAH:
A STUDY IN ISLAMIC ICONOGRAPHY[1]

George C. Miles

W hen the Arabs broke out of their homeland in the early 7th century they had no coinage of their own. In Syria and North Africa the invaders adopted the existing Byzantine gold and copper coinage and later adapted it to Muslim use, while eastward in Mesopotamia and Persia as far as the confines of Central Asia the silver of the last Sasanian kings was copied with only very slight modifications. The portrait of the Sasanian ruler, usually that of Khosrau II, continued to be represented on the observe, accompanied at first by his name in Pahlevi characters, and later by the name of the provincial Arab governor, likewise in Pahlevi (Pl. XXVIII, fig. 1). The one strikingly distinctive feature (aside from the governor's name, when it is present) is the addition of a pious Islamic expression, such as *bi'smi'llāh* or *al-ḥamdu li'llāh* in Kufic characters in the obverse margin. On the reverse the Zoroastrian symbolism of fire-altar and two flanking attendants persisted in defiance of militant Muslim scruples. The mints, indicated by Pahlevi monograms or abbreviations, remained for the most part the same as before the

[1] A preliminary draft of this article was read at a meeting of the American Oriental Society at New Haven in April, 1949. Among the many friends with whom, either orally or in correspondence, I have since then discussed various aspects of the material presented here, and from whose generous and learned suggestions I have richly profited, I should like to mention with particular gratitude Leo A. Mayer, G. Levi Della Vida, E. Baldwin Smith, Florence E. Day, Charles K. Wilkinson and Stephen V. Grancsay.

Arab conquest; and the dates, with some aberrations, were represented successively in the Yazdigirdian, post-Yazdigirdian and finally the Hijrah eras.[2]

This state of affairs continued from the battles of Yarmūk and Qādisīyah in 636 and 637 until the Caliph ʿAbd al-Malik's wide-sweeping administrative reforms about the year 695 (A.H. 75).

There is some not too significant conflict among the historical sources, and between the historical sources and the numismatic evidence, about the exact date of the coinage reform, but in any case we have preserved coins of the new purely epigraphic, purely Muslim-Arab "iconoclastic" type (Pl. XXVIII, fig. 2), beginning at Damascus with the year 75, and at many other mints with the year 79.[3] It is apparent that the reform in the coinage did not take place simultaneously throughout the empire: for example, dirhems of the conventional Sasanian-Arab type were struck as late as 83 at at least one of the eastern mints,[4] and during the years 75 to 79 at quite a number of cities in ʿIrāq and Irān. In other words, there was a period of transition before the pre-Islamic types disappear for good – a circumstance which is in no way surprising, for it must have required time for the new design (and the new techniques needed to reproduce it) to spread to the remote reaches of the vast Arab realm.

It is with a very extraordinary numismatic document of this transition period that I propose to deal in the present article. In the Museum of The American Numismatic Society, there is a remarkable dirhem (30 mm., 3.33 grm.) of distinctly Arab-Sasanian style, but not of the conventional Arab-Sasanian type, unique not only in that no other specimen of like type exists in any collection of which I have knowledge, but unique in each of several features of its design (Pl. XXVIII, fig. 3). Indeed is is from several points of view a very valuable little archaeological document and one of some importance in the history of early Islamic iconography.[5]

The obverse wears the outward aspect of the conventional Arab-Sasanian dirhem — that is, there is the usual bust of the ruler, facing right, the name of

[2] The Arab-Sasanian coinage is definitively dealt with and profusely illustrated in John Walker's *A Catalogue of the Arab-Sassanian Coins (in the British Museum)*, London, 1941.

[3] The reformed-type dirhem of al-Baṣrah supposedly dated A.H. 40 (H. Lavoix, *Catalogue des Monnaies Musulmanes de la Bibliothèque Nationale*, I, no. 158) cannot be of that date; a die-engraver's error is responsible for the anomaly. A reformed dirhem of Marw apparently dated 73 (*ibid.*, no. 202) is doubtless actually 93.

[4] Bishāpūr. Cf. Walker, *op.cit.*, p. 120, no. 238.

[5] The coin, from the collection of E. T. Newell, was illustrated and briefly described in Walker, *op. cit.*, p. 24, pl. XXXI, 5.

Khosrau in Pahlevi at the right, and the somewhat controversial formula, "May his Majesty increase" (or the like), at the left behind the head. But closer examination reveals several novelties. In the first place, Khosrau's familiar winged head-dress has been replaced by a sort of night-cap with two tassels hanging down to the left and, secondly, the ornamentation of the breast differs quite markedly from the usual type. There are a pair of zig-zag lines and another zig-zag between two bars, which I will not attempt to interpret. The important thing is that the breast ornament, like the headdress, is different from that on the hundreds of known Arab-Sasanian coins of the usual type. Finally, it will be observed that the margin is completely filled with a Kufic inscription, beginning in the first quarter, that is, at the upper right. Instead of the usual short phrase, we have the complete *shahādah* بسم الله لا اله الا الله وحده محمد رسول الله. Three of the conventional stars and crescents are preserved, but in place of the fourth, at the top, which usually forms a part of Khosrau II's headdress, there is a circle enclosing an object of indeterminate import. I shall revert to the obverse later on in attempting to interpret the meaning of its unique aspects,[6] but to complete the description attention must now be directed to the extraordinary and entirely anomalous reverse which bears the iconographic details to which this discussion is mainly devoted (enlarged, Pl. XXVIII, fig. 8).

First, to dispose of the epigraphy, at the left, reading downwards, is امير المؤ منين, "Commander of the Believers"; at the right, خلفت الله "Caliph of Allāh", defectively written without the *yā* and spelled with *tā* in place of the *tā marbūṭah*. Neither of these aberrations is exceptional at this early date. In fact, the form of the *tā* is to be expected, and several more or less contemporary instances can be cited, in numismatics at least, of the defective writing of *khalīfah*.[7] In the center, also downward, are the words نصر الله which may be read either *naṣru'llāhi* or *naṣara'llāhu*, "Victory of Allāh" or "May Allāh assist." It probably is not *naṣru bi'llāhi*, for the horizontal stroke at the bottom of the *alif* appears to be no longer than that of any of the three other (free-standing) *alif*'s in the legend. In the margin, at the top, upside down, are the Pahlevi letters ع‍‍ؤ AF, usually taken to be an abbreviation of AFD, "praise," a word appearing on many Sasanian coins. The

[6] See page 169.

[7] *E.g.*, Lane-Poole, *Catalogue of Oriental Coins in the British Museum*, Vol. IX, pl. II, 48; also the Arab-Sasanian dirhem with standing Caliph on the reverse, discussed later in this article (Pl. XXVIII, fig. 5).

mark above the star and crescent at the right is simply a die-break. So much, for the moment, for the legends.

Coming now to the iconography, we approach the heart of the matter. The fire-altar and attendants have disappeared and their place has been taken by two colonnettes and a high rounded arch, ornamented with twisted flutings. The cushion-like bases and capitals are too small, and in any case too blurred, to be described in any detail. Beneath the colonnettes is a beaded horizontal line. Within the arch, stands upright a lance or spear terminating in an apical blade with two basal prongs bent backward, and standing upon what appears to be a bifurcated or crutchlike base. Attached to the shaft just below the blade and waving downward to the left are two streamers which we may take to be the depiction of a single pennant. At the left of the lance-blade is a crescent and at the right a pellet (both common symbols in the usual Arab-Sasanian and the Sasanian coinages); and toward the bottom of the shaft, after the word *naṣr* on the left, a pellet. If there is a balancing crescent at the bottom right, it is obscured by the imperfectly struck and blurred condition of the coin at this point.

Now, what do these several elements represent? Let me say at the outset that I believe the colonnettes and arch to be the representation of a *miḥrāb*, the spear that of the *ʿanazah*, and the pennant or flag that of the *ʿalam*, specifically that of the Umayyad Caliph ʿAbd al-Malik b. Marwān. Let us consider each of these conceptions more closely.

First, the *miḥrāb*. In the earliest days of Islam, when religion and state were entirely inseparable, the mosque was not only the absolute center of the faith but the ceremonial focal point of political leadership. And the very heart of the mosque was the *miḥrāb*. We need not concern ourselves specifically here with the origin of the *miḥrāb*, a subject of much controversy and recently so brilliantly discussed by the late Jean Sauvaget.[8] We must certainly accept the fact that the niche had already in the *jāhilīyah* been the inner and exclusive sanctuary of the prince,[9] and we may, in spite of the contradictory testimony of some traditions, assume for the

[8] Jean Sauvaget, *La Mosquée Omayyade de Médine* (Paris, 1947), pp. 145–9. "... la place et le rôle du mihrab dans la mosquée répondent à la place et au rôle de l'abside terminale des salles d'audience Le mihrab n'est donc *qu'une réplique réduite de l'abside palatine*, et constitue un nouvel élément commun au palais et à la mosquée." For the earlier literatere, see the excellent article *masdjid* by Johs. Pedersen, subtitle I, D, 2, c, in the *Encyclopaedia of Islam*, and the first part of the article by E. Diez, *ibid., s. v. miḥrāb*.

[9] Cf. Qurʾān XXXVIII, 20: اِذْ تَسَوَّرُوا ٱلْمِحْرَابَ, in the sense of going into the innermost chamber

KEY TO PLATE XXVIII

1. Arab-Sasanian dirhem, 'Ubaydullāh b. Ziyād, Rayy, A.H.60 (American Numismatic Society).
2. Reformed-type dirhem, Dimishq, A.H.79 (American Numismatic Society).
3. Unique dirhem with *miḥrāb* reverse (American Numismatic Society).
4. Arab-Sasanian dirhem, Dimishq, A.H.74 (Paul Balog Collection, Cairo).
5. Unique dirhem with standing-Caliph reverse, A.H.75 (*Trudy Moskovskago Numizmaticheskago Obshchestva*, III, pl.V,1).
6. Bronze coin of Marcus Aurelius, Philadelphia in Lydia (*B.M.Cat. of Greek Coins, Lydia*, pl.XXII,9).
7. Visigothic triens, Wamba (A.D.672–680), Toleto (Hispanic Society of America).
8. Detail of reverse of fig. 3.
9. *Miḥrāb* of Jāmi' al-Khaṣṣaki, Baghdad (Creswell, *Early Muslim Architecture*, II, pl.120d).
10. Wood panel, East no.1, Aqṣā Mosque, Jerusalem (Creswell, *op.cit.* II, pl.25a).
11. Wood panel, East no.16, Aqṣā Mosque, Jerusalem (Creswell, *op.cit.*, II pl.26f).
12. Marble grills in west vestibule and *riwāq*, Great Mosque, Damascus (Creswell, *op.cit.*, I, pl.46).
13. Wooden *minbar*, column 4, panel 3, Great Mosque, Qayrawān (Creswell, *op.cit.*, II, pl.89d).
 (Figs. 9–13 courtesy of Professor K. A. C. Creswell)

PLATE XXVIII

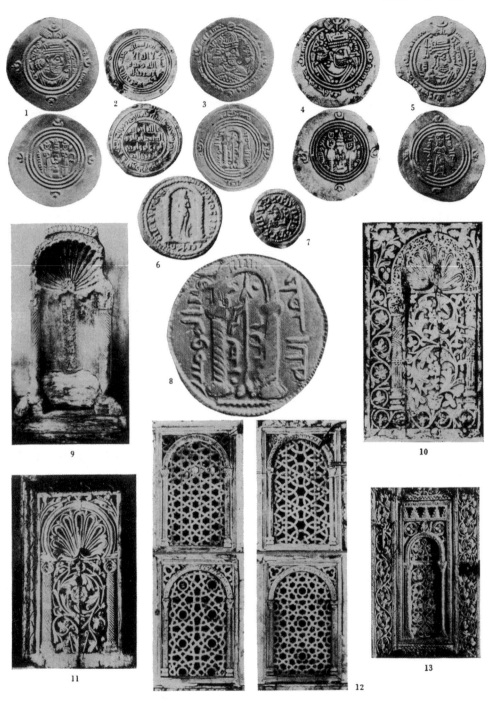

MIHRĀB AND 'ANAZAH: A STUDY IN EARLY ISLAMIC ICONOGRAPHY

moment that at the time this coin was struck it had taken its place in the architecture of the mosque. This aspect of the matter will be reverted to later in discussing the date of the coin. Our immediate concern is with the interpretation of the iconography. If the mint-master had been directed to devise some alternative to replace the distasteful *gabri* symbolism of the fire-altar, what could there be more appropriate than the *mihrāb*? We may even allow ourselves to imagine that it was ʿAbd al-Malik himself who had the idea, and that the mint-master was charged with creating a suitable design.

We must then ask ourselves where the mint-master or die-engraver found his prototype. However abstract the conception, the symbol itself must be rendered in concrete terms, and however generalized or conventionalized the symbol, there must be a model after which the niche here represented was fashioned. The problem is complex, for in all probability there were two sources of inspiration — one numismatic, the other architectural; in other words, there must have been on the one hand a precedent for the basic idea of a symbolic representation of this nature on the coinage, and on the other, a physical model appropriate to the specific Islamic concept chosen as the symbol. One element of the numismatic inspiration is obvious and has already been referred to: the Zoroastrian fire-altar on the Arab-Sasanian coinage which had been slavishly copied and for which a suitable substitute was now required. Such a substitute, presumably devoid of specific objectionable connotations, was ready to hand in a numismatic tradition native to the soil where the new iconographic "language" was in gestation, that is in the lands contiguous to Damascus, which (as I shall demonstrate later) was the mint where the coin in question was struck. I refer to the distyle shrines or *ciboria*, with spiral columns, which appear on many Greek imperial coins of Syria, Phoenicia and Asia Minor (Pl. XXVIII, fig. 6).[10] These types were doubtless as familiar to the Arabs in their newly conquered Syria as were the many Seleucid, Roman, Greek, Imperial and

[10] The example illustrated is actually of Marcus Aurelius at Philadelphia in Lydia (*B. M. Cat., Greek Coins of Lydia*, pl. XXII, 9, p. 199), and is selected because of its close resemblance to the niche under discussion; but many specimens with a closer geographical relationship could be cited, *e.g.*: Julia Domna at Gabala (*B. M. Cat., Greek Coins of Galatia, Cappadocia, and Syria*, pl. XXVIII, 12, p. 245), Commodus, Septimius Severus and Elagabalus at Laodicea ad Mare (*ibid.*, pl. XXX, 8–9, pl. XXXI, 1, pp. 257–8, 261), Severus Alexander at Nicopolis in Seleucis (*ibid.*, pl. XXXI, 10, p. 265), Trebonianus Gallus, Gallienus and Valerian at Tyre (columns sometimes double?) (*B.M. Cat., Greek Coins of Phoenicia*, pl. XXXIV, 3 and 16, pp. 283, 292, and American Numismatic Society). For other examples, presented to illustrate gods and goddesses under the "arch of heaven," see A.B. Cook, *Zeus*, II (Cambridge, 1925), pp. 362, 365, and the references there.

Byzantine types to the Urtuqid and Zengid princes of Syria and Mesopotamia who copied them on their coins five centuries later.[11] The point need not be labored; this numismatic precedent may or may not have influenced the designer of our coin, but in any case it serves to remind us that the Hellenistic architectural feature here represented had already enjoyed wide iconographic currency.[12]

Now, what of the specific Islamic architectural model? Certainly we cannot hope to identify the very model itself, but one can suggest some likely possibilities if not antecedent to, at least contemporary with, the niche after which the present representation was patterned. We cannot say whether the *miḥrāb* on the coin is truly *mujawwaf* (that is, hollowed in the form of a shell niche); we must recognize the limitations of both the artist and his medium in his effort to reproduce exactly the architectural element he had in mind. If it is *mujawwaf*, then, as I hope to show later, it antedates by several years the traditionally earliest niche-formed *miḥrābs* — that introduced into the mosque at Medina by 'Umar b. 'Abd al-'Azīz when he was governor there for al-Walīd b. 'Abd al-Malik, and that of Qurrah b. Sharīk in 'Amr's mosque at al-Fusṭāṭ. But this consideration aside, if we treat only of those elements which are clearly represented on the coin, that is, a niche consisting of two probably engaged colonnettes with twisted or spiral flutings surmounted by capitals on which a rounded arch is directly superimposed, we have a series of very suggestive parallels of very slightly later, or in some cases of perhaps nearly contemporary, date. Among these is probably the earliest extant *miḥrāb*, that of the Jāmi' al-Khaṣṣaki in Baghdad (Pl. XXVIII, fig. 9) attributed by Herzfeld to al-Manṣūr's mosque, at the time of the founding of Baghdad, *i.e., ca.* A.H. 145 (A.D. 762).[13] Creswell, on the basis of similarities of ornament, suggests the earlier date of Mshatta (*ca.* 743–4) as the lower limit.[14] Another is the *miḥrāb* in the cave beneath the rock in the Dome of the Rock in Jerusalem, of indeterminate but early date.[15] This is not a true niche, and the arch of course is dissimilar to ours, but note the spiral columns.

These are the only actual extant *miḥrābs* of anything like pertinent date and of

[11] Cf. *B. M. Cat. of Oriental Coins*, III, especially pp.296ff.

[12] It should be recalled that one of the pre- and early-Islamic meanings of the word *miḥrāb* was "a niche containing a statue" (see the references in Pedersen's article referred to above); the definition brings these Greek imperial coins strikingly to mind.

[13] E. Herzfeld, "Die Genesis der islamischen Kunst und das Mshatta-Problem", in *Der Islam*, I, pp.33ff,; cf. Sarre & Herzfeld, *Archäologische Reise*, II, pp.139ff.

[14] K. A. C. Creswell, *Early Muslim Architecture*, II, p.36.

[15] Creswell, I, p.70.

recognizable form,[16] but there are several very early representations of *miḥrābs*, or at least of colonnettes surmounted by an arch similar to ours. For example, there are certain of the panels of carved wood applied under the beams supporting the roof over the central nave of the Aqṣā Mosque in Jerusalem: East 16, with simple spiral flutings, but with a horse-shoe arch (Pl. XXVIII, fig. 11), and East 1, with rather complicated ornamentation of the colonnettes but a high round arch, similar in shape if not in ornament to that on the coin (Pl. XXVIII, fig. 10). Georges Marçais, supported by Creswell, believes that these lovely panels may date from al-Mahdi's or even al-Manṣūr's reconstruction, and further is tempted "to attribute [them] to a period well before the 'Abbāsids, when the local Christian workshops, perhaps augmented by some Coptic craftsmen, worked for the Caliphs of Damascus. Some forty panels of the Umayyad period, carved before the earthquake of 130 H. (747/8 A.D.) may have escaped destruction and been utilized during the 'Abbāsid rebuildings."[17]

Comparable also are the beautiful marble grills in the west vestibule and west *riwāq* of the Great Mosque of Damascus (Pl. XXVIII, fig. 12), which Creswell[18] believes are to be dated to the time of al-Walīd. In another medium are representations of arched colonnades on the plaster balustrades from the forecourt of Khirbat al-Mafjar, the Umayyad villa near Jericho, datable to the period of the Caliph Hishām, A.H. 105–125 (A.D. 723–743).[19] Of considerably later date (A.H. 248: A.D. 862), but in the same tradition, are representations of niches in the carved panels of the famous *minbar* of the Great Mosque at Qayrawān (Pl. XXVIII, fig. 13).

Examples of similar representations in still other media could be multiplied: — for instance, in a fresco at Quṣayr 'Amrah (*ca.* A.D. 712–715,[20] on a bronze

[16] Recent excavations and studies have revealed traces of other early *miḥrābs*, but they are not well enough preserved to serve for comparison: *e.g.*, a "petite niche de plan semi-circulaire, jadis voûtée en cul-de-four" in a mosque attributed to the period of al-Walīd (A.H. 86–96), J. Sauvaget, "Les Ruines Omeyyades du Djebel Seis," *Syria*, XX (1939), pp. 245, 256. We have, of course historical notices of the earliest *mujawwaf miḥrābs*, Medina (*ca.* A.H. 88), Qurrah b. Sharīk's in the mosque of 'Amr (A.H. 92–3), and the *miḥrāb* of the Companions of the Prophet in the Damascus mosque introduced at the time of al-Walīd; but these are gone. See Creswell, I, pp. 114–5; *cf.* Sauvaget, *op. cit*, pp. 12, 95.

[17] Creswell, II, p. 135.

[18] *Idem*, I, p. 118.

[19] For the dating, see D. C. Baramki, "Excavations at Khirbet el Mefjer, III," *Quarterly of the Dept. of Antiquities in Palestine*, VIII (1939), p. 53, and R. W. Hamilton, "Khirbat Mafjar. Stone Sculpture, I," *ibid.*, XI (1945), p. 47.

[20] A. Musil, *Ḳuṣejr 'Amra*, pl. XV, XVIII; for the date, cf. E. Herzfeld, *s.v. 'Amra*, in *Encycl. of Islām*.

canister of Marwān II (A.H. 127: A.D. 744/5),[21] and on a carved teakwood panel from Takrīt,[22] but these instances are sufficient to demonstrate the affinity of the *miḥrāb* on the coin with at least two 8th century *miḥrābs* and with a number of depictions of niches (whether or not strictly *miḥrābs*) of the late 7th and early 8th centuries.[23] It may be remarked in passing, with general reference to the genesis of the *miḥrāb* and with more specific reference to pairs of columns such as these we have examined, that there is a passage in the *ḥadīth* (which I have not seen frequently quoted) where Bilāl says that Muhammad, when he went into the temple at Mecca, prayed between two columns which were in front of him, or that he stood with one column on his left and another on his right.[24]

So much for the *miḥrāb*. We turn now to the lance which stands upright between the two columns. There can, I believe, be little doubt that this is the *ʿanazah* which played a prominent part in the earliest Muhammadam ritual of the *ṣalāt*. The *ʿanazah* was the *ḥarbah* or spear which the Najāshi of Abyssinia sent to Zubayr b. al-ʿAwwām as a gift and which the latter in turn gave to Muhammad.[25] As early

[21] F. Sarre, "Die Bronzekanne des Kalifen Marwān II im arabischen Museum in Kairo," *Ars Islamica*, I (1934), pp. 10–14, figs. 2 and 5.

[22] M. S. Dimand, "Studies in Islamic Ornament, I," *Ars Islamica*, IV (1937), fig. 5, attributed by him to the second half of the 8th century. The colonnettes are paired, the inner ones being spirally fluted.

[23] Behind all these early Islamic examples of the niche with spiral columns, lies a long series of early Christian *ciboria*, framing the figures of Christ and the Apostles or covering the tombs of Christ and Lazarus, represented on sarcophagi and ivories, and in codices. See, for example, O. M. Dalton, *Byzantine Art and Archaeology*, figs. 70–71; R. Garrucci, *Storia della Arte Cristiana*, III, pls. 128ff., VI, pls. 414, 438, 458, etc., etc. There are examples of arches supported by spirally-fluted columns in early Syrian churches: *e.g.*, Bāṣūfān, H. C. Butler, *Early Churches in Syria, Fourth to Seventh Centuries* (Princeton, 1929), fig. 71 and pp. 236, 238. Likewise in the tradition is the shell niche (*aedicula*) for the Torah in the Synagogue at Dura-Europos, dated A.D. 245 (*The Excavations at Dura-Europos, Preliminary Report of the 6th Season*, 1936, pl. XLVIII and pp.320–23); and there are Spanish Visigothic niches and representations of niches of the same type, *e.g.*, a shell niche framing a *chrismon* from Badajoz in the Museo de Mérida (R. Menéndez Pidal, *Historia de España*, III, p.487). One is tempted to stray away into a discussion of the *ciborium*, the *fornix coeli*, spiral columns and the tree of life — a line of inquiry suggested to me by E. Baldwin Smith — but both space and competence are too limited. It must suffice here to direct the reader's attention to Professor Smith's provocative book, *The Dome, a Study in the History of Ideas* (Princeton, 1950).

[24] Bukhāri (*ed.* Krehl), I, pp.136–7 (VIII, 96) = transl. O. Houdas & W. Marçais, *El-Bokhâri*

(*Publ. de l'école des langues orientales vivantes*, IV³, Paris, 1903, p.180): بين العمودَين المقدمَين and

وجعل عمودًا عن يساره, etc.

[25] For a brief statement on *ʿanazah* and the fundamental bibliography, see the article by A. J. Wensinck, *s.v.* ʿanaza, in *Encycl. of Islām*; also his articles there, *s.v.* ḳibla, sutra, and muṣallā.

as the year 2 of the Hijrah it was carried by Bilāl before the Prophet when he went forth to the *muṣallā* on the two *ʿīds* and was stuck in the ground in front of him to serve the dual purpose of *sutrah* and of *qiblah*, that is, to delimit the piece of ground private to him during his prayers and to point the direction. Likewise it served him for these two purposes, as similar spears served his followers later, during ordinary prayers in the open when on a journey. Both practices are plentifully documented in the *ḥadīth*.[26] In other words, it was in a sense the substitute— actually in certain circumstances, the predecessor— of the mihrāb. In Balādhuri's time, the governors of the provinces set up an *ʿanazah* before them during ceremonial prayers, and Muhammad's own *ʿanazah* was preserved as an important relic of the Caliphate at Samarrā.[27] Later the use of the *ʿanazah* in this manner as an element of the ritual of prayer was abandoned, but a vestige of the practice was preserved in the ceremonial carrying of the *qaḍīb*, the staff ("of the Prophet"), along with the mantle as the insignia of highest office. Also in later Islam, the *khaṭīb* carried a staff or a sword (in Lane's day in Egypt, a wooden sword) as he approached and mounted the *minbar*.[28] All these practices doubtless hark back to dim antiquity, in Becker's words, "Der Stab oder Stock ist für den primitiven Menschen der Ausdruck der Überlegenheit gegenüber dem Stocklosen."

We now come to a more particular examination of the lance on the coin. In considering the shape of the weapon, we have, so far as I know, absolutely no contemporary or nearly contemporary comparative material, either in preserved arms themselves or in pictorial representations. The earliest miniatures are much later, and in the museums there appears to be nothing from the Arab world of nearly this age. In the literature, to be sure, there is a wealth of description of all

[26] Bukhāri, VIII, 17, 90, 92, 93; X, 18 (Krehl, I, pp.107, 135–6, 166 = Houdas & Marçais, pp.144 178–9. See also Ṭabari, *Introductio, Glossarium, Addenda et Emendanda*, p.ccclxxx; Samhūdi (ed Būlāq, 1285) p.187 = F. Wüstenfeld, "Geschichte der Stadt Medina," *Abh. d. K. G. d. W., Göttingen*, IX (1861), pp.127–8. Cf. Wensinck, *A Handbook of Early Muhammadan Tradition* (Leiden, 1927), *s.v. ḥarba* and *ʿanaza*, where there are other references; and Juynboll, *Handbuch des islämischen Gesetzes* (Leiden, 1910), p.84. *ʿAnazah* and *ḥarbah* were synonymous in this context.

[27] See Ṭabari, *loc. cit.* and III, p.1437; cf. Ignaz Goldziher, *Muhammedanische Studien*, II, p.361; Herzfeld, *Geschichte der Stadt Samarra* (1948), p.202. Masʿūdi relates (*Murūj*, VI, p.77) that the robe, *qaḍīb* and *mikhṣarah* of the Prophet were buried by the Umayyad Marwān but were recovered by the ʿAbbāsids.

[28] See C. H. Becker, "Die Kanzel im Kultus des alten Islam," *Orientalische Studien ... Nöldeke*, I, pp.332, 336, 343, 348–9. Cf. Ibn Khaldūn, *Muqaddamah*, II, p.57 (De Slane, II, p.66); Herzfeld, *Geschichte*, p.237; Juynboll, *Handbuch*, pp.87–8; E. W. Lane, *Manners and Customs of the Modern Egyptians* (5th ed., London, 1871), I, pp.106–7; Sauvaget, *op. cit.*, pp.88, 143, 190.

varieties of weapons, and the lexicography is extensive, but one cannot be too certain of some of the terms. The *'anazah* is usually defined as something between a staff and a spear with a head like a spear.[29] The bamboo shaft (probably from India) is *qanāh*,[30] and the apical blade in its entirety is *sinān*.[31] What of the two lateral prongs? Are they perhaps *Dhū ghirārayn*,[32] or does that term simply refer to the two edges of the blade? If the *'anazah* always had these prongs, one would be tempted to etymologize *'anazah* from *'anaza*, "to turn away from," that is, the "spear with bent horns."[33] In any case, this particular form is not unknown in later times and in other lands: there is, for example, an Italian *spetum* of about 1700, with quite similar bent-back prongs, in the Metropolitan Museum of Art.[34]

Now, the *'anazah*, like most Beduin and other spears, had a ferrule with a point at the foot, or shoe, which was called *zujj*.[35] Primarily, the purpose of this buttpoint was to permit the user to stick the lance more firmly in the ground, but it also served as a secondary or auxiliary weapon of attack. Zuhayr in his *Mu'allaqah* says:

وَمَنْ يَعْصِى أَطْرَافَ الزِّجَاجِ فَإِنَّهُ

يُطِيعُ الْعَوَالِى

"Who will not yield to the spears when their feet turn to him in peace,
 Shall yield to the points thereof, and the long flashing blades of steel."[36]

The provision was an ancient one. Polybius tells us that the Romans at first lacked this secondary armament, and later imitated the Greeks who often reversed their spears after the first blow and struck the second with the butt.[37]

How can we then explain this strange bifurcated shoe to the *'anazah* on our coin? It is certainly no ordinary *zujj*. Mr. Stephen Grancsay has assured me that

[29] F. W. Schwarzlose, *Die Waffen der alten Araber aus ihren Dichtern dargestellt* (Leipzig, 1886), pp. 212ff.; G. W. Freytag, *Einleitung in das Studium der arabischen Sprache bis Mohammed und zum Theil später* (Bonn, 1861), pp.252–4. According to Max von Oppenheim ("Der *Djerīd* und das *Djerīd*-Spiel," *Islamica*, II (1926), pp.590–617), the short spear is no longer in common use among the Beduins, and the word itself, in this meaning, has been replaced by *qit'a* and (Persian) *khisht*.
[30] Schwarzlose, pp.214, 227; cf. Burton, *Pilgrimage* (ed. Bohn's Popular Library, 1913), II, p. 106.
[31] Schwarzlose, p.229. [32] *Ibid.* pp.231–2. [33] Cf. Schwarzlose, p.76. [34] MMA 21.182.3.
[35] Schwarzlose, pp.232–3; von Kremer, *Culturgeschichte*, I, p.79.
[36] *Mu'allaqāt* (ed. Ahlwardt), p.97. The translation is from C. J. Lyall, *Translations of Ancient Arabian Poetry* (N.Y., 1930), p.114.
[37] See Gisela M. A. Richter, "Greek Bronzes recently acquired by the Metropolitan Museum of Art," *Am. J. of Archaeology*, XLIII (1939), pp.194–201; cf. *idem, Bulletin of the Metropolitan Museum of Art*, XXXIV (1939), pp.145–8.

it cannot be functional — among other things such an appendage would have thrown the lance completely off balance — and he could only suggest that it had some ceremonial significance. I believe that this very suggestion of a ceremonial usage offers a clue to the explanation. When the mosque was provided with a floor, how could one have stood the ʿanazah upright? Only by setting it in a standard or socket of some sort; and it occurs to me that we may have here a schematic representation on a single plane of a tripod into which the shoe of the lance was placed when in the early days of the Umayyad Caliphate the Amīr al-Muʾminīn led the prayers within the mosque. And we can perhaps, following Sauvaget, go still one step further in speculation to suggest that this socket is the precursor of the ḥalqah, or revolving thimblelike ferrule, which Ibn Jubayr observed attached to the right side of the top step of the minbar of the mosque at Medina and with which, according to tradition, Ḥasan and Ḥusayn played to while away the time while their grandfather was preaching.[38]

There remains the ʿalam, the pennant represented by two streamers attached to the lance just below the blade. I must defer to the experts with regard to the terminology. Is it ʿalam, liwāʾ, rāyah or ʿuqāb?[39] I have chosen to use the term ʿalam because this seems to be the more general and collective term, and it is not entirely clear to me just what the distinction among the words was in Umayyad times. Rāyah was perhaps the banner of the tribe, liwāʾ that of the leader.[40] However, what we have here is surely the ʿalam al-kilāfah. But now we come to the small doubt to which I have referred in discussing the identification of the lance as ʿanazah. A proper ʿalam consisted not only of the piece of cloth or flag which the leader in battle attached to his spear (both in the jāhilīyah and in Islam),[41] but also of the spear itself when so adorned; and, therefore, if these streamers are to be identified as the banner of the Commander of the Believers then, strictly speaking, the lance goes with it, and the whole thing is the ʿalam, and not the ʿanazah. There is no tradition to show that ʿuqāb,[42] the Prophet's flag, with its eagle, was ever attached to the ʿanazah. But my own conclusion is that,

[38] Ibn Jubayr (ed. Wright, *E. J. W. Gibb Memorial Series*, V), pp.192–3: حلقة فضّة مجوّفة مستطيلة
See Sauvaget, p.88.
[39] For the various words for flag and banner, see the articles ʿalam and liwāʾ in the *Encycl. of Islām*; Ibn Khaldūn, *Muqaddamah*, II, pp.44–6; A. Mez, *Die Renaissance des Islāms*, p.130.
[40] Cf. Freytag, *op. cit.*, pp.262–3.
[41] Cf. Georg Jacob, *Alt-arabisches Beduinenleben* (Berlin, 1897), p.126.
[42] Actually ʿuqāb is not exclusively the Prophet's standard; see Lane, *Lexicon*, I, 2102: "the flag attached to a lance, what is bound to a lance for a prefect or governor."

despite the logic of the matter, we have here both *'alam* and *'anazah*: in other words, that the designer of the coin took a forgivable liberty in combining the two for the sake of economy and in order to present the concepts he had in mind.[43] And at this point it is appropriate to bring the iconography into focus with the inscriptions.

Amīr al-Mu'minīn, the Commander of Believers, was the supreme political and military title assumed by the Caliph from the time of 'Umar onward.[44] The symbol is the *'alam*. *Khalīfatu'llāh*, derived from *khalīfah rasūl Allāh*, was a term that had been applied as early as A.H. 35 to 'Uthmān.[45] We know of instances of its use with reference to Mu'āwiyah and 'Abd al-Malik;[46] incidentally, its occurrence here (and on one other coin to be mentioned shortly) is the first in recorded epigraphy. It had already at this early date a more religious connotation than *amīr al-mu'minīn*: the Caliph was the successor to the Messenger of Allāh, not of course in the prophetic or messianic sense developed later in the 'Alid heterodoxy but, at all events, with reference to his supreme authority in everything that con-cerned Islam. And this included, naturally, the leadership of the faithful at the prayers at the very heart of the state. On the coin this concept of religious leader-ship is symbolized by the *'anazah*. As for the *miḥrāb*, it may represent purely the faith of Islam itself, or, as in the case of the mixed symbol of *'anazah* and *'alam*, it may intend to convey both the audience-chamber niche of the supreme *amīr* as well as its derivative, the *miḥrāb* or focal point of the mosque.[47]

[43] Not to be excluded, but suggesting a line of speculation which would lead too far afield, is the possibility that the spear and flag represented on the coin have their origin in an element of very much earlier Semitic iconography, the symbol of Marduk (cf. W. H. Ward, *The Seal Cylinders of Western Asia*, pp.399–400), a spear, frequently with attached streamers. See, for example, H. H. von der Osten, *Ancient Oriental Seals in the Collection of Mr. Edward T. Newell*, p.145, especially figs. 400, 423, 444, etc.; L. Delaporte, *Cat. des cylindres orientaux... de la Bib. Nationale*, nos. 356, 360, 555b, 572–603. The connection, if it exists, with respect to both the ceremonial use of the *'anazah* and its iconographic representation, would be but another example of the persistence of certain basic concepts and their artistic portrayal, in this case the idea of authority.

[44] See Max van Berchem's masterful article, "Titres Califiens," *J.A.*, 1907, p.258, with rich biblio-graphy; cf. Wensinck in the *Encycl. of Islām*, s.v. *amīr al-mu'minīn*.

[45] Goldziher, *Muhammedanische Studien*, II, p.61; van Berchem, *loc.cit.*; T. W. Arnold, s.v. *khalīfa* in *Encycl. of Islām*.

[46] Ṭabari, II, p.78; cf. Mas'ūdi, *Murūj*, V, pp.105, 152, 330; Goldziher, *loc. cit.*; D. S. Margoliouth, "The Sense of the Title *Khalīfah*," in *A Volume of Oriental Studies presented to Edward G. Browne* (Cambridge, 1922), pp.322–8.

[47] The etymology of the word *miḥrāb* has been much disputed; see the bibliography in Pedersen's cited article in the *Encycl. of Islām*. One explanation (apparently accepted by Herzfeld, *Geschichte*

There is one other point related to the legends on the coin that deserves consideration, and here we must turn our attention again to the obverse. As I have remarked earlier, the headdress (as well as the breast and shoulder ornament of the bust) is quite different from that on the coins of Khosrau II after which the usual Arab-Sasanian coins were modeled. The very fact that the head covering differs from the conventional winged headdress of the last Sasanian rulers implies that the bust is not simply an imitation. It is rather the "portrait" of someone; certainly not of a Sasanian, in view of the specific epigraphy and iconography of the reverse. Whose bust then is it but that of the *amīr al-muʾminīn* and *khalīfatuʾllāh*, the bust therefore of ʿAbd al-Malik? The die-egraver lacked the skill, to be sure, to draw a true likeness of the Caliph — it is no more a portrait than are all the late Sasanian representations — but, as with the Byzantine-Arab numismatic portrayals of the standing sword-girt Caliph, the intent is clear and is emphasized by the distinctive non-Sasanian headdress. How is this peculiar headdress to be interpreted? I have found no indigenous prototype in Persian,[48] Syrian or Arab iconography, nor (with one exception mentioned below) any parallel elsewhere. Is it a *tāj* (crown), or an *ʿimāmah* (turban), or a *qalansuwah* (cap)?[49] The question cannot be answered with any certainty, and I propose here only to advance two suggestions in the hope that more competent students of early Islam may support or reject one or the other of them. It may be a *tāj*.[50] If such a view could be ade-

der Stadt Samarra, p.202) is "the place of the lance," from *ḥarbah*; a thesis in support of which our *ʿanazah* (= *ḥarbah*) within the *miḥrāb* might well be adduced. However, the iconography perhaps reflects a *supposed*, or folk, etymology rather than the true one.

[48] Herzfeld tabulated the principal types of Sasanian crowns in *Archaeologische Mitteilungen aus Iran*, IX (1938), p.102.

[49] One correspondent has suggested to me that what is represented is not a headdress at all, but rather the hair gathered up and knotted with a ribbon, the ends of which appear at the left. But I cannot believe this to be the case. Among other things, I doubt that the Caliph would have been portrayed uncovered, even in these early times. Cf. John Walker, "Is the Caliph bare-headed on Umaiyad coins?," in *Numismatic Chronicle*, 1936, pp.321–3. For the three types of headdress, named above, see the articles *kalansuwa*, *tādj* and *turban* (especially the last) by W. Björkman in the *Encycl. of Islam*. Cf. also Herzfeld's interesting remarks on *qalansuwah* and *ṭaylasān* in *Geschichte ... Samarra*, p. 142, note 5, p.150, note 2, and R. Dozy, *Dictionnaire détaillé des noms des vêtements chez les Arabes*, pp.305–11, 365–71.

[50] The *tāj*, though essentially foreign to the Arabs, was not unknown among them. The famous inscription of Namāra (A.D. 328) calls Imruʾl-Qays "King of the Arabs" and ذو أصر التاج (*Répertoire chronologique d'épigraphie arabe*, I, no. 1). H. Lammens emphasizes (*Le berceau de l'Islam*, p.210) that the title of "king" was exceptional among the pre-Islamic Arabs and was limited chiefly to the sedentary populations of ancient Yemen and to the Lakhmids and Ghassānids. In ʿAbbāsid times, the *tāj* became one of the emblems of royalty.

quately defended, one might use this bit of evidence to supplement other more secure argumentation in favor of Umayyad pretentions to monarchy. In this connection, it is not perhaps too far-fetched to point out the remarkable resemblance of this headgear to that of the Visigothic king Wamba (A.D. 672–680) on his coins of Toledo (Pl. XXVIII, fig. 7). The possibility of a relationship is not to be rejected out of hand: we have only to recall the portrait of Roderic at Quṣayr ʿAmrah.

Or it may be rather a turban (covering a *qalansuwah*). This identification need not exclude a significance similar to that of the *tāj*, for to cite two *ḥadīth*, "turbans are the Arabs' crowns" (*al-ʿamāʾim tījān al-ʿArab*), and "wear turbans and thus distinguish yourselves from those who have preceded you" (*iʿtammū khālifūʾl-umam qablakum*).[51] The two tassels at the left might even represent the pendant *ʿadhabah*. While the turban had not commonly been worn by the Arab,[52] early tradition has it that Muhammad urged the Muslims to adopt this distinctive headdress as a badge of their faith; certainly, it was to be worn at prayer and on Friday, and, above all, when delivering the *khuṭbah*. In due course, the turban and lofty *qalansuwah* became important adjuncts of investiture and authority.[53]

All these concepts are in harmony with and complementary to the inscriptions and the symbolism of *miḥrāb* and *ʿanazah* presented on the reverse of the coin; and whether we identify the headdress as *tāj*, *qalansuwah* or *ʿimāmah*, I believe the intent of the artist was to represent an Arab, a Muslim, and probably the Commander of the Believers.

Finally, a word as to the specific date and place of minting of this unique coin — both considerations of more than purely numismatic interest. I have already intimated the approximate date, that is, roughly between the years 75 and 80 of the Hijrah. We can be more specific. There are three unusual anonymous coins of the conventional Arab-Sasanian type but with this exceptional feature: mint and date are rendered in Kufic characters on the reverse. One is dated 73,[54] the two others dated 74,[55] and all three bearing the mint name, Dimishq (Da-

[51] Cf. Björkman, *loc. cit.* (*turban*).

[52] There is evidence that in pre-Islamic times tribal chiefs did wear the *ʿimāmah*, whence *muʿammam*, "leader." See C. A. Nallino, "Sulla costituzione delle tribù arabe prima dell' islamismo," in *Raccolta di scritti editi e inediti*, III, p.66, citing the *Aghāni*. On especially solemn occasions the *ʿimāmah* seems to have been replaced by a *tāj* of some sort.

[53] Björkman, *loc. cit.*, and cf. Sauvaget, *op. cit.*, p.143.

[54] Walker, *op. cit.*, p.23, N.1 (Königsberg Collection).

[55] *Ibid.*, p.23, DD.1 (D. D. Dickson collection, London), and Paul Balog, "An Arab-Sassanian Dirhem with Kufic Inscriptions," in Spink's *Numismatic Circular*, 58, Aug.–Sept. 1950, cols.435–6. I am indebted to Dr. Balog for furnishing me with a photograph of his specimen.

mascus). And in the Historical Museum in Moscow, there is a very remarkable dirhem with the Khosrau II type of obverse but a reverse of Arab-Byzantine type, that is, with the standing sword-girt figure of the Caliph. This is mintless, but almost certainly Damascus, and bears the date 75, again in Kufic.[56] All these coins have in the obverse margin the same religious legends which occur on our dirhem, and furthermore on the reverse of the last coin, at either side of the standing figure, are the words *amīr al-muʾminīn* and *khalīfatuʾllāh*, the latter with the same form of *t* and the identical error in spelling. Thus, we have a series of experimental issues for Damascus, which, together with the rest of the western cities, had had no silver coinage until this time: 73 and 74 with the usual fire-altar, 75 with the standing Caliph and, finally, as noted at the beginning of this paper, 75 in the purely Arab, reformed type. The issues of the years 73 and 74 must surely antedate the *miḥrāb* type, for there cannot have been a reversion to the fire-altar after the experiment with the *miḥrāb*; and our coin cannot be later than 75, when the permanent reformed type was adopted. And so I conclude that the dirhem under discussion was another experimental issue immediately before the complete reform, *i.e.*, that it was struck at Damascus during the course of the year 75 (A.D. 695). The proposed location of the mint is most satisfactory with respect to the comparative architectural and artistic material which has been adduced, for all the material is in the Syrian Hellenistic-Christian tradition — even the *miḥrāb* from the Jāmiʿ al-Khaṣṣaki, which was either imported from Syria or else was executed by Syrian craftsmen. With this almost certain date, I submit that we have here a document of first-rate importance in the history of Islamic symbolism and institutions, for in both respects it is probably the earliest datable relic that has come down to us.

What a misfortune really, from our point of view, that ʿAbd al-Malik was not persuaded to accept this design, or something like it, as the model for his reform! Chance or bigotry rejected the experiment. In place of the endless series of monotonous purely epigraphic coins which persisted almost without interruption in all parts of the Islamic world down to recent times,[57] we might have had a treasure-house of constantly varying iconography reflecting the regional development of Muslim ritual art throughout the centuries.

[56] H. Nützel, "Ein muhammedanischer dirhem mit sassanidischem und byzantinischem typus," in *Trudy Moskovskago Numizmaticheskago Obshchestva*, III (1905), pp.156–9; cf. Walker, p.25, Zub.1.

[57] There are, of course, exceptions, especially in later Seljuq and Mongol times, but they are relatively few. The early Umayyad bronze *fulūs* from Syria, Palestine and North Africa, display some interesting symbols and animal figures. The only one that might conceivably represent a *miḥrāb* is Nützel, *Katalog der orientalischen Münzen*, I, no.2177 (pl.VII); no. 2026 in the same catalogue might also, were it not for the fact that no. 2124 seems to have the same symbol upside down.

7
THE GREEK SOURCES OF
ISLAMIC SCIENTIFIC ILLUSTRATIONS
Kurt Weitzmann

Many years ago, while studying the Greek sources of the iconography of some Bactrian silver vessels,[1] I had the great pleasure of frequently discussing with Professor Herzfeld the relation between Hellenic and oriental art, and I was at that time deeply impressed not only by his profound knowledge of Greek archaeology, but by his sympathetic approach to the various problems of the contribution of the Greek to the oriental world from the Hellenistic period on. Thus I feel that to honour the memory of the great scholar I can do no better than to choose for the present volume a subject which once more deals with the influence of the Greek tradition upon the Orient. This time the material is chosen from Byzantine and Islamic book illumination.

Quite a few of the earliest preserved Islamic manuscripts with illustrations consist of scientific treatises, three of which are, for various reasons, particularly well known: (1) the *Automata* of al-Jazari in the library of Agia Sophia in Istanbul, (2) the *Materia Medica* in the Top Kapu Saray in Istanbul, both of which are today badly mutilated, their best miniatures having been cut out and dispersed, and (3) the *Theriaca* manuscript in Vienna, attributed to Galen. It has generally been assumed that not only the texts of these three treatises but also their pictures are

[1] "Three 'Bactrian' silver vessels with illustrations from Euripides," *Art Bull.* XXV (1943), pp.289ff.

in various degrees dependent on Greek sources. But while a great deal has been written about the miniatures of these three manuscripts with regard to their position in Islamic art, little has been said so far about the nature of the Greek sources from which they stem, although it must be obvious that the degree of inventiveness of the Islamic artists on the one hand and their ability to transform a Greek model oń the other can be properly evaluated only if we have as clear as possible a picture of the character of the illustrated Greek texts. In the present study we have refrained from touching on any of the problems of Islamic miniature painting proper, such as questions of style or locality. Instead we shall focus our attention on defining more precisely than has been attempted hitherto the impact of Greek manuscripts on Islamic book painting, looking at this problem primarily from the point of view of a Byzantinist.

I. Heron and al-Jazari

From the time of their origin to the present day mathematical texts as well as treatises on applied mathematics have always required diagrammatic drawings for the sake of greater clarity through visual means. With the beginning of Hellenism, and particularly in the learned atmosphere of Ptolemaic Alexandria, when the natural sciences became more specialized, the variety and intricacy of the explanatory drawings must have increased proportionally. In the library of the Museion, which, if we may believe the ancient sources, had about half a million volumes in the 3rd century B. C. at the time of its famous librarian Callimachus, a fair percentage of these papyrus scrolls must have consisted of illustrated scientific treatises. Although this library was destroyed in Caesar's time and perhaps even more material was lost through the natural decay of the perishable papyrus, a few such treatises have survived, primarily owing to the fact that they were copied in time in parchment codices.

Thus, what is left to us of scientific treatises from Byzantine times is obviously only a fraction of the classical heritage, and while certain types of technical treatises are lost altogether, others fared better. The need to keep alive the science of war engines was perhaps responsible for the preservation of a whole body of poliorcetic treatises by such ancient writers as Philon of Byzantium, Biton, Heron of Alexandria, Athenaeus, Apollodorus of Damascus, the famous architect of Trajan's forum, Aelianus and Asclepiodotus.[2] Among these the most prolific and

[2] C. Wescher, *Poliorcétique des Grecs*, Paris, 1867.

seemingly also the most popular writer was Heron of Alexandria, of whom more illustrated technical treatises have survived than of any other writer.[3] From his two poliorcetic texts, the Βελοποιϊκά and the Χειροβαλίστρα, an illustration of the former from the 11th century manuscript in the Vatican, *cod. gr. 1164* (= V), may be chosen as a typical example (Pl. XXXIII, fig. 1).[4] It represents one of the comparatively simple war engines which the Greeks called γαστραφέτης, *i. e.*, belly-gun, being a strengthened crossbow pressed against the belly. The illustrator chose the most opportune view to demonstrate the details of the machinery which in this case is the bird's-eye view. Moreover the main part of the weapon is vastly broadened in the design in obvious disregard of natural proportions for the sake of showing the details of the mechanism more clearly.[5] At the same time the object is reduced to a two-dimensional plane, and this is typical of similar construction drawings in all poliorcetic treatises. Although our earliest examples do not go back beyond the 11th century, there is no reason to believe that the drawings deviate in these points from the classical archetype.

Among the many treatises of Heron there was also one on *Mechanics* which, save for a few fragments, is lost in the original Greek, but has come down to us in an Arabic translation made by a certain Costa ben Luca between A. D. 862 and 866. The title of this translation, "About the Lifting of Heavy Objects," signifies the content of the treatise, which in three books deals with apparatuses for the lifting of heavy weights.[6] As might be expected, the text is accompanied by much needed drawings; of these we reproduce two from the manuscript in the University Library of Leyden, *cod. 51 Gol.* (Pl. XXXIII, fig. 2).[7] The upper one shows a tackle,

[3] There is a great deal of writing as to when Heron lived, and the dates vary between the 3rd century B. C. and the 2nd century A. D. Tittel, in Pauly-Wissowa, *R.-E.*, *s.v. Heron,* col. 992 ff. (here the older bibliography).

[4] For Heron's *Belopoiika* in general cf. Wescher, *op. cit.*, pp.71 ff.; H. Diels and E. Schramm, "Heron's *Belopoiika*," *Abhandl. Preuss. Akad.*, Berlin, 1918, no. 2. Here the parallel miniature from the cod. Paris, *Bibl. Nat. cod. gr.* 2442 (=P) is reproduced (=p.9 and fig. 3).

[5] Cf. the modernized drawing and the reconstructed weapon in Diels-Schramm, *op. cit.*, figs. 4 and 5 a–b, and also R. Schneider, *Die antiken Geschütze der Saalburg*, Berlin, 1913, p.24 and fig. 9.

[6] First translated into French by Baron Carra de Vaux, "Les mécaniques ou l'élévateur de Héron d'Alexandrie," *J. A.*, 9th ser. Vol. I (1893), pp.386–472; Vol. II (1893), pp.152–269, 420–514. — Translated into German by L. Nix and edited together with W. Schmidt, *Herons von Alexandria Mechanik und Katoptrik*, Leipzig, 1900.

[7] P. de Jong et M. J. de Goeje, *Catalogus Codicum orientalium Bibliothecae Academiae Lugduno Batavae*, Vol. III, p.46, where no date is suggested. Carra de Vaux, *op. cit.*, I, p. 394, gives A. D. 1445 as *terminus ante quem* on the basis of an entry from that year in the cover. Prof. P. K. Hitti, who kindly gave me his opinion on the date, proposed about the 13th century on palaeographical grounds.

consisting of two supports with a crossbeam on which a pulley is fastened for the lifting of heavy stones; in order to ground the two supports more firmly, ropes are pegged into the ground. It is interesting to see that the illustrator who made the drawings for Carra de Vaux's edition[8] redesigned the apparatuses in modern perspective. This must have seemed perfectly justified in view of Carra de Vaux's verdict (shared also by Nix and Schmidt) that the drawings are very degenerate and lack perspective. It is, of course, true that the drawings of the Leyden codex, far removed as they are from the archetype, are quite crude and full of misunderstandings, but this is not to be confused with the issue of their total lack of perspective. We have observed above that the technically more accomplished poliorcetic drawings in the Greek Heron manuscript also lack perspective and that maximum clarity in every detail, even at the expense of foreshortening, is a consistent principle. Thus we have good reason to believe that the drawings in the Leyden manuscript — and this applies also to the lower apparatus on our page where a pulley is hung up on three converging supports — basically reflect the Greek method of technical drawings.

It therefore seems to us quite certain that in the 9th century translation of Costa ben Luca the drawings of a Greek model were copied with no change in the character of the design, and that from them all further Arabic copies are to be derived, including, of course, those of the Leyden manuscript itself. Typical, moreover, of all classical drawings in technical treatises — and this too is reflected in the Byzantine copies of the *Belopoiika* and the Arabic copy of the *Mechanics* — is the limitation to the absolutely necessary data, with no concession whatsoever to artistic embellishment.

In the 10th century the poliorcetic treatises of Heron were not only copied anew for the great encyclopedic enterprise of the emperor Constantine Porphyrogenitus but were also paraphrased by an anonymous writer who has usually been called Heron of Byzantium.[9] Now it is interesting to observe that the miniatures of this text, of which the 11th century Vatican codex *gr. 1605* is the earliest example,[10] show, in addition to the war engines, warriors who manipulate them. Such "ex-

[8] *Op. cit.*, II, pp.487–8 and figs. 50–51 correspond with those of our photograph. With a few exceptions the same drawings were also used for the edition of Nix and Schmidt. Cf. *ibid.*, pp. XXXIIIff. and figs. 48-49.

[9] R. Schneider, "Griechische Poliorketiker, II, Παραγγέλματα πολιορκητικά," *Abhandl. Göttinger Gesellsch. der Wissensch.*, N. F. XI (1908–09), no. 1.

[10] C. Giannelli, *Codices Vaticani Graeci, Codices 1485–1683*, Vatican, 1950, pp.260ff.

planatory" figures are inventions of the Middle Byzantine period[11] and may have been inspired by Chronicle illustrations where they are familiar types connected with representations of the siege of a city. Significantly, they do not occur in any of the text illustrations to the older Heron of Alexandria, which in this respect preserve the classical tradition in its purity, and the same applies also to the Arabic manuscript of the *Mechanics* in Leyden.

By far the most popular and most frequently copied treatises of Heron are the Πνευματικά and the Αὐτοματοποιητική which deal with the invention of ingenious contrivances in which the love for gadgetry, spreading since the Hellenistic period, found satisfaction.[12] Partly they contain the same type of simple construction drawing as that found in the manuscripts of the *Poliorcetica* and the *Mechanics*. There is e. g., in the earliest copy of the *Pneumatica*, the codex *gr. 516* in the Marciana in Venice from about the 13th century,[13] a drawing of an automatically emptying siphon (Pl. XXXIII, fig. 3, lower sketch), where within one very schematically rendered vessel two different devices are drawn side by side. It seems only natural that the modern illustrator of Schmidt's edition would realistically place each device separately in a vessel of its own and draw the latter more realistically,[14] but to the Byzantine draughtsman, who in this point quite surely follows the classical model, the clear rendering of the mechanical device was more important than the shape of the vessel.

But where compressed air or waterpower is used for moving automatic human figures or for making them act with mechanical motions, the introduction of the human figure is, of course, a necessity. The same page of the Venetian manuscript shows a contrivance in which two figures pour water on a burning altar, the point being that with the expansion of heated air, pressure is put on a water tank and water driven through a pipe within the sacrificing human figure. While the modern reconstruction drawing in Schmidt's edition[15] uses conventional types of a warrior and a woman of the 5th century B. C., *i. e.*, of a period in which this type

[11] K. Weitzmann, *Illustrations in Roll and Codex, a Study of the Origin and Method of Text Illustration*, Princeton, 1947, p.167 and fig. 163.

[12] W. Schmidt, *Herons von Alexandria Druckwerke und Automatentheater. Heronis Alex. opera omnia*, Vol. I, Leipzig, 1899.

[13] *Ibid.*, Suppl. to Vol. I, pp.3ff. — St. J. Gasiorowski, *Malarstwo Minjaturowe Grecko-Rzymskie*, Cracow, 1928, p.173, and figs. 88–89. The manuscript has variously been dated between the 12th and the 15th centuries. In our opinion the 13th century is the earliest possible date.

[14] Schmidt, *op. cit.*, p.83 and figs. 14a–b.

[15] *Ibid.*, pp.80ff. and fig. 13.

PLATE XXXIII

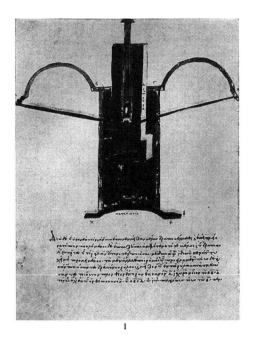

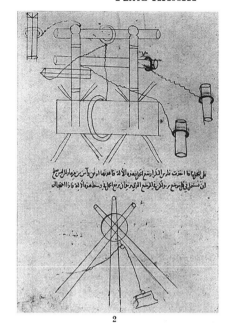

1

2

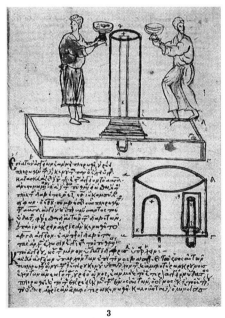

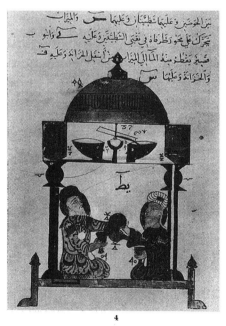

3

4

Fig. 1: Vatican, *Cod. gr. 1164.* Fol. 110ᵛ: Belly-gun. *Fig. 2:* Leyden, Univ. Lib. *Cod. or. 51,* p. 61:
A tackle and a pulley. *Fig. 3:* Venice, Marciana, *Cod. gr. 516.* Fol. 171ʳ: Two automata. *Fig. 4:*
Boston, Museum: Automaton from the codex in Istanbul.

PLATE XXXIV

5

6

7

8

Fig. 5: New York, Morgan Lib. *Cod. 652.* Fol. 77ᵛ: Caraway and Cyperus. *Fig. 6:* Paris, Bibl. Nat. *Cod. arab. 4947.* Fol. 63ᵛ: Caraway and Dill. *Fig. 7:* Paris, Bibl. Nat. *Cod. gr. 2179.* Fol. 5ʳ: Mouseear. *Fig. 8:* Leyden, Univ. Lib. *Cod. or. 289.* Fol. 8ʳ: Malabathrum.

PLATE XXXV

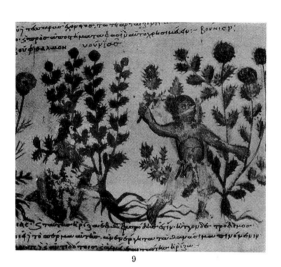

9

10

11

12

Fig. 9: Mt. Athos, Lavra. *Cod.* Ω 75. Fol. 35ᵛ: Bunium and Ox-eye. *Fig. 10:* Mashhad, Shrine Mus.
Dioscurides: Balsam-tree. *Fig. 11:* New York, Morgan Lib. *Cod. 652.* Fol. 346ᵛ: Serpents. *Fig. 12:*
Vienna, Nat. Lib. *Cod. A.F. 10.* Fol. 13ᵛ: Serpents.

PLATE XXXVI

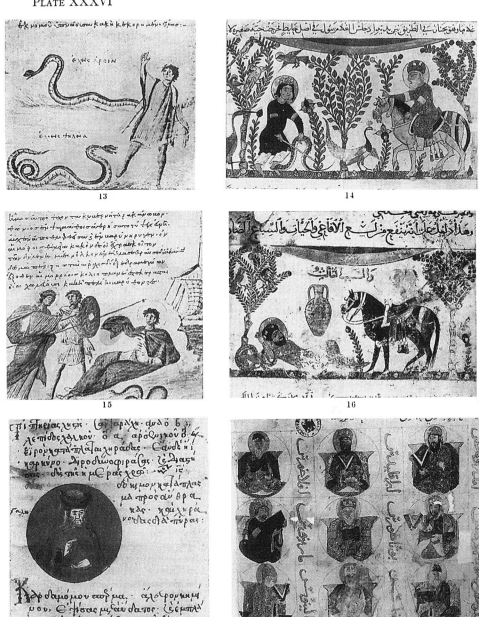

Fig. 13: Paris, Bibl. Nat. *Cod. suppl. gr. 247.* Fol. 6ʳ: Attacking serpent. *Fig. 14:* Vienna, Nat. Lib. *Cod. A.F. 10.* Fol. 2ᵛ: Killing of attacking serpent. *Fig. 15:* Paris, Bibl. Nat. *Cod. suppl. gr. 247.* Fol. 12ʳ: Serpent biting Canopus. *Fig. 16:* Vienna, Nat. Lib. *Cod. A.F. 10.* Fol. 29ᵛ: Serpent biting Tulunus. *Fig. 17:* Milan, Ambros. Lib. *Cod. E. 37 sup.* Fol. 82ʳ: Galen. *Fig. 18:* Vienna, Nat. Lib. *Cod. A.F. 10.* Fol. 1ᵛ: Portraits of Physicians.

of automaton did not yet exist, the two figures of the Venetian codex, crude as they are, reflect the types that must have existed in the archetype of Heron.

When al-Jazari wrote his "Book that Combines Theory and Practice Useful in the Craft of Ingenious Contrivances," in the very first years of the 13th century, each of the 50 constructions dealt with in six books had of course a drawing. Some of the best of these preserved today come from a manuscript in the library of Agia Sophia in Istanbul, *cod. 3606*, from which they were cut out and dispersed through many museums and collections.[16] One of the loose leaves of this manuscript, which as Riefstahl proved is dated A. D. 1354,[17] is now in Boston (Pl. XXXIII, fig. 4)[18] and represents two crouching men under a domed building; each pours a drink into the other's cup, which is then raised to the lips and emptied. The main mechanism is hidden under the cupola and the water runs down through the columns and up again through the figures into the flasks they hold.

That al-Jazari wrote his treatise under the inspiration of Greek models has generally been recognized, though there is some debate as to the precise texts he used. It has been argued that his source was not Heron of Alexandria or Philon of Byzantium, who certainly were not the only writers on automata, although they were undoubtedly the most popular ones in the Middle Ages. Heron is a compiler rather than an inventor and he himself used Archimedes, Ctesibius and other writers whose treatises must have included similar types of illustrations. So whatever al-Jazari had before his eyes must have contained drawings like those of the Venetian manuscript of Heron (if it was not actually a Heron manuscript after all), *i.e.*, illustrations of contrivances in which the automatic human figure played an important role. Of course, the two crouching figures in the Boston miniature are thoroughly Islamic in character. The point is that the Islamic illustrator did not have to invent this type of automaton, but that he was in a position merely to trans-

[16] The bibliography to this manuscript is conveniently gathered by K. Holter, *Die Islamischen Miniaturhandschriften vor 1350*, Leipzig, 1937, pp.6ff., no. 13, and supplemented by H. Buchthal, O. Kurz and R. Ettinghausen in *Ars Islamica*, VII, 1940, pp.148-149. In addition, cf. the more recent remarks by E. Schroeder, *Persian miniatures in the Fogg Museum of Art*, Cambridge, 1942, pp.21ff. and pl. 1.

[17] R. M. Riefstahl, "The date and provenance of the automata miniatures," *Art Bull.*, XI (1929), pp.206ff.

[18] Repeatedly reproduced. E. Blochet, "Peintures de manuscrits arabes à types byzantins," *Rev. Arch.*, 4th ser., IX (1907), p.211 and fig. 9. — F. R. Martin in: *Meisterwerke Muhammedanischer Kunst in München*, 1910, vol I, pl. 3. — G. Marteau and H. Vever, *Miniatures persanes*, Paris, 1913, pl. XXXIX. — A. K. Coomaraswamy, "The Treatise of al-Jazari on Automata," *Museum of Fine Arts, Boston, Communications to the Trustees*, VI, Boston, 1924, p.14 and pl. IV.

form into his own style similar contrivances of Greek models, being perfectly capable of designing seated figures where the Greek model may have had standing ones.

II. Dioscurides

About the time that Costa ben Luca translated Heron's *Mechanics* into Arabic, *i. e.*, about the middle of the 9th century, one of the several translations into Arabic of the *Materia Medica* of Dioscurides, the main source of pharmaceutical knowledge during the Middle Ages, was made by Stephanos, son of Basilios, a Christian from Baghdad. Fortunately, we still possess two illustrated Greek codices of Dioscurides from the pre-iconoclastic period which are close enough to the classical archetype to reflect its original character. These are the so-called Anicia codex in Vienna, *Nat. Lib. cod. med. gr. 1*, from the 6th century[19] and another which formerly was also in Vienna but is now in Naples, *Bibl. Naz. cod. olim Vienna suppl. gr. 28* of the 7th century.[20] Particularly in the former there is to be noticed the exclusive concern of the illustrator with the veracity of the outer appearance of the plants. In the Naples manuscript of the 7th century, however, and even more so in a Paris manuscript, *Bibl. Nat. gr. 2179* from the 9th century (Pl. XXXIV, fig. 7),[21] the realistic element has partly been sacrificed in favour of a more simplifying and at the same time a more ornamentalizing tendency. But in the 10th century again, as can be seen in an imperial manuscript now in the Morgan Library in New York, *cod. M. 652*, which was most likely made for Constantine Porphyrogenitus,[22] a serious and largely successful endeavour was made to copy

[19] A. v. Premerstein, K. Wessely & J. Mantuani, *Dioscurides, Codex Aniciae Julianae picturis illustratus, nunc Vindob. Med. gr.* I (*Codices Graeci et Latini photogr. depicti*, Vol. X) (facsimile), Leyden, 1906. — P. Buberl, *Die Byzantinischen Handschriften*, Vol. I (*Beschreibendes Verzeichnis der illuminierten Handschriften in Österreich*, Vol. VIII, Pt. 4), Leipzig, 1937.

[20] *Palaeographical Society*, II ser., Vol. I (1884–94), pl. 45. — Ch. Singer, "The Herbal in Antiquity," *Journ. Hell. Stud.*, XLVII (1927), p. 24 and fig. 16.

[21] Ed. Bonnet, "Essai d'identification des plantes médicinales mentionnées par Dioscoride, d'après les peintures d'un manuscrit de la Bibl. Nat. de Paris (MS. grec. No. 2179)," in *Janus*, VIII (1903), pp. 169 ff., 225 ff., 281 ff. — H. Omont, *Facsimilés de manuscrits grecs, latins et français du V^e au XIV^e siècle exposés dans la Galerie Mazarine*, Paris (n. d.), pl. VI. — Singer, *op. cit.*, p. 27 and figs. 23 and 25–26. — K. Weitzmann, *Die Byzantinische Buchmalerei des 9. und 10. Jahrhunderts*, Berlin, 1935, p. 82 (here further bibliograhy) and pl. LXXXVIII, 555–556. — *Idem, Roll and Codex*, p. 71 and fig. 57.

[22] *Pedanii Dioscuridis Anazarbaei de Materia Medica*, 2 vols (facsimile), Paris, 1935. — Singer, *op. cit.*, pp. 25 ff. and figs. 35, 42. — B. da Costa Greene and M. Harrsen, *The Pierpont Morgan Library. Exhibition of Illuminated Manuscripts held at the New York Public Library*, New York, 1933/34, p. 7, no. 12, pl. XI. — Weitzmann, *Byz. Buchmalerei*, p. 34 and pl. XLI, 231–233.

faithfully a good model of the quality of the Anicia codex. From a comparison of the picture of the caraway plant, the Greek καρώ,[23] in the Anicia codex[24] with the corresponding one in the Morgan codex (Pl. XXXIV ,fig. 5), we learn that in the latter manuscript the plant is reduced in size and, instead of filling a full page, has to share the surface area with a second plant and a few lines of writing in between. Nevertheless in the realistic approach the painter of the Morgan codex is much akin to his early predecessor, though his plants are slightly less refined in execution.

In many ways related to the Morgan Dioscurides is one of the finest Arabic copies we have today, the codex *arab. 4947* in the Bibliothèque Nationale in Paris, which has been variously dated between the 9th and 13th centuries.[25] It is a codex consisting of thick leaves of parchment, a material which at some time must have been considered so precious that most of the margins are cut away save at those spots where the plant pictures protrude into them (Pl. XXXIV, fig. 6). The organization of the page, in which widely spaced text lines written in monumental script alternate with large plant pictures filling more or less the width of the writing column, is indeed very similar to that of the Morgan manuscript.[26] On the page here reproduced the upper plant is once more the caraway. Though deviating somewhat more from the classical archetype than the corresponding miniature in the Morgan manuscript, it still retains the essential features, in spite of the fact that the Dioscurides text, as is repeatedly the case, has no detailed description of the plant's characteristics. There is a tendency to enlarge the umbels, from which the drug is procured, as being the most important part of the plant, even to the point of reducing the foliage. Moreover a tendency towards stronger symmetry may be observed. However, these abstractions are only in their initial stages, and the illustrator of the Paris manuscript is, in good classical fashion, still primarily con-

[23] M. Wellmann, *Pedanii Dioscuridis Anazarbei de Materia Medica*, Vol. II, Berlin, 1906, p.70 (= Lib. III § 57).

[24] Premerstein, Wessely, Mantuani, *op. cit.*, pl. fol. 188ᵛ.

[25] Ed. Bonnet, "Étude sur les figures de plantes et d'animaux peintes dans une version arabe, manuscrite de la matière médicale de Dioscuride," *Janus*, XIV (1909), pp.294ff. — E. Blochet, *Les peintures des manuscrits orientaux de la Bibl. Nat.*, Paris, 1914-20, p. 5, n. 1. — *Idem, Catalogue des manuscrits arabes des nouvelles acquisitions*, Bibl. Nat., Paris, 1925, p.44. — Prof. P.K. Hitti, who kindly gave me his opinion, dates the manuscript in the 12th c. at the earliest but more likely even in the 13th on account of the profuse use of diacritical marks. The 13th c. date is shared by Bonnet, *loc. cit.*, whereas Blochet proposes the 9th-11th centuries.

[26] The Arabic manuscript, measuring about 40×30 cm., even surpasses the Greek one in the Morgan Library slightly in size, which in both cases is quite monumental.

cerned with the scientific problem of achieving an effect as close as possible to nature, though he did not succeed to the same degree as his Greek colleague.

Of course, the Morgan manuscript cannot have been the direct model, if for no other reason than the fact that both belong to different recensions, the Morgan manuscript to the alphabetical group, in which the plant following the caraway is the *cyperus*, and the Parisian to the non-alphabetical, according to which the next plant is the dill, the Greek ἄνηθον. In the former manuscript the drawing of this plant is lost, but it is preserved in the Anicia codex,[27] and compared with it the relationship in size between the umbel and the feathery leaves is even more unbalanced in the Arabic copy, where the netlike ramifications of the leaves are replaced by a simplified type of bundle-like leaves which have lost their resemblance to nature. Even so, among the illustrated Arabic Dioscurides manuscripts that we are acquainted with this Parisian copy is the closest to a good Greek model.

A desire to enrich the plant pictures artistically beyond the pure scientific requirements led to the addition of human figures who in one way or other busy themselves with a plant. As far as we know, from surveying Arabic Dioscurides manuscripts, the earliest one with a human figure is in the University Library of Leyden, *cod. or. 289 Warn.*, which is dated February, A.D. 1083.[28] In the first book Dioscurides describes among others the plant μαλάβαϑρον[29] as a leaf floating on the surface of water and being without a root. It is collected, dried and lined up on a linen thread, and its usefulness is manifold, including the power of healing inflammation of the eye. The miniature which accompanies this passage (Pl. XXXIV, fig. 8) depicts a pond with leaf-like plants floating on its surface, while a man, seated at the shore with his legs dangling in water, holds a specimen up close to his eyes. Probably the painter wanted in this manner to indicate that the plant is good, as the text says, against inflammation of the eyes. It must be noticed that this picture is the only one in the manuscript (at least in its present state of preservation) to contain a human figure, a fact which seems to point to an experimental stage in the development of a new type of scientific illustration. Was this a fancy of the illustrator of the Leyden codex or, perhaps, its Arabic model, or was there a precedent for it in earlier Greek Dioscurides manuscripts?

[27] Premerstein, Wessely, Mantuani, *op. cit.*, pl. fol. 27ᵛ.

[28] De Jong and de Goeje, *Catal.*, *op. cit.*, III, p.227. — M. Meyerhof, "Die Materia Medica des Dioskurides bei den Arabern," in *Quellen und Studien zur Geschichte der Naturwissenschaft und der Medizin*, III, fasc. 4, 1933, p.81 [289].—The colophon adds that the manuscript was copied from an older one of the year A.D. 990.

[29] Wellmann, *op. cit.*, Vol. I, p.16 (=Lib. 1 § 12).

The latter alternative seems better by virtue of intrinsic probability as well as of the preserved material, fragmentary as it may be. The first appearance of such complementary human figures attached to plants is, as far as our knowledge goes, in the above-mentioned Greek Dioscurides in Paris, *cod. gr. 2179*, which on palaeographical grounds has always been dated in the 9th century.[30] Only a relatively small section of this manuscript — the first seven folios to be precise — has altogether six plants with human figures added to them, but this does not give a true picture of the manuscript in its original state, since at the beginning alone 121 folios are missing which quite possibly contained other plants with human figures. There is, *e. g.*, the plant μυὸς ὦτα (Pl. XXXIV, fig. 7) the root of which is described as having healing power against αἰγίλωψ, *i. e.*, an ulcer in the eye.[31] In order to demonstrate this property, a youth clad in a golden tunic, is represented in a reclining attitude, holding one hand in a protective gesture before his eye. Though the type is somewhat different from the one in the Arabic miniature in Leyden, yet both have a very similar function in explaining the pharmaceutical usefulness of the plant. Significantly, the Anicia codex in Vienna and the Neapolitanus are both devoid of any such human figures, and the fact that in the Greek miniature discussed above, the scale of the human figure is incongruous to that of the plant, serves, on the formalistic side, to strengthen our thesis that human figures like these were added later. In all likelihood we are dealing here with a phenomenon not older than the post-iconoclastic period.

In another Greek Dioscurides manuscript in the Lavra monastery on Mount Athos, *cod. Ω 75*, from about the 12th century,[32] there are about 25 plant pictures with human figures which are distributed over the whole text. Here we find a new category of supplementary human figure: instead of demonstrating his affliction, for which the plant provides a cure, by an indicative gesture, he is concerned with collecting those parts of the plants from which the drugs are prepared. There is, *e. g.*, the plant βούνιον[33] of which Dioscurides says that the seeds,

[30] Cf. note 21. — Montfaucon, *Palaeographia Graeca*, Paris, 1708, pp.256ff., proposed an Egyptian origin, an opinion which has been accepted by many scholars either as proof or at least as a working hypothesis. Egypt seems indeed more likely than the localization to South Italy which we had once proposed (*Byz. Buchmalerei, loc. cit.*), but no longer maintain.

[31] Wellmann, *op. cit.*, Vol. I, p. 253 (=Lib. II § 183).

[32] H. Brockhaus, *Die Kunst in den Athosklöstern*, Leipzig, 1891, pp.168, 232, note 1. — Spyridon and Eustratiates, *Catalogue of the Greek Mss. in the Library of the Laura on Mount Athos*, Cambridge, Mass., 1925, p.343. — Weitzmann, *Roll and Codex*, p. 86 and fig. 68.

[33] Wellmann, *op. cit.*, Vol. II, p. 271 (= Lib. IV § 123).

both moist and dry, as well as the juice gained from the roots, stalks and leaves, are used for healing purposes. The picture, in which this plant takes a central place between two others (Pl. XXXV, fig. 9), shows a bearded man wearing a pointed hat, who in a kneeling position holds one stalk with his left hand, and with the right either cuts the stalk or draws sap from the plant. To the third plant of the same interstice, called βούφθαλμος, a youth is added, who, clad only with a loincloth, swings an axe in order to cut a stalk. In both instances the text does not explicitly say that branches have to be cut, but it is obvious that the painter used this motif in several instances in order to demonstrate how the useful parts of the plant are gathered. There is still another type of figure, most often female, who is busy picking flowers or fruit and collecting them in baskets.[34]

Human figures similarly occupied with a plant can also be found in Arabic Dioscurides manuscripts. A Mesopotamian manuscript of the end of the 12th century in the Shrine Museum of Mashhad[35] has among its almost 700 plant pictures four with human figures, one of which represents a balsam tree (Pl. XXXV, fig. 10).[36] According to the text this tree is to be tapped by iron nails and in agreement with this statement the illustrator added two men extracting the health-giving sap in the prescribed manner. The kneeling man at the left, who is dressed, as Florence Day rightly observed, in the conventional costume of classical antiquity, may well be compared with the kneeling man in the Lavra miniature. Once more the Byzantine parallel suggests that the Arab illustrator was inspired by a Greek model, though at the same time he showed a capability of recasting it in his own, outspoken style.

It is in the light of the Greek and Arabic Dioscurides manuscripts mentioned so far that we have to re-evaluate the historical position of those dispersed miniatures which are cut out from the manuscript in the Top Kapu Saray in Istanbul, *cod. 2148*, which contains Books IV and V of the *Materia Medica* and is dated in the year 1224.[37] Nearly all the dispersed miniatures have been traced to the present

[34] Weitzmann, *op. cit.*, fig. 68.

[35] L. Binyon, J.V.S. Wilkinson, B. Gray, *Persian Miniature Painting*, London, 1933, p.25, no. 6 and pl. V A–B.— M. Bahrami, *Iranian Art, Catalogue of an Exhibition in the Metropolitan Museum*, New York, 1949, p.22, no. 51.— The best writing on this manuscript so far by F. E. Day, "Mesopotamian Manuscripts of Dioscurides," *Bulletin of the Metropolitan Mus. of Art*, N.S., VIII (1949—50), pp.274 ff. with 4 figs. from this ms.

[36] Photograph courtesy of the Metropolitan Museum of Art.

[37] The very extensive bibliography on this manuscript and its cut-out miniatures up to 1940 is conveniently gathered in Holter's list (cf. note 16), pp.11–12, no. 27, and in the supplement by Buchthal, Kurz and Ettinghausen, pp.151–2, no. 27.

owners and, at least photographically reassembled in Buchthal's very useful article,[38] which provides a new basis for future studies of this manuscript so important for the history of early Arabic book illumination. In these miniatures we observe the use of the human figure in connection with plants on a much vaster scale than in any previously discussed herbal. At the same time, it must have become obvious that, after our acquaintance with the Leyden and Mashhad manuscripts (Pls. XXXIV, 8, XXXV, 10), we are not dealing in the Dioscurides of 1224 with a new phenomenon, as many of the previous writers on this subject would have us believe.[39] No doubt these famous cut-out miniatures surpass their predecessors, in Byzantine and Arabic manuscripts alike, in ornamental splendor and richness of narrative details. Even so, the figurative compositions here employed are limited to a rather few schemes nearly all of which can be traced to Greek sources, although it should not be overlooked that the Arabic illustrator has considerable artistic power in transforming whatever the Greek model may have suggested to him into a thoroughly oriental style.

First of all, it must be pointed out that nearly all miniatures with human figures were cut out of the Istanbul manuscript and that in the original codex such miniatures formed the minority among the traditional, simple plant pictures.[40] Where a deer biting a snake is introduced[41] without reference to the text as foil for the plant called *cytisus*, we may recognize a group going back to a Greek *Physiologus* where the story of the deer's fight against the snake is told in detail and was illustrated as we know from the lost Smyrna-*Physiologus*.[42] Actually this very picture already existed in classical animal treatises preceding the *Physiologus* in date and persisted long thereafter in the mediaeval *Bestiaria*.[43] Moreover, there is a plant with a bull alongside it in the Lavra Dioscurides[44] which shows

[38] H. Buchthal, "Early Islamic Miniatures from Baghdād," *Journal of the Walters Art Gallery*, V (1942), pp.19ff.

[39] Buchthal, *op. cit.*, p.32, is not unaware of the earlier Greek parallels, but not having had the full evidence from the Greek as well as the earlier Arabic Dioscurides manuscripts available, he was not yet in a position to establish a connection as close as we believe to have existed.

[40] Cf. Buchthal, *op. cit.*, figs. 5, 6, 9.

[41] *Ibid.*, fig. 7. This miniature belongs now to the W. R. Nelson Gallery of Art, Kansas City. Cf. *Islamic Art. Selected Examples from the Loan Exhibition of Islamic Art at the Cleveland Museum of Art*, 1944, p.5.

[42] J. Strzygowski, "Der Bilderkreis des Griechischen Physiologus" (*Byzant. Archiv*, fasc. 2), Leipzig, 1899, p.37.

[43] Weitzmann, *Roll and Codex*, p.138 and figs. 120 and 122.

[44] Fol. 8ᵛ. Photo Princeton, Department of Art & Archaeology. The meaning of this bull is, how-

that Greek Dioscurides manuscripts also possessed animals as additions to the plants.

As far as the man bitten by a mad dog is concerned,[45] this picture, demonstrating the affliction against which a certain herb is a useful remedy, belongs to the same category as those in the Greek and Arabic manuscripts (Pl. XXXIV, figs. 7—8) which show a sick man afflicted by an inflammation of the eye. The doctor who cuts the stalk of the plant *helioscopius*[46] is involved in the same kind of occupation as those who cut stalks and draw the sap in the Lavra and Mashhad manuscripts (Pl. XXXV, figs. 9—10). Most numerous are the miniatures which demonstrate the preparation of the medicine by a physician, who is usually assisted by one or even two helpers or fellow-physicians.[47] The most common procedure is the preparation of the ingredients in a vessel, and the subsequent boiling of the mixed fluid in a kettle over a fire. Basically the same manipulations, though in a simpler form, are represented in the Dioscurides of the Morgan Library, which depicts the preparation of white oil.[48]

The physician advising or treating a patient[49] has so far not been found in any Greek Dioscurides manuscript. But in the Middle Byzantine period, as exemplified by the 10th century treatise on the dislocation of bones by Apollonius of Citium in Florence, Laurentian Library *cod. Plut. LXXIV, 7*, there still existed copies of ancient medical treatises, where the treatment of a patient by a physician is depicted in a great variety of actions as required by the kind of illness.[50] From a medical treatise of this kind an illustrator of the Dioscurides could easily have taken over some such compositional scheme and adjusted it to the special needs of the botanical text. It only remains questionable whether this adaptation had already taken place, as seems indeed very possible, in a Greek Dioscurides now lost or as yet unknown, or whether it was an Arab illustrator who took this step for the first time.

A final group of pictures shows physicians assembled in a learned discussion.[51] One is immediately reminded of two frontispiece miniatures in the Anicia codex

ever, not quite clear, since he is placed alongside of plants which are not inscribed, and there is no text on this page.

[45] Buchthal, *op. cit.*, fig. 30. [46] *Ibid.*, fig. 8. [47] *Ibid.*, figs. I, II–I4, I6–2I, 3I.
[48] Facsimile (cf. note 22) fol. 225ᵛ: Weitzmann, *Byzant. Buchmalerei*, p.34 and pl. XLI, 233 (here wrongly designated as fol. 235ᵛ).
[49] Buchthal, *op. cit.*, figs. 4, 10, 15, 24, 26.
[50] H. Schöne, *Apollonius von Kitium*, Leipzig, 1896.
[51] Buchthal, *op. cit.*, figs. 23, 27–29.

in Vienna,[52] in each of which seven physicians are arranged in horseshoe form, not unlike the representations of the seven wise men one finds in Roman mosaics. Those physicians in the Arabic miniatures who crouch on the ground and raise their hands with gestures of dispute are particularly comparable to some of the assembled physicians in the Anicia codex, who sit on very low pieces of rock which give the impression of the bare ground rather than a bench or chair. It needed no great imagination on the part of the Arab artist to transform this kind of posture into the typical oriental cross-legged attitude.

On the other hand, that an Arabic illustrator of a Dioscurides herbal may, in certain instances, have been able either to invent a new scene or to take over a compositional scheme from other Arabic manuscripts like the *Maqāmāt* of Ḥarīri, as has repeatedly been suggested, should by no means be excluded as a possibility. It is even quite probable in the case of the boat on the river Gagos,[53] though less likely in that of the scene representing the slaughtering of a bull.[54] We have not been able to trace the latter motif in a Greek herbal or related scientific text, and yet it is a môtif so common in classical art that we should be surprised if it were invented by an Arabic artist rather than having been adapted from some Greek model. We must bear in mind the extremely fragmentary preservation of illustrated manuscripts, Greek and Arabic alike, in those centuries, and we have to realize that the chances of finding a Greek model for every single type of scientific Arabic miniature even where such may have existed, are not too great. But on the other hand we should like to reiterate that Greek scientific manuscripts, which formed the basis for Arabic ones, were enriched in the Middle Byzantine period by figural representations on a much larger scale and with a much greater variety of motifs than has hitherto been realized, and that, therefore, the connection between the two is much closer. The next paragraph, we hope, will lend more support to this contention.

III. Pseudo-Galen

The National Library of Vienna possesses an illustrated 13th century manuscript which bears the signature *A. F. 10* and deals with antidotes against poisonous snake bites.[55] This treatise on *Theriaca*, which is commonly quoted as being by

[52] Premerstein, Wessely, Mantuani, *op. cit.*, pls. fol. 2ᵛ and 3ᵛ. — Buberl, *Byz. Handschriften*, I, pp.14ff. and pls. I—II.

[53] Buchthal, *op. cit.*, fig. 22. [54] *Ibid.*, fig. 25.

[55] For bibliography until 1940 cf. Holter's list, pp.15–16, no. 37 and the supplement by Buchthal, Kurz and Ettinghausen, p.154, no. 37.

Galen, is supposedly a commentary on Galen's *De Antidotis Lib. I* by the learned 6th century Alexandrian scholar John the Grammarian, or Joannes Philoponos, as he is also called. However, Max Meyerhof has brought forth the evidence that the text contains next to nothing of Galen's recipes and consists of a more popular pseudo-scientific piece of writing not worthy of a great scholar like John the Grammarian.[56] The Vienna codex was written, as has generally been assumed, around 1240 in Mosul or Aleppo and contains a number of miniatures,[57] which in more than one respect resemble those of the Dioscurides manuscript of 1224.

Comparable in character to the pictures of the pure plants in herbals are four pages of the Vienna Galen which depict various types of poisonous snakes in strictly scientific fashion (Pl. XXXV, fig. 12).[58] The names of the snakes are sometimes corrupted and their coloring becomes rather abstract, so that an identification from nature would no longer be possible, and yet the artist's method of confining himself to a factual, full-length representation of the serpent without groundline or background, still reveals the very essence of classical scientific illustration. A similar treatise on antidotes against snake bites by Nicander of Colophon, who in the 2nd century B. C. wrote his Θηριακα and ᾽Αλεξιφάρμακα, is preserved in a beautifully illustrated manuscript in Paris, *cod. suppl. gr. 247*, of the 10th century.[59] Individual snakes, scorpions and lizards whose bites are poisonous are depicted in quite the same manner as in the Pseudo-Galen, along with numerous plant pictures which have a healing power against these bites. Moreover, the famous Vienna Dioscurides contains at the end a paraphrase of Nicander by a certain Eutecnius,[60] as does likewise the Morgan Dioscurides (Pl. XXXV, fig. 11).[61] Both of these include the same, simple serpent pictures which surely must have already existed in the Nicander archetype. Thus, as far as the serpent illustrations are concerned, the

[56] M. Meyerhof, "Joannes Grammatikos (Philoponos) von Alexandrien und die arabische Medizin," in *Mitt. des Deutsch. Inst. für Ägypt. Altertumskunde in Kairo,* II (1931), pp.16ff. Meyerhof analyzes the text on hand of a 16th century manuscript in Cairo rather than of the Vienna codex.

[57] The miniatures, save for three pages with snake pictures on fols. 12ᵛ, 13ᵛ and 14ʳ, have been completely published by Kurt Holter, "Die Galen-Handschrift und die Makamen des Hariri der Wiener Nationalbibliothek," *Jahrb. Kunsth. Samml. Wien,* N. F., XI (1937), pp.1ff.

[58] St. J. Gasiorowski, *Malarstwo Minjaturowe Grecko-Rzymskie,* Cracow, 1928, p.152 and pl. 70. — Holter, *op. cit.,* fig. 6.

[59] The illustrations of this codex are completely published by H. Omont, *Miniatures des plus anciens manuscrits grecs de la Bibliothèque Nationale,* 2nd. ed., Paris, 1929, p.34 and pls. LXV–LXXII. — Cf. also Weitzmann, *Byz. Buchmal.,* p.33 (here fuller bibliography) and pl. XLI, no. 228.

[60] Premerstein, Wessely, Mantuani, *op. cit.,* pls. fol. 393ʳ–437ᵛ.

[61] Facsimile (cf. note 22) fols. 338ʳ–360ᵛ and 375ʳ–384ᵛ.

Vienna Pseudo-Galen stands in the direct line of the tradition of ancient scientific illustration.

Two miniatures[62] depict serpents attacking, in one case a youth and in another a decoy, and being in both cases killed themselves. In the former instance (Pl. XXXVI, fig. 14) the bitten youth kills the snake with a staff, and the episode takes place in a setting of laurel trees, the berries of which are used as a drug against the snake bite. Such a scene has a function similar to those in the Dioscurides manuscripts where men cut branches, draw sap and collect fruit. In both cases the human figures demonstrate the usefulness of the plant and in this sense can be termed "explanatory" figures. And just as in the Dioscurides manuscripts the explanatory figures turned out to be later additions, first in post-iconoclastic Greek and then in Arabic manuscripts, so can the same be demonstrated in the case of the *Theriaca* texts.

The previously mentioned Nicander manuscript in Paris possesses, in addition to the illustrations of the serpents as such, a few more elaborate pictures. In one of these a serpent is attacking a boy (Pl. XXXVI, fig. 13)[63] who, unlike the one in the Pseudo-Galen miniature is not counterattacking, but fleeing. There are two reasons for our belief that the fleeing boy and others like him were later additions, most likely of the 10th century when the Paris copy was made. First, there are no human figures in the Nicander paraphrase of the Anicia codex of the 6th and the Morgan manuscript of the 10th century. We do not exactly know when Eutecnius lived, but from the fact that in another paraphrase he used Aelian's *Natura Animalium*[64] we can only conclude that he lived after the 3rd century A.D., and since the first illustrator of this paraphrase surely used an illustrated Nicander as model we can be quite sure that at that time at least no human figures were in the treatise. This is not surprising; indeed it is in complete agreement with our concept of pure scientific illustrations in the classical period. Secondly, from the formalistic point of view it is quite apparent in the Nicander miniature described above that the second, attacking serpent has to be pushed over partly into the inner margin, in order to provide space for the human figure.[65]

The fact that in the Paris Nicander men are represented only as fleeing but not fighting back does not mean that the latter type could not have also existed in

[62] Holter, *op. cit.*, figs. 1 and 7.

[63] Omont, *op. cit.*, pl. LXV, 4.

[64] Schmid-Stählin, *Geschichte der Griechischen Litteratur*, VII, II, 2 (7th ed.), p.788.

[65] Cf. Weitzmann, *Roll and Codex*, p.167 and fig. 162 where two lizards had to be pushed aside and their tails turned up in order to insert the man striken by a poisonous drink.

Greek *Theriaca* manuscripts. We must bear in mind that the Paris manuscript is only an accidental survivor of what once was a widespread recension. The Vienna National Library possesses a richly illustrated 13th century Latin compendium of medical treatises including the Pseudo-Apuleius herbal, where, *e. g.*, above the plant *viperina*, a youth is represented piercing an attacking serpent.[66] Neither the early Pseudo-Apuleius herbal in Leyden, University Library *cod. Voss lat. qu. 9*, of the 7th century, with its excellent plant pictures,[67] nor any of the copies in the centuries immediately following, has any such "explanatory" figure. In the Leyden manuscript we find, in the true classical tradition, the carefully designed plant *viperina*[68] and underneath, as a separate item so to speak, the venomous serpent, but with no story-telling device connecting the two. Thus we see quite clearly that likewise in Latin manuscripts figures of this kind are mediaeval additions of approximately the same period when they became familiar in the East. The style of the miniatures in the codex *Vienna 93* is strongly byzantinizing and this suggests, as in the Arabic manuscripts we have discussed, Greek manuscripts of the post-iconoclastic period as the source for the figures.

A third category of miniatures in the Pseudo-Galen depicts the physician and an assistant or fellow physician preparing the medicine, usually in a cauldron over a fire.[69] Just as in the Arabic Dioscurides miniatures of the year 1224, where we have already had occasion to point out Greek parallels (pp. 255–256), this is understandably the most popular subject among the scenic representations.

Of special interest are those illustrations of an episodic character which come closest to being, and in some cases quite surely are, *ad hoc* inventions. One of them[70] illustrates in vivid fashion the story of how the favourite slave of a king was, out of envy, poisoned with opium and locked up, but revived by the bite of a viper and rescued by country laborers. Another[71] depicts the physician Andromachos who finds a serpent in a jar during a luncheon with his laborers, and a third (Pl. XXXVI, fig. 16)[72] shows Tulunus, the brother of the physician Andromachos, bitten by a

[66] H. J. Hermann, "Die frühmittelalterlichen Handschriften des Abendlandes" (*Beschreibendes Verzeichnis der illuminierten Handschriften in Österreich*, N. F., vol. I) Leipzig, 1923, p.15 and fig.8.
[67] Singer, *op. cit.*, pp.43 ff. and figs. 28, 30, 44, 46. — Gasiorowski, *op. cit.*, p.68 and figs. 19–22. — A. W. Byvanck, "Les principaux MSS à peintures . . . du Royaume des Pays-Bas," *Bull. Soc. Franç. Repr. de MSS à peinture*, XV (1931), p.58 and pl. XVII (here further bibliography).
[68] On fol. 29ᵣ.
[69] Holter, *op. cit.*, pl. II, 2, and figs. 2, 8, 9.
[70] *Ibid.*, fig. 5.
[71] *Ibid.*, fig. 3.

snake while he was peacefully sleeping in the shadow of a tree. Furthermore the physician Andromachos on horseback advising the above-mentioned snake-killer (Pl. XXXVI, fig. 14) is a narrative expansion of the scene beyond the mere explanatory figure of the bitten victim. Precise parallels to these episodic miniatures can hardly be expected in Greek manuscripts, and here more than in any of the miniatures seen so far, the individual capacity, perhaps not of the illustrator of the Vienna codex but of the one who first made up the pictures for these *Theriaca* stories, can be appreciated.

Even so, the idea of enriching a *Theriaca* text with scenic illustrations, as in the case of all the other figurative additions, is basically not an Arabic, but a Byzantine invention. There is, *e. g.*, a passage which speaks about the African serpent αἱμοροίς and how it once killed Canopus, the pilot of Menelaus, after his return from Troy. Helen in her wrath broke the neck of the serpent, yet Canopus died from the fatal bite. This passage is illustrated in a miniature (Pl. XXXVI, fig. 15)[73] where the deadly serpent is depicted in the foreground, attacking Canopus, who lies, seemingly already wounded, at the seashore, while Helen rushes towards him to help and an agitated warrior, probably Menelaus, stands in the center. Once more, it is characteristic that the previously mentioned paraphrase of Eutecnius has, in accordance with classical scientific illustration, only a representation of the αἱμοροίς without the mythological episode,[74] although the text of the paraphrase likewise refers to the Canopus story. We have, therefore, every reason to believe that this and a few other scenes like it were inserted in the Middle-Byzantine period like all the other figurative additions.

Of course, there is this difference, that the Canopus miniature illustrates a myth and was surely not invented for the Nicander text, but made up originally for a mythographical text in which the story was told more in detail. This text may have been the handbook of the 1st century writer Conon whom we know from the excerpt in the Μυριόβιβλον of Photios, the learned patriarch.[75] Yet, a certain similarity in form and content between Canopus lying at the seashore after having been bitten by a serpent, and Tulunus lying in the shadow of the tree and meeting the same fate may not be entirely accidental, and although it was apparently not

[72] *Ibid.*, fig. 4.

[73] Omont, *op. cit.*, pl. LXVI, 1.

[74] Premerstein, Wessely, Mantuani, *op. cit.*, pl. fol. 404ʳ (only fragmentarily preserved). Facsimile of the Morgan codex (cf. note 22) fol. 348ʳ.

[75] K. Weitzmann, "Greek Mythology in Byzantine Art" (*Studies in Manuscript Illumination*, vol. IV), Princeton, 1951, pp. 195 ff.

the former miniature itself which served as model but another like it, some such compositional theme of a Greek miniature may well have given the stimulus to the Arabic illustrator to enrich his *Theriaca* with storytelling pictures.

The sumptuous dedication miniature, which depicts the prince for whom the present copy was made,[76] is of no concern to us in the present context, but the back of the page, which is decorated with a series of nine portraits of famous physicians who wrote about theriacs (Pl. XXXVI, fig. 18),[77] has to be investigated with regard to possible classical prototypes. These portraits are arranged three by three, beginning in the upper row with Andromachos, Herakleides, Philagrios, followed in the middle row by Proclos, Pythagoras, Marinos, and at the bottom by Andromachos the Younger, Magnos and finally Galenos. Placed in medallions they are represented as sages, sitting in oriental fashion with crossed legs and holding books, some opened and some closed. The arrangement is in what must have seemed to the author to be a chronological sequence, ending with Galen, while in reality it is a pseudo-chronological order.[78] It is instructive to compare this miniature with the two assemblies of physicians in the Anicia codex.[79] Galen appears in both sets, though in the latter he takes a more prominent position, being placed in the center on an easy chair. Buberl quite plausibly concluded from this fact that this picture of the Anicia codex was originally invented as a title miniature for some work of Galen rather than Dioscurides. But in spite of the fact that Galen appears in both sets, we do not think that the Arabic miniature is based on the same pictorial tradition as that of the Anicia codex. The latter, as has repeatedly been pointed out, is related in concept and composition to the ancient mosaics of the seven wise men, in which they are represented as a discussion group in a spatial setting. It is true that all spatial elements have been omitted in the Anicia miniature, but even so it is still apparent that the seven physicians have maintained a connection among themselves and thus still form an assembly. In the Arabic miniature, however, we have to do with medallion portraits which are arranged in a decorative system, and although the figures in the outer medallions are slightly turning inward, they are basically conceived as a set of individual portraits and not as a group composition.

The medallion portrait has a long history not only in classical art in general, but in classical book illumination in particular. This, of course, is not the place to

[76] Holter, *op. cit.*, pl. I.

[77] *Ibid.*, pl. II A. — Cf. also F. R. Martin, *The Miniature Painting and Painters of Persia, India and Turkey*, London, 1912, p.9 and pl. 14a. — T. W. Arnold and A. Grohmann, *The Islamic Book*, 1929, pl. 32.

[78] Meyerhof, *op. cit.*, p.17. [79] Cf. pp. 256–257 and note 52.

survey the full evidence and it may suffice to quote two of the best-known examples. The early Virgil manuscript in the Vatican Library, *cod. lat. 3225*, had originally, to judge from an offset opposite the beginning of Book VII,[80] a portrait of Virgil in medallion form in front of every book, and a Carolingian copy of a classical Agrimensores text in the Vatican, *cod. Palat. lat. 1564*, has two emperor medallions on one page[81] which look very much like an excerpt from a series. The best evidence, however, introduced here for the first time, is to be gathered from a Late Byzantine manuscript now in the Ambrosian Library in Milan, *cod. E. 37. sup.*, in which more than 60 medallion portraits of famous physicians are inserted in a text which in the catalogue[82] is described as: *Opus medicum regum philosophorum aliorumque illustrium virorum iconibus parum accurate depictus ornatum.*[83] Among these portraits, as is more or less to be expected, there is also one of Galen (Pl. XXXVI, fig. 17) as a bearded man wearing fashionable robes and headdress. In spite of this contemporary costume, which may be attributed to the copyist's desire to modernize his model, there is good reason to believe that this whole series of portraits of famous physicians goes back, like the medical text itself, to a classical source, and that a classical manuscript of this type inspired the Arabic artist who first added to the Pseudo-Galen treatise a series of medallion-portraits, but placed them all together in front of the text instead of interspersing them throughout.

One cannot speak about a series of portraits of famous men in a classical text without touching the much disputed problem of the original system of illustration in Varro's *Hebdomades*, which as we know were illustrated by 700 portraits of famous men, Greek and Latin. Many scholars have argued[84] that their system of illustration is reflected in the two pictures of assembled physicians in the Anicia codex, not so much for formal reasons but for the simple fact that in both instances the portraits were grouped by sevens. Yet, the grouping in assembly fashion seems, in our opinion, to reflect rather a monumental composition, comparable to the already mentioned mosaics of the wise men, inasmuch as they appear as full-page

[80] *Fragmenta et Picturae Vergiliana codicis Vaticani Latini 3225 (Codices e Vaticanis selecti*, vol. I), 2nd. ed., Rome, 1930, pl. fol. 57ᵛ.

[81] E. H. Zimmermann, "Die Fuldaer Buchmalerei in Karolingischer und Ottonischer Zeit," *Kunstgesch. Jahrb. der K. K. Zentral-Kommission*, 1910, p.90 and pl. XIIa.—A. Goldschmidt, *German Illumination*, vol. I, *Carolingian Period*, 1928, pl. 16a. — Gasiorowski, *op. cit.*, p.76 and fig. 24.

[82] A. Martini–D. Bassi, *Catalogus codicum Graecorum Bibliothecae Ambrosianae*, I, 1906, pp. 313ff., no. 282. Here the manuscript is dated in the 16th century.

[83] There is no printed edition of this text quoted in the catalogue.

[84] Most recently A. von Salis, "Imagines Illustrium," in *Eumusia Festschrift für Ernst Howald*, Zürich, 1947, pp.11ff.

miniatures only after the invention of the codex around A. D. 100,[85] *i. e.*, after the lifetime of Varro. From the formal point of view the medallion portrait seems to us particularly well suited to such an enormous enterprise as the dipiction of 700 portraits, in which the facial features must have been the most important element, and where the association of an individual portrait with an explanatory text underneath within the limits of normal writing columns is in agreement with what we know of the picture arrangement in papyrus rolls.[86] Thus we come to the conclusion that the medallion portraits in the Arabic Pseudo-Galen not only reflect an ancient type of serial portraits, but that it is worth considering whether they might not descend ultimately from Varro's *Hebdomades* or one of the similar collections of *Imagines Illustrium* which began to be popular in the sphere of Hellenistic poetry of Alexandria.

* * * * * * *

In this brief sketch it could, of course, not be our aim to present a comprehensive picture of the Greek influence upon early Arabic miniature painting. There are other Arabic scientific treatises whose connection with the Greek sources has already been pointed out, while in other cases further investigation would, we feel sure, throw more light on this problem. Buchthal, for example,[87] has demonstrated the close relation between the illustrations of a *Kitāb al-Baiṭarah* manuscript in the Egyptian Library in Cairo, which dates from A. D. 1209 and deals with the *Healing of Sick Horses*, and those of a 14th century Greek manuscript in Paris, *Bibliothèque Nationale gr. 2244*, which contains Hierocles' treatise on the *Care of Horses*. Moreover, no detailed study has been made, so far as our knowledge goes, of the Greek sources of the constellation pictures in Al-Ṣūfi's treatise on this subject, and it still remains to be investigated whether, and if so to what degree, the illustrations of the Fables of Bidpai rest on Byzantine animal treatises such as the Physiologus and others. Yet, we hope that a sufficient number of instances has been discussed in this sketch in order to permit a few generalizing conclusions.

Most essential has seemed to us the realization that even in Greek illuminations we have to distinguish between two types of scientific illustrations: (1) the pure type which confines itself as closely as possible to a diagrammatic image, and (2) the expanded type which came into being by adding human figures of different

[85] Weitzmann, *Roll and Codex*, p.70.
[86] *Ibid.* pp.69ff. and especially fig. 60.
[87] Buchthal, *op. cit.*, pp.19ff. and figs. 2 and 3.

kinds for various purposes. The first category corresponds to the classical concept of science, while the second is a later creation and does not become discernible to us before the 9th century. This second type, however, never completely replaces the first and older one, and both exist side by side during the later Middle Ages.

Within the Arabic scientific treatises we find the same two categories. Manuscripts like the *Mechanics* of Heron in Leyden (Pl. XXXIII, fig. 2), the *Automata* of al-Jazari (Pl. XXXIII, fig. 4) and the Dioscurides in Paris, *ar. 4947* (Pl. XXXIV, fig. 6), belong to the first, whereas the Dioscurides miniatures of 1224 and those of the Pseudo-Galen manuscript in Vienna (Pl. XXXVI, figs. 14, 16, 18) are the most outspoken representatives of the second. Moreover, it could be demonstrated that the addition of figurative elements is not due to the caprice of some Arabic illustrators of the early 13th century, but that in Greek as well as in Arabic manuscripts it is the result of a lengthy process in which manuscripts like the Dioscurides in Leyden (Pl. XXXIV, fig. 8) and the one in Mashhad (Pl. XXXV, fig. 10) form intermediary steps. It is thus apparent that Arab illustrators were exposed to Byzantine influences not only in the stage of the first reception from the Greek, but long thereafter, since they adapt step by step the innovations which in the Greek manuscripts themselves developed only gradually.

As time goes on we can observe, as is only natural, that the Arabic illustrator becomes increasingly independent of his Greek models, first in the realm of style, and later, but no less evident, in the realm of iconography. Perhaps the lack of a long tradition in figure painting is one of the reasons that the Arabic illustrator is less inhibited in inventing new figures and compositions alongside those which he copied from Greek models. The Middle Byzantine artist, on the other hand, depends not only on contemporary Byzantine manuscripts as inspiration for his figurative additions, but he still has available, as a second source, classical literary texts. A case in point is the Nicander miniature (Pl. XXXIV, fig. 7), in which a mythological scene is added to the depiction of a specific poisonous serpent, and elsewhere[88] we have shown the incorporation of a whole series of mythological scenes into the manuscript of the *Cynegetica* of Pseudo-Oppian, *cod. Marcianus gr. 479* in Venice, which is a didactic poem on the various techniques of hunting. In the Nicander as well as in the Pseudo-Oppian the source for these additions was a mythographical handbook, a source which was available to Byzantine artists of the 10th century, but which, as far as our knowledge goes, seems nowhere reflected in the early Arabic manuscripts known today.

[88] Weitzmann, *Greek Mythology in Byzantine Art*, pp.93ff.

A similar development within the illustration of scientific treatises can also be observed in Western Europe. A Latin Dioscurides in Munich, State Library *cod. lat. 337*, of the 10th century[89] depicts, alongside some plants, animals and human figures which did not exist in earlier Greek Dioscurides manuscripts on which this Latin copy rests. Moreover, these explanatory figures are so placed in the margins that it becomes quite clear on the basis of formal considerations that they were attached to plants which originally were conceived without them. Later the additional elements in Latin manuscripts likewise increase in scope and variety as they did in Greek and Arabic ones. The already cited medical compendium in Vienna, *cod. 93*, of the 13th century (cf. p. 260), whose Pseudo-Apuleius herbal and similar treatises are prolifically illustrated with human figures and whole scenes, is one of the most striking examples.[90]

It must have become obvious by now, as far as the insertion of human figures and scenes into scientific illustrations is concerned, that we are dealing with a general mediaeval principle. The basic difference, to state this once more with emphasis, is not between Greek and Arabic manuscripts, but between classical on the one hand and mediaeval on the other, no matter what the language. It is in agreement with the highly developed concept of pure science in the Greek world, that the illustrations of scientific texts should also be restricted to the clearest and most economical depiction of a given object. It is also well known that, after the great writers of the 2nd century, such as Galen and Ptolemy, had summed up the scientific knowledge of the classical world in handbook fashion, the Middle Ages was content to draw from the classical heritage with hardly any new observation from nature for centuries to come. A more popular type of writing began to develop in which anecdotes, fables, superstitions, moralizing precepts, etc., penetrated into and often obscured the scientific nucleus. In this process the strict division between scientific and literary writing which had prevailed in the classical world was more and more abandoned. The addition of explanatory figures and episodic scenes expresses in visual form a similar desire, namely, to enrich strictly scientific pictures by elements which also signify either a didactic purpose or a mere tale-telling intention. Whatever the urge may have been, the result is always the same: to draw scientific images into a more humanizing realm.

[89] *Idem, Roll and Codex*, p.135 and fig. 116.

[90] For a treatment of similar problems in Western scientific treatises of the subsequent centuries we refer the reader to the excellent study of Otto Pächt, "Early Italian Nature Studies and the Early Calendar Landscape," *Journal of the Warburg and Courtauld Institutes*, XIII, 1950, pp.13ff.

8

DEACON OR DRINK: SOME PAINTINGS FROM SAMARRA RE-EXAMINED

David Storm Rice

ما زلت استــلّ روح الــدنّ فى لطَـف
واستقـى دمــه من جــوف مجـروح
حتى انثنيــت ولى روحان فى جســد
والدنّ منطرح جسما بلا روح [1]

"Gently, incessantly I extract the 'spirit' from the amphora; from the wounded hollow I draw its blood; until I double up: two spirits in one body, and the amphora is left lying there—a body without spirit".

THE central architectural feature in the superb palace erected between 221-5/836-9 by al-Mu'taṣim at Samarra—the Ǧausaq Ḥāqānī—consists of four T-shaped basilical halls arranged to form

1. ABŪ NUWĀS, *Dīwān*, ed. WĀṢIF, Cairo, 1898, p. 262 ; *Dīwān*, ed. Maḥmūd Kāmil FARĪD, Cairo, 1932, p. 147 ; the BM Ms. Add. 19, 404, f° 170 v, has slight variants :

ما زلت آخـذ روح الــدنّ فى لطف واستــقـى بـدم من غيـر مجروح
حتى انتشيت ولى روحان فى جسدى والــدنّ مطــرح جـســما بــلا روح

IBN QUTAYBA, *Kitāb al-Ašriba*, ed. Muḥ. KURD 'ALĪ, Damascus, 1947, p. 67, attributes the verses in somewhat different form to AL-NAẒẒĀM (ob. 835 or 845). He is followed in this by IBN AL-RAQĪQ, *Quṭb al-surūr fī awṣāf al-ḥumūr*, BM. Ms. Or. 3628, f° 187 v :

ما زلت آخـذ روح الزقّ فى لطف واستبـبـج دمّـا من غيـر مجروح
حتى انثنيت ولى روحان فى جسدى والزقّ مطــرح جسم بــلا روح

Cf. also BN, arabe 3302, f° 4, with the variant منطرح . I prefer the reading انثنيت 'bent in two' to the more hackneyed انتشيت 'drunk'. I am obliged to Dr. S. M. Stern for calling my attention to this Ms.

a crutch-cross round a domed chamber. The southernmost of these basilical halls opens on the harem-court, and across this court it faces the principal room of the harem—the domed chamber—in which the famous frescoes were found[1]. In every corner of the crutch-cross formed by the basilical halls there are sets of four richly decorated rooms. In a room of the southwestern of these units, part of the pavement was missing. This circumstance led the German excavators to probe deeper and, in December 1912, they came upon some remarkable finds.

The hole in the pavement marked a ramification point in the fresh water system. Such ramification points had been previously laid bare by the excavators in other parts of the palace. The pipes (nearly always 20 cm. thick) were made of lead or blue-glazed earthenware. In the room located between the central throne-chamber and the harem, however, the pipes had been removed and the space under the pavement was filled with cylindrical pottery objects covered with paintings. According to the excavator, Ernst Herzfeld, the fresh water system belonging to the earliest building period under al-Muʿtaṣim had probably gone out of use in the reign of al-Mutawakkil (232-45/847-59). The precious lead pipes were removed and the space which they had occupied was filled with the strange, painted pottery objects of which only one (pl. I a-b) was found intact. Others, of which fragments were recovered, had probably been broken before they were placed in the hole under the pavement (pls. II-IV).

Herzfeld surmised that the pictures represented priests, knights and women and he called the vessels on which they had been painted "Picture-columns" (*Bildsäulen*). He also conjectured that the Kufic inscriptions painted on some of the pieces were artists' signatures. Herzfeld further deduced that the objects were idols. Abhorrent to all true Muslims, they had been smashed and concealed beneath the floor by people who, while wishing to remove an abomination, were restrained by superstitious fear of the magical efficacy of the images from utterly destroying them.

Having advanced these assumptions, Herzfeld was tempted to

1. For a description see E. HERZFELD, *Mitteilungen über die Arbeiten der zweiten Kampagne von Samarra*, in *Isl.*, V, 1914, pp. 199 f. ; K. A. C. CRESWELL, *Early Muslim Architecture*, II, Oxford, 1940, pp. 237 ff., plan in fig. 194 ; Seton LLOYD, *Jausaq al-Khaqani at Samarra : a new reconstruction*, in *Iraq*, X, 1948, pp. 73-80.

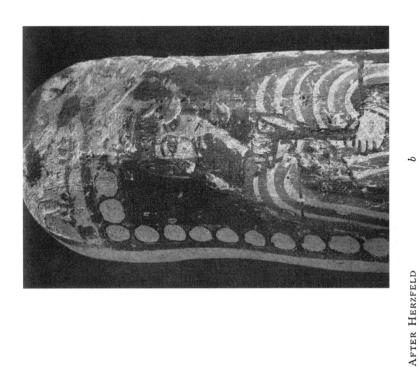

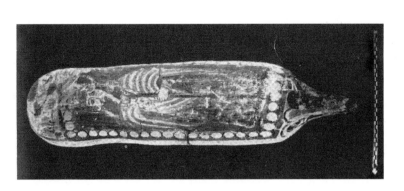

a b

PLANCHE II

B

C

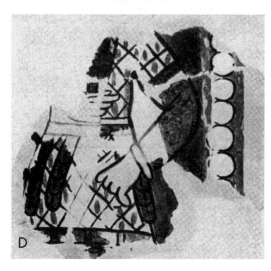

D

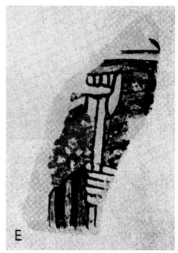

E

A

AFTER HERZFELD

PLANCHE III

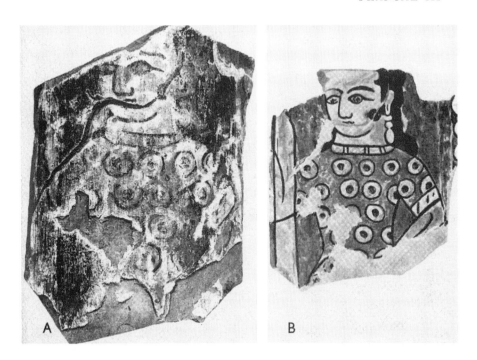

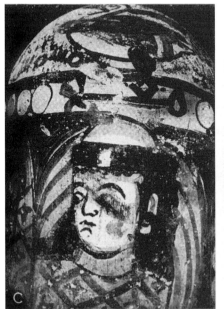

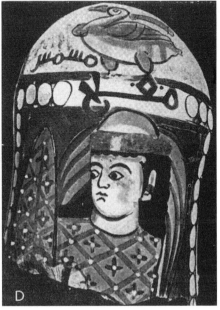

A. Courtesy British Museum; B-D, After Herzfeld

After Herzfeld

PLANCHE V

a. AFTER HERZFELD

b. AFTER HERZFELD

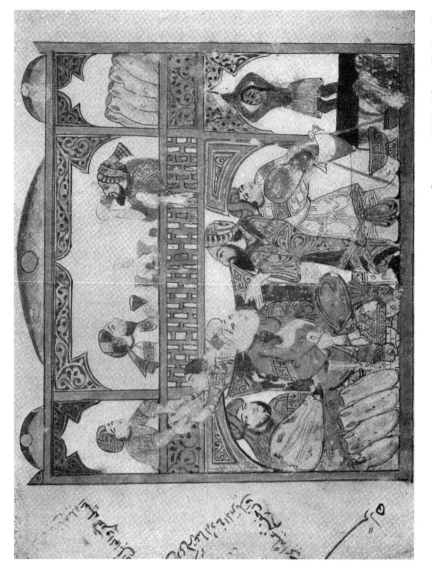

HARĪRĪ: MAQĀMĀT, BN, MS. ARABE 5847, F° 33, DATED 1237

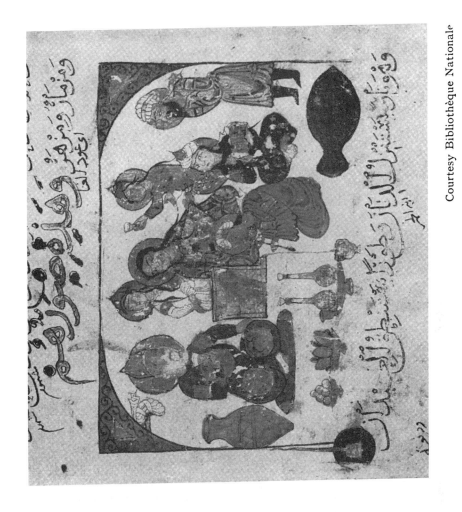

HARIRI: MAQĀMĀT, BN, MS. ARABE 3929, F° 34 V

Courtesy Bibliothèque Nationale

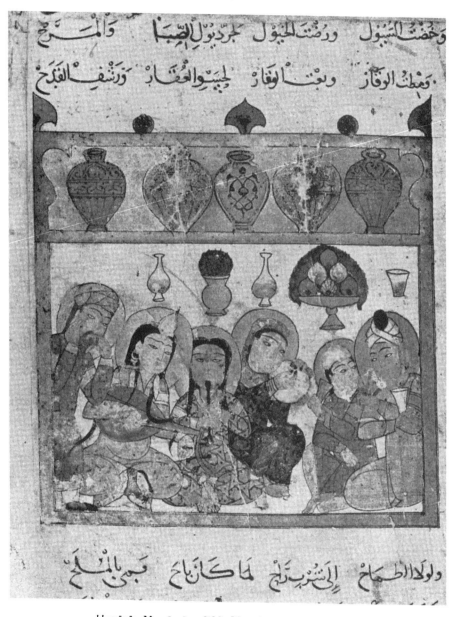

ḤARĪRĪ: MAQĀMĀT, BM, Ms. ADD. 22, 114, F° 26

link the peculiar objects from the Ǧausaq Ḫāqānī with a specific historical event : the apostasy and punishment of Afšīn. This descendant of Soghdian princes and general to the caliph Muʿtaṣim had achieved great fame by quelling the rebellion of the heretic Bābak, who for twenty years (until 838) had defied the caliph's authority. But soon Afšīn found himself accused of conspiracy with the heretics and of being a Muslim in name only. After a spectacular trial (of which we possess an eye-witness account) he was found guilty, starved to death and crucified at Samarra in 226/841 [1]. After Afšīn's death, a search of his residence brought to light sundry idols set with jewels. Herzfeld did not claim that the *Bildsäulen* discovered by him were identical with those idols but merely that they belonged to the same type of images, and that they had been smashed and buried at the time of Afšīn's downfall.

The *Bildsäulen* consist of a type of pottery vessel known as *dann* pl. *dinān* ca. 20 cm. wide at its widest and 80-85 cm. tall. On top, the *dann* has a large opening and the bottom tapers off sharply and forms a stalk or thin foot. For the purpose of using the vessels as *Bildsäulen* the aperture on the top had been closed with plaster and the whole surface covered with a slip of diluted plaster on which the paintings were executed. The pictures occupy only one side, about half the cylindrical surface, the remainder is blank and white. The surviving tops of the vessels (pl. I, III c-d) are decorated with a duck. The stalk or foot of the only complete vessel (pl. I a) which must have been planted in the ground or supported on a stand, has a lotus-leaf pattern on one side.

Disregarding some very small fragments, Herzfeld considered that pieces belonging to twelve *Bildsäulen* had been recovered. Some showed male and female figures painted frontally, some fragments bore only ink sketches [2] and others short inscriptions (pl. V a-b). Among the male figures, Herzfeld distinguished four 'priests' (pls. I, II b, c and e) and two 'knights' (pl. II a, d). One of the priest images was preserved in its entirety, of three others only small fragments had survived. The complete specimen shows a bearded figure holding a staff provided on top with a cross-piece.

1. ṬABARĪ, *Taʾrīḫ*, Leiden, 1879, III, p. 1318 ; for an English translation of the relevant passages cf. E. G. BROWNE, *Literary History of Persia*, Cambridge, 1951, I, pp. 331-6 ; also article 'Afshīn' (W. BARTHOLD-H. A. R. GIBB) in *EI²*, I, p. 241.

2. In addition to the pieces reproduced here see also E. HERZFELD, *Die Malereien von Samarra*, Berlin, 1927, pls. LXXIII-LXXV and figs. 68-71.

The person wears a horizontally striped headgear and a veil which hides the ears and covers the shoulders. The dress consists of a gaily patterned undergarment and a horizontally-striped cape. On one fragment (pl. II c) the staff is held diagonally and Herzfeld suggested that it might have been intended to represent a cross as in the sculptured reliefs in the Monastery of Mār Behnām (near Mosul) which admittedly are four centuries later.

In the two male figures which he called 'knights' (pl. II a, d) Herzfeld saw representations of Persian *dihqāns* and referred to the rock-carvings of Šāpūr I and to later Sasanian models. The headgears of these *dihqān*-figures are not preserved. Their dress consists of a long undergarment worn under a shorter coat which is held together by a well-known type of belt with long straps [1].

Herzfeld identified four other figures as female and believed that the best preserved of these (pl. IV a) showed that energetic Persian lady, Azāde, the favourite of Bahrām Gūr who had trained herself to carry a calf on her shoulder, until by sheer persistance and long practice she was able to carry an ox up a flight of stairs. Sauvaget has already pointed out that this interpretation is not acceptable [2]. The figure on this *Bildsäule* is male not female (note the hair style, absence of tresses ; the dress and above all the belt with straps worn only by men). Nor is the animal which is being carried a calf or an ox, but a spotted gazelle or antelope. Sauvaget rightly concluded that the image was that of a young, beardless hunter with his game.

Another figure (pl. III c-d) was explained by Herzfeld as "perhaps a dancer, a blue-striped cloth thrown behind the head and part of the skirt thrown high in front". Sauvaget wanted to see in the image a young, beardless man with a cloak (*ṭaylasān*) attached to a round headgear (*qalansuwa*) [3]. On this occasion I share Herzfeld's opinion rather than that of Sauvaget, because the scalloped fringe of hair worn by this figure is not to be seen in any other male image from Samarra.

1. There are many parallels for this type of belt. Cf. the examples brought together by D. SCHLUMBERGER, *Le palais Ghaznévide de Lashkari Bazar*, in *Syria*, XXIX, 1952, p. 265 note 4 to which should be added the earlier examples assembled by L. A. EVTUKHOVA, *Kamenie izvayaniya yuzhnoi Sibirii i Mongolii*, in *Materiali po Arkheologii SSSR*, 24, 1952, pp. 71 ff.

2. J. SAUVAGET, *Remarques sur les monuments omeyyades*, in *JA*, 1940-1, pp. 54-6.

3. J. SAUVAGET, *loc. cit.*

The remaining two *Bildsäulen* have undisputably female figures
(pl. III a-b, pl. IV b). The first is in the British Museum and I
have been able to examine it closely[1].

Although none of the larger paintings discovered at Samarra are
signed, Herzfeld explained the Kufic writing on the *Bildsäulen*
as master signatures. Some pieces have two: مسمس and مفلح
(pls. I, III c-d). The second also appears on a fragment with a
female figure (pl. IV b) hence, Herzfeld argued, the writing could
not possibly apply to the persons represented, which are both
male and female, but must be the painter's name. Having decided
that مفلح was a painter's signature, he rejected the most obvious
reading Mufliḥ on grounds of the following reasoning : Mufliḥ
is a purely Arabic name—free from any religious taint—applicable
only to a man of Arab stock, and it is inconceivable that an Arab
would paint pictures of 'priests' 'knights' and 'Persian legendary
figures' as early as the third century of the hiǧra. Rejecting, there-
fore, the reading Mufliḥ he thought of an Aramaic name Miflaḥ or
Mifallah. That this was a good suggestion seemed to Herzfeld borne
out by the second "master-signature" مسمس which he read
Mušammas < Aram. *šammāša*, 'deacon'. The *Mušammas* would
be the cleric who assisted the *Šammās* in religious ceremonies.

The obvious conclusion that the painters of the *Bildsäulen* were
Aramaean Christians did not, however, satisfy Herzfeld because
مسمس also appeared on a fragment devoid of painting together with
a good Muslim name احمد بن موسى Ahmad b. Mūsā (pl. V b).
Admittedly on this occasion مسمس is written with a *calamus* in
thin cursive script, whereas Aḥmad b. Mūsā is painted in bold
letters with a brush, but Herzfeld took both to be signatures of
artists. On another fragment without painting the hand which
wrote Aḥmad b. Mūsā[2] added a third word which Herzfeld trans-

1. According to HERZFELD, *Malereien*, p. 84, the *Bildsäule* with the gazelle-
bearer (his pl. LXIX, here pl. IV a) is erroneously said to be in the British
Museum. The line drawing of this piece is given here after Herzfeld because
the coloured plate, by his own admission, *op. cit.*, p. 89, is inaccurate in an
important detail. I am indebted to Mr. Basil GRAY, Keeper of the Dept. of
Oriental Antiquities, for permission to examine the specimen depicted on
pl. III (a-b) which is the only fragment in the British Museum and also for
help in trying to trace the whereabouts of other fragments. My thanks are
also due to Mr. R. PINDER-WILSON, Asst. Keeper in the Dept., for assistance
in this task.

2. Prof. L. A. MAYER called my attention to the fact that the name of
Aḥmad's father on the piece reproduced here on pl. IVa need not necessarily

cribed مطبّرح (pl. V a). This led him to formulate some extraordinary conjectures. *Muṭawwaḥ* by analogy with *muṭawwaḥāt* ('bedouin songs which are audible over a great distance') would refer to the painter's strong voice ; alternatively, should the reading *Muṭawwiǧ* from *ṭūǧ* ('fibrous plant') be preferred, the interpretation would be 'rope maker' or 'mat maker'. But neither variant sheds any light on the world of ideas to which these images belong, nor does it afford any clue as to the ethnic origins of the painters. So Herzfeld tried a different approach to the problem.

Mani was the painter *par excellence*. He was a native of Iraq. Many Aramaeans from Iraq were followers of Mazdak, Bābak and other heretics who drew their inspiration from Manichaeism. Afšin was a secret devotee of the heretical movement and many prominent persons in the caliph's own *entourage* sympathized with Manichaeism. There was nothing to prevent them having such good Muslim names as Aḥmad b. Mūsā. In his *Fihrist*, Ibn al-Nadīm distinguishes five degrees of Manichaean initiation : (i) *muʿallimūn* (ii) *mušammasūn* (iii) *qassīsūn* (iv) *ṣiddīqūn* (v) *sammāʿūn* [1]. All these terms are Aramaic loan words. The second grade *mušammas* does not mean 'he who is illumined by the sun' but a 'deacon's acolyte'. The word, according to Herzfeld, indicated that the persons named Miflaḥ (or Mifallaḥ) and Aḥmad b. Mūsā were *mušammasūn* or initiates of the second degree. From this it followed that the 'priests' on the *Bildsäulen* were Manichaean heretics not Christians.

This interpretation, according to Herzfeld, offered the most comprehensive and plausible answer to the many problems raised by his finds. This theory explained why the painters had also depicted Persian *dihqāns* (who may be assumed to have clung to old Persian rites under the cloak of Islam), it explained how a Sasanian legendary figure like Azāde should have been included (though no explanation was offered as to her religious significance) ; above all it explained how the *Bildsäulen* came to be smashed and put under the pavement of a room in the Ǧausaq Ḥāqānī after the unmasking of Afšin's heretical conspiracy and his downfall.

The *ensemble* of Herzfeld's interpretation of the painted pottery

be read Mūsā. It must be remembered that the two portions of this jar do not fit perfectly and that a piece is probably missing in the middle.

1. G. FLÜGEL, *Mani, seine Lehre und seine Schriften*, Leipzig, 1862, pp. 294 ff.

vessels has not—to my knowledge—been challenged since its publication in 1927 [1]. The purpose of the present paper is to re-examine the evidence on which it is based.

It is best to begin by redeciphering the writing on the two fragments of jars without paintings. The first of these is written by one hand in a bold cursive (pl. V a) احمد بن موسى مطبوخ Aḥmad b. Mūsā [2] maṭbūḫ. The short upright letter after ṭā' is perfectly distinct [3] (fig. 1) and there is no ground for reading the last word Muṭawwaḥ or Muṭawwiǧ. Immediately the purpose to which the vessel had been put becomes clear : it was a container for 'inspissated grape juice' or 'cooked wine' maṭbūḫ also called ṭilā'. Some authorities held that this beverage was not forbidden

Fig. 1

by Islam; others, like ʿUmar II, considered that "Muslims should keep themselves free of it and should regard it as unlawful" [4]. Al-Nuwayrī (ob. 732/1332) sums the position up as follows : "the

1. HERZFELD, *Malereien*, pp. 84-95 summarized above. The same view is given in Herzfeld's last volume *Geschichte der Stadt Samarra*, Hamburg, 1948, p. 152 ; also E. KÜHNEL, *Samarra* (Staatl. Museen in Berlin, Bilder-hefte der Isl. Abt., Heft 5), Berlin, s.d., p. 22.

2. Aḥmad b. Mūsā was the name of an engineer responsible for building clever automata and contrivances during the reigns of Ibn al-Muʿtazz and al-Muʿtaḍid, cf. ŠĀBUŠTĪ, *Kitāb al-Diyārāt*, ed. Ǧ. ʿAwwād, Baghdad, 1951, p. 72 ; on him and his family see also F. HAUSER, *Über das kitāb al-ḥiyal der Banū Mūsā* (= Abh. zu d. Gesch. d. Naturwissensch. und der Medizin, I), Erlangen, 1922.

3. It is even excellently rendered in Herzfeld's own line-drawing, *Male-reien*, p. 90, fig. 67, and here fig. 1.

4. Cf. H. A. R. GIBB, *The fiscal rescript of ʿUmar II*, in *Arabica*, II, p. 6. A. J. WENSINCK, s.v. <u>khamr</u> in *EI*[1], II, p. 948.

maṭbūḫ is called *ṭilā'* and signifies what has been cooked until two thirds of it have evaporated and only one third remains. It was given this name because of its viscosity and blackness that makes it resemble the tar which is smeared on camels. The doctors of law hold varying opinions as to its lawfulness. Some say that any juice which has been cooked until half of it is gone, may be consumed but is not recommended (*makrūh*), but when two thirds have gone and only a third remains it is lawful. It is then permissible to drink it and sell it, but getting drunk on it remains forbidden" [1].

We may now turn to the second fragment inscribed with the name of Aḥmad b. Mūsā (pl. V b, fig. 2) where, instead of *maṭbūḫ* we

Fig. 2

see the word مشمس . "*Mušammas*", writes the famous lexicographer al-Fīrūzābādī (ob. 817/1415), "is a name for wine. It is derived from *šammās*, the name given to the deacon of a Christian church and it means : a wine grown and nursed by a *šammās*" [2]. ومن

اسمائها المشمَّس من الشمَّاس وهو رأس النصارى الملازم للبيعة كأن المراد التى خدمها وربّاها الشمَّاس

There are other possible etymologies. In Egypt the word seems to have signified "*a mixed inebriating beverage matured in the sun*" [3],

1. NUWAYRĪ, *Nihāyat al-arab*, Cairo, 1935, IV, pp. 108 ff.

2. FĪRŪZĀBĀDĪ, *Kitāb al-Ġalīs fī taḥrīm al-ḥandarīs*, BM. Ms., Or. 9200, f° 54 v. On this Ms. see also A. S. FULTON, *Fīrūzābādī's "Wine List"*, in *BSOAS*, XII, 1948, pp. 579-85.

3. DOZY, *Supplément*, I, p. 787 a "nom d'une boisson énivrante, faite de moût de sucre et d'eau, et qu'on expose au soleil jusqu'à ce qu'elle soit

but basically the meaning is the same : an intoxicating drink. The famous 'Abbāsid musician Ishāq al-Mawsilī (ob. 235/849) was greatly addicted to this particular drink. Once, upon hearing a verse of the poet-prince Ibrāhīm b. al-Mahdī, he went into such ecstasy that he drank thirteen ratls of *mušammas* out of his large jar (*qāṭarmīz*) [1] :

قال فطرب اسحٰق طربًا ما رأيته طرب مثله قطّ وعاجب وعجب
من احسانـه فى صنعتـه وجودة قسمتـه ولم يزل صوتنا يومنا اجمع لا نغنى
غيره حتى شرب اسحٰق قاطرميزه وفيـه من المشمّـس [2] الذى كان يشربـه
ثلاثة عشر رطلا .

From the foregoing it is obvious that the inscriptions on the unpainted jars excavated by the German expedition at Samarra before the first World War consist of "wine labels" and property marks. Ahmad ibn Mūsā could have been the name of the producer of the wine, of the merchant who supplied it or the cellarer of the *dinān*. The terms *matbūh* and *mušammas* indicate different types of wine, the first artificially the second naturally fermented and matured. Further support for this explanation is provided by an inscribed *dann* excavated at Samarra before the last World War by the Iraq Department of Antiquities (pl. V c) [3].

I read this text سعدان ، وكرم المرأة من الشاط التى *'What is*

bonne" (from IBN ḤAŠŠĀ's glossary on RĀZĪ's *K. al-Mansūrī*). Among the interesting Arabic glosses in the *Responsa* of the Babylonian Geonim (X[th] and early XIth centuries A.D.) is the following : יין צמוקים עם דבש של גוים שקורין אותה במצרים נביד שמסי. "Wine of dried raisins with honey which the Gentiles of Egypt call *nabīdh shamsī*" ; see Marcus WALD, *Die arabischen Glossen in den Schriften der Geonim*, Oxford, 1935, pp. 77f.

1. The *qāṭarmīz* was not a drinking vessel. In the Fāṭimid treasury there was a *qāṭarmīz* which held 17 *ratl*, MAQRĪZĪ, *Hiṭaṭ*, Cairo, 1858, I, p. 414 f. The *ratl* (*riṭl*) < Gk. *litron* was a weight and also a measure of liquids whose capacity varied according to place and period ; cf. D. S. RICE, *A datable Islamic Rock Crystal*, in *Oriental Art*, n.s. II, 1956 p. 3 f.

2. The new edition of the *Kitāb al-Aḡānī* from which this passage is taken (Cairo, 1938, X, p. 135) has *mušammas*. The old edition (Būlāq 1895, IX, p. 69) brings the word with two *šīn* : H. ZAYAT, *al-Hizāna al-Šarqiya* II, Beirut, 1937, p. 111, read this *mišmiš* and suggested that Ishāq al-Mawsilī was particularly fond of a drink made of apricots. I am not aware of any such drink nor could Zayat quote any parallels.

3. Iraq Government, Department of Antiquities, *Excavations at Samarra 1936-1939*, Baghdad, 1940, II, pl. IV. For similar vessels *in situ* see *ibid.*, pls. 12 a-c, 14 a. I am indebted to the Director General of the Department for permission to reproduce the photograph on pl. V c.

from the river bank and from the vineyard of the woman. Sa'dān'.
There is some doubt about the reading of the first word. If my
reading is accepted the first word would refer to *ḥamr* 'wine'
which is feminine. الشاط (more correctly الشط) probably refers to
one of the many vineyards which were found near monasteries and
elsewhere along the banks of the Tigris[1]. 'The vineyard of the woman',
a locality surely well-known to the ninth-century inhabitants
of Samarra, defies precise localization at present. Sa'dān adds
another name to the short list of signatures or owners' marks.
He, like Aḥmad b. Mūsā, may have been a wine grower, a cellarer,
a merchant.

In order to be used as wine jars—amphorae is hardly the word
for these vessels without handles[2]—the *dann* pl. *dinān* had to be
coated with bitumen. Many of the plain vessels of this shape
excavated at Samarra by the Iraq Department of Antiquities are
indeed treated with bitumen on the inside. This method of making
cheap, porous vessels watertight has a long history in Ancient
Mesopotamia[3] and Arabic poetry is full of references to the pitch-
coated jars which—because of their thin 'stalks'—had to be car-
ried on supports[4]. Thus e.g. Abū Nuwās (ob. 813 or 815 A.D.) :

وبكر سلافـة فى قعـر دنّ لها درعان من قار وطين[5]

"Hasten the first wine from the bottom of the *dann* which has two coats
of armour, one clay, one bitumen".

Or again the princely poet Ibn al-Mu'tazz (ob. A.D. 904) for
whose father al-Mutawakkil built the palace of Balkuwāra at Sa-
marra :

1. Cf. ŠĀBUŠTĪ, *op. cit.*, p. 51: وهذا الدير على شاطئ دجلة كثير البساتين
والكروم, also pp. 69, 96. ...

2. There are examples of wine jars of similar size and without handles,
both in Ancient Egypt and Mesopotamia ; cf. C. J. GADD, *Two Assyrian
observations*, in *Iraq*, X, 1948, pl. V ; Virginia R. GRACE, *The Canaanite
jar*, in *The Aegean and the Near East*, ed. S. S. WEINBERG (= Studies present-
ed to Hetty Goldman), Locust Valley, 1956, esp. p. 83 and fig. 1.

3. Cf. R. J. FORBES, *Bitumen and petroleum in Antiquity*, Leiden, 1936,
p. 81.

4. Ch. J. LYALL, ed. *The Mufaḍḍaliyyāt*, Oxford, I, p. 848 and II, 353 f.
سلافة الدن مرفوعًا نصائبه.

5. ABŪ NUWĀS, *op. cit.* (ed. FARĪD), p. 343.

دامت ثــلاثين حولا في معاصرها تسامر الدهر في طين من القار ¹

"For thirty years it remained in the presses, enclosed in clay of pitch, keeping Time company"

or again :

عروس خِدرٍ غَدَت لهامتها تيجانِ طين وقُمُصُها قارٌ ²

"A bride approaching on her brow: crowns of clay, and with shirts made of pitch".

From the unpainted fragments we may now turn to the *Bild-säulen* proper. Two of these, the complete specimen which is said to be in Istanbul (pl. I) and the half-preserved piece (pl. III c-d) whose whereabouts I have been unable to trace show the word مسمس, not as a graffito but in beautiful Kufic characters executed in blue pigment. *Mušammas* whatever its etymology, 'wine raised by a priest', or 'an inebriating drink fermented in the sun' (whether derived from *šammās* 'deacon' or *šams* 'sun') means no more than a type of wine.

Immediately above the heads of the figures on these two *Bild-säulen* and over a third which is undeniably female (pl. IV b) there is another word in Kufic letters in the same blue script مفلح. Muflih is a fairly common name. That on the vessels found at Samarra may or may not have been the name of the famous general who commanded the caliph's troops against the Ṭāhirids ³. Herzfeld had originally thought of him but rejected the identification in favour of his Aramaico-Manichaean theory. That the general Muflih was a very powerful personage is well brought out by an anecdote recorded by al-Šābuštī in his 'Book of Monasteries'. Muflih dispatched a messenger to the caliph al-Muʿtamid with the following message : "I have seen your singing girl Hazār and would like to possess her ; I have also seen your slave Badr al-Ġullanār and wish to own him too, kindly send both to me". The caliph was at first not unreasonably incensed by the man's audacity, but after some reflection he said : "One cannot refuse a request by a man like Abū Ṣāliḥ (i.e. Muflih). I have given orders for Hazār to be taken to him in her finery, with all her furniture and attendant slave-girls and all her possessions. As for Badr al-Ġullanār, he is

1. IBN AL-MUʿTAZZ, *Dīwān*, ed. Muḥyī al-dīn AL-ḤAYYĀṬ, Beirut, 1912, p. 227 ; ed. B. LEWIN, Istanbul, 1950 (Bibl. Islamica 17c), p. 60, l. 26.
2. ed. B. LEWIN, p. 56, l. 9.
3. ṬABARĪ, *op. cit.*, III, p. 1697 f. and also 1686.

my highly valued personal attendant, please ask Mufliḥ to leave him in my service". When the messenger delivered the caliph's reply, Mufliḥ said : "Well, I have got Hazār at any rate. Now I am off to fight the Zang and on my return I shall get Badr al-Ġullanār as well". A vain boast; he never returned from his military expedition but was slain on the battlefield[1].

Whoever the Mufliḥ on the Samarra *Bildsäulen* may have been, the word *mušammas* above his name is merely a wine label. The fragment of a *Bildsäule* in the British Museum (pl. III a-b) has on the inside a thin coating of bitumen[2]—further evidence, if any were needed, that it was intended for the storage of liquids. To obtain the *mušammas*-wine the jars were set up in the sun as evoked vividly by the poet :

واستنــود عتهــا رواقـيــد مـقـيّــرة دُكن الظواهـر قـد يرنسن بالطين

مكافـحــات لـحـرّ الشــمس قــائـمـة كانهــن نبـيــط فى تــبــابـين ³

"He put (the wine) in pitch-coated jars (*rāqūd* pl. *rawāqīd*)[4] dark in appearance and clad in clay, upright, defying the heat of the sun like Aramaeans in short trousers (*tubbān* pl. *tababīn*)"[5].

Many connoisseurs preferred the naturally matured *mušammas* to the *maṭbūḥ* as did that oinomaniac Abū Nuwās :

فاطبــخ الـراح بشمس فكفى بالشمس نارا ⁶

"Cook the wine only in the sun—for there is fire enough in the sun"

or Ibn al-Muʿtazz :

اتانى والاصبــاح ينهـض فى الـدُجى بصفراء لم تفسد بطبخ واحراق ⁷

"As the dawn was piercing the darkness, he brought me yellow wine, unspoiled by cooking or burning".

1. ŠĀBUSTĪ, *op. cit.*, p. 66.

2. This has been confirmed by the Research Laboratory of the British Museum.

3. QUṬĀMĪ (ob. 110/728), in NUWAYRĪ, *Nihāyat al-arab*, IV, p. 149.

4. The following information is supplied by an interesting gloss of the Babylonian Geonim : הפיטוסיס הן רקודי בארמית והן דני בטייט "*Piṭusim* (from πίθος) are called *rāqūd* in Aramaic and *dann* in Arabic" ; M. WALD, *op. cit.*, p. 30.

5. This garment seems to correspond to the short trousers worn by agricultural workers depicted on Islamic miniatures, glass and metal work. Cf. e.g. Th. ARNOLD and A. GROHMANN, *The Islamic Book*, London, 1929, pl. 33 b, 34 b ; C. J. LAMM, *Mittelalterliche Gläser*, Berlin, 1929, II, pl. 126 (2) ; D. S. RICE, *The earliest dated 'Mosul' Candlestick*, in *The Burlington Magazine*, December, 1949, p. 338, fig. D.

6. ABŪ NUWĀS, *op. cit.*, p. 214.

7. IBN AL-MUʿTAZZ, ed. ḤAYYĀṬ, p. 239.

Muḥammad b. al-Ḥāriṯ al-Šaḥīr called on Ibrāhīm b. al-Mahdī
(ob. A.D. 839)—He found the prince about to leave for a hunting
party, but to do his visitor honour he had the horses unsaddled
and a full meal served. There were choice dishes and also several
varieties of inspissated (maṭbūḫ) and sun-matured wine (mušammas)

١ ... ثم اتينا بالوان من الشراب المطبوخ والمشمس فاختار منه وسقانی ...

Before storing the fermented wine it was necessary to seal the
jars hermetically. The Romans used *oblinere* (to daub) or *gypsare*
(to plaster) for "corking" and *deradere* (to scrape) or *relinere* (to
break) for "uncorking" [2]. The Arabic equivalents are *ṭayn, taṭyīn*
for "plastering", *ḫatm* for "sealing" and *bazl* for piercing [3].

وما قَهْوةٌ صهباءُ كالمسك ريحها تُعلّى على النَّاجود طوراً وتقدح

ثوت فى سباء الدنّ عشرين حِجّة يطان عليها قِرمَدٌ وتُروّح ٤

"Not wine of the white grape, fragrant as musk (when the jar is broached)
and set on the strainer to clear, and ladled from cup to cup, a captive it
dwelt in the jar for twenty years above it a seal of clay, exposed to the
wind and sun" [5]

Ibn al-Muʿtazz has :

ثم استقرّت وعين الشمس تلفحها فى بطن مختومة بالطين كلفاء ٦

Or from the same poet-prince a verse which vividly evokes a
row of *"Bildsäulen"*

ودنان كمِثـــل صــفّ رجـال قـد اقيموا ليرقصوا دستبنداً ٧

"The wine jars are like a row of men drawn up to dance a *dastaband*."

1. The passage occurs in IBN AL-RAQĪQ, BM.Ms. Or. 3628, f° 5 v. The
name of the narrator is given as al-Šaḥīr. I. GUIDI, *Tables alphabétiques
du Kitāb al-Aġānī*, Leiden, 1900, p. 598 has Bašḥīr.
2. Cf. R. J. FORBES, *Studies in Ancient Technology*, III, Leiden, 1955,
pp. 119 f.
3. *Bazala*, 'he removed it, took it off, namely the clay that closed the
mouth of the head of the *dann* or wine jar', *bizāl*, 'the place that is broached
or pierced in a vessel containing wine' ; *bizāl* also, 'the instrument with which
this is done' ; *mibzal* (i), 'the mouth of a wine jar' (ii) 'a strainer' ; *mibzala*,
'an instrument for broaching' (LANE).
4. LYALL, *Mufaḍḍaliyyāt*, I, pp. 494 ff.
5. *Ibid.*, II, p. 187.
6. IBN AL-MUʿTAZZ, *Dīwān* (ed. LEWIN), p. 3 l. 2 ; (ed. ḤAYYĀṬ), p. 205
has تلكظها for تلفحها.
7. NUWAYRĪ, *op. cit.*, IV, p. 149 and the note explaining that *dastaband*
was a dance of the Zoroastrians.

An eye-witness has preserved for us a most interesting des-
cription of the wine halls built by a predecessor of al-Muʿtazz—
the caliph al-Wāṯiq (227-32/842-7) at Samarra. It deserves to be
translated in full : "al-Wāṯiq loved taverns (*māḥūr* pl. *mawāḥir*)
as he loved stories related about them and songs sung about them.
He himself founded two wine-halls, one in the harem of the palace,
the other by the river. He gave orders for a vintner to be chosen,
clean, of agreeable countenance and an expert in wines. A Christian
from Quṭrabull [1] who met these requirements was found. Moreover
he had two handsome sons and two beautiful daughters. Al-Wāṯiq
added to them some of his own male servants and Greek slave
girls. Then he allotted them to the two taverns, the women served
in the tavern of the harem (*ḥānat al-ḥuram*) and the men in that
on the river-side (*ḥānat al-šaṭṭ*).

"The choicest wines were procured and the taverns were furnished
with the caliph's own furnishings. Curtains were put up [2], gilt
(drinking) vessels (*awānī muḏhaba*) and painted jars (*dinān
madhūna*) were supplied : altogether the wine-halls presented a
splendid and joyful sight".

Having thus prepared the premises, the caliph recruited singers
and musicians and invited a gay company which included our
narrator. The account continues as follows : "The vintner (*ḥammār*)
advanced with his two sons clad in parti-coloured robes (*aqbiyā
musahhama*), held together by ornamented belts (*zanānīr*). Servants
carried measures (*mikyāl* pl. *makāyīl*), ewers (*kūz* pl. *kīzān*) and
tools for broaching the jars (*mibzal* pl. *mabāzil*) [3] on trays (*ṣāniya
pl. ṣawānī*). Then these painted [4] jars were brought forward (their
tops neatly plastered with fragrant plaster) and placed before the
vintner's seat. They were then broached (*buzilat*), as is the practice
in taverns, and samples (*unmūḏaǧāt*) passed to the vintner for
tasting. He sampled the wine and handed it around. Everybody
selected what he preferred and brought the *dann* to the vintner

1. A famous haunt of revellers near Baghdad often referred to in Arabic
poetry, cf. YĀQŪT, *Muʿǧam al-buldān*, ed. Cairo, 1906, VII, pp. 121 f.

2. Sometimes rooms had hangings of gold damask (*Aǧānī*, Būlāq ed.,
III, p. 184 f) and some textile fragments found at Samarra seemed to
Herzfeld to have come from curtain material rather than garments, *Ge-
schichte der Stadt Samarra*, p. 171, note 1.

3. See above p. 27 n. 3.

4. The text here has *dinān muḏhaba* instead of *dinān madhūna* as above,
probably a slip of the pen caused by the proximity of *awānī muḏhaba*.

who ladled the drinks into the guest's drinking vessel, as is the wont in public taverns. Having performed his task the vintner returned to his place and sat down. The guests present had wreathes of myrtle and other aromatic plants on their heads" [1].

This is the description of the inauguration of al-Wāṯiq's wine-hall by the river (ḥānat al-šaṭṭ) which the narrator attended. The caliph had deliberately recreated there the atmosphere of one of those public taverns of which he was so fond. Doubtless the parties given at the wine-hall of the harem (ḥānat al-ḥuram) were reserved for a more exclusive set of guests.

Something of the atmosphere of a public tavern is recaptured in al-Wāsiṭī's delightful illustration to al-Ḥarīrī's XIIth Maqāma (BN. Ms. arabe 5847, dated A.D. 1237, f° 33) (pl. VI). The picture follows the text fairly closely and is, as many of this master's paintings, a genre picture of Mesopotamian life. "So I went by night to the wine-hall (daskara) in disguised habit ; and there was the old man in a gay-coloured dress, amid amphorae (dinān) and a wine press (ma'ṣara) ; and about him were cup-bearers surpassing in beauty ; and candles that glittered, and the myrtle and the jasmine, and the pipe and the lute. And at one time he bade broach the wine jars (yastabzilu al-dinān), and at another he called the lutes to give utterance ; and now he inhaled the perfumes, and now he courted the gazelles . . ." [2].

In the miniature (pl. VI) we see the narrator al-Ḥāriṯ b. Hammām addressing the old man, Abū Zayd, in the gay garb (ḥulla mumaṣ-ṣara) who is seated cross-legged on a throne-like chair. Vases with plants, probably the myrtle (ās) and jasmine ('abhar) and a fruit bowl are placed before him. He is holding a beaker in his left hand and a cloth in his right. A similar cloth may be observed in the hand of the man to the right on the balcony [3]. A bearded man to the left is playing an eight-stringed lute ('ūd). To the right, a

1. The text is preserved in Ibn Faḍl Allāh AL-'UMARĪ, Masālik al-abṣār, ed. Aḥmad ZAKY, Cairo, 1924, pp. 393 f.

2. I have followed Chenery's translation of Ḥarīrī's Maqāmāt with a few slight changes, London, 1867, vol. I, p. 173.

3. In this connection it is interesting to recall a description of a visit paid incognito by Yazīd I, the Umayyad, to a well-known vintner. The scene is described by the ḥammār himself. Called upon to serve the heavily veiled horsemen, he washed his hands each time he broached a jar (naqartu al-dinān), strained each drink and supplied a fresh napkin (mindīl) for the customers to wipe the mouth after each drink ('UMARĪ, op. cit., pp. 321 f.). This was the highest form of refinement.

man (the face has suffered much from repainting) is treading grapes in a vat and the wine runs into a, surprisingly, small container. A youth is pouring wine through a strainer and the cleared liquid passes into a stem cup. The strainer known as *nāǧūd* (see above p. 27) and also *rāwūq* is aptly likened by a poet to "the trunk of an elephant without tusks" [1]. The candles mentioned by al-Ḥarīrī and the courted "gazelles" are nowhere in evidence, nor is there any flute player. In the upper register of the miniature, on a balcony, two guests are drinking : a servant is reaching for a jar passed up by his companion. The amphorae stacked on the balcony and on the floor have handles and lack the thin foot of the jars found at Samarra [2].

The illustration of the same text of the XIIth *Maqāma* in another early thirteenth-century manuscript in Paris (BN, Ms. arabe 3929, f° 34 v) (pl. VII) follows the text even more closely. In an architectural setting reduced to its simplest expression, we see Abū Zayd at ease on a low cushion. He is attired in a blue coat with large gold roundels. In his right is a winefilled beaker and on his head a pointed cap ; his elaborate turban (removed as it was rolled) hangs from a peg by his side. The wine-press is close at hand and again the liquid is pouring into a small vessel. In this miniature the anonymous painter has included the lute player and flute player mentioned in al-Ḥarīrī's text and also, for good measure, a drummer who is not. The jars on either side of Abū Zayd are large and have no handles. A candlestick in the foreground pictorially records the "candles that glittered" in the wine-hall.

Of quite different inspiration—but still in all probability to be dated in the last quarter of the thirteenth century—is a third illustration of the twelfth *Maqāma* in London (BM, Ms. Add. 22, 114 f° 26) (pl. VIII). The emphasis here is on the creation of a compact composition in an almost stage-like setting. Here Abū Zayd is seen "inhaling the perfumes" of a bunch of flowers and

1. NUWAYRĪ, *op. cit.*, IV, p. 149. An example contemporary with the Paris Ms illustration on pl. VI can be observed on a basin made for the Ayyūbid al-Nāṣir (1236-60) in Montreal ; cf. R. ETTINGHAUSEN, *Interaction and integration in Islamic art*, in *Unity and Variety in Muslim Civilization*, ed. G. E. VON GRUNEBAUM, Chicago, 1955, pl. XI a.

2. To my knowledge no wine-jars with handles have been found at Samarra, certainly none are reproduced in the reports of the German expedition and those of the Iraq Dept. of Antiquities.

courting a "gazelle" but the amphorae look more like pharmacist's jars. Remoter still from an observed scene in a tavern is the Mamlūk version of the illustration in a Ms. at Vienna dated A.D. 1334 [1].

Let us now return from the pleasing but later illustrations of al-Ḥarīrī's XIIth Maqāma to the ninth-century account of the opening of al-Wāṭiq's tavern and correlate certain facts gleaned from it with those supplied by the poetic quotations given above :

(i) Wine was kept in jars (dann pl. dinān) which were often pointed at the bottom and could stand upright only with help of a support (naṣā'ib) or when stuck in the ground,

(ii) these jars were coated with bitumen (qār),

(iii) they were sealed (maḫtūm) on top with clay (ṭīn)

(iv) sometimes the jars were painted (dinān madhūna),

(v) after broaching (v. bazala) the jar with a special tool (mibzala), the wine was

(vi) filtered in a filter (rāwūq etc. . .), put in measures (makāyīl), poured into ewers (kīzān) and glasses (ku'ūs) and other drinking vessels (awānī).

Moreover, it has been shown that there existed—at least in al-Wāṭiq's reign (A.D. 842-7)—a wine-hall near or actually in the caliph's harem. It is clear that the Bildsäulen found by the German expedition at Samarra in 1912 under the pavement of a room situated between the central throne-chamber and the harem are remains of painted wine jars. Some are labelled mušammas (to indicate the type of wine they had contained) and also bear the name of a certain Mufliḥ. Other fragments of unpainted jars bear the name of Aḥmad b. Mūsā and another (found by the Iraq Dept. of Antiquities in a later excavation) has the name of Sa'dān. The "wine-label" on one fragment indicates that the jar from which it came had contained inspissated wine (maṭbūḫ). Empty, and "lying there"—to borrow an image from Abū Nuwās —"bodies with no spirit" they were probably used as filling under the pavement of a room from which the more precious lead pipes of a fresh water ramification-point had previously been removed [2].

1. The illustration in the Vienna Ḥarīrī Ms. (AF. 9 f° 42 v) dated 734/1334 is published in K. HOLTER, Die Galen-Handschrift und die Makamen des Hariri in der Wiener Nationalbibliothek, Vienna, 1937, p. 19, fig. 13.

2. Other fragments of jars with graffiti fall within the same category of vessels. Cf. HERZFELD, Malereien, pl. LXXIII and fig. 92, where I feel inclined

As for the subjects painted on the jars, they surely belong to the secular repertoire just as the mural paintings discovered at Samarra. The hunter (pl. IV a), the female entertainers (?) (pls. III, IV b), the military figures (pl. II a, d) and the bearded men with crutch staffs (pls. I, II, b, c, e) aligned in a row would make a pleasing decoration for a tavern and recall the line of Ibn al-Mu'tazz : "jars drawn up like a row of men about to dance a *dastaband*". The bearded figures may well be intended to represent monks, despite the fact that they do not carry crosses. Throughout the golden era of the Abbasid caliphate, the best wines were to be sampled in taverns attached to monasteries. The caliph and his retinue honoured them with frequent visits and his humbler subjects flocked there on many occasions.

Enough has been said to make it clear that we must henceforth dissociate the painted jars found at Samarra from idol-worship and Manichaean heresies unless we are to take literally the verses of that bibulous reprobate Abū Nuwās :

آلَيْتُ ان اشرب مشمولة ١ من خمر فلُّوجٍ ٢ وعانات

من قهوة ما مثلها قهوة تحلف بالـعُـزّى وبالـلات

لو ان لقمان على حكمه يشرب منها خمس شربات

لقام والابـريـق فى كفّه يسجد للـزنـديـق والعاق

to read *aṣfar* rather than *aṣġar*, *ibid.* p. 95, and interpret it as yet another sort of wine.

1. FĪRŪZĀBĀDĪ, *op. cit.*, BM.Or. 9200, f° 55 explains that *mašmūl* and

mašmūla are synonyms for cool wine : قال المشمول والمشمولة ومن أسمائها

الصغانى: المشمول الغدير يضربه ريح الشمال حتى يبرد ومنـه قيل للخمر

مشمولة اذا كانت باردة الطعم ، قلت: ويمكن ان يقال شبهت بالنار فى

فعلها ولونها وحرارتها فان المشمولة النار اذا هبّ عليها الشمال.

Another 'etymology' is given by AL-NĀSĪ who derives *mašmūl* from √šml 'to embrace, to include'

والكرم من كرم الطباع وفضله والراح روح اخى الغرام للجاهد

ولذاك سميت الشمول لجمعها شمل الخليط وضمها للغارد

NAWĀĠĪ, *Ḥalbat al-kumayt*, Būlāq A.H. 1276.

2. The text reproduced here is taken from the Ms. BM, Add. 19,404, f° 164, Both the printed editions have *qulūġ* instead of *fallūġ*. The 1932 edition further has a corruption *mašmūr* for *mašmūla* in the first line and *ḥikma* for *ḥukmihi*.

"I vow that I shall drink the cool wine of Fallūj and ʿAnā—a wine that is unlike any other wine and which makes one swear by ʿUzzā and Allāt [1]. Should Luqmān, for all his wisdom, drink but five draughts of it, he would stand up—a ewer (*ibrīq*) in his hand and perform genuflexions to the heretic (*zindīq*) and tyrant (*ʿātī*)" [2].

1. Allāt and ʿUzzā, two pre-Islamic idols often referred to jointly as in *Qurʾān*, LIII, 19.

2. A similar sentiment is expressed by al-Walīd b. Yazīd

قـد جعلنـا طـوفنـا بالدنان حين طاف الورى بركـن يماني

سجـد السـاجـدون لله حقا وجعـلـنـا سجـودنـا للقنـاني

NAWĀĞĪ, *op. cit.*, p. 179.

THE UMAYYAD DOME OF THE ROCK IN JERUSALEM

Oleg Grabar

IT IS A COMMONPLACE OF CLASSICAL ISLAMIC religious writing that the Prophet himself considered Mekkah, Madinah, and Jerusalem as the three holiest places of the faith. All three centers were places of pilgrimage and in them liturgical requirements, sacred memories, and traditions acquired a monumental expression.[1] Medieval writers and modern scholars and travelers have often described the religious topography of the Muslim holy places and the significance of the numerous structures erected on these sacred spots. But the problem is not only one of description and identification. The question must also be raised whether the current identifications of holy places and their present architectural expression date from the earliest times of Islam, and, if not, when and why these identifications were made and the monuments built. In other words the major sanctuaries of Islam must be considered in their historical context. For the mosque of Madinah, for instance, we possess the masterly study by J. Sauvaget, who succeeded, on the basis of texts and a limited archeological documentation, in reconstructing in detail the nature of this central monument of Islamic religious architecture in the Umayyad period.

In the case of Jerusalem, the problem presents itself differently. First, in dealing with the Ḥaram al-Sharif, we are not dealing with a new holy area, as in Madinah, but with one of the most ancient sacred spots on earth. Second, in Jerusalem, the monuments themselves are better known. The Dome of the Rock is still essentially the Umayyad building. The Aqsā mosque, to be sure, has undergone numerous reconstructions, but recent studies by K. A. C. Creswell, J. Sauvaget, and especially R. W. Hamilton, have given us a good idea of the nature of the Umayyad mosque. The problem, therefore, is neither reconstruction nor dating, but essentially interpretation: if we consider the long tradition of Mount Moriah as a sacred place, what was its significance in the eyes of the Muslims? The *faḍā'il* or religious guidebooks for pilgrims of later times provide us with an answer for the period which followed the Crusades, but it may be questioned whether all the complex traditions reported about the Ḥaram at that time had already been formulated when the area was taken over by the Arabs. Through its location, through its inscription, and through its mosaics, the Dome of the Rock itself provides us with three strictly contemporary documents, which have not so far been fully exploited in an attempt to define the meaning of the structure at the time of its construction. The Dome of the Rock is especially important in being not only the earliest remaining monument of Islam, but, in all likelihood, the earliest major construction built by the new masters of the Near East. The first

[1] Among the Muslim holy places Jerusalem occupies in general a slightly less important place than the two Arabian sanctuaries. The Palestinian city was more important in Umayyad, Ayyūbid, and Mamlūk times than under the 'Abbāsids or the Fāṭimids, although both of the latter dynasties took great care in repairing damaged monuments on the Ḥaram. At times, also, it seems to have had a local importance rather than an ecumenical one; see Nāṣir-i Khusrow, tr. G. LeStrange in *Palestine Pilgrims' Text Society* (hereafter PPTS), vol. 4, London, 1896, p. 23. Or else its importance was only emphasized by specific religious, and especially mystical, groups; see the remarks at the end of S. D. Goitein, *The historical background of the erection of the Dome of the Rock*, Journal of the American Oriental Society (hereafter JAOS), vol. 70 (1950), pp. 104–108.

34

mosques in Kūfah, Baṣrah, Fusṭāṭ, and Jeru-salem were certainly not very imposing struc-tures; little is known about Muʿāwiyah's secu-lar constructions in Damascus, but it is not likely that they were done on a very lavish scale. The Dome of the Rock, on the other hand, has remained to this day one of the most remarkable architectural and artistic achieve-ments of Islam. It is therefore important to attempt to understand its meaning to those who lived when it was built.

Discussion of the meaning of Jerusalem, and especially of the Ḥaram al-Sharīf, in medieval times is greatly simplified since most of the geographical and descriptive texts deal-ing with the city have been gathered by Father Marmarji,[2] and since many of them have been translated into English by G. Lestrange,[3] into German by Gildmeister,[4] into Russian by Miednikov,[5] and into French by Father Mar-marji.[6] Furthermore, the inscriptions found on the Ḥaram have been published and ana-lyzed by Max van Berchem in the second series of his *Matériaux pour un Corpus In-scriptionum Arabicarum.*[7] But, except for Miednikov, whose conclusions have been sum-marized and by and large accepted by Caetani in his *Annali dell'Islam,* and to a certain ex-tent by van Berchem, these authors have dealt largely with purely descriptive texts, for the most part taken from geographers, and have only too rarely tried to set the building up of the Ḥaram area by the Muslims within the historical circumstances of the time.

The Dome of the Rock is dated in the year 72 A.H./A.D. 691–692 and there is some evi-dence that it was begun in 69.[8] It has been de-scribed many times and its location (on a platform to the north of the center of the vast artificial esplanade of the Haram al-Sharīf; *fig. 1*), as well as its plan (an octagonal struc-ture consisting of two octagonal ambulatories and a circular area within which lies the Rock; *fig. 2*), is familiar to all travelers to Palestine and to all students of Muslim archeology. K. A. C. Creswell and Mademoiselle van Berchem have dealt in great detail with the character and the origins of the building and of its mosaics,[9] and Creswell has analyzed the purpose of the building, but only briefly and, as will be shown, incompletely. In this study, as far as possible, only texts earlier than the Crusades will be used, for the Crusades superimposed over the earlier Jewish and Muslim traditions a whole series of more or less artificial Christian ones which confuse all problems connected with the Ḥaram and often prevent certain identifications. As Max van Berchem has shown in a number of cases,[10] the conscious attempt by Saladin to reconvert all buildings to their ancient usage was not always successful and has at times led to extraordinary misunderstandings.[11] It is also quite certain that the numerous legends and

[2] A. S. Marmarji, *Buldāniyah Filasṭīn al-ʿarabi-yah,* Beirut, 1948, pp. 30–42, 243–301.

[3] G. LeStrange, *Palestine under the Moslems,* London, 1890, pp. 83–223.

[4] J. Gildmeister, *Die arabischen Nachrichten zur Geschichte der Harambauten,* Zeitschrift des Deutschen Palästina-Vereins (hereafter ZDPV), vol. 13 (1890), pp. 1–24.

[5] N. A. Miednikov, *Palestina ot zavoevaniya arabami do kristovykh pohodov,* Pravoslavnyj Pales-tinskij Sbornik, vols. 16 and 17 (1897).

[6] A. S. Marmarji, *Textes géographiques sur la Palestine,* Paris, 1951.

[7] Max van Berchem, *Matériaux pour un Corpus Inscriptionum Arabicarum II Syrie du Sud,* 3 vols., Cairo, 1922–23, 1927.

[8] G. LeStrange quotes an unpublished fragment of Ṣibt al-Jawzi to that effect, *Description of the Noble Sanctuary,* Journal of the Royal Asiatic Soci-ety (hereafter JRAS), n.s., vol. 19 (1887), p. 280.

[9] K. A. C. Creswell, *Early Muslim architecture,* vol. I, Oxford, 1932, pp. 42–94 and 151–228.

[10] M. van Berchem, vol. 2, pp. 23–31, 37 ff.

[11] See, for instance, G. LeStrange, in JRAS, vol. 19 (1887), pp. 260–261.

traditions which are associated with the Ḥaram in the group of *faḍā'il* of the Mamlūk period were not introduced in the Umayyad period.[12] The comparative simplicity of the legends accepted even in Ayyūbid times is now fully shown by the published and translated *K. al-Ziyārāt* of al-Harawi.[12a] Except in a few cases it is almost impossible to determine exactly when a specific tradition or identification of a holy place with a sacred event became sufficiently common to be accepted and propagated by the spiritual Baedekers of a given time, but in the early period of Islam the religious system and the spiritual life of the faithful were yet too simple—or too disorganized—to allow for as definitive and complete a system of religious-topographical associations as appears in later writing. More often than not later traditions tend to confuse rather than clarify the essential issue of the purpose and origin of the Umayyad structure.

As far as the Umayyad Dome of the Rock is concerned, two explanations are generally given for its construction. The first has the apparent merit of agreeing quite well with the historical circumstances of the years 66–72 A.H., and it has been adopted by Creswell after having been introduced by Goldziher. This interpretation is based on texts of al-Ya'qūbī (260 A.H./A.D. 874),[13] a shi'ite brought up in Baghdad who had traveled widely throughout the empire, and Eutychius (d. 328 A.H./A.D. 940),[14] a melkite priest from Alexandria. It is also found in other

authors before the Crusades such as al-Muhallabī[15] and Ibn 'Abd Rabbih,[16] but there are indications (a series of errors with respect to attributions and dates about which more will be said below) which suggest that in reality we are dealing with one major tradition, or possibly two, which have been passed on through specific historiographic channels. All these authors claim that the reason for building a sanctuary in Jerusalem was that, since Ibn al-Zubayr was in possession of Mekkah, 'Abd al-Malik wanted to divert pilgrims from the Ḥijāz by establishing the Palestinian city as the religious center of Islam. And it has been asserted that the plan of the Dome of the Rock, with two ambulatories around the Rock itself, originated with the liturgical requirements of the *ṭawāf*.[17]

This interpretation of the Muslim sanctuary has been very recently criticized by S. D. Goitein in a brief communication on the background of the Dome of the Rock.[18] His argument is partly negative. He points out that the statements of al-Ya'qūbī and Eutychius are unique in the annals of early Muslim historiography and that as momentous an attempt as that of changing the site of the *ḥajj* could not have been overlooked by such careful historians as al-Ṭabarī and al-Balādhuri, and especially not by a local patriot like al-Maqdisī. Furthermore it would have been

[12] Two of these late *faḍā'il* have been recently translated by C. D. Matthews, *Palestine-Mohammedan Holy Land* in *Yale Oriental Series*, vol. 24, New Haven, 1949, with important notes.

[12a] Al-Harawi, *Guide des Lieux de Pèlerinage*, tr. J. Sourdel-Thomine, Damascus, 1957, p. 62 ff.

[13] al-Ya'qūbī, *Historiae*, ed. T. Houtsma, Leyden, 1883, vol. 2, p. 311.

[14] Eutychius ibn al-Baṭrīq, *Annales*, ed. L. Cheikho et al., in *Corpus Scriptorum Christianorum Orientalium*, ser. 3, vol. 7, Paris, 1909, p. 39 ff.

[15] Quoted by Abū al-Fidā, *Geography*, tr. M. Reinaud and S. Guyard, Paris, 1848–83, vol. 2, p. 4; cf. also Gildmeister in ZDPV, vol. 13, p. 8.

[16] Ibn 'Abd Rabbih, *al-'Iqd al-Farīd*, ed. M. S. al-'Ariyān, Cairo, 1940, vol. 7, pp. 299–300; this text is one of the earliest ones to include the more or less complete hagiography of Jerusalem as it will appear in later traditions.

[17] Creswell, p. 43, n. 1; I. Goldziher, *Muhammedanishe Studien*, Halle, 1889–90, vol. 2, pp. 35–37.

[18] S. D. Goitein, *op. cit.* See also J. W. Hirschberg, *The sources of Moslem traditions concerning Jerusalem*, Rocznik Orientalistyczny, vol. 18 (1953), p. 318 ff.

36

politically unsound for 'Abd al-Malik to have "marked himself as Kāfir, against whom the Jihād was obligatory." The theologians of his entourage were not likely to have approved of it. Al-Ya'qūbī does say that 'Abd al-Malik leaned on the testimony of al-Zuhrī to justify his decision, but the statement is hardly creditable, since al-Zuhrī was barely 20 years old at the time.[19] An important point of Goitein's article is to have brought attention to the unfortunately still largely unpublished *Ansāb al-Ashrāf* of al-Balādhurī. In the description found there of al-Ḥajjāj's operations around Mekkah, it is made clear that the Syrian forces considered Mekkah as the center for pilgrimage. Before starting for Mekkah the soldiers are told that they must be ready for the pilgrimage; during the fighting al-Ḥajjāj requests permission for his troops to make the *ṭawāf;* and there appears to have been a fairly constant stream of people going on pilgrimage in spite of the fighting.[20] It may also be pointed out that al-Ḥajjāj would not have taken such pains to restore the Ka'bah to its original shape, had it been replaced in the mind of the Umayyads by the new building in Jerusalem. And a statement in Ṭabarī to the effect that in 68 A.H. at least four different groups went on pilgrimage shows beyond doubt that, at that time at least, the bitter factional strifes between Muslims were held somewhat in abeyance during the pilgrimage.[21]

Goitein also shows that the accounts of al-Ya'qūbī and of Eutychius contain errors which indicate that they were highly partisan in their opposition to the Umayyads and not always in full control of the facts. Eutychius and al-Muhallabī attribute to al-Walīd, 'Abd al-Malik's successor, an attempt to divert the pilgrimage to Jerusalem,[22] while al-Ya'qūbī adds that the practice of having the *hajj* in the Palestinian city continued throughout the Umayyad period. Finally it is doubtful whether the comparatively small area of the Dome of the Rock could have been conveniently used for the long and complex ceremony of the *ṭawāf;*[23] and it may be argued that, had 'Abd al-Malik wanted to replace Mekkah, he would have chosen a type of structure closer in plan to the Ka'bah than the Dome of the Rock, since the sacramental and inalterable character of the Mekkan sanctuary is fully apparent in its several reconstructions and, in particular, in that of al-Ḥajjāj.[24]

The second explanation for the Dome of the Rock was destined to become the one that was, and still is, generally accepted by the faithful. It is connected with the complex problem of the exegesis of *sūrah* 17, verse 1, of the Koran: "Glorified be He Who carried His servant [*i. e.*, Muḥammad] by night from the *masjid al-ḥarām* (*i.e.*, Mekkah) to the *masjid al-aqṣā* [*i.e.*, the farthest place of worship]." As early as the first part of the second century, the biographer of the Prophet, Ibn Isḥāq, connected this Night-Journey (*isrā'*)

[19] J. Horovitz, *The earliest biographies of the Prophet and their authors*, Islamic Culture, vol. 2 (1928), p. 38 ff.; cf. also *al-Zuhri* in *Encyclopedia of Islam*. For doubts about al-Zuhri's relationship with 'Abd al-Malik, see now A. A. Duri, *Al-Zuhri, a study on the beginnings of history writing in Islam,* Bull. School of Oriental and African Studies, vol. 19 (1956), pp. 10–11.

[20] Balādhurī, *Ansāb al-Ashrāf*, vol. 5, ed. S. D. Goitein, Jerusalem, 1936, p. 355 ff., esp. pp. 358, 360, 362, 373.

[21] Ṭabarī, *Annales*, ed. M. de Goeje et al., Leyden, 1879–1901, vol. 2, pp. 781–783.

[22] Cf. below for a possible interpretation of Eutychius' error.

[23] Goitein has suggested that the pilgrims from Syria mentioned by Nāṣir-i Khusrow did not in fact accomplish the regular *hajj*, but only the *wuqūf*, a practice which was observed in many provincial cities.

[24] On all these problems cf. Gaudefroy-Demombynes, *Le pèlerinage à la Mekke*, Paris, 1923, p. 49, and *Encyclopedia of Islam* articles on Ka'bah, Mekkah, etc.

with the no less complex Ascension (mi'raj) of Muḥammad, and claimed that the masjid al-aqṣā was in fact in Jerusalem and that it is from Jerusalem that the Prophet ascended into heaven.[25] Al-Ya'qūbī mentions in his account the fact that the Rock in the Ḥaram al-Sharīf is "the rock on which it is said that the Messenger of God put his foot when he ascended into heaven."[26] Furthermore all the geographers describing the area mention a great number of qubbahs, maqāms, miḥrābs, etc. . . . connected with the events of Muḥammad's Ascension. It might thus be suggested that the Dome of the Rock was built as a sort of martyrium to a specific incident of Muḥammad's life.[27] The arguments could be further strengthened by the fact that, without doubt, the architecture of the Dome of the Rock follows in the tradition of the great Christian martyria and is closely related to the architecture of the Christian sanctuaries in Jerusalem, one of which commemorated the Ascension of Christ.

But, just like the first one, this explanation leads to more problems than it solves. A. A. Bevan has shown that among early traditionists there are many who do not accept the identification of the masjid al-aqṣā, and among them are to be found such great names as al-Bukhārī and Ṭabarī.[28] Both Ibn Isḥāq and

al-Ya'qūbī precede their accounts with expressions which indicate that these are stories which are not necessarily accepted as dogma.[29] It was suggested by J. Horovitz that in the early period of Islam there is little justification for assuming that the Koranic expression in in any way referred to Jerusalem.[30] But, while Horovitz thought that it referred to a place in heaven, A. Guillaume's careful analysis of the earliest texts (al-Wāqidī and al-Azraqī, both in the later second century A.H.) has convincingly shown that the Koranic reference to the masjid al-aqṣā applies specifically to al-Ji'rānah, near Mekkah, where there were two sanctuaries (masjid al-adnā and masjid al-aqṣā), and where Muḥammad sojourned in dhū al-qa'dah of the eighth year after the Hijrah.[31] A. Guillaume also indicates that the concepts of isrā' and mi'raj were carefully separated by earlier writers and that Ibn Isḥāq seems to have been the first one, insofar as our present literary evidence goes, to connect them with each other. A last argument against accepting the association between the Ascension and the Dome of the Rock as dating from the time of the construction is archeological in nature. As has been mentioned, all early writers enumerate a series of holy places on the Ḥaram area, many of which

[25] Muhammad ibn Isḥāq, Kitāb rusūl allāh, ed. F. Wüstenfeld, Göttingen, 1859, p. 263 ff., tr. by A. Guillaume, London, 1955, p. 181 ff.

[26] al-Ya'qūbī, loc. cit.

[27] B. Schrieke, art. Isrā' in Encyclopedia of Islam, and Die Himmelsreise Muhammeds, Der Islam, vol. 7 (1916), attempted to show that the Ascension of the Prophet was a sort of Initiationshimmelfahrt for prophethood. On the more general problem of the Ascension, see the recent contributions of G. Widengren, The Ascension of the Apostle and the Heavenly Book, Uppsala, 1950, and Muhammad, the Apostle of God and his Ascension, Uppsala, 1951, whose interesting conclusions go far beyond the specific problem of Muḥammad.

[28] A. A. Bevan, Muhammed's Ascension to

Heaven, Studien . . . Julius Wellhausen gewidmet, Giessen, 1914. The case of Ṭabarī is particularly significant to Bevan, since the medieval writer included the Jerusalem identification in his Tafsīr, but dropped it from his later chronicle. See also Ibn Ḥawqal in Bibl. Geogr. Arab., vol. 2, 2d ed. by J. H. Kramers, Leyden, 1938–39, p. 172, where the masjid al-aqṣā seems to be very generally located in Palestine, but not in any specific place.

[29] Even in later times traditions were maintained which denied that the Rock was the place whence Muḥammad ascended into heaven; cf. Matthews, pp. 20–21.

[30] J. Horovitz, Muhammeds Himmelfahrt, Der Islam, vol. 9 (1919).

[31] A. Guillaume, Where was al-masjid al-Aqṣā?, al-Andalus, vol. 18 (1953).

38

still stand today, most having been rebuilt after Saladin's reconquest of Jerusalem. Next to the Dome of the Rock stood—as it still stands today—the *qubbah al-miʿraj*, the *martyrium* of the Ascension. Had the first and largest of all buildings on the Ḥaram (outside of the congregational mosque on its southern end called al-Aqṣā) been built as a *martyrium* to the Ascension of Muḥammad, there would certainly not have been any need for a second *martyrium*. And the Persian traveler Nāṣir-i Khusrow, one of the first to attempt a systematic explanation of all the buildings of the Ḥaram, still considers the Rock under the Dome simply as the place where Muḥammad prayed before ascending into heaven from the place where the *qubbah al-miʿraj* stands.[32]

It appears then that the textual evidence is incomplete and cannot provide us with a satisfactory explanation of the purpose for which ʿAbd al-Malik built the Dome of the Rock. It is, therefore, necessary to turn to the internal evidence provided by the building itself. The Dome of the Rock can be analyzed from three different points of view: its location, its architecture and decoration, and the inscription (240 meters long) inside the building, which is the only strictly contemporary piece of written evidence we possess. While none of these could alone explain the Dome of the Rock, an analysis of all three points can lead to a much more complex and, at the same time, much more precise explanation than has been offered hitherto of the reasons which led to the erection of the first major monument of the new Islamic civilization.

The first question to be raised is that of the location of the building. More specifically, since it can be shown that the Rock was not considered at the time as the place whence

[32] Nāṣir-i Khusrow in PPTS, vol. 4, p. 49. Cf. below, p. 61.

Muḥammad ascended into heaven, why was it chosen as the obvious center of the structure? In order to answer this question, we must ask ourselves what significance the Rock had at the time of the Muslim conquest and whether there is any evidence for a Muslim explanation of the Rock at the time of the conquest or between the conquest and the building of the Dome by ʿAbd al-Malik.

The exact function of the Rock in the earliest times is still a matter of conjecture. While there is no doubt that the Ḥaram was the site of the Solomonic temple, there is no definite Biblical reference to the Rock. Whether it was "the threshing-floor of Ornan the Jebusite" (I Chron. 3:1; II Sam. 14:18), whether it was an ancient Canaanite holy place fitted by Solomon into the Jewish Temple, perhaps as a *podium* on which the altar stood,[33] or whether it was the "middle of the court" which was hallowed by Solomon at the consecration of the Temple (I Kings, 8:63–64) cannot be certainly determined.[34] The Herodian reconstruction of the Temple is not any clearer, as far as the Rock is concerned. From the *Mishnah Middoth* it would appear that the Rock was only a few inches above the level of the terrace and that it was used as a cornerstone in the Herodian building.[35] Nowhere have I been able to find definite evidence for an important liturgical function of the Rock.

But in medieval times Mount Moriah in

[33] H. Schmidt, *Der heilige Fels in Jerusalem*, Tübingen, 1933, p. 47. See also G. Dalman, *Neue Petra-Forschungen*, Leipzig, 1912, p. 111 ff., and esp. p. 137 ff.

[34] J. Simons, *Jerusalem in the Old Testament*, Leyden, 1952, p. 344 ff., and esp. p. 381 ff., with full bibliography; A. Parrot, *Le Temple de Jérusalem*, Neuchâtel-Paris, 1954, p. 7 ff.

[35] *Mishnah Middoth* in *The Babylonian Talmud*, Eng. tr. by I. Epstein, London, 1948, chap. III; Schmidt, *op. cit.*, p. 31 ff.; Simons, *op. cit.*, p. 39 ff., where no specific information is given about the Rock.

general and the Rock in particular were endowed in Jewish legend with a complex mythology. Mount Moriah, through its association with the Temple, became the *omphalos* of the earth, where the tomb of Adam was to be found and where the first man was created.[36] But another, more specific, tradition was attached to the Rock, that of the sacrifice of Abraham, through a confusion between the land of Moriah (Gen. 22:2) and Mount Moriah.[37] It is not possible to say when the confusion first occurred, but it is already found in Josephus in the first century A.D., and it became common throughout Talmudic literature.[38] In other words, in the Jewish tradition, the Rock and the area surrounding it acquired mystical significance as the site of the Holy of Holies and became associated with a series of legends involving major figures of the Biblical tradition, especially Abraham and Isaac. The importance accorded to the Ḥaram and to the Rock by the Jews is evidenced in early medieval times by the statement of the Pilgrim of Bordeaux who mentions a *lapis pertusus* "to which the Jews come every year and which they anoint,"[39] probably a refer-

ence to the Rock itself which appears here to be thought of as a tangible remnant of the Temple.

During the Roman and Byzantine period, the whole Ḥaram area was left unoccupied,[40] but, under Christian rule, the Holy City itself witnessed a new and remarkable development. This development took place in the "New Jerusalem," and no Christian sanctuary appears to have been built on the area of the Ḥaram, since the prophecy of the destruction of the Temple had to be fulfilled. There is some evidence in patristic literature that the Jewish associations were accepted by some Christians.[41] But, with the building of the Holy Sepulchre, the *omphalos* of the earth was transferred to another hill of Jerusalem, Golgotha, and together with it were also transferred the associations between Jerusalem and Adam and Jerusalem and Abraham.[42]

[36] W. H. Roscher, *Der Omphalosgedanke bei verschiedenen Völkern,* Berichte über die Verhandl. d. Sächs. Gesell. d. Wiss. zu Leipzig, phil.-hist. Kl., vol. 70 (1918), p. 34 ff. with further bibliography. Further references in J. W. Hirschberg, *Sources of Muslim traditions,* p. 321 ff., with, curiously, no mention of Abraham.

[37] G. Dalman, *Jerusalem und seine Gelände,* Gütersloh, 1930, p. 125; L. Ginzberg, *The legends of the Jews,* Philadelphia, 1913–38, vol. 1, p. 285, and vol. 5, n. 253 on p. 253. See also the various commentaries on the book of Genesis.

[38] Josephus, *Jewish antiquities,* vol. 1, p. 225 ff., and vol. 7, p. 327 ff. H. Danby, *The Mishnah,* London, 1933, p. 196; *The Babylonian Talmud,* tr. under direction of Rabbi Dr. I. Epstein, London, 1933 (and subsequent years), pt. 1, vol. 1 (Zebaḥim), p. 305; part 2, vol. 7 (Ta'anith), pp. 74 and 77 ff., etc.; see index.

[39] Text and tr. in PPTS, vol. 1, London, 1896, pp. 21–22.

[40] H. Vincent and F. M. Abel, *Jerusalem II Jerusalem Nouvelle,* Paris, 1926, vol. 1, pp. 16–18. As far as the Roman period is concerned, this is not entirely certain, and there is some evidence that there were Roman monuments on the Ḥaram area.

[41] Simons, p. 383, n. 2; Ginzberg, vol. 5, p. 253.

[42] The relevant texts are all in the collection of the PPTS, vol. 1, p. 24: "Here (Golgotha) Adam was formed out of the clay; here Abraham offered up Isaac his son as a sacrifice, in the very place where our Lord Jesus Christ was crucified." See also vol. 2, pp. 14–16. On the *omphalos* at Golgotha, see A. Piganiol, *L'Hemispharion et l'Omphalos des Lieux Saints,* Cahiers Archéologiques, vol. 1, 1945; A. Grabar, *Martyrium,* Paris, 1946, vol. 1, p. 253. That the Christian tradition was rather confused, at least in the beginning, is shown by the *Terra Sancta* of Theodosius, where both Golgotha and Mount Moriah are seen as the place where Abraham sacrificed Isaac (in PPTS, vol. 1, pp. 25–26, and vol. 2, p. 10). This association between Abraham and the Holy Sepulchre was maintained after the conquest by the Muslims, since it appears in Arculfus (*ibid.,* vol. 3, pp. 10–11) and later in the account of the Russian abbot Daniel (*ibid.,* vol. 4, pp. 15–16). It is interesting to note that the abbot considers the Rock to have been the site of Jacob's struggle with the angel (p. 20). The identification with Jacob occurs also in Eutychius and

40

Such then appears to have been the situation at the time of the Muslim conquest: the Jewish tradition considered the Ḥaram area as the site of the Temple and the place of Abraham's sacrifice and Adam's creation and death, while the Christian tradition had moved the latter two to a new site.

The main features of the chronology of the conquest of Jerusalem are fairly clear and have been fully stated by chroniclers and discussed by scholars.[43] That the taking of the Holy City was a major moment in the conquest of Syria is apparent both in the fact that the Christians demanded the presence of 'Umar himself for the signing of the treaty of capitulation and in the fact that 'Umar acquiesced. Once the treaty was signed, 'Umar, accompanied by the patriarch Sophronius, was led through the city. But as this "tour" of the Holy City was endowed by later writers with a series of more or less legendary incidents, it is not very easy to ascertain what happened. There are two points on which most sources, early or late, Muslim or not, seem to agree. First it seems that 'Umar was definitely intent on seeing one specific site in the Holy City. All sources agree on that, and, in later traditions, his quest and the patriarch Sophronius' opposition to it were transformed into a dramatic contest.[44] Second, the early sources do not refer to the Rock as the main object of 'Umar's quest, but to the Ḥaram area in general, which is seen as the place where the Jewish Temple stood, the miḥrāb Dāwūd of the Koran (38:20–21), the naos tôn Ioudaiôn of Theophanes.[45] The Greek text only men-

tions 'Umar's interest in the area of the Jewish Temple and adds later that a Muslim sanctuary was built on the place of the Jewish Temple.[46] The tradition transmitted by Ṭabarī does mention the Rock, but it plays no part in the prayer and recitations (Kor. 38) made by the caliph when he reached the Ḥaram area, and 'Umar rejects the suggestion made to him by Ka'b, a Jewish convert, that the Rock be on the qiblah side of the Muslim sanctuary. His reason is that this would be reverting to the Jewish practice. Eutychius also mentions the Rock and implies that Sophronius succeeded in persuading 'Umar to take over the Jewish Temple area in exchange for a treaty which would leave the rest of Jerusalem free of mosques. In his relation of the discovery of the Rock and of the construction of the mosque, he follows a tradition similar to Ṭabarī's, but without naming Ka'b.[47] Al-Musharraf emphasizes the fact that 'Umar was looking for the place where the Temple of Solomon stood; he does mention the Night Journey of the Prophet, but not the Rock.[48] Agapius of Manbij, a contemporary of Eutychius, does not mention either Rock or Ascension, but simply states that 'Umar ordered the building of a mosque on the site of the Jewish Temple.[49]

Whenever it is mentioned in these texts, the Rock, together with the whole Ḥaram

must have been a fairly common Christian tradition after the earlier Jewish associations had been moved to the Holy Sepulchre.

[43] L. Caetani, *Annali dell'Islam*, vol. 3, Milan, 1910, p. 920 ff., with all the texts known to that time.

[44] LeStrange, *Palestine*, pp. 139–142.

[45] Ṭabarī, vol. 1, pp. 2408–2409; Theophanes, *Chronographia*, Bonn, 1839, pp. 519–520.

[46] Theophanes, p. 524. The Bonn text is not very explicit, since it simply talks about a *naos*. The de Boor edition (vol. 1, p. 342) has an addition which specifies that we are dealing with a mosque on the site of the Jewish Temple. It is the more likely interpretation of the text, and LeStrange's translation, *Palestine*, p. 91, is incorrect.

[47] Eutychius, vol. 2, pp. 17–18.

[48] Cf. R. Hartmann, *Die Geschichte des Akṣa-Moschee in Jerusalem*, ZDPV, vol. 32 (1909), p. 194, n. 1.

[49] Agapius of Manbij, *K. al-'Unvan*, ed. A. A. Vasiliev, in *Patrologia Orientalis*, vol. 8, Paris, 1912, p. 475.

area, appears as the symbol of the Jewish Temple. But the Rock itself is not taken into any particular consideration by 'Umar. It may be, as is suggested by Eutychius, that 'Umar was merely looking for a large area on which to build a mosque and that Sophronius used the Jewish background of the Ḥaram to try to persuade the caliph to build the mosque in the empty space of the Ḥaram. But it is perhaps more likely in the face of the enormous impact of Jewish traditions on early Islam, and specifically on 'Umar at the time of the conquest of Jerusalem,[50] that 'Umar was genuinely interested in reviving the ancient Jewish holy site, inasmuch as it had been the first Muslim *qiblah*.[51] At any rate, the Mus-

lims took over the Ḥaram area with a definite knowledge and consciousness of its implication in the Jewish tradition as the site of the Temple.

But the later chroniclers are very clear in pointing out that the caliph withstood pressures to transform the site into a major center of Muslim worship. This fact in itself has important implications. It shows, on the one hand, that 'Umar was subject to many pressures from Jewish and Christian groups to take up their religious quarrels. The caliph wisely remained aloof from these and thereby emphasized the unique character of the new faith in the face of the two older ones. But, at the same time, in building anew on the Temple area, even though in primitive fashion, the Muslims committed a political act:[52] tak-

[50] See, for instance, 'Umar's several conversations with Ka'b and other Jews in Ṭabarī, vol. 1, p. 240 ff. On Ka'b and the other major transmitters of Jewish lore into Islam, see M. Lidzbarski, *De Propheticis, quae dicuntur, legendis Arabicis*, Leipzig, 1893. All this makes rather suspect the statement in Ṭabarī, vol. 1, p. 2405, that the treaty between 'Umar and Sophronius contained a prohibition for Jews to live in Jerusalem. See also Michel le Syrien, *Chronique*, tr. J.-B. Chabot, vol. 2, Paris, 1901, p. 425. De Goeje, *Mémoire sur la conquête de la Syrie*, Leyden, 1900, p. 155, explains it as a "concession faite aux Chrétiens, dont la disposition envers les Juifs était tout autre que bienveillante." But there is no evidence that 'Umar would agree to discriminate against the Jews. It was not so in Alexandria, where the Jews were specifically permitted to remain in the city (R. H. Charles, *The Chronicle of John of Nikiou*, London, 1916, p. 194). And in many instances, the Jews actually helped the invading Muslims (Ṭabarī, vol. 1, p. 2579; Balād-hurī, *Futūḥ*, ed. M. de Goeje, Leyden, 1866, p. 167). De Goeje had admitted that parts of this treaty should be considered as later interpolations, although there is no reason to doubt the whole text; it may be advanced that the statement on the Jews is one such interpolation. For a more negative attitude, see Caetani, *Annali*, vol. 4, p. 299 ff.

[51] It may be wondered whether the Muslims would have actually taken over the Ḥaram area simply because it had been the first *qiblah*, since it is in opposition to the Jews that Muḥammad changed the direction of prayer (Ṭabarī, vol. 1, pp. 1680-

1681). The need for a large area and 'Umar's desire not to take churches away from the Christians were probably more important arguments.

[52] It is, of course, often difficult to distinguish between political and religious acts in the Middle Ages. And yet, in the prophecies related by Ṭabarī, vol. 1, p. 2409, to the effect that the conquest of Jerusalem was a victory over the *Rūm* and that it was a revenge of the *banū Isrā'īl* who had been oppressed by the *Rūm*, one can see more than a mere statement of the new consecration of a holy spot, rather a sense of victory over an alien power. It is interesting also to compare the images of Sophronius as given by Eutychius and Theophanes. To Eutychius, a Christian who was living under the rule of Islam, the speaker for a minority under alien domination, Sophronius appears as a shrewd politician who had succeeded in baiting the mighty conqueror away from the Christian sanctuaries. To Theophanes, living in the security of the capital of the Christian empire, the patriarch of Jerusalem was a broken man, who had to submit to the tragedy which befell him and his city, but who remained aloof and contemptuous of the heretical barbarian; cf. below, n. 127. These two attitudes could easily find parallels in recent times, when conquests and foreign occupations have led men of the same nations, but in different places, to varying interpretations of the same events.

42

ing possession for the new faith of one of the most sacred spots on earth and altering the pattern imposed on that spot by the Christian domination, without restoring it to its Jewish splendor. But, in all these undertakings the Rock itself played but a minor part.

Some sixty years after the conquest of Jerusalem, however, the Rock will become the center of the whole area. The question is what occurred between the time of 'Umar and the reign of 'Abd al-Malik. The texts, so far as I have been able to ascertain, are silent on this score and we will have to turn to other sources to find a solution. If we consider only the location of the building and the traditions which were associated with it, two possible solutions can be envisaged, since neither the Ascension of Muḥammad nor the imitation of the Ka'bah can be accepted. One would be that 'Abd al-Malik decided to commemorate the Jewish Temple, and therefore built a *ciborium* over what was thought to be the only tangible remnant of the structure. There is no evidence for this, nor is it likely that 'Abd al-Malik had such an idea in mind at a time when the Islamic state was fairly well settled. A second reason might be that the Muslims had brought back to the Rock and to Mount Moriah in general the localization of some biblical event of significance to them, for instance the sacrifice of Abraham. As such the hypothesis is not impossible. The importance of the "Friend of God" (*khalīl Allah*) in the Koran is well known and it is equally well known that Abraham was considered as the ancestor of the Arabs.[53] In later times the

major events of his later life were associated with Mekkah or the neighborhood of Mekkah;[54] and it is interesting to note that the life of Adam was also transferred to the Holy City of Arabia, just as Abraham and Adam had moved together from Mount Moriah to the Golgotha in Jerusalem. But is there any definite evidence about the localization of the sacrifice of Abraham in the early Islamic period?

Our only almost contemporary source is John of Damascus. In his account of heresies, he has several extremely interesting pages on Islam. As far as Abraham is concerned, he relates that the Black Stone in Mekkah was supposed to have been either the place where Abraham had intercourse with Agar or the place where he tied his camel when he was about to sacrifice Isaac.[55] Neither one of these

[53] On all these problems see art. *Ibrāhīm* in *Encyclopedia of Islam*, also art. *Ka'bah*, both by A. J. Wensinck, who reflected Snouck Hurgronje's ideas on the development of the Abraham concept in the Koran. Recently these ideas have been challenged in part by G. H. Bousquet, *La légende Coranique d'Abraham*, Revue Africaine (1951), pp. 273–288 (cf. *Abstracta Islamica*, Revue des Etudes Islamiques, 1952, p. 156).

And Professor A. Guillaume has informed me that he will bring out a series of documents which will shed a new light on the origins of Muḥammad's view of Abraham. R. Blachère, in his translation of the Koran, gives a complete index and full bibliographical references on all passages concerned with Abraham. For later interpretations, see the major chroniclers and traditionists. For Abraham as related in one way or another to the whole of mankind, see the interesting text in Ibn Sa'd, *Tabaqat*, ed. F. Sachau and others, vol. 1, Leyden, 1905, p. 22. Balādhurī, *Ansāb al-Ashrāf*, ed. W. Ahlwardt, *Anonyme Arabische Chronik*, Greisswald, 1883, pp. 254–255, relates an interesting story going back to al-Mada'inī, in which the descendence from Abraham through Ismā'il and the cousinage with Ishāq are understood as meaning that to the Arabs belong both *mulk* (kingship) and *nubuwwah* (prophethood).

[54] Cf. Gaudefroy-Demombynes, p. 238 ff., and passim.

[55] John of Damascus, *De Haeresibus*, in Migne, *Patrologia Graeca* (hereafter PG), vol. 94 (Paris, 1864), cols. 767–768. Cf. C. H. Becker, *Christliche Polemik und Islamische Dogmenbildung*, Zeitschrift für Assyriologie, vol. 26 (1912), p. 179 ff., who seems to have been the first one to point to the importance of John of Damascus for early Islam. The relationship between Abraham and the Ka'bah is also known

PLATE 1

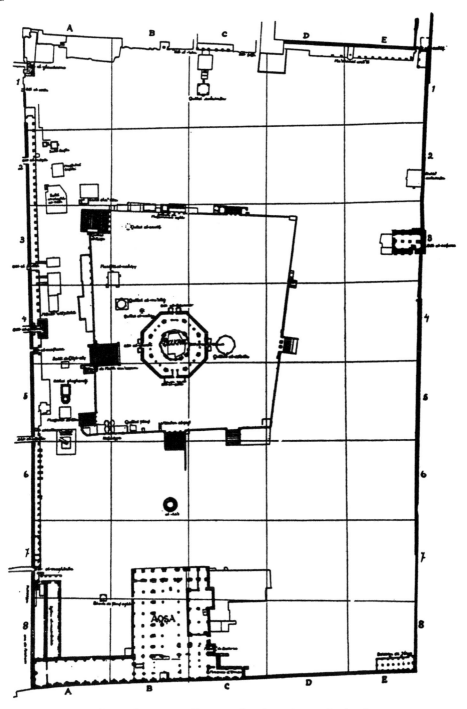

FIG. 1—PLAN OF THE ḤARAM AL-SHARĪF. (After van Berchem.)

PLATE 2

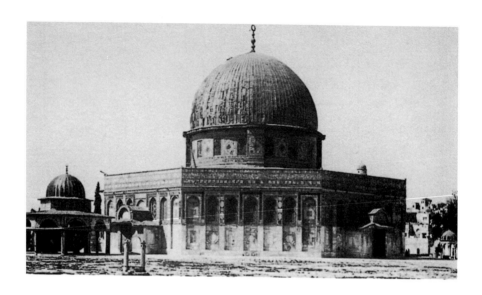

FIG. 2—THE DOME OF THE ROCK: GENERAL VIEW.

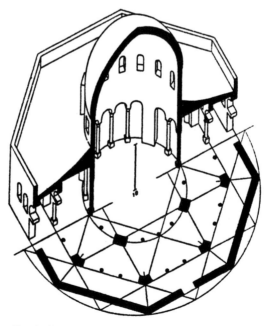

FIG. 3—THE DOME OF THE ROCK: PLAN AND ELEVATION.

PLATE 3

FIG. 4—THE DOME OF THE ROCK: MOSAIC ON THE DRUM.
(After Creswell.)

FIG. 5—THE DOME OF THE ROCK: MOSAIC ON
OCTAGON. (After Creswell.)

FIG. 6.

FIG. 7.

FIG. 8.

FIG. 9.

FIG. 10.

FIG. 11.

FIGS. 6-11—THE DOME OF THE ROCK: MOSAICS ON OCTAGON. (After Creswell.)

PLATE 4

FIG. 12—VENICE: MARCIANA, GR. 1.
(After Weitzmann.)

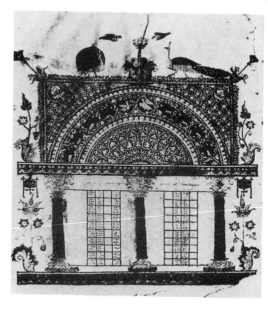

FIG. 13—TREBIZOND GOSPEL, CANON TABLE.
(After Der Neressian.)

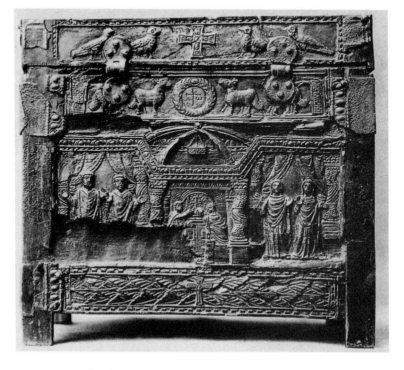

FIG. 14—POLA CASKET. (Courtesy K. Weitzmann.)

stories is a common Muslim interpretation of the Ka'bah and it may be wondered whether this text does not reflect a calumnious Christian tradition. On the other hand the insistence with which John of Damascus "disproves" that the sacrifice of Abraham took place in Mekkah should be construed as indicating that the idea was fairly common at the time in Muslim circles. In the Muslim tradition itself the problem is complicated by uncertainty whether Isaac or Ismā'il was the object of the sacrifice.[56] Ṭabari, after a lengthy consideration of the problem, leans toward Isaac, both in his history and in his tafsir; so do al-Kisā'i[57] and Ibn Qutaybah.[58] It seems true that in the early period the official Muslim tradition tended to consider Isaac as the dhabih.[59] Ṭabari does not try to give a

specific place for the event, but he does bring out one tradition which maintains that the sacrifice took place two mils from Jerusalem at a place called Quṭṭ or Qaṭṭ.[60] Al-Ya'qūbi, as usual, relates the standard hagiographical tradition and puts the event at Minā. But he acknowledges that the People of the Book set the sacrifice in the "land of the Amorites in Syria."[61] Al-Kisā'i relates that the dream of Abraham took place in Jerusalem, but omits any specific mention of the place of sacrifice.[62] Many other writers have omitted any reference to the location. In other words, as far as one can gather, it is impossible to say that the sacrifice of Abraham was, in early Islamic times, definitely connected with any one specific place, whether around Mekkah or Jerusalem. Both identifications were made and the tradition is obviously uncertain, but the majority of the early traditionists and chroniclers have tended to think of Isaac as the sacrificed one and hence of Palestine as the place of sacrifice. The evidence of John of Damascus can be explained through the common polemical device of attacking the opponent's position, even when it is uncertain, in its weakest side. Furthermore there are indications, in the known descriptions of Jerusalem, that certain places on the Ḥaram were definitely associated with Abraham.[63] And one writer, Nāṣir-i Khusrow, some 50 years before the Crusades, recorded that the footprints on the Rock were those left by Isaac when, together with his father, he came to the Temple area.[64] Thus even in

to an anonymous Syriac chronicler (ca. A.D. 680), but he does not refer to the sacrifice of Isaac, ed. and tr. I. Guidi, in Corp. Script. Christ. Orient., ser. 3, vol. 4, Paris, 1903, pp. 31–32; Th. Nöldike, Die von Guidi herausgegebene syrische Chronik, Wien. Akad. d. Wiss. Sitzungb. d. phil.-hist. Kl., vol. 127 (1893), p. 46. See also A. Jeffery, Ghevond's text of the correspondence between 'Umar II and Leo III, Harvard Theological Review, vol. 37 (1944), p. 310. The possibility of a Christian tradition setting Abraham in Mekkah is mentioned with further references in M. Gaudefroy-Demombynes, Mahomet, Paris, 1957, p. 387.

[56] See Ṭabari, vol. 1, p. 290 ff., for an enumeration of the different traditions on the subject. Similar enumerations are also to be found in the other major chroniclers and in Ṭabari's Tafsir, Cairo, 1321 A.H., vol. 23, p. 44 ff. (commentary on Koran 37: 101 ff.). It may be added that in a later tradition the sacrifice was even moved to Damascus, Ibn 'Asākir, Al-ta'rikh al-kabir, Damascus, 1329, I, pp. 232–233. The tradition is uncommon but points to the importance of the Abrahamic legend in Islam.

[57] al-Kisā'i, Qiṣaṣ al-anbiyā', ed. I. Eisenberg, Leyden, 1923, p. 150 ff.

[58] Ibn Qutaybah, K. al-Ma'ārif, ed. R. Wüstenfeld, Göttingen, 1850, pp. 18–19.

[59] I. Goldziher, Die Richtungen der Islamischen Koranauslegung, Leyden, 1952, p. 79 ff.

[60] Ṭabari, vol. 1, p. 273; that Abraham had lived in Palestine and had built a masjid there is not doubted; ibid., pp. 271 and 347–348. This is accepted by other writers.

[61] Ya'qūbi, vol. 1, pp. 25–26.

[62] al-Kisā'i, p. 150.

[63] For instance Maqdisi in Bibl. Geogr. Arab., vol. 3, Leyden, 1906, p. 170, a gate of Abraham.

[64] In PPTS, vol. 4, p. 47.

44

the eleventh century there still was a lingering memory in Muslim circles of a relationship between Abraham and the Rock.

It is not possible, with the evidence in our possession, to prove that the early Muslims considered Jerusalem as the place of sacrifice; but, since the Muslim knowledge of Jewish traditions was mostly derived from Talmudic and other para-Biblical sources,[65] and since a great number of Jews were converted to Islam in the first decades of the new religion, it is very likely that the early Muslims did know of the association between the Rock and Abraham's sacrifice.[66]

One might suggest then that 'Abd al-Malik, in accord with his well-known policies, would have "islamized" the holy place and chosen the one symbol associated with it which was equally holy to Jews and Muslims, that of Abraham. It was a symbol which would, in Muslim eyes, emphasize the superiority of Islam, since in the Koran Abraham is neither a Christian nor a Jew, but a ḥanīf (Kor. 3: 58 ff.) and the first Muslim.[67] This suggestion finds support in one interesting feature of the Christian polemic against the Muslims. John of Damascus and others after him always insist on the fact that the new masters of the Near East are Ishmaelites, that is, outcasts;

and it is with this implication that the old term *Sarakenoi* is explained as meaning "empty (because of or away from?) of Sarah" (*ek tes Sarras kenous*) and that the Arabs are often also called *Agarenoi*, obviously in a pejorative sense.[68] It is true that already Jerome, for instance, when writing about nomadic incursions in Palestine and elsewhere, mentions the posterity of Abraham,[69] but his terms are very vague; and, while of course the term Ishmaelites goes back to Biblical times, there seems to appear in Christian writing with the arrival of the Muslims a new and greater emphasis on the sons of Agar.[70] Whether this

[65] Cf., for instance, all the examples given by C. C. Torrey, *The Jewish foundations of Islam*, New York, 1933, esp. p. 82 ff., on Abraham. See also D. Sidersky, *Les origines des légendes musulmanes*, Paris, 1933, pp. 31–54, esp. pp. 48–49, where, however, the author claims that Ismā'il alone was sacrificed; and J. Finkel, *Old Israelitish traditions in the Koran*, Proc. Amer. Acad. for Jewish Res., 1930–31.

[66] A physical relationship could be established between the *maqām Ibrāhīm* in Mekkah, the stone on which Abraham stood while building the Ka'bah and which bore his footprints, and the Rock in Jerusalem which also has footprints.

[67] Torrey, p. 102. See also the interesting comments of G. Widengren, *Muhammad*, p. 133 ff., who may, however, have been too strongly influenced by the possible impact of Gnostic doctrines.

[68] John of Damascus, *De Haeresibus*, col. 763. See also the Homily to the Virgin in PG, vol. 96, cols. 657–658; for the term "sons of Agar" see also Michel le Syrien, vol. 2, p. 450, and other Greek or Syriac sources.

[69] See the reference in A. A. Vasiliev, *Arabs and the Byzantine empire*, Dumbarton Oaks Papers, vols. 9–10 (1956), pp. 308–309. For the origin of the word, see B. Moritz' article *Saraka* in Pauly-Wissowa, *Handbuch der Altertumwissenschaft*.

[70] Professor Ihor Sevcenko, of Columbia University, has pointed out to me another Greek source, probably to be dated in the seventies of the seventh century, which introduces the concept of the Ishmaelites as forerunners of the Anti-Christ and as enemies of the true faith. The source is the body of prophecies attributed to Methodius of Patara, E. Sackur, *Sibyllinische Texte und Forschungen*, Halle, 1848, pp. 1–96. On p. 68 the invaders against whom Gideon fought are called "sons of Umee" originally from Ethrib. The editor points out, p. 25, that we are probably dealing with a veiled reference to the Umayyads. Through Methodius of Patara the concept of the Ishmaelites was carried over to other "barbarian" invaders, even though the term was misunderstood; see, for instance, *The Russian Primary Chronicle*, S. H. Cross and O. P. Sherbowitz-Wetzor, Cambridge, 1953, p. 184; and the references in Sackur. See also S. H. Cross, *The earliest allusion to the Revelations of Pseudo-Methodius*, Speculum, vol. 4 (1929), p. 329 ff. For other texts pertaining to this problem and a different interpretation, see M. B. Ogle, *Petrus Comestor*, Speculum, vol. 21 (1946), p. 312 ff. But for Methodius and eschato-

new emphasis on the posterity of Abraham in Greek and Syriac writers was the result of Arab claims to descent from Abraham (and the resulting building up of Ismā'īl) or whether it derived solely from a Christian attempt to show contempt for the new masters of the Near East is difficult to say. But granting Abraham's importance in early Islamic thought and in the traditions associated with the Rock, 'Abd al-Malik's building would have had an essentially polemic and political significance, as a memorial to the Muslim ancestor of the three monotheistic faiths.

But the problem of Abraham in early Islamic times can also be discussed in a purely Muslim context. It will be recalled that one of the most interesting acts of Ibn al-Zubayr in Mekkah was his rebuilding of the Ka'bah, after it had been destroyed during the first Umayyad siege. The important point is that he reconstructed it not as it had been built in Muḥammad's youth and with the Prophet's participation, but differently. A later well-known tradition transmitted by 'Ayshah says that he built it as the Prophet said it was in the time of Abraham.[71] Al-Ḥajjāj, on the other hand, rebuilt the Ka'bah as it had been at the time of the Prophet. This curious attempt by Ibn al-Zubayr to use the prestige

of Abraham to justify his building may be brought into relation with another tradition reported by al-Azraqī. The Mekkans were apparently attempting to disprove the contention that Jerusalem was "greater than the Ka'bah, because it (Jerusalem) was the place to which Prophets emigrate (*mahājar al-anbiyā'*) and because it is the Holy Land."[72] Within the Muslim *koiné*, therefore, it may be suggested that 'Abd al-Malik, while "islamizing" the Jewish holy place, was also asserting a certain preeminence of Palestine and Jerusalem over Mekkah, not actually as a replacement of the Ka'bah, but rather as a symbol of his opposition to the old-fashioned Mekkan aristocracy represented by Ibn al-Zubayr.[73] The symbol was chosen from the religious lore which had not yet been definitely localized, but which was important to the new faith as well as in the beliefs of the older People of the Book. It was not, however, infringing—as any change of center for the pilgrimage would have done—on the very foundations of Islam.[74] The opposition be-

logical themes connected with historical events, see now A. Abel, *Changements politiques et littérature eschatologique*, Studia Islamica, II (1954), p. 26 ff. and p. 37. An added argument for a specific meaning of the word "Saracen" can be derived from a passage in Mas'ūdī, *K. al-Tanbīh*, ed. M. de Goeje, in *Bibl. Geogr. Arab.*, vol. 8 (Leyden, 1894), p. 168, whereby, in the early part of the ninth century the emperor Nicephorus was supposed to have forbidden the use of the word "Saracen," since it was thought to be injurious.

[71] Al-Azraqī, K. *Akhbar Makkah*, in F. Wüstenfeld, *Die Chroniken der Stadt Mekka*, vol. 1, Leipzig, 1858, pp. 114–115 and passim, pp. 115–148, where the story is repeated several times; Ṭabarī, vol. 2, p. 592 ff.; Gaudefroy-Demombynes, p. 29 ff.

[72] Al-Azraqī, pp. 39–40, where the statement about Jerusalem is attributed to the Jews; *ibid.*, p. 41, where it is related that the earth of Ṭā'if had been brought from Syria. The statement about the prophets should be related to Ibn Ḥawqal, p. 161, where Jerusalem is mentioned as the city of the prophets, and Iṣṭakhrī, in *Bibl. Geogr. Arab.*, vol. 1, pp. 56–57, where Jerusalem is described as having a *miḥrāb* for every prophet. For Mekkan claims see Azraqī, p. 39, where it is said that 70 prophets were buried in Mekkah. A curious point about the text of Ibn Ḥawqal is that the Rock of Jerusalem is referred to as the Rock of Moses, probably because the tradition has it that it was Moses who made the Rock into a *qiblah*, Nāṣir-i Khusrow, p. 27, unless we meet with a confusion with another Rock of Moses which has been set any place from Antioch to Persia (Maqdisī, pp. 19, 46, 151; Iṣṭakhrī, p. 62).

[73] See H. A. R. Gibb, art. '*Abd allāh ibn az-Zubayr* in the new edition of the *Encyclopedia of Islam*.

[74] Goldziher, Wellhausen, and Nöldeke gave a great deal of importance to the statement in a later

46

tween Jerusalem and Mekkah and 'Abd al-Malik's involvement in it may have given rise to the tradition transmitted by al-Ya'qūbī and others about the *hajj* and Jerusalem. What had been a religious-political act entailing an unsettled point of religious lore would have been transformed by them into a religious-political act of impiety intended to strike at the very foundation of one of the "pillars of Islam." Thus did the propaganda machine of the shi'ite and 'Abbāsid opposition attempt to show the Umayyads as enemies of the faith.

Thus, from the consideration of the location of the Dome of the Rock, it would appear that, at the time of the conquest, the main association was between the Jewish Temple and the Ḥaram area, but that this association does not in itself explain the building of the Dome of the Rock. It is only through the person of Abraham [75] that the ancient symbolism of the Rock could have been adapted to the new faith, since no strictly Muslim sym-

bol seems to have been connected with it at so early a date. In itself this hypothesis cannot be more than a suggestion. There is no clear-cut indication of Abraham's association with the Rock of Jerusalem at the time of 'Abd al-Malik. Furthermore the question remains whether the monument should be understood within a strictly Muslim context or within the wider context of the relationship between the new state and faith and the older religions of the Near East. For clarification we must turn now to the other two documents in our possession.

The second contemporary evidence we can use for understanding the Umayyad Dome of the Rock is in the building itself, its decoration and its architecture. These two features have been painstakingly analyzed by K. A. C. Creswell and Marguerite van Berchem. But circumstances did not permit the latter to complete a thorough examination of the mosaics, so that, so far, there is no exhaustive publication of all the mosaics with a definitive statement concerning which parts of the decoration are without doubt Umayyad. As far as the architecture is concerned, the question is fairly clearly resolved: the Dome is a *ciborium* or "reliquary" [76] above a sacred place, on a model which was fairly common among Christian *martyria* throughout the Christian empire, and which was strikingly represented by the great churches of Jerusalem itself. [77] In other words,

Syriac source that Mu'āwiyah was made king in Jerusalem and then prayed in various Christian sanctuaries; Th. Nöldeke, *Zur Geschichte der Araber . . . aus syrischen Quellen*, Zeitschr. Deutsch. Morgen. Gesell., vol. 29 (1875), p. 95, or *Corp. Script. Christ. Orient.*, ser. 3, vol. 4, Paris, 1903–5, p. 55; J. Wellhausen, *Das arabische Reich*, Berlin, 1902, p. 136 ff. The story seems little reliable as such, especially in its implication of a kind of pilgrimage to Christian sanctuaries, but, if one recalls the dislike of the Umayyads for Madīnah, the first capital of the Muslim state, this Syriac source may indeed reflect some specific relation between the Umayyads and Jerusalem. See, for instance, al-Isfahānī, *K. al-Aghānī*, Būlāq, 1868, vol. 19, p. 90, where Khālid al-Qasrī is said to have been ready to move the Ka'bah to Jerusalem, if the caliph so ordered. In itself that type of statement is not very trustworthy, since it appears to be a literary image, but it may reflect the very same tradition which is more completely expressed in Ya'qūbī.

[75] In theory the person of Adam could also have been used as a connection between Mekkah and Jerusalem, since his life is described in both places. However, to my knowledge, there is no evidence to that effect.

[76] The expression was first used by R. Hartmann, *Der Felsendom in Jerusalem*, Strasbourg, 1909, p. 21 ff., and has been accepted by Max van Berchem, p. 234. See also Ch. Clermont-Ganneau, *L'Hémisphère, abside ou ciborium*, Recueil d'Archéologie Orientale, vol. 3 (Paris, 1899), pp. 88–90.

[77] Creswell, vol. 1, p. 70 ff. It must be added, however, that the excavations carried out by Crowfoot and Detweiler at Busra have compelled a reconstruction of the cathedral which makes it architecturally less immediately related to the Dome of the Rock; cf. J. W. Crowfoot, *Churches at Bosra and Samaria-*

the architecture confirms the symbolic quality of *place of commemoration* of the Dome of the Rock, but it does not provide us with any more specific clue with respect to its meaning at the time of 'Abd al-Malik.

As far as the mosaics are concerned, most of the decorative themes consist of vegetal motives interspersed with vases, cornucopias, and what have been called "jewels."[78] All these elements, except the "jewels," are common enough and their significance in late seventh-century art has been analyzed more than once. But the "jewels" present a peculiarity which may help to explain the meaning of the structure. It must be pointed out first that we will not be dealing here with the gems and mother-of-pearl fragments set on tree trunks, fruits, rosettes, and cornucopias, which belong to a purely decorative scheme. We are only concerned with jewels that are worn, such as crowns, bracelets, earrings, necklaces, and breastplates.[79] We shall not try to

solve all the problems connected with these jewels, inasmuch as J. Deer has announced that he is preparing a special study of their importance for our knowledge of medieval and especially Byzantine royal ornament. We shall restrict ourselves here to a few remarks which bear directly on the problem of the significance of the Dome of the Rock.

Mademoiselle van Berchem has already noted that the jewel decoration does not appear uniformly throughout the building, but almost exclusively on the *inner face of the octagonal colonnade.*[80] The reason for that, it has been suggested, is that the decoration will appear more brilliantly when seen against the light.[81] It can be pointed out, however, that the difference between this part of the mosaic decoration and the rest of it does not lie in the usage of a jewel-like effect, but in the type of jewels used. Had the intended effect been purely formal, gems and mother-of-pearl, as used elsewhere in the building, would have served equally well here. It may rather be suggested that these actual crowns, bracelets, and other jeweled ornaments were *meant* to be shown as surrounding the central holy place toward which they face, and that it is in this sense that they contrast with the purely decorative gemlike fragments seen throughout the building.

Sebaste, British School of Archaeology in Jerusalem, Supplementary Papers No. 4 (London, 1937), p. 7 ff. Recently P. Verzone, *Le Chiese di Herapolis,* Cahiers Archéologiques, vol. 8 (1956), p. 45 ff., has brought to light another very close model of the Dome of the Rock. For the formation of the type see A. Grabar, *Martyrium,* vol. I, pp. 141 ff., and 345 ff. and passim. For domica1 constructions see E. B. Smith, *The Dome,* Princeton, 1950, p. 10 ff., whose conclusions, however, on Islamic domes, pp. 41–43, should be revised.

[78] In Creswell, vol. I, p. 196 ff. That the vegetal elements in the Dome of the Rock (just as probably the landscapes of Damascus) should be interpreted as Muslim parallels to Christian iconographies of paradise (whether interpreted as such by the Muslims or simply taken over) has been shown by A. Grabar, *L'Iconoclasme byzantin,* Paris, 1957, p. 62 ff.

[79] Some of the crowns have been quite recently analyzed briefly by J. Deer, *Mittelalterliche Frauen-krone in Ost und West,* in P. E. Schramm, *Herrschaftszeichen und Staatssymbolik (Schriften der Monumenta Germanica Historica,* vol. 13, 1 and 2, Stuttgart, 1954–55), II, p. 423 ff. J. Deer announces there that he is planning on pursuing the subject of

the type of "jewels" found in the Dome of the Rock in a forthcoming work.

[80] The wing motifs found on the drum (*fig. 4*) do not really belong to the category of actual jewels, as can be seen by comparing to them *fig. 5,* which occurs on the inner face of the octagon and which is a crown. It is certain, however, that the decoration of the drum has been redone and it may be that the later artists misunderstood the crown motif, which was there originally, and transformed it into a purely decorative one of wings. The existence of crowns on the drum of the building would agree with the proposed explanation of the decorative theme in the Dome of the Rock.

[81] Marguerite van Berchem, pp. 196–197.

48

A second point to be made about these jewels is that, although in most cases they have been adapted to the vegetal basis of the decorative scheme, they are identifiable. There are crowns, some of which were discussed by J. Deer, either diadems with hanging and encrusted precious stones, in many cases topped with triangular, oval, or arched forms (*figs. 6–8*), or diadems surmounted by wings and a crescent (*fig. 4*). There is also a variety of breastplates, necklaces, pins, and earrings (*figs. 9–11*), almost all of which are set with precious stones either as incrustations or as hangings. These ornaments can all be identified either as royal or imperial ornaments of the Byzantine and Persian princes, with the former largely predominant, or as the ornaments worn by Christ, the Virgin, and saints in the religious art of Byzantium.[82] Recent studies, in particular those of A. Grabar, J. Deer, and P. E. Schramm, have shown that these were all, in varying degrees and in different ways, symbols of holiness, power, and sovereignty in the official art of the Byzantine

and Persian empires.[83] In other words, the decoration of the Dome of the Rock witnesses a *conscious* (because of its position) use by the decorators of this Islamic sanctuary of representations of symbols belonging to the subdued or to the still active enemies of the Muslim state.

What can the significance of such a theme be in the decoration of an early Muslim holy place? We must ask ourselves first whether

[82] It is in fact in images dealing with religious matters—of which we have a larger number—that we can find most of our parallels with the jewels of the Dome of the Rock. The monuments of Ravenna and of Rome provide us with the best repertory of jewels and crowns. See Marguerite van Berchem and E. Clouzot, *Mosaïques Chrétiennes du IVme au Xme siecle,* Geneva, 1924, figs. 275 (Orans in Florence), 50 (Annunciation Mary in Santa Maria Maggiora), 144 and following (San Apollinario Nuovo), 197 and following (San Vitale); W. de Gruneisen, *Sainte Marie Antique,* Rome, 1911, figs. 77, 105. For royal examples see R. Delbrück, *Die Consulardiptychen,* Berlin, 1926, pls. 16, 22, 32, 38; W. Wroth, *Catalogue of the Imperial Byzantine coins in the British Museum,* London, 1908, vol. 1, pls. XXIII ff.; A. Pasini, *Il tesoro di San Marco,* Venice, 1885, pl. L, 1. All these examples which occur on coins, seals, consular diptychs, silver plates, mosaics, and paintings are no later than the eighth century. For other examples see the studies devoted to the subject of crowns by J. Deer, which are enumerated in Schramm, *op. cit.,* vol. 2, pp. 379–380.

[83] Schramm et al., *Herrschaftszeichen,* passim. See also J. Deer, *Der Ursprung der Kaiserkrone,* Schweizer Beiträge zur Allgemeine Geschichte, vol. 8 (1950), pp. 51–87. For Sasanian crowns, see K. Erdmann, *Die Entwicklung der sassanidische Krone,* Ars Islamica, vol. 15–16 (1951). It is interesting to compare the representations of crowns on the Dome of the Rock with the later ones at Quṣayr ʿAmrah, A. Musil, *Ḵuṣeyr ʿAmra,* Vienna, 1907, vol. 2, pl. XXVI. In the Umayyad bath, the Sasanian crown is, on the whole, quite similar to that of the sanctuary, comprising a row of pearls, a diadem, wings, a stand, and a crescent. The Byzantine crown, however, is different and, to the extent to which it is visible, it belongs to a variety of the "helmet" type (cf. Deer in Schweizer Beiträge) rather than to the "open" crown type which is characteristic of the Dome of the Rock. The Umayyads obviously used two different traditions as models. In Quṣayr ʿAmrah we meet with a strictly imperial tradition, whose characteristic was, as was shown by Deer, the "helmet" type with additions and variations. In Jerusalem the tradition was different. Deer, in Schramm, *Herrschaftszeichen,* suggested that most of the Dome of the Rock crowns were actually crowns of women, which were usually open. Although the problem goes beyond the scope of our study, it may be wondered whether the Byzantine emperor wore "helmet" crowns in all his functions. Furthermore, votive crowns were generally open and it may be wondered whether they should be considered as women's crowns; cf. Schramm, vol. 2, p. 377 ff., and below. It is important to remember also that votive crowns and jewels, just as the crowns and other jewels worn by Christ, the Virgin, and saints (cf. the preceding note), belong to the same typological and, in many ways, ideological repertory as the insignia worn by princes. The open crown was common in the west, A. Boinet, *La miniature Carolingienne,* Paris, 1913, pl. 131, for instance.

there is any evidence in other places for the practice of hanging crowns or for representations of crowns and jewels in sanctuaries. The representational evidence is limited. A group of Gospels, mostly Armenian and Ethiopian, but certainly harking back to early Christian and Byzantine models, show, in the pages devoted to the representation of canon tables, structures, *ciboria* or *tholoi*, at times with hanging curtains between the columns. In a number of cases hanging crowns also appear between the columns or on the side (*figs. 12–13*).[84] Professor Nordenfalk has suggested that these *tholoi* represented the Holy Sepulchre in Jerusalem.[85] The well-known Pola casket (*fig. 14*) shows such a crown in the sanctuary of St. Peter's in Rome.[86] Crowns are also shown hanging over the hands of the bishops of Ravenna in San Apollinario in Classe[87] and over the head of an emperor on an ivory.[88] All these crowns, in a number of

cases difficult to distinguish from lamps with holy oil, serve to emphasize the greatness or sanctity of either person or place. Actual crowns and jewels have also survived to this day. The unique group of Visigothic crowns discovered in Spain,[89] many of which bear such a remarkable resemblance to the crowns of the Dome of the Rock, are among our best examples.[90] A number of texts have also preserved for us evidence for this practice of hanging votive crowns. In Christian Egypt, the builders of a church hung a crown over the altar of the church opposite a gold and silver cross in the center of the edifice.[91] In Constantinople emperors are known to have ordered crowns to be suspended over or around the holiest spot in the sanctuary of Hagia Sophia.[92] Although less precise, similar prac-

[84] C. Nordenfalk, *Die Spätantike Kanontafel,* Göteborg, 1938, pls. 24, 33, 39, fig. 2 in the text, p. 104. Armenian examples are also illustrated in S. Der Nersessian, *Armenia and the Byzantine Empire,* Cambridge, 1945, pl. 21, 1; and K. Weitzmann, *Die armenische Buchmalerei des 10. und beginnenden 11. Jahrhunderts,* Bamberg, 1933, pl. 9, No. 37. Also K. Weitzmann, *Byzantinische Buchmalerei des 9. und 10. Jahrhunderts,* Berlin, 1935, pl. 17, No. 92, for the Greek example from the Marciana Library. Other Greek examples occur on an unpublished Gospelbook in the Greek patriarchate in Jerusalem.

[85] Nordenfalk, pp. 103–108, where, however, the author describes as a lamp what, on the Marciana Gospelbook, appears rather to be a crown with a hanging in the shape of a cross.

[86] It has been illustrated many times. Cf. B. M. Apolloni Ghetti et al., *Esplorazione sotto la Confessione di San Pietro,* Rome, 1951, figs. 118, 121, pl. H.

[87] Marguerite van Berchem-Etienne Clouzot, *op. cit.,* figs. 203–206.

[88] Delbrück, *Consulardiptychen,* pl. 22. The usage of such crowns in the imperial tradition goes back to the ancient practice of giving a crown of laurels, but jeweled crowns are in evidence in Ravenna's represen-

tation of the palace of Theodoric and on certain Carolingian miniatures. It must also be added that the Byzantines were not the only ones to have hanging crowns in royal palaces. It was a common Sasanian practice, as can be seen through the well-known example of the crown of Ctesiphon (A. Christensen, *L'Iran sous les Sassanides,* Copenhague, 1944, p. 397) and through numerous incidents in the *Shāh-nāmeh.* All references to crowns in the latter work have been conveniently gathered by K. H. Hansen, *Die Krone in Shāhnāme,* Der Islam, vol. 31 (1953).

[89] H. Schlunk, *Arte Visigodi* in *Ars Hispaniae,* vol. 2, Madrid, 1947, pl. 328 and following p. 311 ff. These crowns are often discussed in passing in Schramm, *Herrschaftszeichen;* see especially vol. 1, p. 134, vol. 2, pp. 377–379. For other examples of insignia and jewels, many of which were probably used in the same fashion, see, for instance, *Walters Art Gallery early Christian and Byzantine art,* Baltimore, 1947, pl. 57 and following; and *Berlin, Staatliche Museum, Kunst der Spätantike im Mittelmeerraum,* Berlin, 1939, pl. 14 and following.

[90] Both in type and in their probable usage these have been related to Byzantine examples, Schlunk, p. 313.

[91] U. Monneret de Villard, *Les Couvents près de Sohag,* Milan, 1925, vol. 1, p. 23.

[92] See the references in E. H. Swift, *Hagia Sophia,* New York, 1940, p. 198.

50

tices seem to have been common in the Maz-
dean world as well.[92a] In all these cases we are
dealing with an emphasis on the holiness of a
sanctuary—or, as in the cases of Ravenna and
the Visigoths, of a personage—through sus-
pending around it or over it royal insignia.
This explanation might be offered for the use
of the decorative theme in the Dome of the
Rock. It could be argued that, perhaps under
the impact of the Christian sanctuaries of Jeru-
salem, and in particular the Holy Sepulchre,[93]
the Dome of the Rock was decorated with
votive crowns to emphasize the holiness of the
place.

Yet such an explanation would lead to
difficulties. It would not explain the inclusion
of a Persian crown within the decorative
scheme. Moreover, this explanation, while
agreeing with the purely formal aspect of the
decoration, agrees perhaps less well with the
historical and cultural milieu of the Umayyads
and of Islam. It is no doubt true that the early
Muslim civilization owed most of its ideas
and a great deal of its art to the cultures which
preceded it in the conquered areas; but it would
be a mistake to consider that the imitation and
copying which took place were absolutely
blind. It should be possible to explain an early
Islamic monument in Muslim terms. In other
words, we must ask ourselves whether there is
any evidence in the early Islamic period for
the use of crowns and other royal objects in
religious buildings and, if so, for what pur-
poses. Were they really ex-votos? Or did
they have a different significance? An essen-
tial piece of evidence is provided by the list
of objects sent to Mekkah and kept there in

the Ka'bah.[94] This list can be made up from
different authors, especially from al-Azraqī,[95]
whose early date is of particular significance
to us.

In older times the Mekkan sanctuary had
had paintings and sculptures, which were de-
stroyed on the Prophet's order, as a well-
known story tells. Apparently until the time
of Ibn al-Zubayr the shrine also kept the two
horns of the ram which had been sacrificed by
Abraham and other prophets.[96] When he de-
stroyed the Ka'bah, Ibn al-Zubayr tried to
reach for them, but they crumbled in his hands.
In Islamic times a new series of objects was
brought into the Temple. 'Umar hung there
two crescent-shaped ornaments taken from the
capital city of the Persians. Yazīd I gave two
ruby-encrusted crescents, belonging to a Dam-
ascene church, together with two cups.[97] 'Abd
al-Malik sent two necklaces (shamsatayn)
and two glass cups. Al-Walīd I also sent two
cups, while al-Walīd II sent a throne and two
crescent-shaped ornaments with an inscrip-
tion.[98] Al-Saffāḥ sent a green dish, while al-
Manṣūr had a glass cup of an ancient Egyptian
type[99] hung in the shrine. Hārūn al-Rashīd

[94] In a recently published posthumous article M.
Aga-Oglu has gathered much of this information,
although in a totally different connection; M. Aga-
Oglu, *Remarks on the character of Islamic art*, The
Art Bulletin, vol. 36 (1954), p. 182.

[95] Al-Azraqī, *K. Akhbar Makkah*, in F. Wüsten-
feld, *Die Chroniken der Stadt Mekka*, vol. 1, Leipzig,
1858, p. 155 ff.

[96] Cf. above.

[97] Al-Birūnī, *K. al-Jamāhir*, ed. F. Krenkow,
Heyderabad, 1936, p. 67. This text was unavailable
to me and I owe the reference to the article by
Aga-Oglu.

[98] The inscription is supposedly dated in 101/719-
720; E. Combe, J. Sauvaget, and G. Wiet, *Réper-
toire chronologique d'épigraphie arabe*, Cairo, 1931
(and subsequent years), No. 101. The date is, of
course, impossible. Either the name of the caliph or
the date were misread by the chronicler.

[99] Thus (altägyptisch) does C. J. Lamm, *Mittel-*

[92a] See references in K. Erdmann, *Das Iranische
Feuerheiligtum*, Leipzig, 1941, p. 38.

[93] That imperial crowns, both male and female,
were found in the Holy Sepulchre is ascertained by
Antoninus Placentinus, *Itinerarium*, ed. Geyer, Vi-
enna, 1898, p. 171.

put there two gilded and bejeweled cases (*qaṣbatayn*) containing the celebrated oaths of allegiance of his two sons to the complex system he had established.[100] Al-Ma'mūn sent rubies attached to a golden chain, while al-Mutawakkil had a necklace of gold with precious stones, rubies, and topazes hung on a chain of gold. At a later date, the agreement between al-Muwaffaq and al-Mu'tamid about the division of the empire was also sent to the Ka'bah.[101] But the most important group of objects from our point of view is that which was sent by al-Ma'mūn.

The text of al-Azraqī is somewhat confused on this score. This is not the place to define the exact historical circumstances involved, but it would seem that two more or less contemporary sets of events were mixed up by the chronicler. First, an unnamed king of Tibet had an idol of gold with a crown of gold and jewels set on a baldachin throne of silver covered with a cloth with tassels in the shape of spheres. When this king became a Muslim, he gave the throne and the idol to

the Ka'bah. They were sent to Mekkah in 201 A.H. and exhibited at the time of the pilgrimage with an inscription [102] emphasizing the fact that the throne was given as a gift to the Ka'bah as a token of the king's submission to Islam.[103] In 202, during a revolt, the throne was destroyed,[104] but the crown remained in the Ka'bah certainly until the time of al-Azraqī. Second, the Mekkah sanctuary also acquired the spoils of the Kābūl-shāh, who submitted and became converted in 199. His crown seems to have been taken to Mekkah immediately, as is ascertained by an inscription of that date.[105] The throne was kept for a while in the treasury (*bayt al-māl*) of the Orient, but then was also moved to Mekkah in 200.[106] The inscriptions which were put up together with these two objects are quite revealing in showing the extent to which the nature of an inscription in a religious sanctuary is related to the circumstances of the time. They emphasize, on the one hand, the victory of the "righteous" prince al-Ma'mūn over his perjured brother and, on the other hand, the victory of the "Commander of the Faithful" over the unbelievers.[107]

alterlische Glaser, Berlin, 1930, p. 490, translate the word *fara'ūniyah*.

[100] This succession has been described by F. Gabrieli, *La successione di Hārūn al-Rashīd*, Rivista degli Studi Orientali, vol. 11, 1928. The Ṭabarī texts on the subject have been translated by the same scholar, *Documenti relativi al califfato di al-Amīn*, Rend. della R. Accademia Nazionale dei Lincei, ser. 6, vol. 3 (1927), p. 191 ff. Although well known in its modalities this partial division of the empire has not been fully analyzed from the point of view of religious-political ceremonies (see, for instance, Azraqī, p. 160 ff.) or of feudal institutions (a comparison with the almost contemporary Carolingian divisions of an empire may be quite fruitful). For a discussion of the formulas used in the inscriptions made on that occasion see A. I. Mihailova, *K oformleniiu gosudarstvennykh aktov vremeni Abbasidov*, Epigrafika Vostoka, vol. 7 (1953).

[101] Ibn al-Dāyah, *Sīrah Aḥmad ibn Ṭūlūn* in *Fragmente aus dem Mughrib*, ed. K. Vollers, Berlin, 1894, p. 19.

[102] *Répertoire*, No. 119.

[103] See B. Spuler, *Iran in früh-islamischer Zeit*, Wiesbaden, 1952, p. 55, and the bibl. references in n. 4. A. I. Mihailova, *Novye epigraficheskie dannye dlia istorii Srednei Azii IX v.*, Epigrafika Vostoka, vol. 5, 1951, who discusses this whole group of inscriptions, doubts (p. 18) the veracity of the story on the grounds that, aside from al-Azraqī, we only have the testimony of al-Ya'qūbī (vol. 2, p. 550) about the conversion of a Tibetan king. But both authorities are quite early and, while certain features may very well have been invented, the fairly precise statement of al-Azraqī certainly refers to an event which did take place.

[104] See also al-Ya'qūbī, vol. 2, p. 550, where several thrones are implied. The gold and silver of the throne or thrones were used to strike coins.

[105] *Répertoire*, No. 100.

[106] *Répertoire*, No. 116.

[107] The difference in mood between the two in-

52

All these objects found in the Ka'bah can be divided into three categories. Some were merely expensive gifts whose purpose was to emphasize the holiness of the place and the piety of the donors. Just as in Byzantium, there was, in this category, a preponderance of royal jewels. Another category of objects need not concern us here: the statements of oaths were put in the sanctuary not to enhance the sanctuary's holiness, but to acquire holiness and sacredness from it. But there was also a third category of objects, from 'Umar's gift, acquired in the palace of the Persian kings, to the throne and crown of Kābūl-shāh. Such objects had an uplifting value to the beholders, used as they were to symbolize the unbeliever's submission to Islam through the display of the *Herrschaftszeichen* of the unbelieving prince in the chief sanctuary of Islam.

If we return now to the mosaics of the Dome of the Rock, two possibilities are open. One can argue, first, that the crowns and jewels reflect an artistic theme of Byzantine origin which, also in an Islamic context, used royal symbols in a religious sanctuary to emphasize the sanctuary's holiness. But one can also suggest that the choice of Byzantine and

Sasanian royal symbols was dictated by the desire to demonstrate that the "unbelievers" had been defeated and brought into the fold of the true faith. Thus, in the case of the mosaic decoration, just as in the problem of the choice of the location of the building, one can present at the same time an explanation of the Dome of the Rock which would be purely religious and self-sufficient in Islamic terms alone (even though it may reflect practices found in other civilizations) and an explanation which brings up the relationship of the non-Muslims to the new faith. The third document in our possession, the inscription, will give us a definite answer.

The Dome of the Rock is unusually rich in inscriptions,[108] of which three are Umayyad.[109] The major one, 240 meters in length, is found above the arches of the inner octagonal arcade, on both sides. With the exception of the well-known place where al-Ma'mūn substituted his name for that of 'Abd al-Malik, this inscription is throughout contemporary with the building. The other two inscriptions are on copper plaques on the eastern and nothern gates. They, too, have been tampered with by the 'Abbāsid prince, but Max van Berchem has shown that they should be considered as Umayyad.

The content of the inscriptions is almost exclusively religious, the exception being the part that gives the name of the builder and the date, and to a large extent it consists of Koranic quotations. The importance of this earliest Koranic inscription we have lies in the choice of the passages and in the accompanying prayers and praises. That Koranic excerpts were used in Islamic times to emphasize or even to indicate the purpose of a structure can easily be shown by a few examples. For in-

scriptions is apparent in the following quotations: 1, From the 199 inscription dealing mostly with the victory over al-Amin: ". . . he [the *imām*] was obeyed, because he himself held on forcefully to his obedience to God; he was sustained in his work for the Book of God and the revival (*ihyā'*) of the way (*sunnah*) of the messenger of God, and he was delivered of his oath to the one who was cast off (*al-makhlū'*), because of [the latter's] betrayal, perjury, and alteration [of the pact]." 2, From the 200 inscription: "May whoever reads these lines contribute to the glorification of Islam and the abasement of polytheism, through word and through act, for the strengthening of the faith is imposed on men, as is prescribed by the *imams*, and [also] whoever desires asceticism, the holy war, the gates of piety, and a contribution to all that is earned by Islam in this glory and these splendors."

[108] Max van Berchem, *Matériaux*, pp. 223–371.
[109] *Ibid.*, pp. 228–255; *Répertoire*, Nos. 9–11.

stance, the Nilometer of Rawḍah contains Koranic inscriptions from the 'Abbāsid period, which refer to the importance of water as a life-bringing element (42:27–28; 14:37; 16:10–11, and so on).[110] In the mosque of al-Ḥākim a passage was chosen which refers to an imām (28:4).[111] Much later the hospital of Nūr al-Din in Damascus contained various quotations dealing with the art of healing (10:59; 16:71; 26:78–80).[112] Most mosques generally contain in some obvious place 9:18, which specifies the duties of those entering sanctuaries. It is thus perfectly legitimate to infer from the tenor of a Koranic inscription the purpose and the significance of a building. Often, as in the Dome of the Rock, these inscriptions can in fact be read only with difficulty. However, Max van Berchem has shown in numerous instances that the significance of inscriptions was essentially symbolic and this is particularly evident in the Dome of the Rock, since otherwise there would have been no reason for al-Ma'mūn to replace 'Abd al-Malik's name with his own.[113]

The inscription in the interior of the building can be divided into six unequal parts, each of which begins with the basmalah. Each of these parts contains a Koranic passage, except for the one that has the date. The first part has sūrah 112: "Say: He is God, the One; God the Eternal; He has not begotten nor was He begotten; and there is none comparable to Him." The second part contains sūrah 33:54: "Verily God and His angels bless the Prophet; O ye who believe, bless him and salute him with a worthy salutation." The third passage is from sūrah 17: verse 111.

This is the sūrah of the Night Journey, but the quoted passage is not connected with the isrā' of the Prophet, a further argument against the belief that at the time of 'Abd al-Malik the Rock of Jerusalem was already identified with the place of the Night Journey whence Muḥammad ascended into heaven. Verse 111 goes as follows: "And say: praise be to God, Who has not taken unto Himself a son, and Who has no partner in Sovereignty, nor has He any protector on account of weakness."[114] The fourth quotation, 64:1 and 57:2, is a simple statement of the absolute power of God: "All in heaven and on the earth glorify God; to Him is the Kingdom; to Him is praise; He has power over all things." The last part is the longest and contains several Koranic passages. First 64:1, 67:2, and 33:54 are repeated. They are followed by 4:169–171: "O ye People of the Book, overstep not bounds in your religion; and of God speak only truth. The Messiah, Jesus, son of Mary, is only an apostle of God, and His Word which he conveyed into Mary, and a Spirit proceeding from Him. Believe therefore in God and his apostles, and say not 'Three.' It will be better for you. God is only one God. Far be it from His glory that He should have a son. His is whatever is in the heavens, and whatever is on the earth. And God is a sufficient Guardian. The Messiah does not disdain being a servant of God, nor do the Angels who are near Him. And all who disdain His service and are filled with pride, God will gather them all to Himself." This quotation is followed by a most remarkable invitation to prayer: "Pray for your Prophet and your servant, Jesus, son of Mary."[115] But this is

[110] Max van Berchem, Matériaux pour un CIA: I, Egypte, Paris, 1903, p. 19 ff.

[111] Ibid., pp. 50–51.

[112] E. Herzfeld, Damascus, studies in architecture I, Ars Islamica, vol. 9 (1942), p. 5.

[113] M. van Berchem, Matériaux, Syrie du Sud, p. 235 ff.

[114] This last sentence is still fairly obscure, as can be seen from the varying translations by Pickthall, Palmer, and Blachère, but the reference to Christ is unmistakable.

[115] This expression might be compared to the expressions found on early coins: Muḥammad rusūl

54

followed by 19:34–37: "And the peace of God was on me (Mary) the day I was born, and will be the day I shall die, and the day I shall be raised to life. This is Jesus, the son of Mary; this is a statement of the truth concerning which they doubt. It beseems not God to beget a son. Glory be to Him. When he decrees a thing, He only says to it 'Be,' and it is. And verily God is my Lord and your Lord; adore Him then. This is the right way." And the inscription ends with the exhortation and threat of 3:16–17: "God witnesses that there is no God but He: and the angels, and men endued with knowledge, established in righteousness, proclaim there is no God but He, the Mighty, the Wise. The true religion with God is Islam; and they to whom the Scriptures had been given, differed not until after the knowledge had come to them, and through mutual jealousy. But, as for him who shall not believe in the signs of God, God will be prompt to reckon with him." [116]

The two inscriptions on the gates are not as explicit. The one on the east gate bears a number of common Koranic statements dealing with the faith (2:256; 2:111; 24:35, 112; 3:25; 6:12; 7:155) and a long prayer for the Prophet and his people. The inscription on the north gate is more important since it contains two significant passages. First it has 9:33 (or 61:9): "He it is who has sent His messenger with the guidance and the religion of truth, so that he may cause it to prevail over all religion, however much the idolaters may hate it." This is the so-called "prophetic mission" which has become the standard inscription on all Muslim coins. But, while it is true that it has become a perfectly

commonplace one, its monumental usage is rarer and this is its first known example. And second, this inscription contains an abridged form of 2:130 (or part of 3:78), which comes after an enumeration of the prophets: "We believe in God, in that which was passed down to Muhammad (this is not Koranic) and *in that which the Prophets received from their Lord. And we make no distinction between any of them and unto Him we have surrendered."*

These quotations emphasize three basic points. First the fundamental principles of Islam are forcefully asserted, as they will be in many later inscriptions. Then all three inscriptions point out the special position of the prophet Muhammad and the importance and universality of his mission. Finally the Koranic quotations define the position of Jesus and other prophets in the theology of the new faith, with by far the greatest emphasis on Jesus and Mary (no Old Testament prophet is mentioned by name).[117] The main inscription ends with an exhortation, mingled with the threat of divine punishment, pointing to Islam as the final revelation and directed to the Christians and the Jews ("O ye people of the Book"). These quotations do not, for the most part, belong to the usual cycle of Koranic inscriptions on monuments. Just as the Dome of the Rock is a monument without immediate parallel in Islamic architecture, so is its inscription unique. Moreover it must be realized that even those ⌐ tations which will become commonplace were used here, if not for the first time, at any rate at a time when they had

Allāh wa 'abduhu or *Muḥammad 'abd Allāh wa rusūluhu.* See J. Walker, *Arab-Byzantine coins,* London, 1956, p. LXVII.

[116] The last few words are missing on the inscription, probably because the artist miscalculated the space he had at his disposal.

[117] This point had already been made by M. de Vogüé, *Le Temple de Jérusalem,* Paris, 1864, p. 89. Max van Berchem, p. 251, n. 4, has denied that most of the quotations deal with Jesus. While it is, of course, true that the inscriptions on the doors are not overly explicit, the main inscription inside the building is quite unique for its emphasis on the relations between Islam and Christianity.

not yet become standard. Through these quotations the inscription has a double implication. On the one hand it has a missionary character; it is an invitation, a rather impatient one, to "submit" to the new and final faith,[118] which accepts Christ and the Hebrew prophets among its forerunners. At the same time it is an assertion of the superiority and of the strength of the new faith and of the state based on it.

The inscription also had a meaning from the point of view of the Muslims alone. For it can be used to clarify the often quoted statement of al-Maqdisī on the reason for the building of the Dome of the Rock. One day al-Maqdisī asked his uncle why al-Walīd spent so much money on the building of the mosque of Damascus. The uncle answered: "O my little son, thou hast not understanding. Verily al-Walīd was right, and he was prompted to a worthy work. For he beheld Syria to be a country that had long been occupied by the Christians, and he noted there the beautiful churches still belonging to them, so enchantingly fair, and so renowned for their splendor, as are the Church of the Holy Sepulchre, and the churches of Lydda and Edessa. So he sought to build for the Muslims a mosque that should be unique and a wonder to the world. And in like manner is it not evident that 'Abd al-Malik, seeing the greatness of the *martyrium* (*qubbah*) of the Holy Sepulchre and its magnificence was moved lest it should dazzle the minds of the Muslims and

hence erected above the Rock the Dome which is now seen there." [119]

It is indeed very likely that the sophisticated Christian milieu of Jerusalem had tried to win to its faith the rather uncouth invaders. And it is a well-known fact that eastern Christianity had always liked to use the emotional impact of music and the visual arts to convert "barbarians." [120] That such attempts may have been effective with the Arabs is shown in the very interesting, although little studied, group of accounts dealing with the more or less legendary trips of Arabs to the Byzantine court in early Islamic times, or sometimes even before Islam.[121] In most cases the "highlights" of the "guided tours" to which they submitted was a visit either to a church where a definite impact was made by the religious representations or to a court reception with similar results. In the pious accounts of later times the Muslim always leaves impressed but unpersuaded by the pageantry displayed. One

[118] Goitein has also pointed this out, in JAOS, vol. 70 (1950), p. 106. At a slightly later date, John of Damascus, *Homily on the Holy Sabat*, in PG, vol. 96, cols. 641–642, reflects Muslim missionary work: "Whoever does not confess that Christ is the Son of God and God is an Antichrist. If somebody says that Christ is a servant (*doûlos*), let us close our ears in the knowledge that he is a liar and that he does not possess the truth." The reference to the Muslim view of Christ is unmistakable.

[119] Al-Maqdisī, p. 159; LeStrange, *Palestine*, pp. 117–118.

[120] For a later example see *The Russian Primary Chronicle*, tr. S. H. Cross and O. P. Sherbowitz-Wetzor, Cambridge, 1953, pp. 110–111. See also the Arabic traditions mentioned below.

[121] See, for instance, al-Dīnawari, *K. al-akhbār al-ṭiwāl*, ed. V. Guirgass, Leyden, 1888, pp. 21–22; al-Isfahānī, *K. al-Aghānī*, Būlāq, 1868, vol. 14, pp. 5–8; ibn al-Fakih, *K. al-Buldān*, in *Bibl. Geogr. Arab.*, vol. 5, p. 141 ff. There is a whole body of such stories which should be sorted out. Often these stories are connected with the stories dealing with Muḥammad's missions (cf. below), but some have already acquired a literary flavor suggesting that we are in fact dealing with a theme which was not merely historical. For legends and history, see R. Goossens, *Autour de Digínis Akritas*, Byzantion, vol. 7 (1932), pp. 303–316; M. Canard, *Delhemma, ibid.*, vol. 10 (1935), pp. 283–300; H. Grégoire and R. Goossens, *Byzantinische Epos und arabischer Ritterroman*, Zeitschr. Deutsch. Morgen. Gesell., n.f., vol. 13 (1934), pp. 213–232; and especially M. Canard, *Les aventures d'un prisonnier arabe*, Dumbarton Oaks Papers, vol. 10 (1955–56).

56

may wonder, however, whether such was always the case and whether the later stories should not be considered, at least in part, as moral stories intended to ward off defections. That the danger of defections existed is clearly implied in Maqdisi's story. From a Muslim point of view, therefore, the Dome of the Rock was an answer to the attraction of Christianity, and its inscription provided the faithful with arguments to be used against Christian positions.

A priori, as we have seen, two major themes must be present in the construction of the Dome of the Rock. First, the building of a sanctuary on Mount Moriah must be understandable—and must have been understood—in terms of the body of beliefs which had been associated with that ancient holy spot, since Islam was not meant as a totally new faith, but as the continuation and final statement of the faith of the *People of the Book.* In other words, the Dome of the Rock must have had a significance in relation to Jewish and Christian beliefs. Second, the first major Muslim piece of architecture had to be meaningful to the follower of the new faith. These two themes recur in the analysis of all the three types of evidence provided by the building itself. Its location can be explained as an attempt to emphasize an event of the life of Abraham either in order to point to the Muslim character of a personage equally holy to Christians and Jews or in order to strengthen the sacredness of Palestine against Mekkan claims. The royal symbols in the mosaics could be understood as simply votive or an expression of the defeat of the Byzantine and Persian empires by the Muslims. Finally the inscriptions are at the same time a statement of Muslim unitarianism and a proclamation to Christians and Jews, especially to the former, of the final truth of Islam.

But in the inscriptions the latter theme is preponderant and it is in the inscription, with its magical and symbolic significance,—far greater than that of representational art in Islam from the very inception of the new faith [122]—that we find the main idea involved

[122] Cf. references to Max van Berchem, above, n. 113. This point poses again the question of the formation of Muslim iconoclasm. The earliest definite evidence from a literary source derives from the complicated body of documents known as the "edict of Yazid," which has been recently analyzed by A. A. Vasiliev, *The iconoclastic edict of the caliph Yazid II, A.D. 721,* Dumbarton Oaks Papers, vols. 9–10 (1956). But the archeological evidence of the Dome of the Rock and of the mosque of Damascus shows that, even before the time of Yazid, it was fully accepted that a Muslim religious building did not admit of representations of living beings. There was thus a definite distinction in Umayyad times between an imperial art which permitted images and a religious art which did not. It is unlikely, however, that Muslim theology in the second half of the first century of the Hegira had already made all the conclusions which will be drawn later from the concept of God as the only Creator. It may be that the simple incident of the destruction of idols by Muhammad in Mekkah created a precedent which was followed without being fully rationalized. The conscious destruction of religious representations in Central Asia by the Arab conquerors, which is evidenced both in literary sources and by archeological documents, seems to have been the result of an opposition to idols rather than to representations. It may also be suggested that the Muslim opposition to religious images was connected with the tremendous importance of images in Christianity and that we are in fact dealing with a reaction against means of conversion and teaching with which the Muslims could not compete. The whole question of the origins of Muslim opposition to religious images is far from being solved, but a solution should not mean, as it has at times, the attribution to early Islam of the systems of thought and conclusions characteristic of a later period, but rather an understanding of the problem within its historical context. On the question of the work of art as a symbol of sovereignty, it may be interesting to relate the following story told by Eutychius, ed. L. Cheikho, vol. 2, pp. 19–20. At the time of the conquest, we are told, the Arab forces under Abū 'Ubaydah signed an armistice for one year

in the erection of the Dome of the Rock. What the inscription implies is a forceful assertion of the power and of the strength of the new faith and of the state based on it. It exemplifies the realization by the Umayyad leadership of its own position with respect to the traditional heir of the Roman empire. In what was in the seventh century the Christian city *par excellence* 'Abd al-Malik wanted to affirm the superiority and the victory of Islam. This affirmation, to which was joined a missionary invitation to accept the new faith, had its expression both in the inscription and in the Byzantine and Persian crowns and jewels hanging around the sacred Rock. But its most

immediately striking expression was the appropriation for Islam of the ancient site of Mount Moriah. Thereby the Christian prophecy was voided and the Jewish mount rehabilitated. But it was no longer a Jewish sanctuary; it was a sanctuary dedicated to the victorious faith. Thus the building of the Dome of the Rock implies, on the part of 'Abd al-Malik, what might be called a *prise de possession* of a hallowed area, in the same sense that, as Max van Berchem has shown, the substitution of al-Ma'mūn's name for that of 'Abd al-Malik in the inscription was not the act of a counterfeiter or a vainglorious prince but had a political aim: "détourner à son profit le prestige religieux et politique attaché aux créations de ses prédécesseurs." [123] In meaning, therefore, the Dome of the Rock should not so much be related to the monuments whose form it took over, but to the more general practice of setting up a symbol of the conquering power or faith within the conquered land. Such were the *tropaia* of the Roman empire.[124] Such were, in a different way, the inscriptions in the Christian basilica of Bethlehem.[125] Such were the well-known inscriptions of the Nahr al-Kalb north of Beyrouth. Such was probably the meaning of many an Assyrian sculpture, whose brutality was really meant to strike fear in the heart of the subdued. And even today such commemorative inscriptions or monuments are not

with the Christians of Qinnasrīn whereby a frontier would be established between Christian and Muslim possessions, in order to allow those Christians who so desired to leave Syria and follow Heraclius into Anatolia. The frontier was defined by a pillar or column (*'amūd*), beyond which the Muslims were not to go. On this column the Christians painted a portrait of Heraclius seated in majesty (*jālis fi mulkihi*), with the agreement of Abū 'Ubaydah. But one day, while practicing horsemanship, a certain Arab accidentally planted the point of his spear in the eye of the image and put its eye out. The chief of the Christians (*al-batrīq, patricius*) immediately came accusing the Muslims of betraying the truce. When asked by Abū 'Ubaydah what he would like in return, he said: "We will not be satisfied until the eyes of your king are put out." Abū 'Ubaydah suggested having his own image mutilated, but to no avail, since the Christians insisted on having a likeness of the Muslim's great king (*malikukum al-akbar*). Finally Abū 'Ubaydah agreed. The Christians made an image of 'Umar, whose eye was then put out by one of his men. Then the *batrīq* said: "You have treated us equitably." Here again the important point is not whether or not the event actually took place, although, even if arranged, it is not inconceivable during the "free for all" period of the conquest. The story may have been simply invented in order to satisfy, in one small instance, the vanity of the Christians defeated by the great caliph. But the essential point of this account is in showing once again the significance of a work of art as a magic symbol of state and sovereignty through the actual identification of emperor and image.

[123] Max van Berchem, p. 238. It may be added here that, of all later Muslim caliphs, al-Ma'mūn was probably one of the most likely to understand the symbols involved in the Dome of the Rock, since, it will be recalled, he was responsible for the inscriptions on the treasure of Kābūl-shāh, above.

[124] See, for instance, the monument of La Turbie in southern France, J. Formigé, *Le Trophée des Alpes*, Paris, 1949.

[125] See the content of the inscriptions in H. Stern, *Les représentations des conciles dans l'église de la Nativité: les inscriptions*, Byzantion, vol. 13 (1938), p. 420 ff., esp. pp. 437–440 and 449 ff.

58

uncommon within the territory of the conquered peoples. The forms may change according to the time, place, and circumstances, but the monumental expression of an essentially political idea is as ancient as the existence of empires. And in Umayyad Islam this affirmation of victory is bound with a definite missionary spirit.

Two points remain still to be discussed. We must see first in what ways such an interpretation of the Dome of the Rock agrees with the Byzantine-Umayyad relations of the time. Then we must try to find out at what time the Dome of the Rock and the area surrounding it acquired the significance which became prevalent in later times.

The years 69–72 were not very favorable for the fortunes of the Umayyad caliphs. They were fighting Muslim forces in Arabia and Iraq. They were paying an enormous tribute to the Byzantines and, furthermore, they had to face the invasion of that odd group of Christian irregulars, the Mardaites, while the Cyprus situation was still unsettled.[126] However, the interesting point is not in the actual events, but in the psychological climate of Christian-Muslim relations in the latter

[126] On the relations with the Byzantines see J. Wellhausen, *Die Kämpfe der Araber mit den Romäern in den Zeit der Umaijaden,* Nachrichten von d. K. Gesell. d. Wiss. zu Göttingen, 1901, p. 428 ff.; on the Mardaites see art. by H. Lammens in *Encyclopedia of Islam,* with further bibl.; for wars in Asia Minor see E. W. Brooks, *The Arabs in Asia Minor (641–750),* Journal of Hellenic Studies, vol. 18 (1898), p. 182 ff.; for the Byzantine side see G. Ostrogorsky, *History of the Byzantine Empire,* Oxford, 1956, p. 116; and for the Cyprus problem, R. J. H. Jenkins, *Cyprus between Byzantium and Islam,* Studies presented to D. M. Robinson, Saint-Louis, 1953, vol. 2, p. 1006 ff. Just recently the psychological aspect of Umayyad relations with the Byzantines has been admirably sketched by H. A. R. Gibb, *Arab-Byzantine relations under the Umayyad caliphate,* Dumbarton Oaks Papers, vol. 12 (1958), pp. 231–233.

part of the seventh century. The important fact here is that there was a constant ambiguity in these relations, for they were, on the one hand, relations between two faiths and, on the other, between two empires. By the end of the seventh century it appears fairly certain that an important fraction of the Christian population within the Muslim empire—and especially the hierarchy of the church—was in reality a sort of "fifth column" for the Byzantine state,[127] which was all

[127] It is in fact in Christian sources that this phenomenon becomes evident, since from a Christian point of view this was a very desirable activity. See the epistle of Sophronius to Sergius in Migne, PG, vol. 87, pt. 3 (Paris, 1865), cols. 3197–3200; cf. also the texts gathered by M. de Goeje, *La conquête de la Syrie,* pp. 174–176. The Sophronius letter was read anew at the sixth ecumenical Council in Constantinople in 680, J. D. Mansi, *Sacrorum Conciliorum . . . collectio,* Florence, 1765, vol. 11., cols. 459 and following. The pretext offered by Theodore, the representative of the see of Jerusalem (col. 455), was his desire to know whether the thoughts expressed in it were orthodox. This is a strange pretext at best, since the theological position of Sophronius was always recognized as one of the strongest expressions of orthodoxy in the face of Monotheletism. It is much more likely that Theodore wanted to draw the attention of the Council to the situation of the see of Jerusalem and, in a disguised form, to invite intervention. It had, of course, to be done in a disguised form, since there were, at the Council, representatives of other "occupied" areas, who were favorable to Macarius and the heretics on trial (see cols. 618–619) and who might have informed the Umayyads of orthodox activities. The stories dealing with John of Damascus' betrayal of the caliph to the emperor are probably legendary (PG, vol. 94, cols. 453–456); see the article (*Saint*) *Jean Damascène* in *Dictionnaire de Théologie Catholique,* Paris, 1924. Yet what is unlikely is not the story itself but the fact that John of Damascus would have been plotting with Leo. Theophanes (Bonn ed., p. 559) relates that 'Abd al-Malik wanted to use the columns of the Gethsemane church for the rebuilding of the Mekkan Temple; various Christian notables requested him not to do so, but suggested instead that they would ask Justinian II's permission to substitute columns from another church. So it was

the easier, since communications were not interrupted between the two empires, as has recently been shown again.[127a]

'Abd al-Malik directed himself against the Christian danger no less effectively than against the danger of disaffectation in the very ranks of Islam. The Mardaites were taken care of by an expedition[128] and by a treaty with Byzantium.[129] A few years later, 'Abd al-Malik changed the coinage[130] and transformed it into an instrument of opposition to the Byzantine empire. Already the earlier experimental issues had contained symbols of the

done. The point here is not whether the story is true or not but that both the Christians and, curiously enough, 'Abd al-Malik seemed to accept Justinian's sovereignty over Christian buildings in Jerusalem. Theophanes, pp. 641–643, also relates that, under al-Walīd II, the archbishop of Damascus had to be exiled for making anti-Muslim speeches; see also p. 632. Other sources, Denys of Tell-Mahre, *Chronicle,* tr. J. B. Chabot, Paris, 1895, p. 10, and Michael the Syrian, tr. J. B. Chabot, p. 475, attribute to 'Abd al-Malik a persecution of the Christians. And the inscriptions of Bethlehem, perhaps slightly later than the Dome of the Rock, while, according to Stern, they did not follow a purely Byzantine tradition, but a local Syrian one, imply a condemnation of heretics which may have been directed against the Maronites, but also against the Muslims, who were considered as heretics (probably Arians, C. Güterbock, *Der Islam im Lichte der byzantinischen Polemik,* Berlin, 1912, p. 6). The unusual lack of representations of living beings does suggest that the mosaics were made with a definite consciousness of the existence of Islam and not exclusively within a Christian world of its own. On this problem and other related ones, see now the texts, images, and commentaries in the second chapter of A. Grabar, *L'Iconoclasme byzantin,* Paris, 1957.

[127a] H. A. R. Gibb, in Dumbarton Oaks Papers, vol. 12, p. 221 ff.

[128] Balādhurī, *Ansāb,* vol. 5, p. 335.

[129] Theophanes, pp. 558–559.

[130] Ṭabarī, vol. 2, pl. 939, and the other chroniclers. On all questions of coinage, see now J. Walker, *Arab-Byzantine coins,* London, 1956, esp. pp. XXV, XXIX, LVII ff., for expressions showing political concern.

new state,[131] but the new coinage included in a nutshell all the themes of the inscription of the Dome of the Rock: the unitarian affirmation (There is no God but God, One, without associate), the emphasis on Muhammad (Muhammad the Apostle of God), and the mission verse from the Koran quoted above. The argument that coinage was an element of ideological warfare is all the more convincing since, around the same time, and probably before the Muslim change of coinage, Justinian II introduced a new Byzantine coinage with a definite Christological emphasis (*servus Christi* in the inscription and an image of Christ with the inscription *rex regnantium*) which had hitherto been absent.[132] It may be pointed out in passing that it is on problems of Christology that all later discussions between Muslims and Christians will center.[133] As to the third Christian element, the Christians of the Muslim empire, 'Abd al-Malik's attitude toward them was a mixture of sternness and persuasion. It is exemplified in the erection of the Dome of the Rock, whose meaning was that the Islamic state was here to stay and that the new faith was simply the

[131] See, for instance, G. C. Miles, *Miḥrāb and 'Anazah: a study in early Islamic iconography,* Archaeologica Orientalia, in Memoriam Ernst Herzfeld, New York, 1952, pp. 156–171. Grabar, *Iconoclasme,* p. 67 ff.

[132] Wroth, Catalogue, vol. 2, p. 330 ff.; cf. A. Grabar, *L'Empereur dans l'art byzantin,* Strasbourg, 1936, p. 19, n. 4, where the symbolic elements of Justinian's coinage are emphasized. See also E. Kitzinger, *The cult of images before iconoclasm,* Dumbarton Oaks Papers, vol. 8 (1954), p. 126, where the change is explained in purely Byzantine terms. This was no doubt so, but it may be suggested that, in the case of Justinian II, just as in the case of 'Abd al-Malik, important changes or decisions had both an internal and an external significance. See the extensive discussion in A. Grabar, *Iconoclasme,* p. 67 ff.

[133] Güterbock, *op. cit.,* passim; C. H. Becker, in *Zeitschrift für Assyriologie,* vol. 26, 1912; Jeffery, in Harvard Theological Review, vol. 37, 1944.

60

final statement of what was true in Christianity.

One may introduce here yet another document which may have a bearing on the problem. Most Arab chroniclers, when relating the major events of the Prophet's life, relate that Muḥammad had sent a series of embassies to the rulers of the world, and, among them, of course, to Heraclius.[184] The historical value of many of these stories has been questioned[185] and there is no doubt that much in their later forms was certainly made up, although the mere fact of Muḥammad's sending messengers is not implausible, especially after his first successes over Jews and pagans, when he began to emphasize the universality of the new faith. One of the stories transmitted by Ṭabarī may have some significance in our investigation. It goes back to al-Zuhrī, who claims to have heard it from a Christian bishop *at the time of 'Abd al-Malik,* and, like many other accounts, it says that Heraclius himself was quite convinced of the truth of the Prophet's mission, but that the upper ranks of the church refused to follow him and that he had to submit to them.[186] Regardless of whether Muḥammad sent messengers, it is extremely improbable, to say the least, that Heraclius would have even considered becoming a Muslim. But it could be suggested that the Umayyads, in order to arouse the Christians against the hierarchy of the church, which was closely tied to the Byzantine empire, and in order to further the aims of conversion which certainly existed among their followers, might have created the fiction that the hero who brought the True Cross back to Jerusalem was ready to become a Muslim. And it is under 'Abd al-Malik and at the time of the construction of the Dome of the Rock that such a story might have been put into circulation.

By itself this account has little significance, but, together with the coins, the inscriptions of the Dome of the Rock, and the Christian activities in the Muslim empire, it contributes to the suggestion of an interesting group of propagandistic activities taking place during the ideological "cold war" between the Christian and Muslim empires at the time of 'Abd al-Malik. All together they created a climate of opinion which certainly influenced the spirit of crusade and the consciousness of a struggle between the two faiths and the two states, which characterized the great Muslim expedition against Constantinople in the years 97–99/715–717.[187]

These facts would, I believe, show that the interpretation here proposed of the Dome of the Rock does agree with the known historical development of Islam and Byzantium in Umayyad times. But this significance could only last so long as the circumstances permitted. Its faint echo is still apparent in Maqdisī, but it may be noted that the Muslim geographer claimed that in the tenth century A.D. Christian and Jews still maintained the upper hand in the affairs of the city;[188] the building, therefore, still served its original purpose, albeit on a very restricted level.

In the meantime, however, the whole

[184] There are many versions of the story and some are confused with other similar themes (cf. above, n. 121); see Ṭabarī, vol. 1, p. 1585 ff.; *Aghānī,* vol. 6, p. 64 ff.; Ibn Sa'ad, *Ṭabaqāt,* ed. E. Sachau, vol. 1, 2, p. 15 ff., etc.; see also M. Hamidullah, *Corpus des Traités et Lettres Diplomatiques,* Paris, 1935, pp. 14–15. Gaudefroy-Demombynes, *Mahomet,* p. 178 ff.

[185] C. L. Caetani, *Annali dell'Islam,* vol. 1, Milan, 1905, p. 725 ff.

[186] Ṭabarī, vol. 1, p. 1565; see also pp. 1561–1562 for another tradition transmitted by al-Zuhrī to the effect that Heraclius dreamed that "circumcised people" will rule over Jerusalem.

[187] M. Canard, *Les expéditions Arabes contre Constantinople dans l'histoire et la légende,* Journal Asiatique, vol. 208 (1926), p. 80 ff.

[188] al-Maqdisī, *op. cit.,* p. 165 ff.

Ḥaram area underwent considerable change, both in its physical aspect and in its significance. The identification of the *masjid al-aqṣā* with Jerusalem was more generally accepted than before and all the small memorial structures connected with the Ascension of Muḥammad were built. The question is whether one can date the moment when this change took place. The inscriptions are not very helpful. The earliest one to mention the *isrā* of the Prophet and to quote Koran 17:1 is the one which was seen by Harawi and which is dated in 426/1035.[139] It was in the large congregational mosque at the southern end of the Ḥaram, which is generally called the Aqṣā mosque. Basing himself on that inscription, Max van Berchem suggested that it is there and not on the Rock that the Muslim tradition had first localized the event of the Prophet's life.[140] This is quite possible, inasmuch as Ibn al-Faqih, one of our earlier sources, mentions that in this mosque there was a black plaque with the inscription *khilqah Muḥammad*,[141] and behind the *qiblah* there was another inscription connected with the Prophet. At the same time, the existence of a *qubbah* of the Ascension on the central platform of the Ḥaram would lead one to believe that it is in a more central part of the esplanade that the miraculous event was thought to have taken place. Were both places accepted at the same time? Or was there a difference in meaning between them? Could one

have been more definitely commemorative than the other? The question of localization is still not clear.

As far as dating is concerned, it may be suggested that it was under al-Walīd, 'Abd al-Malik's successor, that the identification of the *isrā*' and *mi'raj* with the Ḥaram area was accepted and translated into architecture. Al-Walīd was known as a great builder. He built the new mosque at Madīnah, the royal mosque at Damascus, and he restored a great deal in Mekkah.[142] In the case of Madīnah, Sauvaget has shown that the plan of the new mosque depended in many ways on the preceding structure which was like the shrine of the house of the Prophet.[143] And the Egyptian papyri show that under al-Walīd a major mosque was built in Jerusalem. There is little doubt that it is the present Aqṣā mosque which was centered on the previously built sanctuary of the Rock, perhaps in *architectural* imitation of the complex of the Holy Sepulchre, as has been suggested, although the *idea* of adapting a congregational mosque to a formerly built sanctuary is also that of Madīnah.[144] If, then, the Ascension of Muḥammad was supposed to have taken place on the site of the mosque, there is some justification in attributing to al-Walīd the monumental recognition of the fact. If, on the other hand, the localization was on the central platform, we can still argue that al-Walīd was responsible for it. And this for the following reason.

It will be recalled that two writers, al-Muhallabī, quoted by Abū al-Fidā,[145] and

[139] Max van Berchem, p. 382 ff.; Guide des Lieux de Pélerinage, p. 64. It is only after the arrival of the Ottomans that we meet with inscriptions on the Dome of the Rock itself with the theme of the Night Journey.

[140] *Ibid.*, p. 383.

[141] It is not clear whether we should understand the word to mean "form (of the name) of Muḥammad" (LeStrange, *Palestine*, p. 100) or "figure de Muḥammad" (Marmarji, *Textes*, p. 211), the former being more likely, unless we are dealing with some imprint on a stone which was associated with the Prophet.

[142] On all these activities see J. Sauvaget, *La Mosquée Omeyyade de Médine*, Paris, 1947, passim and esp. p. 93 ff.; also Gibb, *op. cit.*, p. 224.

[143] *Ibid.*, p. 121.

[144] R. W. Hamilton, *The structural history of the Aqsa Mosque*, London, 1949, p. 74; Sauvaget, pp. 100–101; Creswell, vol. 2, p. 119 ff.; E. Lambert, *Les origines de la mosquée*, Studia Islamica, vol. 6 (1956), pp. 14–18.

[145] Text in Gildmeister, ZDPV, vol. 13, p. 18.

Eutychius [146] attribute the building of the Dome of the Rock to al-Walīd. Al-Muhallabī adds that al-Walīd was also responsible for the small *qubbahs* around the Dome of the Rock, while Eutychius claims that the dome of the main sanctuary was taken from a Christian church in Baalbek and brought to the Holy City. The errors of these two writers could be explained if we suppose that al-Walīd was indeed responsible for the building of the small mausoleums and consequently for the architectural translation of the Ascension of the Prophet. It may even be that al-Walīd did have a small cupola moved from some remote Christian church, while it would of course be unthinkable to imagine the transportation of the dome set over the Rock. Knowing al-Walīd to have been the builder of the large congregational mosque and of the small mausoleums, al-Muhallabī and Eutychius would have simply concluded that the building up of the Ḥaram in general was his doing. It may finally be added that all the religious foundations of al-Walīd are characterized by their concern with a lavish expression of the power of the Umayyad state and with their emphasis on the places sanctified by Muḥammad. It would have been natural for the builder of the mosque of Madīnah to have used the Ascension of the Prophet as a reason to build a large mosque in Jerusalem.

Be this as it may, we can see that the evidence which can be gathered from the mosaics, the inscriptions, and the location of the Dome of the Rock shows that the first major Muslim attempt at monumental architecture can only be understood in all its complexity and uniqueness when seen in its Umayyad context. Political and religious, directed to the Muslim as well as to the Jew and especially the Christian, symbol of a state and of a mission, the Dome of the Rock reflected the centuries of traditions and beliefs which had accumulated

on Mount Moriah, just as it was intimately tied to the specific historical situation of the time.[147] As a political and immanent structure, the Dome of the Rock soon lost its meaning. But as a religious building it continued the great tradition of the Temple and its significance went far beyond that of a mere *martyrium* to a moment of the Prophet's life. It must be seen as the first of a long series of Muslim sanctuaries connected with the lives of Prophets, although it is still to be investigated whether, and, if so, to what extent, both architecturally and conceptually the Dome of the Rock influenced the development of later *qubbahs* and *welis*. Moreover, with the development of mysticism the concept of the Ascension of Muḥammad became one of the richest and most profound themes of Islamic thought and reached even beyond the frontiers of Islam, influencing the spiritual progress of the western world.[148] Thus the Ḥaram area in Jerusalem acquired a sacredness far greater than and much different from the temporal significance that was given to it at the time of its revival by the Umayyads through the building of the Dome of the Rock.

[146] Eutychius, ed. Cheikho, vol. 2, p. 42.

[147] Max van Berchem, p. 252, n. 1, pointed out that the 'Abbāsid chroniclers were curiously reticent about 'Abd al-Malik's work in Jerusalem, while quite voluble about al-Walīd's programs, and suggested that the reason was 'Abd al-Malik's reputed impiety. It might be more likely to consider that the later chroniclers were not fully conscious of the significance of the building in the historical situation of the time.

[148] See lately H. Adolf, *Christendom and Islam in the Middle Ages*, Speculum, 32 (1957), pp. 103–115, with an extensive bibliography on the question of the impact of the Muḥammad stories on the West. See also, Americo Castro, *The structure of Spanish history*, Princeton, 1954, p. 130 ff., for an interesting explanation of the formation of the sanctuary of Saint James in Sanʿiago. The apostle is seen as a "counter-Muhammad, and his sanctuary [as a] counter-Ka'bah" (p. 151). Here also the development of a religious center is explained through its relation to a specific historical situation.

10
ZANDANĪJĪ IDENTIFIED?
D.G. Shepherd and W. Henning

The early Arab geographers and historians abound in references to textiles and garments produced in the various weaving centers of Islam and even supply us with considerable second-hand information concerning these industries under the Sasanian empire[1]. Unfortunately, it has almost never been possible to relate any of the innumerable names of the textiles recorded in these sources with the actual textiles which have come down to us. An exception is the term *mulḥam* which Lamm[2] is probably right in identifying with a type of fabric, represented in many collections, which is of tabby weave with fine silk warps almost completely covering coarser cotton wefts. This is the only instance[3] where a reasonably positive identification has been made. One of the greatest difficulties which stands in the way of identification is the fact that the names of textiles then, as now, were essentially commercial terms and not related to design or technique. Frequently the names were derived from the place of origin, but even this provides little help as most weaving centers produced more than one type of fabric and because the name for a fabric made famous in one city was soon applied to similar fabrics copied in other centers. Thus one reads in the Arabic sources that 'Attābī, from 'Attābīya, one of the quarters of Baghdad[4] was also woven in such widely separated centers as Almeria[5] and Nishapur[6]. Other cities also mentioned as producing 'Attābī are: Antioch[7], Isfahan[8], and Tabriz[9]. Similarly, the famous Marvian stuffs from Marv in Khurasan are mentioned as being produced in Baghdad[10], Tustar[11], and Isfahan[12].

A name which occurs in the sources, but which has been little remarked is that of Zandanījī, derived from the town of Zandane in the neighborhood of Bukhara. Our principle source concerning Zandanījī stuff is Narshakhī who wrote the history of Bukhara in the mid 10th century[13]. In writing of Zandane he says:

[1] Thanks to the industry and scholarship of Dr. R. B. Serjeant, the majority of the material contained in these Arabic sources has been conveniently brought together in his important »Material for a History of Islamic Textiles up to the Mongol Conquest,« which appeared in sections in *Ars Islamica*, vols. 9—16 (1942—1951).

[2] C. J. Lamm, *Cotton in Mediaeval Textiles of the Near East*, Paris, 1937, p. 104.

[3] A similar instance with respect to European textiles was the identification of *diasper* by Otto von Falke, cf. *Kunstgeschichte der Seidenweberei*, Berlin, 1913, II, p. 31.

[4] Serjeant, *op. cit.*, vol. 9, p. 82.

[5] *Ibid.*, vol. 15—16, p. 33.

[6] *Ibid.*, vol. 11—12, p. 116.

[7] *Ibid.*, vol. 11—12, p. 138.

[8] *Ibid.*, vol. 11—12, pp. 107—8.

[9] *Ibid.*, vol. 10, p. 99.

[10] *Ibid.*, vol. 9, p. 81.

[11] *Ibid.*, vol. 10, p. 74.

[12] *Ibid.*, vol. 11—12, p. 107.

[13] Muḥammad ibn Ja'far al-Narshakhī, *The History of Bukhara*, translated from a Persian abridgement of the Arabic original by Richard N. Frye, Cambridge, 1954.

»The speciality of the place is Zandanījī, which is a kind of cloth made in Zandana. It is fine cloth and is made in large quantities. Much of that cloth is woven in other villages of Bukhara, but it is also called Zandanījī because it first appeared in this village. That cloth is exported to all countries such as Iraq, Fārs, Kirman, Hindustan and elsewhere. All of the nobles and rulers make garments of it, and they buy it at the same price as brocade.«[14]

In another passage on Bukhara he writes of the workshop which once existed there between the fortifications and the Shahristan and he says:

»It happened that this workshop was abandoned, and the people who plied this trade dispersed. In the city of Bukhara there were artisans who were specialists in this work. Merchants came from various places and carried those cloths, just as they brought Zandanījī, to Syria, Egypt, and the cities of Rum Today Zandanījī is everywhere more famous than that material.«[15]

Another source concerning Zandanījī is contained in the *Siyāsat-Nāme,* written in 1092 by Niẓām al-Mulk, which tells us, in describing the first year of service of a Turkish slave in the Samanid court, that: »He served on foot in the capacity of a groom,« and that ». . . at this period he wore garments of Zandani cloth.«[16] In the time of Yākūt[17] we read that Zandanījī textiles were still well known. There is a reference to a cloak of Zandanījī at Bamiyan in 1211 A.D.[18] and even later, Juwainī[19] lists Zandanījī among the fabrics with which merchants tried to defraud Genghis Khan.

Nowhere do we find a clue to the kind of cloth that Zandanījī was. One thing stands out as certain: the name was not limited to textiles from Zandane alone but was applied to a class of textiles, probably originating in Zandane, but evidently produced in the whole Bukhara region[20]. We have seen, according to Narshakhī, that it was widely exported and that nobles and rulers had garments of it and that they paid as much for it as for brocade. On the other hand, less than 100 years later, we read in the *Siyāsat-Nāme* that it was used for the clothing of slaves of the lowest rank at the Samanid court. Fashion may have changed or the quality of the production may have declined over this period — the former perhaps contributing to the later. Vullers[21] describes Zandanījī as a »wide robe of white cotton very coarsely woven and quilted.« Frye[22] notes that most New Persian dictionaries describe Zandanījī as white cloth, usually made of cotton. These definitions seem not to be supported by the evidence in the texts and perhaps are derived, by inference, from the reference in the *Siyāsat-Nāme*. The evidence would seem to indicate that at least as late as the time of Narshakhī's history Zandanījī was an important and valuable fabric — fit for a king[23].

[14] *Ibid.*, pp. 15—16; Serjeant, *op. cit.*, p. 123, translates this passage with slight variations.

[15] Narshakhī, *op cit.*, pp. 19—20.

[16] V. V. Barthold, *Turkestan at the time of the Mongol Invasion,* London, 1927, p. 227.

[17] Serjeant, *op. cit.*, vol. 11—12, p. 124.

[18] *Ibid.*, p. 124.

[19] *Ibid.*, note 11, p. 124.

[20] In addition to the reference quoted above Narshakhī, *op. cit.*, p. 16, also mentions, for example, another town called Vardana and says »Well made Zandanījī also comes from there.« Henning, in the *Appendix*, p. 39 quotes a reference to Zandanījī of Khwarezm!

[21] As quoted by Serjeant, *op. cit.*, p. 124.

[22] Narshakhī, *op. cit.*, note 74.

[23] Frye in Narshakhī, *op. cit.*, note 74 gives an interesting reference to *zenden* being used for silk fabrics in Russia in 17th century.

By great fortune, unique in the annals of the history of textiles, an inscription with the name Zandanījī has come to light on a textile that, perhaps, may therefore be assigned to this famous center. The textile is one that has long been known — though inaccurately and

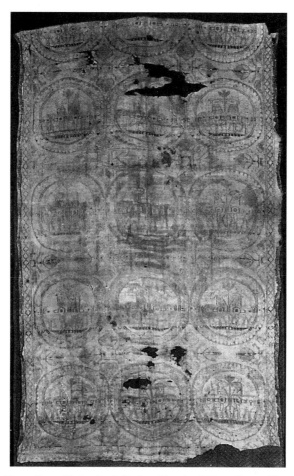

Fig. 1. Ram silk in the Collegiate Church of Notre Dame, Huy.
Copyright A.C.L. Bruxelles.

inadequately — having been first published in 1913 by von Falke[24]. It is the so-called «lamb-stuff« in the Collegiate Church of Notre Dame at Huy, Belgium.

The writer went to Huy to see this textile expecting to find only a fragment with a single small roundel and parts of the interstice motives as it is illustrated in von Falke. The fragment proved to be almost a complete loom piece *(fig. 1)* consisting of four and one half rows of three large-scale roundels each. The whole is framed on two sides and below with

[24] *Op. cit.*, I, p. 98, fig. 141.

ornamental borders and preserves both selvedges and the finished edge at the bottom of the
piece; a strip of indeterminable width has been cut from the top of the fabric. The overall
measurements are 1.915 m. high by 1.22 m. wide. An examination of the back of the textile
revealed a curious inscription scrawled in India ink *(fig. 2)* which immediately suggested
a custom's or merchant's mark such as the writer has seen occasionally on other textiles. At
first examination the inscription appeared to be Arabic but it could not be read as such.
Through the kind offices of Dr. D. S. Rice a photograph of the inscription was shown to
Dr. W. B. Henning, noted authority on obscure Asiatic languages, who succeeded in deci-
phering it. The inscription proved to be written in Sogdian in a style which Dr. Henning
attributes to 7th century Bukhara! Dr. Henning has had the great kindness to write an

Fig. 2. The Sogdian inscription on the reverse of the silk at Huy.
Copyright A.C.L. Brûxelles.

analysis of this inscription and its contents and has permitted its inclusion herein as an
appendix to this article. (cf. pp. 149–50).

 Whether or not this textile, on which the name Zandanījī is inscribed, is the same as
the Zandanījī to which Narshakhī and others had reference cannot be proven, but certainly
the author of the inscription considered it to be a fabric of that type. As the inscription
is not inwoven, but only written on the surface, it also cannot be proved that it was written
at the same time and place that the textile was woven. We can only say, with certainty,
that sometime in the 7th century the textile, before moving westward to Huy, passed
through the region of Bukhara where the inscription was written.

 Bukhara was one of the most important cities in ancient Sogdiana[25]. It was strategically
located on the great silk route to China and from a very early date was one of the most
important emporiums where goods from East and West were exchanged. We have con-
siderable evidence, both historical and archaeological, of the importance of the Sogdians
as merchants along this ancient trade route and of the colonies which they founded, as far
east as the Chinese border and even in Mongolia[26]. There is evidence, too, that Chinese

 [25] The al-Sughd of the Arab authors was the region between the Oxus and the Jaxartes. It formed part
of the area variously known as Transoxiana or West Turkestan; today it is divided between the Tadzhik
and Uzbek S.S.R.s. The original Iranian population became Persianized under the Samanids and Turkicised
after Timur. Sogdian was an Iranian language similar to, but not the same as, Persian; it was eventually
replaced by Persian and much later by Turkish.
 [26] Cf. P. Pelliot, »La ›Cha tcheou tou fou t'ou king‹ et la colonie Sogdienne de la région du Lob Nor«
in *Journal Asiatique*, VII (1916), pp. 111–123 and E. G. Pullyblank, »A Sogdian Colony in Inner Mon-

merchants and artisans established themselves in Sogdiana at an early date[27]. It should not be surprising then that Sogdiana early developed its own silk weaving industry utilizing the silk it imported from China. There is evidence which attests to the fact that the industry did actually exist in pre-Islamic times. Hiuen Tsiang[28], for example, reported concerning Samarkand that »the inhabitants are skillful in the arts and trades beyond those of other countries.« Baladhurī[29] tells us that textiles were included in the tribute sent by Transoxiana to the early Arab conquerors. The recently discovered Sogdian wall paintings of

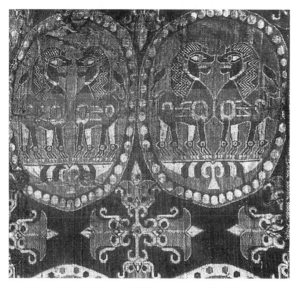

Fig. 3. Lion silk in the Biblioteca Apostolica Vaticana.
Photo Giraudon.

the 7th and 8th centuries at Pyandzhikent[30], near Samarkand, show figures clad in richly decorated fabrics[31] and seated on figured textiles revealing strong Sasanian influence[32]. As the authors have indicated, the paintings appear to be truly Sogdian and we may presume that the fabrics represented were those current in the area at the time. That this was actually the case is strongly indicated by a number of textiles discovered in 1934, together with other objects of Sogdian art of the 7th and 8th centuries, at Mount Mugh in Tadzhi-

golia« in *T'oung Pao*, 41 (1953), p. 137 ff. Particularly interesting are the Sogdian »Ancient Letters« found by Stein in Central Asia which contain correspondence from agents at posts along the silk route to their merchants back home in Sogdiana (cf. M. A. Stein, *Serindia*, Oxford, 1921, II, p. 671 ff. and W. B. Henning, »The Date of the Sogdian Ancient Letters,« *Bull. of the School of Oriental and African Studies*, XII (1948), p. 601 ff.

[27] Iṣṭakhrī (ref. Frye, *op. cit.*, note 175, p. 133).
[28] Samuel Beal, *Si-yu-ki, Buddhist Records of the Western World*, London, n.d., I, p. 32.
[29] Serjeant, *op. cit.*, vol. 11—12, p. 121.
[30] A. Yu. Yakubovskiĭ & M. M. D'yakonov, *Zhivopis' drevnego Pyandzhikenta*, Izdatel'stvo Akademii Nauk SSSR, Moscow, 1954.
[31] *Ibid.*, pls. X, XII, XXXV.
[32] *Ibid.*, pls. XXIV, XXVII, XXXV, XXXVII.

kistan. The textiles have recently been published by M. P. Vinokurova[33]. Unfortunately, they are not illustrated so that one can draw ones own conclusions, but the author provides sketches of the designs of some of the silks of the group and points out their relationship with the textile patterns represented in the paintings of Pyandzhikent. She concludes that these silks were actually woven by local Sogdian weavers. Her technical analyses support this evidence. She found that the silks with »Sogdian« designs were different in technique from those which she believed were imported from China and Iran.

The Arab historians and geographers give glowing accounts of the weaving industry and its products which existed in Sogdiana in Islamic times. Serjeant[34] has recorded the principal information contained in these Arabic sources and it is not necessary to recapitulate it here. It suffices to say that in Islamic times, weaving, including silk weaving, was an important industry in Sogdiana, especially in the region of Bukhara, and there is every reason to believe that it had enjoyed an uninterrupted development from pre-Islamic times.

We do not have evidence of a comparable weaving industry in the other regions of Central Asia and we can only infer from the silence of the sources that it did not exist. China, of course, is out of the question in this instance as will quickly be seen from an examination of the designs of the Huy silk and those which are related to it. Although there is ample evidence of the importance of silk weaving in Persia proper, under the Sasanian and later under the Muhammedan rulers, this possibility need not be considered as it would be absurd to look for a source for the Huy silk west of Bukhara. Therefore, there seems every reason to accept the evidence of the inscription on the silk and to assign it to the region of Bukhara, to approximately the 7th century, and to consider it as an example of Zandanījī.

Fortunately, the silk at Huy is not an isolated example but is one of a very closely-knit group which for a variety of technical and stylistic reasons must be considered as having a common origin. These can now, with the evidence provided by the Huy silk, be assigned to Sogdiana and, roughly, to the 7th century. Von Falke[35], has already pointed out the existence of this group and identified the major examples. He attributed it, albeit by partially faulty reasoning[36] to East-Iran and suggested that the silks might have been woven as for east as Transoxiana or even Afghanistan and he assigned them to the 8th to 10th centuries. The group, as defined by von Falke, actually consists of two sub-groups which can be separated on the basis of technical differences, and differences in color and design. The two sub-groups are clearly related and are certainly products of work-shops in the same area; they are perhaps contemporary or one is slightly later than the other. The first group, revolving around the silk at Huy, may for convenience sake be

[33] M. P. Vinokurova, »Tkani iz zamka no gore Mugh,« *Izvestiya Otdeleniya Obshchestvennykh Nauk, Akademiya Nauk Tadzhikskoi SSR*, 14 (1957), pp. 17—32. I am indebted, again, to Dr. D. S. Rice for his kindness in not only bringing the article to my attention but also for providing a copy of this rare publication.

[34] *Op. cit.*, pp. 121—7. Cf. also Barthold, *op. cit.*, pp. 235—6, who quotes, from Maqdisī, a list of merchandise exported from Transoxianan towns.

[35] *Op. cit.*, p. 98 ff.

[36] Von Falke referred to Grisar and Dregar (*Die Römische Kapelle Sancta Sanctorum und ihr Schatz*, Freiburg, 1908, pp. 129—30 and 153—5) whom he said had sought the origin of the Vatican lion silk in East Asia because of the stiff, unnaturalistic character of the lions which they believed agreed with lions of Buddhist art. Then saying that this stiff, unnatural character of the animal was opposed to Chinese art, he went on to point out the features in the silks which showed Sasanian influence and concluded that they must have been woven somewhere between the Far East and the Sasanian Empire — hence Khurasan or Transoxiana.

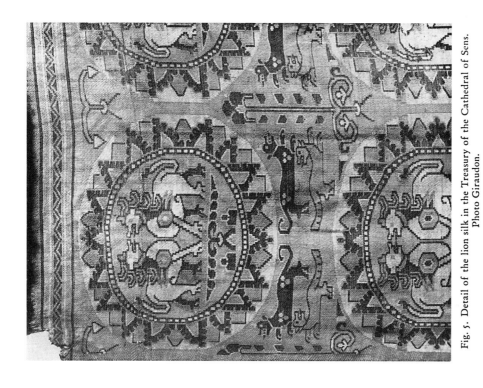

Fig. 5. Detail of the lion silk in the Treasury of the Cathedral of Sens.
Photo Giraudon.

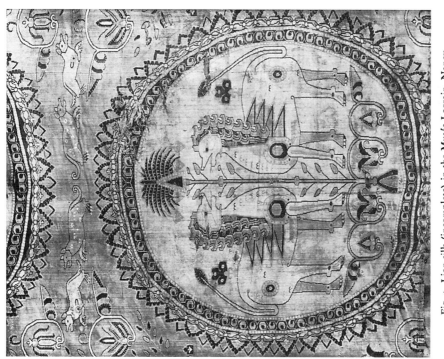

Fig. 4. Lion silk (incomplete) in the Musée Lorrain, Nancy.
Photo Giraudon.

referred to as Zandaniji I; the second, and larger, group which includes such well known silks as that with horses at Sens[37] may then be called Zandaniji II[38] (cf. fig. 3).

There are in all eleven silks which can be identified with Zandaniji I. Of these nine have been preserved in Europe and two were found in Central Asia. Of the nine silks in Europe seven were preserved in reliquaries associated with saints of the 7th, 8th and 9th centuries. The provenance of the other two, now in Museum collections, is not known but we may safely assume that they too were originally taken from reliquaries in European churches. The following are the silks of Zandaniji I which it has, so far, been possible to identify:

Lion silk in the Musée Lorrain, Nancy[39] (fig. 4). It is believed to have been originally associated with the relics of St. Amon in the Cathedral of Toul. St. Amon lived in the 4th century and the first translation of his relics seems to have been made in 820 A.D. by Bishop Frothaire, at which time the silk *could* have been placed with them.

Lion silk in the Cathedral Treasury, Sens (figs. 5, 6). This textile, generally known as the »suaire de Ste. Colombe et St. Loup,« actually consists of two pieces. One half was found in 1852 in the châsse of Ste. Colombe, a 6th century martyr; the other in 1896 in the châsse of St. Loup, Archbishop of Sens who died 623 A.D. As Chartraire has pointed out, the two pieces which fit perfectly could only have been cut and placed in the two châsses at the time of the simultaneous translations of the relics of these two saints in the year 853 A.D. when Bishop Wénilon took their bodies from the ground and placed them on the altar.

Lion silk in the Victoria and Albert Museum, no. 763.1893 (fig. 7). Two other fragments of the same silk are in the Cooper Union Museum, New York, and in the Museo Nazionale, Florence. There is no indication of the provenance of any of these pieces but certainly they were originally from a reliquary.

Lion silk in Berlin, no. 84.225 (fig. 8). This piece is composed of several fragments pieced together. (It has recently been remounted and the illustration given here shows it in its present and correct form). There are two additional fragments in Berlin (not illus.) and another fragment of the same textile is in the Musée Diocésain, Liége. An unpublished fragment in the Maastricht Cathedral Treasury may also be from this same textile. According to Lessing the Berlin piece was from a shrine in the Netherlands; von Falke said from Belgium. That all are from the same source is indicated, aside from the textiles being identical, by the fact all are similarly cut in vertical strips that cut the roundels in half.

Second lion silk in the Victoria and Albert Museum, no. 1746–1888 (fig. 9). There is no information concerning the provenance of this piece. It is also cut in vertical strips like the preceding and might have come from the same source; it is very close in design but not the same textile. Von Falke mentions that the London piece came from a Belgian reliquary shrine but he seems to have been confused by the two pieces in London and one cannot be sure which of the two this information concerns.

Lion silk from Ch'ien-fo-tung (figs. 10, 11). Fragments of the same silk are preserved in the British Museum and in the Musée Guimet. They were brought back by Stein and

[37] Von Falke, *op. cit.*, fig. 142.

[38] Von Falke, and after him others, considered the lion silk in the Vatican (fig. 3) as a key in the consideration of the group which I have called Zandaniji I, but it actually belongs which the second group. Unfortunately space does not permit the inclusion of the second group in this discussion but the writer hopes to take it up in some future publication.

[39] The principal references pertaining to this and each of the following silks are set forth in the chart, fig. 18, and the accompanying bibliography.

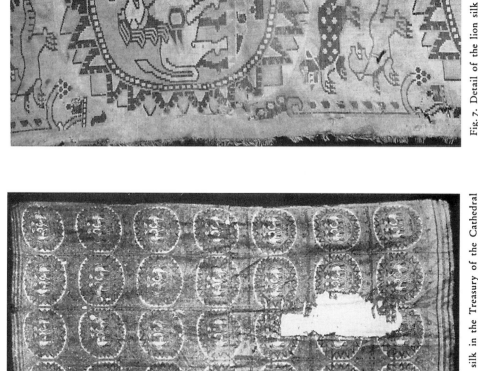

Fig. 7. Detail of the lion silk in the Victoria and Albert Museum, London.
Victoria and Albert Museum Crown copyright.

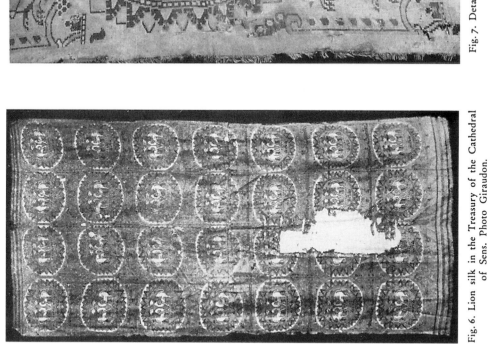

Fig. 6. Lion silk in the Treasury of the Cathedral
of Sens. Photo Giraudon.

Pelliot, respectively, from the walled up library in the caves at Ch'ien-fo-tung, near Tun-huang in Kansu in Eastern Turkestan, which Stein discovered in 1908[40]. The silks were sewn as ornamental borders or frames on manuscript-roll covers, which, unfortunately, provided no indication of a precise date. The contents of the library, according to Stein, included dated manuscripts from the 5th through the 10th centuries and the majority were of the 10th century. Stein believed, because of the fact that there were no manuscripts in the Tangut script, that the cave must have been walled up before the conquest of the region by the Tanguts in 1034. Beside providing a *terminus ante quem* these archeological factors give little help in dating the silks.

Lion silk, Brussels *(fig. 12).* According to Errera the two fragments came from the tombs, in the Münster at Bilsen, of St. Landrade who died between 680–90 and of St. Amour who died in the 9th century. According to von Falke, it would seem that in 1913 there was still a piece in Bilsen. The writer has not been able to confirm whether this still exists.

Lion silk in the Cathedral of Toul (not illus.). The writer has been unable to learn anything of the origin of these two fragments but we may presume they were also at one time with the relics of St. Amon.

Ram silk in the Collegiate Church of Notre Dame, Huy *(figs. 1, 13).* This silk and another, of later and unrelated type, were originally in two reliquaries which are known to have been made by Godfroid de Claire between 1170 and 1175. These châsses contained the relics of St. Mengold and St. Domitien. It is no longer sure with the relics of which of the two saints each silk was associated. But it is believed that the ram silk was originally with the relics of St. Domitien, Bishop of Tongres, who died in 560 A.D. and was elevated to sainthood in the time of Charlemange. His relics were translated, evidently into the new châsse, by Raoul de Zachringen, Bishop of Liége in 1173[41].

Ram silk from Ch'ien-fo-tung *(fig. 14).* Fragments of this silk are preserved in both the British Museum and in the Musée Guimet. The facts concerning their origin are the same as for the lion silk from the same source described above.

Rosette silk, Musée Diocésain, Liége *(figs. 15, 16).* This silk is from the shrine of St. Lambert, Bishop of Tongres, who was murdered at Liége in 705 A.D. After having been taken to Maastricht, his relics were returned to Liége in 718 A.D. where they became the center of an important cult. According to the ancient accounts a special mausoleum was built to house the relics and it was ornamented with gold, silver and jewels[42]. We can well imagine that the relics may have been wrapped in a precious silk such as this which was later found with them.

There are a number of technical features which link together the silks of Zandanījī I. The most obvious is the color combination in which dark blue is combined with several curious faded-tan or buff shades. All of the group exhibit this characteristic except two which are brightly colored: the ram silk from Ch'ien-fo-tung and the rosette silk in Liége. Careful examination revealed that the faded-tan shades were, in every case, four in number ranging from almost white to a dark golden tan; pink and green tones were sometimes faintly detectable. Fortunately, we have a clue to the original colors in the lion silk from Ch'ien-

[40] *Serindia, op. cit.,* pp. 791–1088.
[41] L. van der Essen, *Étude critique et littéraire sur les Vitae des saints mérovingiens de l'ancienne Belgique,* Paris-Louvaine, 1907, p. 168.
[42] Edouard de Moreau, *Histoire de l'Église en Belgique,* Bruxelles, 1940, p. 92 ff.

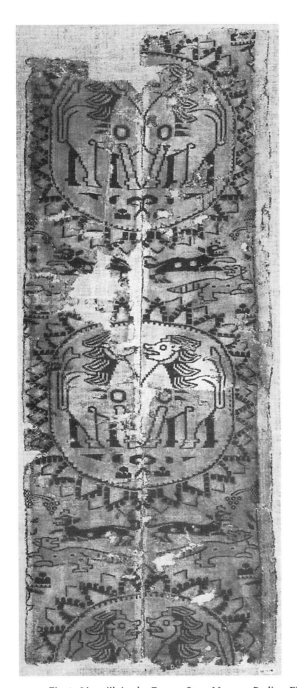
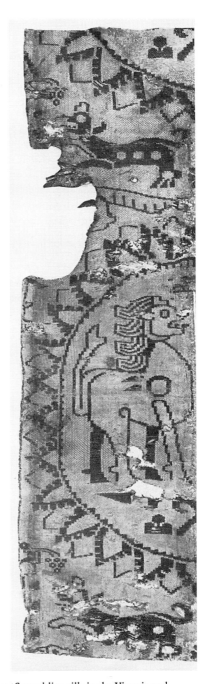

Fig. 8. Lion silk in the Former State Museum, Berlin. Fig. 9. Second lion silk in the Victoria and Albert Museum, London. Victoria and Albert Museum Crown copyright.

fo-tung which by and large shows the same faded colors as the rest. But, traces of the original color were still to be detected in small areas almost hidden in the seams and folds where the framents were joined to form the binding of the manuscript-roll cover. Andrews had observed these colors and accurately published them in his catalogue of the textiles in *Serindia*[43]. I had the good fortune to be on hand at the British Museum to assist in the remounting and cleaning of the Stein collection when it was decided that for the sake of science the lion silk should be removed from the roll cover which it ornamented so that it could be properly studied. When the strips were removed and laid flat there, in parts that had been previously covered, were revealed the brilliant colors in which the silk had no doubt originally been woven. The colors are dark green, changing in arbitrary bands to dark blue, a true chartreuse, bright rose-pink, orange and white! Careful examination and comparison of the others of the group with the British Museum lion silk leaves no doubt that they too originally had very nearly identical colors. The chart, *(fig. 17)*, sets forth the colors as they appear in the various silks and compares them with the British Museum silk.

A study of the chart reveals that not only were the same, or very nearly the same, colors used but that the color schemes were also, with minor exceptions, the same throughout. These will be seen, on the basis of the British Museum silk, to be the following: The ground outside the roundels pink; ground inside the roundels orange. Green (or dark blue) used throughout for the drawing and solidly for some details. White used for the lions and in

43 *Op. cit.*, II, p. 1049.

Ch'ien-fo-tung lions	Nancy lions	Sens lions	V & A 763.1893	Berlin 84.225
1. dark green to cobalt blue	1. dark blue-green	1. green-blue to cobalt blue	1. blue-green to cobalt blue	1. blue-green to cobalt blue to brown
2. white	2. shade of tan	2. ivory	2. shade of tan	2. ivory
3. pink	3. shade of tan	3. shade of tan	3. shade of tan	3. pinkish-tan
4. orange	4. shade of tan	4. shade of tan	4. shade of tan	4. yellowish-tan
5. chartreuse	5. apple green	5. chartreuse	5. light green	5. chartreuse

V & A 1746.1888	Brussels lions	Huy rams	Ch'ien-fo-tung rams	Liege rosettes
1. dark green to dark blue	1. blue-green to cobalt blue	1. green to blue-green	1. true green	1. dark blue
2. shade of tan	2. ivory	2. shade of tan	2. white	2. white
3. shade of tan	3. shade of tan	3. shade of tan	3. rose red	3. ivory
4. shade of tan	4. shade of tan	4. shade of tan	4. orange	4. orange-red
5. shade of tan	5. yellowish-tan	5. shade of tan	5. coral	

Fig. 17. Chart comparing colors of the Zandanī jī silks.

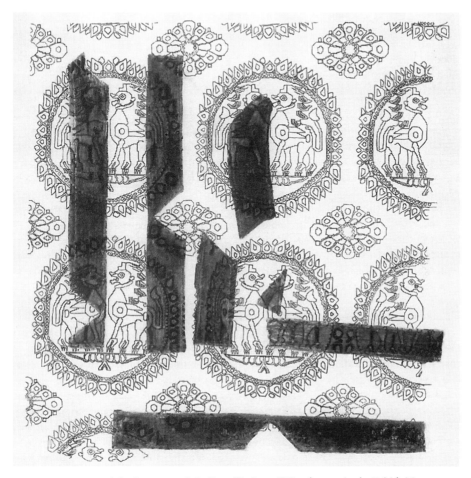
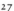

Fig. 10. Collage of the fragments of the lion silk from Ch'ien-fo-tung in the British Museum.

most instances (but not in B.M. silk) as a solid field against which the leaves of the roundel frame are set. The leafy frame utilizes dark blue and pink as solid areas and orange and white for outlines. Pink occurs in details on the lion's body and in the interstice motives. At the level of the lion's shoulder, cutting through exactly above the first lock of the mane, and in most cases extending upward for the width of the two middle locks of the mane, chartreuse or light green replaces the pink used elsewhere in the details. In the British Museum silk, for example, this strange interruption of the color provides two green locks of the mane, green teeth and »collar« and at the same level, the end of the tail is also green. It is interesting and extremely important as evidence of the unity of this group that this curious interruption of the pink by green can be recognized in every instance. In those silks with running animals between the roundels the lower animal is always represented in this same chartreuse or light green, which also interrupts the rest of the design on that level.

Perhaps one of the most interesting features with regard to the colors of these silks is the extreme tendency of all the dyes, but the dark blue, to fade. There are quantities of early textiles which have come from reliquaries and tombs and were certainly preserved under no better conditions than those of the Zandanījī group and, while many have surely faded to a degree, in no other group have the colors so completely disappeared from the threads as here. This fact would seem to indicate the use of some fugitive dye for which the weavers, or the dyers from whom they got their yarns, could not find an appropriate mordant. An important factor in this connection is the relationship of the colors of the Zandanījī group with the T'ang textiles from China. The chartreuse, orange and pink are most unusual among Western textiles of the early middle ages and do not exist among those generally attributed to Sasanian Persia or Byzantium, but they are extremely typical of many of the Chinese silks which Stein found at Ch'ien-fo-tung. These colors also occur among the Chinese silks which the writer has had the opportunity to examine from the Shosoin[44]. It is interesting to speculate that our weavers in Sogdiana not only got their silk yarns but also their dyes from the Chinese who perhaps withheld the secret of setting the dye, which they must have known, because these colors are always bright and fresh in the Chinese silks. Unfortunately until such a time as it is possible to have dye analyses made to determine the nature of the dye-stuffs and whether those of the Chinese and Sogdian silks are actually the same we cannot safely draw conclusions from this fact. This is an instance which points up the tremendous need for a systematic analysis and recording of colors and dye-stuffs of historic textiles — from which surely much is to be learned.

From the standpoint of the weave itself there is not a great deal to be said. The weave is the usual compound twill which characterizes the majority of early medieval silks of the Near East and Byzantium. It is more a question of the character and quality of the weave which unites the group. The binding warps in every case are a relatively coarse silk poil, twisted moderately to the right. The main warps are considerably coarser than the binding warps being composed, variously, of two or more poil threads, each about the same weight as the binding warp, also twisted right. The warps are arranged in the proportion of three, sometimes two, main warps to one binding warp. The wefts are very heavy tram[45] silk. It is the relative coarseness of the warps and wefts and the closeness of the weaving which imparts the thick, compact, heavy quality which characterizes these silks. It is, incidentally, this feature which provides one of the chief means of distinguishing between Zandanījī I and II.

The technical feature which distinguishes the group more decisively than any other is the peculiar character of the selvedges which are totally different than those known on any other textiles, including those of Zandanījī II. Normally, in the textiles of all periods, the selvedge is formed by the turning back of the wefts around the outer warp, or groups of warps, and it is frequently reinforced by the use of one or more heavy cords formed either by bundles of the warps or sometimes by heavy cords of hemp, linen or some other material not serving as the warp of the rest of the fabric. The selvedge warps are interwoven with the wefts, frequently with a different binding than in the rest of the fabric. The purpose of the selvedge is to form a strong rigid edge which will help

[44] The Cleveland Museum of Art was fortunate in acquiring an album with fifty-eight small fragments of silks from this important Japanese repository. Cf. *Bulletin of the Cleveland Museum of Art* (June, 1955).

[45] Technical terms used throughout are in accordance with terminology tentatively agreed upon by Centre International d'Étude des Textiles Anciens and soon to be distributed to CIETA members.

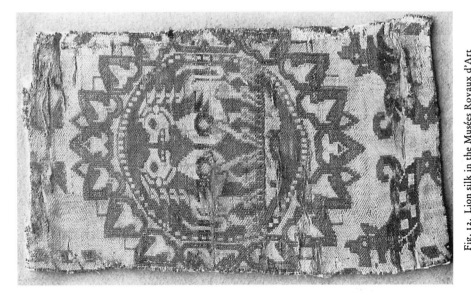

Fig. 12. Lion silk in the Musées Royaux d'Art
et d'Histoire, Bruxelles.
Copyright A.C.L. Bruxelles.

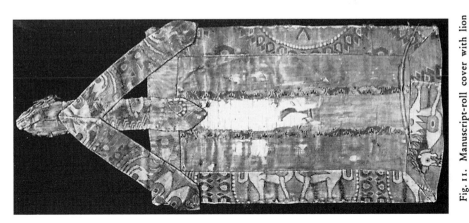

Fig. 11. Manuscript-roll cover with lion
silk from Ch'ien-fo-tung, in the Musée
Guinet, Paris.

D. G. Shepherd and W. B. Henning

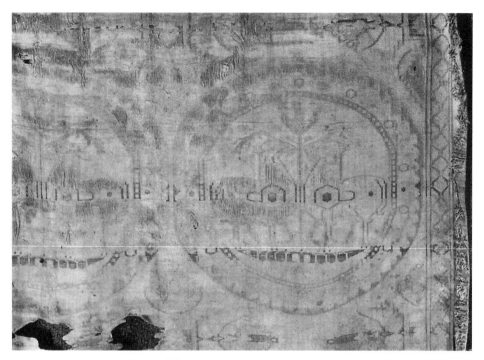

Fig. 13. Detail of the ram silk in Huy. Copyright A.C.L. Bruxelles.

the fabric keep in shape both during and after weaving. In this group the selvedge is very different. Of the eleven silks of Zandanījī I, seven have selvedges; the best and most complete examples are on the silk at Huy, the Ste. Colombe silk at Sens and the St. Lambert silk at Liége. In all of these the wefts are left to form a long shaggy fringe at either side of the fabric. Before forming the fringe the wefts of the face all go over, and the wefts of the reverse all go under, one rather heavy warp; then all of the wefts in each pass are brought together as one and alternately cross over and under, as in tabby construction, two fine outer warps. Originally we may suppose that some sort of heavy outer cord around which the wefts turned must have existed and that this cord was cut off when the textile was removed from the loom. Such a cord would have been necessary to strengthen and control the tension of the wefts during weaving. In several of the silks with preserved selvedges this fringe has been trimmed off possibly by the weaver or, more likely, by some subsequent owner but otherwise these selvedges exhibit the same characteristics as the more complete ones. This is such a unique technical feature that it alone should be sufficient to guarantee the unity of the group.

It is unusual among early medieval textiles to have so many complete, or nearly complete, loom pieces as there are in Zandanījī I. This enables us to know more about the weaving methods and equipment which was used than is generally possible when only fragments are known. From the widths of the tree pieces in Sens, Huy and Liége, 1.16 m., 1.22 m. and 1.18 m. respectively, we can judge the width of the loom. The finished piece in Sens measures 2.415 m. long; the Huy piece which is incomplete in its length is 1.915 m.

long and the Liége silk is 1.9c m. long. The measurements would seem to indicate that a normal loom piece was about two meters to two and a half meters long. From the regularity with which the designs are repeated we can be sure that a drawloom was used. But it is clear that the drawloom was not fully developed such as the drawloom used in the later middle ages and on into the 18th century. An examination of the Sens silk, for example, reveals that the diameter of the circles across each row varies from a maximum of 28.7 cm. to a minimum of 24.3 cm. M. Félix Guicherd, former Director of the École de Tissage, Lyon, who has made a mise en carte from this textile and actually reproduced it at the School assures me that there are the same number of warps used in each repeat and he explains the difference as resulting from the fact that the loom was not equipped with a reed to evenly space the warps. An examination of the vertical repeat of the Sens silk also reveals certain discrepancies in the design from one repeat to the next. This can easily be seen in the illustration *(fig. 5)*, where the scale of the lions (not e.g., the size of the disc above the front legs) is different in the upper and lower motives. M. Guicherd[46] explains this as resulting from the fact that the loom was not fitted with a system of lashes and simples to mechanically control the entire repeat but that the cords had to be selected individually for each line of the repeat as the weaving proceeded. This allowed for errors and changes in the pattern from one repeat to the next. It was due to this method of weaving that the elaborate borders on the Huy, Liége, and Nancy silks were possible. Similar discrepancies occur in the repeats of the Huy and Liége silk and can also be traced, though to

[46] »Le Tissu aux Griffons du Monastier-sur-Gazeilles,« *Bulletin de Liaison du Centre International d'Étude des Textiles Anciens,* Lyon, January, 1958, p. 43.

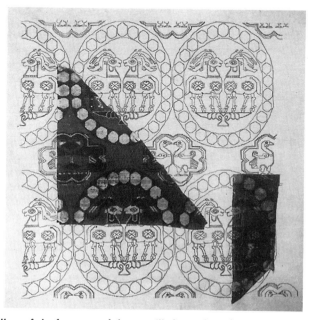

Fig. 14. Collage of the fragments of the ram silk from Ch'ien-fo-tung in British Museum.

a lesser degree, in some of the incomplete fragments, notably the lions of Ch'ien-fo-tung and the Berlin lion silk. We may be sure that all were woven on the same type of loom.

Thanks to the good fortune of having complete loom pieces among the Zandanījī textiles, we know the character of the total design concept; this is rare, indeed, among early medieval textiles which are generally known only through fragments. From the three complete pieces we see that the total design was one of repeated rows of roundels framed above and below, and sometimes also on the two sides, by ornamental borders. In the St. Lambert silk all four borders exist; certainly there were originally four on the Huy silk but the upper one has been removed[47]. The Ste. Colombe silk had only borders at the top and bottom. The Nancy silk preserves only the left border[48] which, we can be certain, was repeated on the right side and most probably there were also borders at top and bottom.

From the standpoint of the individual elements of the designs there is an interrelationship from one end to the other of Zandanījī I which spills over into Zandanījī II. Alone, the similarity between the pairs of confronted winged-lions which occurs on eight of the eleven silks can leave little doubt as to the common origin of at least these eight silks, which have nevertheless been mercilessly separated by other writers as will be seen by an examination of the chart, *fig. 18*. The leafy frames on these same eight silks, are likewise clearly dependent upon a common source. The tree motives which separate the lions are similarly related, the most elegant and elaborate is on the Nancy silk. The palmettes, however, on which all of the lion pairs stand, are clearly a simplified rendering of the beautiful flowering branches beneath the Nancy lions; intermediary stages of the modification of this motive no doubt once existed. The two Victoria and Albert Museum silks preserve only »shorthand« indications of the tree separating the lions; in the others this tree is omitted altogether. The beautiful bell flowers which grow from the branches beneath the feet of the lions and from the trees in the interspaces in the Nancy silk are not present in the other lion silks but they occur again in the borders of the Liége silk and they will be found frequently in the silks of Zandanījī II. The elaborate tree in the interstices of the Nancy silk are similarly reduced to simplified forms on the majority of the other lion silks and omitted altogether on the Ch'ien-fo-tung piece. The leaves, which grow on delicate branches springing from the stem of the Nancy tree, are reduced to mere detached »spots« on the others. The triangular clusters of fruit which hang from the Nancy palm are transferred to the trees in the interspaces in several of the other silks. The pairs of running animals which occur in seven of the eleven silks are unquestionably part of a common tradition. Although these animals have been variously described as dogs and lions, they surely were intended to represent a fox and a leopard. The fox is indicated by its bushy tail and the leopard by its feline tail and spots. It is important to note that although the two animals undergo a considerable transformation from the Nancy silk to the impoverished little creatures on the Brussels silk, these characteristics are never lost sight of. Such minor details, so easily open to misinterpretation or willful change, offer in themselves conclusive proof, in my opinion, that the silks in which they occur must have been woven in the same center. One of the most fascinating, and perhaps most significant, motives is the curious little device, which looks

[47] The writer wishes to express sincere thanks to Dr. Paul Coremans for his kind assistance in arranging to have the photographs of the Huy silk especially made. Without them publication of this article would not have been possible.

[48] This not shown in fig. 4, but can be seen in A. Prisse d'Avennes, *L'Art Arab*, Paris, 1897, vol. III, pl. 147.

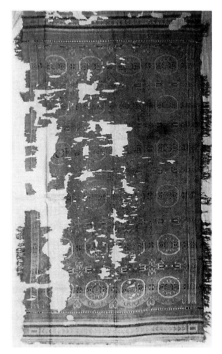

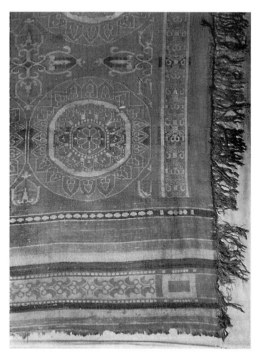

Fig. 15. Rosette silk in the Musée Diocésain, Liége. Copyright A.C.L. Bruxelles.

Fig. 16. Detail of Rosette silk in Liége. Copyright A.C.L. Bruxelles.

like a collar-button, that stands on either side of the base of the tree in the interspaces of the Nancy silk and at the base of the palmettes within the roundels of several other of the silks. Von Falke[49] identified this motive, which he called a »triple rounded hill« as a representation of ground; which may, I believe, be regarded as a symbol of land-scape. He has discussed this rather fully and convincingly and gives illustrations of the same motive on Sasanian silver; it is, therefore, not necessary to repeat his arguments here. However, it may be added that Zandanījī silks are not the only textiles where this motif occurs, but other textiles, perhaps actually Sasanian, have the same motive used in the same way[50].

The three silks which show the greatest deviation from the lion group, which may perhaps be considered the norm of Zandanījī I, are the Huy silk, the ram silk from Ch'ien-fo-tung and the Liége silk with rosettes. It is not possible to discuss here the relationship between the silks of Zandanījī I and II but it can be stated briefly that these three have design elements common to both groups and that, from a design standpoint, they may be regarded as transitional between them. But, as they are related from a technical point of view with Zandanījī I they must be considered as belonging to that group rather than to the later one. The design elements which compare with Zandanījī I are the ornamental borders on the

[49] *Op. cit.*, p. 100.
[50] Lamm, *op. cit.*, fig. 19, and Lessing, *op. cit.*, pl. 24a.

Huy and Liége silks that relate to the border of the Nancy silk. The Huy and British Museum ram silks preserve the palmette base for the pairs of animals, and in the Huy piece there is also the rudimentary tree between the animals. It is extremely important to note that the Huy animals described, and reproduced in a drawing, by von Falke as »lambs«, have exactly the same long horns and in fact, except for a variation in the ornament on the bodies, are identical, even to the same curious ornament on the neck, with the rams in the silk from Ch'ien-fo-tung. The roundel frame on the Huy silk preserves the inner pearl border common in the lion silks but replaces the leaves with another and larger band of pearls separated from the first by a band with a more widely spaced pearl motive. The frame of large pearls in the British Museum ram silk heralds the pearl frame which will be common in Zandanījī II. The interstice motive in the Huy silk consists of four flower motives which grow out from a common center to fill the four angles of the interstice. These flowers are clearly derived from the bud of the bell flower which alternates with the open flowers on the branch beneath the feet of the Nancy lions. The same motive, a little more simplified, is to be seen in the Liége silk. Of the three, the Liége textile has departed farthest from tradition in design and color. However, the ornamental borders, the remnant of the leaf frame around the center rosette, the bell flower in the borders and the bell-flower bud of the interstice motive assure its belonging to the group, as does its technique.

In studying the silks of Zandanījī I from a stylistic point of view one is constantly aware of the relation of the designs with those in the Sasanian art of Persia. Von Falke has pointed out the frequent occurrence of the little landscape symbol on Sasanian silver and on textiles which may be Sasanian. The bell flower, likewise, is common on Sasanian silver[51] and it occurs on sculpture[52] as indeed does the whole concept of the plant motive on which these flowers grow. It is found used and reused on the silks of Zandanījī I and II and on others which are generally agreed to be Sasanian. One motive which occurs only on the Nancy silk of the Zandanījī group is the little tree form which grows above the back of the lions. The presence of this motive is not easy to explain. It may simply be the artist's effort to fill a left over space in compliance with ancient Near Eastern distaste for empty space; or, on the other hand, it may be another stylized rendering of landscape similar to that of the little three-lobed hill. In a Sasanian silver plate in the Hermitage[53], there is a single plant growing behind the tiger and filling the space above and below which actually serves both of these purposes and may well show a precedent for the motive on the silk. Kendrick[54] seeing a relationship with this motive and a similar theme on the great Imperial Byzantine silks at Siegburg and Düsseldorf[55] was led to seek a center for the production of the silks to the west rather than the east of Persia as von Falke had done. The relationship between these motives cannot be denied, but there is nothing to indicate a Byzantine priority for it. On the contrary, there is evidence that this motiv traveled westward to Byzantium very likely from the same source from which it had traveled eastward to Sogdiana, i.e., from Sasanian Persia.

Although Sasanian influence has been stressed in their designs, the Zandanījī silks can by no means be considered as representing true Sasanian style. The drawing is too stiff; it is less

51 J. Orbeli and C. Trever, *Orfèvrerie Sasanide*, Leningrad, 1935, pl. 48.
52 Ernst Herzfeld, *Am Tor von Asien*, Berlin, 1920, pls. LVII, LX.
53 Orbeli, *op. cit.*, pl. 27.
54 »The Persian Exhibition, III — Textiles a General Survey,« *Burlington Magazine*, 58 (1931), p. 21.
55 J. Lessing, *Die Gewebesammlung des Kgl. Kunstgewerbemuseums*, Berlin, 1913, pls. 62—64.

refined and the repetitive character of not only the main motives but many of the ornamental details is suggestive of a provincial center, which having borrowed from the more important centers to the west continued to do the same thing over and over, perhaps for a very long period. As a matter of fact, the principal motives, the pairs of stiff, striding lions, are not at all Sasanian in character but seem to hark back to even more ancient Persian sources such as the great Achaemenid winged lions at Susa[56]. Unfortunately, in studying these Sogdian textiles we are hampered by having almost no other Sogdian material for comparison. The recent Russian publications of the paintings at Pyandzhikent and the textiles from the castle at Mount Mugh provide us with our only comparative material. Although the paintings at Pyandzhikent do not represent textiles like those in the Zandanījī group they do show a number with strong Sasanian influence. There is also obvious Sasanian influence in many other details of the ornament, in costumes, etc. thus confirming – as one would well expect – the importance of Sasanian influence in Sogdiana at this period. Even though Sogdiana did not come under the direct political control of the Sasanian kings, the role of these people as merchants who provided the principal link in Persian trade with the Far East and the fact that they were closely allied ethnically and linguistically with the Persians, would have naturally brought them under the cultural influence of this powerful kingdom on their western border. Miss Vinokurova in her study of the textiles from Mount Mugh expresses the belief that one group of the silks had been imported from Iran while another group was actually woven locally. As the silks are not illustrated in her work, one cannot safely draw conclusions regarding them, but on the basis of the evidence of the Zandanījī silks one might venture to guess that her »Iranian« group may also have been of local manufacture.

As to the date of the Zandanījī silks, our point of departure is the inscription of the Huy silk. If we accept this evidence as providing an approximate date at the end of the 7th century for the Huy silk, what can be said for the others? In the discussion above it was indicated that the Huy silk showed characteristics which set it apart from the main body of the Zandanījī I group and which seemed to be transitional between it and the silks of Zandanījī II. There is also, as is obvious in the accompanying illustrations, a great difference in the quality of design and drawing from one silk to another throughout the group. As always in such matters, one cannot be certain whether such differences are due to differences in date or simply to differences in the ability of the designers and weavers. In every way, in scale, in elegance and elaborateness of design, quality of draftsmanship and weaving, the Nancy silk stands out as the masterpiece of the group. The various elements of the design, particularly the elegant flowering tree in the interstices and the flowering branch beneath the lions are closer to the Sasanian prototypes than those in the rest of the group. One cannot but feel that this silk is actually earlier than the rest and that it is not just a matter of superior workmanship. It is difficult to judge how long an evolution of this type would have required, but, we might be permitted to guess a hundred years and thus place the Nancy silk at the beginning of the 7th century, with the transitional group at the end; and the rest, as well as probably lost intermediary stages, would belong in between. The Nancy silk would then be contemporary with the Sasanian period, the others would belong perhaps to the years just prior to the Muhammedan conquest, which did not take place in Sogdiana until the beginning of the 8th century.

[56] A. U. Pope, *Survey of Persian Art*, New York, 1939, IV, pl. 77.

D. G. Shepherd and W. B. Henning

	NANCY	SENS	V & A 763–1893	BERLIN 84.225	V & A 1746.1888
Prisse d'Aven-nes, 1897	Arab	Italian copy			
Chartraire, 1897		Inspired by Persian type	Byzantine		
Fischbach, n. d.				Orient, 10th C.	
Chartraire, 1911	"Arab"	Persian/Byz. copy of Persian	Byzantine 10th–11th C.		
Lessing, 1913				Orient, 10th C.	
Falke, 1913	East-Iran, 7th C.	East-Iran, 8th–9th C.	East-Iran, 8th–9th C.	East-Iran, 8th–9th C.	East-Iran, 8th–9th C.
Lethaby, 1913	Saracenic	Sasanian/ Byz. copy of Sasanian	Sasanian/ Byz. copy of Sasanian		
Riefstahl, 1916			Persian, 8th–9th C.		
Stein, 1921		Sogdiana	Sogdiana		
Kendrick, 1925	Hither Asia, 10th C.	Hither Asia, 9th–10th C.	Hither Asia, 9th–10th C.	Hither Asia, 9th–10th C.	Hither Asia, 9th–10th C.
Flemming, 1927	East-Iran, 8th–9th C.			East-Iran, 8th–9th C.	
Errera, 1927					
Migeon, 1927	Persia, 10th–11th C.	East Persia, 10th–11th C.		East-Persia, 10th–11th C.	
Migeon, 1929	W. Persia/ Mesop. 8th–10th C.				
Schmidt, 1930	N. E. Persia, 7th C.	N. E. Persia, 8th–9th C.	E. Persia, 8th–9th C.	N. E. Persia, 8th–9th C.	
d'Hennezel, 1930	Musulman	Byzantine			
Duthuit & Volbach, 1933	Byzantium, 7th–8th C.				
Sabbe, 1935	Arab, 8th–9th C.	Turkestan, 9th C.			
Serra, 1938			Orient, 7th–8th C.		
Peirce & Tyler, 1941	Byzantine				

Fig. 18. Chart showing previous attributions for the silks of Zandanījī I. Cf. full bibliography p. 38.

	BRUSSELs	CH'IEN-FO-TUNG (lions)	HUY	CH'IEN-FO-TUNG (rams)	LIEGE
Prisse d'Avennes, 1897					
Chartraire, 1897					
Fischbach, n. d.					
Chartraire, 1911		Persian			
Lessing, 1913					Orient, or Byz. 8th–10th C.
Falke, 1913	East-Iran, 8th–9th C.	East-Iran, 8th–9th C.	East-Iran, 8th–9th C.	East-Iran, 8th–9th C.	East-Iran, 8th–9th C.
Lethaby, 1913		Sasanian			
Riefstahl, 1916					
Stein, 1921		Sogdiana		Sogdiana	
Kendrick, 1925	Hither Asia, 9th–10th C.	Hither Asia, 9th–10th C.	Hither Asia, 9th–10th C.	Hither Asia, 9th–10th C	
Flemming, 1927			East-Iran, 8th–9th C.		
Errera, 1927	Byzantine, 9th C.				
Migeon, 1927			East Persia, 10th–11th C.		
Migeon, 1929					
Schmidt, 1930	N.E. Persia, 8th–9th C.	N.E. Persia, 8th–9th C.	West-Iran, 7th C.	Persia, 7th C.	Sasanian/ Byz.
d'Hennezel, 1930					
Duthuit & Volbach, 1933					
Sabbe, 1935					
Serra, 1938					
Peirce & Tyler, 1941					

D. G. Shepherd and W. B. Henning

Bibliography for Chart, fig. 18:

E. Chartraire, *Inventaire du Trésor de l'Église Primatiale et Métropolitaine de Sens,* Paris, 1897, no. 13, p. 15.

E. Chartraire, »Les Tissus anciens du trésor de la Cathédral de Sens,« *Revue de l'Art Chretien,* LXI (1911), pp. 372–6, figs. p. 374 and op. p. 374.

M. Dreger, *Künstlerische Entwicklung der Weberei und Stickerei,* Wien, 1904, pl. 88 b.

George Duthuit and F. Volbach, *Art Byzantin,* Paris, 1933, p. 78, pl. 99.

Isabelle Errera, *Catalogue d'étoffes anciennes et modernes,* Brussels, 1927, no. 4.

Otto von Falke, *Kunstgeschichte der Seidenweberei,* Berlin, 1913, I pp. 98–101, figs. 138, 140, 141.

F. Fischbach, *Die wichtigsten Webe-Ornamente bis zum XIX. Jahrhundert,* Wiesbaden, n. d., pl. 172 a.

Ernst Flemming, *Das Textilwerk,* Berlin, 1927, pl. 22.

Henri d'Hennezel, *Pour comprendre les Tissus d'art,* Paris, 1930, figs. 39 and 46.

A. F. Kendrick, Victoria and Albert Museum, *Catalogue of Early Medieval Woven Fabrics,* London, 1925, pp. 19–23, 26, pl. IV.

J. Lessing, *Die Gewebesammlung des K. Kunstgewerbemuseums,* Berlin, 1913, pls. 25 and 32 b.

W. R. Lethaby, »Byzantine Silks in London Museums,« *Burlington Magazine,* 24 (1913), pp. 185–6.

Gaston Migeon, *Manuel d'Art Musulman,* Paris, 1927, II, pp. 290–94, fig. 411.

Gaston Migeon, *Les Arts du Tissu,* Paris, 1929, fig. p. 47.

D. José Pascó, *Catalogue de la Collection de Tissus anciens de D. Francisco Miquel y Badia,* Barcelona, 1900, no. 14, pl. XXVII.

Hayford Peirce and R. Tyler, *Three Byzantine Works of Art,* Cambridge, 1941, p. 19.

A. Prisse d'Avennes, *L'Art Arabe,* Paris, 1897, I, pp. 230–1; III, pl. 147.

R. Meyer-Riefstahl, »Early Textiles in the Cooper Union Collection,« *Art in America,* III (1915), p. 253, fig. 4.

C. Rohault de Fleury, *La Messe,* VII, Paris, 1888, pl. 179.

E. Sabbe, »L'Importation des Tissus Orienteaux,« *Revue Belge de philogie et d'histoire,* XIV (1935), pp. 838–9.

H. Schmidt, »Persian Silks of the Early Middle Ages,« *Burlington Magazine,* 57 (1930), pp. 289–90, pl. ID.

Luigi Serra, *L'Antico Tessuto d'Arte Italiano,* Rome, 1937, p. 23, pl. 4.

Mark Aurel Stein, *Serindia,* Oxford, 1921, II, pp. 907–9, 939, 1049–50; IV, pls. CVI, CXI, CXV, CXVI.

APPENDIX

Writing on a woven surface is as difficult to read as a reproduction made with too wide a screen; the most common words may then assume a strange guise and become unrecognizable. One may assume that what the scribe of these two lines wanted to write was this: —

The uncertainty is greater in the first line than in the second.

The last letters of the second line prove without doubt that the writing is Sogdian. Their forms – evidently – *sδh* – are so characteristic that we may resolutely set aside the doubt caused by a letter in the first line (last but two), which at first sight looks like a Parthian *š*, i.e. ; it will be merely a somewhat distorted Sogdian *t* (i.e.). Since Sogdian writing was adopted unchanged by Turks (Uigurs, etc.), one has to consider whether the language might be Turkish; but as – *sδh* (–*sdh*) is an unlikely, virtually impossible, word-ending in that language, we may discard that alternative and assume that the language of this inscription will be Sogdian, or at any rate a variety of Sogdian.

On this assumption one could tentatively read as follows: –

Except for the last word (which might be β'sδh or even n'sδh) meanings can be suggested, again quite tentatively: »Long 61 spans, Zandanīčī..............« Perhaps the last word meant »cloth« or some special kind of it. Some remarks are necessary on the various words: –

(1) βrz, which may be 'long' or perhaps 'length', deviates a little from the standard Sogdian forms, which are βrz'k, Chr. brzy 'long' and βrzkw/βrzwk – 'length'.

(2) The thrice repeated sign for '20' does not agree with the normal Sogdian sign (𝟮), but agrees well with its ancestral form, which is still found in the Sogdian 'Ancient Letters' dating from the beginning of the 4th century, viz. 𝟯 (which in its turn still strongly resembles the Old Aramaic form).

(3) *wytšp* may confidently be assumed to be a measure of length, therefore presumably a word continuing Avestan *vītasti* 'span'. Now this word again does not occur in Sogdian (as far as is known – at present), which possesses a different word for 'span', viz. *wyδ't* – [57]. Nevertheless, it should be noted that, from the point of view of language history, *wytšp* could well constitute the correct Sogdian development of Old Iranian **witasti*, with the palatalization of –s– by following –i– and the dissimilation of –st– into –sp– (or–*št*– into –*šp*), which incidentally happens to occur in this very word in another Iranian language (Balōčī *gidisp* 'span').

(4) *znδn'k-čy* is an ordinary adjective of relation (ending –*čy*) derived from *znδn'k*. In Sogdian this word would have been pronounced as *zanδane* (earlier as *zanδané*) and *znδn'kčy* as *zanδanečī*. There is no doubt that this (provided the reading is correct) is the stuff زنديجى *zandanīčī* familiar from Muslim authors, described as a rather coarse textile resembling canvas. Zandanīčī, in Arabic and also older Persian manuscripts usually spelt زنديجى (zandanījī), is derived, as Yākūt correctly stated, from زندنه *Zandane*, a village four leagues distant from Bukhara. Our inscription, however, indicates that the correct forms were زندنه and زلديجى. The principal passages were given by Mirza Muhammad Qazvini in the Persian preface to his edition of Juwainī, vol. II, p. xiii sq. A further interesting passage, apart from *Siyāsat-nāme* (95⁸ ed. Schefer)[58] occurs in the Khwarezmian law-book *Qunyatu 'l-Munyah*, of which I have some extracts thanks to the kindness of Prof. Zeki Velidi Togan. The present passage (No. 276a), as far as it is available at the moment, runs as follows: –

اشترى زلديجيّات ببخارا على أن كُلّ واخد لها سما سنّة عشر ذراعاً

..... فالزلديجى البخارىّ مع الخوارزىّ جنسان

»(Someone) bought Zandanījī pieces in Bukhara on the understanding that each piece should be 16 cubits (in length)...... the Zandanījī of Bukhara and Khwarezm are two different kinds.....«

⁵⁷ Cf. *Journal of the Royal Asiatic Society*, (1942), p. 236, no. 4.
⁵⁸ Discussed by Barthold, op. cit., p. 227.

From this one learns that the standard length of a roll of Zandanījī cloth was 16 δirāʿ in its country of origin, while according to our inscription it was 61 spans. Unfortunately we do not know the relation of the Muslimic δirā to the indigenous *witašp* (at least I do not), and it would perhaps be rash to infer it from our inscription, since the reading of the figures is not sufficiently certain and may have to be emended.

To conclude, the style of writing strongly resembles that of the documents found on Mount Mugh, which belong to the beginning of the 8th century, but if anything is older rather than later. The language appears to deviate, though slightly, from standard Sogdian, i.e. Samarkandian. A notable difference lies in the antiquated form of the numeric signs. Allowing ourselves to be guided by the hint given by *znδn'k-čy* we shall hardly go wrong if we attribute the inscription to 7th century Bukhara.

THE THRONE AND BANQUET HALL
OF KHIRBAT AL-MAFJAR

Richard Ettinghausen

The third type of cultural interaction, that of integration, presupposes, as we have noted, a more profound and more far reaching process, one in which the components of the cultures involved are more evenly matched. The monument with which we shall demonstrate this dynamic type of encounter is the so-called "Bath Hall" of Khirbat al-Mafjar within a large complex near Jericho (Fig. A). It was built in the period of the Umayyad Caliph Hisham (724-743) as the first unit of a spacious compound that also included a large two-story palace, a fair-sized mosque, and a forecourt with a pavilion in a pool (Fig. B).[1]

Two basic facts about this structure should be clarified at the outset. The first is the historical situation in which it was built. In this period the new Arab overlords could readily combine artistic features of both Classical and Iranian origins. Through conquest they had gained complete control over Byzantine Palestine and Syria, and through annihilation of the independent Sasanian dynasty they had fallen heir to all of Iran and its cultural traditions. Although there had been artistic interplay even during the time when Byzantium and Sasanian Iran were opposing each other, the process could proceed at a much accelerated pace when both civilizations were brought together under the same ruler who in view of this novel situation "employed workmen from all quarters" (Severus ibn al-Muqaffaʿ). The second consideration is the purpose of this building, and it is at this point that current conceptions have obscured proper interpretation. It is therefore necessary to establish first the ideas that motivated the lord of this elaborate structure when he had it built. Happily, its forms and decoration are specific enough to provide the basic clues.

According to the current explanation, the large hall with its stately porch, sixteen massive pillars, eleven exedrae and an elaborate decorative scheme involving no fewer than thirty-eight different mosaic carpets, rich stucco and stone work, and wall paintings, was a "frigidarium combined with vestiary and reception room" or "frigidarium-apodyterium."[2] It has thus been thought to have formed an essential part of the specific bath establishment attached

[1] The basic publication is R. W. Hamilton, *Khirbat al Mafjar. An Arabian Mansion in the Jordan Valley*. With a contribution by Oleg Grabar. Oxford, 1959. Other general presentations are Oleg Grabar, "The Umayyad Palace at Khirbat al-Mafjar," *Archaeology*, vol. 8, 1955, pp. 228-235; D. C. Baramki, *Guide to the Umayyad Palace at Khirbat al-Mafjar*. Amman, 1956; K. A. C. Creswell, *Early Muslim Architecture. Umayyads. A.D. 622-750*. Second edition. Oxford, 1969, vol. 1, part 2, pp. 561-576 (with complete bibliography). A later, more specific publication is R. W. Hamilton, "Who built Khirbat al Mafjar?" *Levant*, vol. 1, 1969, pp. 61-67.

[2] Hamilton, *Khirbat al Mafjar*, p. 47.

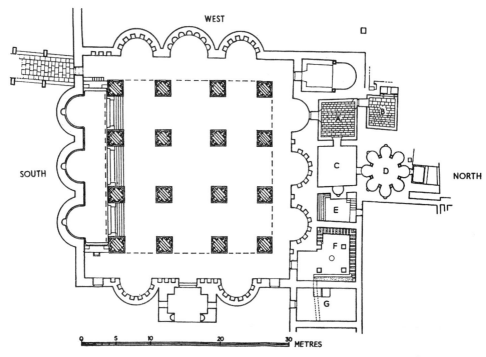

Fig. A. Khirbat al-Mafjar, Plan of the "Bath Hall" (After Hamilton, drawing by G. U. Spencer Corbett, slightly modified to indicate the core building resting on 16 pillars outlined by a broken line, and the surrounding lower ambulatory).

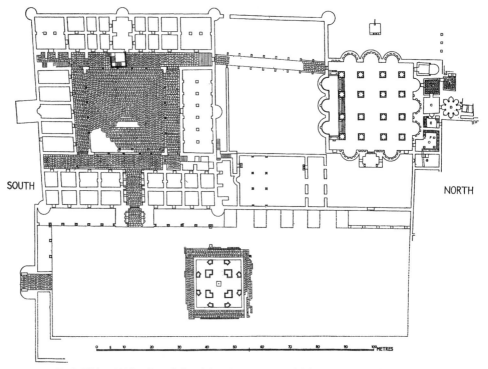

Fig. B. Khirbat al-Mafjar, General Plan of the Palace, Mosque, "Bath" (in the Northwest Corner) and Forecourt. (After Hamilton, drawing by G. U. Spencer Corbett).

to it on the north side. In the latter, besides the "Diwan" or private reception room in the northwest corner and extensive latrines at the other end (F), there were a waiting room or vestiary (A) with benches on all four walls, which may have been more specifically the apodyterium, a smaller water-proofed room with two tanks (B), which may have been the frigidarium, and two heated rooms (C and D), which were the more temperate and the hotter caldaria respectively. Even certain architectural details of the "Bath Hall" have been explained in conformity with this interpretation: for instance, the niches along the walls are presumed to have held the bathers' clothes.[1] Other scholars have accepted this general hypothesis,[2] or (following J. Sauvaget's earlier explanation of the large halls at Qusayr 'Amra and Hammam as-Sarakh)[3] they have regarded the big pillared unit as the room where the users of the hammam rested after the hours spent in the bathing establishment.[4]

In addition to this interpretation of the function of Khirbat al-Mafjar, there has also been a kind of moral evaluation, based on the lavish, even luxurious aspect of the building. More specifically, the domed room in the entrance porch contained numerous male and female figures with bare chests, which have suggested either athletic activities or love-making. Certain elements in the decoration have also been construed as reflecting an eccentric, even whimsical personality (Fig. E and Fig. 60). A long, shallow plunge pool contained by a barrier with steps on the south side of the interior was judged in the same fashion. According to the *Kitab al-Aghani*, it was thought to have been used by the presumed owner of the mansion, Walid ibn Yazid, the heir-presumptive of the Caliph Hisham, as the locale for revelry. Wine was served by beautiful boys and girls while the prince listened to songs. After the performance he would jump stark naked into the basin which was filled with water or wine.[5] In the same vein, it has been hypothesized that the second of the tanks in the frigidarium on the north side was meant to contain wine.[6] Finally, a less specific but more suggestive explanation of the Diwan is that its use was conditioned by "his personal or private status,"[7] which an

[1] *Loc. cit.*, p. 50.

[2] Grabar, *op. cit.*, p. 231 (apodyterium), Creswell, *op. cit.*, pp. 562-570 (frigidarium).

[3] Jean Sauvaget, *La Mosquée omeyyade de Médine*. Paris 1947, p. 126.

[4] D. et J. Sourdel, *La Civilisation de l'Islam classique*. Paris 1968, fig. 40: la grande salle de repos du bain omayyade de Khirbat al-Mafjar. In the caption the hall is also called "salle de reception et de deshabillage à l'imitation de l'apodyterium des thermes antiques." This idea was first expressed in general terms by G. Lankester Harding (*The Antiquities of Jordan*. London, 1959, p. 181) where the "Hall" is called "a special retiring room." The one exception to the usual interpretation of the "Bath Hall" is to be found in R. A. Jairazbhoi's review of Hamilton's book (*Journal of the Royal Asiatic Society*, 1960, p. 73)

where out of general historical considerations, he suggests a secondary use as a "banqueting hall." With this view this writer fully agrees as it is indicated by specific architectural features (see below pp. 60-62) although there is still another, primary purpose which has apparently so far escaped detection (see pp. 21-39).

[5] The pertinent passages from the *Kitab al-Aghani* are quoted by Alois Musil, *Kuṣejr 'Amra*. Wien, 1907, vol. 1, p. 159; Hamilton, *op. cit.*, p. 104; *idem*, "Who built...?" pp. 65-67.

[6] Hamilton, *op. cit.* p. 67, fig. 4.

[7] Hamilton assumed that the Diwan had an official or ceremonial character and he saw in it "an audience room, perhaps even a throne room" (*Khirbat al Mafjar*, pp. 63-64, 103).

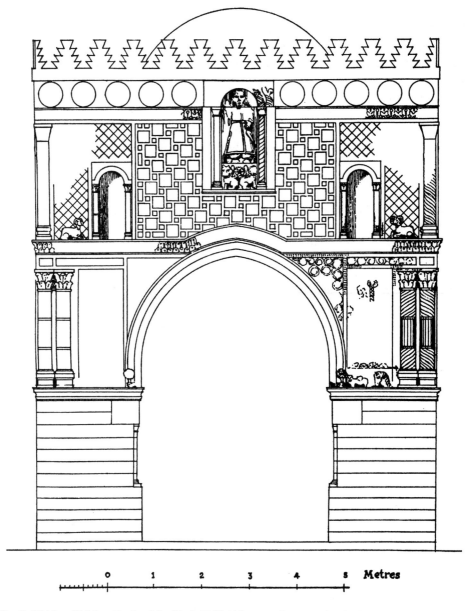

Fig. C. Khirbat al-Mafjar, Porch of the "Bath Hall" (After Hamilton, drawing by G. U. Spencer Corbett).

unofficial but nevertheless often heard explanation has associated with orgiastic scenes. The "Bath Hall" has thus been quite officially called "Frivolity Hall."[1]

Scholars are generally aware of the two cultural strains apparent in the mansion as a whole and the "Bath Hall" in particular. It has been pointed out that the various Sasanian features—a statue of a caliph in Persian costume, stepped crenellations over the entrance porch (Fig. C), the four winged horses in the Diwan (Fig. D), and the extensive stucco reliefs—were combined with elements strongly inspired by Classical tradition, especially the floor mosaics, including the splendid scene of a lion and gazelles under a tree in the apse of the Diwan (Fig. 58). But this assumption of a rather general non-programmatic decoration—which has been called "a desert of meaningless ornament"[2]—has apparently prevented full recognition of this building's cultural implications, just as, in the study of Arabic epigraphy, Koranic inscriptions and common expressions of good wishes were formerly designated as *"formules banales."*[3] This assessment of the decoration as eclectic and insignificant, suited to *nouveau riche* taste, has also affected the appreciation of the building itself.

How should we then evaluate the iconographic content of this impressive building? It seems important first to note certain weaknesses in the current interpretation in order to demonstrate that reappraisal is indeed imperative. For example, why should a functionally limited unit in a bathing establishment have a large and elaborate porch with such precise royal connotations as the figure of the caliph, two lions, battlements, and a large entrance on the order of a Roman triumphal arch with two additional doors to the outside? Why should the "Bath Hall" be so immense when the actual *hammam* is so small and appears to be a mere appendage of the "Hall?" Why should the "Hall" have a central dome and an ambulatory along its walls? Why should there be such ostentatious display in a mere "vestiary?" And why, finally, should a small bath for not more than fifteen users have not only a large "vestiary" but also toilet facilities for at least twenty-three (and possibly for as many as thirty-three) persons? (According to modern architectural standards these hygenic facilities would be sufficient for at least 250 persons).

Happily the 1959 excavation report by R. W. Hamilton in collaboration with G. U. Spencer Corbett and with a contribution on the wall paintings by Oleg Grabar is so explicit and so well documented that our proposed solutions for many (though not yet all) of the riddles posed by this building and its decoration can be fully supported. The writer feels greatly indebted to the numerous trenchant observations of the excavator and his associates.

The main clues are provided by the most unusual aspects of the "Bath Hall," especially by two elements in its decoration. The first is the only pictorial mosaic among the thirty-eight different panels decorating the floor. It shows a simple knife beside a fruit, from which a

[1] Hamilton, *op. cit.*, p. 346, see also pp. 7, 64, 103-105, 235-236.

[2] Hamilton, *op. cit.*, p. 336.

[3] Jean David-Weill, "Encore une formule banale," *Ars Islamica*, vol. 15/16, 1951, pp. 136-137.

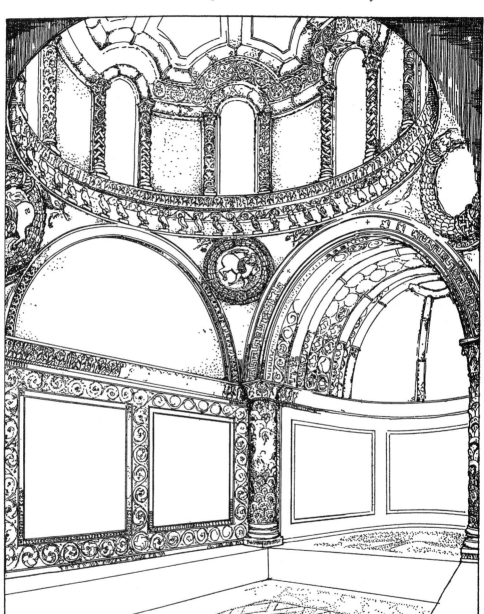

Fig. D. Khirbat al-Mafjar, Diwan—Restored Perspective View of the Interior (after Hamilton, drawing by G. U. Spencer Corbett).

leafy shoot emanates (Fig. 59). According to the opinion of several (unnamed) Arab visitors to the site which was accepted by R. W. Hamilton, G. Lankaster Harding and the Rev. A. Gervase Mathew this picture has been interpreted as a kind of riddle: an allegorical repre-

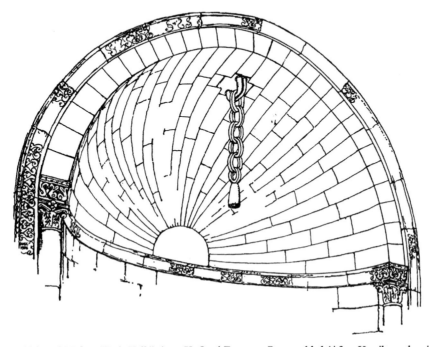

Fig. E. Khirbat al-Mafjar, "Bath Hall," Apse V, Semi-Dome as Reassembled (After Hamilton, drawing by G. U. Spencer Corbett).

sentation of the caliph with his wife and her child.[1] But three considerations argue against such an interpretation. First, neither the Classical nor the Sasanian world seems to have developed vegetal or culinary symbolism for royalty, nor is there any trace of it in later Mus-

[1] Hamilton, *op. cit.*, pp. 336-337. That the interpretation of the scene as the caliphal family seems most unlikely has recently been brought out by another investigation; it showed that out of a fear of desecration "clearly meaningful and undisputed crosses are not very frequent on mosaic pavements (of churches) and that when they do occur they are usually in places not open to general traffic;" it also pointed out that the Edict of 427 A.D. forbade the sign of Christ on the floor (Ernst Kitzinger, "The Threshold of the Holy Shrine. Observations on Floor Mosaics at Antioch and Bethlehem," in *Kyriakon. Festschrift für Johannes Quasten*, ed. Patrick Granfield and Josef A. Jungmann. Münster, Westf., 1971, pp. 640-641, 646). A critical attitude toward Hamilton's opinion is to be found in Jairazhboi's review (*op. cit.*, p. 73), but no other solution was offered by him.

lim iconography. Second, in such a male-centered civilization as the Arab world it seems unlikely that the lord of the mansion would be represented by a narrow-bladed, unpretentious knife while the bigger, more conspicuous fruit placed in the center of the composition should stand for his spouse. Finally, and more seriously, it seems most improbable that the one specifically royal representation in the building should have been on the floor and thus exposed to the utmost expression of disrespect from all and sundry: to the possibility of being stepped on.

The second clue—like the one just described, thought to be rather bizarre in nature—is a chain with a cone-shaped pendant (altogether 1.5 meters long) cut from a single block of soft conglomerate limestone (Fig. 60), which originally hung from a ring affixed to the top of the very same niche in which the mosaic of the "caliph and his wife" was found (Fig. E). It may thus be possible to perceive some basic connection between these two features. The chain and its pendant have been compared to "those trick devices, more often wrought in wood or ivory which are still offered to tourists in Oriental bazaars." The excavator could not "imagine any practical purpose for which the chain could have served, neither, for example, to support a lamp nor as a stage property for some gymnastic display." So the only remaining suggestion was that it represented "some ingenious mason's tribute to the eccentric personality of Walid ibn Yazid," the assumed owner of the whole establishment.[1]

To "break the code," as it were, it is necessary to be fully aware of the locations of the two unusual features in Exedra V, opposite the entrance from the porch. Indeed, as Hamilton states of the chain and its attached object: "Pendant there on the axis of the hall, it would meet the eye of all who passed the threshold of the main door." But there is more to the problem than that. This exedra is at the end of the central nave, which is wider than the other passages leading to the west wall, 5.50-5.60 meters compared to 4.40-4.60 meters for the intermediary aisles flanking it, and 2.50-3.36 meters for the four lower aisles closest to the walls. Furthermore, this central nave, which one entered through an ornately decorated projecting porch, with royal symbols on the outside and an elaborately domed chamber in its interior, also had a dome in the center of the nave, the highest point of elevation in the structure, with a large, very spectacular mosaic on the floor beneath it (Figs. F. and G, Fig. 61).

Finally, a quick glance suffices to show that Exedra V, of all the apses in the building, was by far the richest in decoration (Fig. H). For instance, instead of the usual group of six square niches, each crowned by a simple round arch and with a single niche above it on the wall, found in at least six of the apses, Exedra V had seven round niches, whose more richly decorated horseshoe-shaped arches rested on colonettes, while above it there were apparently two niches whose arches rested on triple colonettes. Exedra V was also unique in that its semi-

[1] Hamilton, *op. cit.*, p. 91, pl. XII, 6, where the they could apparently be photographed only in this
chain and pendant are published horizontally as way.

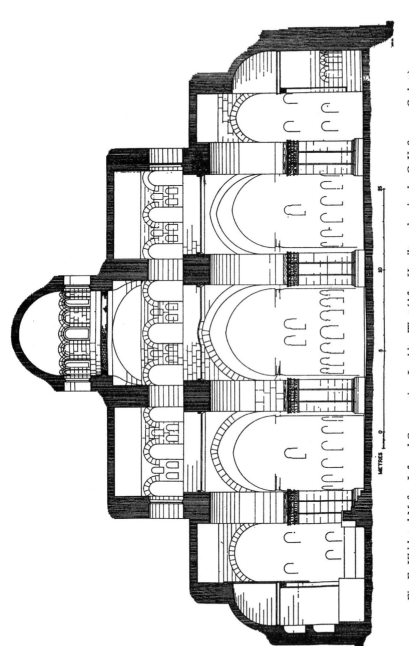

Fig. F. Khirbat al-Mafjar, Inferred Cross-section, Looking West (After Hamilton, drawing by G. U. Spencer Corbett).

26 THE THRONE AND BANQUET HALL OF KHIRBAT AL-MAFJAR

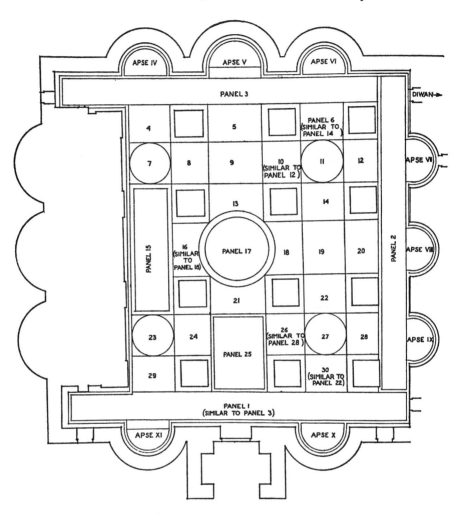

Fig. G. Khirbat al-Mafjar, "Bath Hall," Index Plan of Mosaic Floor (After Hamilton, drawing by G. U. Spencer Corbett).

dome was built of courses radiating from a round unit in the center of its lower edge, whereas the other semidomes had the usual horizontal stone courses (Figs. E and H). One other aspect distinguished this part of the elevation: "the masonry of the semidomes was plastered white, except for Apse V, of which the archivolt had a painted border of fretwork and floral designs in alternate panels," and in the same apse "the moulding which surmounted the

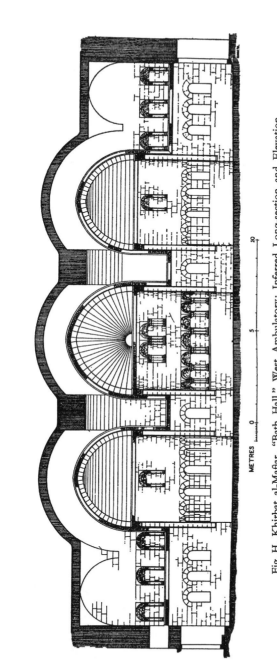

METRES 0 5 10

Fig. H. Khirbat al-Mafjar, "Bath Hall," West Ambulatory; Inferred Long-section and Elevation. (After Hamilton, drawing by Albert Henschel).

archivolt was also painted red, green and yellow."[1] The floor decoration was also different. Whereas all the other apses had single, all-over patterns framed by simple, unified borders (Figs. 62 and 63), Exedra V had two more elaborate patterns, set off in front by a wide border of three different patterns, with the mysterious "caliph and wife" panel in the center (Fig. 64). The conclusions are obvious: first, the central nave is axial (though this scheme is counterbalanced by a centralized arrangement around the dome in the middle of the building and the huge, round mosaic below it), and, secondly, Exedra V is of singular importance, possibly the focal point of the whole interior.

For the most striking and unusual feature of this most important unit of the interior, the mysterious stone object suspended in the niche by a chain, there exists, happily, a parallel, at least in historical sources: the "hanging crown" in the throne hall of the Sasanian kings at Ctesiphon.[2] Our source is Ibn Ishaq (704-767), a young contemporary of the Caliph Hisham, whose *Sirat an-Nabi (Life of the Prophet)* has come down to us in the edition of Ibn Hisham (d. 833). There it is stated that

the Kisra-Khosrow I Anoshirvan, [531-578] used to sit in his audience-hall where was his crown, like a mighty bowl... set with rubies, emeralds and pearls, with gold and silver, suspended by a chain of gold from the top of an arch in this his audience-hall, and his neck could not support the crown, but he was veiled by draperies till he had taken his seat in this his audience-hall, and had introduced his head within his crown, and had settled himself in his place, whereupon the draperies were withdrawn. And no one who had not previously seen him looked upon him without kneeling in reverence before him.[3]

This association of the "hanging crown" with Khosrow I is repeated by Tabari (839-923), who reports it in connection with Khosrow II Parviz (590-628):

This throne vault was so superbly built that no one had seen anything like it elsewhere. In it his crown was suspended and he sat there when he gave an audience to people.[4]

The practice is again related by Tha'alibi (961-1038):

The crown of Khosrow II was of 60 *mann* pure gold studded with pearls as big as sparrow eggs and with garnet-colored rubies... and emeralds... A golden chain, 70

[1] Grabar in Hamilton, *op. cit.*, p. 320; see also p. 91.
[2] The pertinent texts have been collected in "Exkurs I: Die hängende Krone", in Kurt Erdmann, "Die Entwicklung der sasanidischen Krone," *Ars Islamica*, vol. 15/16, 1951, pp. 114-117. The following makes full use of this valuable study. For an earlier short presentation of the "hanging crown" see

Arthur Christensen, *L'Iran sous les Sassanides*. Second edition. Copenhagen, 1944, pp. 397-398. In the Persian translation of this work (Tehran, 1317) the crown is described as follows: "tāj... bevasīleh-ye zanjīrī az ṭalā be-saqf āvīkhteh būd" (p. 278).
[3] Quoted after Tabari, ed. T. Nöldeke. Leyden, 1879, pp. 221-222; Erdmann, *op. cit.*, p. 114.
[4] *Op. cit.*, p. 304; Erdmann, *op. cit.*, p. 114.

cubits long, hung from the vault of the palace on which the crown was fastened, so that it touched the head of the king without troubling him or being a load on him.[1]

Although the custom of suspending the crown is thus generally believed to have been introduced by Khosrow I and to have been adopted by subsequent Sasanian kings, Mirkh(w)and (d. 1498) reports that already at the election of the young Shapur II (309-379) the grandees of the realm had had the crown suspended over the child's head and had paid homage to him according to the usual protocol.[2] According to this very late and possibly aetiological explanation, the suspension was thus thought to have been installed on account of the tender age of the new king—although it was more generally thought to have become the rule for adult rulers from Khosrow I on.

The custom of suspending the crown from the vault and over "the ivory throne" is also repeatedly mentioned by Ferdowsi (932-1021) in connection with five mythical Iranian kings and four Sasanian rulers.[3] According to him the crown is said to have been suspended for the ruling king not only in the permanent throne hall of the palace in the capital city, but also wherever he resided, even for short periods during his travels. It was also suspended in this fashion over the mother shortly before the delivery of the royal son, over the child after its birth, over the body of the dead king placed on his ivory throne, and in his mausoleum. That means it was regarded as a basic, visible symbol of royalty, and as such it was, of course, especially important at enthronements, audiences, and public feasts.

With regards to this institution we even have a historical account indicating a cultural interaction, because the hanging crown was said to have entered Byzantine court ceremonial; this is implied by the report, written about 1170, of Rabbi Benjamin of Tudela's visit to Constantinople:

> The Emperor (Manuel) had built for himself a palace at the shores of the sea, to which he gave the name of Blachernes. The walls and columns he had covered with gold and silver and the paintings represented former wars, as well as those which he had conducted himself. His throne was of gold, incrusted with jewels, and above it hung on a golden chain the golden, jewel-studded crown whose value is unaccountable, as its luster makes one dispense with light at night.[4]

[1] Ed. H. Zotenberg. Paris, 1900, pp. 699-700; Erdmann, *op. cit.*, pp. 104-105.

[2] *Histoire des rois de Perse de la dynastie des Sassanides*, tr. S. de Sacy. Paris, 1793, p. 306; Erdmann, *op. cit.*, 115.

[3] See Erdmann, *op. cit.*, pp. 115-116.

[4] *Die Reisebeschreibung des R. Benjamin von Tudela*, ed. et tr. L. Grünhut and M. N. Adler. Frankfurt a. Main-Jerusalem, 1903-1904, vol. 2, p. 17; Erdmann, *op. cit.*, p. 117. Since it is unlikely that R. Benjamin

ever saw the crowned Byzantine emperor in his palace, he must have reported a folk tale. In the same way Evliya Çelebi gives a fictitious account of what the Turkish Ambassador saw at the Imperial Court in Vienna in 1665: "when an extraordinary privy council took place on account of our Pasha-Ambassador, the Emperor had the crown . . . suspended . . . in such a way that it appeared to hang on 18 golden and jewelled chains from a small vault over his throne." (*Im Reiche des Goldenen Apfels*, tr. and expl. by R. F.

30 THE THRONE AND BANQUET HALL OF KHIRBAT AL-MAFJAR

The concept of the hanging royal symbol was to all appearances taken over by the Umayyad owner of the mansion; yet it is obvious that the suspended object in Apse V is not a crown, nor, apparently, is it a contraption to which a crown could have been fixed. From the total setting it can, however, be assumed that the cone-shaped unit must have represented a kind of headgear proper for a ruler and worn by him on official occasions, and also one worn by the Umayyad caliphal house. We suggest that it represents one of three types of official headgear worn by the Umayyads, the one called *qalansuwa* (or *qalansiya*), more specifically, *qalansuwa tawila*—"*le bonnet haut en forme de pain de sucre, porté par les califes (abbasides)...*" (as defined by R. Dozy).[1] The others were the *taj*, or crown, and the *'imama*, or turban, neither of which, obviously, can have been intended by the craftsman who made the object at Khirbat al-Mafjar. As the qalansuwa was commonly worn in post-Umayyad periods by Muslims across a broad social range and by non-Muslims as well,[2] it has been often mentioned in Arabic texts and discussed by Western scholars. These discussions have, however, been based almost exclusively on literary and historical sources, without reference to pictorial representations, for no early examples of this tall bonnet seem to have been preserved.

We shall turn now to the results of this earlier research, especially as it applies to Umayyad times. We shall begin with an early reference to this headgear, one of the most pertinent such references, in a passage in Alois Musil's famous work on Qusayr 'Amra, in which he speaks of the future Caliph al-Walid II (the Umayyad generally thought to have built Khirbat al-Mafjar). Musil remarks that "the prince usually wore a precious headgear which resembled a sugar loaf and had gold decoration."[3] This comment, together with the texts on the "hanging crown," clearly points to the cone-shaped stone object in Exedra V.

The early history and use of the qalansuwa deserves, however, further elucidation based on the research of various scholars. Let us begin with one of the more recent and most comprehensive statements, by the late Reuben Levy:

> The Abbasid period brought an influx of Persian clothes, so that the Persian qabā' and sarāwīl (drawers) and the tall hat known as the qalansuwa tawīla (or simply as the ṭawīla), became popular articles of wear. Frequently the latter appears to have been cone-shaped and tapered to a point (Mas'ūdī, *Murūj*, VIII, 377). The ordinary short qalansuwa had long been known and worn. The Prophet is credited with one (Ya'qūbī, *Historiae*, II, 97f) and the Caliph 'Uthmān is described as wearing one when he received his wife

Kreutel. Graz, 1957, p. 166). Similarly the huge crown of King Ahasverus in a drawing made in 1893 in Safed by one Josef Geiger is suspended on a hook (Fig. 90, after Y. Shahar, *Osef Feuchtwanger*. Jerusalem, 1971, color pl. on p. 160). These two parallels were kindly pointed out to me by Professor Otto Kurz and Mr. Erwin Offenbacher.

[1] R. Dozy, *Supplément aux dictionnaires arabes.* Leyden, 1881, vol. 2 p. 401.
[2] This was already fully recognized by Dozy *(loc. cit.,)*.
[3] Musil, *Kuṣejr 'Amra*, vol. 1, p. 157 and footnote 349 quoting the *Kitab al-Aghani*, vol. 6, p. 144.

Nā'ila (*Aghānī*, XV, 71). In Umayyad times the Caliph Walīd I preached in one (*Fragmenta Hist. Arab.*, p. 7) and Hunayn, the Christian camel-hirer and poet of Hīra, is said to have worn a tall one in the reign of Hishām (*Aghānī* II, 121, l. 7), but even the Arabs of the Jāhiliya are known to have regarded their variety as Persian (G. Jacob, *Altarabisches Beduinenleben*, p. 237). The shorter kind was probably shaped like a skull cap or a fez and was made of fur or cloth (Cf. Ibn Saʿd, VI, 196, and VII (II), p. 25, l.5), and it was worn with a turban around it. The tall shape of the *ṭawīla*, which might be made of silk (Tabarī, III, 1442), was maintained by means of an internal framework of wood or reeds (*Aghānī*, IX, 121, 11.), so that it resembled the long tapering wine-jars known as *dann*, whence the tall qalansuwa came also to be known as a danniya (*Aghānī*, X, 123; Yāqūt, *Irshād*, I, 373; Badīʿ al-Zamān Hamadānī, *Rasā'il* [Beyrout, 1890], p. 168).[1]

From this resume it might be assumed that the qalansuwa tawila appeared mainly in Abbasid times, especially as Dozy says so, too. This belief is apparently based on a statement by Tabari, that al-Mansur (754-775), the second Abbasid caliph, had introduced the tall qalansuwa and the wearing of black silk.[2] The archaeological evidence from Khirbat al-Mafjar now disproves this assumption of an Abbasid origin.

Ernst Herzfeld remarks that the qalansuwa tawila was placed on the head of the caliph when homage was paid to him, and he believes that it had already become customary in Umayyad times.[3] Björkman has pointed out a passage in Yaqut, who tells us that this part of the costume was first adopted during the reign of the first Umayyad by ʿAbbad b. Ziyad from inhabitants of Qandahar, which he conquered.[4] This statement is contradicted by the archaeological evidence (to be examined), which suggests an earlier Iranian origin.

Oleg Grabar is still another author who has dealt with this subject, as he has discovered two important references. According to Tabari and Yaʿqubi, al-Walid I wore a qalansuwa when he inaugurated the new Mosque of Madina: evidence of its use by an Umayyad caliph at an important formal occasion.[5] According to a passage in al-Jahiz' *Kitab al-Taj*, "al-Hajjaj used to appear in audiences in a qalansuwa and no one was allowed to wear a similar one." Before this statement, al-Jahiz relates that no one was permitted to appear in dresses like those worn by the Sasanian king.[6] Grabar recognized that this passage illustrates the cere-

[1] Reuben Levy, "Notes on Costume from Arabic Sources," *Journal of the Royal Asiatic Society*, 1935, pp. 324-325.

[2] R. B. Serjeant, "Material for a History of Islamic Textiles up to the Mongol Conquest," *Ars Islamica*, vol. 1942, p. 69, footnote 1, quoting Tabari, *Annales*, ed. M. J. de Goeje. Leyden, 1879-1906, series III, vol. I, pp. 417-418.

[3] Ernst Herzfeld, *Geschichte der Stadt Samarra* (*Die Ausgrabungen von Samarra*, vol. 6). Hamburg, 1948, p. 142, n.5.

[4] W. Björkman, "Ḳalansuwa," *Encyclopaedia of Islam*. Leyden-London 1927, vol. 2, pp. 677-678.

[5] Oleg Grabar, *Ceremonial and Art at the Umayyad Court*. Princeton Ph. D. thesis, 1955, (typescript manuscript), p. 58 quoting Tabari, II, pp. 1233-1234; Yaʿqubi, II, pp. 339-341.

[6] *Op. cit.*, p. 59 and footnote 56, quoting *Kitab al-Taj*, ed. Ahmad Zaki Pasha, 1914, p. 57. There is some question about the authorship of this text, but even if it was not by al-Jahiz, it was, according to C. Brockelmann, by one of his contemporaries

monial importance of the qalansuwa and its Sasanian origin, but it also shows that a person other than the reigning caliph could wear it.

Finally, in his study of the early history of textiles, R. B. Serjeant mentions a passage in Mas'udi that refers to the extravagant and improper use by the Umayyad Caliph Sulaiman (714-717) of patterned silk *(washi)* for various costume pieces, including the qalansuwa. All his friends, governors, and attendants wore this costly material, and "even the cook entered his presence only in patterned silk, used by him also for the tall qalansuwa (tawila)."[1] This reference makes it clear that the tall bonnet was a very important and elegant part of the dress and that its use by a servant was thought to be most inappropriate.

All this evidence adds up to the fact that the qalansuwa tawila, which looked like the old fashioned "sugar loaf," was a highly regarded form of official headgear, worn by the Umayyad caliphs and their grandees (and occasionally even by lesser folk) at important functions, just as the caliphs used the taj, or crown, as shown by a sculptured figure in Qasr al-Hair al-Gharbi.[2] To suspend such a qalansuwa on a chain in what we must now recognize as the "Throne Apse" at Khirbat al-Mafjar was therefore fully appropriate especially for a prince known to have favored this form of head covering. The only change is in the material: stone was used at Khirbat al-Mafjar (though it may have been gilded or colored) instead of the gold of Sasanian times. Apparently this variation in shape and material fully satisfied the symbolic and ceremonial requirements of the time.

As headgear the qalansuwa had undoubtedly had a long pre-Islamic development; in earlier times it often had lappets over the ears. Herzfeld was reminded of the *kyrbasia* of the Achaemenids.[3] Björkman mentions the high, pointed bonnets in the painting of the "Sacrifice of Conon" (Fig. 65) in the Temple of the Palmyrene gods at Dura-Europos (first century A.D.).[4] Other examples include the similarly shaped high caps at Nimrud Dagh (first century B.C.),[5] and in various Parthian reliefs and statues found at Hatra and Susa (Fig. 66).[6] Closer to Umayyad times are examples on such various Sasanian monuments as a graffito in Persepolis, the rock relief in Firuzabad (third century A.D.; Fig. 67), and a textile in Persian style from Antinoë in Lyons, dated to the sixth century.[7] In Umayyad times the ordinary or "low

(Geschichte der arabischen Literatur. Leyden, 1937-1949, Supplement, vol. 1, p. 246.)

[1] Serjeant, "Material...," p. 67, quoting Mas'udi, *Muruj al-Dhahab*, vol. 5, p. 400. A later important use of the qalansuwa was at the reception for the Byzantine Embassy by the Abbasid Caliph al-Muqtadir in 917 (Guy Le Strange, "A Greek Embassy to Baghdad in 917 A.D.," *Journal of the Royal Asiatic Society*, 1897, p. 43.

[2] Daniel Schlumberger, "Les Fouilles de Qasr el-Heir el-Gharbi (1936-1938). Rapport préliminaire, deuxième article," *Syria*, vol. 20, 1939, p. 353,

pl. XLVI, 1. Schlumberger points out that one had previously believed that the taj was an Abbasid innovation, but that this particular find had corrected this assumption. As we have seen the same rectification has now to be made for the qalansuwa.

[3] Herzfeld, *Geschichte*, p. 142.

[4] Björkman, "Kalansuwa," p. 677; often illustrated, see, e.g. Ghirshman, *Parthians and Sasanians*, fig. 59.

[5] *Idem. loc. cit.*, figs. 73-76.

[6] *Idem. loc. cit.*, figs. 70, 100, 102; see also fig. 82.

[7] Erich F. Schmidt, *Persepolis I*. Chicago, 1953,

model" qalansuwa appears on the extraordinary dirham with the effigy of the Caliph 'Abd al-Malik, struck in Damascus in 695 (Fig. 68).[1] The "tall model" is shown on what is apparently an Umayyad silk woven after a Persian model, part of the Wolvinius Altar in S. Ambrogio in Milan (Fig. 69), and in the simplified version of this same textile design on a fabric from the Cunibert Reliquary in the Diocesan Museum of Cologne.[2] Like the suspended chain over the throne, this particular form of headgear was also therefore of Iranian origin, and both were adopted by the Umayyads. Considering the fact that the tall qalansuwa was symbolically represented in hunting scenes, one may assume that its shape was not shown as elongated as it was for the actual ceremonies of an elegant seigneur which were rendered in the Throne Apse of Khirbat al-Mafjar. The memory of this fashion persisted a long time, since Persian miniatures of the fourteenth and fifteenth century still show occasionally pre-Islamic dignitaries and *mobeds* with very high pointed hats (Fig. 89).

At this point a word should be said about the semidome of Exedra V. We have noted that, in contrast to all the others which were built of horizontal courses, this one was constructed with voussoirs radiating from a center at the back and thus deliberately emphasized (Fig. H). The obvious intent was to imitate a scalloped shell in stone. In the Umayyad period this form was especially used for secular throne niches, and it thus occurs in what seems to be the throne apse of a palace structure on a mosaic in the Great Mosque of Damascus (Fig. 70). Eventually the scalloped shell appeared in mihrabs, as one of the earliest preserved examples, generally assumed to have served the Mosque of Mansur in Baghdad, indicates.[3]

Whereas the preceding investigations have dealt with the early Muslim and Iranian aspects of the qalansuwa and its suspension in the Throne Apse, two apparently related issues should also be mentioned, at least briefly. A more extensive discussion of these problems would lead us too far away, in space and time, from our main topic.

The first issue is the much discussed history of the papal tiara, or pointed bonnet, which was, according to the *Liber Pontificalis*, used for the first time by Pope Constantine I (708-715).[4] It was called *camelaucum*, a term currently explained as referring to the camel hair

pl. 199 B; Ernst Kitzinger, "The Horse and Lion Tapestry at Dumbarton Oaks. A Study in Coptic and Sasanian Textile Design," *Dumbarton Oaks Papers*, vol. 3, 1946, fig. 32.

[1] George C. Miles, "Miḥrāb and 'Anazah: A Study in Early Islamic Iconography," *Archaeologica Orientalia in Memoriam Ernst Herzfeld*. Locust Valley, N.Y. 1952, pp. 156-171, pl. XXVIII, especially pp. 169-170 and pl. XXVIII, 3. At the time of writing this article Dr. Miles was not certain which of the three possible headgears—taj, 'imamah or qalansuwa—was represented on the coin of 'Abd al-Malik, but there seems now little doubt that the image of the caliph shows a low qalansuwa.

[2] Otto von Falke, *Decorative Silks*. Third edition. New York, 1936, fig. 58.

[3] Often illustrated, e.g. F. Sarre und Ernst Herzfeld, *Archäologische Reise im Euphrat- und Tigris-Gebiet*. Berlin, 1911-1920, vol. 2, fig. 185, vol. 3, pl. XLV; K.A.C. Creswell, *Early Muslim Architecture*. Oxford, 1940, vol. 2 pl. 120, d; Miles, "Miḥrāb...," pl. XXVIII, 9.

[4] For a general discussion see H. Leclercq, "Tiare," in F. Cabrol and H. Leclercq, *Dictionnaire d'archéologie chrétienne et de liturgie*. Paris, 1953, vol. 15 part 2, cols. 2292-2294; Percy Ernst Schramm, *Herrschaftszeichen und Staatssymbolik*. Stuttgart, 1954-1955, vol. 1, pp. 52-53.

originally used for this type of headgear. There are, however, variants of this odd term, specifically *calamaucus* and *calamaucum*. Between 685 and 741 there were several popes of Syrian or Greek origin, and it is possible that the introduction of this formal cover of the head was among the innovations made by these successors of St. Peter, since, as we have seen, the general shape was used earlier by the Persians and by various other Oriental peoples. It is startling to observe that the pope (and before him possibly high imperial dignitaries) was wearing headgear resembling the qalansuwa at just about the time that the latter achieved formal acceptance by the Umayyads. The first syllables of at least the two variant terms that we have cited are remarkably similar to those of the non-Arabic term, qalansuwa, used by the Arabs.

The second issue is the suspension of an ostrich egg above the Madonna enthroned before an apse capped by a scalloped shell, as in Piero della Francesca's altarpiece for Count Federigo of Urbino, now in the Brera (Fig. 71). All the symbolism and allusions in the individual features of this work have been explained by Millard Meiss,[1] but the whole *mise-en-scène* deserves possibly renewed consideration, in view of its striking parallel to the setting at Khirbat al-Mafjar. These two are obviously structurally parallel, and both depart from the standard use of ostrich eggs suspended in churches and mosques, usually in connection with lamps. At Khirbat al-Mafjar, however, the object suspended in the apse is an elongated cone, whereas in the altarpiece it is an egg; both are, however, fixed over enthroned regal persons. If there is a connection between the two instances, how it spanned a gap of about 650 years remains a mystery. It may well be that the custom of hanging a qalansuwa in a throne apse had gone out of fashion in the Near East or had become so rare an institution that its meaning was no longer grasped by visiting foreigners. Impressed as they were by the curious rite, they then adapted the more widely used ostrich egg for this particular function. Possible missing links in this development include the suspended crown that Benjamin of Tudela reported as existing about 1170 in the Palace of Constantinople and an imitation ostrich egg of green glazed pottery made in late-twelfth-century Iran, though the function of the latter is not known (Figs. 72 and 73).

Once we recognize that Exedra V represents a Throne Apse, the question arises whether or not the floor mosaics—or at least certain parts of them—have special significance, possibly

It seems worthwhile noting that in Italian paintings a similar form of headgear is given to the high priest of the Jewish temple (see Millard Meiss, *Painting in Florence and Siena after the Black Death*. New York, Harper Torch Books, 1964, figs. 12-14, 18, 28, 36).

[1] Millard Meiss, "Ovum Struthionis. Symbol and Allusion in Piero della Francesca's Montefeltro Altarpiece," *Studies in Art and Literature for Belle da Costa Greene*, ed. Dorothy Miner. Princeton, 1954, pp. 92-101; *idem*, "Addendum Ovologicum," *Art Bulletin*, vol. 36, 1954, pp. 221-222; see also M. A. Lavin, "Piero della Francesca's Montefeltro Altarpiece: A Pledge of Fidelity," *op. cit.*, vol. 51, 1969, p. 371, n. 34. Quite recently attention has been drawn to the much earlier fresco above the tomb of Antonio dei Fissiraga (d. 1327) in Lodi (Isa Ragusa, "The Egg Reopened," *op. cit.*, vol. 53, 1971, pp. 435-443). Here the ostrich egg is suspended directly over the Christ-child (rather than over the Madonna) thus recalling the Persian custom with regards the royal Sasanian baby as described by Ferdowsi (see p. 29).

even as additional forms of royal symbolism. Let us begin with the mysterious central square of the border, whose current interpretation as "the caliph with wife and offspring" (Fig. 59) was discussed above (p. 21-24).

To understand the design properly we should apply the principle that has been used successfully in other aulic settings, from Persepolis to Lashkari Bazar, and for pagan, Christian, and Muslim monuments: that the given imagery is related to the situation or activity that took place in or near the particular spot. Among contemporary or near-contemporary Christian and Muslims examples, we can note several. Epiphanios, a monk of Constantinople who wrote before 820, states that "the two grottoes [of the Church of the Nativity in Bethelehem] are... decorated with images which represent the event as it happened."[1] A mosaic still existing in the apse of Justinian's Church in the Monastery of St. Catherine at Mount Sinai, shows the "fiery bush," which is said to have burned right on this spot;[2] an image of a bush is found even on the first wooden door of that church, which was carved during the Fatimid period. Finally, the central alcove in the Throne Room at Qusayr 'Amra, where the Umayyad princely owner was at times formally enthroned, has a painting of a ruler enthroned in just this manner, with two attendants and in a symbolic cosmological setting.[3]

We must recall that Khirbat al-Mafjar was the mansion of an agricultural estate.[4] With this basic fact in mind, and taking into consideration the iconographic principle of "the pictorialized happening of the site" we must conclude that the picture is most likely that of an offering made on that spot—the presentation of a highly esteemed fruit to the lord of the plantation. It may be a welcoming gift, the first produce of the season, the symbol of the tithe, or possibly a kind of local hors d'oeuvre; any of these suggestions might have been pictorically rendered and clearly understood by contemporaries of the Umayyads. Nowadays, though, it is difficult, if not impossible, to select one explanation over the others. In any case the main object seems to be a fruit (possibly a citrus fruit[5] such as the *ethrog*), which, like the offering in the Yusuf Sura of the Koran (XII, v. 31), required a knife to be eaten, as it was either too large or had an inedible skin. The fruit is not an exotic product but must have been locally grown, for it occurs repeatedly in the mosaics of the Dome of the Rock (Fig. 74), and is already found on the Byzantine mosaic in the Dominus Flevit Monastery on the Mount of Olives, dated to the sixth or seventh century.[6] Topographically, the little vignette must have

[1] Migne, *Patrologia, Series Graeca*, CXX, col. 264, quoted by Marguerite van Berchem, "The Mosaics of the Dome of the Rock in Jerusalem and of the Great Mosque in Damascus," in Creswell, *Early Muslim Architecture*, Second edition., vol. 1, part 1, p. 243.

[2] Kurt Weitzmann," The Mosaics in St. Catherine's Monastery on Mount Sinai," *Proceedings of the American Philosophical Society*, vol. 110, No. 6, December 1966, pp. 393-396, figs. 3-6, 9; for a color reproduction see *idem*, "Mount Sinai's Holy Treasures,"

National Geographic, vol. 125, 1964, p. 110.

[3] Musil, *Ḳuṣejr 'Amra*, vol. 2, pls. 8, 15.

[4] Hamilton, *Khirbat al Mafjar*, pp. 5-7; Oleg Grabar, "Islamic Art and Byzantium," *Dumbarton Oaks Papers*, vol. 18, 1964, pp. 74-76.

[5] If this is indeed a citrus fruit, its high esteem in the Greek and Arab tradition should be stressed (F. Rosenthal, *Four Essays on Art and Literature in Islam*. Leiden, 1971, p. 13).

[6] Van Berchem, "The Mosaics...," fig. 179.

been just in front of the throne; iconographically, it would be comparable, on a minor scale, to the tribute bearers on the walls of the Apadana of Persepolis.[1]

An interpretation of the other mosaics is less certain, primarily because they are abstract and their specific meaning is thus ambiguous. Special pains have therefore been taken to understand their iconographic function apart from that as mere decoration and to consider them as far as possible within the conceptual context of the structure and of Umayyad and Sasanian art in general. In this way we hope to avoid the projection of notions that would have been foreign to the period.

The motif closest to the one previously analyzed is a half-flower or half-rosette consisting of four heart-shaped petals, separated by sharply pointed cone-shaped sepals. Although such flowers have had a long history in Greater Syria[2] and have also been observed in the Dome of the Rock and Qasr al-Hair al-Gharbi,[3] the placement of this one in a focal point may have served more than a merely decorative purpose. Confirmation can be found in the conspicuous use on the bath hall porch of a related type of flower (with only six petals and no sepals but still a rosette); it is right beneath the feet of the caliph and between the two addorsed royal lions (Fig. 75). A four-petaled form appears as an interstitial pattern in the senmurv panel in the "Palace" compound of the same building (Fig. I). Both motifs have undeniable Sasanian iconographic connections, and in addition the senmurv has clear royal associations; it appears in roundels with rosettes as interstitial patterns in the design on Khosrow II's garment in the grotto of Taq-i Bustan (Fig. 76); two forms of the rosette (without the beast) are also found on the clothing of the royal attendants there.[4] In addition, four-petaled rosettes occur as the sole

Miss Barbara Schmitz kindly drew my attention to the occurrence of this fruit in the mosaics of the Dome of the Rock.

[1] Often reproduced, see, for instance, Erich F. Schmidt, *Persepolis. I. Structures, Reliefs, Inscriptions.* Chicago, 1953, pls. 27-49; Gerold Walser, *Die Völkerschaften auf den Reliefs von Persepolis.* Berlin, 1966; Donald N. Wilber, *Persepolis, The Archaeology of Parsa, Seat of the Persian Kings.* New York, 1969, figs. on pp. 19-22, 26-28.

For some time another explanation suggested itself to the author, namely that the mosaic represents the *lulab* and *ethrog*, the garnished palm branch and citrus fruit used ritually in the Jewish Feast of the Tabernacles (Erwin R. Goodenough, *Jewish Symbols in the Greco-Roman Period.* New York, 1953, Vol. III, figs. 575, 576, 602, 639, 689-692, 877, 878). This seemed to be supported by the fact that writing exercises with Hebrew letters scribbled on discarded slabs of stone proved the presence of Jewish workmen at the site (Hamilton, *op. cit.*, pl. CXIV, 1 and 2). However, the so-called lulab is too small in relation

to the ethrog and is not shown with the usual other branches, quite apart from the fact that it really looks more like a knife. The presence of the mosaic in the front of the throne of a very high Muslim dignitary makes it most unlikely that a Jewish symbol was applied at this spot. It is, however, not impossible that the fruit is an ethrog, only here not shown with Jewish religious connotations, but as an agricultural product.

[2] Florence E. Day, "The Ṭirāz Silk of Marwān," *Archaeologica Orientalia in Memoriam Ernst Herzfeld*, pp. 39-61.

[3] Day, *op. cit.*, figs. 8 and 9; van Berchem, *op. cit.*, figs. 327-331.

[4] Elsie Holmes Peck, "The Representation of Costumes in the Reliefs of Taq-i-Bustan," *Artibus Asiae*, vol. 31, 1969, pls. IXb-XI, XIII, XVII, XIX. The fact that we find here two different alternating types of rosettes indicates that the concept of a rosette as such was the main issue and not the individual execution of the emblem.

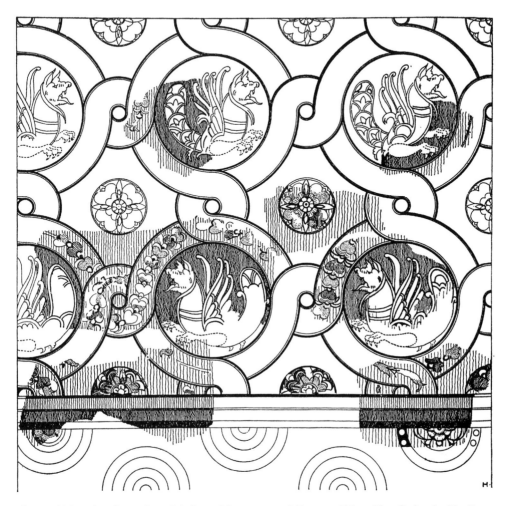

Fig. I. Khirbat al-Mafjar, Palace. Painting of Senmurvs and Rosettes (After Oleg Grabar in Hamilton, drawing by G. U. Spencer Corbett).

decorative motif on the red and white glass disks encircling the carved rock-crystal medallion of Khosrow I on the famous gold "Cup of Solomon" in the Bibliothèque Nationale, Paris (Fig. 50). Even more important, the same type of flower is the main motif of a silk (Fig. 77) made, according to its inscription, in Tunisia (Ifriqiyya) for the Umayyad Caliph Marwan (though it is still uncertain whether it was for the first caliph of that name, 684-685, or the

second, 744-749). Finally, the royal horseman with a tall qalansuwa on the (probably) Umayyad silk in the Wolvinius Altar in Milan wears a four-petaled flower (without sepals) on his tunic right over his heart and another over his right knee (Fig. 69). The motif with all its implications passed on into late Sogdian art as a floral figure of this nature is seen jutting out from under the carpet on which the feasting king on a well-known silver plate—possibly of the ninth century—is sitting (Fig. 78). The fact that there is no functional reason for its curious use in this instance gives further support for the belief that the rosette must have had a royal connotation in Umayyad times, just as it did before and afterwards.

We can go even one step further. Whereas the full-fledged design with senmurvs and rosettes (associated with Khosrow II in Taq-i Bustan) does occur in a wall painting in the more intimate milieu of the Palace at Khirbat al-Mafjar, the animal is omitted in the more formal and public setting of the Throne Apse of the Great Audience hall.[1] The same underlying restrictive attitude is apparent in the official silk fabric of Marwan. The elevation of secondary, nonfigural Sasanian designs to the rank of sole (or major) motifs on early Islamic objects can be regarded as a general rule.

Commonplace as a rosette design might seem, it nevertheless appears to have had royal (and possibly divine) associations which existed already in the Achaemenian period. A rosette occurs as the only ornament on the tomb of Cyrus the Great (just below the gable of the roof) where it certainly must have had a specific significance; rosettes are to be found in great abundance in the framing borders in Persepolis; and finally they are met with twenty-four times in the field of the "Pazyryk Carpet" in the Hermitage in Leningrad where they are the sole decoration of the area where the king or chieftain for whom this carpet was knotted was seated—in other words, in a location which forms a parallel to the half-rosette in the Throne Apse of Khirbat al-Mafjar; it is also important to note that these rosettes (which occur also in a less prominent position among the borders of the carpet) are presented within a composition which has strong royal connotations thus making this Persian floor cover a product which is much more significant than its simpler and more decorative Assyrian prototype.[2]

At Khirbat al-Mafjar the half-flower forms an ensemble with the large mosaic in the surrounding half-circle (Fig. 64). As we have noted, this mosaic differs totally in design from

[1] The senmurv alone and the small bust of a nude woman appear, however, in what must be regarded as the least accessible part of the big Hall. Carved in stone in the niche head of Exedra III they are found at the far side of the pool and were therefore hardly recognizable. (Hamilton, *Khirbat al Mafjar*, pp. 152-153, fig. 118, pl. XXIX, 26.

[2] For the decoration below the roof of the tomb of Cyrus at Pasargadae see David Stronach, "A Circular Symbol on the Tomb of Cyrus," *Iran*, vol. IX, 1971, pp. 155-158, Fig. 2, pls. II and III; for Persepolis, see Schmidt, *op. cit.*, vol. I, *passim*; for the "Pazyryk Carpet" see S. I. Rudenko, *The Culture of the Population of the Upper Altai Region* (in Russian), Moscow-Leningrad, 1953, pls. CXV/VI; R. D. Barnett and W. Watson, "The World's Oldest Persian Carpet...," *The Illustrated London News*, July 11, 1953, pp. 69-71. figs. 2 and 10; R. Ettinghausen, "The Boston Hunting Carpet in Historical Perspective," *Bulletin: Museum of Fine Arts, Boston*, vol. 69, Nrs. 355-356, 1971, fig. 44.

those of the other apses, which consist of stepped patterns, chevrons, scales, staggered rows of little flowers, and overlapping diamonds, all purely decorative in nature. After having described the design in the Throne Apse (which he places among the "basketry patterns") and having explained the manner of its creation, Hamilton points out that "the design, composed of scales...is articulated by radial lines" and suggests "perhaps a deliberate reflection of the radial lines in the construction of the semidome above."[1] The two motifs—the half-flower and the large-scale design with what seem to be overlapping, petal-like leaves—are therefore morphologically related, both variations on radiating centrifugal patterns. Indeed, the half-flower seems to be the core of the larger design.

Quite apart from the fact of its reflection on a flat surface of the radiating stone courses in the semidome above (Fig. E), this type of pattern—whether abstract or floral in character—also had a specific place in sacred and secular Sasanian imagery. In the scene of the investiture of Ardashir II (379-383) at Taq-i Bustan, Mithras' head is surrounded by a circle of rays, and he stands on flowers with two rows of radiating petals (Fig. 79). We can also note the large epaulettes sometimes worn by the Sasanian kings, as shown on some silver plates, especially that of Shapur III (383-388) in the Hermitage (Fig. 80). As we must imagine that the throne at Khirbat al-Mafjar stood just on the half-flower, the radial apse mosaic must then have appeared as a strong, mysterious force emanating from the royal figure. It may have invoked associations with the sun, as the rayed halo of Mithras at Taq-i Bustan was apparently meant to do, suggesting that the Umayyad lord was a "sun king." Or perhaps—in this particular setting—the radial mosaic can be explained as a rendition of the *hvarnah*, or *farr*, the glory that had radiated from the legitimate kings of Iran and whose manifestations had been transferred to a member of the Umayyad caliphal house.[2]

In summary we can say that Exedra V is *the* Throne Apse. Its structure and decoration provide the proper setting for a royal enthronement and reflect royal aspirations, most of them in the Sasanian tradition, though, as far as the mosaics are concerned, executed in the Classical manner. The semidome, the stone chain with its pendant, official and often royal headgear, the offering of tribute, and the symbols of royal splendor all combine to proclaim the majesty of a new Khosrow of Arab blood. We note, however, that in this whole official ambiance there is no reference to the Muslim religion of the princely lord of the mansion.

It is imperative that we explore the other mosaics and decorative elements in the building with the symbolism of the Throne Apse in mind in order to determine whether they are purely ornamental, as has been believed, or whether further royal associations can be found among them. The obvious place to begin is with the large circular mosaic (No. 17 in Hamilton's chart, Fig. G and Fig. 61), which is to be found strategically placed under the central

[1] Hamilton, *op. cit.*, p. 336.

[2] Frye, *The Heritage of Persia*, pp. 64-65. For a parallel see Ernst H. Kantorowicz, "Oriens Augusti-Lever du Roi," *Dumbarton Oaks Papers*, vol. 17, 1963, pp. 119-177 to which Professor M. Barasch has kindly redrawn my attention.

dome midway between throne exedra and monumental porch in the axial nave. It rivals, if it does not surpass, in coloring, fine articulation, and size all the various pre-Islamic parallels that can be cited.[1] It draws immediate attention to itself, for its diameter is greater than the width of the nave and it thus penetrates the two flanking aisles. Finally, it consists of a strong, radiating rosette pattern of overlapping petals, closely related to that of the Throne Apse. It may, of course, have been intended merely as a decorative centerpiece, to reflect in its size and artistic quality the dome above it, the apex of the whole large, resplendent structure. Even if this function was the main consideration in its placement and exceptional workmanship, its character and setting show deliberate choice by the supervising architect; this artistic aware-ness becomes particularly clear when we compare it with similar designs in the pavements in the Prophets, Apostles and Martyrs' Church of Gerasa and the Church of the Nativity in Bethlehem. These are simply single units within sets of equally prominent patterns and in no way stressed. Because of the big roundel's relation to the mosaic in the Throne Exedra, however, it is also possible to see in it another, secondary royal station, possibly for certain spectacles in which a more central position for the royal seat was warranted.

Of the other mosaic panels, three stand out because of their unusual size: panels 1 and 25 just inside the entrance to the building from the porch and panel 3 directly in front of the Throne Apse and leading to the side entrance from the palace in the southwest corner and to the Diwan in the northwest corner (Fig. G and Figs. 81-83). These three compositions—and only these three—are distinguished by large numbers of eight-petaled flowers at the focal points of their designs, that is, by inclusion of the same flower that occurs in the Throne Apse, most likely right under the throne. They may therefore very well have marked significant stations in the ceremonial approach to the throne in royal audiences—those near the porch as a stage where one was first exposed to the exalted view of the enthroned prince in Exedra V and then one in front of the throne itself, on the mosaic carpet covering the passage to the palace and to the special audience room.

Rosettes—like the ubiquitous fleur-de-lis in French royal art—are also to be found in other parts of the decoration, where they may also have been intended as heraldic symbols. They are carved in stone and plaster, or they are painted.[2] Particularly important is their repetition on the entrance porch,[3] where, as we have already noted, the caliphal statue standing above two lions, originally flanked by two retainers, and the crenellations associated with Sasanian crowns and palaces (Fig. J)[4] also demonstrate the quintessential qualities of royal Sasanian symbols.

[1] Carl H. Kraeling, *Gerasa, City of the Decapolis.* New Haven, 1938, pl. LXXVIII; E. T. Richmond, "Basilica of the Nativity. Discovery of an Earlier Church," *Quarterly of the Department of Antiquities in Palestine*, vol. 5, 1936, pl. XLIV.

[2] Hamilton, *op. cit.*, figs. 34, 36a, 44, 52, 86, 116, 120, 125, 126a-i, 128, 133a-c, 135, 137, 149, 172, 177, 182, 191, 194-198, 200, 201, 206-212, 225, 241, 246, 248, 251, 253, 254, 256.

[3] *Loc. cit.*, fig. 52.

[4] Oscar Reuther, "Sasanian Architecture," *A Survey of Persian Art*, ed. A. U. Pope. London-New York, 1938-1939, vol. 1, p. 523, fig. 145.

Our growing awareness of these profuse and varied Iranian elements allows us to identify one more Sasanian feature on the porch. As it is of such a startling nature and as we wish to forestall any accusation of having overstepped the bounds of historical probability by having presented exaggerated claims of royal significance in a purely Iranian frame of reference, we shall begin by stressing once more two Iranian characteristics of the period of Hisham. First, not only Khirbat al-Mafjar but also Qasr al-Hair al-Gharbi have yielded a great deal of sculpture and decoration in stucco. This medium was unknown in Syria and Palestine before Umayyad

Fig. J. Ctesiphon. Taq-i Kisra: Stepped Crenellations with Frieze of Rosettes below (After Reuther in *A Survey of Persian Art*).

times, but it was common in Sasanian Iraq and Iran, from where the Syrian builders borrowed it, along with the technique and many of its patterns, like birds, feline animals, and various other quadrupeds.[1] Even more significant is the garb of the caliph and his two only rudimentarily preserved retainers on the porch of Mafjar's Throne Hall: they wear the trousered dress of the Iranians. At Qasr al-Hair al-Gharbi, the sculptured image of the caliph wears another form of Iranian dress, also with trousers, and a Sasanian type of crown as well.[2] In this iranophil atmosphere one idea must have struck the princely lord of this mansion with special intensity: that of the *hvarnah*, "the royal splendor," by virtue of which the Sasanian kings could legitimately wear the Persian crown and had the right and obligation to impress their subjects with their inherent and supreme majesty. Whether Khirbat al-Mafjar was built for the fourth son of Abd al-Malik, Hisham who had seen three brothers ascend the caliphal throne

[1] Hamilton, *op. cit.*, pp. 156-157, 239.

[2] Schlumberger, "Les Fouilles de Qasr el-Heir el-Gharbi...," pl. XLVI, 1.

before him and still another caliph, Umar ibn 'Abd al-Aziz,[1] or whether (as seems more likely) it belonged to the long-time heir apparent Walid ibn Yazid, it must have given its owner great personal satisfaction to uphold the doctrine of the divine right of kings, with its assurances of succession and legitimate royal claim. Even more satisfying must have been the opportunity to express one's title and privilege at a very conspicuous place and within the framework of all the other official trappings of royalty.

On this premise we refer to an account in the Pahlavi book of *Karnamak-i Artakhshatr-i Papakan*, composed about A.D. 600, which mentions another transfer of the divine *hvarnah* from one dynasty to another. It deals with the flight of Ardashir from Ardavan's court, together with a beautiful and wise maiden, called Gulnar by Ferdowsi:

> Thereupon Ardawan equipped an army of 4,000 men and took the road towards Pars after Artakhshir. When it was mid-day he came to a place by which the road to Pars passed, and asked, "At what time did those two riders whose faces were set in this direction pass by here?" Then said the people, "Early in the morning, when the sun rose, they passed by swiftly... and a very large ram ran after them, than which a finer could not be found. We know that already ere now he will have put behind him a distance of many parasangs, and that it will be impossible for you to catch him." So Ardawan tarried not there, but hastened on. When he came to another place, he asked the people, "When did those two riders pass by?" They answered, "To-day at noon did they go by... and a ram ran after them." Then Ardawan was astonished and said, "Consider: the two riders we know, but what can that ram be?" Then he asked the Dastur (priest), who replied, "That is the Kingly Splendour...; it hath not yet overtaken him, but we must make haste; it is possible that we may catch them before it overtakes them." Then Ardawan hastened on with his horsemen. On the second day they had put behind them seventy parasangs: then a caravan met them. Ardawan asked the people, "In what place did you meet those two riders?" They replied, "Between you and them is still a distance of twenty parasangs. We noticed that beside one of those riders a very large and mighty ram sat on the horse." Ardawan asked the Dastur, "What signifies this ram which is beside him on the horse?" He answered, "May'st thou live for ever! The Royal Splendour [*khurrak-i-Kayan*, the *hvarnah* of the Avesta, and Ferdowsi's *farr-i-kayani*] hath overtaken Ardashir; in no wise can we now take them captive. Therefore weary not yourself and your horsemen more, nor further tire the horses, lest they succumb. Seek in some other way to prevail against Artakhshir." When Ardawan heard this, he turned back and betook himself again to his home.[2]

[1] F. Gabrieli, "Hishām," *The Encyclopaedia of Islam*, Second edition. Leyden-London, 1967, vol. 3, p. 494.

[2] E. G. Browne, *A Literary History of Persia*. Cambridge, 1929, vol. 1, p. 143.

This myth of the ram as the embodiment of the hvarnah was still alive in Ferdowsi's time, and he gives a similar account of Ardashir's flight. Let us quote only the passage in which the king asks about the two fugitives and receives an interpretation of the answer from his counselor:

Answered one, "Yea, hard by on the road here,
Forth to the plain fared two with their horses,
And at the horses' heels galloped a wild sheep *(ghorm-i pāk)*,
Which, like the horses, hurled dust-clouds behind it.

Then quoth King Ardawan to his adviser,
"What was this mountain-sheep *(ghorm-i bārī)* which ran behind them?"
Answered the other, "That Royal Splendour *(farr)*
Which, by his lucky star *(nīk-akhtarī)*, leads him to kingship *(shāhī)*."[1]

With this lore in mind let us now look once more at the porch that leads to the splendid audience hall. Indeed we find not only the caliph at the highest point but also on each side of the panel "a row of bearded rams or ibexes," the same type of "ram" that so often appears in Sasanian art, on silver plates (Fig. 84), silks, and stuccoes (Fig. 85), and that is here obviously meant to stand as a symbol of the hvarnah. Hamilton sensed this point:

...the presence and prominence of the statues, of the lion pedestal and of the ibexes (actually, they are mountain sheep), both attributes of royalty and both implying it would seem, an owner of princely rank, are factors of direct consequence for the historical interpretation of the building.[2]

Of course, on a more immediate level these animals did suggest the royal hunt, a theme often depicted on Sasanian silver plates. On an even less profound level they must have been regarded as mere decoration. For the onlooker who understood the meanings of the caliph in Persian dress and the suspended qalansuwa, however, this additional allusion to divine kingship must have been perfectly clear.

These rams appear once again, more ambiguously, at the bottom of the drum on which the dome of the porch rests. There they are combined with the effigies of athletes and female dancers, allusions both to royal aspirations and to royal pastimes. The theme of the hvarnah is thus strongly stated both outside and inside the porch, to be echoed by other related symbols inside the main part of the building.

The strong royal associations of the Main Hall and its porch dictate renewed examination

[1] *Loc. cit.*, pp. 144-145; see also *The Shāhnāma of Firdausī*, tr. A. G. Warner and E. Warner. London, 1912, vol. 6, pp. 220-223; the *Burhān-i Qāṭiʿ* (Tehran, 1332-33, vol. 3, p. 1406) explains *ghorm* as *mīsh-i kūhī* or *gūsfand-i mādeh-yi kūhī*, that is a female mountain sheep (ewe) or mouflon. The adjective "bārī" in the second use of *ghorm* means "royal."

[2] Hamilton, *Khirbat al Mafjar*, p. 102.

of the small side room in the northwest corner, called the Diwan. It was apparently used for private audiences, so that the combination of a large official Throne Hall and a small, more intimate diwan corresponds already to the *divan-i 'amm* and *divan-i khass* of later Persian and Mughal palaces (the general and special audience halls).

The best starting point is the mosaic floor in its apse, which Hamilton had already in 1950 characterized as "unique amongst Palestinian floors both in subject matter and in artistic perfection." It shows a large apple or quince tree; to its left are two gazelles eating leaves, and on the right a ferocious lion has just leaped onto the back of a third gazelle, which tries frantically but unsuccessfully to escape (Fig. 58). Again we must ask ourselves whether or not there is a particular significance in this theme. Scenes with peaceful animals and attacks by ferocious beasts were, of course, common in Roman and Byzantine mosaics. They occur, for instance, in the mosaics of the Great Palace in Constantinople, now attributed to the third quarter of the sixth century,[1] and in those at Antioch.[2] The motif originated, however, in the ancient Near East; in particular, the theme of the lion killing a weaker animal had been current there for millennia, apparently with royal connotations. These connotations are apparent, for instance, on the embroidered tunic of Ashurnasirpal II,[3] on the shield of Sargon II,[4] and among the reliefs at Persepolis.[5] The theme continued in use for many more centuries and occurs, in the form of a lion killing a bull, on a Sasanian silver plate within a larger zoological series that has obvious royal connotations.[6] Later a lion killing a camel appeared on the formal robe made for King Roger II by Arab artisans in Palermo in 1133-1134,[7] and a similar rendering occurred as late as 1578 on the seal of the Ottoman Grand Vizier Qara Oweis Pasha.[8]

This long history poses the question whether the representation at Khirbat al-Mafjar should be considered primarily a genre subject or one with symbolic meaning. As it is the only figural mosaic in the audience hall complex and the only large figural mosaic in the whole compound and as, furthermore, it paves the raised dais where the lord of the mansion would have been seated, it seems more than likely (in view of all the other royal symbolism employed in the building and, particularly, in the main Throne Apse) that this design had special significance too. This significance becomes all the more apparent when we recall that the stucco

[1] Gerard Brett et al., *The Great Palace of the Byzantine Emperors, Being a First Report on Excavations Carried out in Istanbul...*, London, 1947, pls. 33, 38, 41, 42.

[2] Doro Levi, *Antioch Mosaic Pavements*. Princeton-London, 1947, vol. 1, p. 358, fig. 147, vol. 2, pl. 174b.

[3] A. H. Layard, *The Monuments of Nineveh*. London, 1849-1853, vol. 1, pl. 9; T. A. Madhloom, *The Chronology of Neo-Assyrian Art*. London, 1970, pl. XLII.

[4] Edith Porada, "An Assyrian Bronze Disc," *Bulletin of the Museum of Fine Arts, Boston*, vol. 48, February, 1950, No. 271, pp. 2-8.

[5] Schmidt, *Persepolis I*, pl. 20; Wilber, *Persepolis*, fig. 25. About the whole problem: Willy Hartner and Richard Ettinghausen, "The Conquering Lion, the Life Cycle of a Symbol," *Oriens*, vol. 17, 1964, pp. 161-171.

[6] Orbeli et Trever, *Orfèvrerie sasanide*, pls. 26, 30.

[7] Often illustrated; good reproduction in black and white and color (detail) in Hermann Fillitz, *Die Insignien und Kleinodien des Heiligen Römischen Reiches*. Wien-München, 1954, figs. 23, 24.

[8] Joseph von Hammer-Purgstall, *Abhandlungen über die Siegel der Araber, Perser und Türken*. (Wien, n.d.), p. 35 (datable: 1578-1580).

sculpture of the so-called caliph, placed conspicuously within the ceremonial gateway to this very hall stands on a base guarded by two lions, indicating the lion's close association with the concept of supreme power. Beyond its decorative qualities, then, the apse mosaic in the Diwan also had a specific function: to demonstrate symbolically the irresistible power of the caliph, an Oriental theme expressed in the artistic language of the West. We may add that in the Persian-style silk in the Berlin Kunstgewerbemuseum, to which we have already referred (Fig. 47), the theme of a lion killing a gazelle appears twice on each side among the lions that form part of the main scene of the royal hunt; there must have been a specific reason for the inclusion of this particular motif. On the other hand, the unperturbed attitude of the two gazelles on the left hand side of the mosaic at Khirbat al-Mafjar suggests the reign of peace in the caliph's realm, a parallel to the zoological expression of a messianic theme in the mosaics of Antioch and elsewhere.[1] We thus find the polarity of the Islamic world view expressed in pictorial terms: the *Dar al-Islam* versus the *Dar al-Harb*, "the Abode (or Realm) of Islam" versus "the Abode of War."

Further internal proof that such an interpretation must have been intended is provided by the placement of the two animal scenes to the right and left of the person who sat in the apse. The implication is that the right represents a good and blessed condition, whereas the left has connotations of evil and damnation. Literary evidence for this suggestion is provided by the Gospel of St. Matthew (25: 31-46), which reflects local Palestinian lore drawn from a pastoral milieu:

> When the son of man shall come in his glory and all the holy angels with him, then shall he sit upon the throne of his glory. And before him shall be gathered all nations; and he shall separate them one from another, as a shepherd divideth his sheep from the goats; and he shall set the sheep on his right hand, but the goats on the left. Then shall the king say unto them on his right hand, Come ye blessed of my Father, inherit the kingdom prepared for you from the foundation of the world... then shall he say also on to them on the left hand, Depart from me, ye cursed into everlasting fire, prepared for the devil and his angels... and these shall go away into everlasting punishment; but the righteous into life eternal.[2]

This parable of placing the good on the right and the bad on the left eventually found its proper pictorial realization. It suffices to mention just two cogent comparisons. The earlier, more telling example occurs on the cover of a late third century sarcaphogus in the Metropolitan Museum (Fig. 86). In a landscape indicated by trees Christ turns to the sheep and goes so far as to place his right hand upon the head of the first animal, thus indicating his approval and acceptance of the evenly and peacefully rendered group. But his raised left hand strongly

[1] Levi, *Antioch Mosaic Pavements*, vol. 1, pp. 318-319, vol. 2, pl. 72.

[2] Consider also the phrase: "Sedet ad dexteram Patris" in the *Gloria* and *Credo* of the Mass.

implies rejection, as the first goat understands clearly; it shies back as the other more un-evenly placed animals lower their heads in defiance.[1] A briefer, more formalized version of this theme is found in a mosaic at S. Apollinare Nuovo in Ravenna (first half of the sixth century), but there color symbolism further underlines the lesson of the story. The sheep on the left have bright, white fur, and they are accompanied by a good angel whose red body suggests light; the gray goats with black spots stand before a demonic figure in a dark blue color. Christ motions to the sheep on his right, but his left arm is hidden under his garment, thus expressing his lack of interest in the animals on the left.[2] This basic arrangement of good and bad continued into the Middle Ages, as is indicated by the many scenes in which paradise and the blessed appear on the right of the enthroned Christ while hell and damnation are on his left.[3]

This same arrangement must have been at once clear to any Arab. To this day in his daily life the right hand is the proper, good and clean one, while the left is considered improper and unclean. Right and left are even significant in warding off the evil eye; when Arab boys begin to wear earrings, in order to look like girls, only the right lobe is pierced, for the left is associated with bad luck.[4]

The apse mosaic is, however, not the only piece of decoration in the Diwan that allows conceptual interpretation. In the reconstruction of the domed area just before the apse we find roundels containing winged horses applied to the four pendentives (Fig. D). As already noted (p. 14), in Sasanian and post-Sasanian art the winged horse represented the mount of the king and the vehicle of ascension, implying semi-divinity (Figs. 40-43, 47-50 and 52,). That such an idea was clearly intended is shown by the circle of birds just above the winged horses; though they seem to be only slow, low-flying partridges, they nevertheless stand here as in the arch above the painting of the enthroned prince at Qusayr 'Amra[5] for the heavens. The ultimate goal of the heavenly journey is demonstrated by yet another most unusual motif: six handsome human heads—those of young men and young women—alternately spaced between luscious acanthus leaves and surrounded by two bands of large-scale vegetal ele-ments (Fig. 87). They occur at the apex of the dome, the usual place of the *oculus*, which in the symbolic cupola paintings of the late Classical and later times indicates the "great beyond" or the domain of the all-highest divinity.[6] This oculus imagery was appropriated in the Muslim setting, so that the youthful heads and the lush vegetation may well have suggested paradise,

[1] Beat Brenk, *Tradition und Neuerung in der christlichen Kunst des ersten Jahrtausends. Studien zur Geschichte des Weltgerichtsbildes (Wiener byzantinische Studien*, Band III). Wien, 1966, pp. 38-39. I am obliged to Professor Buchthal for having referred me to this publication as well as to the mosaic quoted in the following footnote.

[2] Brenk, *op. cit.*, pp. 41-42.

[3] Professor Marvin Eisenberg kindly drew my attention to this aspect of the problem.

[4] Yedida Stillman, "The Evil Eye in Morocco," *Folklore Research Center Studies*, vol. 1, Jerusalem, 1970, p. 86; see also Martin Plessner, "New and Old Topics Relative to Left and Right," *op. cit.*, p. 107 (English resume) and p. 239-258 (in Hebrew). Plessner points in particular to Jacob's blessing of Ephraim and Manasseh (Genesis, XLVIII, 15).

[5] Musil, *Kusejr 'Amra*, vol. 2, pl. 15.

[6] Karl Lehmann, "The Dome of Heaven," *The Art Bulletin*, vol. 27, 1945, pp. 1-27.

the final abode of the blessed and the reward of the faithful, as proclaimed by the Koran. It is difficult to offer specific proof of this hypothesis. All that we can venture is to argue that such an interpretation would have fitted Muslim concepts, quite apart from the apparent general tendency in official Umayyad art to render paradise. The location and specific character of this unusual architectural decoration may very well have expressed this idea. If so, the decorations of the private reception hall would have symbolized both the aspirations for temporal power and the religious hopes of the original owner of the palace.

Before leaving this room we should examine one more composition—and a related one in the main hall—that may carry a meaning, though final judgement on this issue will remain difficult to prove. On the threshold of the Diwan and of the Throne Hall, right behind the Porch, are mosaics whose pattern, unlike those of other units, is set in a diamond-shaped frame and is therefore more eye-catching (Figs. 81 and 88). The design itself represents a knot composition, which may be more than a mere decorative theme, for such motifs were often used to ward off evil forces thought to be particularly dangerous near doorways. Knot designs were therefore frequently applied in these areas and are found even in churches. Examples whose magic function is incontrovertible are especially found in Syria and Palestine, among them being a mosaic panel in Constantine's Church of the Nativity in Bethlehem.[1] The apotropaic purpose of certain knot designs was not undermined by their occurrence with other purely decorative panels with knot designs in the same room or ensemble—as happens in the Diwan. As Ernst Kitzinger has noted, we must allow for a whole range of likely meanings, running from precise symbolism through vague associations to the purely ornamental.[2] In view of the location of the panels in the Diwan and Throne Hall, their unusual compositions and the attested existence of local beliefs in the magic power of knot designs, we must conclude that an apotropaic content for these mosaics is quite possible.

As the specific meaning of the most important unit of Khirbat al-Mafjar is now more apparent, we should say a word about the original owner of the palace compound. In spite of the fact that the intended message was one of imperial authority and omnipotence, no real evidence has been found to indicate that the palace was built for the Caliph Hisham himself, rather than by his nephew and eventual successor Walid ibn Yazid, as Hamilton assumed. We find similar imperial pretensions in the Throne Hall of Qusayr 'Amra—especially in the images of the enthroned ruler and the six kings; yet, as Sauvaget has shown,[3] the inscription above the imperial throne does not refer to a caliph. In this connection it may not be accidental that the statue of the caliph on the outside of the porch at Khirbat al-Mafjr—unlike the one at Qasr al-Hayr al-Gharbi (which is much more definitely associated with Hisham)—wears no

[1] Kitzinger, "The Threshold of the Holy Shrine...," pp. 641-642, fig. 3.

[2] *Loc. cit.*, pp. 643-644.

[3] J. Sauvaget, "Remarques sur les monuments omeyyades I: châteaux de Syrie," *Journal Asiatique*, vol. 231, 1939, pp. 14-15; Oleg Grabar, "The Paintings of the Six Kings at Qusayr 'Amrah," *Ars Orientalis*, vol. 1, 1954, p. 187.

crown. As Walid was about thirty-five years old in February 743 when he became caliph (a position that he held only a little more than a year, until April 744) and as he must have been at least in his twenties before he could build such an ambitious structure, we arrive at a date

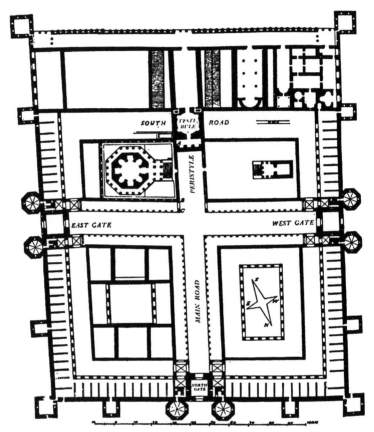

Fig. K. Spalato, Diocletian's Palace, with Large Audience Hall, Small Reception Room and Bath in the Southwest Corner. About A.D. 300 (After Kähler).

of about 730-743 for Khirbat al-Mafjar. Indeed the whole setting (though it has now been proven to be less bizarre and frivolous than was previously believed), the peculiar feature of the long, narrow plunge pool (represented in effigy in a fresco of Qusayr 'Amra)[1] and various other artistic elements all point to the libertine Walid. In a way the many iconographic features

[1] Musil, *Kuṣejr 'Amra*, vol. 2, pl. XXVI.

of the building that express the original owner's imperial aspirations seem all the more poignant.

At this point consideration of the building itself, apart from its decorations, may further illuminate its historical implications. Especially significant is the fact that the stone chain with the royal headgear is not suspended in a barrel-vaulted eyvan, as was its prototype, the precious crown of the Sasanians, in the Taq-i Kisra at Ctesiphon. In our architectural investiga-

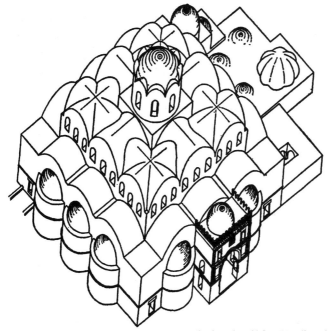

Fig. L. Khirbat al-Mafjar, "Bath Hall," Reconstructed Elevation (After Hamilton in *Levant* I).

tion it seems best to begin with the concept underlying the whole structure, then to focus on the higher core unit, and to end with a special feature thus far not found in other Umayyad monuments—the eleven exedrae and the low ambulatory on which they open.

The idea of combining a large audience hall and a smaller reception room, each with an apse at the end of its longitudinal axis (though in a different alignment) with a third complex, a bath of very limited size next to the reception chamber, had already occurred in Diocletian's Palace at Spalato about A.D. 300 (Fig. K).[1] The basic concept of the Throne Hall of Khirbat al-Mafjar therefore goes back to an older Roman prototype.

[1] Frequently illustrated, see for instance, Heinz 1965, fig. 44.
Kähler, *The Art of Rome and her Empire*. New York,

The ground plan (Fig. A) of the central group of architectural elements and various views of its elevation, especially a new bird's eye view of the exterior published by Hamilton in 1969 (Figs. F, G and L),[1] make it clear that we are confronted with a "quincunx" structure to which a low, outer ambulatory has been added. The inferences from these facts are considerable. First, the core unit, the quincunx itself, is the same type of structure that had already served as an audience hall for the Ghassanid Pylarch al-Mundhir b. al-Harith b. Jabala (569-582) in Rusafa-Sergiopolis (Fig. M).[2] Walid ibn Yazid (if indeed he was the builder of

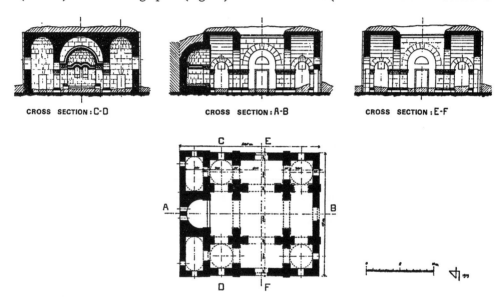

CROSS SECTION: C-D CROSS SECTION: A-B CROSS SECTION: E-F

Fig. M. Rusafa-Sergiopolis, Elevation and Plan of the Audience Hall of al-Mundhir (569-582).
(After Spanner-Guyer).

Khirbat al-Mafjar) had thus drawn upon an architectural prototype from an earlier Arab ruler of the region, an official ally of the Byzantines, who had naturally been subject to the influence of their artistic conventions. But Walid expanded the original scheme by adding the low ambulatory, the eleven exedrae, and the entrance porch. That the model had been erected in Rusafa has additional significance for our understanding of Khirbat al-Mafjar, for the former, more northern Syrian town was Hisham's residence.

More startling is Khirbat al-Mafjar's relation to Byzantine architecture. It reflects, on the

[1] Hamilton, "Who built...?" fig. 1.

[2] H. Spanner und S. Guyer, *Rusafa*. Berlin, 1926, pp. 42-44, pls. 31-32; J. Sauvaget, "Les Ghassanides et Sergiopolis," *Byzantion*, vol. 14, 1939, pp. 115-120;

Richard Krautheimer, *Early Christian and Byzantine Architecture*. Hammondsworth, 1965, pp. 188, 232-233, 246, pl. 136 B.

whole, the standard quincunx, or cross-in-square, arrangement of the Middle Byzantine church, a plan in nearly universal use from the tenth century to the fall of Constantinople (Fig. N). For the record, let us repeat its formal description:

> ...Enclosed in the outline of a square its core—the *naos*—is composed of nine elements: a tall center bay, resting on four supports, either columns or piers; a high, well-lit drum of a dome rising as a rule from pendentives; subordinate to it, four short barrel-vaulted

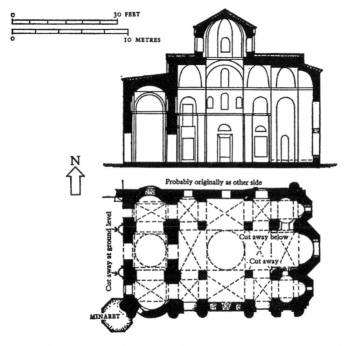

Fig. N. Plan and Elevation of a Quincunx Church with Narthex: Upper Structure of the Myrelaion Church (Budrum Cami) in Constantinople, circa 930 (After Krautheimer).

cross arms expanding in the main axes; lower in the diagonal axes, four corner bays, groin-vaulted, barrel-vaulted or domed; jointly these corner bays and the taller main dome form the five spots of the quincunx. At the same time, the term "cross-in-square" is justified by the way in which the arms of the cross issue from the center bay and meet the outer square of the structure. Three apses project from the naos. The core is at times enveloped by a narthex, by lateral open porticoes or by closed side chapels (parekklesia).[1]

[1] Krautheimer, *op. cit.*, p. 245.

As Hamilton is convinced of the correctness of his reconstruction,[1] on the basis of careful consideration of his finds, and as in his publications he does not concern himself with this Byzantine aspect of the monument—a connection which otherwise might have influenced his reconstruction of the Throne Hall—we have no reason to question his design. As it now appears, the Throne Hall has indeed the "steep, lithe elevation" that Richard Krautheimer finds so characteristic of the later quincunx churches, and the internal composition is in both cases identical (with the possible exception of the groin-vaulted corner bays, which in Khirbat al-Mafjar were not lower but as high as the intermediary barrel-vaulted bays). The Throne Hall of Khirbat al-Mafjar may, therefore, constitute the missing link between al-Mundhir's hall at Rusafa (and the much earlier quincunx structure of A.D. 180 at Musmieh in Syria)[2] and

[1] Upon my inquiry Mr. Hamilton was kind enough to give me the following information about the reconstruction of what was then still called the "Bath Hall" (letter dated April 9th, 1970):

"The reconstruction hazarded in *Levant* I is, in fact, based in all respects but one on the theoretical reconstruction that Corbett and I arrived at, piecemeal, in the book. I think on the whole the essential articulation of the superstructure is reasonably well based on physically extant data.

(1) Was the "ambulatory" lower? Another form of the same question would be: "Did the high walls containing the outer windows (pp. 70-5) really rest on arches connecting the 16 piers and not on the peripheral walls?" We were convinced, in excavation, that the high walls we were finding had in fact fallen from the central square (9 bays) and not from the outer walls. I am not really sure now whether this could be rigorously proved; but I believe if the outer walls had been carried up high enough above the exedra arches to contain windows, we could not have failed to detect this in the way the masonry had fallen. Furthermore, I believe the plan must confirm our interpretation. For if the system of vaulting (outside the central dome) had been carried at a uniform height across the ambulatory to the outer walls, I do not think the relatively low apsidal exedrae would have afforded the necessary abutment. Our reconstruction, on the other hand, with progressively descending vaults, makes the whole thing satisfyingly stable. In a word, to illustrate my point, I could not be persuaded that it would be safe to carry the wall which confronts you in my Plate CVI high enough *above the apses* to contain a row of large windows such as we found. That would be architectural nonsense. It follows, then, that if the high walls containing the windows belonged where I think we found them, to the middle area of the

building, they must have looked out *over* the vaults of the ambulatory, for some of them were definitely glazed external windows.

(2) "Were the inner corner elements (cross-) vaulted and the "cross" barrel vaulted"? I cannot prove that (see my pp. 74-75), but have merely chosen it as a logical and simple arrangement barrel-vaults over oblong compartments, cross-vaults over squares. Further, it amuses me to imagine that the cruciform arrangement of mosaic floors vertically below those corners reflected a crossvault above, but that, I admit, is no more than a private fancy.

The detail in which my *Levant* reconstruction of the bath differs from that in the book is in the central dome. I am now convinced that the three pendentives of which we found remains (pp. 79-81) must have been the survivors of eight, not just four. A reconstruction with eight lunettes biting into the lower part of the dome fits the facts better, I now believe, than the four suggested in figure 36. As usual we have only a small fraction of the original fabric to work from. The survival of as many as three bits of pendentives argues the existence of more than four originally, if the survival rate of other features is typical. Just one stone, for example, of figure 36a (p. 77, presumably from the substructure of the dome); just one, too, of figure 47— but what a lot it says."

[2] Krautheimer, *op. cit.*, p. 246, pl. 136 A.

the later church plans, of which the earliest, S. Maria delle Cinque Torri at San Germano near Cassino, dates to 778-797, and the next to the ninth century. It seems significant that all three of the earliest quincunx buildings are in Syria or Palestine and that two, and possibly all three, had the same secular character. How this type was then converted into a church plan is still an unsolved problem which does not concern us here. In any case, it seems to present a curious parallel to the earlier adoption of the secular basilica for ecclesiastical purposes.

More than has been recognized so far, Khirbat al-Mafjar contributes to our general understanding of early Muslim architecture. Let us first consider the earliest preserved congregational mosque, the Great Mosque of al-Walid I in Damascus, constructed in 705-715 (Fig. O). It is the only early hypostyle mosque whose wider axial nave was built with a dome in its *center*; even though the present dome dates only from 1082, there was an earlier, possibly wooden, dome at the same spot in al-Walid's time.[1] The mosque thus has, despite the broad, rectangular orientation of its sanctuary, a centralizing feature, in the form of a dome. In this respect its main parallel is the Throne Hall at Khirbat al-Mafjar, though the feature is prefigured in al-Mundhir's hall at Rusafa (and also in the audience hall of Kharaneh).[2] There are, furthermore, three mihrabs in the same mosque, of which the one at the end of the central nave is larger than those flanking it, a tripartite feature that is again most unusual for a mosque (though it was later adopted in certain Egyptian mosques modeled after the one in Damascus). Now, as various Arabists have shown, the word "mihrab" in pre-Islamic and early Islamic texts has the primary connotation of "niche as throne recess or princely seat.[3] It thus applies to Exedra V at Khirbat al-Mafjar as well. Do these archaeological and philological considerations not justify the belief, already strongly supported by Sauvaget,[4] that in that early period the mihrab was also a symbol of supreme authority, especially appropriate in the main mosque of the capital?

Such a belief is not contradicted by the fact that in the Mosque of Madina of 706-710 the mihrab marked the place where the Prophet had performed the ritual prayer.[5] This religious association seems to have been purely local, for there is no sign that it was consciously transferred to other mosques. Indeed the mihrab was at first rejected as the least holy place,[6]

[1] Creswell, *Early Muslim Architecture*. Second edition, vol. 1, part. 1, pp. 167-168.

[2] Sauvaget, *La Mosquée omeyyade de Médine*, p. 128, fig. 17.

[3] N. Rhodokanakis, "Zur semitischen Sprachwissenschaft," *Wiener Zeitschrift für die Kunde des Morgenlandes*, vol. 25, 1911, pp. 71-78; Josef Horovitz, "Bemerkungen zur Geschichte und Terminologie des islamischen Kultus," *Der Islam*, vol. 16, 1927, pp. 260-263 with references to other earlier investigations. See also Sauvaget, *op. cit.*, pp. 145-149; R. B. Serjeant, "Mihrāb," *Bulletin of the School of Oriental and African Studies*, vol. 22, 1959, pp. 439-453 (and Creswell, *op. cit.*, vol. 1, part 1, p. 148.)

[4] Sauvaget, *op. cit.*, pp. 145-149.

[5] Sauvaget, *op. cit.*, p. 117; Henri Stern, "Les Origines de l'architecture de la Mosquée omeyyade à l'occasion d'un livre de J. Sauvaget," *Syria*, vol. 28, 1951, p. 272.

[6] C. H. Becker, *Islamstudien*. Leipzig, 1924, vol. 1, p. 439 with all Arabic references. This particular chapter "Zur Geschichte des arabischen Kultus," appeared first in *Der Islam*, vol. 3, 1912, pp. 374-399.

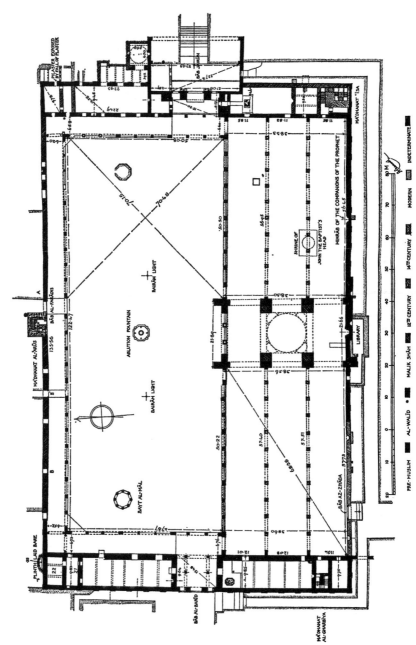

Fig. O. Damascus, Plan of the Great Mosque Built by al-Walīd I (705-715) (After Creswell).

a comprehensible reaction to the use in mosques of the mihrab, since it was conceptually connected with a secular ruler, be he pagan (as in Trier and Piazza Armerina) or Muslim (as in the slightly later Khirbat al-Mafjar), and also because of its connection with a church. It would have been less unacceptable had it been widely associated with the Prophet, yet even then the temporal role of the Prophet as the head of the new Muslim state might very well have merged with the secular concept of the throne recess. That our linking of the Mosque of Damascus with a palatial unit (such as the one at Khirbat al-Mafjar) is not far fetched is supported by the fact that the closest parallel to its facade is that of the "Palatium" of Theodoric as depicted in a mosaic of S. Apollinare Nuova.[1]

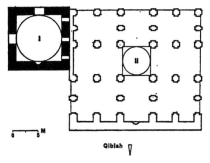

Qiblah

Fig. P. Partial Plan (Reconstruction) of the Shrine-Complex of Turbat-i Shaikh Jam Showing the Domed Funerary or Memorial Mosque of 1236 and the Old Masjid-i Jami' of the First Third of 14th Century (After L. Golombek in *Iran*).

While the Great Mosque of al-Walid in Damascus represents a near contemporary parallel for important aspects of the Throne Hall of Khirbat al-Mafjar, this Umayyad building nevertheless also shows pronounced dissimilarities, particularly with regard to its broad rectangular shape which forms such a contrast to the near-square form of the Palestinian structure. This different character may possibly be explained by the fact that the Damascus Mosque represents, so to speak, a cross of the old Byzantine-Arab Throne Hall with a church of the usual *Langhausbau* scheme which has been turned 90 degrees to face Mecca.[2]

There is, however, some evidence that a true "Mafjar type of mosque"—of near square shape, hypostyle structure, with a dome over the wider central aisle and lacking a co-ordinated, developed court—did exist, although we have now only a rather late example in a ruined condition, the Old Masjid-i Jami' of the first third of the fourteenth century found within

[1] Creswell, *Early Muslim Architecture*. Second edition, vol. 1. part 1, fig. 102; see also Ejnar Dyggve, *Ravennatum palatium sacrum*, Copenhagen, 1941.

[2] Creswell, *Early Muslim Architecture*. Second edition, vol. 1, part 1, pp. 17-22 (with bibliography) and fig. 8.

56 THE THRONE AND BANQUET HALL OF KHIRBAT AL-MAFJAR

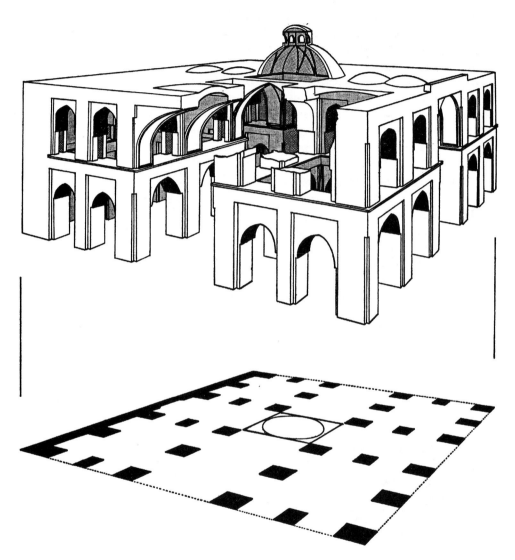

Fig. Q. Reconstruction of Elevation and Plan of the Old Masjid-i Jami' of Turbat-i Shaikh Jam (After L. Golombek in *Iran*).

the Turbat-i Shaikh Jam complex, halfway between Mashhad and Herat (Figs. P and Q). The reconstructions by John McCool of 1938 as published by Donald N. Wilber[1] and the more recent one of Lisa Golombek of 1966[2] both agree on these basic features, so that we are, here, in the far-away conservative setting of a shrine dedicated to a saint, apparently faced with an only slightly modified survival of an early mosque type. But if this is so and we can therefore assume that other such mosques existed in earlier times we are entitled to ask ourselves whether the Anatolian hypostyle mosque of the thirteenth to the fifteenth century with the central element of an "inner court" distinguished by an opening in the roof or covered by a lantern or dome is not possibly a variant in a marginal region of the hypostyle mosque with a central dome, or was at least inspired by it. For the time being we have, however, to be satisfied with having raised this question. We are unable to come to more definite conclusions at this time, as no monuments prior to 1200 are known.

There is still another mosque type—so far unexplained—which may owe its original formation to structures like the Throne Hall of Khirbat al-Mafjar. Although the connecting links are still unknown to us, there seems to be a specific relationship between the Audience Hall and the unusual square, nine-bay mosque, of which nine examples, dated from the first half of the ninth century to 1159, have been found in Egypt, Iraq, Tunisia, Spain and Central Asia (Fig. R).[3] The prototype for this group has so far escaped detection, but could it not be a building on the order of the core unit at Khirbat al-Mafjar (see the indicated core unit in Fig. A)? Certain features have changed, it is true. The bays, which were originally of different sizes, are now of uniform dimensions, the varied roofing has been equalized to nine domes, and there are more exits. The basic elements—the square shape, the nine bays, the arcades on pillars or columns, and the absence of a courtyard—are, however, still present. Even a secondary feature like the triple front entrance occurs occasionally in the mosques, where this feature is equalized in comparison to the more varied Umayyad arrangement. The mysterious

[1] D. N. Wilber, *The Architecture of Islamic Iran, The Il-Khānid Period*. Princeton, 1955, p. 174, pl. 172, fig. 52.

[2] Lisa Golombek, "A Thirteenth Century Funerary Mosque at Turbat-i-Shaykh Jam," *The Bulletin of the Asia Institute*, Nr. 1, 1969, pp. 13-18, Figs. 1, 3 and 4; *idem*, "The Chronology of Turbat-i Shaikh Jām," *Iran, Journal of the British Institute of Persian Studies*, vol. IX, 1971, pp. 28, 32-34, Figs. 1-3, pl. IV.

The Turbat-i Jam plan actually represents a refinement on the original Mafjar plan. Here the dome has a logical place within the structure as it is placed over the crossing of the wider central aisle leading to the mihrab and the "transept" running across the middle of the hypostyle hall. In this

fashion the placing of the dome would be a parallel of the dome over the crossing of the wider central nave and the wider arcade in front of the qibla wall found in the T-shaped mosque.

[3] Golombek, "Abbasid Mosque at Balkh," *Oriental Art*, vol. 15, 1969, pp. 13-16; A. S. Melikian Chirvani, "La plus ancienne mosquée de Balkh," *Arts Asiatiques*, vol. 20, 1969, pp. 3-9; this type eventually recurs in Ottoman architecture (Eski Cami of Edirne, begun 1402 and Mosque of Çelebi Sultan Mehmed of Dimetoka, 1421, or in modified form in the Mosque of Bīyĭklĭ Mehmed Paşa of the early 16th century and even in Sinan's Şehzade Mosque of 1548, both in Istanbul, see A. Kuran, *The Mosque in Early Ottoman Architecture*. Chicago-London, 1968, figs. 220, 221, 233, o and s).

nine-bay mosque type can therefore be regarded as a later, more standardized version of the core unit of Khirbat al-Mafjar.[1]

Finally, there is a genetic connection between a specific architectural feature of Khirbat al-Mafjar and of later buildings. The monumental projecting porch does not occur in mosque architecture until the Great Mosque of Mahdia, built about 916.[2] It may very well have been suggested by the porches of secular structures, though these latter have long since disappeared. Yet that they must have existed is suggested by the Porch of Khirbat al-Mafjar.

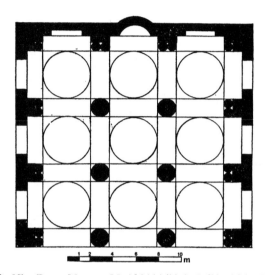

Fig. R. Typical Plan of a Nine-Dome Mosque: Masjd-i Ta'rikh in Balkh, Afghanistan. First Half of Ninth Century (Reconstruction L. Golombek).

Turning now to the outer, enveloping parts of the Throne Hall and its function, we realize once more how complex they must have been. The Byzantine type of ambulatory seems hardly to have served the usual purpose of permitting circulation around the core unit, for the pool on the south side made complete circumambulation impossible. Rather it provided

[1] Examples of nine-bay churches in the Latin West are the Oratory of Germigny-des-Prés of 806 (see K. J. Conant, *Carolingian and Romanesque Architecture*. Baltimore, 1959, pp. 16-17,—where the author points to the connection with Musmieh— fig. 2, pls. 4 and 5) and the "Bishop's Chapel" in Hereford of 1079-95 (G. Bandmann, "Die Bischofskapelle in Hereford," *Festschrift für Herbert von Einem*, ed. G. v.

d. Osten. Bonn, 1965, pp. 9-26. The nine-bay theme is also to be found in the fifteenth century synagogue of Tomar, Portugal (J. M. Santos Simões, *Tomar ea sua Judaria*. Tomar, 1943, pl. 3).

[2] G. Marçais, *L'Architecture musulmane d'Occident. Tunisie, Algérie, Maroc, Espagne, Sicile*. Paris, 1954, p. 106, fig. 64.

Fig. S. Plan of Palace Compound of Antiochos in Constantinople Showing in the Northeast Corner the Triclinium with the Added Six Apses of the Sixth Century (After Naumann).

access passages from the private palace entrance to the Throne Apse and Diwan and from the Entrance Porch to the Bath and latrines. If our hypothesis that spectacles were held within the Throne Hall and viewed by its lord from a seat on the central mosaic is correct, these passages could also have served for preparations and spectators.

The eleven half-round exedrae, which on three sides project beyond the walls (and on the fourth abut into the masonry of the adjacent Bath) and of which the one opposite the central entrance is larger, suggest an additional function. Wall niches were, of course, a feature of Roman and Byzantine audience halls, but they seem usually to have been concave elements in the walls themselves. Projecting apses occurred in the Imperial thermae, like that in Trier

Fig. T. Plan of Lateran Palace with Triclinium before 1588 (After Krautheimer, based on Lauer).

dated about 300 A.D.,[1] but their alignment is different from that at Khirbat al-Mafjar. They also served different functions within the three basic units of the actual bathing compound. The closest Khirbat al-Mafjar approaches to this plan is in the eight apses in Room D, the caldarium. Still, it seems significant that the architectural ensemble of the thermae had such semicircular projections.

There is yet another type of building with protruding though regularly spaced apses in which the central one is more prominent: the Byzantine or late Roman triclinium, which served for state banquets and receptions. The earliest surviving example is a building of the

[1] Kähler, *op. cit.*, fig. 40; M. Wightman, *Roman Trier and the Treveri*. London, 1970, pp. 98-102, figs. 6 and 9; H. Mylius, *Die römischen Heilthermen von Baden-weiler*. Berlin-Leipzig, 1936, fig. 14, pls. 1-2, 9.

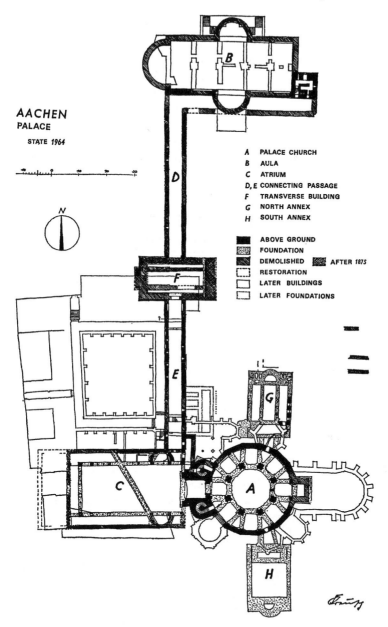

AACHEN
PALACE

STATE *1964*

A PALACE CHURCH
B AULA
C ATRIUM
D, E CONNECTING PASSAGE
F TRANSVERSE BUILDING
G NORTH ANNEX
H SOUTH ANNEX

ABOVE GROUND
FOUNDATION
DEMOLISHED AFTER *1875*
RESTORATION
LATER BUILDINGS
LATER FOUNDATIONS

Fig. U. Palace Compound of Aachen (Aix-la-Chapelle) with Throne Hall—Aula Triclinium—in the North (Marked B on Plan; the Inner Cross Walls of the Triclinium are Later Additions) (After Naumann).

early fifth century next to the Palace of Antiochos in Istanbul.[1] Originally this long, narrow structure had only a large central apse at one end, but in the sixth century three protruding apses, or *akkubita* (diwans), were added to each of the long side walls (Fig. S). Of the same type, but a later date, is the triclinium built about 800 by Leo III in the Lateran Palace in Rome (Fig. T); beside the central exedra, it had five projecting apses on each side and, as does Khirbat al-Mafjar, a porch and a passage connecting it to the palace as well.[2] This architectural type recurred, though in a reduced fashion, even in Aix-la-Chapelle, where two single apses flank the throne exedra, and a porch and a passage lead to the palace (Fig. U).[3] The probable prototype of this genus is the *Decanneacubita*, a triclinium of nineteen divans (or of one central and eighteen side exedrae), in the Imperial Palace compound in Istanbul, which, according to Krautheimer, was probably built in the late fourth or early fifth century and possibly even in the period of Constantine.[4] That Khirbat al-Mafjar does not have the long, narrow space typical of the buildings in Istanbul, Rome and Aix-la-Chapelle suggests that its architectural scheme was deliberately adapted to the requirements of the square audience hall, which was of basic importance. Additional niches were thus added at the sides and opposite the throne exedra, and it is also possible that the ambulatory served a related purpose. How far these special possibilities for banqueting were actually used is a different and more difficult question. That the only pictorial mosaic in the Audience Hall depicts a fruit for whose consumption a knife was needed lends further weight to the theory that one of the functions of the Hall was as a feasting room; the existence of these *akkubita* thus suggests still one more facet to this complex building which apparently had to serve many functions.

To sum up, then, the coordinated multipurpose arrangement of the Throne Hall complex at Khirbat al-Mafjar is Roman, but the building itself is Byzantine, representing an elaboration of an architectural type used by earlier Arab chieftains in Syria. The floor mosaics are also of Roman and Byzantine derivation. Technically and artistically they are exceptionally fine and surpass in most instances the work done for the churches of the region. Although the range of figural motifs is very limited, they approach in quality even the work done in the

[1] Rudolf Naumann, "Vorbericht über die Ausgrabungen zwischen Mese und Antiochus-Palast 1964 in Istanbul," *Istanbuler Mitteilungen*, vol. 15, 1965, pp. 135-148; Rudolph Naumann—Hans Belting, *Die Euphemia-Kirche am Hippodrom zu Istanbul und ihre Fresken*. Berlin, 1966, pp. 15-23, fig. 1. I am much obliged to Mr. S. Ćurčić for his comments about the buildings mentioned in this and the following two footnotes.

[2] Richard Krautheimer, "Die Decanneacubita in Konstantinopel. Ein kleiner Beitrag zur Frage Rom und Byzanz," W. N. Schumacher ,(ed.), *Tortulae, Studien zu altchristlichen und byzantinischen Monumenten*

(Festschrift Johann Kollwitz). Rom-Freiburg-Wien, 1966, pp. 197-198. See also Ph. Lauer, *Le Palais de Latran*. Paris, 1911, pp. 101-107, pl. XXXV. Here the triclinium functioned also as reception hall and council chamber.

[3] Felix Kreusch, "Kirche, Atrium und Portikus der Aachener Pfalz," *Karolingische Kunst*, ed. Wolfgang Braunfels und Hermann Schnitzler. Düsseldorf, 1965. vol. 3, fig. 1 opposite p. 464. Here the triclinium-like structure had probably the main function as "aula" or throne hall (*loc. cit.*, p. 307).

[4] Krautheimer, *op. cit.*, pp. 195-199.

Imperial Palace of Constantinople. The decoration of the walls and particularly the stuccoes is, however, Iranian, both in technique and in imagery. This observation is not contradicted by the fact that certain designs from the Iranian repertory originally came from the West. The symbolism used is clearly Oriental and specifically Iranian.

We can therefore say that the structure and what belonged to the floor were Western, more specifically Byzantine, whereas the wall decorations and most of the iconography were Iranian. Three further conclusions suggest themselves. First, the basic Byzantine and Sasanian elements co-exist here as "equal but separate" entities; there seems thus to be no true inter-mingling of the two strains, only a skillful co-ordination. One reason for this may possibly have been that the local Palestinian or Syrian masons were not able to construct a major vaulted hall on the order of the Taq-i Kisra at Ctesiphon, the original setting of "the suspended crown." Secondly, while the architecture itself is due to functional considerations—of which the wish to impress and present a grandiose and luxurious setting for major ceremonial occasions was just one aspect—the decorations at the Porch, Throne Apse and elsewhere were meant as proclamations of the owner's special pretentions and general ideas. As such they reflected his self image which centered around imperial ambitions, but they also presented his world view which ranged from beliefs in evil spirits and the means of their magical entrap-ment, to a preference for Persian costume, and included even a value judgement of war and peace. Finally, it can be said that while the whole setting and imagery is pre-Islamic, the way in which the various features were impressively combined is both novel and a specific Umayyad achievement. It is also noteworthy that in this complex, concerted effort, the new religious ideas reveal themselves, if at all, in only one place and then in the spatially more limited and private Diwan.

The strong emphasis on the Iranian element may come as a surprise, considering that the building was erected in territory with a long-standing Byzantine tradition, in which the Umayyads had established a successor state to the East Roman Empire. We should, however, realize that it was just during the reign of Hisham that the Arab government grasped that the various efforts to conquer the heartland of the Byzantine Empire in Anatolia and Europe, and particularly the capital at Constantinople, had failed; it therefore turned toward Iraq and the East.[1] This shift went beyond a mere political reorientation and seems to have affected the whole mental outlook of the caliphs. Hisham, for example, commissioned an Arabic trans-lation of a Persian illustrated history of all the Sasanian kings,[2] and we know that Walid ibn Yazid used Persian idiomatic expressions.[3] This change in the caliphs' official and personal

[1] H. A. R. Gibb, "Arab-Byzantine Relations un-der the Umayyad Caliphate," *Dumbarton Oaks Papers*, vol. 12, 1958, pp. 232-233.

[2] Mas'udi, *Kitab al-Tanbih* (*Bibl. Geogr. Arab.* ed. M. J. de Goeje, vol. 8). Leyden, 1894, p. 106;

Grabar, "The Painting of the Six Kings...," p. 187.

[3] Mas'udi, *Les Prairies d'or*, ed. et tr. C. Barbier de Meynard. Paris, 1871, vol. 6, p. 12 where he uses the Persian expression: *haft hafteh*-"seven weeks."

orientations naturally led to identifications with the "Kisra,"[1] an identification plainly reflected in the Throne Hall of Khirbat al-Mafjar. Here the integration of Byzantine with Iranian elements finds its finest expression and much of the subsequent art in Muslim lands is due to the catalytic effect of this combination.

There is, however, one further important point to be made. The data here presented established the nature and various aspects of the Throne Hall, but they also stressed the dichotomy of the structure, that is, its origins in both Classical (Roman and Byzantine) and Sasanian sources and in addition, its connection with a third historical root, the Ghassanid subculture of Syria. However the formalistic motif-by-motif, mosaic-like approach and the categories used are those of a 20th-century historian. Whether they truly reflect the all encompassing architectural concepts of the lord of Khirbat al-Mafjar is uncertain. As no detailed records are available of the Umayyad concept of architecture and in particular of this building, it may well seem impossible to be more specific about this point. Yet help can be derived from the medieval European viewpoint which to all intents and purposes appears to have had a similar notion as to the function and main aspects of architectural monuments. Richard Krautheimer[2] in his pioneering work dealt with the iconography of medieval European architecture, especially with architectural copies of revered, pivotal buildings such as the Holy Sepulchre in Jerusalem. Such a comparison is all the more warranted as the building of Khirbat al-Mafjar was obviously inspired by, possibly even endeavored to imitate a celebrated model, the Sasanian palace of Ctesiphon.

Krautheimer's research has shown that the medieval copies (of which the earliest example quoted by him dates from the early ninth century) followed certain principles. There was never an exact reproduction *in toto* of the building, only a "selective transfer" of architectural elements from the prototype to the copy, particularly of the most significant features and symbolic functions. This means that the original coherence of the structure and its proportions were given up and the essential components reshuffled and at times even further endowed with collateral features. This partial re-use usually consisted of a few basic visual features but the selection could also have been restricted to some immaterial aspects such as the mere name and the symbolic function of the original monument. This procedure resulted in "copies" which to the uninitiated have often little or no resemblance with the prototype, just as the various "copies" hardly resembled each other. Yet in using just minimal reminders the copy was apparently as effective in providing the same general content as the prototype and in arousing the same associations.

[1] Oleg Grabar, "An Introduction to the Art of Sasanian Silver," *Sasanian Silver. Late Antique and Early Medieval Arts of Luxury From Iran*. Ann Arbor, The University of Michigan Museum of Art. 1967, pp. 19-21.

[2] Richard Krautheimer, "Introduction to an 'Iconography of Medieval Architecture'," *Journal of the Warburg and Courtauld Institutes*, vol. 5, 1942, pp. 1-20; republished in *idem, Studies in Early Christian, Medieval and Renaissance Art*. New York, 1969, pp. 115-130.

What the Palestinian architect apparently meant to do was to create the local equivalent of the throne *eyvan* of Ctesiphon inasmuch as in the new Throne Hall he used as many of the Sasanian trappings as possible and in particular the all important royal headgear hung above the throne emplacement. He also chose the regional equivalent of the *eyvan* by building a wide, clearly marked central nave. These aspects, then, it may be said, were enough to create the image of Ctesiphon. Hence the differences of the visual forms, the contrast between the Byzantine structure and the symbolic Sasanian decorations, are conceptually of no real significance.

The Sasanian Throne Hall was thus recreated and further elaborated with additional features in typical *nouveau riche* fashion. Should this point of view be admissible—and there seems little reason to question it although it might be difficult to prove it—Khirbat al-Mafjar emerges as a case of true integration of the various elements used so as to serve in the most specific fashion the exigencies of the Umayyad builder.

The Throne Hall provides two additional insights of a different nature. First, the statues of the slave girls high up in the Porch are part of the courtly setting along with athletes and warriors but resemble remarkably the female figures of Dionysiac origin on the Sasanian silver vessels which were discussed in the first chapter (pp. 5-6). In both instances these images are frontal and half-nude with a cloth covering the lower part of the body; both types reveal a strongly stressed bosom; the faces show full cheeks, large eyes and long straight noses; and the arms hold flowers or fruits (compare Fig. 91 with Figs. 20-22). Thus, a motif which in Sasanian Iran had been of Classical derivation has returned as an Iranian feature to what had been Classical territory. The development has come full circle and the sacred imagery has been completely secularized. It is not, however, just this iconographic aspect which was re-imported from Persia. The introduction of singing maidens into Arab society as well as that of the boon companions (*nudama*) and of wine drinking was also of Persian origin.[1]

The second point to be made is of a more general character. As the decoration in the Throne Hall appears to a large extent to be deliberate and meaningful, other allegedly meaningless decorations, particularly in public structures, may also deserve to be studied as to whether they, too, have been purposeful and significant. This opens up a whole new field of investigation, the importance of which could carry far beyond the early Islamic period.

[1] S. D. Goitein, "Formal Friendship in the Medieval Near East," *Proceedings of the American Philosoph-* *ical Society*, vol. 115, December 1971, p. 485.

LIST OF TEXT ILLUSTRATIONS

PLATE VI

18

19

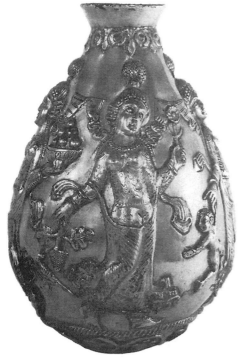

20

21

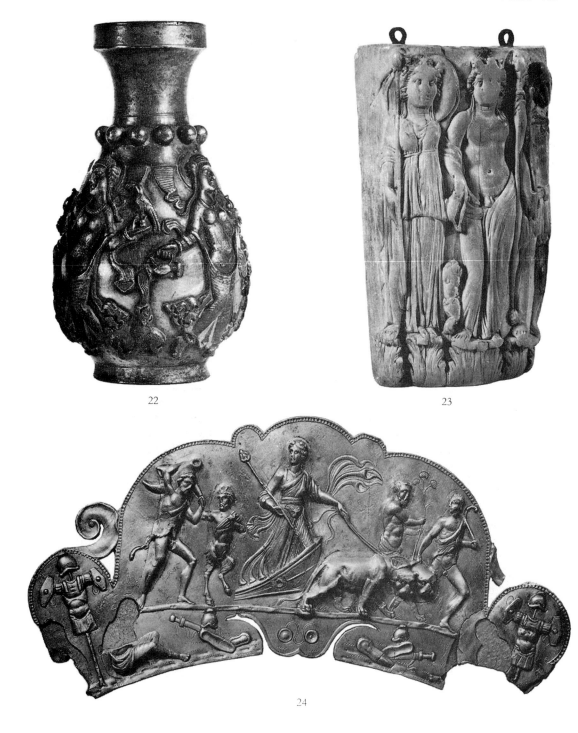

22

23

24

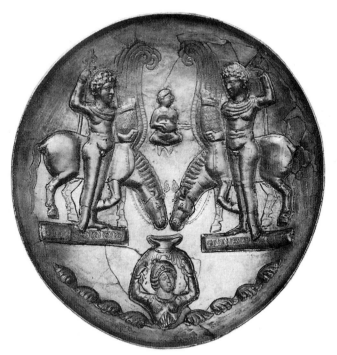

38

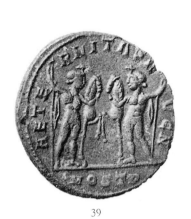

39

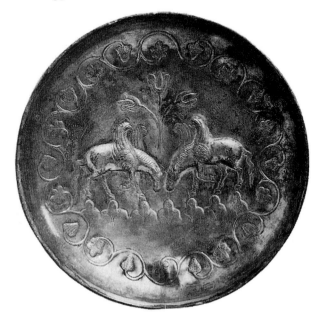

40

PLATE XII

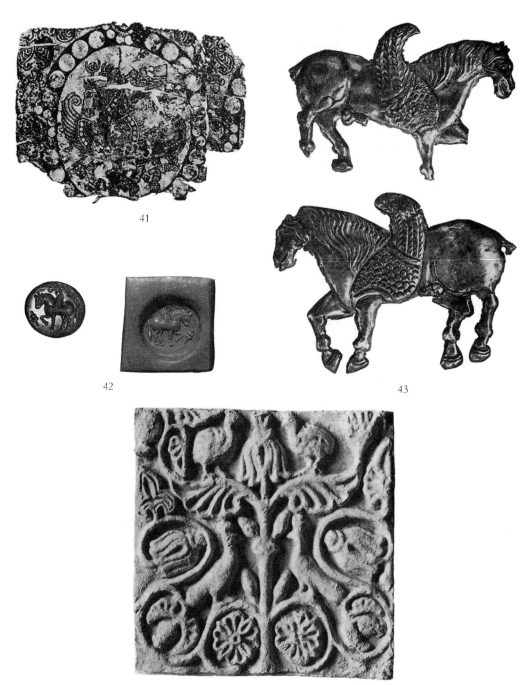

41

42 43

44

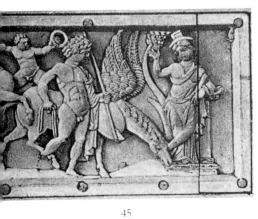

45

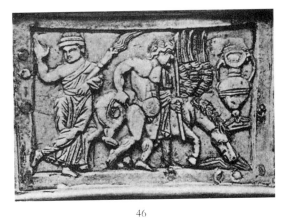

46

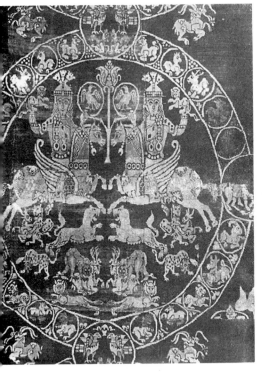

47

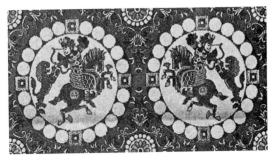

48

PLATE XIV

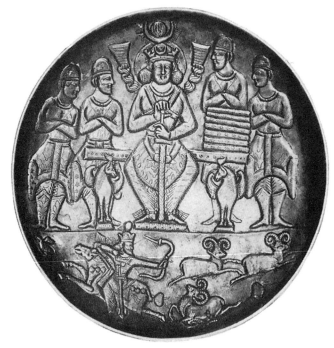

49

50

51

PLATE XV

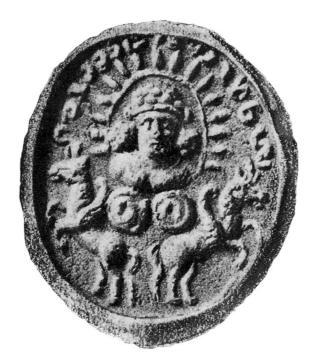

52

53

54

PLATE XVII

58

59

60

PLATE XVIII

61

62

63

64

PLATE XIX

65

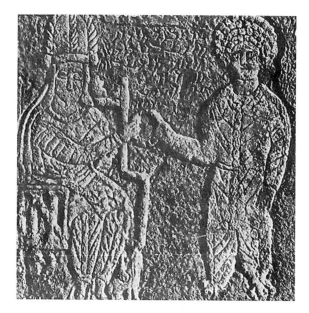

66

67

PLATE XX

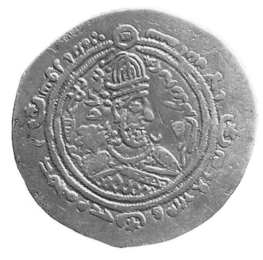

68

69

70

71

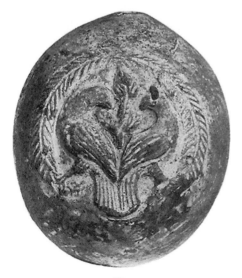

72

73

PLATE XXII

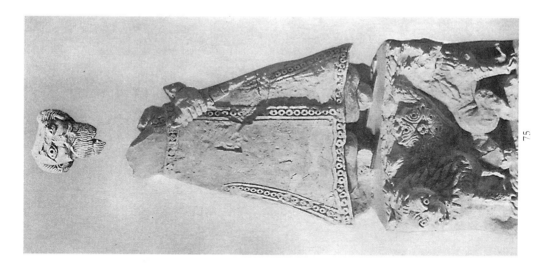

75

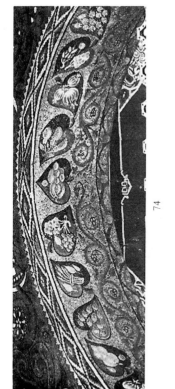

74

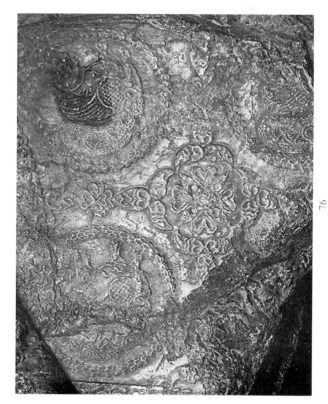

76

77

78

79

80

PLATE XXIV

81

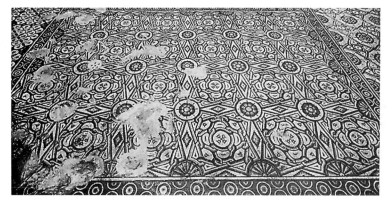

82

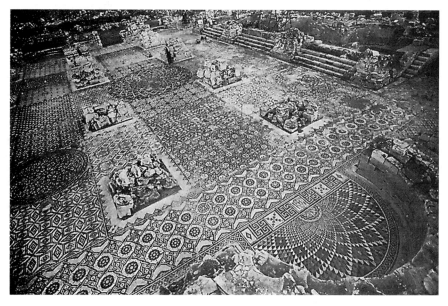

83

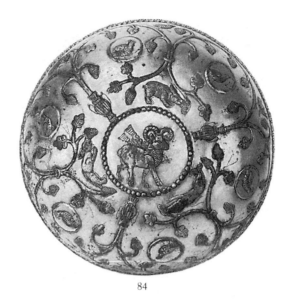

84

85

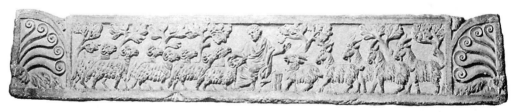

86

PLATE XXVI

87

88

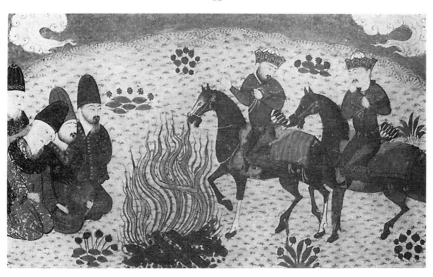

89

PLATE XXVII

90

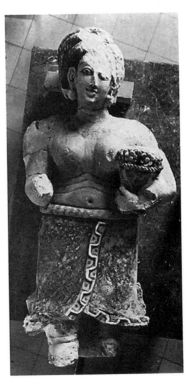

91

LA DOLCE VITA IN EARLY ISLAMIC SYRIA: THE EVIDENCE OF LATER UMAYYAD PALACES

Robert Hillenbrand

This paper discusses certain problems of interpretation posed by the residences of caliphs and princes of the Umayyad dynasty (AD 661-750) in the Syrian desert. Some typical palaces will be examined, and their functions explored, in the light of the literary sources. This will lead naturally to a detailed account of the life-style followed by the Caliph al-Walīd II, who is generally accepted as the builder of the finest Umayyad palaces. Reflections of his personality, tastes and activities are, it will be seen, legion in these buildings.

Unfortunately, the literary sources are all of post-Umayyad date and it has often been pointed out that many of them are bitterly hostile to that dynasty and therefore not entirely reliable.[1] Even where bias is not a major factor, the late date of composition may be a problem. Perhaps the principal source for Umayyad court life, the *Kitāb al-Aghānī* or 'Book of Songs' by Abu'l-Faraj al-Iṣfahānī, was written as late as c. 349/c. 960.[2] Clearly a tenth-century account of the personalities, events and customs of two centuries earlier can scarcely compete with the surviving architecture of that period as a reliable index of its aulic culture.[3] On the other hand, the literary sources can bring to bear a wealth of illustrative detail and anecdote which the architecture itself of course cannot yield. Perhaps the most successful sustained attempt to use the physical and literary evidence in conjunction with each other is that of Oleg Grabar;[4] but much remains to be done, especially by historians of the Umayyad period.[5]

The point of departure of the present paper, then, is to investigate what light can be shed on court life in Umayyad times, as described in literary sources, by some of the major surviving secular buildings in Syria which date from this period. In their generally accepted chronological order these are: Khirbat al-Minya, Usais, 'Anjar, Quṣair 'Amra, Qaṣr al-Ḥair al-Sharqī, Qaṣr al-Ḥair al-Gharbī, Khirbat al-Mafjar and Mshattā.[6] To keep the investigation within manageable bounds it seems sensible to concentrate on three of these structures which have often been attributed to al-Walīd II: Quṣair 'Amra, Khirbat al-Mafjar and Mshattā. However, the literary evidence for Umayyad court life in general has a distinct bearing on the buildings not associated with

al-Walīd II.[7] Moreover, the time span of the entire series of these buildings is remarkably short — a mere forty years or so between 705 and 744. Thus many of the conclusions that can be drawn for the buildings of al-Walīd II apply to at least some extent to other Umayyad palaces. The enquiry which follows therefore has a rather wider scope than the three buildings on which it focuses.

As a group, the Umayyad palaces are surprisingly varied in their architecture, their decoration and their appointments. This makes it all the more unfortunate that in no single case is there precise evidence as to the patron or the date, though there is general agreement that Khirbat al-Minya, Usais and 'Anjar were at least begun in the reign of al-Walīd I (705-15), that Qaṣr al-Ḥair East and West were built in the reign of Hishām (724-43) and that probably Quṣair 'Amra, Khirbat al-Mafjar and Mshattā were the work of al-Walīd II either as caliph (he reigned 743-4) or as heir-apparent.[8] This bracketing of specific buildings with specific caliphs might suggest that only some of the caliphs had a penchant for this kind of architecture, and that these caliphs had more than one such residence, a fact attested by literary sources.[9] It is perfectly possible, however, that a good many of these buildings were put up by members of the royal family other than the caliph,[10] or even by wealthy nobles or other magnates eager to ape the royal example. An inscription at Quṣair 'Amra proves as much.[11] It will be clear, therefore, that the paucity of buildings, their variety, the limited time span within which they were erected and the doubt as to whom they were built for are all factors which hamper a precise understanding of this genre of building. The texts, on the other hand, do help to explain how they were used.

The Umayyad desert palaces tend to conform to a single type. Their central feature was an enclosure roughly 70m. per side — a common Umayyad unit, based on a multiple of the Roman foot — fortified by bastions set at intervals and with a projecting entrance gateway in the centre of one side (plate 1).[12] This led into a long hall which opened into a courtyard surrounded by arcades on two tiers. Behind these lay a warren of small, pokey, ill-lit rooms. In many palaces which had two storeys, the ground floor probably served for the ruler's retinue and the upper apartments principally for himself and his family. Even the roof could serve as the *mise-en scène* of a literary symposium.[13] The wider environment of such a building is revealed in a surrounding hotch-potch of tents and buildings accommodating soldiers, Bedouin chiefs, poets and the prince's entourage.[14] Yazīd II is known to have constructed such buildings near his castle of al-Muwaqqar,[15] though no doubt it was commoner for tents to serve this purpose.

At Mshattā, on the other hand, which by general consent is the last of this series of buildings, domestic housing seems to have been ignored with positive ruthlessness,[16] even though this is the largest of the Umayyad 'castles' (plate 2). Nor was that all. In a foundation of al-Walīd II described as a city in a tenth-century text and frequently identified as Mshattā,[17] the same exclusive concern with the ruler's comfort was taken to even greater lengths, for the nearest water to the site was apparently fifteen miles away, and 1,000 camels could not bring enough water for the daily needs of the conscripted workmen, many of whom died.[18] It must be admitted that there is no sign that the area around

2

LA DOLCE VITA IN EARLY ISLAMIC SYRIA: THE EVIDENCE OF LATER UMAYYAD PALACES

Mshattā was intended to be cultivated,[19] whereas most of the Umayyad residences were set amidst expensively irrigated land. On the other hand Mshattā, measuring about 150 yards per side, though by no stretch of the imagination a city,[20] also seems too big to qualify as a typical Umayyad ḥīra or bādiya[21] — a desert encampment for occasional use with the royal dwelling at the centre. But then Mshattā obstinately refuses to fit easily into any of the categories of Umayyad architecture, perhaps because it is so prophetic of the nakedly despotic palaces associated with the early 'Abbāsid caliphs in their capitals of Baghdād and Sāmarrā'.

The casual overspill into the countryside found in many Umayyad palaces may help to explain the accent on open courtyards (presumably gardens) and on running water in a palace like al-Mafjar,[22] whose very name suggests a spring. Even in the close confinement of cities the caliphs were at pains to evoke memories of the countryside. Mu'āwiya's palace at Damascus was dubbed 'the Green One';[23] we read that it

> was paved throughout with green marble. In the middle of the court was a great fountain, flowing perpetually to water a garden of the fairest flowers, and all kinds of trees. Birds innumerable quickened and thrilled it.[24]

Gardens surrounded it even though it was in the centre of Damascus.[25] The reference here to a great fountain in the middle of a courtyard at once recalls the identical feature in the slightly later palace of Khirbat al-Mafjar (plate 3).

The variables of palatial architecture in the Umayyad period are clearly such that no one explanation of its function will suffice. The belief was held early this century that these buildings were the pleasure palaces of half-wild sons of the desert who lived a nomadic and hedonistic life loosely based on a network of hunting lodges.[26] The Umayyads, it was agreed, feared the endemic plagues of Damascus.[27] Quite apart from this, they had an inborn distaste for city life, eloquently expressed in verses spoken by Mu'āwiya's Bedouin wife in the palace at Damascus:

> A tent flapping in the desert air is dearer than this towering house;
> Wind rustling over the sandy waste hath a sweeter sound than all the king's trumpets;
> A crust in the nook of a wandering tent more relish than all these delicate cakes;
> And a noble clansman's more to my lust than the paunchy longbeards about me here.[28]

This hypothesis, perhaps because it was thought to be rather romantic, was largely discarded long ago as the principal *raison d'être* of the Umayyad residences, to be replaced by a theory which stressed the economic importance of these sites.[29] A highly organised agricultural development of the countryside had taken place in the Levant in the Roman and early Byzantine period involving massive investment in hydraulic works (plate 4). Often, the Muslims took over the rich agricultural estates thus created and continued to work

3

them; in others they built palaces at sites which could be serviced by already existing hydraulic installations. Indeed, the Caliph Hishām was reproached for digging canals and building pleasure gardens[30] rather than defending his realm.[31] But the fact that so many Umayyad palaces were abandoned unfinished suggests that the agricultural and economic importance of such sites was not paramount. Besides, is there not something faintly ironic about the master of half the world diligently cultivating a small estate as if he were a retired country gentleman?

Other explanations for these palaces might therefore be entertained. The excavations of later Umayyad palaces have disclosed decoration of hitherto unsuspected richness. These finds are enough to prove the existence of a conscious iconographic programme of royal themes, stressing not only majesty and dominion but also the pastimes of the ruler and his court.[32] The architecture and decoration alike testify to the increasing exaltation of the ruler. The buildings get bigger and bigger until they reach a scale which could not easily be accommodated in long-established cities like Jerusalem, Damascus or Aleppo. Perhaps the caliphs reasoned further that it would do their popularity no service if they paraded such secular ostentation in the major cities of Islam. Even the reckless al-Walīd II thought it prudent, having rewarded the poet Ma'bad, to caution him: 'O Ma'bad: who seeks provision from kings keeps silence on their secrets.'[33] The secret in question was presumably the spectacle of the Commander of the Faithful thrice tearing off a costly scented robe to plunge into a pool 'filled with rose-water mixed with musk and turmeric'.[34] History was parodying itself, for a song performed by this same Ma'bad had thrown al-Walīd's father, Yazīd II, into such an ecstasy that he sprang to his feet and capered around his reception hall until he fell senseless and was carried out.[35]

Such stories might encourage a fallacy that most Umayyad caliphs were libertines. The truth is, of course, more complex. But amusements that to us seem purely light-hearted also had a more practical purpose with the sanction of long tradition behind it. For example, very varied ceremonies attended the formal installation of the sovereign, an occasion at which he proclaimed his manifesto for his coming reign and held serious political discussions. Interspersed with this solemn business, however, were lengthy celebrations which comprised lavish feasts, payments in money and animals to cancel vendettas, and festivals of poetry. The whole affair took several days, for the caliph, as Lammens has shown, was the successor of the great desert chiefs and was charged like them — in the words of a contemporary poet — to keep 'brimful the buckets that slaked the thirsts of their guests'.[36]

To summarise, then, it seems likely that the Umayyads were attracted to the desert for a variety of reasons: an instinctive hankering after a semi-nomadic life, a desire to visit the agricultural estates which they had taken over or created, and finally a desire to develop a sybaritic and ostentatiously royal life-style free from the moral and spatial constraints inseparable from city life. Those caliphs with a special penchant for building had, as already noted, several such desert residences and periodically moved from one to another. None of these palaces, therefore, need be seen as the permanent seat of a given caliph.

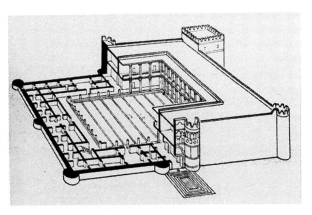

1. Qaṣr al-Ḥair West: combined plan and section
(after Leacock)

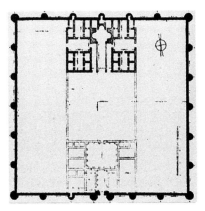

2. Mshattā: plan (after Creswell)

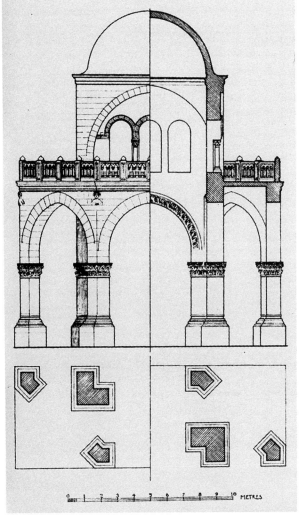

3. Khirbat al-Mafjar: fountain in courtyard
(after Hamilton)

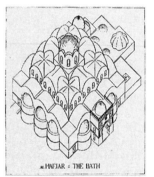

al-MAFJAR : THE BATH

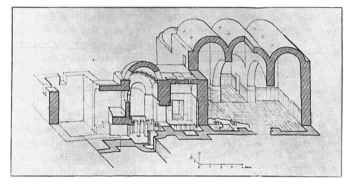

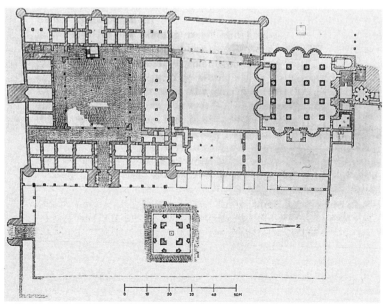

4. (top) The Habarqa dam near Qaṣr al-Ḥair West

5. (above left) Khirbat al-Mafjar: isometric reconstruction of the bath hall (after Hamilton)

6. (above right) Quṣair 'Amra: section (after Almagro)

7. (left) Khirbat al-Mafjar: ground plan, with the bath hall to the north-west (after Hamilton)

LA DOLCE VITA IN EARLY ISLAMIC SYRIA: THE EVIDENCE OF LATER UMAYYAD PALACES

Two elements present in most of the palaces deserve closer examination, for it is by means of them that some of the principal features of Umayyad court life can most readily be recovered. They are the bath and the entrance gate. The category of bath presents in some ways the most complex problems. Umayyad baths defy classification.[37] But it seems significant that they are to be found on most Umayyad sites. Some, as at 'Anjar, Qaṣr al-Ḥair al-Sharqī and Qaṣr al-Ḥair al-Gharbī, were extremely large but surprisingly plain — if indeed they were for royal use.[38] Smaller examples are found at Khirbat al-Minya[39] and, underground this time, in the palace at Khirbat al-Mafjar.[40] Close by that underground bath is the great bath hall itself, the gem of the whole site (plate 5). The existence of two baths on the same site is a clue, if any were needed, that the great hall was used for more than just bathing. The concept of multiple functions for such a building is already present at Quṣair 'Amra, as the variety of paintings there attests. It seems to have served as a hunting lodge, a banqueting hall and a ceremonial audience chamber in addition to primarily being a hot bath (plate 6). The bath hall at Khirbat al-Mafjar was clearly a multi-purpose building too, with the difference that it was designed with incomparably greater care (plate 7). The signs are legion: lavish seating capacity, extensive latrines, public and private entrances, the *dīwān* — probably a kind of Star Chamber, in view of the judgmental overtones of its figural mosaic — the central apse and, above all, the decoration.[41] Naturally, there are reminders of its function as a bath too — the narrow but deep pool, the hot rooms (though these occupy less than a tenth of the bath's surface area) and even the use of mosaic for the floor, as at 'Anjar,[42] Quṣair 'Amra,[43] Hammān al-Ṣarākh[44] and the palace bath at al-Mafjar itself.[45]

How then was such a building used in Umayyad times? It is recorded that al-Walīd I gave audiences in the bath, and indeed the spaciously conceived bath hall at Khirbat al-Mafjar would be ideal for such formal occasions.[46] A curious structure near Mshattā might be a bath but is outside the pattern. Placed as it is, a short distance from the audience chamber but outside the enclosure, it seems to reflect the same random order of construction work as the other features of the site, for in a building which demonstrates otherwise integrated planning one is almost obliged to regard it as an afterthought. This reflection prompts a reappraisal of the role of the bath in later Umayyad palaces. In the other two buildings often associated with al-Walīd II — Quṣair 'Amra and Khirbat al-Mafjar — the bath plays a very significant role indeed. The obvious Umayyad parallel for a bath located outside the main palace is Qaṣr al-Ḥair al-Gharbī,[47] a foundation of the caliph Hishām. It seems, however, that the latter monarch preferred to live in central and northern Syria and did not frequent the area of Mshattā. He is therefore most unlikely to have been the patron of that building.

A more satisfactory explanation for the unusual location of the bath at Mshattā might be that the patron of the building thought it more important to emphasise his audience chamber by means of a formal processional tract incorporating much deliberately empty space than to jeopardise the psychological effectiveness of the entire layout by cramming other functions into that space. A bath would inevitably have frustrated that aim — and the bath at

Mshattā is sizeable. Its location just outside the palace makes it almost certain that there was no smaller bath built or planned within the enclosure. It seems fairly clear, therefore, that the side tracts of the palace were intended to house the prince's retinue. One final puzzling detail may be noted: the lack of direct access between the royal quarters and the bath. In such Friday mosques of the early Islamic period as adjoined the royal palace it was standard practice to pierce the *qibla* wall of the mosque with a door to allow the caliph easy and private access to the mosque from the palace. Some similar feature could easily have been introduced at Mshattā. That it was not suggests once again that the bath was something of an afterthought. It is tempting to conclude that by the very end of the Umayyad period (Mshattā is commonly dated to 744) the bath was beginning to lose its earlier importance.

However the bath at Mshattā is to be explained, there can at least be no doubt that the halls in the baths of Quṣair 'Amra and Khirbat al-Mafjar were used for formal royal ceremonies. These ceremonies are recorded from the very beginning of the Umayyad period. The texts draw a distinction between Mu'āwiya's audiences at the mosque and at the palace. At the mosque the atmosphere was usually informal. He

> would take his seat on the chair which had been set for him, leaning his back against the screen, with his bodyguards about him, and let approach who would: poor men, wandering Arabs from the desert, women, children, destitute folk, and so forth. Someone would complain of injustice — he would order redress; another of some encroachment — he would send guardsmen to put a stop to it; a third of some insult — he would order an inquiry.[48]

But at the palace, greater formality reigned. The caliph seated himself on his throne — not his chair, as in the mosque — and ordered the people to be summoned in order of rank. When his courtiers were all appropriately seated, he would address them formally, inviting them to submit petitions on behalf of others. He gave two such audiences every day.[49] 'Abd al-Malik continued this tradition[50] and al-Walīd I was reproached by his wife for giving informal audience to an Arab in armour — and the bloodthirsty al-Ḥajjāj at that.[51] But the borderline between 'mosque' and 'palace' audiences was not always clear-cut. The scene when al-Walīd I and his court assembled in the Damascus mosque to honour the conqueror of North Africa and Spain would not have disgraced a Roman triumph. Al-Walīd, sitting cross-legged on the caliphal throne, received the homage of hundreds of European nobles. To his right stood his paternal relatives in order of seniority, with his maternal relatives in corresponding order on his left; at a suitable distance behind him were his courtiers, poets, officials, clients and petitioners.[52] This tradition was perpetuated in Umayyad Spain.[53]

Court ceremonial became increasingly formal as the Umayyad period drew to its close, although the exact chronology of the individual innovations is a vexed question. The notion of a formal axial progression underlies the layout of the bath hall at Khirbat al-Mafjar and of the central tract at Mshattā, and may

very well be linked with formal processions. In this connection it may be relevant to note that some sources ascribe to al-Walīd II the introduction into Islam of key features of formal court life, such as the harem system and eunuchs.[54] Similarly, the sinister figure of the chamberlain appears with significant frequency in anecdotes about al-Walīd's activities in his palaces;[55] indeed, a fresco at Quṣair 'Amra seems to represent such an official carrying his staff of office.[56]

The entrances of the Umayyad palaces, even more than their baths, present in microcosm some of the problems of this palatial architecture. The degrees of elaboration in these gateways varied considerably. Thus in the later palaces elaborate gateways are more common than in the earlier ones. Siting also seems to have been a contributory factor, for the official residences in the cities of 'Anjar and Qaṣr al-Ḥair East are notably more modest than those of palaces in open country. In the case of Khirbat al-Mafjar, where there were at least three gates,[57] the most elaborate was apparently that of the bath, presumably because of the ceremonial functions of that establishment.

The type of decoration used in these gateways also presents problems. In view of the persistent classical flavour of so much Umayyad architectural decoration, it is strangely unclassical. The Roman triumphal arch with its rich iconographic repertoire might have been expected to exert some influence on these Umayyad buildings. Yet themes of religious content, of victory, military display and submission — even plain narrative — are all conspicuously absent, as are religious themes of any kind. It is easy enough to isolate the foreign motifs and ideas in Umayyad gateways, but it is difficult to ascertain whether any threads run through this varied iconography. Perhaps the most that can safely be asserted about the really ambitious Umayyad gateways is that they were intended quite generally to glorify by their sheer magnificence the caliph or prince who erected them. Confronted as they were with the artistic traditions of Byzantium and Sasanian Persia, in which royal iconography had a long and distinguished history, the Umayyads can scarcely have failed to realise the potential of art as a vehicle for propaganda and symbol. But it was quite another matter to devise a fitting series of interlocked images that would convey the distinctive flavour of the new Islamic court. Throughout most of the Umayyad period one can watch artists floundering in their attempts to achieve this aim. Only in the last twenty years of the dynasty did they wake up to the potential of the gateway as a vast hoarding, a public advertisement of an enviably exotic lifestyle. Given time they would no doubt have streamlined the rich figural material at their disposal and created a set of coherent imperial images suitable for such external settings. But time was what they never had.

One may test these theories by examining a typical Umayyad gateway. At Qaṣr al-Ḥair West delicate, even finicky, stucco ornament is crammed into a monumental ensemble (plate 8).[58] The fortifications are as extravagantly sham as anything built by Ludwig II of Bavaria. It is true that the architecture goes some way towards integrating the various images visually but it cannot disguise the fact that they are thematically unrelated. The seated caliph placed in the tympanum above the door is a straightforward image, straightforwardly placed,[59] but elsewhere on the façade are scattered a group of figures reclining

as if at a banquet, a youth carrying an animal, and the pagan goddess Atargatis, one hand bearing the dove which is her attribute.[60] In its ostentatious wealth the gateway epitomises royal pomp and display but the sculpted figures refuse to fit into a meaningful pattern.

The bath porch at Khirbat al-Mafjar seems at first sight to be a much more carefully organised composition (plate 9).[61] It even bears a passing resemblance to a triumphal arch. But this favourable impression evaporates on closer scrutiny. Almost the entire surface is overgrown with dense geometric or floral ornament. There is no cavilling at its quality but the total effect is messy. Only the caliph, almost lifesize, painted in bright colours and set in a niche high up in the centre of the façade, stands out.[62] Thus the main purpose of the bath, to glorify the ruler, is clear. Robert Hamilton's forensic skill has shown that the ruler's niche was empty for some time and that it was on the death of the caliph Hishām that his heir, al-Walīd II, completed the façade by adding this statue of himself. At the same time he added statues of animals, including sheep or ibexes and a horse.[63] These have been taken as symbols of apotheosis and divine right on the Sasanian model.[64] But it is important to note that they had not been foreseen in the original arrangements. Indeed, they covered up previous non-figural decoration. Thus, whatever symbolic connotations they might have had for al-Walīd, they were essentially an afterthought. In fact the remaining decoration of the bath porch gives little support for such an elaborately symbolic interpretation. Since it is known that al-Walīd II sent to eastern Persia for sculptures of mountain goats, gazelles, deer and lions,[65] it may be preferable to see these creatures, perched precariously on a narrow ledge, as display pieces, perhaps imported. This interest in animals was nothing exceptional in the Umayyad house. Yazīd I before him was referred to contemptuously as a 'tender of falcons, dogs, apes and leopards',[66] and was traditionally the first Muslim to tame a cheetah to sit on the crupper of his horse. Horseracing actually had the sanction of the Prophet's example and was enthusiastically practised by the early caliphs.[67] Hishām once arranged a race for 4,000 horses[68] and his daughter herself took part in races;[69] and al-Walīd II himself 'was passionately fond of horses'.[70] He also kept a menagerie.[71] What could be more natural than that he should indulge these tastes, and those of an eager collector, in the sculpture of his bath porch? Whether or not this idea is acceptable, it does seem unjustified to invest the bath porch with the same high seriousness as the interior of the bath; for unlike that interior it was not conceived and executed as a unity. Finally, it may clinch the argument if one recalls that the gateway leads into a domed porch where the statuary, comprising as it does half-naked girls and gymnasts, implicitly disclaims political themes.[72]

It will be seen that these inconsistencies make it difficult to set Umayyad palaces into the wider context of luxury palatial architecture in late antique times. Various analogies could be made but none is really satisfactory. Clearly they are conceived on a lesser scale than a great imperial foundation like Diocletian's palace at Split[73] or the possibly imperial residence at Piazza Armerina in Sicily.[74] On the other hand the villas of the Roman world catered for a less powerful and wealthy clientele than did the Umayyad castles. In the

LA DOLCE VITA IN EARLY ISLAMIC SYRIA: THE EVIDENCE OF LATER UMAYYAD PALACES

country villas of Roman nobles or well-to-do provincial notables, whether in North Africa or England, the practical function of the whole complex dominated the design. Such a villa was conceived as the nucleus of a thriving estate, not as a pleasure palace.[75] Yet, like the ambitious imperial or quasi-imperial foundations of the fourth century and like the long line of Roman frontier forts guarding the borders of the Provincia Arabia,[76] it left its mark on the Umayyad desert 'castles'.

What, one may ask, were the arrangements to receive visitors at one of these desert residences or castles? And for what kind of activities and ceremonies were they designed? Few of them had extensive living quarters. It seems clear that only a skeleton court could be accommodated at them and that other courtiers were either constrained to pitch their tents outside the principal building or — less likely — to occupy other residences in expectation of a caliphal visit. Certainly there was constant movement from one residence to another. Al-Walīd II, a political exile from the Umayyad court for much of his adult life,[77] was aware of the inconvenience that this way of life caused and so he ordered a kind of royal motel to be erected in the desert at al-Zīza.[78] Here any guests of his could stay in comfort — but only for three days.[79] Those who urgently had to see him were often so numerous that they had to wait outside his residence, an arrangement which his chamberlain considered unworthy of a caliph. Both Mshattā and Khirbat al-Mafjar have entrance vestibules specifically designed for those waiting to enter the palace,[80] and it is recorded of Umm al-Banīn, the wife of al-Walīd I, that she kept the all-powerful governor of Iraq, al-Hajjāj, waiting in her anteroom.[81]

Inside the palace — and it is tantalising that these palaces are neither named nor precisely located in the texts — the main feature was a hall with a curtain opposite the entrance (plate 6).[82] Qusair 'Amra fits this description perfectly: indeed, there are several representations of curtains in its frescoes. The curtain was periodically drawn open or closed. Behind it was the caliph, either reclining on soft bolsters[83] or sitting on a throne or chair, and a bath was often in readiness. A servant and a female slave were usually beside him; other attendants were waiting in inner chambers. Here again the layout suggests Qusair 'Amra, where the image of the enthroned caliph, flanked by two figures of which at least one is a servant, was set in a deep niche opposite the entrance. If, as seems almost certain, the owner of the building sat there — for the niche would be the ideal architectural feature to be associated with the ceremony of the curtain — there may be a close connection with Khirbat al-Mafjar. For two of the most obviously royal elements in the iconography of that site are the mosaic locally known as the Tree of Cruelty, which *inter alia* shows the king of the beasts bringing down a gazelle, and the stone sugar-loaf hat suspended from a chain. Both features, again, are set in deep niches. It seems justified to conclude that there was a deliberate intention to equate the decoration of key niches in these palaces with the princes who sat in them. Thus when the prince himself was not there he would be represented by an appropriate image.[84] One may suggest in this general context that the small, choicely decorated *dīwān* at Khirbat al-Mafjar was a retiral room reserved for the prince and that its entrance may well have been closed by a curtain.

9

In the hall itself the caliph's boon companions sat on rich carpets surrounded by male and female singers, musicians and dancers.[85] Here too the scene is vividly reflected in the frescoes of Quṣair 'Amra. Pages circulated among them pouring wine. A contemporary poet, Ḥammād b. Sābūr, sets the scene as follows:

> Al-Walīd invited me to his residence. As I entered it, a servant told me the Commander of the Faithful was behind the curtain. I greeted him and sang some songs. Then I saw the exquisitely formed hand of a girl reaching me a goblet from under the curtain, and, by God, I don't know which was more beautiful, the hand or the goblet.[86]

Another poet tells a similar story, also about al-Walīd II:

> Once he sat in his throne room, behind a curtain. A slave of fair countenance standing by him was ordered to lift the curtain. Then there appeared forty comely boys and maidens with ewers and towels, who served the guests wine. And so the entertainment continued until the first rays of the sun. Then the attendants laid us on soft carpets and carried us to rooms set aside for the guests.[87]

It is a scene from the *Arabian Nights*. Even so, the casual detail of rooms set aside for guests recalls the admittedly small rooms flanking the 'caliphal' niche at Quṣair 'Amra. Lack of space frequently constrained the caliph's guests to spend the night elsewhere. The sublimely egocentric nature of some of these buildings is mirrored in the fact that there was sometimes barely enough room for the caliph's own family to sleep in his residence. Presumably — as suggested above — tents were pitched all around it. The Bedouin nearby looked after the caliph's animals and occasionally his guests. Not surprisingly, he was on good terms with them; indeed, his free and easy way of life would have been impossible if they had been hostile. It is even recorded that he filled the waterskins for their wives.[88] But this egalitarian touch is deceptive.[89] Khirbat al-Mafjar exudes pomp and circumstance while Mshattā can only be seen as the creation of an extreme autocrat. It comes as no surprise to learn that al-Walīd always had his bodyguard near him;[90] it seems that they camped around his residence.[91]

The tableaux described by the Umayyad poets vividly evoke the new-found and practically limitless wealth of the Arab élite and the luxurious tastes which they developed. And this, of course, makes imperative some discussion of the personalities of the Umayyad royal family. Among these princes one, by general consent, stands out as a profligate among profligates, the most dedicated playboy of the age: al-Walīd II. The main outlines of his career as voluptuary and caliph, in that order, are sufficiently well known, but since apparently casual details about his personality and lifestyle have furnished clues to some of the more curious features of Khirbat al-Mafjar at least, it seems worth while to extend the scope of the enquiry to the other buildings attributed to him.

It must be admitted at the outset, however, that the accuracy of the many scandalous anecdotes told about this prince is virtually impossible to establish.

10

LA DOLCE VITA IN EARLY ISLAMIC SYRIA: THE EVIDENCE OF LATER UMAYYAD PALACES

Against the possibility that 'Abbāsid writers would eagerly assemble and retail defamatory stories about the Umayyads must be set the suspicion that it was simply *pour épater* that al-Walīd so often behaved in a deliberately outrageous fashion. Whatever the authenticity of any given anecdote, his status as perhaps the greatest of Umayyad patrons of architecture seems ample justification for a detailed assessment of his personality and interests. Certainly he was a worthy rival of al-Walīd I, who built the Great Mosque of Damascus, or of 'Abd al-Malik, who ordered the Dome of the Rock, and unlike them he allowed his buildings to proclaim his private tastes instead of serving primarily religious and political purposes.

Al-Walīd was born around the year AH 90/708-9 AD.[92] Dubbed *al-fāsiq*, 'the debauched one', he was a worthy son of his epicurean father Yazīd II.[93] In the case of al-Walīd, this serious pursuit of pleasure attained epic proportions. It was plain for all to see long before he was raised to the caliphate, and quite early on it nearly proved his undoing. His uncle Hishām, for example, wanting to ensure the succession of his own son rather than al-Walīd, gave the latter charge of the pilgrim caravan to Mecca and Madīna, hoping that he would disgrace himself by his profligacy. This was probably in 116/734. The scenario opened promisingly enough for Hishām, since al-Walīd assembled all his boon companions, musicians, dancing girls, hunting dogs[94] and horses and laid in a plentiful supply of wine. He made no secret of his plans to erect a huge tent next to or on the Ka'ba[95] and to give himself over to feasting. At this stage the accounts of the affair diverge sharply, and it is indicative of the character of al-Walīd II that both are plausible. According to one account, at the last moment cooler heads among his entourage persuaded him to scuttle these plans and he confounded his uncle by behaving perfectly and positively charming the Ḥijāzīs.[96] The lightning changes of mind and mercurial temperament which this anecdote suggests are amply borne out not only by other literary sources but also — though necessarily in a more indirect fashion — by the monuments themselves. However, according to the other — and more widely diffused — tradition he did in fact scandalise the inhabitants of the holy cities and Hishām duly removed his stipend.[97]

His physical appearance was striking. 'Al-Walīd', we read, 'was one of the comeliest of men, and one of the most violent.'[98] This violence was all the more to be feared because he was uncommonly strong: it is recorded that in leaping into the saddle he could pull out of the ground an iron tent-peg tied to his foot[99] and that he could drink wine from a container that other men could not even lift.[100] His personal vanity was well developed. In this respect too he ran true to type within his house.[101] Of his predecessor, the Caliph Sulaimān, for example, we read:

> he loved luxurious stuffs, and above all a kind called *washi*. Everyone
> began to wear the material, for robes, cloaks, drawers, turbans, caps. The
> Caliph wore it for riding, at audience, and in the pulpit. No servant at the
> Palace presented himself wearing any other stuff, even the cook would not
> have dared to appear without an apron of it. And the Caliph gave order
> that his shroud must be made of the same.[102] [This same] Sulaiman once

looking in a mirror was struck with his own youth and beauty. Yes, he said, Muhammad was the Prophet, and Abu Bakr was called the Truthful, Omar was called the Discriminator and Othman the Modest, Mu'awia the For-bearing, Yazid the Patient, Abd al-Malik the Administrator, Walid the Oppressor. And I, I am Prince Charming![103]

The same story could more appropriately have been told of al-Walīd. His fine clothes were a by-word: on one occasion he appeared entirely in gold brocade,[104] and he customarily wore his under-tunic (*qamīs*) only once.[105] He preferred colourful patterned garments (especially in the shade of saffron yellow[106]); and it is perhaps no accident that minute traces of a floral pattern have been detected on the trousers of a caliphal statue which in lordly isolation dominates the entrance to the great bath hall at Khirbat al-Mafjar.[107] Rings festooned his fingers[108] and the jewelled golden chains heaped around his neck were changed every day.[109] He is recorded as wearing footwear of gold brocade,[110] while on the day of his murder he wore a tunic of that material (*qasab*) and wide pantaloons of heavy damask.[111] Such trousers can be glimpsed in the statue at Khirbat al-Mafjar (plate 10). On his head he wore a costly, gold-stitched sugar-loaf hat[112] in place of the *kuffiyya*[113] or the modest turban of 'Abd al-Malik.[114] This sugar-loaf hat, the *qalansuwa tawīla* of the texts, is memorialised in stone at Khirbat al-Mafjar, where it hung from a stone chain in the royal apse, presumably over the caliphal throne, in a tableau which can be seen as a broad parody of Sasanian royal pomp (plate 11).[115] For in the great *iwan* at Ctesiphon where Khusrau of the Immortal Soul kept his court there was suspended from a golden chain, directly above the throne, the great crown of the King of Kings, so heavy that its weight would have broken the royal neck. But possibly the stone *qalansuwa* was intended as an almost blas-phemous reference to the caliph's role as *imām* in the mosque; for when the Umayyad caliphs led the Friday prayer, dressed completely in white,[116] they wore that same *qalansuwa*.[117]

When Khirbat al-Mafjar was being excavated it quickly became clear that the most lavish structure on the site was not, as might have been expected, the royal palace, but the bath hall. This could confidently be identified as such by reason of the deep narrow pool, approached by a flight of steps, which lay along the north side (plate 12). A wide pipe connected with the water and drainage system served to fill the pool with water. But one puzzling detail eluded easy explanation. A small narrow pipe, quite inadequate to function as an outflow or overflow facility, also led into the pool, and had its own separate outlet for drainage.[118] This second pipe presumably conducted some substance other than water into the pool. Its purpose is graphically clarified in an eye-witness account retailed by a celebrated singer, a certain Abū Hārūn 'Atarrad, who had been invited to perform in front of al-Walīd. 'Atarrad takes up the tale:

I was brought in to him and he was sitting in his palace (*qasr*) on the edge of a small pool . . . lined with lead and filled with wine. I had hardly time to give him the greeting when he said 'Are you 'Atarrad?' 'Yes, Commander

LA DOLCE VITA IN EARLY ISLAMIC SYRIA: THE EVIDENCE OF LATER UMAYYAD PALACES

of the Faithful,' said I. 'I have been longing to hear you', said he . . . So I sang to him. I had barely finished when, by God, he tore apart an embroidered robe that was on him, worth I know not what, flung it down in two pieces,[119] and plunged naked as his mother bore him[120] into that pool; whence he drank, I swear, until the level was distinctly lowered. Then he was pulled out, laid down dead to the world, and covered up. So I got up and took the robe; and no-one, by God, said to me 'take it' or 'leave it'. . . .[121]

Drunkenness was something of a family failing among the Umayyads, despite the Qur'ānic prohibition, though it is surely relevant to note that the rulers of Sasanian Persia, perhaps models for the Umayyads in this as in so much else, drank every second or third day,[122] while the Lakhmid kings of Ḥīra drank one day and one night per week.[123] Most of the Umayyad caliphs, too, are recorded as wine-drinkers. Yazīd I was perhaps the worst offender,[124] but 'Abd al-Malik used emetics to aid his monthly carousals,[125] al-Walīd I held drinking parties every other day, Sulaimān one day in three, and even the parsimonious Hishām, according to one tradition,[126] gave himself up to wine every Friday[127] — after divine service. Yet it would be mistaken to interpret these reports as evidence of nothing more than a regular debauch. Wine-drinking was not, it seems, a serious, solitary, guilt-ridden activity but occurred within the social context of a courtly festival of music, poetry and song.[128] Thus the cup-bearer figures frequently in the anecdotes told about al-Walīd II and customarily plied with wine the singers who performed before the prince.[129] It has to be admitted, however, that the drunken spells of al-Walīd were unusually frequent.[130] In his cups he was apt to be short-tempered,[131] moody[132] and vicious.[133] Yet no shadow of this is allowed to fall over the many poems which he devoted to this congenial topic:

Come, put my robe round me and pour us a drink;
Hell-fire's my destiny — I don't think!
To teach men the worship of booze is my mission;
Let the paradise-seekers plod on to perdition.[134]

'For saying this', noted the lexicographer al-Fīrūzābādī, 'his blood was deemed lawful.'[135] With such a background in mind, it is certainly tempting to speculate that some of the many mutilated statues of semi-nude girls at Khirbat al-Mafjar bore flagons of wine in their outstretched hands (plate 13), as do their Sasanian predecessors on many a gilded ewer.[136] A vine trellis is the basic motif in the palace vestibule and in the caliph's private retiring room.[137] Similarly, the walls of the two rooms opening off the 'caliphal niche' at Quṣair 'Amra are entirely engulfed with vine scrolls punctuated by bunches of grapes and by chalices or vases. Seen in this general context, the lavish vine[138] ornament at Mshattā also acquires a new significance (plate 14). No other part of the building exhibits this type of decoration. It is confined to that part of the façade which corresponds to the central, princely tract of the building. Could the unparalleled obsession with vine ornament there, which even includes a

13

vintaging scene,[139] be interpreted as a celebration of this most typical Umayyad pastime? It has even been suggested that the façade depicts the apothesis of the vine.[140] The felines drinking from chalices on the façade, and the semi-nude women within, have been interpreted in other contexts as Dionysiac themes,[141] and may retain some of that significance in their debased form at Mshattā. But perhaps al-Walīd himself, whose Bacchic poems prefigured 'Abbāsid modes,[142] can have the last word here:

> Pour, and let me hear the chuckle of the flask;
> Lutes have stolen from us the souls we thought our own,
> So pour! my sins mount up like wine climbing the cup.
> Nothing can now atone.[143]

Yet by no means all his output consisted of wine poetry. He was even known to preach in verse.[144] Well over fifty of his poems survive — even though his status as prospective and actual caliph meant that no collection of them was made in his own lifetime[145] — and many are love-songs or satires. It is therefore entirely appropriate that the bath hall at Quṣair 'Amra should bear, amidst many other types of decoration, the bust of a personification, in approved classical style, labelled in Greek.[146] Most of the Umayyad caliphs turned their hands to verse[147] but al-Walīd II was by general consent the greatest of them in this respect. He was noted for his capacity to improvise, and never did he give a more scandalous exhibition of this talent than in the verses he extemporised, wine-cup in hand, to the messenger who brought him the news of his uncle Hishām's death at Ruṣāfa (6 Rabī' II 125/6 February 743)[148] and his own elevation to the caliphate:

> I hear a weeping from Rusafa! 'Tis
> Some ladies whom I know;
> And forth to pay a call of condolence
> In trailing robe I go.
> The daughters of the late Hisham bewail
> His death in bitter woe.
> Woeful indeed their fate is; well may they
> Cry out they are undone;
> For call me impotent if I do not
> Ravish them one by one![149]

He was an exceptional connoisseur of Arabic,[150] unlike a previous caliph, his uncle and namesake, who had been debarred from the governorship of Arabia because of his defective knowledge of the language[151] or like others of his house who were sent to live with the Bedouin to purify their Arabic.[152] Ibn Khallikān relates that a certain Ḥammād[153] once said to al-Walīd II, 'I can recite to you, for each letter of the alphabet, one hundred long poems rhyming in that letter... composed exclusively by poets who lived before the promulgation of Islam.' The caliph had sufficient professional interest to take him up on his boast and actually listened to him for a space. But an understandable

fatigue supervened and he left, having taken the precaution of leaving a representative behind to hear out Ḥammād to the bitter end, which occurred some 2,900 *qaṣīdas* later. Al-Walīd rewarded him with 100,000 *dirhams*.[154] Elsewhere it is recorded that al-Walīd frequently corrected the poetry of others.[155] His patronage of poetry was wide and generous as well as discriminating; he is said to have been the first caliph to pay 1,000 *dirhams* per distich.[156] Poets such as Muṭīʿ ibn Iyās, whom the *Aghānī* characterises as 'accomplished, dissolute, an agreeable companion and excellent wit, reckless in his effrontery and suspected in his religion'[157] were always part of his circle. They therefore provide invaluable eyewitness evidence on the details and the physical setting of his everyday life.

His amatory verses were as celebrated at his *khamriyyāt*, or odes to wine. Like his father Yazīd, al-Walīd was madly in love with a woman who died prematurely, and that after having rejected him for twenty years.[158] While he did not, like his father, himself die within a fortnight of his beloved's death,[159] his threnodies became classics of their kind and were models for later poets.[160] But the following lines are more typical of his output, not least in the sly discrediting of orthodox religion implied by the opening phrase:[161]

> The Imám Walíd am I! In all my glory
> Of trailing robes I listen to soft lays.
> When proudly I sweep on towards her chamber,
> I care not who inveighs.[162]

Al-Walīd loved the open-air life, and indeed often slept under the stars;[163] he probably spent his early years in his father's desert residence of al-Muwaqqar. It is therefore not surprising that among his favourite amusements were horse-racing and hunting. He owned the best horse of his time and was himself an expert horseman.[164] Indeed, he was something of a stunt-man. Thus the story is told that

> Once at a race run by his command for over a thousand four and five-year-olds, a horse of his named Dazzler was in the lead; but not far from the finish the rider was thrown. Al-Walīd spurred his own mount to a gallop, came up with Dazzler, swung into the empty saddle, and came in first. He was the first man who ever did that; and the sanction of his example put it within the rules.[165]

Such acrobatic feats may explain the important role played by gymnasts in the iconography of Quṣair ʿAmra and Khirbat al-Mafjar.[166]

He loved all kinds of hunting, like several princes of his house,[167] sending as far afield as Persia for hunting falcons.[168] For hunting antelopes and gazelles he used Saluki dogs,[169] seen in the hunting frescoes at Quṣair ʿAmra (plate 15).[170] Also seen is a technique he is recorded as having used to hunt onagers. This technique involved arranging beaters in a gradually contracting circle and driving the animals into the centre, where he killed many himself;[171] he has been called the best marksman of the Umayyads.[172] But he was also apt to

15

capture these animals, mark them with his name and let them go, and he was called the veterinarian (*al-baiṭar*).[173] A man of proven courage, as he demonstrated in the last battle he ever fought,[174] he often attacked lions while hunting.[175] One of the more curious conceits — crudely expressed — in his poetry is a wish that women were lionesses so that only the brave could approach them.[176] In this general context it is entirely appropriate that the plinth of his statue at Khirbat al-Mafjar should be formed by a pair of snarling lions,[177] the very emblem of royalty, and that in his private retiring room in the same palace pride of place should go to the only figural mosaic of the site, which shows a lion rending a gazelle.[178]

Al-Walīd II, like many of the later Umayyad princes, was, it seems, indifferent to orthodox religion. There is no record that he ever built a mosque for public use, though Mshattā has a mosque and Khirbat al-Mafjar has two. While to all appearances he worshipped the one true God, said his prayers and was capable of holding his own in complex theological arguments,[179] he was widely regarded as impious by his contemporaries[180] and by later generations. Abu'l-'Alā' al-Ma'arrī, for example, numbers him among the *zindiqs* or heretics.[181] According to one source at least, one of al-Walīd's tutors, 'Abd al-Ṣamad b. 'Abd al-'Alā', was a *zindiq* who taught him to drink wine and to despise religion.[182] In his inaugural address Yazīd III, whose conspiracy had removed al-Walīd, said: 'al-Walīd gave himself over to every heresy . . . [believing] neither in the Day of Judgement nor in the Qur'ān, though he was my cousin and kinsman.'[183] When his uncle Hishām asked him directly whether or not he was a Muslim he replied with an ode to wine,[184] and in another poem he disparages the Prophet,[185] denying the trust of his revelation. Small wonder that some pious Muslims likened him to Fir'aun (the Pharaoh of Egypt), on whom God's punishment would fall.[186] Scurrilous anecdotes relate how on different occasions he installed a client (*maulā*)[187] and even one of his women[188] in the pulpit of the mosque to pronounce the *khuṭba*,[189] how he had forbidden traffic with his own daughter just as the Zoroastrians were thought to do,[190] and how, once, when drunk, being displeased with an augury he had taken from the Qur'ān, he had set up the Holy Book and shot arrows at it.[191] When it was cut to pieces in this way he extemporised, so the story goes, the following epigram:

Thou tauntest the rebel and tyrant? Ah, well!
A tyrant am I and prepared to rebel.
When thou meetest thy Lord on the last judgment morn,
Then cry unto God 'By Walid I was torn'.[192]

But this story must be equated with another, which records that when the hour for prayer came he would shed his dyed and scented garments and, donning the plain white robe that became his office of prayer, would discharge his duties as *imām* (prayer leader) impeccably — with all the right pauses, genuflections, prostrations and other prescribed forms. He would then put on his pleasure robes once more.[193] The authenticity of some of these rather technicolour anecdotes seems inherently open to doubt and is hard to reconcile with the

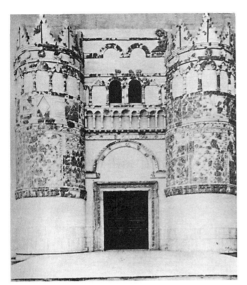

8. (*above left*) Qaṣr al-Ḥair West: gateway (after Creswell)

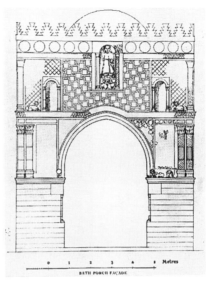

9. (*above right*) Khirbat al-Mafjar: reconstruction of the bath porch (after Hamilton)

10. (*left*) Khirbat al-Mafjar: statue of the caliph (after Spuler and Sourdel-Thomine)

11. (*below*) Khirbat al-Mafjar: stone chain in apse of bath hall (after Spuler and Sourdel-Thomine)

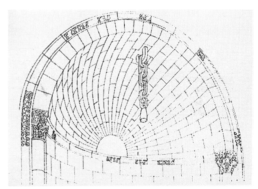

12. (*at foot*) Khirbat al-Mafjar: floor of bath hall, with steps on the right leading to the pool (after Hamilton)

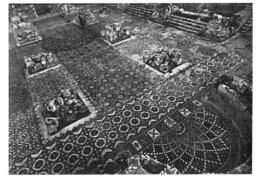

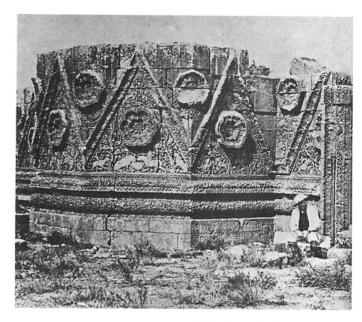

13. (*above left*) Khirbat al-Mafjar: statue of girl, from palace vestibule (after Spuler and Sourdel-Thomine)

14. (*above right*) Mshattā: detail of façade (after Creswell)

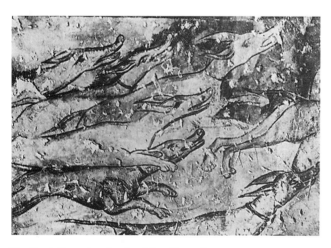

15. Quṣair ʿAmra: hunting dogs (after Almagro)

16. Quṣair ʿAmra: dancing girl on soffit of arch in audience hall
(after Almagro)

report that in what proved to be the last year of his life he had planned to go to Mecca on pilgrimage.[194] In particular they must be set against the moving account of his last hours, when, realising that all was lost, he retired to an inner room in his citadel and, like the caliph 'Uthmān before him — indeed, he said at the time 'Another day like 'Uthmān's'[195] — read the Qur'ān while he awaited his slayers (27 Jumādā II 126/16 April 744).[196]

Thus the evidence of the literary sources themselves is contradictory. The archaeological evidence provided by later Umayyad palaces is equally ambivalent. It offers positive proof neither of al-Walīd's piety nor of his allegedly irreligious stance; at most one might comment on the flamboyantly secular nature of the statuary there and try to reconcile it with the presence of a mosque or even two mosques at the major palaces.

Quṣair 'Amra has been somewhat neglected in most earlier assessments of al-Walīd's personality and way of life. The building is unfortunately not dated and the internal evidence allows no conclusions more concrete than that it was built by some prince (emphatically not the caliph)[197] between 711 and 750. This is an inadequate foundation to sustain an attribution to al-Walīd II in his pre-caliphal period, but at least it may be noted that his most favoured residence was in the nearby Azraq oasis[198] and that the subject matter of the frescoes accords excellently with his known tastes. In the matter of women these tastes were shared by many of the Umayyad house, and were expressed with an almost comic refinement and precision.[199] Sometimes the details are reflected with remarkable accuracy in Umayyad art; thus one type of paragon — who is to be found at Quṣair 'Amra[200] — is the fertile woman with a boy at the breast, another on her arm and a third following her.[201] A relevant anecdote relates that the viceroy of Iraq, al-Ḥajjāj,

> chanced to receive a letter from the Caliph Abd al-Malik ordering thirty women for palace use: ten to be women of *najib* type, ten of *qu'd al-nikah* type and ten of *dawat al-ahlam* type. Not understanding the meaning of these expressions, the Governor consulted his court at audience. Nobody knew. However, one man spoke up: God save the Prince! The meaning of these terms can only be found out from some man who has lived as a wandering Arab and knows the desert people, a past master of raid and booty, and a man, moreover, who has been a wine-drinker, and is familiar with tipplers' foul language.

Such a man was eventually found, and he defined the *qu'd al-nikāḥ* type as 'a woman with well-creased buttocks and heavy breasts, full in flesh, every part of her body pressing some other part'.[202] It is a concise but adequate description of the female effigies of Quṣair 'Amra[203] and Khirbat al-Mafjar.[204] Yet it is noticeable that the statuary at Hishām's palace of Qaṣr al-Ḥair West is markedly more svelte in type.[205] The figures at Quṣair 'Amra offer the most detailed gallery of feminine beauty which survives from Umayyad times — though the painted plaster belles from Khirbat al-Mafjar, resplendent in lipstick, mascara, and scarlet finger-nails and toe-nails, run them close. It may be relevant to quote in this context the description of the ideal woman which Ettinghausen

has extrapolated from the works of the pre-Islamic poets;[206] of course many of these clichés remained in vogue in the century of the Umayyads:[207]

> the ideal Arab woman must be so stout that she nearly falls asleep; that she must be clumsy when rising and lose her breath when moving quickly; that her breasts should be full and rounded, her waist slender and graceful, her belly lean, her hips sloping and her buttocks so fleshy as to impede her passage through a door. Her legs are said to be like columns of alabaster and marble, her neck like that of a gazelle, while her arms are described as well-rounded, with soft delicate elbows, full wrists and long fingers. Her face with its white cheeks must not be haggard, her eyes are those of a gazelle with the white and black of the eyeball clearly marked.[208]

It remains to add that al-Walīd had, besides several wives, many concubines;[209] he even tried in vain to have his son by one such concubine recognised as his heir.[210] These women were often of foreign birth;[211] indeed, the mothers of his sons were Greek, and as crown prince he was mocked at court for his predilection for Greeks.[212] Al-Walīd had been tutored carefully by scholars and, to the horror of orthodox opinion, he knew Greek well.[213] When, in addition to these facts, his literary tastes are also borne in mind, it is tempting to regard the Greek inscriptions at Quṣair 'Amra as a reflection of his own personal preferences. These inscriptions identify the personifications of Victory, History, Poetry and Philosophy.[214] Portrait busts of these abstractions were of course an accepted classical convention. The presence of Poetry is indeed peculiarly apposite, but the choice of History too can be explained by a chance detail of his biography: that he commissioned the professional memoriser Ḥammād b. Sābūr to collect for him historical anecdotes about pre-Islamic Arabia.[215] Finally, in the context of Quṣair 'Amra — especially the zodiacal map in the dome of the *calidarium* — it is worth noting that al-Walīd employed astrologers.[216]

> 'Beware of music, you Umayyads', said Yazid the Retrencher once; 'it lessens modesty and increases lust; and it saps virility. It is indeed like wine, and does what strong drink does. If you must needs have it, at least keep your women from it, song being such a spur to lechery.'[217]

Yazīd I had been a composer and had introduced music to the Umayyad court,[218] while al-Walīd's father Yazīd II had surrounded himself with male and female singers and musicians[219] and the great love of his life, Ḥabbāba, who virtually usurped political power, was a singer.[220] Even the severe Hishām had a floor fresco depicting a flautist and lutanist in his palace of Qaṣr al-Ḥair al-Gharbī.[221] Al-Walīd himself wrote very rhythmical verse, often in dialogue form and suitable for musical accompaniment.[222] Much of his poetry extols the charms of music, often coupling it with wine. The following lines are typical:

> There's no true joy but lending ear to music,
> Or wine that leaves one sunk in stupor dense.
> Houris in Paradise I do not look for:
> Does any man of sense?[223]

LA DOLCE VITA IN EARLY ISLAMIC SYRIA: THE EVIDENCE OF LATER UMAYYAD PALACES

But his enjoyment of music was far from passive. He was a composer to whom many popular melodies were attributed[224] and he knew how to play most contemporary instruments,[225] including the drum, lute and cymbals,[226] and how to move in cadenced step according to the rhythm of a tambour.[227] More than one fresco at Quṣair 'Amra seems to depict such a dance (plate 16).[228] When he was at Mecca — ostensibly for the pilgrimage — he took singing lessons from the best of the local singers, a certain Yaḥyā Qail.[229] On his accession his first act was to send to Mecca and Madīna for minstrels,[230] and he even ordered musical instruments (guitars and lutes) brought from distant Khurāsān. An anonymous poet celebrated the event:

Mules laden with liquor, their bags full of lutes;
Pretty wantons exotic, with drums, strings and flutes;
What with thrumming and trilling and boozing and love
It's all fun for you now and in heaven above.[231]

Music — and of course wine[232] — often played a part in the more bizarre of his practical jokes. Thus he would appear in the audience hall of one of his palaces mounted on a horse or a donkey while girls hopped in front of him playing drums or tambourines.[223] Or, in the same setting, he would mount a horse, tie a drum to it and beat the drum so that the horse would shy and rear, endangering the guests — to his great amusement.[234] A puckish rather than a boisterous sense of humour is repeatedly displayed at Khirbat al-Mafjar — in the whimsical caricature of the Sasanian hanging crown,[235] the enigmatic panel in front of the royal apse,[236] and in the single deliberately misplaced triangle among the 8,000 or so which make up the largest mosaic panel on that site,[237] a kind of gigantic Catherine wheel.[238] But it is Quṣair 'Amra again which seems the natural setting for the occasion when al-Walīd told the poet-cum-clown Ash'ab to perform a dance while wearing trousers made of a monkey's skin, complete with tail.[239] The frescoes at Quṣair 'Amra do in fact include depictions of a dancing monkey[240] and of a bear playing a lute,[241] the latter presumably a man in disguise. The dance with zoomorphic masks has a long subsequent history in Islamic art and culture.[242]

Musicians could expect the richest rewards from al-Walīd. Ma'bad, for example, received a purse of 15,000 dīnārs for a single song.[243] One of the most detailed anecdotes of this kind concerns a certain Abū Ja'far Muḥammad b. 'Ā'isha and it throws much light on al-Walīd's religious stance, both by the cynical reference to the ḥajj contained in the poem itself and in the allusions to celebrated figures of pre-Islamic Arabia in al-Walīd's subsequent oaths. The story is perhaps worth quoting in full in the spirited paraphrase of Schroeder:

I once, says a courtier,[244] heard Ibn Aisha sing Walid this song:

I saw Heaven's Maids too soon, at Sacrifice:
Chastity could not look into those eyes,
Fair as the stars which stand about night's rim
Waiting to light the Moon when she shall rise.

My Pilgrimage the merit of Works to win
Ended tottering home with a load of Sin.

O God, how beautiful, my Prince, as you are![245] Walid exclaimed. By
the faith of Abd Shams (his Unbelieving ancestor), sing that again!

O by God and the faith of Umayya (another Unbeliever),[246] once
more! he cried when it was done. Over and over again he adjured him by
one ancestor after another, to sing the same again, till he came to himself,
and cried: By my own soul, once more!

At the end Walid ran from his throne and kneeling down before Ibn
Aisha covered every part of his body with kisses.[247] When he came to the
sexual parts, the singer crossed his legs, not willing to be kissed in that
place; but the Caliph, crying: There too, by God! I must! thrust down his
face, exclaiming: O rapture! rapture! Then, tearing off his clothes, he
heaped them on the musician, and stood naked till they bought him fresh
things. Finally he ordered a thousand dinars and made the singer a present
of his own riding-mule.

Bestride my saddle and begone! he said, for thou hast made me burn
with a fire hotter than coals of tamarisk![248]

It is no wonder that the tales of such doings should have scandalised the
rest of the royal family. Al-Walīd realised this and defiantly answered 'They
preach, but they wouldn't give it up if they liked it themselves.'[249] But he be-
came progressively alienated from his family and hope long deferred soured
him. Well could he be called The Loser — *al-khāsir*. Hishām had ruled for two
decades; al-Walīd was vouchsafed a single year and, as if clairvoyant, said on
inheriting the caliphate, 'Hisham has taken away my life.'[250] And if that life is
viewed as a whole, the appropriate expression of it is surely not the cold
absolutism of Mshattā, marooned in a desert far from humanity, but in the
joie de vivre of Khirbat al-Mafjar, set in the smiling fertile valley of Jericho and
advertising for all to see a flamboyant life-style that would be the envy of lesser
men. With that palace in mind, then, one can savour the epitaph that al-Walīd
penned for himself:

White hairs — what of them? Foes — who cares? I've had my day:
Ripe girls like statues, wine, slaves, steeds to hunt the prey.[251]

20

LA DOLCE VITA IN EARLY ISLAMIC SYRIA: THE EVIDENCE OF LATER UMAYYAD PALACES

NOTES

1 The point is a familiar one; for a recent discussion, see A.A. Dixon, *The Umayyad Caliphate 65-86/684-705 (A Political Study)* (London, 1971), 1. For its particular relevance to accounts of al-Walīd II, cf. C.A. Nallino, *Raccolta di scritti editi e inediti* VI, ed. M.A. Nallino (Rome, 1948), 164.

2 Ed. Būlāq, 1285/1868; this is the edition used in this paper. For the work and its author, see M.A. Nallino, 'Abu'l- faradj al-Iṣbahānī', *The Encyclopaedia of Islam*, 2nd ed. (Leiden, 1960), 118; G. Rotter (ed. and tr.) *Abu l-Faradsch. Und der Kalif beschenkte ihn reichlich* (Tübingen and Basel, 1977), 7-18.

3 Cf. the warning note which R. Blachère sounds on the reliability of the *Aghānī* (*Histoire de la littérature arabe des origines à la fin du XVe siècle de J.C.* I [Paris, 1952], 133-8).

4 'Ceremonial and Art at the Umayyad Court' (unpublished PhD thesis, Princeton, 1954). Similar work has been done, but on a less comprehensive scale, by A. Musil (to whose pioneer studies this article owes much) in *Ḳuṣejr 'Amra* (Vienna, 1907) and by J. Sauvaget, especially in his 'Remarques sur les monuments omeyyades', *Journal Asiatique* CCXXXI (1939), 1-59. More recently the same theme has been taken up in a long series of articles by V. Strika, especially 'Note sull' evoluzione della maestà califfale', *Annali dell' Istituto Orientale di Napoli* 26, n.s. XVI (1966), 105-35; 'Aspetti aulici dell' arte ommiade', *Rendiconti morali dell' Accademia Nazionale dei Lincei*, ser. VIII, 22 (1967), 235-68; 'Qaṣr aṭ-Ṭūbah: considerazioni sull' abitazione ommiade', ibid., 23 (1968), 69-83; 'Sull' interpretazione di ḥayr nel periodo ommiade', *AION* 28, n.s. XVIII (1968), 139-49; 'Origini e primi sviluppi dell' urbanistica islamica', *Rivista degli Studi Orientali* XLIII (1968), 53-78 and 'I madīḥ di Ğarir per Hishām ibn 'Abd al-Malik', *AION* 30, n.s. XX (1970), 483-510. Finally there is the work of R.W. Hamilton, which, while concentrated on a single palace, has much wider implications: *Khirbat al Mafjar. An Arabian Palace in the Jordan Valley* (Oxford, 1959); 'Who built Khirbat al Mafjar?', *Levant* I (1969), 61-7; 'Pastimes of a caliph: another glimpse', *Levant* IV (1972), 155-6; 'Khirbat al-Mafjar: The Bath Hall reconsidered', *Levant* X (1978), 126-38 (the text of my article was complete when Dr John Onians kindly drew this latter paper to my notice, and so references to it here are confined to the footnotes).

The present article has a more closely defined scope than most of these works. It is confined to assembling the very scattered references to a single Umayyad caliph, al-Walīd II, referring to the original sources wherever possible; I am very grateful to my wife for sharing with me the labour of checking them. Literal translations are acknowledged when these are used in the main text. The aim has been to select and evaluate textual material that can be related directly to later Umayyad palatial architecture and to the life-style which those palaces seem to reflect. Much of this material has been used before, especially in the context of Khirbat al-Mafjar, but it seemed that there was still room for a concerted attempt to gather it together and to compare it systematically with the visual and archaeological evidence. Many unexpected correspondences have indeed appeared as a result of this method.

5 Unfortunately, very few such historians have been fully alive to the complex problems presented by Umayyad architecture.

6 The most accessible publication of these buildings is that of K.A.C. Creswell, *Early Muslim Architecture. Umayyads. A.D. 622-750* I/2 (Oxford, 1969). Creswell devotes a chapter to each monument and gives an exhaustive bibliography, chronologically arranged, for each.

7 Indeed, the fact that many of the Umayyad princes and caliphs shared similar tastes — wine, poetry, hunting, music and so on — is a reminder that the scope of possible choice for the patrons of the surviving Umayyad palaces is quite wide. Quṣair 'Amra is a case in point. T. Nöldeke, while accepting that al-Walīd II is the most likely patron of the building, nevertheless suggests that his father Yazīd II, who among other princes is recorded as visiting a castle in this area, could also have ordered it (review of Musil, *Ḳuṣejr 'Amra*, in *Zeitschrift der Deutschen Morgenländischen Gesellschaft* LXI [1907], 227). Khālid b. Yazīd also had a castle in the area around Quṣair 'Amra (Musil, op. cit., 153).

8 For evidence which bears on these suggested datings and patrons see Creswell, *EMA* I/2, 388, 475-6, 480-1, 506-7 and 512-14, 532, 400-1, 574 and 576, and 623-41 respectively. In the case of Quṣair 'Amra alone is there a substantial disagreement about dating; for a summary of the argument in favour of a later Umayyad date see A. Grohmann, *Arabische Paläographie. II Teil. Das Schriftwesen. Die Lapidarschrift* (Vienna, 1971), 73, n.3.

9 It seems likely, too — though here the evidence is archaeological — that Khirbat al-Minya, Usais and 'Anjar were all built in the reign of al-Walīd I and that at least the first two were intended as royal residences. 'Abd al-Malik had many residences and moved from one to another according to the season

LA DOLCE VITA IN EARLY ISLAMIC SYRIA: THE EVIDENCE OF LATER UMAYYAD PALACES

(Creswell, *EMA* I/2, 403-4). Although F. Gabrieli notes that the caliph Hishām very rarely left Ruṣāfa in the twenty-odd years of his reign (*Il Califfato di Hisham. Studi di storia omayyade* [Alexandria, 1935], 134) — indeed, he built two palaces (*qaṣrain*) there (al-Ṭabarī, *Tārīkh al-Rusul wa'l-Mulūk*, ed. M.J. de Goeje et al., [Leiden, 1885-9], series II, 1738,$_{4-5}$) and one variant of the text says he settled in them (*fa nazala fī himā*) — he also lived before this time at a place called al-Zaytūna. This has most recently been identified as Qaṣr al-Ḥair al-Sharqī: see O. Grabar, R. Holod, J. Knustad and W. Trousdale, *City in the Desert. Qasr al-Hayr East* (Cambridge, Mass., 1978), 13; for the opposing view, and an assessment of the literary evidence, see Creswell, *EMA* I/2, 512-14. Finally, he had a palace at Quṭaiyifa (al-Ya'qūbī, *Kitāb al-Buldān*, ed. M.J. de Goeje in *Bibliotheca Geographorum Arabicorum* [Leiden, 1892], 325). Yazīd II occupied al-Muwaqqar (Yāqūt, *Mu'jam al-Buldān*, ed. F. Wüstenfeld [Leipzig, 1866-70], IV, 686$_{22-3}$, 687$_{1-2}$) and Bait Rā's in Palestine (*Aghānī*, XIII, 165$_4$).

As for al-Walīd II, he remodelled as a desert palace a Roman fort called al-Bakhrā' (al-Ṭabarī refers to it as *al-hiṣn . . .min bina al-'ajam* — *Tārīkh*, Series II, 1796$_{17}$). It has been sited variously in eastern Syria (C. Huart, *Histoire des Arabes* [Paris, 1911] I, 276; near al-Qaryatain between Damascus and Palmyra (A. von Kremer, *Culturgeschichte des Orients unter den Chalifen* [Vienna, 1875] I, 152; on the northern frontier of the Ḥijāz, which is against all probability (Baron M. de Slane [tr.], *Ibn Khallikan's Biographical Dictionary* [Paris, 1871] IV, 448, n.18); 5km. south of Palmyra (Nöldeke, op. cit., loc. cit., with full assessment of the relevant literature); and 25 km. south of Palmyra (D. Derenk, *Leben und Dichtung des Omaiyadenkalifen al-Walīd ibn Yazīd. Ein quellenkritischer Beitrag* [Freiburg im Breisgau, 1974], 46) — this is approximately the correct location. Al-Walīd II also inhabited Qasṭal (*Aghānī* VI, 113$_8$). Yāqūt (*Mu'jam* IV, 95$_{6-10}$) mentions two sites of this name. One is the site on the pilgrim road to Medina (this would be not far from Mshattā); the other is on the road from Damascus to Ḥims. This latter one was a residence of al-'Abbās b. al-Walīd I (al-Ṭabarī, *Tārīkh*, ser. II, 1784$_8$; cf. Nöldeke, op. cit., loc. cit.). Al-Walīd II is also recorded as living at Zīza (al-Ṭabarī, *Tārīkh*, ser. II, 1754$_{11}$) and at Ubāyir, possibly the modern Qaṣr Bāyir (*Aghānī* II, 108$_{19}$ — the text actually has Ubāyīn) and, most frequently of all, at al-Azraq in the Aghdaf oasis (al-Tabarī, *Tārīkh*, ser. II, 1743$_{13}$; cf. ibid., 1795$_{11}$) — though Musil argues that the site in question is Qaṣr al-Ṭūba (op. cit., 157), some 60 km.

from al-Azraq. Al-Walīd also lived at the caliphal court at Ruṣāfa for a dozen years or so (Derenk, op. cit., 30). Al-Walīd's successor, Yazīd III, stated in his inaugural address, 'I bind myself not to lay one stone on another, not one brick on another . . . to build no palace' (von Kremer, op. cit., I, 388, citing the anonymous *Kitāb al-'Uyūn wa'l- Ḥaqā'iq*, ed. M.J. de Goeje and P. de Jong [Leiden, 1869], 150$_{12-13}$). This would suggest that previous rulers, notably al-Walīd — who is systematically denigrated in this long speech — built several palaces at great cost. Al-Walīd certainly continued to build right to the end of his life, for one source notes that when he succeeded to the throne he ordered a palace to be built (J. von Hammer-Purgstall, *Literaturgeschichte der Araber bis zum Ende des 12. Jahrhunderts der Hidschret* [Vienna, 1851] II, 41). It is hard to resist the conclusion that this was Mshattā.

10 E.g. al-Abbās b. Walīd I owned Qasṭal (see previous note), the maternal uncle of al-Walīd II, Ṭuraiḥ, had a castle (*Aghānī* IV, 78$_{23-4}$) and al-Ghamr b. Yazīd, besides living in the castles of Kharāna and Muwaqqar (Musil, op. cit., 159), had his own castle named Dhū Khushub (*Aghānī* II, 77$_9$).

11 For the clearest drawings of this much-damaged inscription, see J. Jaussen and R. Savignac, *Mission archéologique en Arabie. III. Les châteaux arabes de Qeseir 'Amra, Ḥarâneh et Ṭûba* (Paris, 1922), pl. LV/3 and fig. 17 on p. 98; see ibid., 98, for a first reading of it. Far-reaching conclusions were drawn from this inscription by Sauvaget (op. cit., 14-16). It should be emphasised that no photograph of this crucial inscription has been published.

12 For the relationship to the Roman foot, see Creswell, *EMA* I/2, 650; cf. ibid., I/1, 20 and D. Schlumberger, 'Les fouilles de Qasr el-Heir el-Gharbi (1936-1938). Rapport préliminaire', *Syria* XX (1939), 345-6. The sham nature of the fortifications has often been noted, and is given extra and ironic point in the report that in his last days al-Walīd II was advised to fortify his palace — a sure indication of its defenceless nature (F. Gabrieli, 'Al-Walīd ibn Yazīd. Il califfo e il poeta', *RSO* XV (1935), 21).

13 Al-Ghamr, the brother of al-Walīd II, invited the singer Ibn 'Ā'isha to visit him in his castle of Dhū Khushub. The singer was drinking with the prince one evening on the terrace which formed the roof of the castle and performed a pleasing air. The prince asked him to repeat it, which Ibn 'Ā'isha twice refused to do, as this was against his custom. In a fit of drunken irritation the prince had him pitched off the roof — though another account says he fell — and he died of his injuries (*Aghani* II,

LA DOLCE VITA IN EARLY ISLAMIC SYRIA: THE EVIDENCE OF LATER UMAYYAD PALACES

77$_{9-12}$). Similarly, al-Walīd II menaced the buffoon Ash'ab with throwing him headfirst from the top of the castle (Aghānī VI, 114$_{17-18}$). Musil (op. cit., 158) has taken the details of this anecdote (which is fully translated by F. Rosenthal in his book Humor in Early Islam [Leiden, 1956], 88-9) as evidence that the scene is set at Quṣair 'Amra, but the clear reference to a second storey surely excludes that. R.E. Brünnow, in his review of Musil's book (Wiener Zeitschrift für die Kunde des Morgenlandes XXI [1907], 296) argues persuasively that the locale is Kharāna, which has two inner cisterns and a roof reached by stairs; but one crucial detail brings Khirbat al-Mafjar to mind. The Ash'ab story is recounted twice in the Aghānī (the other version is in XVII, 99$_{8-24}$) and both anecdotes have al-Walīd threatening to kill Ash'ab or to pitch him into a fountain (bi'r). No trace of such a fountain remains at Kharāna and that building has virtually no room for it either, so it seems justifiable to seek elsewhere for the setting of this story. There is every likelihood that at Khirbat al-Mafjar the prince's audience chamber (majlis) was on the second floor of the palace, and from the window of that chamber the magnificent fountain, over sixty feet high and girdled by an arcade — the dominant feature of the courtyard — would have been clearly visible. The poet Ismā'īl b. Yasār, who prided himself on his Persian descent, so enraged the caliph Hishām by reciting before him verses which vaunted the Persians that he was thrown into a fountain, dragged out half dead and banished to the Ḥijāz for his pains (Aghānī IV, 125$_{12-30}$). Elsewhere it is recorded that it was al-Walīd II who visited this punishment upon him (Aghānī IV, 121$_{12-14}$) for the same reason; presumably there is confusion in the sources here and he received his ducking only once.

14 H. Lammens, Etudes sur le siècle des omeyyades (Beirut, 1930), 343. The information refers to one of the residences of al-Walīd II. In this respect he was continuing, though on a larger scale, the tradition of the Ghassānid phylarchs (T. Nöldeke, Die Ghassānischen Fürsten aus dem Hause Gafna's [Berlin, 1887], 47-9; cf. Musil, op. cit., 150). The court life of the Ghassānids, as evoked nostalgically by Hassān b. Thābit, was virtually indistinguishable from that of the more sybaritic Umayyad princes (Aghānī XVI, 15$_{22-30}$).

15 Lammens, op. cit., 344.

16 For the various reconstructions which have been proposed, see Creswell, EMA I/2, 590-3. Even if the side tracts were indeed used for domestic housing, they are each smaller than the central tract. It is inconceivable that there

were two storeys to these side tracts, for the presence of the royal audience chamber in a setting so dependent on open spaces is itself ample indication that the whole palace was single-storeyed.

17 For a detailed discussion of this matter, see my paper 'Islamic art at the crossroads: east versus west at Mshattā', in the Festschrift for Katharina Otto-Dorn, ed. A. Daneshvari (Los Angeles, 1981).

18 Quoted in full and analysed by Creswell in EMA I/2, 631.

19 However, there is nothing strange in the work taking place so to speak in reverse order, i.e. with architectural construction preceding agricultural work. This process may be noted at Khirbat al-Mafjar, where the bath hall was finished some time before the palace (Hamilton, 'Who built Khirbat al Mafjar?', 61-2).

20 Cf. Derenk, op. cit., 41.

21 For a discussion of these terms see Lammens, op. cit., 325-50; E. Herzfeld, 'Mschattā, Ḥīra und Bādiya. Die Mitteländer des Islam und ihre Baukunst', Jahrbuch der preuszischen Kunstammlungen XLII (1921), 130; and Grabar, op. cit., 283-308.

22 Khirbat al-Mafjar comes naturally to mind as the setting for the occasion when one Ḥakam al-Wādī sang before al-Walīd who, mounted on a magnificently caparisoned Egyptian mule, was one day taking the air in the gardens of his palace followed by his retinue (Aghānī VI, 654$_{-7}$). Similarly, the existence of extensive grounds in the royal palace is implied in the account of the funeral of the singer Ma'bad. His cortège was preceded by al-Walīd II and by the caliph's brother al-Ghamr, both in simple attire, until it left the precincts of the palace (Aghānī I, 19$_{26-9}$).

23 Ibn Jubair, Riḥla, ed. M.J. de Goeje (Leiden, 1907), 269$_3$; the Aghānī is more specific, calling it the Green Dome (VI, 159$_{24}$). Mu'āwiya thereby inaugurated a long tradition reflected in palaces at Ruṣāfa, Wāsiṭ and Baghdād (O. Grabar, 'Al-Mushatta, Baghdād and Wāsiṭ', in The World of Islam (Studies in Honor of P.K. Hitti), ed. J. Kritzeck and R.B. Winder [London, 1959], 105-7).

24 Tr. E. Schroeder, Muhammad's People (Portland, 1955), 205, without indication of source. Von Kremer, who uses the same passage, gives the source as the anonymous Ghurar al-Siyar (provenance unidentified; perhaps Bodleian Library, Oxford, D'Orville 542), f. 68 (op. cit., I, 135).

25 P.K. Hitti, History of the Arabs (London, 1943), 215; von Kremer, op. cit., I, 134-6. Al-Walīd II had several gardens (Aghānī VI, 112$_{28-9}$). He spent much time in the gardens of Dair Salība near Damascus, one of the many Christian monasteries which he visited

LA DOLCE VITA IN EARLY ISLAMIC SYRIA: THE EVIDENCE OF LATER UMAYYAD PALACES

regularly (al-ʿUmarī, *Masālik al-Absār fi Mamālik al-Amsār*, ed. M. Gaudefroy-Demombynes [Paris, 1927], I, 349₆). Another monastery in the same area, also surrounded by gardens, was Dair Būnā. Al-Walīd, attracted by its beauty, stayed there for a few days 'in debauchery and buffoonery' (ibid., 351₄).

26 Perhaps the classical exposition of this theory is to be found in Lammens, op. cit., 325-50. It is perhaps worth emphasising that there is nothing intrinsically nomadic about such practices; they were also followed by the Sasanian nobility (P.R. Brown, *The World of Late Antiquity. From Marcus Aurelius to Muhammad* [London, 1971], 163).

27 Lammens, op. cit., 300. Similar motives are attributed to Sasanian monarchs in the Muslim sources; e.g. Yazdigird the Sinner wanted a palace far from the city where disease raged, and thus ordered the legendary palace of Khwarnaq (cf. T. Nöldeke, *Geschichte der Perser und Araber zur Zeit der Sassaniden* [Leiden, 1879], 80, n.82).

28 For the text see T. Nöldeke, *Delectus veterum carminum arabicorum* (Berlin, 1890), 25₃₋₉. The translation is from Schroeder, op. cit., 209. For a fuller, rhyming, version see R.A. Nicholson, *A Literary History of the Arabs* (Cambridge, 1930), 195.

29 See O. Grabar, 'Umayyad "Palace" and the 'Abbasid "Revolution" ', *Studia Islamica* 18 (1963), 5-18 and J. Sauvaget, 'Châteaux umayyades de Syrie. Contribution à l'étude de la colonisation arabe aux Iᵉʳ et IIᵉ siècles de l'hégire' (ed. D. Sourdel and J. Sourdel-Thomine), *Revue des Etudes Islamiques* XXXVI (1968), 1-52.

30 The caliph Sulaimān before him is recorded as having loved gardens (G.E. von Grunebaum, *Kritik und Dichtkunst. Studien zur arabischen Literaturgeschichte* [Wiesbaden, 1955], 36, citing al-Ibshaihī, *Kitāb al-Mustatraf*, tr. G. Rat [Paris and Toulon, 1899-1902], II, 405 ff.).

31 This is a standard reproach among the Muslim chroniclers, and can be found also in non-Muslim sources, who stress his activities in building palaces, planting gardens and irrigation (J. Wellhausen, *Das arabische Reich und sein Sturz* [Göttingen, 1902], 207, 218). The matter is thoroughly investigated by Gabrieli, *Il Califfato di Hisham*, 129, 135-6, who concludes that these accusations are only partially justified.

32 This idea was first explored in depth by Grabar (*Ceremonial*, 192-243).

33 *Aghānī* I, 27₂₆; the translation is by Hamilton, 'Who built Khirbat al Mafjar?', 67.

34 *Aghānī* I, 27₅₋₆, as translated by Hamilton, ibid., 65. As will be shown later, the colour of turmeric or saffron was one particularly

affected by al-Walīd, while musk was clearly one of his favourite perfumes (see Gabrieli, 'Al-Walīd', 63, no. XCIX [tr. Derenk, op. cit., 51], where al-Walīd describes one of his women as having perfumed limbs, as if her mouth were filled with musk; Gabrieli, 'Al-Walīd', 62, no. XCV [tr. ibid., 29], where wine is compared to musk [the Arabs borrowed from the Greeks the custom of perfuming their wine – see G.E. von Grunebaum, *Medieval Islam*, Chicago, 1961, 315]; and Gabrieli, 'Al-Walīd', 37, no. X [tr. ibid., 31], where the saliva of his beloved Salmā is likened to musk).

35 Von Kremer, op. cit., I, 150. His female retinue fared likewise.

36 Lammens, op. cit., 188-9.

37 A recent attempt to formulate general conclusions about Umayyad baths may be found in Y. Crowe, 'Survival of classical elements in the ground-plan of Khirbat al-Mafjar', *Akten des VII. Kongresses für Arabistik und Islamwissenschaft, Göttingen, 15 bis 22 August 1974*, ed. A. Dietrich (Göttingen, 1976), 92-100.

38 See respectively Creswell, *EMA* I/2, 477; Grabar *et al.*, *City*, 90-7 and Schlumberger, op. cit., 213-23. However, it may be significant that, at ʿAnjar and Qasr al-Ḥair al-Sharqī at least, the bath is not part of the palace but is situated some distance away. Perhaps, therefore, it was not reserved for the private use of the caliph and his entourage. The bath at Qasr al-Ḥair al-Gharbī, though near the palace, may fall into the same category.

39 O. Grabar, J. Perrot, B. Ravani and M. Rosen, 'Sondages à Khirbet el-Minyeh', *Israel Exploration Journal* X (1960), 236 and 241 – though this identification is admittedly speculative. Sauvaget had suggested that the area in the south-western corner of the complex might have served the function of a bath ('Remarques', 37), but the excavation carried out by Grabar and his colleagues ruled this out ('Sondages', 226, n.2).

40 Hamilton, *KaM*, 31-3. This feature, though paralleled later, seems to be unique in the Umayyad period. Mshattā, also generally recognised to be a foundation of al-Walīd II, is equally prophetic of later developments. For 'Abbāsid *sirdābs* at Ukhaiḍir, Sāmarrā' and Baghdad see K.A.C. Creswell, *Early Muslim Architecture* II (Oxford, 1940), 64, 76, 81-2; 241, 362; and 390 respectively.

41 Hamilton, *KaM*, 103-5.

42 M. Chehab, 'The Umayyad palace at 'Anjar', *Ars Orientalis* V (1963), 24; Creswell, *EMA* I/2, 480, fig. 542 and pl. 78C.

43 C. Kessler, 'Die beiden Mosaikböden in Qusayr 'Amra' in *Studies in Islamic Art and Architecture in Honour of Professor K.A.C. Creswell* (Cairo, 1965), 105-31.

LA *DOLCE VITA* IN EARLY ISLAMIC SYRIA: THE EVIDENCE OF LATER UMAYYAD PALACES

44 A small portion of floor mosaic has been un-
covered during recent excavations at the site.

45 D.C. Baramki, 'Excavations at Khirbet el
Mefjir', *Quarterly of the Department of
Antiquities in Palestine* VI (1937), 164 and
pls LXI and LXII.

46 For the various functions of the bath in the
medieval Islamic world, see H. Grotzfeld, *Das
Bad im arabisch-islamischen Mittelalter*
(Wiesbaden, 1970).

47 See n. 38 *supra*. At first sight 'Anjar and Qaṣr
al-Ḥair al-Sharqī appear to be further relevant
parallels, but these two sites are settlements
rather than palaces alone. Moreover, it is clear
that neither of them has a royal palace of the
type represented by Qaṣr al-Ḥair al-Gharbī,
Khirbat al-Minya or Khirbat al-Mafjar. It is
therefore not surprising that their baths are
public.

48 Al-Masʿūdī, *Murūj al-Dhahab*, ed. and tr.
C.A.C. Barbier de Meynard as *Les Prairies
d'Or* (Paris, 1869), text, V, 74₉-75₂. Since
text and translation occur on the same page
in this edition, references to the text alone
will normally suffice. The translation here is
by Schroeder (op. cit., 206).

49 Al-Masʿūdī, loc. cit., 74₁. For the role of the
chair in the Umayyad period as a tribal
emblem and an object of veneration, see
Dixon, op. cit., 68-9.

50 Nevertheless it is said of him that when he sat
down to administer justice, men armed with
swords stood next to him (al-Suyūṭī, *Tārīkh
al-Khulafāʾ*, ed. M.A. Ibrāhīm [Cairo, 1976],
348₁₅₋₁₆]).

51 Al-Masʿūdī, *Murūj* V, 364₄₋₆.

52 Hitti, op. cit., 497. The sources he cites,
however, give a rather different picture, and
indicate that al-Walīd was dead by the time
Mūsā arrived in Damascus (see Ibn Khallikān,
op. cit., III, 26-7 and Ibn al-Athīr, *Al-kāmil
fiʾl-tārīkh*, ed. C.J. Tornberg (Leiden, 1860),
IV 448₂₁-449₂. Hitti was presumably using a
third source which he does not cite.

53 Al-Maqqarī, *Nafḥ al-Ṭīb*, ed. R.P.H. Dozy *et
al.* (Leiden, 1855-61), I, 252₁₈-253₁₄.

54 Von Kremer, op. cit., I, 142. He adds that the
first such eunuch is mentioned in the entour-
age of al-Walīd when he was still crown prince
(see *Aghānī* IV, 78₂₈). Other sources indicate
that it was Yazīd I who brought eunuchs into
court life (von Hammer-Purgstall, op. cit., 23)
and yet others that it was Muʿāwiya (al-Suyūṭī,
Tārīkh al-Khulafāʾ, 317₁₇).

55 Cf. the statement attributed to al-Walīd II by
Ibn al-Ṭiqṭaqā: 'Keep an eye on your
chamberlain, and let him be the best of your
household, for he is your face and your
tongue. Let none stand at your door without
his informing you of his being there' (*Al-
Fakhrī*, ed. H. Derenbourg [Paris, 1895],
172₁₀₋₁₁, as translated by C.E.J. Whitting,
Al Fakhri [London, 1947], 122).

56 M. Almagro, L. Caballero, J. Zozaya and A.
Almagro, *Qusayr ʿAmra. Residencia y baños
omeyas en el desierto de Jordania* (Madrid,
1975), Lám. XIVb.

57 Hamilton, *KaM*, 3-4 and pl. CIX.

58 Schlumberger, op. cit., 327, fig. 13 for a
drawing; for a colour plate, see B. Spuler and
J. Sourdel-Thomine, *Die Kunst des Islam*
(Berlin, 1973), pl. XI.

59 See K. Brisch in Spuler and Sourdel-Thomine,
op. cit., 182-3 and pl. 59.

60 Schlumberger, op. cit., pl. XLVI/2, pl.
XLVII/3 and fig. 21 respectively.

61 Hamilton, *KaM*, pl. CVII.

62 Brisch, op. cit., 182 and pl. 58.

63 Hamilton, 'Who built Khirbat al Mafjar?', 63,
65.

64 R. Ettinghausen, *From Byzantium to
Sassanian Iran and the Islamic World* (Leiden,
1972), 41-3.

65 Al-Ṭabarī, *Tārīkh*, ser. II, 1765₁₀₋₁₁ (*tamathīl
al-ẓibāʾ wa ruʾūs al-sibāʾ waʾl-ayāʾil wa ghair
dhālika*). Cf. Hamilton, *KaM*, pl. XLII/5, 7.

66 Al-Masʿūdī, *Murūj* V, 156₇₋₈. For his role in
training cheetahs see F. Viré, 'Fahd', *EI²*, II,
739.

67 G. Douillet, 'Furūsiyya', *EI²*, II, 953.

68 Al-Masʿūdī, *Murūj* V, 466₅₋₆. The caliph
Sulaimān also indulged a taste for horse-
riding (Ibn al-Jauzī, *Sīrat ʿUmar ibn ʿAdb al-
ʿAzīz* [Cairo, 1331/1913], 564₄) and the
clover-leaf race-track in ninth-century
Sāmarrāʾ eloquently testifies to the continued
popularity of horse-racing under the ʿAbbāsid
caliphs (E. Herzfeld, *Geschichte der Stadt
Samarra* [Berlin, 1948], pl. IV at back).

69 Von Kremer, op. cit., I, 142. She also kept a
stud (*Kitāb al-ʿUyūn*, 69₁₂).

70 Al-Masʿūdī, *Murūj* VI 13₄; tr. Schroeder, op.
cit., 252. One of his poems deals with horse-
racing (Gabrieli, 'Al-Walīd', 60, no.
LXXXVIII).

71 This seems to be implied by the report that he
threatened to cast the bearer of unwelcome
tidings to the wild beasts (Ibn ʿAbd Rabbih,
Al-ʿIqd al-Farīd, ed. Cairo, 1321/1903, II,
285). Nöldeke, however, points out that the
corresponding story in the *Aghānī* (VI, 114₁₈)
has al-Walīd threatening to throw the mes-
senger (Ashʿab) into a fountain (*ZDMG* LXI
[1907], 227; cf. n. 13 *supra*).

72 It contains a series of almost life-size images
of scantily dressed girls and gymnasts en-
circling the base of the dome (Hamilton,
KaM, pls XLIV/4, LVI/1, 4-9 and CVII).

73 A. Boëthius and J.B. Ward-Perkins, *Etruscan
and Roman Architecture* (Harmondsworth,
1970), 524-9.

74 H. Kähler, *Die Villa des Maxentius bei Piazza
Armerina* (Berlin, 1973).

75 A.G. McKay, *Houses, Villas and Palaces in the

Roman World (Ithaca, 1975), 100-8, 233-7.

76 R.E. Brünnow and A. von Domaszewski, *Die Provincia Arabia* (Strassburg, 1905), *passim*; S.T. Parker, 'Archaeological Survey of the *Limes Arabicus*: a Preliminary Report', *Annual of the Department of Antiquities of Jordan* 21 (1976), 19-31.

77 Even at Qaṣr al-Ṭūba, one of the largest Umayyad palaces, the 'accommodation' was — if Creswell is right — scarcely worthy of the name, for some rooms seem to have been intended to remain roofless (*EMA* I/2, 612).

78 But see n. 9 *supra.* The evidence of the sources appears to be contradictory, but this may simply reflect the nomadic way of life which al-Walīd followed. He may, in short, have spent most of his time away from Ruṣāfa even before he left the city for good around 122/740 (cf. Wellhausen, op. cit., 219).

79 Al-Ṭabarī, *Tārīkh*, ser. II, 1754$_{10-12}$. Zīza was the stage nearest Quṣair 'Amra and al-Azraq on the *ḥajj* road.

80 Cf. the account in al-Mas'ūdī (*Murūj* VI, 129$_{9-10}$) of al-Walīd's chamberlain telling him that crowds of people were awaiting his pleasure at the gate of his palace — *bi'l-bāb*, which could (in view of the architecture of Khirbat al-Mafjar and Mshattā) well mean *inside* the gate.

81 Schroeder, op. cit., 220; no source given.

82 This was a custom borrowed from the Sasanian kings (*Kitāb al-Tāj*, ed. A. Zakī Pāshā [Cairo, 1914], 28$_7$-29$_3$). The authorship of this work is still disputed. It has often been attributed to al-Jāḥiẓ, and purely for the sake of convenience he will be cited as the author in what follows. The curtain was of signal importance as a visual reminder of the status of the caliph, as al-Jāḥiẓ explains (*Kitāb al-Tāj*, 32$_{1-7}$). From a casual reference in the *Aghānī* (VI, 123$_8$) it appears that it was red, a colour that in the Hellenised society of Syria would at once have connoted royalty. The curtain was also used for formal purposes in the homes of the well-to-do in the Umayyad period. It is a standard feature of many an anecdote in the *Aghānī*. Yazīd II, for example, the caliph whose life-style approximated most closely to that of his son al-Walīd II, was particularly noted for his predilection for using a curtain (al-Mas'ūdī, *Kitāb al-Tanbīh wa'l-Ishrāf*, ed. A.I. al-Ṣāwitī [Cairo, 1357/1938], 277$_7$: *yasta'milu al-ḥijāb*). For a general account of the ceremony of the curtain in this period, cf. H.G. Farmer, *A History of Arabian Music to the XIIIth Century* (London, 1929), 67-8.

83 The caliphal image at Quṣair 'Amra includes a bolster, which is of standard Byzantine type (Almagro *et al.*, op. cit., 158, Lám. Xa).

84 The obvious Byzantine parallel is the image of Justinian making the imperial *oblatio* at San

Vitale, Ravenna; he never visited the city. Al-Jāḥiẓ reports the Sasanian custom of regarding the audience hall (*majlis*) of the monarch as equally sacred in his presence and in his absence (*Kitāb al-Tāj*, 69$_{15}$). A casual detail noted by the same author in another work, to the effect that it had long been traditional for caliphs to be attended by a girl wielding a fly-whisk and fan, is embodied in the fresco within the royal niche at Quṣair 'Amra — except for the detail that there are two such figures, both men (Almagro *et al.*, op. cit., Lám. Xb and XI; for the text, see *Risālat al-Qiyān* [ed. and tr. A.F.L. Beeston: *The Epistle on Singing-Girls of Jāḥiẓ*, Warminster, 1980], 8$_{12-13}$).

85 For a male musician, see Almagro *et al.*, op. cit., 190, Lám. XLIIb; for a female musician see ibid., Lám. XXVIIb; and for a dancer see ibid., Lám. XXVIIc. For a depiction of the spectators, presumably courtiers, see ibid., Lám. XVIIIa.

86 *Aghānī* VI, 123$_{6-9}$; tr. Musil, op. cit., 159 (the shortened version quoted here) and Rotter, op. cit., 117-18 (the full story). On this occasion, incidentally, Ḥammād was mortified because al-Walīd directed two words at him twice in succession before he realised that this was his cue to recite the poem which opened with them. Such a detail eloquently expresses the quality of connoisseurship required of such poets and professional memorisers.

87 Musil, op. cit., 159.

88 Aghānī VI, 124$_{20}$.

89 Thus the poet 'Aṭarrad, on being dismissed from the royal presence, asked permission to kiss al-Walīd's hand; he was refused (*Aghānī* III, 99$_{16-17}$). The poet Yazīd b. Ḍabbah, who had come to Damascus to witness al-Walīd's accession, went further still: he kissed the caliph's hands and feet and then the earth in front of him (von Hammer-Purgstall, op. cit., 717). A ritual of this kind recalls *proskynesis* (N.Q. King, *'There's such Divinity doth hedge a King'* [Legon, 1960], 9-10). Such elaborate expressions of respect bordering on veneration were not confined to the caliphs; cf. the anecdote of Jamīla and 'Abdallāh b. Ja'far in Mecca (A. Caussin de Perceval, 'Notices anecdotiques sur les principaux musiciens arabes des trois premiers siècles de l'islamisme', *JA* VII Série, II (1873), 435), or of the singer Ma'bad and the merchant from Ahwāz (*Aghānī*, I, 269$_9$).

90 At the time the fatal rebellion broke out, al-Walīd, who was at al-Azraq, had 200 men with him (Wellhausen, op. cit., 227). On the day that he was killed in his castle of al-Bakhrā' 1,200 of his men were camped around the site. They were bought by Yazīd, the pretender to the throne, and their

LA DOLCE VITA IN EARLY ISLAMIC SYRIA: THE EVIDENCE OF LATER UMAYYAD PALACES

defection sealed al-Walīd's fate.

91 Aghānī VI, 136$_{6-7}$.

92 Derenk, op. cit., 27, with full discussion of the sources.

93 The devotion of Yazīd II to al-sharab wa 'l-lahu (al-Mas'ūdī, Murūj V, 447$_6$) is especially prophetic of his son.

94 The dog is ritually unclean for Muslims (G.R. Smith and M.A.S. Abdel Haleem [ed. and tr.], The Book of The Superiority of Dogs over many of Those who wear Clothes, by Ibn al-Marzubān [Warminster, 1978], XXIX-XXX).

95 On the same occasion, according to one account, he brought with him an iron coffin which he intended to place on top of the Ka'ba (an unheard-of blasphemy) and be buried in it (von Hammer-Purgstall, op. cit., 36).

96 Musil, op. cit., 156; he gives a reference to al-Ṭabarī, Tārīkh, ser. II, 1743, but this deals only with al-Walīd's departure from Ruṣāfa with his entourage. It may be, therefore, that Musil's version of the episode is inaccurate.

97 This account of the event is the one most likely to be correct (Aghānī VI, 102$_{10-12}$; cf. the previous note).

98 Al-Suyūṭī, Tārīkh al-Khulafā', 400$_{5-6}$; tr. Schroeder, op. cit., 252.

99 Al-Ṭabarī, Tārīkh, ser. II, 1811$_{1-3}$.

100 Aghānī VI, 112$_{25-6}$. His drinking vessels were huge Pharaonic bumpers (von Hammer-Purgstall, op. cit., 44).

101 It may even have extended to the caliph Hishām. An open contradiction in the sources is well expressed in their extremes: according to one account seven hundred camels were needed to carry his wardrobe, while another report states that he had a single green robe which he wore his whole life long. Gabrieli is inclined to credit the sources which stress the caliph's sobriety (Califfato, 135), but it has to be said that the evidence of the paintings and sculptures of Qaṣr al-Ḥair al-Gharbī, generally accepted as a foundation of Hishām and not excavated at the time that Gabrieli was writing, points to the contrary view (cf. Schlumberger, op. cit., 347-60, figs 18-26 and pls XLIV-XLVII; and R. Hillenbrand in Spuler and Sourdel-Thomine, op. cit., 172-5 and colour pls XII-XIII). Cf. in this connection n. 9 supra.

102 Schroeder, op. cit., 231. This is a free rendering of al-Mas'ūdī, Murūj V, 400$_{3-10}$. The uncle of al-Walīd II, Maslama b. 'Abd al-Malik, was reproached for wearing brightly coloured robes (Ibn Khallikān, op. cit., I, 198).

103 Al-Suyūṭī, Tārīkh al-Khulafā', 359$_{17}$-360$_3$; freely translated by Schroeder, op. cit., 231. For further evidence of Sulaimān's vanity see al-Mas'ūdī, al-Tanbīh 275$_{12-13}$ and idem,

Murūj V, 402$_9$-403$_4$.

104 Caussin de Perceval, op. cit., 511.

105 Al-Jāḥiẓ, Kitāb al-Tāj, 154$_{9-11}$.

106 In Aghānī II, 65$_{23-4}$ he is described as wearing two yellow coats and a saffron-yellow burnous. In view of the Indian influence which can be seen in monuments associated with al-Walīd (Grabar, Ceremonial, 248, 251), it is perhaps significant that in India it was a prerogative of the king and of his family to wear yellow garments, and this clothing – like that of the caliphs – was of silk (von Kremer, op. cit., I, 152, n.1). Patterned robes are, incidentally, worn by the enthroned figure at Quṣair 'Amra (Spuler and Sourdel-Thomine, op. cit., pl. 33).

107 Hamilton, KaM, 229. The beard and moustache of the figure were painted a golden brown (ibid.). In one of his poems al-Walīd compares wine to saffron (za'fran): al-Mas'ūdī, Murūj VI, 7$_6$; cf. Ibn 'Abd Rabbih, Al-'iqd (1321/1903 ed.), II, 289$_{17}$.

108 Hamilton mentions that a ring can still be seen on the left little finger of the caliphal statue at Khirbat al-Mafjar (KaM, 229); the resolution of the published photographs is too poor to show this detail.

109 Aghānī VI, 129$_{27-8}$. The statue adds the further sartorial detail of a jewelled belt. The sources often mention that al-Walīd, in a gesture that became typical of later Muslim rulers, bestowed his clothes on those he wished to honour; in this he was perhaps following an immemorially ancient Persian custom, whereby the ruler at the time of the New Year celebrations symbolically gave his own magnificent but cast-off clothing to his subjects (cf. Brown, op. cit., 203).

110 Caussin de Perceval, op. cit., 511.

111 Kitāb al-'Uyūn, 143$_{13}$.

112 Aghānī VI, 144$_{27}$. However, in one of his poems he calls for an iklīl (a diadem, garland or chaplet) and a tāj (crown) (Gabrieli, 'Al-Walīd', 62, no. XCV; tr. Derenk, op. cit., 60). If iklīl is indeed intended to signify 'garland' in this drinking poem, the parallel cases of Bishr b. 'Abd al-Malik and of Muṭī' b. Iyās could be cited (Caussin de Perceval, op. cit., 428 and Aghānī XII, 92$_6$ respectively). Von Grunebaum notes this practice among several others which demonstrate the strength of Greek influences in the drinking habits of early Islamic society (MI, 315).

113 J. Walker, A catalogue of the Arab-Byzantine and post-reform Umayyad coins (repr. Oxford, 1967), pp. XXVIII, LIV-LV and 43, no. P. 14.

114 G.C. Miles, 'Miḥrāb and 'Anazah: a Study in Early Islamic Iconography', in Archaeologica Orientalia in Memoriam Ernst Herzfeld, ed. G.C. Miles (Locust Valley, 1952), 158, 169-70 and pl. XXVIII/3.

LA DOLCE VITA IN EARLY ISLAMIC SYRIA: THE EVIDENCE OF LATER UMAYYAD PALACES

115 Ettinghausen, op. cit., 28-33; Hamilton, 'Bath Hall', 132.

116 *Aghānī* VI, 141₅.

117 *Kitāb al-'Uyūn*, 7₉-₁₀.

118 Hamilton, 'Who built Khirbat al Mafjar?', 66, fig. 4 and 67.

119 This extraverted gesture is recorded of al-Walīd's own father, Yazīd II (al-Jāḥiẓ, *Risālat al-Qiyān*, 11₅) and is mentioned elsewhere in the *Aghānī*, e.g. of 'Umar b. abī Rabī'a (Caussin de Perceval, op. cit., 440) and of Abū Rīhāna (ibid.); it may well have been an accepted symbol of extreme delight in a fine performance. Ibn 'Abd Rabbih in the *'Iqd al-Farīd* devotes an entire chapter to describing those who fainted or even died on hearing a song (ed. M.S. al-'Uryān [Cairo, 1953], III, 210₅-211₂₇).

120 Al-Jāḥiẓ attributes the same exhibitionism to Yazīd II (*Kitāb al-Tāj*, 32₈-₁₁).

121 Hamilton, 'Who built Khirbat al-Mafjar?', 67, translating *Aghānī* III, 98₂₅-99₄).

122 Von Kremer, op. cit., I, 149. According to al-Jāḥiẓ, however, all the Sasanian kings drank once every three days, except three who drank daily (*Kitāb al-Tāj*, 151₈-₉).

123 According to al-Jāḥiẓ at least (loc. cit., ₁₀-₁₁).

124 Hence his nickname Yazīd al-Khumūr — 'Yazid of the Wines'. He drank every day (al-Jāḥiẓ, loc. cit., ₁₂-₁₃; cf. al-Mas'ūdī, *Murūj* V, 157₅).

125 Al-Jāḥiẓ, *Kitāb al-Tāj*, 151₁₄-152₄.

126 There is an alternative tradition to the effect that Hishām abstained from wine and condemned the enjoyment of it (*Aghānī* V, 167₂₈).

127 For the information on these three caliphs, see al-Jāḥiẓ, *Kitāb al-Tāj*, 152₅-₆, ₉. For the timing of Hishām's wine-drinking see *Quṭb al-Surūr*, f. 114, *apud* von Kremer, op. cit., I, 149.

128 It was Yazīd I who initiated the habit of holding great festivities in the palace, featuring wine and song (*Aghānī* XVI, 70₂₉-₃₀; al-Mas'ūdī, *Murūj* V, 156₈-157₄). For the role of wine-drinking in pre-Islamic society see I. Goldziher, *Muslim Studies*, ed. S.M. Stern, tr. C.R. Barber and S.M. Stern (London, 1967), 29-38.

129 *Aghānī* II, 65₂₆. He also figures in the poems (e.g. al-Mas'ūdī, *Murūj* VI, 7₁₀).

130 He alone among the Umayyad caliphs is recorded as having completed, with his boon companions, a Persian *haftja* or *hafta hafta* — a truly royal orgy of 49 days of consecutive drinking (al-Mas'ūdī, *Murūj* VI 12₇-₈), but one which had the sanction of Persian tradition behind it when a particular type of drink was taken at the prescribed time of year (*Aghānī* VI, 130₁-₄). On another occasion he filled a big stone basin with wine and drank it all with a boon companion (*Aghānī* VI, 112₉).

131 He had composed a scurrilous poem at the time of Hishām's death (see n. 149 *infra*) and when one 'Umar al-Wādī rashly repeated this during a drinking bout al-Walīd said, 'If I hear those verses from you again I'll kill you' (von Hammer-Purgstall, op. cit., 41).

132 Cf. the vivid scene evoked in the *Aghānī*, where al-Walīd has quarrelled with his wife and his ill humour hangs like a thundercloud over his court the whole day long (III, 116₃₀-117₂₀).

133 When one of his boon companions left his presence while al-Walīd was drunk, the latter told the retainer who stood by his head to bring the head of the man in question, al-Qāsim b. al-Ṭawīl. This was done (*Aghānī* VI, 132₃₀-133₃). For the grim catalogue of his acts of revenge on attaining the caliphate, see Wellhausen, op. cit., 221 and 224, and Derenk, op. cit., 43-4. To regard him simply as a frivolous hedonist is to miss the darker side of his nature. The visual evidence substantiates the picture of a somewhat schizophrenic personality which emerges from the literary sources: against the manifest *joie de vivre* expressed in the statues of half-naked girls must be set the uncompromising exercise of absolute power symbolised in the 'Tree of Cruelty' mosaic in the *dīwān* at the very same site of Khirbat al-Mafjar.

134 For the text, see al-Fīrūzābādī, *Al-Jālis al-Anīs fī Tahrīm al-Khandarīs* (British Library, MS. Or. 9200), f. 10a; for the translation, see A. Fulton, 'Fīrūzābādī's "Wine List"', *Bulletin of the School of Oriental and African Studies* XII/3-4 (1948), 582.

135 Ibid.

136 R. Ghirshman, *Iran. Parthians and Sassanians*, tr. S. Gilbert and J. Emmons (London, 1962), pls 256 and 258.

137 Hamilton, *KaM*, 169, 194, 203-4, fig. 26 and pls XLIX-LII.

138 Almagro *et al.*, op. cit., Lám. XII and XIIIa. The broad central band of the ceiling of the royal niche also bears predominantly vine ornament (ibid., Lám. IXc).

139 Creswell, *EMA* I/2, pl. 129.

140 C. Clermont-Ganneau, 'La Province d'Arabie', *Recueil d' Archéologie Orientale* VII (1907), 206 — though he believed the building to have been erected by a Lakhmid rather than by an Umayyad prince. He suggests that when the façade is read from right to left, the vine can be seen at various stages of maturity until it is finally invaded by all the beasts of creation and — last among them — man. It might be added parenthetically that this theory would explain why the right-hand façade does have one or two living creatures near the main gate, a detail which demolishes the theory that the right-hand façade is kept deliberately free of living creatures because it includes the rear

LA DOLCE VITA IN EARLY ISLAMIC SYRIA: THE EVIDENCE OF LATER UMAYYAD PALACES

wall of the palace mosque. Clermont-Ganneau notes the Dionysiac connotations of the sole human being on the façade, who wears — he suggests — a Phrygian bonnet (Creswell, *EMA* I/2, pl. 129). Could this headgear in fact be a *qalansuwa ṭawīla*? And if so, would it be within the realms of possibility to see this figure as a reference to al-Walīd himself? Such a rebus would accord well with the spirit of the cryptic panel in front of the royal apse at Khirbat al-Mafjar (Hamilton, 'Bath Hall', 130-2, 135-6). One further theory may be hazarded here. The remarkable quantity and variety of creatures depicted on the façade could be intended to evoke Solomonic associations. Solomon is celebrated in Islamic tradition for his dominion over all the beasts of creation, and also over the *jinns* who were only part-human (could the centaurs have acquired this new and distinctively Islamic connotation here?). In the later middle ages it became quite common to associate the ruler with Solomon, though admittedly this seems to have been especially prevalent in Iran and India rather than in the Levant (cf. A.S. Melikian Chirvani, 'Le royaume de Solomon. Les inscriptions persanes de sites achéménides', *Le monde iranien et l'Islam* I (1971) 6-8, 16-17 and P.P. Soucek, 'The influence of Persepolis', *Actes du XXIX Congrès des Orientalistes* [Paris, 1975], 195 ff.). Strzygowski drew attention to the other Solomonic resonances at Mshattā ('Mschatta', *Jahrbuch der königlichen preuszischen Kunstsammlungen* XXV [1904], 232), but the point was not followed up in the later literature on Mshattā. More recently, P.P. Soucek has interpreted certain elements at Khirbat al-Mafjar in this light (see her review of O. Grabar, *The Formation of Islamic Art*, in *Iranian Studies* VIII/4 [1975], 254-63). Islamic tradition did, after all, credit Solomon with the building of Palmyra (Musil, op. cit., 147-8). As for the particular disposition of the animals within roundels and triangles at Mshattā, the obvious source appears to be the standard 'inhabited scroll' mosaic pavement of Byzantine Syria; the transposition of floor mosaic themes to a stone façade is typical of Umayyad procedure.

141 Ettinghausen, op. cit., 3-10.
142 R. Blachère, *Analecta* (Damascus, 1975), 398-9.
143 Al-Mas'ūdī, *Murūj* VI, 7_{10}-8_1; tr. Schroeder, op. cit., 254. For a different, fuller, text see Gabrieli, 'Al-Walīd', 48, no. L. The melancholy self-knowledge which pervades this poem is paralleled elsewhere in his output. Cf. for example:
 In wine lies my undoing.
or

I'll shroud myself in purple wine,
For empire vanishes before my eyes.
 (von Hammer-Purgstall, op. cit., 43).
144 *Aghānī* VI, 128_{23-4}. For the text, see Gabrieli, 'Al-Walīd', 44, no. XXXVII.
145 F. Sezgin, *Geschichte des arabischen Schrifttums. II. Poesie bis ca. 430H.* (Leiden, 1975), 318; Wellhausen, op. cit., 223. Even so, he sent a *rāwī* ('memoriser') to the court of Hishām occasionally to recite some of his latest verses (Sezgin, loc. cit.,). The absence of a collected edition, however, does not mean that these verses were little known. Von Kremer notes that al-Walīd courted the daughters of noble fathers and, to the embarrassment of their families, wrote poems about them which were assured wide circulation by his position and his fame as a poet (op. cit., I, 150).
146 Creswell, *EMA* I/2, 397.
147 The poems of Yazid I were deemed worthy of collection after his death (Sezgin, op. cit., 316) and a certain al-Sha'bī said that he had never recited a verse to 'Abd al-Malik without the latter capping it (Ibn al-Ṭiqṭaqā, *al-Fakhrī*, 170_{1-3}; al-Suyūṭī, *Tārīkh al-Khulafā*, 343_{14-15}). For some verses of 'Abd al-Malik, see ibid., 351_{5-12}. For a rare poem by 'Umar b. 'Abd al-'Azīz see al-Mas'ūdī, *Murūj* V, 428_{6-7}. Even a verse by Hishām is recorded (al-Suyūṭī, *Tārīkh al-Khulafā*, 395_{5-6}), and he seems to have heard the greatest poets of his time (Gabrieli, *Califfato*, 137). On the very day that al-Walīd's cousin Yazīd, after patient plotting, declared his rebellion and was proclaimed caliph he recited some warlike lines from one of the pre-Islamic poets, and his supporters noted with chagrin that until then his talk had been larded with Qur'ānic verses (*Aghānī* VI, 138_{17-21}).
148 Derenk, op. cit., 39.
149 Al-Mas'ūdī, *Murūj* VI, 55_{-9}; tr. Schroeder, op. cit., 252. This translation is very free. For the complete text see Gabrieli, 'Al-Walīd', 62, no. XCVI. For another version of the same story see *Aghānī* VI, 109_{4-8}.
150 *Aghānī* XIV, 115_{15-16}.
151 Al-Suyūṭī, *Tārīkh al-Khulafā*, 355_{4-9}. His father 'Abd al-Malik chided him: 'Only he who speaks their language well will rule the Arabs' (Ibn al-Ṭiqṭaqā, *al-Fakhrī*, tr. Whitting, 123).
152 For the barbarisms which al-Walīd I inflicted upon the Arabic language, see Ibn 'Abd Rabbih, *Al-'iqd* (1321/1903 ed.) I, 240_{20} and II, 273_{18}. His father, 'Abd al-Malik, regretted not having given him a proper education (ibid., I, 277_6 and 240_{24}). Al-Mas'ūdī gives similar anecdotes (*Murūj* V, 412_5-413_{10}).
153 Ḥammād b. Sābūr — a Persian, as his patronymic shows — was known as al-Rāwiya because of his memory. For a brief biography see

LA DOLCE VITA IN EARLY ISLAMIC SYRIA: THE EVIDENCE OF LATER UMAYYAD PALACES

C. Huart, *A History of Arabic Literature* (London, 1903), 59-60.

154 Ibn Khallikān, op. cit., I, 470.

155 *Aghānī* XIV, 115$_{7-9}$.

156 *Aghānī* VI, 148$_{25-27}$. On al-Walīd as a patron see Derenk, op. cit., 66-8.

157 *Aghānī* XII, 80$_3$; the translation is by Nicholson, op. cit., 291. Cf. Huart, *HAL*, 65-6, and G.E. von Grunebaum, 'Three Arabic Poets of the Early Abbasid Age. (The Collected Fragments of Muṭī' b. Iyâs, Salm al-Ḥāsir and Abû'š-Šamaqmaq)', *Orientalia* n.s. 17 (1948), 160-204.

158 This was his own sister-in-law Salmā, who repelled his advances until he became caliph and then died forty days (some sources say only a week) later. See *Aghānī* VI, 113$_{19}$-114$_2$, and the extended discussion by Blachère (*Analecta*, 383); Derenk (op. cit., 116) and von Kremer (op. cit., I, 150-1). For the texts of some of his odes to her, see Gabrieli, 'Al-Walīd', 37, no. XII; 38-9, no. XVII; 50, no. LVI; 55, no. LXXIII; and 56, no. LXXIV. For translations of these poems, see Blachère, *Analecta*, 394-6.

159 *Kitāb al-'Uyūn*, 76$_2$-80$_{12}$. Of al-Walīd II it is also recorded that his absorption with singers caused the reins of power to slip from his fingers (O. Rescher, *Abriss der arabischen Literatur*, I [Stuttgart, 1925], 174).

160 Musil, op. cit., 158. Blachère disagrees with this judgment (*Analecta*, 392-3) but nevertheless praises one of al-Walīd's poems in this genre (ibid., 396). For specimens of such threnodies, see Gabrieli, 'Al-Walīd', 42, no. XXIX; 50, no. LVI and 58-9, no. LXXXIV; for translations of them, see Derenk, op. cit., 116, 116-17 and 83 respectively.

161 The caliph habitually used the title *amīr* ('commander') for the secular arm of his power; the title *imām* (broadly translatable as 'religious leader') was reserved for such religious contexts as his function of leading the congregation in prayer at the Friday service. The poem therefore comes close to blasphemy. F. Gabrieli has further suggested that some of al-Walīd's poetry contains sacrilegious parodies of Christian rites, possibly referring to masquerades in some desert convent (*La letteratura araba* [Rome, 1948], 115).

162 Tr. Nicholson, op. cit., 206. For the original text, as handed down by Abu'l-'Alā' al-Ma'arrī, see R.A. Nicholson's edition: '*The Risālatu'l-Ghufrān*: by Abū'l-'Alā al-Ma'arrī. Part II', *Journal of the Royal Asiatic Society* (1902), 829$_{13-16}$ or *Aghānī* VI, 122$_{19-21}$. The literal translation of the first two lines, as given by Nicholson (*JRAS* [1902], 342) runs as follows:

I boast myself to be Walīd, the Imām,
 trailing my striped robe and listening
 to words of love.
I drag my skirt to the chambers of my
 mistress, and I heed not those who
 blame and rebuke me.

In the context of al-Walīd's noted philhellenism (see notes 212-14 *infra*) it is interesting to note that it was originally a Greek custom to express light-hearted *joie de vivre* by trailing one's robe along the ground (von Grunebaum, *MI*, 315). However, a drunken Walīd is recorded as dragging his silken robe behind him on the day of his cousin's death as he goes to condole with Hishām, the father (*Aghānī* VI, 104$_8$; *yajurru miṭrafa khazzin 'alaihi*).

163 Musil, op. cit., 160; cf. al-Mas'ūdī, *Murūj* VI, 5$_{10}$-6$_1$, where al-Walīd describes his one remaining pleasure as intimate conversation on a moonlit night on a hillock of fine sand. It may be permissible to recall in this context the map of the heavens which decorates the dome of the *calidarium* at Quṣair 'Amra (Almagro *et al.*, op. cit., Lám. XLVIIIa, b).

164 Al-Mas'ūdī, *Murūj* VI, 13$_5$.

165 Ibid., VI 14$_{1-2}$,8-9 and 15$_{3-5}$ as paraphrased by Schroeder, op. cit., 252-3.

166 For Quṣair 'Amra see Almagro *et al.*, op. cit., Láms XXIa, b; for Khirbat al-Mafjar, see Hamilton, *KaM*, pl. LVI/5.

167 When it became clear that Yazīd b. Mu'āwiya, and not a son of 'Alī, was to inherit the caliphate, the 'Alid 'Abdallah b. Hishām al-Salūlī wrote a bitter epigram:

We're filled with wrath, and were we to
 drain
The blood of Umayyah, our thirst would
 still pain;
While wasting your people, ye still without
 care,
Ye sons of Umayyah, go hunting the hare.

For the text, see al-Mas'ūdī, *Murūj* V, 50; the English version is that given by D.S. Margoliouth in his translation of J. Zaydan, *Umayyads and 'Abbásids* (London, 1907), 143. Some decades later, a fatal hunting accident which befell Mu'āwiya b. Hishām drew from his father the ironic epitaph 'I brought him up for the caliphate, and he pursues a fox' (al-Ṭabarī, *Tārīkh*, ser. II, 1739$_{1-2}$; tr. Hitti, op. cit., 223).

168 Wellhausen, op. cit., 223. Al-Walīd's fondness for falcons is attested by numerous references in the sources; these have been assembled by Nöldeke, *ZDMG* LXI (1907), 227. It was at this period, significantly enough, that Persian influences began to infiltrate Arab falconry (M. Allen, *Falconry in Arabia* [London, 1980], 128). Yazīd b. Mu'āwiya was also an avid collector of falcons among other animals such as dogs, apes and lynxes (al-Mas'ūdī, *Murūj* V, 68; cf. ibid., V, 156$_8$).

LA *DOLCE VITA* IN EARLY ISLAMIC SYRIA: THE EVIDENCE OF LATER UMAYYAD PALACES

169 Huart notes that he kept a pack of dogs (*HA* I, 276); in this he was continuing Ghassānid tradition (Musil, op. cit., 150). For the background to some of these practices, see R.B. Serjeant, *South Arabian Hunt* (London, 1976).

170 Almagro *et al.*, op. cit., Láms XXVIIIb and XXIXa, b.

171 *Aghānī* VI, 148$_{31-2}$. This information lends extra credence to the suggestion that the isolated hunter spearing onagers in the relevant fresco at Quṣair 'Amra is the caliph (or prince) himself (Almagro *et al.*, op. cit., 178 and Láms XXXb and XXXI).

172 Hamilton, 'Who built Khirbat al Mafjar?', 65.

173 *Kitāb al-'Uyūn*, 126$_8$; Derenk, op. cit., 33.

174 G. Flügel, *Die Geschichte der Araber* (Leipzig, 1840), 97.

175 Al-Ṭabarī, *Tārīkh*, ser. II, 1797$_{8-9}$.

176 *Aghānī* VI, 130$_{19}$. On the last day of his life, lounging on a couch (*sarīr*), he vaunted his courage in attacking lions and vipers (ibid., 188$_{29-31}$).

177 Brisch, op. cit., pl. 58.

178 Hamilton, *KaM*, frontispiece.

179 Wellhausen, op. cit., 223.

180 In the *Aghānī* he is dubbed a free-thinker (VI, 102$_{13}$). However, the word *zandaqa* employed here was often used as a blanket term of disapproval without precise connotations of heresy (Gabrieli, 'Al-Walīd', 17-18).

181 See Nicholson (ed.), *The Risālatu 'l-Ghufrān*, 829$_2$-830$_{14}$.

182 *Aghānī* II, 78$_{26-7}$.

183 *Kitāb al-'Uyūn*, I, 150$_{7-8}$. Typical of his impious attitude was his violation of the sanctity of asylum in the case of the poet Ibn al-Qa'qā' (*Kitāb al-'Uyūn*, 122$_{1-2}$) and of Ibrāhīm, the son of the caliph Hishām (*Aghānī* VI, 108$_{24-9}$).

184 *Aghānī* VI, 102$_{19-23}$.

185 Gabrieli, 'Al-Walīd', 35, no. VI; for partial translation, see Barbier de Meynard's translation of al-Mas'ūdī, *Murūj* VI, 11.

186 See T. Nagel, *Untersuchungen zur Entstehung des 'Abbasidischen Kalifates* (Bonn, 1972), 117. Cf. al-Suyūṭī, *Tārīkh al-Khulafā'*, 369$_{11-12}$ and 401$_{8-9}$. Nevertheless, it must be conceded that the same analogy was made in the case of 'Abd al-Malik (al-Ya'qūbī, *Tārīkh*, ed. M.T. Houtsma [Leiden, 1883], II, 336) and of Yazīd I (al-Mas'ūdī, *Murūj* V, 160$_{2-3}$).

187 S. Khuda Bukhsh, *Studies Indian and Islamic* (London, 1922), 79. It was bad enough for the caliph to neglect his duty as *imām* by sending a representative to lead prayers; but to send a *maulā* (presumably in this case a non-Arab) was a gratuitous insult. Earlier in his career, when entrusted by Hishām with the oversight of the *ḥajj*, he made merry in the Holy Cities and delegated a *maulā* to represent him in the ceremonies (*Aghānī* VI, 102$_{11}$).

188 The story goes that dawn had come upon him unawares while he was in the arms of a slave girl; he put his robe around her and sent her to the mosque to lead the morning prayer in his place. In all probability she was ritually unclean, which of course compounded the offence (*Aghānī* VI, 124$_{6-8}$).

189 Here again his actions echo those of his father Yazīd II; the latter was persuaded by a song performed by Ḥabāba, his favourite *chanteuse*, to send his brother Maslama to take his place as *imām* in the mosque (Caussin de Perceval, op. cit., 505). The *Aghānī* relates that he was drunk when he went to the mosque to be confirmed as caliph (VI, 109$_{3-4}$).

190 *Aghānī* VI, 130$_{10-16}$. But Abu'l-Faraj explicitly says that the verse which refers to this incident is not by al-Walīd, contrary to the assertion of the source he himself is quoting. On the last day of his life he was charged with harbouring incestuous desires (*Aghānī* VI, 139$_{23}$). In the context of alien faiths it is relevant to recall a bizarre anecdote (*Aghānī* VI, 135$_{27-31}$), earlier noted by Rescher (op. cit., I, 175) and to which Hamilton has recently drawn attention ('Bath Hall', 132-3). Al-Walīd, in the company of a man from the Banū Kalb who professed the dualist (i.e. 'Persian') faith, exhibited to the narrator of the story (a pious Muslim) a mannikin with movable quicksilver eyes, and outrageously identified it as Mānī, the only true prophet. If al-Walīd did indeed have strong Persian sympathies, this might have predisposed him to make the ample use of Sasanian iconography and artistic clichés found at Khirbat al-Mafjar. His successor Yazīd III, incidentally, was the son of a Soghdian princess, Shāh-Afrīd (or Shāhfarīd), (al-Ṭabarī, *Tārīkh*, ser. II, 1874$_{12}$), whose great-grandmother was a daughter of a Byzantine emperor and was also descended from the daughter of one of the Khaqāns of Central Asia. Thus it was not empty boasting (as has been thought) for him to sing in his own honour:

I am the son of Khusrau; my father was Marwān,
Caesar was my ancestor, and so was the Khaqān.

On this whole matter, see Sir William Muir, *The Caliphate: Its Rise, Decline and Fall* (repr. Beirut, 1963), 417 and al-Ṭabarī, loc. cit., $_{11-14}$. Al-Walīd II produced verses testifying to the same pride of ancestry; see Gabrieli, 'Al-Walīd', 58, no. LXXXII (tr. ibid., 28 and Hamilton, 'Bath Hall', 128).

191 To use the Qur'ān as an oracle, as al-Walīd seems to have done in this case, was in itself

a highly unorthodox act, but by ill chance he had lighted upon a verse (Sūra XIV, 16) which in rhyming prose condemns every tyrant to drink pus in hell.

192 For the original, see *Aghānī* VI, 125$_{12-13}$; the English rendering is by Margoliouth in his translation of Zaydan, op. cit., 104. Compare the story told of his grandfather 'Abd al-Malik (which may be apocryphal; see Dixon, op. cit., 20-4, for evidence of his genuine piety), who when news of his appointment as caliph reached him closed the Qur'ān he was reading with the words 'This is our final parting' (al-Suyūṭī, *Tārīkh al-Khulafā*', 345$_{4-5}$; tr. Margoliouth, op. cit., 102)

193 *Aghānī* VI, 141$_{4-7}$.

194 Cited by G. Weil, *Geschichte der Chalifen* I (Mannheim, 1846), 663. However, in view of his frivolous conduct on the *ḥajj* earlier in his life it is perhaps licit to question his motivation on this occasion. Earlier, he had ironically declared that he would have to refrain from going on the *ḥajj* because of the reaction of the people of Madina to his voice (*Aghānī* I, 21$_{5-7}$).

195 *Aghānī* VI, 139$_{25}$.

196 Blachère implicitly accepts this story, which is certainly the most widely related account of al-Walīd's death, but draws attention to *Aghānī* VI, 141$_{29}$, which describes how in his last hours al-Walīd listened to 'Umar al-Wādī singing (*Analecta*, 389). Elsewhere in the *Aghānī* it is related that he entered his *qaṣr* and recited verses beginning:
 Leave me Hind and al-Rabāb and a few boys and a singing-girl: that is wealth enough for me . . .
(tr. Nicholson, *JRAS* [1902], 343; for the text, see *Aghānī* VI, 139$_{12-17}$, which omits the first *bait* translated by Nicholson). According to al-Mas'ūdī, he was buried at al-Bakhrā' (*Murūj* VI, 2$_{1-2}$), wrongly identified as a village of Damascus. But according to another, earlier, source he was buried in Damascus — and, of all places, in the cemetery called 'The Gate of Paradise' (*bāb al-faradīs*) [Derenk, op. cit., 47, citing al-Balādhurī, *Ansāb al-Ashrāf*, f. 168b].

197 Nöldeke, *ZDMG* LXI (1907), 225-6.

198 Wellhausen, op. cit., 219.

199 Al-Mas'ūdī, *Murūj* V, 394$_{10}$-396$_1$.

200 Almagro *et al.*, op. cit., Láms XLIVa and XLV; the damaged state of the painting makes it impossible to determine whether an older child accompanies this woman.

201 Al-Mas'ūdī, *Murūj* V, 347$_{3-4}$.

202 The whole anecdote is given by Schroeder, op. cit., 223-4; he does not identify the source.

203 Almagro *et al.*, op. cit., Láms XIX, XXVIIa, c and XLIIIb - XLV.

204 Hamilton, *KaM*, pls LV/2 and LVI/6, 7 and

9. Cf. the last line of al-Walīd's epithalamium to Salmā, with its reference to five full-bosomed girls (Gabrieli, 'Al-Walīd', 48, no. LI). The girls at Khirbat al-Mafjar wore elaborate make-up (Hamilton, *KaM*, 234 and P.K. Hitti, *History of Syria* [London, 1957], 506).

205 Schlumberger, op. cit., 354, fig. 25.

206 R. Ettinghausen, *Arab Painting* (Geneva, 1962), 32.

207 Cf. R. Blachère, 'La poésie érotique au siècle des Umayyades de Damas', *Analecta*, 348-61.

208 This last detail is especially marked in the statues from Khirbat al-Mafjar (see the colour plate in K. Otto-Dorn, *L'Art de l'Islam*, tr. J.-P. Simon [Paris, 1967], 54).

209 Musil, op. cit., 158.

210 *Aghānī* VI, 135$_{19-20}$. This was the last straw for many of those who had hitherto remained loyal to him; it was an unheard-of practice to swear allegiance to a minor. According to Ibn Qutaiba (*Kitāb al-ma'ārif*, ed. F. Wüstenfeld [Göttingen, 1850], 186$_{6-7}$) homage was done to two of his sons, al-Ḥakam and 'Uthmān, and both were killed along with their father.

211 *Aghānī* VI, 103$_2$.

212 Musil, op. cit., 158.

213 Ibid., 157.

214 See Creswell, *EMA* I/2, 397; cf. also the three busts in the *apodyterium* at Quṣair 'Amra (ibid., 399).

215 Sezgin, op. cit., 317. Mu'āwiya had similar tastes (al-Mas'ūdī, *Murūj* V, 77$_{10}$-78$_2$; tr. Schroeder, op. cit., 207-8).

216 Al-Suyūṭī, *Tārīkh al-Khulafā*', 401$_{1-2}$; so did 'Abd al-Malik (al-Mas'ūdī, *Murūj* V, 244$_4$; cf. ibid., 212$_{10}$-213$_3$). That al-Walīd and his courtiers had a knowledge of astrology is shown by an anecdote related by al-Mas'ūdī, *Murūj* VI, 12$_{3-7}$. There is also a record of a kind of masque performed before al-Walīd in which the actors were dressed as stars and planets (O. Grabar, *The Formation of Islamic Art* [New Haven, 1973], 156; cf. idem, *Ceremonial*, 254). What better setting could be devised for such a spectacle than Quṣair 'Amra with its frescoed map of the heavens?

217 Al-Suyūṭī, *Tārīkh al-Khulafā*', 404$_{11-14}$. Elsewhere these edifying sentiments are attributed to al-Walīd II — the poacher turned gamekeeper (von Hammer-Purgstall, op. cit., 45).

218 *Aghānī* XVI, 70$_{29-30}$; al-Mas'ūdī, *Murūj* V, 156$_{7-8}$-157$_{3-5}$.

219 See for example al-Mas'ūdī, *Murūj* V, 446. For the musical tastes of the Umayyad caliphs who preceded him, see Farmer, op. cit., 60-3.

220 See the article devoted to her in the *Aghānī* (XIII, 154$_{28}$-166$_{12}$). On the role of women singers in early Islamic times see J. Ribera y

LA DOLCE VITA IN EARLY ISLAMIC SYRIA: THE EVIDENCE OF LATER UMAYYAD PALACES

Tarragó, *Music in Ancient Arabia and Spain*, tr. E. Hague and M. Leffingwell (Stanford, 1929), 36-7.

221 See D. Schlumberger, 'Deux fresques omeyyades', *Syria* XXV (1946), pl. B opposite p. 96. Although Hamilton, quoting al-Tabarī, *Tārīkh*, Series II, 1733$_{11}$, calls him 'the smasher of lutes' (*KaM*, 105 — in fact the text says that he caused a mandolin (*ṭunbūr*) to be broken over a man's head), Hishām did, it seems, have a taste for poetry and music and despite his fabled frugality was even known to reward performers who pleased him (Caussin de Perceval, op. cit., 431). It was said of the famous singer Siyāṭ that his performances were always accompanied by a flautist and a lutanist (ibid., 524) — precisely the subjects of the upper tier of the floor fresco at Qaṣr al-Ḥair al-Gharbī.

222 J. Vernet, *Literatura árabe* (Barcelona, n.d.), 70. Gabrieli notes the rhythm of the drum and castanets in al-Walīd's poetry (*Letteratura*, 115).

223 Translation by Nicholson, *History*, 206. For the original text, as handed down by Abu'l-'Alā' al-Ma'arrī, see Nicholson's edition: *The Risālatu 'l-Ghufrān*, 829$_{17-20}$; for a literal translation, see ibid., 342.

224 *Aghānī* VIII, 161$_{29}$.

225 Such as the *barbūt* and the *ṭunbūr*; see the discussion of this matter in Gabrieli, 'Al-Walīd', 3.

226 Von Hammer-Purgstall, op. cit., 45. He played the *'ūd* (lute), the *ṭabl* (drum) and the *daff* or *duff* (square tambourine) in the manner of Ḥijāzī musicians (*Aghānī* VIII, 161$_{29-30}$ and 162$_{3-4}$).

227 Huart, *HAL*, 58. Cf. *Aghānī* VIII, 161$_{29-30}$.

228 Almagro *et al.*, op. cit., Lāms VIa, XXVIIc and XLIIc.

229 *Aghānī* VIII, 162$_{9-12}$.

230 *Aghānī* III, 98$_{17-19}$; cf. al-Mas'ūdī, *Murūj* VI, 4$_{5-8}$ and Farmer, op. cit., 64, who lists thirteen musicians who were welcomed at his court. It was in the time of al-Walīd II that it became fashionable for people to hold as slaves women who had received their training in Mecca and Madīna (Ribera, op. cit., 44). Al-Walīd seems to have been as dependent on musicians as his father before him; he called 'Umar al-Wādī, who beguiled his last hours, 'the joy of my life' (Farmer, op. cit., 88) and said of Abū Kāmil al-Ghuzzayyil 'When he is away I am like one bereft' (ibid., 89; on this singer see *Aghānī* VI, 144$_{18}$-146$_9$).

231 Tr. Hamilton, 'Pastimes', 155, quoting al-Tabarī, *Tārīkh*, ser. II, 1765$_{16-19}$.

232 Thus a chamberlain who tried to press affairs of state when al-Walīd was in a drinking vein had a tube rammed down his throat and was forced to drink himself into insensibility (al-Mas'ūdī, *Murūj* VI, 13$_{1-2}$). In a similar story retailed by al-'Umarī, the chamberlain — who said that he had never tasted wine before — was forced to drink himself to death (*Masālik* I, 350$_{13-14}$).

233 Musil, op. cit., 159 and 182.

234 Ibid., 159. A less anti-social sense of fun is revealed in the anecdotes of how he joked with a courtier whose hair was excessively long (*Aghānī* VI 109$_{25}$) or disguised himself as an olive-oil seller in order to gain admittance to the house of his beloved Salmā (Rotter, op. cit., 114-15).

235 Part of the humour lies in reversing the proportions of the model, so that the huge hanging chain ends not with a bang but a whimper, in a shrunken version of the *qalansuwa ṭawīla* which al-Walīd habitually wore. See now Hamilton, 'Bath Hall', 129-30, 132.

236 This has now been explained by Hamilton, with some plausibility, as a pun on al-Walīd's own name (ibid., 130-2, 135-6). This is certainly ingenious, but one cannot help feeling that the images in the panel are not quite specific enough to fit the explanation. The choice of the citrus fruit and the knife in preference to other, less roundabout, symbols needs to be explained. The dominant role of the fruit, which forces the attached sucker into a very subsidiary role from the visual point of view, is also at odds with the proposed explanation. Would this modest reference to himself really have satisfied so gross an egoist as al-Walīd? If there is indeed a *jeu de mots* lurking in this panel, it may go deeper still, for the name of al-Walīd's mother was Umm Ḥajjāj (*umm* being the Arabic for 'mother'), and his father's name, Yazīd, derives from the Arabic root *zāda*, 'to expand', 'to increase'. The appropriateness of these personal names to the images in the mosaic requires no exegesis. But such reflections do not remove the principal difficulty which confronts Hamilton's theory, namely that the panel accords pride of place to the citrus fruit itself, not to its sucker. No one will suggest that al-Walīd built the bath hall with his mother in mind.

I am indebted to Michael Morony for one further suggestion: that the immediate association of the citrus fruit and knife to an early Muslim mind would have been the story of Joseph in Sūra 12 of the Qur'ān. This suggestion acquires extra plausibility when it is remembered that the ladies who attend Potiphar's wife cut their hands while eating oranges because the beauty of Joseph overwhelms them. Since al-Walīd was celebrated for his personal comeliness (al-Suyūṭī, *Tārīkh al-Khulafā'*, 400$_{5-6}$) could the mosaic be interpreted as an oblique attempt at self-glorification, with an added suggestion of

LA DOLCE VITA IN EARLY ISLAMIC SYRIA: THE EVIDENCE OF LATER UMAYYAD PALACES

blasphemy for good measure?

One near-contemporary Christian parallel to the mosaic of Khirbat al-Mafjar may be cited here; it is also in sign language and, like the symbolic fish at Bethlehem cited by Hamilton, and of course the Islamic mosaic, represents something edible. This is the mosaic before the altar — thus in the key position, like the mosaics at Bethlehem and Khirbat al-Mafjar — of the Church of the Multiplication at al-Tabgha, not far distant from Khirbat al-Mafjar. It depicts a basket of loaves with a fish on either side (*Israeli Mosaics of the Byzantine Period*, introduction by E. Kitzinger [New York, 1965], 11 and pl. 3). Like the Muslim mosaic, it is a visual acrostic, using the same terse symbolic language, but in this case to identify the *raison d'être* of the church rather than to identify the patron. There are numerous references in al-'Umari's *Masālik al-Abṣār fī Mamālik al-Amṣār* to the sociable encounters which al-Walīd, like caliphs before and after him, had with the abbots of Christian monasteries in Syria (for a list of them, see Hitti, *History of Syria*, 487) and it may well be that it was the precise combination of everyday images of food with religious symbols in Christian mosaics such as those of Bethlehem and al-Tabgha which intrigued al-Walīd and inspired him to emulate such work. Sūra 12 might well have struck him as offering an acceptable Islamic equivalent to such symbols.

237 An appropriate scenario springs irresistibly to mind — some convivial gathering, perhaps, in which the prince enjoins a tipsy courtier to find the maverick triangle within a set time, on pain of some grotesque or humiliating penalty.

238 This too has its humorous side. The design of key mosaic panels in the bath hall seems to correspond, as has often been noted, to the vaults above, and thus the panel in question would correspond to the main dome of the building placed directly above it. The progressive diminution of the triangles towards the centre could even be seen as a perspective device evoking the remote upper reaches of the dome. Hence, perhaps, the lack of a central medallion of the kind that is standard in classical pavements of this type. Instead, there is a small blank circle at the centre of the mosaic. The analogy with actual architecture would require such a feature to be interpreted as an oculus, and would invest it with all the portentous symbolism which this concept had acquired in such buildings as the Pantheon or the Baptistery of the Orthodox at Ravenna. But at Khirbat al-Mafjar it spells complete anticlimax — for the 'oculus' serves as a drain.

239 *Aghānī* VI, 123_{31}-124_1. The poet got 1,000 *dirhams* for his pains.

240 Almagro *et al.*, op. cit., Lám. XXXIX. But there are also many stories about the fondness of Yazīd I for his pet monkey, on whom he bestowed the dignified name of Abū Qais (al-Mas'ūdī, *Murūj* V, 157_{5-6}).

241 Almagro *et al.*, op. cit., Lám. XLIIa.

242 R. Ettinghausen, 'The dance with zoomorphic masks and other forms of entertainment seen in Islamic art' in *Arabic and Islamic Studies in Honor of Hamilton A.R. Gibb*, ed. G. Maqdisi (Cambridge, Mass., 1965), 211-24.

243 *Aghānī* I, 27_1. Cf. ibid., VIII, 88_{24}, where he is recorded as receiving 10,000 *dirhams* for a single verse; notes 154 and 156 *supra*; and Farmer, op. cit., 81, where Ma'bad is stated to have received 12,000 pieces of gold for a song. However, Yazīd b. Ḍabba received 1,000 *dirhams* from al-Walīd for a single verse (see n. 156 *supra*) and the *Aghānī* notes that this remained a record sum for a verse until Hārūn al-Rashīd exceeded it. Understandable doubts have been expressed as to the reliability of such figures — see for example C. Defrémery, 'Note Préliminaire', *JA* VII Série, II (1873), 398 and Hamilton, 'Who built Khirbat al Mafjar?', 67.

244 This was a *shaikh* of the Banū Tamuh who witnessed the whole episode in his role as Master of the Curtain (*ṣāḥib sitar*); see al-Mas'ūdī, *Murūj* VI 83_{-4}. The role of the *ṣāḥib sitar* became even more complex as Islamic royal ceremonial developed; under Hārūn al-Rashīd he was responsible for seeing to it that performers played on certain days of the week only while the sovereign laid down what they were to play (Ribera, op. cit., 47).

245 Ibn 'A' isha was in fact singularly handsome (von Hammer-Purgstall, op. cit., 709).

246 It seems that this same song, performed by the same artist, had earlier driven Yazīd II, al-Walīd's father, to such a pitch of ecstasy that he too became impious (al-Mas'ūdī, *Murūj* VI, 9_{10}); cf. n. 35 *supra* for another example of this parallelism.

247 The poet Muṭī' b. Iyās received a comparably warm salute from al-Walīd on one occasion (Caussin de Perceval, op. cit., 513); he was himself of elegant and handsome appearance (von Grunebaum, 'Three Arabic Poets', 169, citing M.I. al-Marzubānī, *Mu'jam al-Shu'arā'* [Cairo, 1354/1935], 480).

248 Al-Mas'ūdī, *Murūj* VI, 84-9_8, tr. Schroeder, op. cit., 253-4. Not surprisngly, it has been conjectured that al-Walīd had homosexual tendencies, though perhaps Derenk is nearer the mark when he ventures to suggest that th caliph inclined towards infantilism (op. cit., 38). Cf. in this connection the anecdote

LA DOLCE VITA IN EARLY ISLAMIC SYRIA: THE EVIDENCE OF LATER UMAYYAD PALACES

describing how in a scabrous burlesque of royal ceremonial he exposed himself to his buffoon (*Aghānī* XVII 100_{1-7}; for translation and commentary see Rosenthal, op. cit., 90).

249 *Aghānī* VI, 106_{24}; tr. Hamilton, 'Who built Khirbat al Mafjar?', 67.
250 Ibid.
251 Gabrieli, 'Al-Walīd', 38, no. XV; tr. Hamilton, 'Pastimes', 156.

THE ORIGINS OF THE MIḤRĀB MUJAWWAF: A REINTERPRETATION

Estelle Whelan

Since the publication of Edward Said's *Orientalism* in 1978, every Western student of the Near East, regardless of his or her position in the ensuing debate, has been forced to examine afresh the assumptions underlying even the most respected historical studies. As far as the first century of Islam is concerned, a significant contradiction emerges from such reexamination. Although the reliance of the Muslim conquerors on indigenous administrative classes, their continuation for some time of pre-Islamic coin types, and their acceptance of late antique material culture in general are commonly recognized, the conclusion usually drawn from these facts is rather a curious one: that the Arabs, entirely lacking in experience of government and a distinctive material culture, were forced to adopt the essentially alien practices that prevailed in the conquered lands. Yet an inherently more plausible reading of the same facts suggests that the active commercial classes of Mecca, from which the early Muslim leaders, and particularly the Umayyads, were largely drawn, had direct experience of administrative practices relating at least to trade in Syria and Palestine; made common use of coinage struck in the mint cities of antiquity; and were familiar, through their traffic in luxury goods if not more immediately, with the prevailing material life of the Near East—in fact, were themselves participants, however provincial, in the late antique civilization over which they eventually came to rule.

The distinction drawn here is a narrow one, yet its implications are far reaching, in that the former view seems to have led to a characterization of the Umayyad period as fundamentally incoherent, a time in which Muslim leaders, despite their military dominance, were still groping for an "Islamic" identity among cultural forces beyond their comprehension, let alone their control. An example of this perspective is provided by Jean Sauvaget's pioneering study of the functioning and architecture of the Umayyad congregational mosque, which he linked with the basilical audience hall of antiquity. In the nearly forty years since its publication, this work has hardly been challenged either as a whole or in detail. Yet its author seems to have seriously underestimated the extent to which Umayyad rulers consciously understood their historical position and formulated policies to express both their achievements and their aspirations.

In this study the early development of the *miḥrāb* in the mosque will be explored in an effort to provide a more convincing alternative to the theory of its function and significance put forward by Sauvaget. Although the focus is on the

206

miḥrāb, which usually occurred in the center of the *qiblah* wall,[1] in the earliest decades of Islam the minbar and the *maqṣūrah* seem to have shared with it certain connotations and to have fulfilled overlapping functions. It will therefore occasionally be necessary to deal with all three elements together.

The formal study of the miḥrāb properly begins with the reconstruction of the Mosque of the Prophet at Medina during the caliphate of al-Walīd I (86–96/705–715) and the governorship of ᶜUmar ibn ᶜAbd al-ᶜAzīz (87–95/706-712), for, according to the documentary sources, that is where the *miḥrāb mujawwaf*, or semicircular niche, was first introduced into a mosque.[2] Before turning to the semicircular miḥrāb, however, it is necessary to determine whether or not miḥrābs had existed in any form at all in the mosques built before the reign of al-Walīd.

The precise origin of the word "miḥrāb" itself is not clear. One group of scholars has maintained that it was borrowed from Ethiopic *mekuerāb*, either directly or via South Arabian, and was then assimilated to the Arabic root ﺣﺮﺏ. As *mekuerāb* is the Ethiopic term by which *naos* was translated from Greek evangelical texts, this supposed derivation gave rise to the notion that "miḥrāb" had originally referred to a sanctuary.[3]

On the other hand, Praetorius and Nöldeke claimed that an Ethiopic derivation is unconvincing historically and phonologically; furthermore, the first recorded uses of "miḥrāb" to mean "sanctuary" are in the Qurᵓan and thus relatively late. Serjeant pursued this line further, arguing that Abyssinian culture was primitive and derivative relative to that of South Arabia; he and Ghūl, like Praetorius before them, thus turned to the known South Arabian inscriptions. Rhodokanakis, following Becker, linked the word "miḥrāb" etymologically with the *ḥarbah*, the spear or lance that symbolized authority in ancient Arabia.[4]

Although the origins of the term "miḥrāb" thus remain somewhat clouded, a rapid survey of its various uses in early Arabic literature is suggestive. Horovitz and Serjeant collected extracts from poetry of both the pre-Islamic and early Islamic periods that indicate that "miḥrāb" could mean the part of a palace in which the ruler stood or sat, a niche for an image, a raised place for musk or incense, a colonnaded platform, and the part of a house reserved for women.[5] This last interpretation was based on the use by the poets Waddāḥ al-Yamanī and ᶜUmar ibn ᶜAbī Rabīᶜah of the phrase ربة محراب or ربة المحراب ("mistress of a miḥrāb" or "of the miḥrāb"). Sauvaget, however, preferred to interpret such phrases as metaphorical expressions comparing a woman's beauty to that of a statue in a miḥrāb.[6]

Serjeant argued that the term was originally understood in the purely formal sense, as referring to a row of columns raised on a plinth.[7] This interpretation is consistent with all the uses noted in early poetry.[8] Nevertheless, Serjeant's historical sources are, for the most part, rather late, and he relied primarily on linguistic and architectural evidence from the modern Hadramaut and Africa, areas that were culturally peripheral through most of the Islamic period.

Fehérvári has offered still another interpretation of the word "miḥrāb" as referring to a tombstone.[9] His sole piece of evidence for this usage at an early date is a couplet from a poem attributed to the Arab poet al-Aᶜshā (d. after 4/625):[10]

وَحَطَّتْ بِأَسْبَابٍ لَهَا مُسْتَمَرَّةٍ أُذينة فِي مُحْرَابٍ تَذْمُرْ ثَاوِياً

Horovitz had already translated these two lines:

> Und es (das Aufeinanderfolgen der Nächte) hat mit
> seinen starken Stricken heruntergeholt
> Den Uḏaina, der im Miḥrāb von Tadmur verweilte.[11]

Here is the alternative translation provided by Fehérvári and J. A. Abū-Haidar:

> She lowered with ever moving robes of her Udhaynah
> into the mihrab of Tadmur, where he lies buried . . . [12]

The wording of this couplet suggests that the "miḥrāb of Tadmur" was not a tombstone but a burial space. Udhaynah's tomb is no longer extant, but it seems likely from Gawlikowski's recent study that it was a funerary temple of the kind that wealthy Palmyrene families had first adopted around the middle of the second century.[13] The later and more richly decorated examples consisted primarily of cellas with internal peristyles; the most common forms of burial were in stone banquettes, into which the bodies were lowered from above, and in subterranean crypts. The latest surviving example of this type is Gawlikowski's no. 144, dated to A.D. 253, only about fourteen years before Udhaynah's death, which strengthens the probability that he too was buried in such a temple.[14]

It cannot be assumed that al-Aʿshā had seen the tomb of Udhaynah. More likely he drew this allusion, like many others in his poem, from earlier literary sources. If these sources were accurate, then the "miḥrāb of Tadmur" would have been a crypt or, more probably, a cella with engaged columns or pilasters around the walls and a peristyle in the center. This form is not inconsistent with those already noted, the most specific references to which suggest colonnaded spaces.[15]

In the Qurʾan, "miḥrāb" signifies an indeterminate part of a building, a sovereign's tribunal or audience hall, and a temple sanctuary.[16] With the exception of the last, these references reinforce those that have been gathered from the poets. But, as they involve incidents in the lives of the prophets before Muhammad, they offer no direct evidence for the forms and significance of the miḥrāb in the mosque.

As for the material evidence, there are only two instances in which it has been suggested that a surviving miḥrāb can be dated to the period before al-Walīd's reconstruction of the Mosque of the Prophet at Medina. Creswell provided a thorough analysis of the question whether or not ʿUqbah ibn Nāfiʿ, Muʿāwiyah's governor in North Africa, installed a miḥrāb in the Great Mosque of Kairouan, which he founded before 55/674–675.[17] The ninth-century historian al-Balādhurī cited a report from "a group of people from Ifrīqiyah" to the effect that the site of the mosque had been shown to ʿUqbah in a dream, but he did not mention a miḥrāb.[18] The eleventh-century author Abū ʿUbayd al-Bakrī (c. 413–487/

208

1021–1094) recorded a series of subsequent renovations at this mosque, beginning in 84/703, when Ḥassān ibn al-Nuᶜmān tore it down and rebuilt it completely, supposedly retaining only the miḥrāb from ᶜUqbah's structure. Yazīd ibn Ḥātim again rebuilt the mosque in 157/773–774, and he too was said to have incorporated the old miḥrāb into its fabric. When the Aghlabid governor Ziyādat Allāh installed his own marble miḥrāb in 221/836, al-Bakrī reported, he sealed up the ancient miḥrāb of ᶜUqbah in the wall behind it. Finally, in 248/862–863 Abū Ibrāhīm Aḥmad added marble paneling and faience tiles to the miḥrāb, and Creswell has demonstrated that it is this version that survives today. It is important to recognize that the existence of ᶜUqbah's miḥrāb was mentioned for the first time only in al-Bakrī's text of 460/1067–1068.[19]

Creswell's investigations at the Great Mosque of Kairouan have revealed no trace of an older miḥrāb behind the present one. The present niche is lined with marble panels, some of them carved in openwork; in order to increase the effectiveness of this decoration, the walls behind those panels have been hollowed out. It was Marçais who first provided a convincing explanation of the apparently contradictory evidence: "La présence d'un décor ajouré, dont l'emploi semble tant naturel dans un intérieur du IXe siècle, ne s'expliquerait au XIe que comme un subterfuge de l'architecte désireux de satisfaire à la fois l'orgueil de son maître et la pieuse curiosité des fidèles. Le vieux mur anonyme, qu'on entrevoyait dans l'ombre sans pouvoir l'atteindre, devint un mur sacré, et la légende du miḥrāb de ꞈOqba prit corps par un processus banal."[20]

ᶜUqbah is, of course, much venerated in North Africa even today, and so it may have been predictable that his name should have become attached to the mysterious "miḥrāb" behind the openwork panels. It seems, then, that, for the moment, there is no reliable evidence for the existence of a miḥrāb at Kairouan as early as 55.

The more frequently cited instance of a supposedly seventh-century miḥrāb is to be found in a cavern beneath the Dome of the Rock in Jerusalem; Dalman fancifully identified it as the praying place (*Betort*) of Sulaymān.[21] Creswell believed it to be contemporary with the Dome of the Rock itself, that is, datable to about 72/691–692. In support of his conclusion, he compared the incised arabesque ornament outlining the arch and inner rectangular frame with that on a milestone of ᶜAbd al-Malik (65–86/685–705) now in the Louvre.[22] This comparison seems unconvincing, however. Below the inscription on the milestone is a symmetrical design incised with considerable care: From a vase in the center, two stems, rendered as single lines, undulate in perfectly matched curves toward the sides. From these stems sprout shorter stems, which terminate in curls arranged in such a way that the negative space forms half-palmettes of simplified profile. In contrast, the undulating thick vine stem on "Sulaymān's prayer niche" is rendered with double lines so that it appears as a continuous chain of lobed leaves shown in profile, each growing from the next. Indeed, a close parallel can be found in the more finely detailed vine ornament framing the open tubes through the spandrels of the arcades at the Mosque of ibn Ṭūlūn in Cairo, built in 263–265/876–879.[23]

As for the composition of "Sulaymān's prayer niche," it is echoed in the outer frame of the main miḥrāb in the Mosque of ibn Ṭūlūn, which Creswell considered

contemporary with the mosque itself.[24] In each instance, there are round bosses centered in the spandrels, elongated teardrop bosses following the curve of the arch at the top and sides, and small round bosses in the upper corners of the frame. According to Creswell, the Cairo miḥrāb is the oldest surviving example of a composition with round bosses in the spandrels, the next being the units of the interior transition zone at the early tenth-century Sāmānid mausoleum at Bukhara.[25] Clearly he overlooked "Sulaymān's prayer niche" in this connection. He did, however, call attention to the similarity between the cresting along the top of the niche and that encircling the wall of the Mosque of ibn Ṭūlūn.[26] The rows of alternating rosettes and lozenge-shaped bosses flanking the engaged colonettes of the miḥrāb are also related to the ornament on a stucco window frame at the same mosque.[27] The round capitals on the engaged colonettes, each topped by a pair of half-palmettes like wings, are repeated in openwork in the marble miḥrāb of the Great Mosque of Kairouan (248/862–863).[28]

The "tie beam" of the arch on the Jerusalem niche is inscribed with the profession of faith, in what Creswell called "archaic Kūfic" script.[29] One detail of this very simple script makes it almost impossible to accept a seventh-century date for the miḥrāb, however: the arched ligature between the lām and the hā in "Allāh," which is particularly pronounced in the first of its two occurrences. An arched ligature of this type occurs several times on the Nilometer at Rawḍah, which Creswell dated to the year 247/861, in the reign of al-Mutawakkil at Sāmarrā.[30] Among a number of inscriptions with such arched ligatures on funerary steles in the Museum of Islamic Art, Cairo, the earliest dated example is of 243/857.[31] From Sāmarrā itself there is a stucco miḥrāb with similar arched ligatures in its inscription.[32] Although this miḥrāb cannot be dated precisely, it certainly does not belong to the period before the construction of the city, which began in 222/837, and the style of the decoration suggests a position rather later in the ninth century. There appear to be no examples of this particular arched ligature in monumental paleography earlier than those on the three ninth-century monuments mentioned.[33]

Although no close counterpart to "Sulaymān's prayer niche" as a whole has been found, nevertheless the best parallels for its composition, individual ornamental motifs, and paleographic details all belong to the second half of the ninth century. It therefore seems unlikely that this crudely decorated flat miḥrāb is to be dated any earlier.

So far, then, there is no evidence that a miḥrāb existed in any mosque before the time of al-Walīd. Nevertheless, a series of historical texts does suggest that the Mosque of ʿAmr ibn al-ʿĀs in Fusṭāṭ already had a miḥrāb before Qurrah ibn Sharīkh assumed the governorship in 89/709. Ibn ʿAbd al-Ḥakam (d. 257/871) reported two versions of an incident in which Qurrah, upon his arrival in the city, went directly into the miḥrāb of this mosque, prayed there, and afterward seated himself cross-legged in the same place and began to issue official orders.[34] Yet several later sources include reports on good authority that Qurrah himself was the first to add a miḥrāb mujawwaf to this mosque, in 92/711.[35] Sauvaget therefore dismissed ibn ʿAbd al-Ḥakam's reports as erroneous.[36]

But the later texts suggest still another possibility. The clearest statement is that by ibn Duqmāq (c. 750–809?/1349–1406?), who reported that, when Qurrah

210

destroyed and rebuilt the Mosque of ᶜAmr ibn al-ᶜĀs, he put his miḥrāb in the vicinity of the miḥrāb that had been in the old mosque. Indeed, ibn Duqmāq then added that the qiblah of the old mosque had been marked by four columns, "two in front of two," at a point where there was a row of sarcophagi (tawābūt) in his own day. This columned bay was the special area reserved for people of the tribes of Qays. Qurrah retained the four columns and had their capitals gilded.[37] Al-Maqrīzī (766–845/1364–1442) reported the same story in almost identical words.[38] Ibn ᶜAbd al-Ḥakam had also mentioned Qurrah's gilding of capitals in the majālis of Qays but without using the term "miḥrāb."[39]

The reports of the columned bay with gilded capitals, convincingly circumstantial in themselves, are also based on authorities as good as—indeed, largely identical with—those for the story of Qurrah's adoption of the miḥrāb mujawwaf. The bay must have belonged to the period of ᶜAbd al-ᶜAzīz ibn Marwān, who had completely destroyed and rebuilt the Mosque of ᶜAmr ibn al-ᶜAs in 79/698–699. Both in its form (a rectangular space marked by columns at the corners) and in its function (as an area reserved for a particular group and used both for prayer and for the exercise of authority) this miḥrāb appears to have conformed to notions of the miḥrāb that had been current in early Arabia.[40]

It seems then that the story of Qurrah's behavior upon his first arrival in Fusṭāṭ, which Sauvaget had dismissed, must be readmitted as evidence. Two references to a "miḥrāb" in the seventh-century mosque at Damascus, usually considered erroneous or anachronistic, should perhaps also now be taken more seriously. The earlier of the two is that of ibn al-Faqīh, who completed his geographical compendium in about 290/903; on the authority of Kaᶜb, he reported that Muᶜāwiyah was the first to establish miḥrābs and maqṣūrahs, as well as several other sovereign institutions.[41] The later reference is by ibn ᶜAsākir (499–571/1105–1176), who reported that after Khālid ibn al-Walīd (d. 21/642) had first conquered Syria and had prayed in an already existing structure at Damascus, "les compagnons du Prophète se placèrent dans la partie appelée le miḥrāb des compagnons du Prophète, et, toutefois, on n'avait pas encore percé la muraille, pour y pratiquer un miḥrāb cintré. . . ."[42] It is possible, too, that al-Bakrī's sources on the earliest renovations of the Great Mosque at Kairouan and the preservation of the initial miḥrāb referred to a bay, rather than to a niche.[43]

It is noteworthy, however, that in the seventh century functions similar to those of the miḥrāb were also fulfilled by the maqṣūrah. Scholars generally agree that the maqṣūrah was a space enclosed by a screen or railing, an assumption that is borne out by the texts.[44] The earliest known maqṣūrah was that of the Caliph ᶜUthmān (23–35/644–656) at the Great Mosque of Medina; it was a wall of libn with openings so that the congregation could see the imām as he led the prayers.[45] In 44/665 it was replaced by a more permanent structure in dressed stone at the command of Marwān ibn al-Ḥakam, who at that time was Muᶜāwiyah's governor in Medina. Apparently Muᶜāwiyah had already established a maqṣūrah in Damascus four years earlier; ibn Taghrībirdī reported that he enlarged it in 44, the same year in which his governor reconstructed the example at Medina.[46] In Damascus Muᶜāwiyah used to spend a period each day

seated in the mosque with his back against the maqṣūrah while receiving petitions from the poor and the helpless.[47] This maqṣūrah was still in use in the time of ᶜAbd al-Malik (65–86/685–705), who heard arguments between partisans of Kalb and Qays there.[48] In 45/665 Ziyād ibn Abīhī, Muᶜāwiyah's governor in Iraq, added a maqṣūrah to the mosque at Basrah.[49]

That several maqṣūrahs were established or enlarged and strengthened in such close temporal proximity suggests that Muᶜāwiyah had adopted a deliberate policy of taking measures to protect the imāms in major congregational mosques of Dār al-Islām, probably as a response to the Khārijite attempt on his own life in 40/661.[50]

The conclusion, then, is that in the seventh century the miḥrāb and the maqṣūrah both served as places from which the imām led the prayers and as centers for the dispensation of justice and the conduct of other official business. The difference between them seems to have been only a formal one: The miḥrāb was a columned bay; if it was enclosed by a railing or screen, it was called a maqṣūrah.[51] The miḥrāb mujawwaf thus represented a genuine *formal* innovation in the mosque. It was first introduced in the Mosque of the Prophet at Medina, built on the site of Muhammad's house. The present mosque has been largely rebuilt in modern times; scientific archeological researches have not been conducted there, nor are they likely in the foreseeable future. The reconstruction of its early history thus depends entirely upon documentary sources and comparisons with the few remains of contemporary buildings.

The two most important attempts at such reconstruction have been those by Creswell and Sauvaget, each of whom was highly critical of the other's efforts. Creswell spent many years examining Islamic monuments firsthand, and, thanks partly to his training as a draftsman, was able to produce a series of detailed studies of particular formal and technical features that are of undeniable usefulness to historians. He drew on his familiarity with Islamic architecture, as well as on historical texts, for his reconstruction of the Mosque of the Prophet, which has been generally accepted in outline. Sauvaget, however, strongly objected to Creswell's characteristic piecemeal approach, divorced from consideration of the broad social and historical context in which the monument was built, as well as to his limited choice of documentary sources.[52]

Sauvaget himself compiled a bibliography of ninety documents (including the twenty-five used by Creswell) from local histories of Medina, travelers' accounts, devotional literature, and the like. For each work, he provided a concise assessment of the author's reliability and the authority of his sources, as well as translations of relevant passages; he found the most informative passages among those that Creswell had hardly considered.[53]

Like other early writers, Sauvaget rejected the notion that the miḥrāb mujawwaf had been adapted from the apse of the Christian church or the Buddhist cult niche.[54] Instead, he sought to trace both form and function directly to the throne apse of the ancient royal audience hall: "La place et le rôle du mihrab dans la mosquée répondent à la place et au rôle de l'abside terminale des salles d'audience, tout comme sa forme répond à celle de l'abside, et la ressemblance entre ces deux éléments architecturaux devait être plus frappante encore dans le cas de mihrabs

212

de grande ouverture, comme ceux de Médine et de Ramleh. Le mihrab n'est donc qu'*une réplique réduite de l'abside palatine*, et constitue un nouvel élément commun au palais et à la mosquée."[55]

Central to Sauvaget's argument was his belief in the "secular" character of the Umayyad mosque. He emphasized the irregular intervals at which communal prayers were held; the impossibility of determining even now whether communal prayer preceded or followed the *khuṭbah*; the political and often threatening tone of the khuṭbah itself; the informal, even argumentative responses of the congregation; and other kinds of behavior that he considered unseemly in a religious setting.[56]

But so sharp a distinction between religious and secular seems inappropriate to discussions of the first Islamic century. In fact, the social or communal aspects of early Muslim life were permeated with religious significance, as the requirement for communal prayer itself attests; at the same time, it is not surprising to find that religious ceremonies incorporated what may today be considered "secular" forms and even "secular" purposes. Even the title of the leader of the community, Amīr al-Muʾminīn—usually translated as "Commander of the Faithful" or "Prince of the Believers"—reflects the inseparability of the two aspects.[57]

That early Muslim leaders were also seriously concerned about maintaining the purity of ritual performance in the mosque is clear from a number of episodes. Probably in 17/638 the Caliph ʿUmar ordered the earthen floor of the mosque at Medina paved with pebbles because the people had fallen into the habit of clapping their hands to remove the dust before praying and he feared that, with time, this practice would come to be considered part of the prayer itself. Such a pebble floor was also installed in the first mosque at Fusṭāṭ, built in 21/641–642. Ziyād ibn Abīhī, Muʿāwiyah's governor in Iraq, gave the same reason for paving the floors of the Great Mosques at Basra and Kufa, in about 45/665 and 50/675 respectively.[58]

Sauvaget himself called attention to the irregular pentagonal plan of the screen enclosing the Prophet's burial place in the mosque at Medina, installed by ʿUmar ibn ʿAbd al-ʿAzīz, the same governor who was in charge of constructing the miḥrāb mujawwaf. According to one source, ʿUmar deliberately chose a pentagonal, rather than a quadrilateral, plan in order to prevent the faithful from treating the tomb as a kind of second *Kaʿbah* and adopting it as the *qiblah*.[59]

It is thus difficult to accept Sauvaget's characterization of the early mosque as one in which assemblies had no liturgical significance. His argument that the miḥrāb mujawwaf was simply a reduced version of the ancient palace throne apse also requires closer scrutiny. The three main activities that took place in the Umayyad congregational mosque were the delivery of the khuṭbah, the communal prayer, and the public audience. The khuṭbah was delivered from the *minbar*. During the prayer the imām stood before the congregation and performed the proper ritual movements for each section of the service. Sauvaget and Grabar have agreed that he is unlikely to have stood in the miḥrāb mujawwaf to lead the prayers, for then he would have been invisible to most of the congregation.[60] Clearly the supposed throne niche could have had no role in either of these

activities. It would, however, have provided an appropriate locus for the public audience, at which petitions were heard and justice administered. Sauvaget noted that most known Umayyad miḥrābs are of fairly uniform size, so that they seem disproportionately small in large mosques but disproportionately large in small mosques. In his view the size was dictated not by requirements of architectural proportion but by function: the niche had to be just big enough to encompass a man enthroned.[61]

Unfortunately, the original semicircular miḥrābs of the three most important Umayyad mosques—those at Medina, Damascus, and Fustat—do not survive, nor is there reliable information on their dimensions. The twelve Umayyad miḥrābs, the dimensions of which are at least partly known, show more variation in size than Sauvaget suggested, but some at least were too small to have served comfortably as settings for single enthroned figures.[62]

Sauvaget did acknowledge some of the difficulties inherent in his argument, but he considered them of little importance: "En regard des similitudes nombreuses et étroites que nous avons relevées, les dissemblances entre le dispositif de la mosquée et celui de la salle d'audience apparaissent comme peu importantes, pourvu que l'on ne s'obstine pas à envisager leur côté formel."[63] In his view, the plan of the royal audience hall had to be compromised in the mosque at Medina—and by extension elsewhere—in order not to alter more than necessary the original dispositions of the Prophet's house. As a result, the miḥrāb mujawwaf was indeed too small to serve adequately as a throne niche. Sauvaget concluded then that the minbar had had to serve not only for the khuṭbah but also for the public audience; as the curtain customarily drawn back from the niche and then redrawn across it to signify the beginning and the ending of the audience in ancient times then became superfluous, it was replaced by the maqṣūrah.[64]

But in putting forth this interpretation Sauvaget ignored the actual order of events. As has been demonstrated here, the maqṣūrah had already been in use in major mosques for more than fifty years before al-Walīd ordered construction of the semicircular niche at Medina. The history of the minbar goes back even further, to the lifetime of the Prophet, who habitually addressed the community while sitting on a two-step stool. This stool remained at Medina after his death, and in the year 50/670–671 Muʿāwiyah ordered it raised upon a base of six additional steps.[65]

Muʿāwiyah already had a minbar of his own in Damascus in 36/657, during the period when he was struggling with the Caliph ʿAlī (35–40/656–661) for supremacy; ʿAlī, too, preached and exhorted his followers from a minbar in Kufa. It seems from this evidence that the minbar was an accepted setting for the exercise of legitimate authority almost from the beginning of Islam; Muʿāwiyah even underscored this aspect by displaying on his minbar the blood-stained relics of the murdered Caliph ʿUthmān as a challenge to the legitimacy of ʿAlī's claim to the caliphate.[66]

Viewed in this light, the somewhat checkered history of the minbar at the mosque of ʿAmr ibn al-ʿĀs seems less mystifying. Its founder had placed one there in 21/641–642 but had been ordered by the Caliph ʿUmar to remove it

214

because of the implied usurpation of authority. Already in the time of ᶜUthmān (23–35/644–656), however, the minbar was reintroduced when the King of Nubia sent one as a gift. This or another minbar was still in use when Qurrah ibn Sharīkh arrived in 89/709; he replaced it yet again.[67]

Both the maqṣūrah and the minbar were thus familiar features of the main mosques well before the adoption of the miḥrāb mujawwaf. It seems hardly likely that al-Walīd adopted the niche to fulfill functions that were already being fulfilled—and in a size that was inadequate to their fulfillment in any event. It is surely necessary to seek elsewhere for an explanation of the miḥrāb mujawwaf. In particular, what was the functional requirement that caused this form to be adopted as a standard part of the mosque?

Grabar pointed out that, had the semicircular miḥrāb been a feature of primarily royal significance, it would not immediately have become an automatic part of all mosques. He found in this very universality evidence that it had "a liturgical or symbolic sense in the faith itself."[68] In the attempt to define this sense more precisely, some reports gathered by al-Samhūdī are central. The Prophet, after he had established the second qiblah, in the direction of Mecca, was accustomed to lead the prayers from a position next to a tree trunk in the courtyard of his house at Medina. After a mosque was established on the site, ᶜUmar moved the qiblah wall further south and introduced a row of supports in front of the line on which the tree trunk had stood; the Prophet's former position was thus two bays north of the new qiblah wall. ᶜUthmān then lengthened the qiblah wall at one end, so that the Prophet's *maqām* was no longer on the main axis of the building. At the time of al-Walīd's reconstruction, ᶜUmar ibn ᶜAbd al-ᶜAzīz introduced the miḥrāb (that is, the miḥrāb mujawwaf), taking great care to locate it correctly, on the axis of the "qiblah" of the Prophet.[69] The commemorative function of this first semicircular miḥrāb is thus quite clear: it marks the point toward which Muhammad himself had faced when leading the prayers in his courtyard at Medina. Its placement two bays to the east of the main axis of the mosque underscores the primacy of this function over purely architectural considerations.[70]

In clarifying the precise meaning of the miḥrāb mujawwaf in general, it is helpful to turn to the texts on the Prophet's use of the *ᶜanazah*, a spear presented to him by Zubayr ibn al-ᶜAwwām, who had in turn received it from the Negus of Abyssinia. In the year 2/623 Muhammad began to have it carried before him on holidays, when he went to pray in the *muṣallā* at Quḍāʾ, near Medina. There it was planted in the ground both to indicate the qiblah and to serve as a focus and boundary for the Prophet's *sutrah*, or praying space.[71] This space, which could be defined by any handy object, was supposed to be an area of undisturbed concentration during prayer. The *aḥādīth* contain a number of pronouncements on whether or not prayer would lose its validity if the sutrah were invaded. Furthermore, at the Friday prayers the sutrah of the imām was to serve as the sutrah for the entire congregation.

Clearly, the *ᶜanazah* was a conveniently portable substitute for the fixed qiblah in the courtyard of Muhammad's house. When mosques were constructed throughout the Islamic world after the conquest, the qiblah was also incorporated into the architectural fabric of each; the miḥrāb mujawwaf would thus have been

redundant for this purpose. Curiously, however, scholars have so far paid little attention to the sutrah and its possible expression in the mosque.[72] Yet, from its inception, the miḥrāb mujawwaf was the focus for the imām as he led the Friday prayers; it thus served to indicate the sutrah for him and for the entire congregation. Surely it was this very precise function in the Islamic worship service that caused the miḥrāb mujawwaf to be adopted almost immediately for every mosque in Islam, large or small.

It seems likely that a subliminal reference to the person of the Prophet was also understood even outside Medina, where the reference was clear and direct. A parallel, which may already have been known to al-Walīd and his contemporaries, is the practice of leaving unoccupied the top of the minbar and of addressing the congregation from the steps below.[73] As the *khaṭīb* thus placed himself below the symbolic seat of Muhammad, so the imām led the communal prayers while facing the symbolic "qiblah" of Muhammad; in this way, both dramatically underscored the intangible presence of the Prophet before his followers. Because Islam has produced no decorative cycles incorporating a religious iconography centered on the life of Muhammad, modern scholars may have underestimated the power of symbolism related to his person, especially in the early mosque, even though the literature abounds in episodes revealing the reverence shown toward his relics in the Umayyad period and later. A general study of this subject would be of considerable value.

As for the choice of the niche form, it should occasion no surprise: as Diez remarked, the semicircular niche was a cliché of late antique architectural decoration.[74] Evidence from later periods does suggest, however, that uninhabited niches were sometimes used in public settings as substitutes for direct representation of princes, which would have been considered inappropriate.[75] It is possible that similar considerations influenced the choice of the semicircular niche, widely used in the period as a frame for statuary, in a context in which a reference to Muhammad was to be understood.

It has also occasionally been suggested, most forcibly by Miles, that the miḥrāb sheltered the ʿanazah or the ḥarbah, the spear carried as a badge of authority in processional before the caliphs and leading provincial governors from the time of Muʿāwiyah through the early ʿAbbāsid period; it was the head of the *shurṭah*, or civil police, who customarily carried it.[76] The main evidence on which Miles' argument is based is a rare silver dirham, probably issued by ʿAbd al-Malik just before his definitive reform of the coinage in 75/695–696. It contains on one side the image of a beribboned spear on two legs (apparently the visible parts of a tripod) beneath an arch supported on two spiral columns. Flanking the columns and the spear shaft itself is an inscription consisting of titles and phrases associated with the caliphate:

1. Amīr al-Muʾminīn
2. Naṣr
 Allāh
3. Khalīfah Allāh (in a defective spelling)

In a brilliant study of this coin type, Miles identified the spear as the ʿanazah[77] and traced its numismatic prototypes to Greek imperial coins of Syria and other

216

Near Eastern provinces on which statues were represented sheltered by ciboria on spiral columns.[78] The one significant alteration made by ʿAbd al-Malik was to substitute a symbol with sovereign meaning in the Islamic world—the spear— for the statues. The arch, however, cannot represent the miḥrāb mujawwaf, for that form was not introduced until approximately a decade later by ʿAbd al-Malik's son and successor.

Other evidence for the use of the miḥrāb as a kind of reliquary is sparse. The verbal root common to the words "ḥarbah" and "miḥrāb" was pointed out long ago, and Miles noted that ʿanazah is still a term applied to exterior miḥrābs in the Maghrib.[79] More suggestive is ibn ʿAbd Rabbihī's report of his visit to the Great Mosque at Medina in the early tenth century; there he saw in the miḥrāb a staff (*watad*), said to be the one on which Muḥammad had leaned when rising from his prayers.[80] The miḥrāb at Medina was, then, at least for a part of its history, a repository of one relic of the Prophet, but such use must always have been secondary. The existence of miḥrābs in the most humble and out-of-the-way mosques, where certainly no relics could have been preserved, underscores the likelihood that their primary function was liturgical.

It is thus clear that Sauvaget's thesis of the royal audience hall must be revised, at least as far as it applies to the miḥrāb; more important perhaps is a close scrutiny of some of the assumptions that underlay it, for similar assumptions all too frequently distort modern thinking about the art and architecture of early Islam. To imagine that early Arab leaders were so dazzled by the advanced material culture of Syria that they simply adopted significant forms without genuine comprehension, even, as Sauvaget suggested, forms that were unsuited to their purposes, is to assume a kind of intellectual simplicity and cultural passivity that are simply not borne out by events.

On the contrary, what the history of the period reveals, even through a study as limited as this one, is that the most innovative of the early caliphs acted consciously and with considerable sophistication in their formulation of symbols expressive of the mission of Islam and their own roles as its leaders. Muʿāwiyah was clearly adept at manipulating such symbols, as in the display of ʿUthmān's relics on his minbar; furthermore, his elevation of Muhammad's stool and related moves reveal a finely tuned sensitivity to the potency of the Prophet's relics as legitimizing symbols.[81]

One of Muʿāwiyah's most energetic successors, ʿAbd al-Malik, produced, in the Dome of the Rock, one of the world's great masterpieces of architectural propaganda, as well as experimenting with imagery on coinage, ultimately choosing more direct expression of the Islamic message.[82]

It was left to ʿAbd al-Malik's son al-Walīd, however, to bring truly monumental form to the Muslim house of prayer. In the congregational mosques at Medina, Damascus, and Fustat, he not only introduced a kind of sovereign magnificence but also completed the process of giving precise architectural expression to all aspects of Islamic communal worship. By incorporating the sutrah into the structure, as the qiblah had been incorporated, he established a symbolic focus for the congregational prayer comparable in power to the symbolism associated with addresses from the minbar. He thus ensured, through

architectural arrangements, a continued balance between the two main constituents of religious performance in the mosque.

NOTES

Author's note: The following abbreviations are used throughout:

Caetani: L. Caetani, *Annali dell'Islam* (10 vols.; Milan: 1905–1926)
EI: The Encyclopaedia of Islam (Leiden: 1913–1938; 2nd ed., Leiden: 1960–)
EMA: K. A. C. Creswell, *Early Muslim Architecture* (2 vols.; Oxford: 1932–1940; 2nd ed. of vol. 1, in 2 parts, Oxford: 1969)
Sauvaget: J. Sauvaget, *La mosquée omeyyade de Médine* (Paris: 1947)

I wish to acknowledge debts of gratitude to Chris Filstrup and his staff in the Oriental Division of the New York Public Library for their cheerful and unstinting assistance with many aspects of the research embodied here; to Professor Pierre Cachia for help in deciphering some of the more opaque passages of al-Samhūdī; and to Judith Kolbas, Professor Richard Martin, and Dr. Richard Verdery, whose comments on an earlier draft contributed significantly to shaping the final version.

[1] In later periods subsidiary miḥrābs might also appear on the qiblah wall, on columns or piers in the sanctuary, in the porticos of the courtyard, and on the exterior facade.

[2] For documentation of this tradition back to the ninth century, see Sauvaget, pp. 15–19. His hypothesis that ibn Duqmāq, ibn Taghrībirdī, and al-Suyūṭī drew their reports from the copy of a manuscript by ibn Saʿīd in the Dār al-Kutub, Cairo, cannot be confirmed from the fragmentary remains of the manuscript, but the other aspects of his reconstruction still stand. See ibn Saʿīd, *al-Mughrib fī hūlaʾl-Maghrib*, ed. by Z. M. Ḥasan (Cairo, 1953); and *EMA* I(1)², 147–148.

[3] S. Fraenkel, *Die aramäischen Fremdwörter im Arabischen* (Leiden, 1886), p. 274; F. Schwally, "Zur ältesten Baugeschichte der Moschee des ʿAmr in Alt-Kairo," *Strassburger Festschrift zur XLVI. Versammlung deutscher Philologen und Schulmänner* (Strassburg, 1901), p. 110, n. 4; J. Horovitz, "Bemerkungen zur Geschichte und Terminologie des islamischen Kultus," *Der Islam*, 16 (1927), 261–262; Sauvaget, p. 145, n. 6.

[4] F. Praetorius, "Äthiopische Etymologien," *Zeitschrift der Deutschen Morgenländischen Gesellschaft*, 61 (1907), 261–262; T. Nöldeke, *Neue Beiträge zur semitischen Sprachwissenschaft* (Strassburg: 1910), p. 52, n. 3; R. B. Serjeant, "Miḥrāb," *Bulletin of the School of Oriental and African Studies*, 22 (1959), 441–444; M. Rhodokanakis, "Zur semitischen Sprachwissenschaft," *Wiener Zeitschrift für die Kunde des Morgenlandes*, 25 (1911), 74–76. See also M. A. Ghūl, "Was the Ancient South Arabian Mdqnt the Islamic Miḥrāb?" *Bulletin of the School of Oriental and African Studies*, 25 (1962), 331–335. It has also been suggested that, as the term "miḥrāb" has parallels in Old Testament Hebrew and other Semitic dialects, it was probably not a loan word in Arabic. See S. Daiches, "The Meaning of חׇרְבוֹת," *Jewish Quarterly Review*, 20 (1908), 637–639; see also Nöldeke, *loc. cit.*, and Serjeant, p. 441.

[5] Horovitz, pp. 260–263; Serjeant, pp. 451–452; see also Serjeant's translation from *Tāj al-ʿarūs*, pp. 439–441.

[6] Sauvaget, p. 145, n. 4.

[7] Serjeant, pp. 447–453.

[8] In connection with the functioning of the miḥrāb as a niche for a statue, it should be noted that in Arabia in late antiquity such niches were commonly placed in facades between columns supporting a variety of broken pediments, as was characteristic of the Roman *scena frons*, for example. See M. Bieber, *The History of the Greek and Roman Theater* (Princeton: 1961), especially pp. 208–211, where examples in the Near East are discussed; and J. A. Hanson, *Roman Theater Temples* (Princeton: 1959), esp. chap. 4. Particularly relevant is the famous Hercules clock of early sixth-century Gaza, which Diels reconstructed from the fairly detailed description by Procopius. If the reconstruction is correct, three statues of Hercules that adorned the clock were sheltered under columned aedicules; H. Diels, "Über die von Prokop beschriebene Kunstuhr von Gaza," *Abhandlungen der Königlich-Preussischen Akademie der Wissenschaften*, vol. 7 (1917).

[9] G. Fehérvári, "Tombstone or Mihrab? A Speculation," *Islamic Art in the Metropolitan Museum of Art*, ed. by R. Ettinghausen (New York: 1972), pp. 241–254.

218

[10]*Ibid.*, p. 250.

[11]Horovitz, p. 260. Fehérvári, p. 250, copied Horovitz's translation incorrectly.

[12]Fehérvári, p. 250. "Udhaynah" is the Arabic version of "Odenatus," the name of the ruler of Palmyra (Tadmur) who was killed in about A.D. 267.

[13]M. Gawlikowski, *Monuments funéraires de Palmyre* (Warsaw, 1970). According to Gawlikowski, p. 51, in the second century the funerary temple replaced the tomb tower in the preference of leading Palmyrene families; from then on it constituted the sole type of surface funerary monument (as distinct from the commercially operated hypogea) constructed until the fall of Palmyra in 272 (pp. 172–176).

[14]*Ibid.*, pp. 129–146, 51.

[15]Fehérvári, p. 254, n. 67, has, however, promised a book, *The Origin of the Mihrab and Its Development Down to the 14th Century*, in which a more detailed presentation of his tombstone theory is to be expected.

[16]Horovitz, p. 261; Nöldeke, p. 52, n. 3; Sauvaget, p. 145; Serjeant, pp. 439–444. The verses are 3:38–40, 19:2, 34:14, 38:22.

[17]*EMA* I(1)², 61, 139–141; II, 211–213, 221, 308–314.

[18]Al-Balādhurī, *Futūḥ al-buldān*, ed. by M. J. de Goeje (Leiden, 1866), pp. 229–230. Creswell reported that "the site of the mosque (or of the miḥrāb)" had supposedly been indicated to ᶜUqbah in a dream. The word used by al-Balādhurī was *masjid*, however. The earliest source in which the "miḥrāb" is mentioned is Abū ᶜUbayd al-Bakrī's *al-Masālik wa'l-mamālik*, written in 460/1067–1068; see W. M. de Slane, *al-Maghrib fī dhikr bilād Ifrīqiyah wa'l-Maghrib* (Algiers, 1857), pp. 22–23. The anonymous author of *Kitāb al-istibṣār*, compiled in 587/1191, reported a different version of ᶜUqbah's dream, in which the miḥrāb is said to have been established; he appears to have taken this story from ibn al-Raqīq (d. after 418/1027–1028), whose work is now lost. See S. Z. Abdel-Ḥamīd, ed., *Kitāb al-istibṣār fī ᶜajāᵓib al-amṣār* (Alexandria, 1958), p. 114. This version is the one reported in the later sources mentioned by Creswell, *EMA* I(1)², 61, n. 7.

[19]De Slane, pp. 22–24. According to E. Lévi-Provençal, in his article on al-Bakrī in *EI*², the chronicler's basic source of information on Ifrīqiyah, which he never visited, was the lost *al-Masālik wa'l-mamālik* of al-Warrāq, who had migrated from Kairouan to Córdoba in the time of al-Ḥakam II (350–366/961–976), but there is no specific citation in the text where these events are reported. See also de Slane's introduction.

[20]G. Marçais, *Manuel d'art musulman*, vol. 1 (Paris, 1926), 22; and *EMA* II, 308.

[21]K. O. Dalman, *Neue Petra-Forschungen und der heilige Felsen von Jerusalem* (Leipzig, 1912), p. 128, fig. 81; *EMA* I(1)², 100, fig. 374 (following p. 308), II, pl. 120a; *Propyläen Kunstgeschichte*, 2nd ed., vol. IV (Berlin, 1973), fig. 22.

[22]*EMA* I(1)², fig. 35 (facing p. 114); A. Welch, *Calligraphy in the Arts of the Muslim World* (New York and Austin, 1979), p. 45.

[23]*EMA* 2, pl. 101b.

[24]*Ibid.*, pp. 335–336, 348–349, pl. 122. Creswell pointed out that the lining of the latter miḥrāb belongs to Lājīn's restoration of 696/1296.

[25]*Ibid.*, pl. 119e.

[26]*Ibid.*, p. 100.

[27]E. Herzfeld, "Die Genesis der islamischen Kunst und das Mshatta-Problem," *Der Islam*, vol. 1 (1910), 42, fig. 5.

[28]*EMA* II, pl. 88a, top right.

[29]*Ibid.*, I(1)², 100. There is an additional Kūfic inscription on the three outer sides of the niche frame, but it has not yet been deciphered, nor do the published photographs permit close analysis of the paleography.

[30]The relevant inscriptions occur in and above the eastern niche and above the western niche on the first platform, *EMA* II, pls. 80d, 81a–b, and pp. 296–304; see also S. Flury, *Islamische Schriftbänder Amida-Diarbekr XI. Jahrhundert* (Basel and Paris: 1920), pl. IA.

[31]See *Catalogue générale du Musée Arabe du Caire: Stèles funéraires* (10 vols.; Cairo: 1932–1942). The stele of Yaḥyā ibn Ḥammād of 243/857 is no. 469 (inv. no. 1271), p. 35 and pl. XII in vol. II (1936).

[32]*EMA* II, pl. 121d. This miḥrāb belonged to a chapel mosque contained in House II, a large villa excavated in the southern portion of old Sāmarrā in the 1930s; see Iraq Government Department

of Antiquities, *Excavations at Samarra 1936–1939*, vol. 1. *Architecture and Mural Decoration* (Baghdad, 1940), 14, pl. LVII.

[33]Cf. Flury, "Das Schriftband an der Türe des Maḥmūd von Ghazna (998–1030)," *Der Islam*, vol. 8 (1918), 216–217.

[34]Ibn ʿAbd al-Ḥakam, *Futūḥ Miṣr*, ed. by C. C. Torrey (New Haven, 1922), pp. 238–239; the source for both versions was ibn ʿUfayr (146–226/764–841).

[35]For the citations, see *EMA* I(1)², 150, n. 1. The earliest source mentioned by Creswell is Murtaḍī (or Murtaḍā) ibn al-ʿAfīf, a contemporary of the Ayyūbid al-Malik al-Kāmil (615–635/1218–1238). Unfortunately, the Arabic text is lost, and the only version known is a French translation made in the seventeenth century. There it is said that, according to "several authors," the first who installed a *jubé voûté* [sic] in the Mosque of ʿAmr ibn al-ʿĀs was Qurrah ibn Sharīkh; P. Vattier, trans., *L'Égypte de Múrtadi fils dú Gaphiphe* (Paris, 1666; reprint ed. by G. Wiet, Paris, 1953), pp. 253–254. Although the text is somewhat garbled—whether through the fault of the copyist of the lost manuscript or of the translator it is impossible to say—one of these authors can be identified as al-Ḥārith ibn Miskīn (d. 250/865), a *qāḍī* of Egypt; see Vattier, reprint ed., p. 130, and R. Guest, ed., *The Governors and Judges of Egypt or Kitāb al-Umarāʾ (el-Wulāh) wa Kitāb el-Quḍāh of el-Kindī* (Leiden and London, 1912), p. 25. Ibn Duqmāq, *Kitāb al-intiṣār li-wāsiṭah ʿiqd al-amṣār*, ed. by K. Vollers, vol. 1 (Cairo, 1893), 62, cited only the thirteenth-century author ibn Saʿīd. Al-Maqrīzī, *Kitāb al-mawāʿiz waʾl-iʿtibār bi dhikr al-khiṭaṭ waʾl-athār*, vol. 2 (Būlāq, 1853), 247, relied on ʿAbdullāh ibn Lahīʿah (69–174/715–791), who quoted from "our sheikhs." Ibn Taghrībirdī, *al-Nujūm al-zāhirah fī mulūk Miṣr waʾl-Qāhirah*, ed. by T. G. J. Juynboll and B. J. Matthes, vol. 1 (Leiden, 1855–1857), 76, and al-Suyūṭī, *Kitāb ḥusn al-muḥaḍarah fī akhbār Miṣr waʾl-Qāhirah*, vol. 2 (Cairo, 1860), 135, cited both ibn Lahīʿah and al-Layth ibn Saʿd (94–175/713–792), considered a much more reliable source; Guest, pp. 29–32. The ultimate authorities for the story are thus these two figures, both members of the generation immediately following the reported event. According to Sauvaget, pp. 17–18, the medium through which their information was most probably transmitted was *Akhbār masjid ahl al-rayah al-aʿzam*, a history of the Mosque of ʿAmr ibn al-ʿĀs written by al-Kindī (283–350/897–961); it is now lost. See also Guest, p. 9.

[36]Sauvaget, p. 148.

[37]See ibn Duqmāq, I, 64, where the discussion ends with the expression "according to al-Kindī." The source was thus probably the lost history of the mosque cited n. 35 *supra*; see also Guest, p. 9.

[38]Al-Maqrīzī, II, 249. The expression "according to al-Kindī" was, however, omitted both here and from ibn Taghrībirdī's similar account, I, 79. Al-Suyūṭī did not include the story at all, despite Creswell's reference, *EMA* I(1)², 150, nn. 1–2.

[39]Ibn ʿAbd al-Ḥakam, p. 131; the source seems to have been either Yaḥyā ibn Bukayr (c. 155–231/772–846) or ibn ʿUfayr. According to Guest, pp. 55–56, the traditions of ibn Bukayr reported by al-Kindī in another work, *Kitāb al-umarāʾ*, all go back to al-Layth ibn Saʿd or, less often, to ibn Lahīʿah. Ibn ʿUfayr's range of sources was much broader.

[40]There may have been a miḥrāb even in the earliest mosque on this site, for al-Dīnawarī (d. 281–282/894–895 or before 290/902–903) reported, without naming a source, that the Khārijite assassin ʿAbdullah ibn Malik al-Saydawī stationed himself in front of the miḥrāb when he made his attempt on the governor in 40/661; see al-Dīnawarī, *Akhbār al-ṭiwāl*, ed. by V. Guirgass (Leiden, 1888), pp. 217–218. For skeptical assessments of the reliability of this report, see "Ibn Muldjam" and "Khāridjites" in *EI*².

[41]This Kaʿb was most probably Kaʿb ibn Juʿayl al-Taghlabī (d. after 59/679), an intimate of Muʿāwiyah whose poetic works were quoted several times by ibn al-Faqīh. Another possibility is Kaʿb ibn al-Malik (d. 50 or 53/670 or 673), a partisan of the Quraysh who transmitted aḥādīth to ibn Hishām and al-Wāqidī through his sons ʿAbdullāh and ʿAbd al-Raḥmān.

[42]This quotation has been drawn from an unpublished manuscript of ibn Shākir (d. 764/1363), *ʿUyūn al-tawārīkh*, Ar. 638, Bibliothèque Nationale, Paris, translated in M. Quatremère, *Histoire des sultans mamlouks de l'Égypte*, vol. II (Paris, 1842), part I, 262–263. Ibn ʿAsākir is cited as the source, and indeed the same story appears in the fragment of his *Taʾrīkh madīnah Dimashq* preserved in Berlin, also unpublished; see Caetani, vol. III, part 1, 384. It does not occur, however, in important copies of ibn ʿAsākir's manuscript preserved in Damascus and Cairo. See S. Munajjid, ed., *Taʾrīkh madīnah Dimashq*, vol. II, part I (Damascus, 1934); N. Elisséeff, trans., *La description de Damas d'Ibn ʿAsākir* (Damascus, 1959); and Taʾrīkh Taymūr 1041, Dār al-Kutub, Cairo. The author

220

is grateful to Sam Gellens for the information that the last is a copy of the autograph manuscript preserved in the library of al-Azhar University.

Another anecdote from ibn ʿAsākir is also pertinent. He cited his teacher al-Akfānī (d. 524/1129) as one source for a report that, when al-Walīd personally launched the demolition of the Christian church in the temenos at Damascus, he set up a ladder against the miḥrāb of the altar; Munajjid, vol. II, p. 20; Taʾrīkh Taymur 1041, vol. II, pp. 21–22. Even though this report does not seem to be supported by early tradition, it is worth noting the use of the term "miḥrāb," which certainly referred in this instance to an apse. It seems a mistake, however, to assume that it necessarily referred to the apse *form*; rather, in view of the situation at the mosque of ʿAmr ibn al-ʿĀs, it is more likely that it designated a space in which certain functions were performed.

[43]See n. 19 *supra.*

[44]For example, see Sauvaget, pp. 150–151; *EMA* I(1)², 43; J. M. Rogers, *The Spread of Islam* (London: 1976), pp. 144–145. See also Abū Bakr Aḥmad al-Bayhaqī, *Kitāb al-sunan al-kubrā*, vol. III (Hyderabad, 1929–1930), 109–110; and ibn Khaldūn, *Muqaddimah*, ed. by M. Quatremère, vol. III (Paris, 1858), 62–63. Some of the ideas about the maqṣūrah incorporated here, along with accompanying references, are owing to J. Marquardt, who presented them in a graduate seminar on the development of the early mosque conducted by the author at the University of California, Los Angeles, in 1978.

[45]Al-Samhūdī, *Kitāb wafāʾ al-wafā bi akhbār Dār al-Muṣṭafā*, vol. I (Cairo, 1908), 362, gave several sources for this report, including Mālik ibn Anas (95–179/715–795), ibn Zabālah (writing in 199/814), and ʿUmar ibn Shabbah (172–262/789–876). Ibn Zabālah relied in part on descendants of al-Ṣāʾib ibn Khabbāb, who had been in charge of the work on the maqṣūrah.

[46]The texts related to this sequence of events seem, at first glance, to be much more confused and contradictory than the account given here suggests, especially reflecting uncertainty whether it was Muʿāwiyah or Marwān who first adopted the maqṣūrah; see, for example, ibn Khaldūn, II, 62; and al-Samhūdī, I, 362–363. It is relatively easy to sort out these apparent contradictions, however. Al-Balādhurī, p. 6; al-Ṭabarī, *Taʾrīkh al-rusūl wa'l-mulūk*, ed. by M. J. de Goeje, 2e série, vol. I (Leiden, 1879–1901), 70; ibn al-Athīr, *al-Kāmil fī'l-taʾrīkh*, vol. III (Beirut, 1965), 446; and ibn Taghrībirdī, I, 141, all reported that the first maqṣūrah in the Great Mosque at Medina had been established by Marwān in 44/665. Al-Yaʿqūbī, *Taʾrīkh*, M. T. Houtsma, vol. II (Leiden, 1883), 265, ascribed the responsibility to Muʿāwiyah. The former was, however, governor on behalf of the latter, and there is thus no real contradiction here. Of all the authors cited only al-Samhūdī named his authorities: the most relevant were Mālik ibn Anas, ibn Shabbah, and Yaḥyā ibn al-Ḥusayn (d. 277/890), the last relying on ʿAbd al-Ḥakīm ibn ʿAbdallāh ibn Ḥantab, who has so far eluded identification.

Al-Mubarrad, *al-Kitāb al-kāmil*, ed. by W. Wright, (vol. II; n.p.: n.d. [1865–1874]), 553–553; al-Dīnawarī, pp. 217–218; ibn al-Faqīh, *Kitāb al-buldān*, ed. by M. J. de Goeje, 2nd ed. (Leiden, 1967), p. 109; al-Ṭabarī, 1e série, VI, 3465; ibn al-Athīr, III, 446; ibn Taghrībirdī, I, 141; and al-Samhūdī, I, 363, also reported that Muʿāwiyah had installed a maqṣūrah in Damascus; most of them indicated the date 40/661.

[47]Al-Masʿūdī, *Les prairies d'or*, ed. and trans. by C. Barbier de Meynard, vol. V (Paris, 1861–1877), 74.

[48]Al-Balādhurī, *Ansāb al-Ashraf*, V (Jerusalem, 1936), 311, on the authority of Hishām ibn al-Kalbī (c. 120–204 or 206/737–819 or 821).

[49]Al-Balādhurī, *Futūḥ*, p. 348, on the authority of al-Walīd ibn Hishām ibn Qaḥdham, who has not yet been identified.

[50]There may even have been a maqṣūrah in the first mosque at al-Fusṭāṭ. Al-Maqrīzī, II, 247 (on the authority of Muḥammad ibn Salāmah al-Quḍāʿī, d. 454/1062); ibn Duqmāq, I, 63; and ibn Taghrībirdī, I, 76–77, described an incident that occurred during the governorship of Maslamah ibn Mukhallad (47–62/663–682), who enlarged the mosque in 53/673: The head of the shurṭah, a man named Abū'l-Ḥusayn Saʿīd ibn ʿAnnān (or ʿUthmān), was said to have died suddenly while standing behind the maqṣūrah to lead the prayers. Ibn Taghrībirdī noted, however, that some people did not accept this story. Abū'l-Ḥusayn Saʿīd was not mentioned among the three men who served as director of the shurṭah under Maslamah; Guest, pp. 38–40.

[51]Serjeant, pp. 448–449, has already recognized the relationship between the two but has drawn conclusions somewhat different from those presented here.

Origins of the Miḥrāb Mujawwaf 221

[52]*EMA* I, 97–99; Sauvaget, pp. 7–23. For Creswell's response to Sauvaget's criticisms, see *EMA* I(1)², 142–149; Creswell's reconstructed plan is to be found on p. 146, fig. 7.

[53]Sauvaget, pp. 7–39.

[54]See, for example, "Miḥrāb," *EI*¹, p. 485. Creswell proposed the Coptic *haykal* as a source, *EMA* I(1)², 148.

[55]Sauvaget, pp. 122–157; the quotation, with Sauvaget's emphasis, is on p. 149.

[56]*Ibid.*, pp. 134–137.

[57]This title was first adopted by ᶜUmar ibn al-Khaṭṭāb; for references, see "Amīr al-Muᵓminīn," *EI*², p. 445.

[58]For the mosque at Medina, see Ibn Saᶜd: *Biographien Muhammads, seiner Gefährten und der späteren Träger des Islams bis zum Jahre 230 der Flucht*, vol. III, part 1, *Biographien der mekkanischen Kämpfer Muhammads in der Schlacht bei Badr*, ed. by E. Sachau (Leiden, 1904–1940), 204; and Caetani, vol. III, part 2, 965. The ultimate source was ᶜAbdullāh ibn Ibrāhīm via ᶜAlī ibn Zayd (d. 131/747), Ḥammād ibn Salāmah (d. 169/784), and ᶜAffān ibn Muslim (169–232/784–846). ᶜAbdullāh was a resident of Medina and one of those said to have collected traditions from Abū Hurayrah; ᶜUmar ibn ᶜAbd al-ᶜAzīz in turn is said to have heard traditions from ᶜAbdullāh, probably while serving as governor in Medina. No dates for ᶜAbdullāh are available, but, as Abū Hurayrah died in 59/678–679 and as ᶜUmar left Medina in 95/712 and died in 101/720, it can be concluded that he was active in the last quarter of the seventh century and the beginning of the eighth. He thus belonged to the generation immediately following that of the event. The remaining members of the *isnād* all belonged to the intellectual circles of Basra, though some made their careers in Baghdad. The historian al-Balādhurī reported the same story, which, however, he attributed to the Caliph ᶜUthmān, ᶜUmar's successor; he did not mention his source, *Futūḥ*, p. 6.

That the mosque of ᶜAmr ibn al-ᶜĀs was paved with pebbles before Maslamah laid down reed mats was reported by ibn al-ᶜAfīf, ed. Wiet, p. 257, citing Amīr ibn ᶜUmar as ultimate source; and al-Maqrīzī, II, 248, citing ᶜĀbid ibn Hishām al-Azdī.

The story of Ziyād's pebble floor at Basra is to be found in al-Balādhurī, *Futūḥ*, p. 277; and Yāqūt, *Kitāb muᶜjam al-buldān*, ed. by F. Wüstenfeld, vol. I (Leipzig: 1866–1870), 642–643. The source for the former was Abū ᶜUbaydah Maᶜmar ibn al-Muthanna of Basra (c. 110–209/c. 728–824), who had heard the story from "some people." For Kufa, see al-Balādhurī, *Futūḥ*, pp. 276–277.

[59]This story was reported by al-Samhūdī, I, 385–386, relying ultimately on Abū Ghassān, who had personally examined and sketched Muḥammad's tomb in 193/808–809, a century after the installation of the screen.

[60]Sauvaget, p. 146; and O. Grabar, *The Formation of Islamic Art* (New Haven: 1973), p. 121.

[61]Sauvaget, p. 149.

[62]The following list has been compiled from *EMA* I(2)², where original excavation reports and related texts are cited:

Location	Date	Width	Depth	EMA References
Khirbat al-Minyah	93–96/712–715	1.62 m.	1.12 m.	383–385, pl. 67b
Jabal ᶜUsays	95–96/714–715	1.07	1.37	476, pl. 77f.
ᶜAnjār	95–96/714–715	1.93		480–481, plan facing 478
Buṣrah (mosque of ᶜUmar)	101–102/720–721	.95	.62	489, pl. 80a, fig. facing 485
Qaṣr al-Ḥayr al-Sharqī	110–112/728–730	1.70	.70	531–532*
Khirbat al-Mafjar (public mosque)	121–125/739–743	2.05	1.02	559, 575–576, 640, pl. 103e
Khirbat al-Mafjar (palace mosque)	121–125/739–743	2.05	1.02	275, 553–554, 575–576, 640, pl. 102d
Mshatta	125–126/743–744	1.62	1.48	582–584, 623, 641, pl. 115b

222

Ḥarrān (Great Mosque)	126–132/744–750	2.23	1.95	644–647, pl. 140c–d
Quṣayr al-Ḥallābāt	before 132/750	1.20		503–504
Umm al-Walīd	before 132/750	**		505–506
Khān al-Zabīb	before 132/750	1.48	1.80	505

*The most recent exploration of this site is reported in Grabar et al., *City in the Desert: Qasr al-Hayr East* (Cambridge, Mass.: 1978), pp. 50–51. The estimated height to the springing of the arch was 2.30 m.

**No dimensions are given, but the plan on p. 505 shows a niche of exceptional narrowness and depth.

[63]Sauvaget, p. 153.

[64]*Ibid.*, pp. 154–155.

[65]The most complete history of the Prophet's minbar at Medina is to be found in al-Samhūdī, I, 274–288. Other references for early use of the minbar in the mosque were collected by C. H. Becker, "Die Kanzel im Kultus des alten Islam," in C. Bezold, ed., *Orientalische Studien, Theodor Nöldeke zum siebzigsten Geburtstag*, vol. I (Giessen: 1906), 331–351. See also R. Mielck, "Zur Geschichte der Kanzel in Islam," *Der Islam*, 13 (1923), 109–112; and F. Meier, "Der Prediger auf der Kanzel (Minbar)," *Studien zur Geschichte und Kultur des Vorderen Orients: Festschrift für Bertold Spuler zum siebzigsten Geburtstag*, ed. by H. R. Roemer and A. Noth (Leiden, 1981), pp. 225–248. For the latter reference and several valuable suggestions the author is grateful to Professor J. van Ess; thanks are also owing to Professor G. Fehérvári for his helpful comments on this study.

[66]For Muꜥāwiyah, see al-Ṭabarī, Iᵉ série, VI, 3255. For ꜥAlī, see al-Mubarrad, II, 550; al-Balādhurī in Caetani, X, 326; al-Ḥarīrī, *Durrat al-Ġawwāṣ*, ed. by H. Thorbecke (Leipzig, 1871), p. 133; and ibn al-Athīr, *Usd al-ghābah fi maꜥrifat al-saḥābah*, vol. V (Cairo, 1869–1871), 96.

[67]See ibn Duqmāq, I, 63–64; al-Maqrīzī, II, 247; ibn Taghrībirdī, I, 78; and al-Qalqashandī, *Ṣubḥ al-aꜥshā*, vol. III (Cairo, 1914), 338.

[68]Grabar, p. 121.

[69]Al-Samhūdī, *Khulāsah al-wafāʾ bi akhbār Dār al-Muṣṭafā* (Būlāq, 1869), 114–115, 132, 135. Among the ultimate authorities cited are Mālik ibn Ānas, Khārijah ibn ꜥAbdallāh ibn Kaꜥb ibn Mālik, and Muḥammad ibn ꜥAmmār, on the authority of his grandfather, who had probably witnessed the reconstruction. Khārijah was a grandson of Kaꜥb ibn Mālik (see note 41 *supra*) and thus probably also a contemporary witness.

[70]Sauvaget himself recognized the commemorative function of the miḥrāb at Medina and implied similar connotations in discussion of the mosque in general, pp. 84, 111, 117–121, 155. Nevertheless, he interpreted the details cited here as factors limiting the size and functioning of the supposed throne apse, rather than as clues that would help to explain the adoption of the miḥrāb mujawwaf.

[71]The ꜥanazah was also carried before each of the first three caliphs and subsequently before the governors and imāms at Medina, where it remained until al-Mutawakkil had it brought to Sāmarrā in the ninth century. See al-Balādhurī, *Ansāb*, ff. 115ᵛ, 345ʳ, quoted in al-Ṭabarī, *Introductio*, p. ccclxxx; al-Samhūdī, *Wafāʾ*, II, 2 (on the authority of al-Wāqidī, 130–207/747–823); al-Ṭabarī, Iᵉ série, III, 1281; and al-Bukhārī, *Saḥīḥ*, vol. I, part 1 (Cairo, 1902), 106.

[72]After this study had been substantially completed, the author was privileged to hear a paper by Dr. Klaus Brisch, read at the Deutsches Archäologisches Institut in Cairo on the occasion of its seventy-fifth anniversary in October 1982, in which he argued that portable wooden miḥrābs of the Fāṭimid period were used to define the sutrah for individual worshipers. Considerations related to the sutrah may also have underlain the multiplication of miḥrābs in single mosques and the adoption of miḥrābs in private houses, both of which seem to have taken place in the late ninth century. For miḥrābs on piers flanking the main aisle of the mosque of ibn Ṭūlūn, Cairo, and an approximately contemporary example from the Great Mosque of Damascus, see *EMA* II, 349, 356, pl. 123a–c, fig. 257 facing p. 250. For miḥrābs from a private house in al-Qaṭāʾī and a lavish residence in Sāmarrā, see *EMA*, II, 366, pl. 123d, and note 32 *supra*.

[73]In the tenth century ibn ꜥAbd Rabbihī, *al-ꜥIqd al-farīd*, vol. IV (Cairo, 1935), 286, reported seeing a plank fastened to the top of the Prophet's minbar in the Great Mosque at Madīnah, to prevent anyone else from sitting there. It is difficult to date the inception of this practice, however. According to al-Samhūdī, *Khulāsah*, p. 120, Abū Bakr always positioned himself one step down from the top of the Prophet's stool, with his feet on the lower step, and ꜥUmar one step below that, with his feet on the ground; then ꜥUthmān, in the seventh year of his caliphate, took his seat on the

top. The ultimate source for this story was ibn ʿAbd al-Zanād, who was born in Medina in 100/718 and died in 174/790 in Baghdād, presumably in the service of the ʿAbbāsid court. It was repeated by al-Yaʿqūbī, II, 142, 157–158, 187. Caetani considered the report to be tendentious but noted that it can be taken to reflect popular views at the time of its initial circulation, III, 120, n. 1; VII, 9–12 (see also Becker p. 235, n. 4). If he is correct, then the notion that Muhammad's own seat should be left vacant was already well established by the late eighth century (this interpretation is quite different from that offered by Caetani). In the same connection Meier, p. 236, has cited the early Iranian mystic al-Ḥakīm al-Tirmidhī (d. 285/898), who dreamed of following Muhammad as he climbed the minbar at Tirmidh and of sitting at his feet one step down from the top.

There are numerous reports in the texts relating to the question of sitting and standing on the minbar, especially to changes in procedure introduced by Muʿāwiyah; the precise place on the minbar is rarely, if ever, mentioned, however. In this author's opinion, the fact that it seems not to have become an issue is an indication that the practice of leaving the top vacant was already well established in the time of Muʿāwiyah, who raised the minbar of the prophet on six additional steps. For references, see note 65 *supra* and "Minbar," *EI*[1].

Nevertheless, as Meier has demonstrated in his thoroughly documented study, the custom of leaving the top of the minbar vacant seems never to have been officially prescribed and was ignored at Mecca on at least one important occasion before the twelfth century.

[74]"Miḥrāb," *EI*[1], p. 485.

[75]See E. Whelan, *The Public Figure: Political Iconography in Medieval Mesopotamia*, unpublished doctoral dissertation, Institute of Fine Arts, New York University, 1979, pp. 90–91, 804–805, 837–838.

[76]For the use of the ḥarbah by Muʿāwiyah, Ziyād ibn Abīhī, and ʿUmar ibn ʿAbd al-ʿAzīz, see al-Yaʿqūbī, II, 276; ibn al-Ṭiqtaqā, *Taʾrīkh al-duwal al-islamiyyah* (Beirut, 1960), p. 106; al-Damīrī, *Ḥayāt al-hayāwān al-kubrā*, part 1 (Cairo, 1898), p. 52; al-Ṭabarī, 2ᶜ série, I, 77, 79; and ibn al-Jawzī, *Manāqib ʿUmar ibn ʿAbd al-ʿAzīz*, ed. by Becker (Berlin, 1900), p. 34. For the ʿAbbāsids, see al-Ṭabarī, 3ᵉ série, I, 193; II, 455, 571; V, 1437.

[77]G. C. Miles, "Mihrab and ʿAnazah: A Study in Islamic Iconography," *Archaeologia Orientalia in Memoriam Ernst Herzfeld* (Locust Valley, N.Y., 1952), pp. 156–171. Both in this work and in the article "ʿAnaza," *EI*[2], Miles treated the terms "ḥarbah" and "ʿanazah" as interchangeable. Nevertheless, in the texts cited here, a distinction seems to have been observed. Ḥarbah, or ḥirāb, was used for the spear that served as a symbol of authority in pre-Islamic Arabia and continued to be used in the same way for the first two centuries of Islam. ʿAnazah was generally reserved for the specific spear that belonged to the Prophet. The caliphal inscriptions on the coin thus suggest that the associated image is that of the ḥarbah.

[78]Miles, "Mihrab and ʿAnazah," pp. 161–162. Although Miles by no means limited his quest for sources to Greek imperial coins, his other suggestions, based on linguistic and architectural evidence that has already been dealt with in this study, need not be pursued here.

[79]See Rhodokanakis, *loc. cit.*; and "ʿAnaza," *EI*[2].

[80]Ibn ʿAbd Rabbihī, III, 285. It should be pointed out here that the earliest surviving complete decorated miḥrāb, found in the mosque of al-Manṣūr at Baghdad and possibly dating from his reign (136–158/754–775) or that of Hārūn al-Rashīd (170–193/786–809), is distinguished from every other known miḥrāb by a column of superimposed vases entwined with richly curling palmette and vine scrolls, which is carved on the vertical axis of the interior. This decoration may have been intended as a reference to the Prophet's staff or as a backdrop for a similar object. For illustrations, see *EMA* II, 34, fig. 26, pl. Ia–e.

A specific relic of the Prophet—another staff, called the qaḍīb, on which he leaned while addressing the congregation—was associated with the minbar. It was also used by his immediate successors at Medina, and the practice of planting a staff on the minbar was emulated elsewhere. See al-Samhūdī, *Khulāsah*, pp. 113–114; and Becker, *op. cit.*, pp. 337, 343–344, 349–351.

[81]For a general summary of his life, with references, see "Muʿāwiyah," *EI*[1], especially pp. 619–620.

[82]See Grabar, "The Umayyad Dome of the Rock in Jerusalem," *Ars Orientalis*, III (1959), 33–62; and M. L. Bates, "The 'Arab-Byzantine' Bronze Coinage of Syria: An Innovation by ʿAbd al-Malik," *A Colloquium in Memory of George Carpenter Miles (1904–1975)* (New York, 1975), pp. 16–27, and references given there.

14
AL-MA'MUN'S BLUE KORAN?
Jonathan M. Bloom

Magnificent single leaves from a Koran written in gold kufic on deep blue vellum and attributed to the patronage of the 'Abbasid caliph al-Ma'mun, who supposedly ordered the manuscript for the tomb of his father, Harûn al-Rashîd, at Mashhâd, have been turning up in the West since the beginning of the century[1]. They have become prized in American and European collections and repeatedly exhibited and published (fig. 1). The occasion of Dominique Sourdel's sixty-fifth birthday is a fitting moment to reconsider the attribution of these pages to this remarkable caliph whose religious policies Professor Sourdel has examined so thoroughly[2]. Neither the style of the writing nor the unusual technique of these pages points directly to ninth century Iran, and only circumstantial evidence can be adduced to support the attribution. In 1977, Christie's reported seeing "some other leaves clearly from the same Qur'ân manuscript, loose, within a fine sixteenth-century dark brown tooled morocco binding from Persia, obviously made for a section of the same Qur'ân." "According to documentary evidence, it has been stated that the Qur'ân was sent by the Abbasid Caliph al-Ma'mûn (813-833) to the Great Mosque at Mashhad"[3]. From this one could only have concluded that the manuscript had never left Iran and had been rebound in the sixteenth century, were it not for the great 1976 exhibition of Korans at the British Library and other shows held for the Festival of Islam in London that year.

1. Leaves are in the Chester Beatty Library, Dublin ; the collection of Sadruddin Aga Khan, Geneva ; two other private collections in Geneva ; the Harvard University Art Museums, Cambridge, Mass. ; the Museum of Fine Arts, Boston ; the Institut du Monde Arabe, Paris ; private collections in London and in Saudi Arabia ; in addition, a number of pages have passed recently through the art market : e.g., *Sotheby's* (London) 15 October 1984, lot 220 and *Sotheby's* (Geneva) 25 June 1985, lot 11.
2. Dominique Sourdel, « La Politique religieuse du caliphe 'Abbaside al-Ma'mun » *Revue des études islamiques* 30 (1962) : 27-48.
3. Christie's (London), *Khurasan* November 9, 1977, lot 66.

JONATHAN M. BLOOM

That exhibition included a page of a "nearly complete" blue Koran manuscript from the National Institute of Art and Archaeology in Tunis. Martin Lings and Yasin Safadi, the authors of the exhibition catalogue, attributed the manuscript to the early 4th/10th century in Qayrawan[4]. Another show across the Thames at the Hayward Gallery simultaneously exhibited a double page from the same manuscript and attributed it to "Mesopotamia, 9th century"[5]. No wonder Christie's could not untangle the web of attributions when it concluded, "From this evidence, it would suggest an early Persian provenance, but the illumination would appear to be of eastern [read "western"] Islamic influence. We are reminded that Kairouan in the ninth century was an important centre for Quranic learning and manuscript production, the caliph al-Ma'mûn well known for his patronage of the arts and the court at Baghdad for the dominance and influence of its Persian viziers and courtiers"[6].

The manuscript was also said to have other peculiarities. "The blue and gold color scheme is apparently unique, and though the Arabic script moves from right to left, the pages of this Qur'an — unlike almost all others — were turned from left to right, the left-hand page preceding the right"[7]. Given these oddities — blue ground, gold writing, and reverse pagination —the pages would seem to demand special attention and given their extraordinary beauty and attribution to al-Ma'mûn, it is surprising that they have never received it. If they had, close examination would have revealed that almost everything that has been said about them is false : the manuscript reads like any normal Arabic manuscript, its color scheme is unusual but not unique, and it was never associated with Harun al-Rashid's tomb at Mashhad.

All of the pages said to come from this manuscript share common characteristics : page size, ruling, average number of letters per line and words per page[8]. Silver marks punctuate the text : each verse ends with a round marker ; every fifth verse terminates with a ha', the abjad (alphabetic) numeral five. Tens are similarly marked by abjad[9]. Other silver markers divide the text into thirtieths and fractions of thirtieths[10].

4. Martin Lings and Yasin Hamid Safadi, The Qur'an (London, 1976), p. 25, no. 11.
5. Arts Council of Great Britain, The Arts of Islam (London, 1976), p. 316, no. 498.
6. Christies Nov. 9, 1977, lot 66.
7. Anthony Welch and Stuart Cary Welch, Arts of the Islamic Book : The Collection of Prince Sadruddin Aga Khan (Ithaca and London, 1982), pp. 20-22. The authors derive this "reverse" pagination from Lings and Safadi, op. cit., p. 25, no. 11, "In its normal position in this Qur'ân, the left-hand folio precedes that on the right".
8. Pages vary between 27.6 by 35 cm and 31 by 41 cm due to trimming of the supple parchment dyed blue apparently with indigo. An average of 17.5 letters fills each of the 15 lines, although individual counts may vary enormously. None of the pages shows any evidence of voweling, but occasionally diacritical marks have been inconsistently added.
9. Clearly visible on folio 1 b line 2 of the Chester Beatty examples, where the letter sad indicates the end of the sixtieth verse. Illustrated in A.J. Arberry, The Koran Illuminated (Dublin, 1967), no. 4.
10. The verso of the Harvard University folio is marked with a marginal silver rosette keyed to the end of 2:231, itself marked by a gold disk. Under ultraviolet light enough of it is visible to see that it marks three-quarters of a thirtieth.

Virtually all of the pages dispersed in European and American public and private collections contain text from Koran chapters 2, 3, or 4[11]. Only a few published pages, particularly those from Tunisian collections, contain text from other portions of the Koran[12]. In no case is text duplicated and the gaps between extant sections of text are consistent with a logical sequence of pages. Thus, the pages must have come from a once-coherent manuscript which was subsequently divided and misarranged. Extrapolating from the published leaves suggests the original manuscript had approximately 650 folios. Adjacent text pages are known only through the Beatty folios. The lack of catchwords to help assemble the folios may have led to the miscollation that in turn led to the spurious hypothesis that the manuscript was paginated in reverse. Originally, the manuscript was paginated like any other Arabic manuscript.

Manuscripts of the Koran on colored grounds are uncommon but not unusual. A page from a kufic Koran in the Freer Gallery was decorated with blue outside the reserve panels surrounding dark ink letters, and a leaf in the Metropolitan Museum of Art was prepared in red[13]. Gold writing was relatively common for medieval Korans, to judge from the contents of the libraries of Qayrawan and Istanbul[14]. The books of the Manichaeans, the books of al-Hallaj's followers, and the poems of al-Mu'tamid were all written in gold[15]. In 403/1013, 1,298 Koran manuscripts, many written in gold, were taken in bound volumes and chests from the Fatimid palace to the Mosque of 'Amr[16]. Sixty years later, 2,400 Korans in chests (rab'a), many written in gold and silver, were found in the treasury of books when hungry troops

11. In tabular form :
2: 57- 61 Beatty Library
2: 61- 65 Beatty Library
2: 93-100 Beatty Library
2:148-155 Prince Sadruddin Aga Khan, Geneva
2:190-194 Private collection, Geneva
2:229-233 Harvard University Art Museums
2:261-264 Khalili Gallery, London
2:282- Private collection, Geneva
2: 47- 55 Museum of Fine Arts, Boston
3:181- 88 sold at Sotheby's, Geneva (25.6.85)
4: 8- 12 Institut du Monde Arabe, Paris.
12. For example, Sotheby's (London), 16 April 1984, lot 147 contains Koran 18:82-90 ; a double page from the National Institute of Archaeology and Art in Tunis (Lings and Safadi, *op. cit.*, p. 25, ill. 11) contains text from Koran 31, 32 and 34 ; and a page from the National Library in Tunis (*The Arts of Islam,* no. 498) has text from Koran 33.
13. Esin Atil, *Art of the Arab World* Washington, 1975), no. 2 and Metropolitan Museum of Art 40.164.1, summarily published by Hannah E. McAllister, "An Aquisition of Leaves from Early Korans", *Bulletin of the Metropolitan Museum of Art* 36/8 (August 1941) : 165.
14. For example, Istanbul, Nurosmaniye library no. 27, illustrated in Martin Lings, *The Qur'anic Art of Calligraphy and Illumination* (London, 1976) and Lings and Safadi, nos. 16-19.
15. Adam Mez, *The Renaissance of Islam* (Patna, 1937), p. 175.
16. Al-Maqrizi, *Khitat* (Cairo, 1853) 2:350.

looted the Fatimid palace. Bound volumes (*khitmat*) of the Koran written in gold on blue were among them [17].

F.R. Martin, the great collector and diplomat, first mentioned the manuscript in his 1912 book, *The Miniature Painting and Painters of Persia, India and Turkey* [18]. He wrote that in Constantinople he had recently acquired leaves from the Koran which was written on blue vellum. It had been commissioned by the caliph al-Ma'mun for the tomb of his father, Harun al-Rashid, at Mashhad, where he is buried under the same dome as Imam Riza, who was poisoned by al-Ma'mûn. Blue was the color of mourning in Islam and was therefore appropriate. Scholars such as T.W. Arnold and Adolf Grohman not only accepted Martin's unsupported attribution but embellished it [19], and modern scholars, dealers, and connoisseurs have continued to repeat it until the appearance of the Tunisian pages. Then they tried to reconcile two irreconcilable opinions. "If the manuscript was ordered by al-Ma'mun, it must have been produced in North Africa, whence it never left or to which it was later returned [20]".

As early as 1956, Ibrahim Shabbûh noticed that the manuscript matches the description of the very first item in the inventory of manuscripts contained in the library of the Great Mosque of Qayrawan in 693/1293, a Koran in seven large sections all contained in an aloeswood case decorated with copper inlaid with gold [21]. Each section was bound in tooled leather and wrapped in silk. Every page of dark vellum had five lines of gold kufic writing. The chapter and verse markers as well as the marginal numbers were done is silver. One only had to emend the inventory entry to read "fifteen" lines instead of "five" — as easy a slip in Arabic as it is in English — to recognize the pages under consideration.

The most plausible hypothesis to explain this is that the complete seven-volume manuscript was in Qayrawan in the late 7th/13th century and subsequently broken up ; most of it remained in Qayrawan, but the first of the seven volumes, which would have ended about Koran 4:55, must have been taken elsewhere eventually to be dispersed among discerning connoisseurs. In the late 10th/16th century, the first volume passed into Ottoman hands and they made its "sixteenth-century 'Persian' tooled leather binding" in Istanbul. Martin, who purchased manuscripts from the imperial collections, bought the manuscript, took it to Persia and then to Europe, and eventually sold it page by page, having disguised its immediate provenance

17. Al-Maqrizi, *Khitat* (Cairo, 1853) 1:408 and al-Qadi al-Rashid b. al-Zubayr, *al-Dhakha'ir wa'l-Tuhaf* (Kuwait, 1959), 255, § 383.

18. (London, 1912), pp. 106, 141 n. 83.

19. T.W. Arnold and Adolf Grohman, *The Islamic Book* (Paris, 1929), p. 20.

20. A. Welch, *Calligraphy*, 49 n. 3.

21. Ibrahim Shabbûh, "Sijil qadîm li-maktaba jâmi'al-qayrawân;" *Revue de l'institut des manuscrits arabes* 2 (1956) : 345. David James was apparently the first European scholar to connect the Tunisian and Beatty pages : *Korans and Bindings from the Chester Beatty Library* (London, 1980), p. 22.

with a romantic Persian attribution. The upper left recto of the leaf in the Harvard University Art Museums is stamped with a violet customs stamp, indicating that the page passed through Persian customs in 1902 (fig. 1)[22]. One assumes that the stamp records when the page left Persia and that it had spent time there. This hypothesis at least fills in the later history of the manuscript, but it still leaves unresolved its place of production.

The script of the leaves exemplifies what François Déroche has labeled group D IV in his classification system based on the Koran manuscripts in the Bibliothèque Nationale[23]. Groupe D IV also includes manuscript Arabe 336 which carries a waqf deed of 329/940-41[24]. Wisely, Déroche did not attempt to pin down where the script came from, since both calligraphers and manuscripts traveled easily in the medieval Islamic world. However, a previously unnoticed feature of the blue manuscript gives it an unmistakably western origin. This is the Maghribi system of *abjad* used to mark the text. The letter used to mark verse 60 on folio 1b of the Chester Beatty blue pages is a *sâd*, which is only used for the number sixty in the Maghribi system. In the Muslim east, sixty would be represented by *shîn*, and ninety by *sâd*. Ninety in the Maghribi system is *dâd*[25]. Two illustrations from *La Civilisation de l'Islam classique* by Dominique and Janine Sourdel neatly illustrate the point : figures 203 and 205 show respectively a fourth/tenth-century Iraqi astrolabe made by Ahmad b. Khalaf in the Bibliothèque Nationale and an Andalusian one in the Germanisches Museum, Nuremberg, which was made in 472/1079. The Iraqi astrolabe uses the eastern *abjad* system to mark the degrees on the circumference while the Andalusian astrolabe uses the western system. Thus, there can be no doubt that the blue manuscript of the Koran was made in the Muslim west and stayed there for many centuries.

22. Although it is not noted, the stamp is clearly visible in the color reproduction of the page in Anthony Welch, *Calligraphy in the Arts of the Muslim World* (New York, 1979), pp. 15, 48-49. The stamp reads :

murâja'a va taftîsh shud sana 1320

"Reviewed and passed in the year 1320/1902".

As the language of the stamp is Persian, the manuscript passed through Iranian customs ; the stamp was designed with the date 13 —, leaving the tens and digits to be inserted later by hand in ink. According to the lunar hijra calendar, 1320 corresponds to 1902-3. The solar hijra calendar was officially introduced in Iran in 1925 [S.H. Taqizadeh, "Various Eras and Calendars used in the Countries of Islam", *Bulletin of the School of Oriental and African Studies* 9 (1937-38) : 916] ; according to that system, the date on the stamp would correspond to 1942, when the page must have long been out of Iran.

23. "A l'intérieur de notre groupe D, cette graphie a une allure archaïque — dont il est difficile, en l'absence de datations positives, de dire s'il s'agit d'une allure ou si effectivement D IV fait figure d'ancêtre", François Déroche, *Les Manuscrits du Coran aux origines de la calligraphie coranique* [Bibliothèque Nationale, Catalogue des Manuscrits Arabes, 2e partie : Manuscrits musulmans, tome I, 1] (Paris, 1983), p. 42.

24. Déroche, *Manuscrits,* p. 51, notes that the manuscript could be substantially earlier, but prefers a date closer to that of the waqf.

25. W. Wright, *A Grammar of the Arabic Language*, 3rd. ed. (Cambridge, 1971) 1:28 § 32 and *The Encyclopaedia of Islam,* 2nd ed. (Leiden, 1954), s.v. "Abdjad".

There is no basis for any attribution connecting the manuscript either to al-Ma'mun or to Harun al-Rashid, or to Mashhâd, or to mourning.

A more exact attribution must await publication of the fabulous manuscripts recently discovered in the Yemen[26]. However, the manuscript may be attributed to Qayrawan in the mid-fourth/tenth-century. I have argued elsewhere that the blue and gold scheme must be understood as an intentional imitation of Byzantine imperial manuscripts, which were customarily written in gold and silver on parchment dyed with murex[27]. As the Fatimids are known to have had blue Korans written in gold and as the manuscript was produced in the Maghrib, an early Fatimid date before the move to Egypt in 358/969 seems likely. It would certainly make a splendid example of early Fatimid patronage of the arts exercised to realize imperial aspirations through the visual arts[28].

26. For the moment, see the exhibition catalogue of the Dar al-Athar al-Islamiyyah, Kuwait National Museum, *Masâhif Sana'â'* (Kuwait, 1985).

27. Jonathan M. Bloom, "An Early Fatimid Blue Koran Manuscript", *Proceedings of the Second International Conference on Greek and Arab Studies* (Delphi, 1985), in press.

28. Jonathan M. Bloom, "The Origins of Fatimid Art", *Muqarnas* 3 (1985).

AL-MA'MUN'S BLUE KORAN ? 65

Index

Note: Page references in *italics* indicate illustrations. The index follows the transliteration system of each chapter, using cross-references from one spelling to another where necessary.